FROM IMPRESSIONISM
TO MODERN ART

FROM IMPRESSIONISM
TO MODERN ART

JEAN CLAY

CHARTWELL BOOKS INC.

Published by Chartwell Books Inc.
A Division of Book Sales Inc.
110 Enterprise Avenue
Secaucus, New Jersey 07094

This book was produced by the editors of Réalités
under the direction of Jean Clay

Layout by Jean-Louis Germain

Translation from the French by Arnold Rosin, revised
and edited by John P. O'Neill and Alexis Gregory

Originally published in French under the title DE
L'IMPRESSIONISME A L'ART MODERNE
copyright © 1975
This edition © 1978 by Librairie Hachette
English translation © 1978 by The Vendome Press
Inc.
Reproduction rights courtesy of S.P.A.D.E.M. and
A.D.A.G.P.

Printed in Hong Kong
by South China Printing Co.

**Library of Congress Cataloging in Publication
Data**

Clay, Jean.
 Modern Art, 1890–1918.

 Translation of De l'impressionnisme à l'art moderne.
 Bibliography: p.
 1. Art, Modern—20th century. 2. Color in art.
3. Art—Psychology. I. Title
N6490.C58913 709′.04 80-80665
ISBN 0-89009-354-7

ACKNOWLEDGEMENTS

We wish to express out thanks for the help given to us to the director of the Musées de France and to the curators of the Musées National d'Art Moderne, the Musée d'Art Moderne de la Ville de Paris, the Musée des Arts Décoratifs, the Musée du Jeu de Paume, the Musée des Arts Africains et Océaniens, the Musée de l'Homme, the Musée d'Histoire de l'Éducation, the Musée de l'Homme, the Cabinet des Dessins du Musée du Louvre, the Musée du Petit Palais, and the Musée Rodin, all in Paris, as well as to the curators of the Musées des Beaux-Arts of Besançon, Bordeaux, Dijon, Grenoble, Marseilles, and Rouen; the Musée Matisse, Nice; and the Musée de l'Annonciade, Saint-Tropez.

We also wish to thank the curators of the following museums:

Austria—Vienna: Osterreichische Galerie, Osterreichisches Museum für angewandte Kunst
Belgium—Antwerp: Musée Royal des Beaux-Arts; Brussels: Musée Royal des Beaux-Arts;
Canada—Ottawa: National Gallery of Canada
Denmark—Copenhagen: Royal Museum of Fine Arts
Germany—Berlin: Museum of Asiatic Art; Dusseldorf: Kunstsammlung Nordrhein-Westfalen; Essen: Museum Folkwang; Frankfurt: Goethe Museum; Leipzig: Museum der Bildenden Künste; Munich: Bayerische Staatsgemäldesammlung, Neue Pinakothek, Städtische Galerie; Saarbrück: Saarland Museum; Seebüll: Nolde Museum; Stuttgart: Staatsgalerie
Great Britain—London: Tate Gallery; Oxford: Bodleian Library
Holland—Amsterdam: Stedelijk Museum; Eindhoven: Stedelijk van Abbemuseum; The Hague: Gemeentemuseum; Leiden: University; Otterlo: Kröller-Müller Museum
Italy—Ferrara: Civica Raccolta d'Arte Moderna; Milan: Galleria Nazionale d'Arte Moderna; Naples: Pinacoteca; Rome: Galleria d'Arte Moderna; Turin: Museo Civico
Japan—Tokyo: Bridgestone Museum
Norway—Oslo: Kommunes Kunstsammlinger, Nasjonalgalleriet, Munch Museet
Poland—Lodz: Sztuki and Lodzi Museum
Soviet Union—Leningrad: The Hermitage; Moscow: Tretyakov Gallery, Pushkin Museum
Sweden—Stockholm: Moderna Museet, Nationalmuseum

Switzerland—Basel: Kunstmuseum; Bern: Kunstmuseum; Geneva: Musée d'Art et d'Histoire; Zürich: Bührle Foundation, Kunsthaus
United States—Buffalo: Albright-Knox Art Gallery; Cambridge: Fogg Art Museum; Chicago: Art Institute; Cleveland: Museum of Art; Columbus, Ohio: Gallery of Fine Arts; Detroit: Institute of Arts; New Haven: Yale University Art Gallery; New York: Museum of Modern Art, Solomon R. Guggenheim Museum; Oberlin: Allen Art Museum, Oberlin College; Philadelphia: Museum of Art; Washington, D.C.: National Gallery of Art

Finally, we wish to express our gratitude to the following collectors who kindly have authorized us to reproduce paintings in their collections:
Frau Hannah Höch, Berlin; Mme Anne-Marie Gillion-Crowet, Mme Giron, M. Marcel Mabille, M. Spilliaert, Brussels; Mrs. Milada S. Neumann, Caracas; M. Franco Gilardo, Dusino San Michele (Asti); Dr. Rüdiger, Graf von der Goltz, Düsseldorf; Mr. Tarello, Genoa; Sir Roland Penrose, London; Mr. Massimo Carrà, Mr. E. Jesi, Dr. Riccardo Jucker, Mr. Gianni Mattioli, Mr. Pietra, Milan; Mr. and Mrs. Armand P. Bartos, Mr. Walter P. Chrysler, Jr., Mr. Samuel S. Kurzman, McCrory Corporation, Mr. Arnold Saltzmann, Mr. and Mrs. Burton G. Tremaine, Mr. J. Slifka, New York; Mme Arp, Mme Sonia Delaunay, Mme Duchamp-Villon, Mme Nina Kandinsky, M. Boris Kochno, Mme Larionov, M. and Mme Claude Laurens, Mme de Maublanc, Mme Lucie Manguin, M. N. Manoukian, M. Molher, M. Georges Sirot, Mme Jean Walter, Paris; Mme S. Frigerio, M. Henri Gaffié, M. Pierre Lévy, France; Mrs. Boldini, Pistoia; Prof. Louis Sprovieri, Rome; Mr. Edwin Janss, Jr., Thousand Oaks, California; Mr. G. Agnelli, Turin; Mr. and Mrs. Hermann Berninger, Mr. Franz Meyer, Zürich

We also wish to thank the Beyeler Gallery, Basel; the Withofs Gallery, Brussels; the d'Offay Couper Gallery, Grosvenor Gallery, Lefèvre Gallery, Marlborough Fine Art Gallery, Piccadilly Gallery, London; Galleria Giuseppe Bergamini, Galleria del Levante, Galleria Schwarz, Milan; Leonard Hutton Galleries, Perls Galleries, New York; and the Berggruen, Denise René, Maeght, Petit, and Tarica galleries, Paris.

CONTENTS

PREFACE

"During the period I am talking about, the one that saw the blossoming of new theories, as so many spring seasons, that is, in the first fifteen years of this century. . . ." Let us add the last ten years of the preceding century: the words of the poet Georges Ribemont-Dessaignes will be but even truer. In a restlessness that made it comparable to that of the Florentine Renaissance, painting during the 28-year period from the death of Vincent van Gogh (1890) to the creation of Kazimir Malevich's *White Square on a White Background* (1918) continued to invent and reinvent with a kind of frenzy until it was caught in a compulsive dizziness suddenly suspended by the intrusion of another History (on this occasion we shall see that it was also that of painting). Radical proposals followed from month to month, even from week to week, in the frantic bidding of an artistic milieu that placed *innovation* (and not knowledge or craftsmanship) in the front rank of its values.

Apparently, the period denied Impressionism. "I don't believe," stated Wassily Kandinsky in October 1912, "that there exists today a single critic who does not know that 'Impressionism is finished.' Some know that it was the natural conclusion of the desire to be natural in art." Actually, it is now clear that the fertility of Impressionism stemmed precisely from the fact that it transgressed the naturalistic code. We shall see that Kandinsky himself—who owed his vocation to the contemplation of one of Claude Monet's *Haystacks*—had realized as early as 1895 how the material components of the painting "spoke" for themselves in the work of the older artist *beneath* what was represented.

Thus setting aside the scholastic opposition of generations (Impressionism against Post-Impressionism), one is granted in the history of modern art a linked, two-sided process: the materialization of painting and the liquidation of illusionism. From the first works of Claude Monet, Camille Pissarro, and Paul Cézanne (but we must revert to Eugène Delacroix and Jean-Baptiste-Camille Corot), painting expressed itself with increasing insistence as an *object* in which the image—even before claiming to re-present this or that aspect of the outer world—reveals the fact that it is a tributary of its physical constituents. Formerly depth and *trompe-l'oeil*, a window onto the beyond, painting henceforth admitted to being texture and treatment, pigment, space-plane, boundary.

This materialization process—that will be reenacted *ad nauseam* in the avant-garde of the 1970s when surface, canvas, folds, and tears become the subject of an endless awareness—this process that seemed to torment the entire production of the turn of the century is revealed and shown from beginning to end in the present volume as in my previous one, entitled *Impressionism* (in which the work of Paul Gauguin, Édouard Vuillard, Pierre Bonnard, the Pont-Aven School, the Nabis, and Neo-Impressionism was discussed in greater detail).

I had no desire to write here for the hundredth time a chronological, exhaustive, and nominative history in which all the facts would be organized according to the reassuring development of a genealogical tree, or the implacable linearity of a diagram. I have attempted the opposite. From the corpus of the productions of the period—already limited in this case to what the present division of cultural categories designates as *painting*, a division that by no means covers every area of pictorial practice—I have selected six of the possible axes, and shown in them some three hundred paintings in pertinent series in a presentation intended to be tabular and synchronic in order to emphasize visually—by the methodical repetition of an attitude or of a plastic arrangement—certain constant factors, certain main lines that cross and depict the art of the twentieth century at its moment of decisive crisis.

This method implies that I relativize these groupings of circumstance with their journalistic labels (Fauvism, Expressionism, Cubism, etc.) and also that I avoid a biographical emphasis: paintings by the same artist are categorized under different headings the moment the various and often contradictory effects that they produce seem more important to me than the name under which they were exhibited.

In **Chapter 1** we shall see color becoming intransitive. It frees itself from its ancient descriptive function and conquers its autonomy to become henceforth merely itself.

In **Chapter 2** the distortions of Renaissance canons reveal spacings, shapeless areas in which the pictorial substance begins to create a specific atmosphere and to work as such.

Chapter 3 is devoted to the fragmentation and atomization of representative signs that gradually cancel one another in their constituent excipient.

In **Chapter 4** painting proves itself as surface and assumes the frontality of the canvas.

Chapter 5 groups various attempts to introduce into painting such elements as manufactured and vegetable objects that are foreign to the traditional mode of elaboration. The question then is— Should the external object be inscribed in the coherence of the work? Or does the work explode under the massive, excessive presence of the imported object?

Chapter 6 studies and criticizes the static representations of movement. Here again in the spacings between the signs, one observes the emergence of new surface economy independent of any reference to empirical reality.

The tabular presentation I have chosen creates relationships and confrontations that extend beyond any geographical or national presuppositions. By juxtaposing Maurice Denis and Michael Larionov; Charles Filiger, Giacomo Balla, and Piet Mondrian; Franz Marc and Umberto Boccioni, I have enlightened them reciprocally and enhanced the formal process that associates them.

By breaking the customary genealogical schema, I have also escaped from certain tics in the history of modern art. If Georges Braque's and Pablo Picasso's researches inaugurated modern art between 1907 and 1910, they were quickly supported, rivaled, even relayed by all those who in Europe were working *at the same time as they were* at new solutions. Umberto Boccioni created his most important paintings in 1911. Frantisek Kupka executed his *Fugues* about the same time. Piet Mondrian, who was in Paris in 1912, attacked the problem of frontality with as much authority as Braque. Robert Delaunay's "target," his most advanced painting,

also dates from 1912. Marcel Duchamp's first ready-made in 1913 took the Cubist collage, then only a few months old, to the extreme. This was the period in **Russia** in which **Kazimir Malevich**, according to his own statement, conceived his *Black Square on a White Background*, a manifesto painting stating "the sensibility of the absence of the object." Soon it was the painting itself, that was questioned. The acceleration characteristic of these prodigiously rich prewar and war years can certainly not be related by a one-way chronology of "influences."

In short, my ambition is not so much to reveal by approximate reconstructions the atmosphere of the period but rather to show, from the point of view that is ours today, paintings as they were perceived as near as possible to their actual execution. It is in the works themselves, in the choice of the means that created them (form, dimension, material, treatment, etc.) that meaning and history reside, such as we rewrite it every day.

Another advantage to be found in the formula of explanation and division used here is that by emphasizing the structural and formal aspects of works, it places on a secondary level the very sterile and endless opposition of *figuration* and *abstraction* on which a good part of art criticism has been working itself to death for the past fifty years. The moment Impressionism appeared, the argument of creative subjectivity (Émile Zola speaks of "nature seen through a temperament") served to dissimulate the liberties that painters took with the conventions of "realism." From the time that systems of notation diversified—moved further and further away from the academic standard—the fiction of a "natural" vision became self-evident. The frontier became vague between the application of this or that projective code and what was offered under the label of *abstraction*.

A number of artists moreover put us on our guard. In 1946 Marcel Duchamp said: "Abstract or naturalist, this is merely a way of speaking too much in fashion today. That is not the problem: an 'abstract' painting will perhaps not be perceived at all as 'abstract' in fifty years." And Naum Gabo stated in 1937: "A materialized form being necessarily concrete, this term of 'abstraction' is in itself an absurdity. . . . [All the more so] as any work of art, even objective, is in

itself an act of abstraction, since it is not of material form, not in natural fact capable of being twice reproduced."

Refusing all claims to enclose them in a category, many of these "abstract" painters went to the point of claiming a realistic dimension for their work. Some such as Piet Mondrian explained that they simplified description to the point of reducing it to a diagram; others, that they tried to render the *imperceptible* aspects of the physical world, everything that is situated on all sides of "bodies that fall under the senses" (Blaise Pascal). "Today," wrote Paul Klee, "the relativity of the visible has become evident and we agree to see here merely a special single example in the entire universe inhabited by innumerable latent truths." In 1931 Wassily Kandinsky stated: "With time, we will clearly show that 'abstract' art does not exclude the link with nature but that, on the contrary, this link is greater and more intense than was the case in the past." El Lissitzky presented this argument in the form of a question: "Are radio waves abstract or naturalist?" To quote Henri Focillon, art became a "metaphor of the universe," which one finds as such in other areas of artistic life, when, for example, Theo van Doesburg, founder of the review *De Stijl*, wrote in 1925: "The truly exact work of art is a metaphor of the universe obtained by artistic means."

But one will see as he reads this book, especially the introduction entitled "Signs and Men," that such arguments arising in the very heart of "abstraction" to oppose a rationalist and positivist tendency to the mystical and decadent currents stemming from Symbolism still place painting as a projective space in which a discourse, foreign to its specific field, will be placed: that of science. It would take its legitimacy only from statements coming from elsewhere and whose mission it would be to record and propagate. Painting would be a *document* on something beyond itself before becoming, according to the fruitful terminology of Michel Foucault, a *monument* whose meaning, on the contrary, is to be sought in the structure of the object called painting and in its strategic position in the very core of all the means of expression.

We shall summarize the articulation of this volume and justify the absence of a chapter on "abstraction" by writing that it is based on two statements:

Every figure acts as surface.

"Abstract" or not, it operates as a textural element. In its way of producing itself as a pictorial happening, of inscribing itself in the coherence of the work as surface, it is material, gesture, and color.

All surface becomes configuration.

Any occupation of the canvas, whether or not it has an iconic reference, whether or not it wishes to *represent*, states itself as *configuration*. These figures first come into view as associative images, and with Paul Klee one easily sees that even the formless can produce meaning; "As the work acquires material, it easily happens that an association of ideas is grafted on, ready to play the demon of representational interpretation. For with a bit of imagination, any somewhat advanced arrangement lends itself to a comparison with the known realities in nature."

But the meaning proliferates also before the "representational" interpretation at the symbolical and *thematic* level (to use Gaston Bachelard's term): any material refers to other materials of which it is the sign. The work reveals the gesture that has made it as well; it is a significant trace of the energy catalyzed there.

Finally and above all, it operates as structural arrangement. Its place in the surrounding space, the interaction of the *outside setting* and of the inner form, and the organization of the latter are so many *figures* (in the geometric or choreographic sense) that constitute the very language of painting.

I have carefully divided my commentary into three levels: for the hurried reader, a sentence in large type on each double page indicates the reason for the proximities of the plates, reasons that are almost always based on a consideration of plastic and not anecdotal order; a detailed commentary to, the works shown and justifies their being grouped together. Finally, a series of introductory texts in each section sums up much of the recent data on the theory of art. The last section of the book includes a description in traditional historical terms of the art movements of the period and a bibliography listing books suggested for further study of the structuralist theories that form this volume's bases. Finally, a glossary of certain very precise and meaningful terms that are used throughout this volume has been added by the publisher.

JEAN CLAY

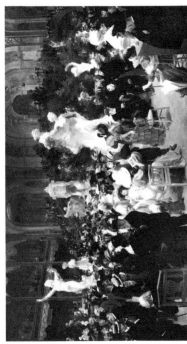

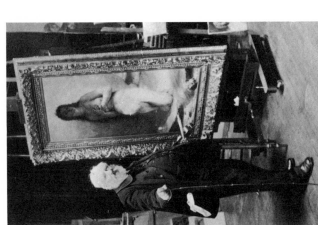

SIGNS AND MEN

At the age of twenty-two, Henri Matisse arrived in Paris from Saint-Quentin. "I showed some of my paintings to [Adolphe William] Bouguereau, who told me that I know nothing about perspective," he said. The man who advised him had been awarded the Grand Prix de Rome and was a member of the Institute, a commander of the Legion of Honor, and the most esteemed French painter at the turn of the century. In 1875 a work of his cost 30,000 gold francs. Twenty-five years later, one of Bouguereau's paintings cost 100,000 gold francs—at the same time that a miner's annual salary for 55 hours of work per week was 1,000 gold francs. Bouguereau was so busy and his work so expensive that he often said in studio jargon: "I lose five francs every time I piss." Matisse watched him in his studio "redoing" for the third time

a painting of his that had enjoyed much success at the Salon: *Le Guêpier*, the picture of a young woman pursued by Cupids. The original, which had been exhibited at the Salon, was there; just alongside it was a finished copy, and on the easel a fresh canvas on which Bouguereau was sketching a copy of this copy. Two of his friends were present. "Oh, Monsieur Bouguereau," one exclaimed, "what a conscientious man you are! What a worker!" Bouguereau replied, "Ah, yes, I work hard, but art is so difficult!"

How could there be anything in common between the old academician, covered with glory, and the young provincial listening to him hold forth? One represented the final avatar, the chlorotic limb, the degenerate finalization of a pictorial tradition four centuries old; the other was the bearer of all the potentialities and all the schisms that were to follow in the next thirty years. Only a few years were needed to reverse their roles. Bouguereau died in 1905, and his paintings remain now only as a symbol of conventional art. At the Salon d'Automne that year Matisse acquired sudden glory by leading the first battle of the century in his scandalous "Fauve" room.

In the 1890s official art had been a three-headed hydra: the École des Beaux-Arts, the Institute, and the Salon (soon there were to be two salons when Jean Louis Meissonier launched his own). All this was dominated by a small group of coopted notables who controlled both the style and the circulation of paintings. Never had so few persons been entrusted with so much responsibility for culture. This network guided thousands of youths enrolled in provincial art schools toward Paris and the city's academies, toward their teachers, and toward the Grand Prix de Rome, which was the guarantee of immortality and a never-failing income. There was no way out. At the École des Beaux-Arts, the studios functioned according to the ancient model inherited from the Renaissance. Omniscient and

irremovable masters, for instance Léon Gérome who taught there for thirty-nine years, until 1903, the eve of his death—transmitted to their pupils the laws of painting that were considered eternal. Everything was codified: subject matter (historical painting, expressive figures, and so on), technique (polished technique, balanced composition), and themes (Classical, edifying, biblical). The pupil began by transcribing engravings, moved on to drawing from plaster casts, and finished with nudes. The model's pose was inspired by Classical art. Raphael and Giulio Romano were copied (each studio had its own historical artist), as was the blackish varnish that partially dissimulated the painting.

This implacable system tolerated no deviation. "I was tortured by my teacher," wrote Odilon Redon, Gérome's pupil at the École des Beaux-Arts. "He visibly sought to inculcate in me his own way of seeing and to make me his pupil—or cause me to be disgusted by art itself. He overworked me, he was severe; his corrections were vehement to the point where his approaching my easel created suffering in my comrades. . . ." Hence the scarcely pleasant judgment that Matisse had for his fellow students at the École des Beaux-Arts: "Their paintings reminded me of the cardboard chickens served up on the stage of the Opéra-Comique. . . . Stripped of their instinct and curiosity, the poor artists were crippled forever at this period of their life, when, from the age of fifteen to twenty-five, they set out on the road."

The Salon proved this. It was an astonishing institution that witnessed the exhibition of thousands of canvases, received millions of visitors, and whose artistic contribution was practically nil. 1801: 258 exhibiting artists; 1831: 1,290; 1880: 3,200. Average visits: 400,000 in the 1880s. This painting was as much an escapism as Cecil B. De Mille's films, which also took Roman subjects, such as *Fabiola* and *Ben Hur*, and historical ones, such as *The Assassination of the Duke of Guise*, and rendered null and void the heroic deeds shown in academic painting.

As the end of the century approached, painters gave an ever-larger place to eroticism. Bacchants, women bathing, adulterous females, and various varieties of sin proliferated on the Salon walls (*The Captain's Spoils, A Slave Merchant, Lady Godiva, After the Moorish Victory*). These "harem ferocities" (Henri Focillon) flattered the basic needs of a public whose taste for the "little woman," the woman of easy virtue, voluntarily reconciled itself with rigid principles. What was striking here was the quantitative aspect: painting as a butcher's stall, the body as merchandise, and the Salon as a brothel. Like today's specialized magazines, academic painting created a subtle idealization of the human body. Enclosed, smooth, with careful punctilliously-painted strokes, conventionally lascivious, colorless and odorless, "with paint makeup and face powder" (Émile Zola), a nude by Alexandre Cabanel or William Bouguereau was practically nothing more than a vitrified figuration of Eros. The sweetish perfection of its external appearance led to a manner of disincarnation.

The same idealizing treatment was used for the description of nature. Among the forms of escape from industrial development at the threshold of the twentieth century, the countryside was—already—in the front rank. *The Angelus*, which Jean François Millet had sold in 1860 for 1,000 francs, realized 553,000 francs in the Secrétan sale in 1889. A few years later, Chauchard, a former draper's assistant, at that time the owner of the Parisian department store Magasins du Louvre, acquired it for 800,000 francs. This was the record for a painting during that century. As for history, painting reduced it to a series of grandiloquent gestures and memorable acts: *Saint Louis Rendering Justice, The Crowning of Charlemagne, The Excommunication of Robert the Pious*. It deviated from the obscure advance of collective phenomena.

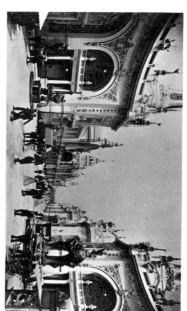

The palace of the esplanade of the Invalides at the Universal Exposition of 1900

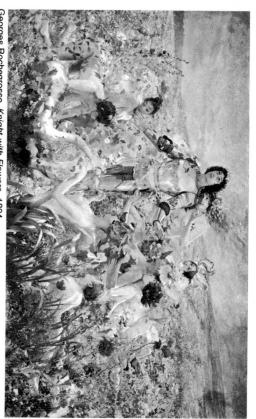

Georges Rochegrosse, *Knight with Flowers*, 1894

Triumphant academic art imposes its stars, its themes, and its architecture everywhere

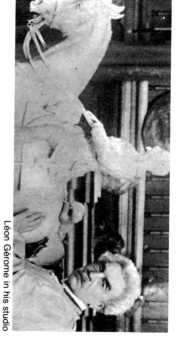

Georges Rochegrosse, *The Death of Babylon*, 1891

Léon Gérome in his studio

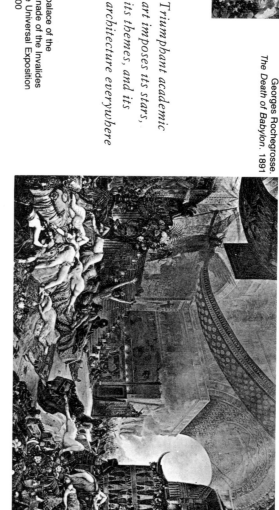

An amateur glider. c. 1907

Poster for Lumière's cinematograph: *The Sprinkler Sprinkled.* 1895

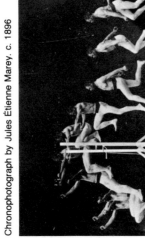

Chronophotograph by Jules Étienne Marey. c. 1896

Dieppe Circuit.
Grand Prize of the
French Automobile Club. 1912

Construction of the
Paris subway. 1907

Often the artist served in the military to save face. Ten or fifteen years after the Battle of Sedan [1870], paintings by Detaille and Alphonse Neuville transformed a military rout into a series of moving deeds (*The Last Cartridges, The Charge of the Cuirassiers of Morsbronn,* and so on).

Although a school of illusion, official art, stated its claim to authenticity by an obsession with the finicky and the slick, and with the precision of the documentary survey. Visiting Alphonse Neuville, a specialist in battle scenes, a columnist of the period admired his impressive collection of weapons and military headgear. "The artist has a very special way of decorating the room in which he works," the columnist reported. "A faithful historian of the tragedies of war, he surrounds himself only with picturesque horrors. Broken cannon wheels, bloody mattresses, muddy straw, these are the curios that in his studio replace bookshelves." Jean Louis Meissonier bought two old carriages in order to rebuild them. His wife sewed together for him pieces of cloth and costumes copied from ancient engravings to be used to dress his models. One day when he wanted to depict the emperor Napoleon, he installed himself in his courtyard at Poissy, dressed like his illustrious model, astride a hobbyhorse. "He held in his hand a tablet on which a sheet of white paper was pasted, and he painted himself in watercolor, glancing at a large vertical mirror placed in front of him" (quoted by Jacques Lethère). To deviate from the reigning aesthetic was to betray—not only the beautiful but France as well. In December 1912, Jean-Louis Breton, a deputy, demanded that the Cubists be banned from the Salon d'Automne. "It is totally inadmissible that our national palaces should be used for such antiartistic and antinational manifestations."

The gulf between living art and institutions was the result of a much greater break. Whereas certain representatives of the ruling class, such as the Steins [Gertrude and Leo], the Bernese

Hermann Rupf, the Frenchman Dutilleul, and the Russian Shchukin, showed an early interest in the various movements of modern art and all bought Matisses or Picassos before 1910, the *petite bourgeoisie* and the middle classes could tolerate only a reassuring, escapist painting, an idealized image that made them forget their daily tensions and struggles. The France of more than 500,000 *rentiers* in 1890 (persons of independent means who lived on unearned incomes) did not digest Impressionism. How could it accept the Cubist puzzles that seemed to defy commonsense? In his *La Révolution Industrielle,* Jean-Pierre Rioux stated: "Paternally advised by the family notary or by the local agent of a great credit bank, busily reading the financial newspaper and cutting out the coupons of their securities, jumping to their feet at the slightest social agitation or the slightest dock strike in Shanghai or a gathering of muzhiks, the *rentiers* formed a closed world, as far as the county towns and often on fairly rich farms."

This France of President Félix Faure felt innovation as a threat to its patrimony. The country was frightened by a world of accelerating changes, of new social strata, and of new urban concentrations. Interpersonal relationships, old communal hierarchies, the city-county balance, all were torn apart. Paris numbered 500,000 inhabitants in 1800, 2,500,000 in 1896 (London numbered 1,000,000 in 1800, 4,500,000 in 1900; Chicago, 5,000 in 1840, 1,500,000 in 1900). The great capitals absorbed almost the entire national demographic growth, yet restricted the working classes to the city's periphery. There were socio-professional upheavals: in France employees increased from 770,000 in 1876 to 1,800,000 in 1911, factory workers from 1,200,000 in 1850 to 4,500,000 in 1910. In 1850 the nation's rural population was 75 percent, in 1910 56 percent. Tasks were parceled out, factory time not being that of the farmer. In 1871 a law reduced the workday of children aged 11 to 16 to 12

hours. In 1892, a law established a workday of 12 hours for men and 11 hours for women and children. Until the end of the nineteenth century, "structural" unemployment averaged about 15 percent; but the division of profit did not change. In 1850, 10 percent of the French shared 40 percent of the national income. Thus the class struggle increased. Founded in 1895, the C.G.T. made a workday of eight hours its primary aim. Long strikes in 1898, 1901, and 1906 resulted. The Socialist movement gathered force: it received 100,000 votes in the 1885 elections and 600,000 in 1893. In 1914 the Socialists received 1,400,000 votes and elected 103 deputies. The holocaust of World War I was necessary to channel and to postpone the worker's rights.

In the closed setting of the museum or the Salon, the distant echo of social, economic, scientific, and philosophical changes was heard. Painting was also changing. "The thread that linked the Quattrocento to Impressionism in three centuries and a half," wrote John Golding, "is clearer than that which, fifty years later, led painting from Impressionism to Cubism. . . . A portrait by Renoir appears to us infinitely closer to a portrait by Raphael than to those of Picasso's Cubist period."

At the turn of the twentieth century, the avant-garde—whatever its complexion—discovered a main adversary: illusionism. It attacked the secular convention, inherited from Aristotle, which saw in the painting the *analogon* of perceived reality. In the Renaissance, illusionism imposed itself as the dominant aesthetic of the West. Europe, gradually freed from its medieval theocratic conception, launched into the methodical exploration of the world. The environmental reality became the subject matter of painting. The divine withdrew into its own spheres. In the Middle Ages the opposite had held true: the physical world had seemed struck by abstraction, owing its existence only to the will of the Creator. The solid, the tangible

had become identified with the mystical body of the Church, with the celestial Jerusalem in which everyone participated.

By making painting an unraveling, an inquiry into the reality of palpable, quantifiable things, the Florentines of the fifteenth century placed the principle of a specular fidelity to the visible world in the center of their theoretical device. Precision, reproduction: a painting was considered successful when it imitated outside appearances to the point of being mistaken for reality. Painting was compared to a window, and it claimed to show "life itself," a "natural" vision, a "literary reality." The sign was worth the thing—or vice versa. The Florentines believed they had discovered once and for all the most precise, the most "neutral," and the most transparent technique for projecting an image, and no one until Paul Cézanne questioned the strange invariance of such a system whose explicit subject matter, nature, was constantly being reinterpreted by scientific exploration. For it is man's very situation in the cosmos that the Johannes Keplers, the Galileo Galileis, and the Isaac Newtons basically questioned throughout the course of the centuries. For these scientists, the immediate reality, which we believe we perceive with the naked eye, was merely a very modest part of the material world. A huge and, strictly speaking, *imperceptible* field developed on either side of the visible, which no "realism," however minute, can take into account.

A waste of effort: in various forms, it is always the same pretension of faithfulness that is seen from age to age in the history of Western art. Vitruvius had explained already that "painting is the representation of things that are or that can be like a man, an edifice, a ship, or any other object whose form or figure we imitate." For Leon Battista Alberti in the fifteenth century, "the painter's function consists in circumscribing and painting on a panel or a given wall by means of lines and colors the visible surface of any kind of body in such a way that, seen

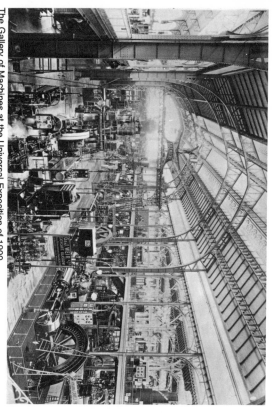

The Gallery of Machines at the Universal Exposition of 1900

Telephone exchange, Rue Lafayette, Paris, c. 1900

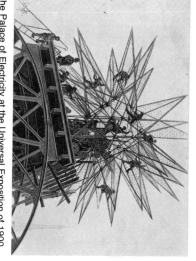

A class in Lyons, 1899

The Palace of Electricity at the Universal Exposition of 1900

The acceleration of techniques and obligatory nonreligious education upset attitudes

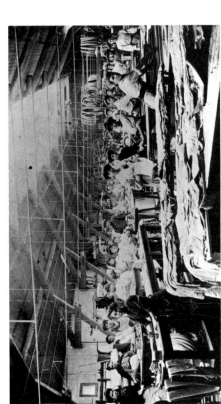

The Dunlop plant at Argenteuil. 1908

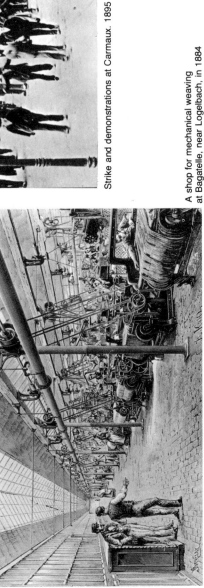

A shop for mechanical weaving
at Bagatelle, near Logelbach, in 1884

Strike and demonstrations at Carmaux. 1895

from a certain distance and from a certain angle, everything that will be represented appears in relief and has exactly the appearance of the body itself." According to Leonardo da Vinci, "the painting that conforms most exactly to the imitated object is that which deserves the greatest praise." On seeing a landscape, Denis Diderot exclaimed: "This is not a canvas, this is nature, a portion of the universe that we have before us!" Jean-Auguste Dominique Ingres repeated like an echo: "Art is never at such a high degree of perfection as when it so strongly resembles nature that we can take it for nature itself." James A. M. Whistler, calling out to his model, Robert de Montesquiou, said: "Look at me again for a moment, and you will look forever." In 1866 even Émile Zola still thought he recognized in a work by Edouard Manet "the healthy and keen scent of true nature."

Every kind of machine, perspective device, camera obscura, including in the end the photographic camera, was invented for a better rendering of "the effect of reality." An anecdote related by Pliny made the round of the studios. Two famous Greek artists challenged each other to see which one was the more faithful to nature. Each one set to work. Zeuxis painted grapes with such veracity that birds came to peck at them. A visit was made to the other challenger, Parrhasios. His work was hidden behind a curtain. Zeuxis requested that the curtain be drawn, and that judgment be rendered. But the curtain was painted . . . and Parrhasios was declared the winner. If Zeuxis had fooled the birds, Parrhosios had fooled Zeuxis. This apocryphal anecdote (for what kind of bird would be attracted to a painting?) reveals clearly where the stated ambition of the classicists lay: art was confused with trompe-l'oeil (illusion). To seize the illusionist roots of Western painting, we must recall its original relationship to the theater. According to Vitruvius, Aeschylus was the first dramatist to use painted decors,

executed by Agatarchos—probably a curtain suspended from a scaffolding. "In the service of the theater," wrote Charles Sterling, "painters then never ceased to develop an imitative realism." They tried to deepen the fictitious stage space by endowing it with additional veracity. Certainly, we should be careful here about falling into a far too mechanical causal explanation of painting as a product of scenic decor. If Aeschylus felt the need to add spatial illusion to representation, this was because he was dependent upon a collective aspiration in which painting, among others, initially played its significant part. But the collusion of approach is significant, and it is not by chance that Vitruvius, mentioning the impressive quantity of mural paintings in Roman houses, at Pompei for example, compared them to theater decor. Here as there, perspective, shadows, the interplay of light and dark seemed, as R. Bianchi-Bandinelli stated in his Rome, the Center of Power, "natural attributes of the scholarly artistic expression and were as such the basis of great European civilization from the eighth to the twentieth century."

We have seen that it was precisely this bolted lock that was smashed at the dawn of modern art, when, on the heels of the Impressionist movement, all existing researches, no matter how disparate, united for the same goal: the liquidation of illusionism. Painting finally assumed its status as a material object and considered itself as surface, as picture-plane. The discovery was made that any projection of a three-dimensional figure onto a panel that has only two dimensions postulates the existence of a code. An apple by Jean-Baptiste-Siméon Chardin is no more real or objective than one by Pablo Picasso. They show two conventional methods of representation, based on two different systems of denotation. It is not a question, as Félix Fénéon wrote, "of deciphering but of codifying the outer world." For Gaston Bachelard, "One demonstrates reality, one does not

10

show it." Schematization was the law of painting. In transposition," according to Claude Lévi-Strauss, "always implies the renunciation of certain dimensions of the object: in painting, the volume, the colors, the odors, the tactile impressions . . . the temporal dimension." Now painting revealed the evidence, for long little known, of the cultural character of perception. There was no immediacy of perceptive naturality. Vision itself always involves the intermediary of a code on "reality."

Painters took this statement to its logical limit. The moment that whatever is denoted echoes its denotation and every apprehension of the visible requires the interlocution of a sign system, why conceal the existence of the actual pictorial transcription? We have seen that the dream of academic painting that claimed to restore an object to its identical form, like an exact copy, is impossible. Jacques Derrida has noted that, "The project of repeating the object corresponds to a social passion and contains a metaphoricity, an elementary transfer. . . The perfect representation is always something other than what it repeats and re-presents. The allegory begins here. 'Direct' painting is already allegorical and passionate. That is why there is no *true* inscription."

Modern art—Fauvism, Cubism, Expressionism—ceaselessly hammered on this new truth that wherever there is art there is sign. We go from a concealed code to a code exhibited as such. In 1923, Pablo Picasso said: "We all know that art is not *truth*. Art is a lie that enables us to approach *truth*, at least the discernible truth." Picasso added to this statement in 1966: "I merely want *to say* a nude, I don't want to make a nude as a nude. I want to find the way *to say* all this—that is all. I don't want to paint a nude from head to foot. [. . .] The necessary thing is

that the gentleman who is looking has available everything he needs to make a nude. If you really give him all the things he needs, and the best of them, he himself will put it all into place with his eyes. Everyone will make for himself the nude that he wants with the nude that I will have made for him."

For boldness and certainty, artists turned to Paul Cézanne, who died the very year Pablo Picasso began his *Les Demoiselles d'Avignon*. For the latter, as well as for Henri Matisse, Georges Braque, and Fernand Léger, Cézanne was a living source. Impressionism, by the growing independence of its style and color, had already transcended and transgressed the old realism. With Claude Monet, a large green spot largely exceeded the surface that would have been occupied by the tree that it denotes if he had inscribed it in the manner of the Classical scheme of perspective. But Cézanne, who was the first to propose explicitly to *interpret* his optical sensations by chromatic equivalences, stated that they were by no means the literal interpretations of what they designated. "Light does not exist for the artist," he said. It was a question of expressing light by a play of colored brushstrokes, which become so many freely interpreted pictorial metaphors of an impossible substitution. Paul Gauguin took up this lesson when, in reply to Émile Zola's phrase mentioned above, he denounced "the pretentious intention to imitate true nature," and after him Maurice Denis wrote: "We knew that any work of art was a transposition, a caricature, the passionate equivalent of a received sensation." If it were absolutely necessary to legitimize the Cézannian breakthrough, one could turn to child psychologists whose work proves that the academic pretension to specular "realism" is by no means a trait of human "nature." Dr. Daniel Widlöcher seemed to speak of a Cubist when he wrote: "The child's concern is not to represent things as they are but to illustrate them in such a way that we can easily identify them. Every

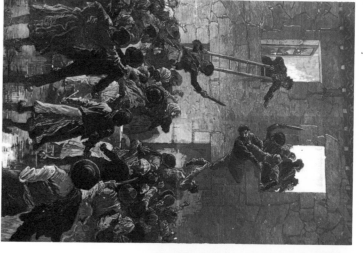

A defenestration at Decazeville. 1886

The workers' struggle for better conditions, the Dreyfus Affair, separation of Church and State: each helps to divide France

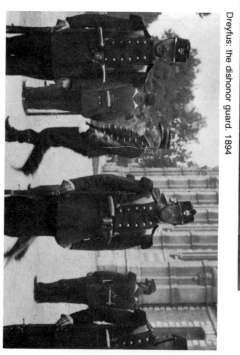

Dreyfus: the dishonor guard. 1894

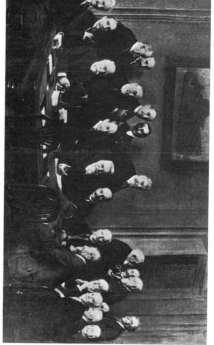

An employers' organization: *The French Association of Heavy Industries*, painted in 1914 by Adolphe Déchenaud

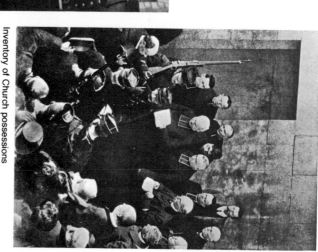

Inventory of Church possessions (here Saint-Servan, Paris), 1906

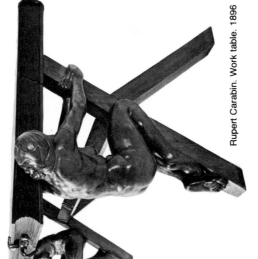

Rupert Carabin. Work table. 1896

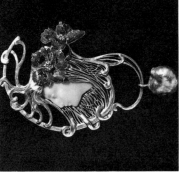

René Lalique. Jewel. 1900

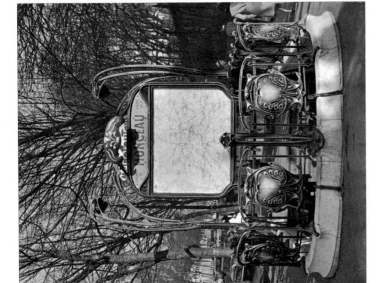

Hector Guimard.
Subway entrance, Paris. 1899

Seat. About 1892

The modern style imposes itself in every great city. Created in England, it develops both a floral, organic vein, chiefly in Paris, and a geometrizing vein with the Glasgow School and the Viennese Sezession (Hoffmann)

artifice he uses: the employment of characteristic details, the multiple points of view . . . is aimed at this goal of representation. . . . The child increases what we could call the quantity of information contained in his drawing."

This fresh truth was poorly received by a public conditioned by centuries of *trompe-l'oeil*, the prisoners of a restricting spatial consensus. Photography, which had appeared in the first third of the nineteenth century, played here a decisive and ambiguous role. We would have to document the stages of its technical development for a proper understanding of the high point of its intervention. In 1839, the daguerreotype, an iodized silver plate made in a dark room, was worth 25 gold francs. It was a rare object often kept in a case, like a jewel. The years 1850–1860 saw the appearance of processes on glass and paper that brought it within popular reach. It was only about 1871 that the invention of photoengraving offered the possibility of infinite reproduction and, therefore, of the unlimited extension in quantity of the photographed image. As photography spread, painting lost its informative function. To quote Walter Benjamin: "The painters were dismissed by the technicians."

The photograph made it absurd for an artist to claim literal "faithfulness" because he was easily beaten in this field by a simple device. "At first," according to Walter Benjamin, "people did not dare to look long at Daguerre's images. They were intimidated by the clear vision of these men and believed that these small, these very small human faces on the plate were themselves capable of seeing you." Hence the bewildered flight of these artists from the demonic instrument. "Photography is a very fine thing," said Ingres, "but one shouldn't say so." He signed petitions "against any assimilation that could be made of photography to art." But how could the artist avoid the insulting confusion? At first by playing on size: the more the century advanced, the more paintings increased in size, while

photography confined itself to small formats. Then the artist distinguished himself by color—a privilege that, for the moment, the technical instrument did not attempt to approach. Then by the brushstroke. Some, joining Eugène Delacroix and the Impressionists, revealed the "doing" of the painting, the "touch of the hand." Finally, confusion was avoided through the choice of themes: painting escaped into the imaginary (allegory), into the past (historical anecdote), and into the exotic (Egyptian fantasies).

Finally other artists—and this is the basis of the entire history of modern art—found here the occasion for profound reflection on the specific final goal of painting and undertook a journey in which photography had no role (except in the very different context of *collage* and *assemblage*; see Chapter 5). But they could not venture into this field without finally ridding themselves of the "effect of the real." Yet it was precisely this effect that the photograph (soon reinforced by the cinema) was about to establish as a universal vision. On the one hand, it reinforced by mass reproduction what, on the other, it radically questioned by its mere existence: the function of the painted image as an analogical representation of the object.

It would be an error to believe, as was long the case in painting, that the photograph is finally the adequate means to re-produce the objective world *as such*. At the very moment of its birth—by the choice of its lenses—it became an adherent of the painter's perspective space. Early photographers, chiefly "recycled" miniaturistes, were prisoners of dominating spatial conceptions. Louis Jacques Daguerre's first intention—he himself was a painter—was to invent a process for the rapid "engraving" of existing works or for projecting in two dimensions the still lifes he arranged on his table after the fashion of the Dutch masters or the French painter Jean-Baptiste-Siméon Chardin.

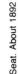

12

Here lies the cause of the original misunderstanding between the modern artist and his public. The latter—hemmed in on all sides by magazines, films, television—often asks from a painting a "photographic" truth, although ignorant of its ideological and cultural bases. The modern artist refuses to think in terms of equivalence and, on the contrary, wants to reveal in his work what participates in the code, in the projective system, in the language of art. We shall note in passing that the hazards of this conflict are still evident today in the posters that cover our walls. Some, arising from the requirements of rapid reading, directly borrow their formal innovations—frontality, simplification of outline, large flat color areas—from the pictorial researches of the first quarter of the century (Henri Matisse, Juan Gris, Fernand Léger). Others are enlarged photographs, precise in detail. In order to convince the reader, they speculate on the "effect of reality." They suggest more than a deciphering: they suggest a mimetism. They use for their own benefit and that of the product they praise the mechanisms of Classical painting that are still operative in the collective unconscious five centuries after their codification.

To support its struggle against the set of canons of illusionism, inventive painting at the turn of the twentieth century chose an important ally: exoticism. Paul Gauguin had paved the way: "You will always find nutritious milk in the primitive arts." They were imposed at the precise moment that the revolution in Western art summoned up and justified their presence. Between 1905 and 1911 all the important painters—André Derain, Henri Matisse, Georges Braque, Pablo Picasso, and Maurice de Vlaminck—collected African and Polynesian masks. These artists also turned their attention to Japanese art, to popular Russian woodcuts (Michael Larionov, Nathalie Gontcharova, Kazimir Malevich), to Javanese marionettes, to Bavarian naïve glass painting (Wassily Kandinsky, Franz Marc,

Paul Klee), to tarot and playing cards, to astrological and Masonic charts, and to *images d'Épinal*—an early form of strip cartoons—(Fernand Léger). Modernity offered its hand to archaism. The most advanced forms of research in industrial societies opened onto solutions that other cultures treated in a very different context. In 1907 Guillaume Apollinaire wrote: "All plastic creation: hieratic Egyptian, refined Greek, voluptuous Cambodian, the products of ancient Peru, the statuettes of African Negroes proportioned according to the passions that inspired them, can interest an artist and help to develop his personality."

Why this sudden curiosity? The exotic arts never fall into the naturalistic illusion. They transcribe the human figure, to quote Apollinaire again, "by not using any element borrowed from direct vision." The representational object does not claim to be the equivalent of its model. It signifies it just as a Chinese ideogram signifies "house." In African sculpture, explained Jean Laude, "each element constitutes a sign endowed with a precise and consecrated meaning. . . . All these signs constitute a 'message' (in the linguistic sense of the term), capable of being read, interpreted, and understood in relation to a mythical system to which (the sculptor) refers and which relies on the spectator's level of initiation." In a Wobé sculpture, the eyes are indicated by two projecting cylinders on the face of the mask. Where the *sign* "eye" calls for interpretation, either concave or convex can be used. If European artists wished to justify their revolutionary attitude toward the Western ethnocentric tradition, they could now comfort themselves with examples borrowed from every culture on the planet.

The crisis of illusionism and the awareness of the semiotic character of all pictorial production were the first fractures that were recognized in modern art. As obstinately as it attempted to conceal itself as a system, art stemming from the Renaissance

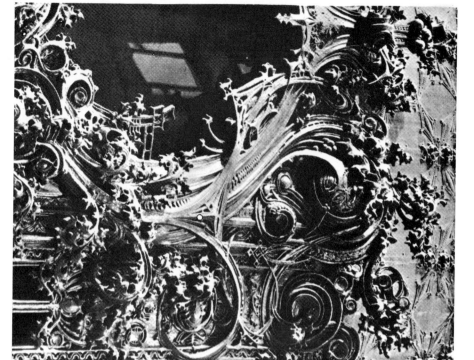

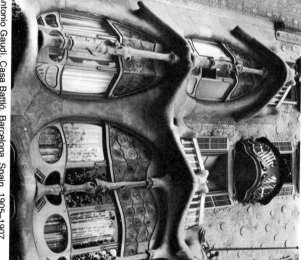

Louis Sullivan, Ornamental detail of the entrance to the Schlesinger Department Store in Chicago, Illinois, 1899–1904

Antonio Gaudí, Casa Batlló, Barcelona, Spain, 1905–1907

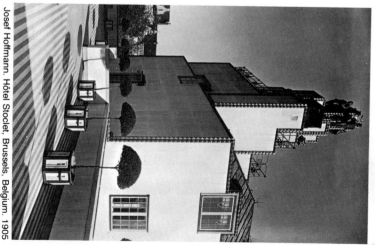

Josef Hoffmann, Hôtel Stoclet, Brussels, Belgium, 1905

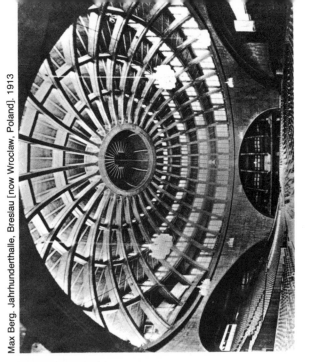

Max Berg. Jahrhunderthalle, Breslau [now Wrocław, Poland]. 1913

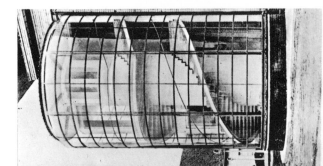

Walter Gropius. Office staircase of a model factory. 1914

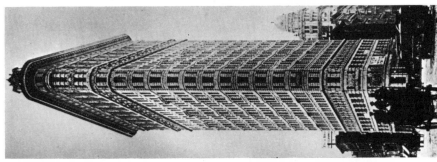

Daniel Burnham. The Fuller Building in New York, New York. 1904

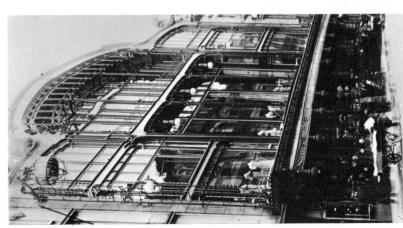

Victor Horta. The Innovation Department Store, Brussels, Belgium. 1901

was, nevertheless, dependent upon a code of planimetric projection, and new codes—for example, the Cubist analysis of the object—could legitimately claim to have supplanted the old ones at the dawn of this century in the new arrangement of pictorial images.

But this crisis concealed another—even more profound. This was a crisis of the sign itself insofar as it claimed *to separate itself* from the material aspect of its support, from its very space, by denying the physical reality of the texture. It was as this second problem that the art of the first twenty years of the century continued to confront. Cubism could act here as inductor. We will see it deny and outmode the method of Classical transcription, then accumulate notations on the still life or the landscape that it wishes to represent to the point of saturation. Up to the moment when this very accumulation, this "hodgepodge" of fragmentary signs finally speaks for itself, takes on its own surface, grain, color, physical gesture—as though we had to go through the iconic sign in order to reach the texture, the material substance that basically constitutes the pictorial object.

To have a proper understanding of this melting away of the iconic sign, we must go back in time and indicate the state of dependence of painting on language in the West until the twentieth century; this relationship was a thousand-year-old submission (in Greek *graphos* means not only "writing" but also "drawing" and "painting"). In his *Of Grammatology* Jacques Derrida has revealed in a masterly manner the subordination to linguistics of all the other sign systems: "Although semeiology was actually more general and more comprehensive than linguistics, it continued to rule on the privilege of one of its areas. The linguistic sign remained exemplary for semeiology, it dominated it as the master sign and as the generator model: the first postulate of Saussurian linguistics is to

consider language as an arbitrary system, independent of the fabric that materializes it. To quote Ferdinard de Saussure: "Every conventional value presents this characteristic of not confusing itself with the tangible element acting as its basis.""

In the face of this arbitrariness of the linguistic "pattern," the submission of Classical painting is seen in two ways. On the one hand, the figure has no material existence: its only value is that of an image-concept, and it finds its legitimacy only in its relationship to what it refers to. On the other hand, everything in the painting that is not figurative is considered worthless. The only thing that counts is what can be named. "For the painter, there are only surfaces which are *projectives*," wrote Hubert Damisch in his essential work *Théorie du Nuage*, which we are going to follow here step by step. The painting is a scene in which objects and figures stand out. The rest, the interval between the figures, is "background," "void," and it does not count. "Everything occurs," the author has remarked, "as though the painting had to be arranged from a text. . . . A linguistic element should correspond to every pictorial element." This subordination to language goes so far that even before starting to paint, the Classical artist, in his empirical observation of the outer world, *sees* only what he can delineate, outline, quantify. Nature is a nomenclature. The rest participates in the *unmentionable*—and, therefore, in the unfigureable.

Beginning with Paul Cézanne, modern art devoted itself to summoning this unmentionable. For the painter of Aix, the *readable* was not everything *visible*, the iconic sign was absorbed in texture, it participated in an overall plastic organization ("my canvas links the hands together") whose specific economy gradually relegated to the background the relationship between painting and the appearance of nature. "The lateral relationships of brushstroke to brushstroke, tone to tone," said

Damisch, "win out decisively over the vertical relationship between the figures and what they refer to, the only criteria possible through a reading restricted to the order of verbal denotation."

Deflation of the iconic sign: the painting is revealed as *spacing* between the figures, as overflowing the historical coherence (story), as assumption of "emptiness," "background," as the matter of the work. In his *Théorie du Nuage*, Damisch stated that, "Nothing authorizes us to think that a group of lines recorded under the headings of color, contour, etc., is systematically articulated for the production of a *meaning* (perhaps they merely produce an *effect*)." If a comparison with nature were required here, we would say that the sky at night produces an effect on the person looking at it without his having to decipher and to recognize the figures, such as the Great Bear, and so on, that the human eye believes it discerns there.

It is this same idea of an *effect* independent of the iconic reading of the work that was expressed in 1923 by the Russian theoretician Nikolai Tarabukin when he remarked that "the 'saturation' of the canvas in pictorial matter [beginning with Édouard Manet] was inversely proportional to the density of the subject matter." In a laconic note, this idea also followed in Pablo Picasso's remark to Jean Metzinger in 1910: "It's useless to paint what it's possible to describe."

The science of language follows paths parallel to painting when it makes a return to what Derrida has described as the *signifié transcendantal* (that which, although outside the work, bestows meaning upon it) in which Western metaphysics has had its roots since Plato. We see linguistics both privileging the independent study of phonemes and disarticulating the word-concept by making an inventory of units smaller than the word itself. We also see its passion for the "accidents" of spoken expression: silences, alliterations, redoublings, chiasmi, "white"

spaces on the written page, paragrams, and so on. With Stéphane Mallarmé, Filippo Tommaso Marinetti, and Guillaume Apollinaire's *Calligrammes*, poetry took on a spatial dimension, whereas Raymond Roussel, who inspired Marcel Duchamp, developed his account from an arbitrary substitution of phonemes, and it became purely mechanical. In 1913, going beyond Paul Valéry who had defined the poem as "a prolonged hesitation between sound and meaning," the Russian poets Khlebnikov and Krutchenykh invented the principle of a "transrational language"—rawness, glossolalia—that wanted to escape from the dictatorship of image-concepts and to produce meaning without using words. In 1916 Chklovski remarked: "Perhaps most of the joy of poetry is contained in the articular aspect, in the harmonious movement of the organs of speech." In 1925 Eikhenbaum stated: "The sounds of verse are not only the elements of an outer harmony, they not only accompany the meaning, but also they themselves have an autonomous significance." The moment that this reexamination of what is significant in the very core of language took place, it was foreseeable that in the plastic arts—where *spacing* works in a more tangible manner—the reduction of everything to iconic signification would be questioned to an even greater degree.

Beginning with Paul Gauguin, painters explicitly insisted that the spectator consider the *painting* rather than the *image*. What is referred to was reduced to secondary importance (and was soon dismissed altogether). Red is less the color of an apple than that of a radiating energy, and it inscribes itself as an active part in the differential structure of the colors that occupy the canvas. "The goal is not *to reconstitute* an anecdotal fact but to constitute a pictorial fact," wrote Georges Braque in 1917. In the following year, the poet Jacques Reverdy said: "A work of art cannot be satisfied with being a *representation*; it should be a *presentation*. One presents a newborn child; *he* represents

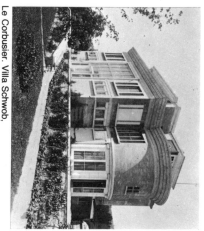

Le Corbusier. Villa Schwob. La Chaux-de-Fonds. France. 1916

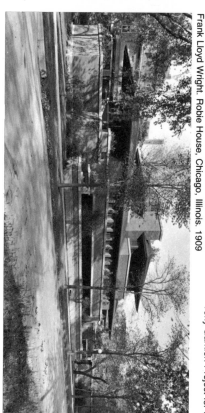

Frank Lloyd Wright. Robie House, Chicago, Illinois, 1909

Tony Garnier. Project for collective apartment houses. 1901-1904

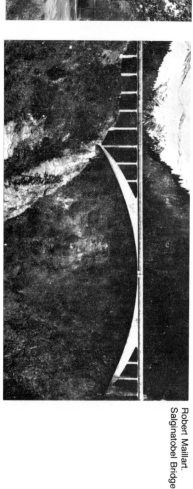

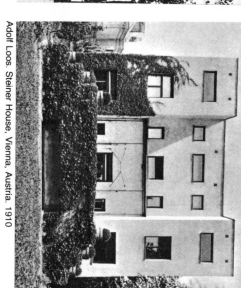

Adolf Loos. Steiner House, Vienna, Austria. 1910

Robert Maillart. Salginatobel Bridge

Edvard Munch at Kragerø. c. 1910

Dandies or solitaires who were often ill, rebels but generally peaceful and laborious good bourgeois, the "bohemian artists" of the turn of the century scarcely correspond to the legend they created

Giorgio de Chirico. *Self-Portrait.* 1908

Gustav Klimt

Giovanni Boldini

Fernand Khnopff

that cover and overlap one another. There is a textural level, a level of plastic relationships (composition, construction), an iconic level, a thematic level (as Gaston Bachelard understood the word), and a socio-historical level, and each of them works on all others. To isolate them is to betray them. Thus, the constellations of circular black spots in Georges Braque's Cubist paintings can be interpreted at the same time as (1) a conventional musical code referring to sounds; (2) the representation of a music score on a piano; (3) the presence of a musical atmosphere with its connotations of lightness, immateriality, harmony, and so on; and (4) the plastic values that intervene simultaneously on the formal level (balance, the relationship of curves and straight lines, and so on); as color (black as related to the other colors), as texture (the grain), as gesture (the traces of the painter's hand), and so on. It is not insignificant for the understanding of this work that these spots denote a musical partitur and not, for example, a handful of olives.

Still the multiple effects of what is denoted should not mask what we described as the main theoretical breakthrough of modern art: the awareness of the materiality of the pictorial object, an awareness that sends us back to the workshop, to the process of production. The work finally offers itself for what it is: material worked by hand, gestures invested in material. The question as to *how this is done* is of primary importance. The painting becomes self-reflexive. It questions itself as a technique. The size, the relationship between height and width, the frame as limit and/or passage, the pigmentary substance, even the brush module are attentively questioned. It is here that we seek the work's expressivity—and no longer in an eventual relationship to its subject matter. It seems that it is at the *doing* stage, at the first level of physical development that the painter's fundamental role is enlightened in his hand-to-hand

nothing." It is the physical being-there of the work that Henri Matisse, for example, displayed the moment he considered not only the size of the canvas but also the form of the frame as integral parts of his painting. "The arabesque only exists if upheld by the four sides of the painting," he stated. "With this prop it acquires its force." Although desiring to reveal the way the pictorial object signifies, we must avoid falling into the opposite excess and neglecting the interrelationship that exists between what makes up the work and what it signifies. In the case of representative painting, it is not unimportant for the "plastic" economy of the canvas that a pearl-gray surface should act as a wing. The artist turns to the symbolic code, the cultural connotations of his time (wing equals angel equals lightness, and so on) in order to constitute his "atmosphere." There is a constant flow of the substance of subject matter to the substance of expression and vice versa. Moreover, there is no need to turn to a representative image in order to create the interaction of subject matter and the way it signifies. "Every effect," Damisch has noted, "is finally symbolic." There is no pigmentary texture that does not release an infinite play of connotations. Any material arranged on the canvas—even the most lacking in referential allusion—creates a *reading*. It refers to other materials, if only in an archaic fashion to the *materials* in which the child recognizes his work. As Jacques Lacan has written in his *The Four Fundamental Concepts of Psychoanalysis*: "The creator will ever participate only in the creation of a small dirty deposit, a series of small dirty deposits, juxtaposed. . . . Our colors, we have to look for them where they are, that is, in shit."

By definition a painting is tabular (and not linear as speech pretends to be). Each element of the canvas is overdetermined (in Sigmund Freud's sense). It participates in a multitude of networks. It is inscribed into a weave of indissociable systems

struggle with the work.

The question of the process of production engages that of the producer. In its texturality, the painting makes a critical return to the painter's aim and to the painter himself. It is the *complete Self*, the Cartesian subject that is questioned here, in the artist's will to dominate his canvas (and the world). One refuses the pretensions of the artist as demiurge who believed that he created his work in his mind before easily achieving it through mere execution. If it has to be conceived in order to be done, it must be done in order to be conceived. Thus, Picasso stated, "You must have an idea what you are going to do—but a vague idea." On this subject his friend and dealer Daniel-Henry Kahnweiler commented: "Everything happens as though the mental image, the fruit of emotion, becomes precise for the painter only in accordance with its materialization, as though the painter discovered this image gradually." If the work is never in a pure state (the state of thought to be projected by the artist), this is because it doubly escapes him: it is an eradication, a multilating ablation, a work of body and mind that the artist produces and is produced by a work that works back on him pointing out his incompleteness, his morcellation. But it escapes him also as something in the process of becoming, as a structure open to the greeting eyes of others. All the elements of its makeup are articulated in an independent organization, a "machine" fed by viewers' questioning and inherent with an infinite number of meanings and effects.

Onto the evident content of the work projected by its "first" author is superimposed an unlimited number of *latent* contents seen by later viewers who pass in front of it. If the work produces a discourse, any discourse can produce the work, which is the screen on which every projection, learned or naïve, is authorized. From here new *texts* gush forth unceasingly. There is a *textu(r)al* infinity which no univocal speech can imprison

unless it becomes, almost by impossibility, the work itself. Julia Kristeva spoke here of painting as "a semblance between the world and language."

The questioning of linguistic domination should not lead one to conclude that painting has entered the sphere of the ineffable, of the generalized asemantic. No expression or aesthetic communication is possible without the intermediary of a code, which questions and transforms the system of signs, which previously made up the empirical apprehension of the spirit of a period. To quote Jacques Derrida: "The moment the sign appears, that is to say since always, there is no chance of encountering anywhere the purity of reality." On the contrary, in the series of systems that painting produces (and that produce it), should we not notice ideological blockages, inhibitions, ossifications that tend to delay its dialectic development and whose origins are to be sought in a socio-economic context. For support we shall turn here to a volume by Jean-Joseph Goux, *Économie et Symbolique*, in which the author, starting with Karl Marx's theory of value, has developed a fruitful parallel between, on the one hand, the increasingly unreal principle of human work submitted to monetary values and, on the other, the development throughout the course of history of different processes of symbolization taken in their political, libidinal, analytical, or linguistic order. If we displace Goux's argument to the terrain that concerns us, we see how, in both the economic and pictorial field, the same case of neutralization and idealization occurs in the concrete reality of the product. Just as money—as a general equivalent of any merchandise—tends to remove the materiality of the work that was its source, so the linguistic code that controls painting tends to hide *what is working* in the painting. Just as human production seems to reduce itself to the abstraction of its "financial surface,"

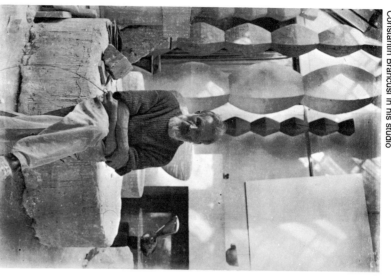

Constantin Brancusi in his studio

Constantin Brancusi. *Male Torso*, 1917

Raoul Dufy and his wife in 1918

André Derain

Henri Matisse, Charles Camoin, and Albert Marquet. c. 1907

17

Picasso in his studio on the Boulevard de Clichy. 1910

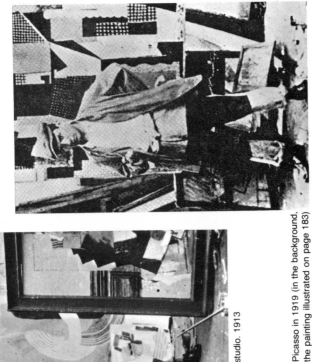

Picasso in 1919 (in the background, the painting illustrated on page 183)

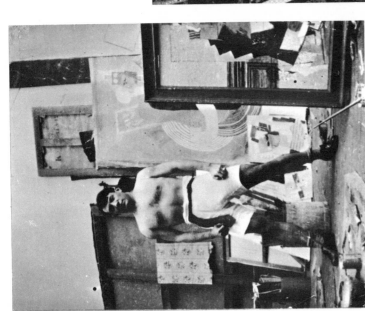

Pablo Picasso in his Montparnasse studio. 1913

so the significant value of the painting impoverishes itself in an assortment of designations and iconic figures that obliterates its historical and biological roots: canvas, texture, gesture, color. The peremptory transmission of a *logos* hides the potential proliferation of *effects*.

This reduction is not limited to the removal of the inherent value of the work by its general equivalent (money or iconic sign); it operates on the very level of production to require a transformation in its image. In the economic field, the rationalization of profit creates the division of labor: commands human labor, which becomes the product and no longer the producer of economic order. The same is true in the field of aesthetics: the hypostasis of the iconic signification reduces the painting to a message, a signaling, an anecdote that redoubles the spoken channel. In both cases we obtain what Goux has called "a process of counterinvestment whose effect is to drive back (or to trade upon) the primary investments of energy (the sphere of production) while allowing their idealized representatives [here the iconic signs] to circulate."

By exposing the inhibited part of painting, modern art has for more than a century been trying to break its logocentric yoke to reveal, as Goux has stated, "the biological rooting of the subject as an irreducible source of significant innovation." The corporeal, sensory values burst into pictorial immediacy. "The animal nature in us," stated Paul Gauguin shortly before his death, "is not so much to be despised as one would like to say." Only a few decades were required for the canvas to become, according to Harold Rosenberg in reference to Jackson Pollock, an "arena" in which the artist engages his vital energy. Denouncing the "murderous violence that any significant systematization harbors," Julia Kristeva, in reference to Stéphane Mallarmé and the "Comte" de Lautréamont—but she could also have been referring to Paul Cézanne and to Vincent

van Gogh—explained that "the avant-garde . . . seems to be precisely what is opposed to this murderous violence of the code and on the contrary opens it up obviously to redo it *otherwise* and *without end*."

To redo it: in a period in which, as we have seen, painting wants to be self-reflexive, in which each production produces both its technical basis and its theory, it would be useless to name here all the changes by which contemporary art has escaped from the complacent logocentric sclerosis of Classical art. At best we can list a few dozen examples in the following chapters. We know henceforth that the transgression of traditional codes is not to be sought on the level of representation (this was the general error of Surrealism). But it would be a mistake to want to confine these transgressions at any price to the *workshop* level, thus restricting the critical analysis to the enumeration of the different textural practices that are the source of painting. The question of *how it is done*, a necessary passage in any theory of art, should create the question: What is the *why* of this *how*? If this question does not arise, as Julia Kristeva has pointed out, we would fall into "the ideology of production." Any gesture, any act merely refers only to itself. Painting is not "up in the air." The choices implied in the *production* infer an entire battery of new meanings, and the relative autonomy of pictorial practice does not prevent its articulating dialectically all the processes of intellectual and material production of the period. If we limit ourselves to the stage of *doing*, enclose ourselves in an autarchic conception of the pictorial *being-there*, how can we, for example, examine *the outside-of-the-frame compulsion*, the will to emerge from the painting, the museum, and even from art that, since Futurism, has characterized a major twentieth-century current? In fact, everything has occurred as though an incoercible disruptive surge had seized a huge sector of artistic activity with no other

aim than to destroy the institutional limits of culture (limits identified here as painting, sculpture, and even the museum) for massive preoccupation with extrapictorial fields. (Alongside this developed a tendency that henceforth continued to reinforce the primacy of the object—*art concret* in the 1930s marked the theoretical breakthrough and the results were seen in American painting of the years 1950–1960, notably in the work of Barnett Newman, Mark Rothko, Ad Reinhardt, Frank Stella, Kenneth Noland, and so on.)

From this point of view, the Cubists were the last candid easel-picture painters. After them—whatever attitude the artist adopted for or against closing his work—the question arose of what was "outside the frame." It is, moreover, one of the paradoxes of present museology to present the creations of disruptive artists who transgressed the cultural site in the same manner as those of the objectival current (*art concret*, painting-in-itself), since the former acquired their outlook by wanting to finish with the institution. Thus tracts and Dada photomontages of Berlin, *agitprop* material that museums offer to us today are out of context in the form of inoffensive small paintings, cozy relics that are deprived of their impact and meaning.

In 1908 the Italian poet Filippo Tommaso Marinetti glimpsed the possibility of applying to the circulation of his work the propaganda and publicity techniques used in other sections of society. He wrote: "I suddenly felt that the articles, the poetry, and the polemics no longer sufficed. There absolutely had to be a change in methods. I had to go down into the street, attack the theaters, and throw punches into the artistic struggle." It matters little that in this case the policy of scandal that began here was immediately used for chauvinism, warmongering, and racial hatred (Marinetti soon became a Fascist). It matters little that the tone, the themes, even certain techniques that were

employed were borrowed largely from nineteenth-century European anarchism (we are aware of the role Mikhail Bakunin played in Italy), then deviated from their stated goal (the denunciation of the excesses of the capitalistic industrial revolution) for the benefit of a hollow rhetoric exalting struggle for struggle's sake. (But the adversary remained vague: museums, "old folks," women, *passéisme* or addiction to the things of the past, pessimism, and so on.) Finally, it mattered little that this rhetoric, by flattering the *machismo*, the "virility" of a nation recently introduced into the economic development of Europe, merely served as an ideological foil for the new business bourgeoisie that was attempting in Italy to make itself into an industrial force in order to delay the social struggle as long as possible. This was not the message that was important here, but the will that was needed to break with the traditional role and setting of art.

Moreover, the techniques of Marinettian provocation were quickly reassimilated by the "leftish" wings of the artistic movement—Russian Futurism and Dada—on the triple level of startling the bourgeois, social utopia, and political contestation. In 1913 Michael Larionov easily scandalized Muscovites by showing himself with his face daubed in color on Marshals' Bridge, and Vladimir Mayakovsky exhibited himself in blouses, which, as described by Benedict Livshits, "resembled both a jockey's jacket and a Jewish prayer shawl." But as early as 1915 the aim was enlarged. "We consider the first part of our program of destruction achieved," stated Mayakovsky. "Thus do not be surprised to see in our hands, instead of the court fool's cap and bells, the architect's blueprint and to hear the voice of Futurism, yesterday still softened by sentimentality, unleash itself in prophetic power!" And while in the United States of America, Marcel Duchamp invented the ready-made, an *antiart* war machine based on "visual indifference" (see

In Montmartre, then in Montparnasse and Puteaux, in a small circle of painters and poets, a war machine was invented against illusionism. In seven years—from Les Demoiselles d'Avignon to the first ready-made—the entire edifice of Western art was destroyed

Juan Gris

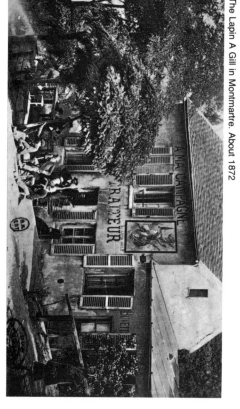

The Lapin A Gill in Montmartre. About 1872

The brothers Jacques Villon, Raymond Duchamp-Villon, and Marcel Duchamp at Puteaux. 1912

Pablo Picasso. *In the Café.* Drawing. 1898

Georges Braque. 1922

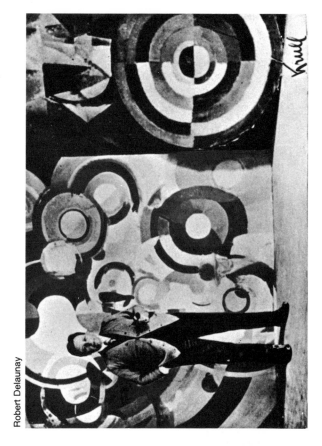
Robert Delaunay

Kazimir Malevich. 1915

Paul Klee

Wassily Kandinsky and Gabriele Münter

Research becomes abstract and radical. Some painters refuse to make any reference to empirical reality, others want to extend their practice into the social field

Chapter 5), in Europe the watchword was the expansion of painting beyond its reserved space.

"Abstract-realistic painting will be able to disappear the moment we are able to carry forward its plastic beauty by spreading its colors around the room," wrote Piet Mondrian. Fernand Léger dreamed of changing Paris into a vast palette: "There is a plan about of distributing colors in a modern city: a red street, a yellow street, a blue square, a white boulevard, a few polychromatic monuments." In 1937, Léger even suggested using during the Exposition "the 300,000 unemployed to scrape all the Parisian houses [in order to] create 'an astonishing event' for the visitors. Paris would become completely white, and in the evening airplanes and projectors would flood the city with lively and mobile colors."

World War I magnified into an often naïve Messianism what could only have been—with Pierre Bonnard, for example, or with Henri Matisse—a decorative attempt carried here to the level of an entire city. World War I! It is to say very little to say that the 1914–1918 conflict seriously disturbed the world of art. The war was experienced by a number of European painters and intellectuals as a true moral suffering. Some felt "guilty" of massacre. After returning from the front, André Derain ended his avant-garde researches and accused himself of having disoriented his fellow artists. Paul Colin in 1919 commented in *L'Art Libre*: "Artists have uglified, debased, and degraded Thought, which they represented. They made it into an instrument of passions and, perhaps without knowing it, of the selfish interests of a political and social clan, of a homeland, or of a class."

The "stars" of pre-1914 discovered wisdom. Pablo Picasso changed both his style and his public. Georges Braque, trepanned, devoted himself to the impossible marriage of Cubism and Classicism. Henri Matisse became suave, Marc

Chagall insipid, and Maurice de Vlaminck sank into Expressionist mess. In Italy, Filippo Tommaso Marinetti, after bewailing death for four years and continuing his glorification of "war, the only hygiene in the world" and "the ultraintense expression of life," enrolled, on Benito Mussolini's instigation, as a "propagandist in the combat of Fascism."

But for others, drowned for four years in an ocean of horrors and heroic crassness, it was time to revolt. The artilleryman Max Ernst was obliged to sing a martial air: "Victorious, we are going to fight France, to die as valorous heroes!" A great admirer of Pablo Picasso, Marc Chagall, and Robert Delaunay, Ernst was determined to settle in Paris the moment the war ended; his sole anxiety was that the capital of painting should not be destroyed. "In February 1917," Paul Éluard related, "the Surrealist painter Max Ernst and I were at the front, scarcely a kilometer from each other. The German artilleryman Max Ernst bombarded the trenches where I, a French infantryman, was on guard duty. Three years later we were the best friends in the world."

For this youth who had a narrow escape in the war, the guilty parties of the great massacre were the logic of reasoning and the cold delirium of the general staffs. In the face of the charnel houses, of the thousands dying each day, in the face of what Hans Richter has described as "the locomotive of reasoning that runs at hellish speed across the fields of cadavers and above ourselves," the period of the absurd began, a time of sneering, of "joyful nothingness," a period of vehemence and the "great African holiday"—the age of Dada.

First in New York and Zürich, soon in Berlin, Cologne, and Paris, Dada featured the same irrational explosion, the same methodical and spectacular organization of mockery. Dada was born in 1916 in a Zürich cabaret frequented by an international colony of artists and poets. The name for the movement was

20

chosen because it meant nothing. According to Tristan Tzara, Dada's program was "to work with all its force to install the idiot everywhere." In the presence of the serious and frightened burghers of Zürich, one extravagant "happening" followed another, reflecting in snooks and snickers the general chaos. In his *Memoirs*, Jean Arp wrote: "We were given the honorable title of nihilists. The directors of *crétinisation* ['the process of making people stupid'] used this word for anyone who did not follow their path."

But if, in Zürich, the Dada holiday retained the character of a great parade of gifted students, all of them not without talent, in Berlin, in the explosive contact of the Spartakist agitation, the tone rose very quickly, and the Dadaists took a direct part in the political battle. Their slogan was: "Enough work, long live direct action!" Art for them was agitation. It acted, one of the Berlin members explained, "to shake the crowd's silent dullness." In 1919, in the Weimar Staatstheater, during the inaugural and solemn meeting of the First German Republic, Baader threw from the gallery a shower of treatises entitled *The Green Horse*, in which he applied for the post of president. He interrupted a sermon in the Berlin cathedral by shouting from the choir: "I couldn't care less about Jesus!" In 1920, in Cologne, Max Ernst, Baargeld [Alfred Grünewald], and Jean Arp organized a Dada exhibition in the glass-enclosed courtyard of a café. Access to it was through the toilet room. At the entrance to the courtyard, a little girl in a white Communion dress recited obscene poems. In the courtyard there was a wooden sculpture to which a hatchet was attached—the spectator was invited to destroy the sculpture. In one corner there was an aquarium filled with water the color of blood; at the bottom of it was an alarm clock and, floating on the surface, a woman's head of hair. The room was invaded and sacked by the public several times before the exhibition was closed by the

police. That same year in Berlin the Burchard Gallery was the scene of the first Dada international fair, featuring George Grosz, John Heartfield, Raoul Hausmann (see page 264), and Otto Dix (see page 262). One hundred and fourteen paintings and *assemblages* of an extreme aggressivity were on view. A straw-filled mannequin of a German officer with a pig's head was suspended from the ceiling with the words: "Hung by the revolution." It created a new scandal. Dada was everywhere: it intervened in shows, it interrupted plays. Max Ernst, who signed himself *Minimax Dadamax in person*, distributed his extremely violent newspaper, *Der Ventilator*, of which 20,000 copies were printed, at the gates of factories. "Our rage," he later explained, "was aimed at total subversion. A horrible and stupid war had frustrated us for five years of our existence. We had been present at the collapse into ridicule and shame of all that had been taught to us as being just, beautiful, and true. My works during this period were not meant to fascinate but to make people shout. . . ." In 1923 came the apotheosis: the Dadaist anarchist Franz Jung hijacked a cargo ship on the Baltic Sea and forced it to go to Leningrad. He presented the ship to the Soviet authorities, who, highly embarrassed, soon sent it back to Germany. Striking and subversive actions ceased only when the situation in Germany stabilized itself around the Weimar Republic—almost at the same time as in Paris, where Tristan Tzara, transplanted from Zürich to Paris, had exercised (up to 1922) his program of provocation, creating monstrous uproars and seriously proposing a congress to discuss "whether a locomotive is more modern than a top hat." In 1921 Francis Picabia exhibited a stuffed monkey attached to a canvas, *Portrait of Cézanne*, and Georges Ribemont-Dessaignes stated that, "If you place your finger on a Dadaist chair, when you remove it, it is moist, sticky, and smelly. . . ." Mockery and derision. Others, however, refused the attempt

Piet Mondrian. 1911

Umberto Boccioni. Caricatures of Gino Severini and Carlo Carrà. 1912

Jean Arp, Tristan Tzara, and Hans Richter in Zürich, Switzerland. 1917

Giacomo Balla

Umberto Boccioni and Filippo Tommaso Marinetti in Paris. 1912

Boulevard Montmartre at the end of the century

Étretat in 1906

Flight of steps on Rue Labat, Montmartre. c. 1888

at nothingness; they wanted, not without idealism, to make a blueprint for the new world. For the *De Stijl* painters, the war was the logical consequence of universal selfishness. They believed what was needed were "new morals and a conception of beauty freed from matter," and that these "will regenerate the materialist society." Man, finally dominating nature, would eliminate anxiety, the *tragedy* of his life and art: painting would disappear, and the equilibrium it proposes would be realized in things, in men, and in social organization. "For the new beauty," wrote Piet Mondrian in 1919, "a new man is needed." And, in 1942, Mondrian stated: "Art is only a product of replacement in a period in which life lacks beauty." He painted in order to create the model of "a new society based on the equivalent duality of the material and the spiritual, a society consisting of balanced relationships." At the other end of Europe, Cubo-Futurism, likewise sought to forge its social utopia. Vladimir Mayakovsky believed that the Revolution was unfinished as long as it had not produced "a revolution of the spirit." But soon Vladimir Lenin decreed "a pause" in the Revolution, and the industrial preoccupations of the Soviet Union took an imperative turning. Artists, whether they liked it or not, submitted to the N.E.P. (New Economic Policy). Thus was born *productivism*, or total submission to the ideology of production—so strangely comparable to Western functionalism. The new program postulated not only the abandonment of the "revolution of the spirit," which enlivened the artists' projects, but also the radical annulment of the concept of art. "Death to art!" was a common slogan in the 1920s. "The old Pegasus is dead," wrote Nikolai Tarabukin in 1923. "The Ford automobile has replaced it. It is not the Rembrandts who create the style of our period but the engineers." Vladimir Tatlin, the former leader along with Kazimir Malevich of the art scene in Russia, stated that he

would no longer make "useless counterreliefs but useful pots. . . . The workers and peasants do not need oil paintings, but chairs, tables, and *bourjouiakas* [small heating devices whose name derived from the French word *bourgeois*]." Alexander Rodchenko designed cars, kiosks, exhibition stands, posters, and furniture—which industry, still in its embryonic stage, very rarely produced in multiples. Rodchenko stated: "The mission of art is not to distract us from life but to organize it. . . ." In November 1921, twenty-five artists, including Rodchenko, Lyubov Popova, and Varvara Stepanova, solemnly renounced painting and decided to devote themselves exclusively to applied arts. They gained admittance into factories. Others specialized in theater, photography, and layout. All of these sincere artists had the same obsession: to stick to the period, to the Revolution, to participate in the general effort. They did not want to be mandarins or, as in former times, to be clowns and jugglers of a generation struggling and sacrificing for a better world. Nor did they wish to isolate themselves from the people who understood innovations poorly and who were hungry and cold. Finally, they wanted to reply to the pressure of a power hardening its positions by showing that the most modern researches play a role in society and contribute to everyone's progress.

But while these artists were exhausting themselves in satisfying the supposed desires of the masses, the conventional artists of the czarist period gradually went back to their easels along with the new regime's benediction to exalt the heroic and edifying values of Stalinism. With the exceptions of such exiles as Naum Gabo, Antoine Pevsner, Wassily Kandinsky, Marc Chagall, and Ivan Puni, Russian artists had all but disappeared in silence when Leon Trotsky formulated this judgment in 1938: "It is impossible to contemplate without physical repulsion mingled with horror the reproduction of Soviet paintings and

22

General Mobilization Order, August 2, 1914

The Third Republic is established and seems eternal, and the "fresh and joyous" war breaks out in 1914 with cries "To Berlin!" The beginning of World War I is followed by a period of disillusion, ruins, and millions dead. The artistic milieu emerges completely bewildered

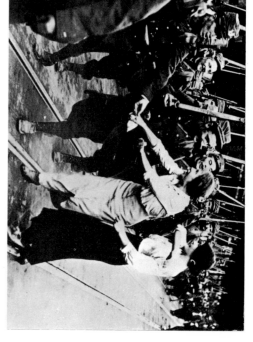

The belfry of Arras in 1917

An armament factory during World War I

The ruins of La Targette, near Béthune, February 2, 1916

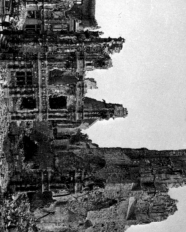

sculptures in which functionaries armed with a brush, under the vigilant eye of functionaries armed with Mausers, glorify the 'great' and 'ingenious' leaders actually deprived of the slightest spark of genius and greatness. The art of the Stalinist period will enter history as the most patent expression of the profound decline of the proletarian revolution."

Failure in the East, candor in the West. While the Dadaists sank into the absurd, such painters as Fernand Léger, Robert Delaunay, Theo van Doesburg, El Lissitzky, and Sophie Taeuber-Arp, and such movements as *L'Esprit Nouveau*, Purism, the Bauhaus, and the ICA (International Congress of Architecture), developed an optimistic philosophy whose decor was the city and whose talisman was the machine. Just as his friend Blaise Cendrars, Fernand Léger considered "the street as one of the fine arts." He felt exalted before lights and posters, and he was pleased to see attractive window displays. The master words of the period were "clarity," "transparency," "happiness," "reason," "hygiene." We are far from the time when Paul Gauguin wrote: "The machines have arrived. Art is gone." For Le Corbusier "the second era of machine civilization has begun, the era of harmony, in which the machine serves man." He called his lodgings "dwelling machines" and upon arriving in New York in 1935 said that "the skyscrapers are too small." One could think this a rational and positive organization, what Léger, in 1924, had called "a society without frenzy, calm, orderly, a society that knows how to live naturally in beauty, without exclamations or romanticism. This is merely useful and beautiful. It is a religion like any other. I think it's where we are heading."

The worship of mechanics, scientism, a lyrical illusion of progress. A whole generation believed that its dream of order could escape from the implacable questioning of History. One figure symbolized this impenitent optimism: the wheel, the circle. Jean-Joseph Goux pointed to the "heliocentric thought of the pivot, of the axle, of the luminous and sublime hearth that enlightens and governs the particular and the accidental." We see it radiating in Fernand Léger, Robert Delaunay, Giacomo Balla, Vladimir Tatlin, Wassily Kandinsky, El Lissitzky, László Moholy-Nagy, Le Corbusier, Amédée Ozenfant, Oskar Schlemmer, Josef Peeters, August Herbin, Vertov, and others, whereas Marcel Duchamp, Max Ernst, and Francis Picabia offer a caricatured version, and such filmmakers as Abel Gance (*La Roue*), Fritz Lang (*Metropolis*), and Charlie Chaplin (*Modern Times*) an evil version. In his book *Utopie et Civilisations*, Gilles Lapouge has noted the omnipresence of pivots, gears, and clock movements. "We recognize a strict image of the utopic structure. . . . To open a watchcase and observe the regular, stable, and coherent mechanism is to cast an eye on a Radiant City (Corbusier): a closed, mechanical world without mystery or wear." For Lapouge "time enrolls itself," it denies its linearity, it operates indefinitely on the same surface.

Here, however, History—dismissed from the space of art, banished from the technical utopia—makes a noisy entrance. The manner in which the great currents of the first quarter of the century have cancelled themselves out in their opposites causes one to reflect: Futurism in Fascism, Suprematism and Constructivism in Stalinism, Neo-Plasticism in the technocratic and commercial ideology of the Bauhaus, Dada in aestheticism. Art has no vocation of eternity. We saw it die out in Nazi Germany, disappear for half a century in Soviet Russia—with no collective creativity making up for the effacement of individual studies. Nor does anything exclude the fact that in Western societies, characterized by an extreme specialization in the division of labor and by a mercantilism that controls distribution and hence form, these attributes result little by little in art's radical effacement."

COLOR

By the fullness and intensity of flat areas, simultaneous contrast, and optical vibration, the artist liberates color from the constraints of representation

Odilon Redon. Pegasus Triumphant. 1905–1907.

Cloudy, volatile, Redon's color everywhere exceeds the outlines of the object represented

Pierre Bonnard. The Omnibus. 1895.

Maurice Denis. The Red Roofs. 1892.

With the Nabis, the tones, placed in patches, frontalize the image

In the 1870s Impressionism made color the primary object of painting. It revealed it as an excess, as an outflow, and it tore color away from the descriptive functions in which Classical art wished to enclose it. Color-passion: Claude Monet abhorred black to the point that his family felt they had to cover his coffin with a light-colored fabric. In 1895, Wassily Kandinsky, upon seeing one of Claude Monet's *Haystacks* painted four years earlier at Giverny, marveled at the "incredible power, unknown to me, of a palette that exceeded all my dreams. The painting appeared to me endowed with a fabulous power." Flowers spread with vermilion, a caparison of hardened spots, a suppuration of the pigment layer beyond the geometrical outline, beyond the figure outline: color confuses the perspective order and the delineation of objects, and it reverses the subordination of the pictorial field to logocentrism. According to Julia Kristeva, "However operative it may have been in the face of color, the analogy language/painting becomes impossible." We have seen it exude the most designed works in wallpaper, carpets, and the tablecloths of the early Edgar Degas (*The Bellelli Family*) as it had earlier, almost in a clandestine manner, in the abstraction of the marble slabs that Fra Filippo Lippi, Fra Angelico, and Luca Signorelli distributed on their staircases and throughout their architectures.

Color *dribbles*. A significant metaphor: here it is a question of body. Studying the symptom of the "black veil" that is common in some neurotics, Karl Abraham sought the cause in the "frustration of a libidinous tendency." It is this sensory, impulsive character that, beginning during the Renaissance, created suspicion and blame. "It would seem that, when I look at the works of one of these men especially called colorists, I offer myself a pleasure that is anything but noble," complained Charles Baudelaire, as if in reply to William Blake's imprecation: "Venetian, your color is merely plaster to disguise a vile prostitute." For the Classical age, color was *makeup*. It concealed the painting's spiritual finality. According to Immanuel Kant: "The essential is the drawing . . . The colors that illuminate the drawing are an attraction: they can very well animate the object in itself for a sensation but not make it worthy of being looked at and beautiful." According to Jean-Jacques Rousseau: "The interest and the feeling are not due to the colors: the lines of a painting that move us even more in a print. If you remove these lines in the painting, the colors are no longer effective." The primacy of line and of the figure responds to a threat of dissolution. The specific economy of colors escapes the conditionings of the Renaissance line. It is the *other* pattern. It superposes itself on the Euclidean arrangement, perverts it, and finally—in the twentieth century—expels it from the painting. In the distance between the two grids, in the *play* that articulates them and opposes them, lies a new liberty: that of the *subject* (the spectator) until now nailed to the floor by the specular equivalence of the viewpoint and of the vanishing point, trapped by a scene whose three-dimensional hollowing out he ensured by a fixed position.

Hence the cries and protestation ("A pot of paint," said Camille Mauclair, "has been thrown in the public's face") when it seemed that the Fauves, in 1905, in order to paint their portraits and landscapes (in the words of Georges Duthuit): ". . . break the lines of perspective and retain only a kind of sparkling, morcellated, dislocated film, which is then reestablished to produce a system of ardent and pure spots." Certainly, as has been seen with the Impressionists, they are not the first to "push" color. By hardening Georges Seurat's pointillism and exceeding its denotative intentions, Paul Signac and Henri Edmond Cross updated the chromatic autonomy implicit in Michel Eugène Chevreul's law of simultaneous contrasts. The reciprocal activation of complementaries can also very well exclude subject matter. In 1902 Cross stated: "I am returning to the idea of chromatic harmonies established out of nothing (so to speak) and beyond nature, as a point of departure." There was also Paul Gauguin—Henri Matisse acquired his painting *Young Man with a Flower* as early as 1898. Gauguin's posthumous retrospective exhibition in 1903, during the first Salon d'Automne, marks an era. Matisse studied Gauguin at leisure during the decisive summer of 1905 when Daniel de Monfreid, in Collioure, showed him the paintings of the exile of the Marquesas Islands that were stored in his place. He saw large flat areas without gradation, indifference to "local tone," a metaphorical value of color that denoted not so much the object as its *climate*. About 1896 Gauguin wrote: "O you painters who demand a color technique, study carpets!" Enthusiastically, he added: "Color is thus determined by its own charm, and it is not determined as the designation of objects perceived in nature." Matisse retained this advice, as did Robert Delaunay, Paul Klee, and a number of other artists who sought in applied arts and in popular fabrics for the frontal affirmation of a colored structure (see Chapter 4). The Orient fascinated this generation as it had Vincent van Gogh. During his student days, Matisse

shared with Pierre Bonnard the habit of buying in the Rue de Seine, for a few sous, Japanese prints, which revealed that "one can work with expressive colors beyond descriptive ones." As for Islam, it was to prove an inexhaustible source. In 1910 Matisse visited Munich to study the great exhibition there and was fascinated. He brought back many photographs of miniatures, carpets, and metal objects. "The Persian miniatures, for example, reveal the entire possibility of my sensations. . . . By its accessories, this art suggested a greater space, a real plastic space. This enabled me to emerge from Intimist painting." Later, in Moscow, Matisse discovered icons. Against this background of influences, two attitudes took shape. Sometimes color was summoned for the "nonfigurative" purity of its effects. At other times its aim was to interpret and to restore, in the manner of synesthetic equivalence, the "sensation" provoked by the subject matter.

(We have seen earlier—see "Signs and Men"—the defects of a division of different pictorial practices according to categories entitled "abstract" and "figurative." Every surface *becomes sign*, whether bare of the slightest iconic denotation; it is always a trace of something beyond itself, and it produces, from the moment of its imposition on the support, a chain of associations. Reciprocally, any representative figure functions *also*, at once, as surface, color, and matter. However, these oppositions—"abstraction" and "figuration"—in their arbitrariness, document the painters' attitude; they remain useful from the moment one replaces them in their historical context, and when one wishes, in order to begin, to seize them as polarities nonexclusive of one another.)

The first of the two attitudes—known as nonfigurative—often borrows its comparisons from music which is not, besides, without indicating an idealistic will to tear away from the materiality of the support. As early as 1895, Gauguin spoke of "symphonies" and "harmonies," which "should make us think as music makes us think, without turning to ideas or images, simply by the mysterious affinities between our brain and any arrangement of colors and lines." Wassily Kandinsky, hearing Richard Wagner's *Lohengrin* in the 1890s, recognized his own painting. "I mentally saw all my colors, they were before my eyes. Wild almost crazy lines drew themselves before me." But more often this tendency is based on the empirical experience of vision that places the chromatic range like an autonomous operator who hollows out and blows up the canvas according to the differential play of

juxtaposed tones. In 1913 Guillaume Apollinaire wrote: "No longer does color depend on the three known dimensions, it creates them. . . . We are shown here colors that should no longer impress us as symbols but as concrete forms." Kandinsky used the characteristics of the spectrum to add to the material surface of the painting what he called in 1912 "an ideal surface." Color breathes: "Employed as it should be, it advances or retreats and makes of the image a being floating in the air."

Using the same "nonfigurative" premises, Piet Mondrian—in his classic phase (1920–1936)—sought the opposite result. He attempted to eliminate the optic-chromatic modulation through the scrupulous calculation of tonal equivalences. By balancing his color spots, by increasing those that risk withdrawing before the retina, by diminishing the most intensive ones to prevent them from "coming forward" on the canvas, by enclosing the whole with black parallels that emphasize frontality, the theoretician of Neo-Plasticism wanted to identify his colored fields with the frontality of the canvas.

It was quite different with Matisse—who participated in the second synesthetic and figurative current. Certainly, he intended to create "a work that bears in itself its significance and imposes it on the spectator before he is able to identify the 'subject,'" and he even claimed "to use color for its luminous intensity in its various combinations, harmonies, and not to define objects." Yet for all that painting cannot sacrifice the iconic denotation. If only by a mere hint, Matisse takes us back to representation. Where academic painting claimed that it restored the subject matter to its specular truth, the author of *The Joy of Life* —like Paul Cézanne—advocated a bias of chromatic *equivalences*: "No struggling with nature to create light: we must look for an equivalent, work on parallel paths, since we are using dead things. Otherwise, we would have to have the sun behind the canvas. The painting must have the power to generate light. This power is felt when the composition, placed in the shade, retains its quality, when, placed in sunshine, it resists its striking effect." Matisse frankly chose these *equivalences* from the antipodes of "local color." "When I place a green, this does not mean grass, when I place a blue, this does not mean sky. . . . I use red for a green marble table. Elsewhere, I needed a black spot to create the idea of the sun's rays sparkling on the sea." And when asked what hat Mme Matisse wore when she posed for the outrageously gaudy *Portrait* of 1905, he

Paul Gauguin. *Three Tahitian Women on a Yellow Background.* 1899

Gauguin wrote in 1898: "Color being in itself enigmatic, in the sensations it gives us, logically we can only employ it enigmatically every time we use it not to draw but to give the musical sensations stemming from it, from its own nature, from its inner, mysterious, enigmatic force"

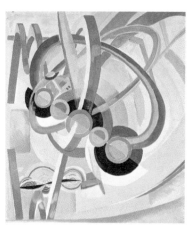

Robert Delaunay. *Project for the Panel of the Palais de l'Air.* 1936-1937

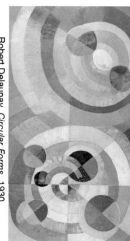

Robert Delaunay. *Circular Forms.* 1930

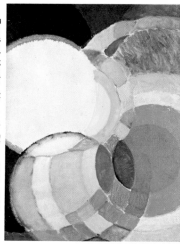

Frantisek Kupka. *Newton's Discs.* 1911-1912

The circular organization of color creates a visual vitality in the spectator. In his research on the occasion of the International Exposition of 1937, Delaunay wanted to enlarge this effect of optical acceleration on a scale of a monumental environment.

replied: "Obviously black. . . ." Matisse presented his research in *equivalences* as a manner of "realism." According to him, there is a close relationship between "the color relations of your painting" and "the color relations of the model." In his opinion, the colored ensemble occupying the canvas would have its pendant—and not its equal—in the subject matter. The doctrine here reveals its arbitrary aspect. In short, *equivalence* is merely the name the painter gave to his liberty to invent the painting in his own way. The very moment he believes that he has selected from the motif an ensemble of "objective" tones, he has already taken in the logic of the work. It is this logic that dictates the assortment of "local colors" from which he claims to depart. This assortment is no more natural and real than the first sketch he made of it. Passing from the subject matter to the sketch, then from the sketch to the final painting, he works in both cases with the same independence.

This independence was confirmed by the second part of Matissian "realism": synesthesia. His ambition was not only to produce *equivalences* of objects, but also to restore polysensory sensations: heat, odor, tactile values, etc: the entire climate and "the sentimental moment" that created the painting. These sensations can even spread out in time, on either side of the actual time of execution: "I didn't want to do a woman. I wanted to give my impression of the South of France." "It is the individual's vibration before the sea that counts rather than the object producing this emotion."

In short, it is the infinitude of the world—even of "cosmic space"—that Matisse summons in his canvases. The supposed components intervening in the development of the work are so vast, diffused, and heterogeneous that they finally lose any referential or indicative precision. Here again the argument of equivalents and the type of shifted "realism" claimed by the artist should be understood as the alibi of a total liberty. More than a lyrical report on the ambience of the Riviera or allusions to such and such a landscape, Matisse's paintings are chromatic and formal organizations that act on the spectator as *painting*.

Whether they appear as "abstraction" or "figuration," the modern conceptions of color often yield to the predeterminations of a contextual symbolism when each tone is credited with a psychological dimension. It was not without emotion that Kandinsky saw emerging from the tube "these strange beings we call colors . . . alive in themselves and for themselves, autonomous, and having qualities necessary to their future autonomous life."

Although the Fauvism of André Derain and Maurice de Vlaminck rarely succumbed to such a conception of the tone in itself, isolated from its chromatic context—we shall see, with Matisse, that it was a pure fiction—it fell into another irregularity of the period by emphasizing the energetic and "wild" characteristics of color. An entire primitivism—taken up once again from Gauguin and Van Gogh—was stated here whose aim was

Character-like and/or mystical, "hot" or "cold," the symbolical color intends to be endowed with specific properties that are unhindered by the proximity of other tones. Each would create a separate optical apprehension. "Concentrating first on color alone, considered in isolation, letting it act on you," stated Kandinsky in 1912. "Yellow colors are endowed with an 'excentric movement'" of dilatation beyond form, the "cold' colors with a 'concentrated movement.'"

With Kazimir Malevich, we emerge upon a monism, even a color mysticism. He invests white—considered as a synthesis of the spectrum—with a metaphysical dimension (see page 216). A chasm that engulfs the world of objects, the white surface represents a limitlessness that could be that of Being: "The blue of the sky," he wrote in 1919, "'is transcended, broken in the Suprematist system, and the white makes its entry as the real and true representation of infinity."

He characterized colors as "jubilant," "ostentatious," "of sparkling mischievousness," "reflective," or "dreamy." Not only did each of these "beings" emit its own specific climate, but also it revealed character traits. "Yellow torments man, it pricks and excites him, it imposes itself on him with a kind of insufferable insolence.... Absolute green is in the society of colors what the bourgeoisie is in that of men: an immobile element, with no desires, satisfied, in full bloom, etc." These conceptions—already present in Gauguin ("There are noble tones, others that are common. . . .")—have their origin in emblematic, heraldic, and religious history. The error here is to believe that a symbolical grid of interpretation can be consubstantial with the "nature" of colors. This grid disappears at the same time as the cultural, religious, economic, or political system that produces it. Concerning Russian icon painting, Nikolai Tarabukin mentioned "a symbolical coloring established by tradition that precisely defines the place and meaning of each color as having a determined ideology." Without making a special study, it is clear that this code does not intervene in our immediate reading of icons.

to make color an incoercible flux. It was a question of producing in the spectator a double effect of astonishment and excitement. Color would reveal a "state of nature" atrophied by modern society. Derain compared his colors to "sticks of dynamite." Vlaminck explained: "With my cobalts and vermilions, I want to burn down the École des Beaux-Arts."

Color as a vital source: this was the leitmotiv of a whole generation. Othon Friesz spoke of "passionate transpositions," Matisse of an "energetic blow on a gong." Matisse believed in the tonic, therapeutic characteristics of his paintings and hung them in the rooms of his sick friends. For Fernand Léger, color was "an indispensable raw material of life, like water and fire." He described World War I as "four years without color." Le Corbusier exclaimed, "Color? It's the sign itself of life." In 1913 Carlo Carrà demanded in a manifesto, "Reds, redddddddds, very redddddds that shououououout. Greens, the never enough greens, the very striiiiiiiiiiident greeeeeeens." On seeing the landscapes near Kairouan, Tunisia, Paul Klee experienced "a great delirium." He stated, "Color possesses me. There is no need to seize it. It possesses me, I know. Here is the meaning of the happy moment: color and I are one. I am a painter."

For the most exalted, the holiday was a brief one. Harshness in repeated form degenerates into monotony. In 1907, on leaving the Salon des Indépendants, Derain told Vlaminck that he was fed up. "It finally becomes dyeing." They took the exacerbation of color to such a point that they had nothing more to say. "I suffered," Vlaminck was to explain, "for not being able to hit harder, for having arrived at the maximum intensity." Derain stated: "Signac got us all involved in his theory of pure colors. First of all, there are none in nature; next, vermilion is always the same vermilion, yellow is always the same yellow. This soon ceases to be funny. . ." Or original. The century was to have less and less fear of color. With the advent of the poster, window displays, packaging, it became the privileged condition of merchandising. In cities that are all too often, as Georges Ribemont-Dessaignes has described them, "horrible suburbs remaining alone around a city that has disappeared," color proliferates in proportion to the grayness. The "great bursts of sunshine that appeared upside down on the canvas with the attitude of go-where-I-push-you" (*ibid.*) could not alone justify and satisfy the pictorial practice. The trap was to believe that a few

splashes of scarlet were enough to reanimate the pleasure principle, to remove the interdiction of the body. If pure color stupefied the first viewers of Fauvism, the reason was that it contrasted in the heart of the museum and the exhibition with the multitude of tarred canvases inspired by the Academy. Thus, it was already taken in its differential structure. As the general tone rises, the transgression repeats itself and ends in canceling itself. Matisse—after the first phase of Fauve exaltation—was to agree that the "corporeal," the libidinous stasis required by color could be expelled only by at once inscribing a sign in the coherence of an articulated system of contrasts. "Pure color with its intensity, its reactions on its neighboring quantities, is a difficult medium. . . . An avalanche of colors remains without force. Color achieves its full expression only when organized."

The "Symbolist" conception of color (Kandinsky) like the Vitalist one of early Fauvism, postulated a passive spectator, whose eye—target, funnel, sponge—was merely a receptor of the colored flux. They took for nothing the structuralizing activity of looking, the work of selection that is constantly done in the entire visual field in which, henceforth, vacillating, spinning, in a chasm, constantly demanded and summoned, it ever continues to construct and deconstruct itself as vision. Now the painting, Jacques Lacan tells us, would be like a halt in this relentless labor of perception, a place where the act of looking *settles*. It would be a looking process already "done," stopped, where the eye of the spectator can flow, can suspend itself. The economy of the work will require spacings, a *play*, a discourse that allows the insertion, the projection of looking as *subject*, that is, as the carrier of an individual and collective history. Here are marked the limits of a painting that admits no other project except to overpower, to fascinate the spectator by the violence of its pigments and that succeeds—like an effect of rebounding—only in excluding him.

This explains Matisse's importance after the most virulent phase of Fauvism, which ended in 1907. Exceeding the contradictions of Vitalism, he opened the broad road of modern color. Far from seeking a color that hits you in the face, the painter of *The Dance* began by allowing us to invent part of *our* range. "The mutual influence of colors is wholly essential to the colorist, and the most beautiful, the most stationary, the most immaterial tones are obtained without being materially expressed." Josef Albers later systematized this position by stating that all color is *deceptive*, a psychic result of the

André Derain. *The Two Barges*. 1904

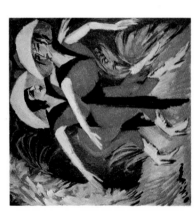

Ernst Ludwig Kirchner. *Dancers in Red*. 1914

For the Fauves as for the Expressionists, colors are "sticks of dynamite"

Henri Meunier. A poster before lettering. 1900

At the turn of the century, advertisement discovers the stimulating function of the flat colored area

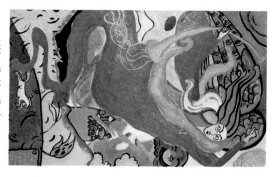

Wassily Kandinsky. *Saint Gabriel*. 1911

In his paintings on glass, Kandinsky borrows from the ex-votos of naïve Bavarians their technical means and their efficacy of palette

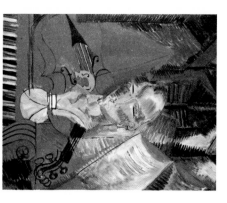

Raoul Dufy. *Homage to Mozart*. 1915

The chromatic grill is superimposed on the formal grill without coinciding with it

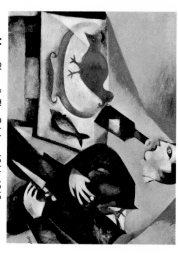

Marc Chagall. *The Drinker*. 1911-1912

spectator's eye (actual fact) by no means covering the physical facts that produce it (factual fact). The articulation, the interaction are at the very core of Matisse's aesthetics. In 1905, at the outset of his pointillist period, he experimented with what he called, from a formula borrowed from Édouard Vuillard, the *final brushstroke*. The work seems to produce itself by endogeny. "I placed my color, it was the first color on my canvas. I added a second color and then, instead of wiping this second color off when it did not appear to harmonize with the first, I placed a third that would agree with both. Then I had to continue until I had the sensation that I had created a complete harmony in my canvas."

With Matisse every tone is plural in its effects, a tributary of the tones that border it, that change it. A tone does not exist in itself, it works as a structure of response. The surface is mobilized from end to end—as in the last paintings of Cézanne. "The relationship between the tones will be established in such a way that it will support rather than fight them." The moment a desire for "pacification" keeps the entire canvas under control, the artist can finally heighten the tone and propose—in the 1940s —zigzags, gaudy colors that are almost kitsch, and spotted areas that would anticipate Pop Art if they did not express more than ever in their surmounted aggressivity a scholarly art of organization and chromatic economy.

Again it is a relationship of interaction that associates form and color in modern art. "Can you actually make me believe," wrote Gauguin in 1890, "that drawing does not stem from color and vice versa? As proof, I will reduce or enlarge for you the same drawing according to the color with which you want me to fill it." Matisse used this argument. "There is a necessary proportion of tones that can lead me to modify the form of a figure or to change my composition."

There was also another arrangement in which Matisse, beginning in 1908-1910, made an essential contribution: the relationships between quality and quantity. A reflection by Cézanne, quoted by Gauguin ("A kilo of green is greener than half a kilo"), took over in his thinking on the subject as he took it up for his own use in terms of surface: "A square centimeter of blue is not so blue as a square meter of blue." In his large canvases of 1910-1911—in which "the essential was the quantity of color surface"—he invented a new spatiality from which American art in the years 1950-1960 (Barnett Newman, Frank Stella, Kenneth Noland, and others) took its scale, its power, and its frontal simplicity.

Rejecting nuances and gradations, assuming the entire wall space (Matisse's *The Dance* is almost 13 feet wide), purifying the anecdote to the point of submitting it completely to formal and chromatic logic, Matisse mobilized the spectator's kinesthesia and changed his approach into a course (see Chapter 6). Something is transcribed here— far from any denotative "realism"—that is of the order of a modern perception of width. "Our civilization, even for those who have never piloted a plane, has led to a new understanding of the sky, extension, and space. Today we demand a total possession of this space." Logical consequence: the potential extensibility of the canvas beyond its frame. Already during his years at the École des Beaux-Arts, Matisse had arranged one of his still lifes in the center of the studio, exclaiming, "Look how it illuminates the room!" More than a wall, the work—by an effect of energetic amplification—invested a *milieu* ("Our canvas introduces a new element in the room it enters. The lighting is modified. The walls recede."). Here color is given its contemporary dimension; in its own way it bears the mark of a History, and the flight of the painter's spirit beyond its *setting* —even if it takes us back to pre-Socratic cosmogonies—nevertheless expresses on the mythic level the blending reverie of the period. "I escaped from the space lying at the bottom of the painting motif," said Matisse in 1946, "to feel in spirit, above myself, above any motif, studio, even house, a cosmic space in which I no longer felt the walls any more than do fish in the sea."

Edouard Vuillard. *Head of a Man*. 1890–1892. on cardboard. 11 × 9".

Edouard Vuillard (1868–1940). *Self-Portrait*. c. 1892. Oil on cardboard. 14¾ × 11".

Vuillard surrenders to Gauguin's order: "Pure color! You must sacrifice everything to it...."

Anticipating the Fauve explosion by some fifteen years, the young Édouard Vuillard painted a series of small canvases whose aggressivity of color amazes us. Nothing at that time—either in Paul Gauguin's or in Vincent van Gogh's painting—can compare to the puddle of red that submerges the upper torso and face in Vuillard's *Head of a Man* (left). The *Self-Portrait* (above), in an octagonal frame, seeded with a scattering of pink and blue strokes, is cut in two by a stroke of lightning—from the painter's canary-yellow hair to his orange beard—that, however, locks together areas of Vuillard's violet

face as though they were pieces of a jigsaw puzzle. Nothing could better illustrate Van Gogh's statement: "Color in itself expresses nothing." Here Gauguin—by way of Paul Sérusier—certainly influenced the young Nabi, who was a companion of Pierre Bonnard, Albert Roussel, and Félix Vallotton. Vuillard learned from the Pont-Aven School what Maurice Denis described as "the system of solid strokes, the basis of the delicate and intense charm of his compositions." But Vuillard soon carried arbitrariness to its extreme limit. In his interiors and gardens of the 1890s he returned to a palette whose subtle tones reveal a much quieter range.

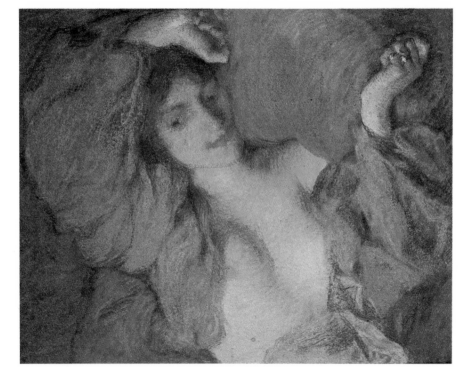

Edmond Aman-Jean. *Farniente.* c. 1900.
Pastel on paper glued to the canvas. 24 × 19⅝"

Italian Divisionists, such as Giuseppe Pellizza, Giovanni Segantini (see page 274), and Giacomo Balla's early work. In Charles Léandre's *Portrait of a Woman* (right), recently rediscovered by Geneviève Lacambre, the gold curtain that stiffly silhouettes the woman's figure against the light achieves a beautiful chromatic boldness.

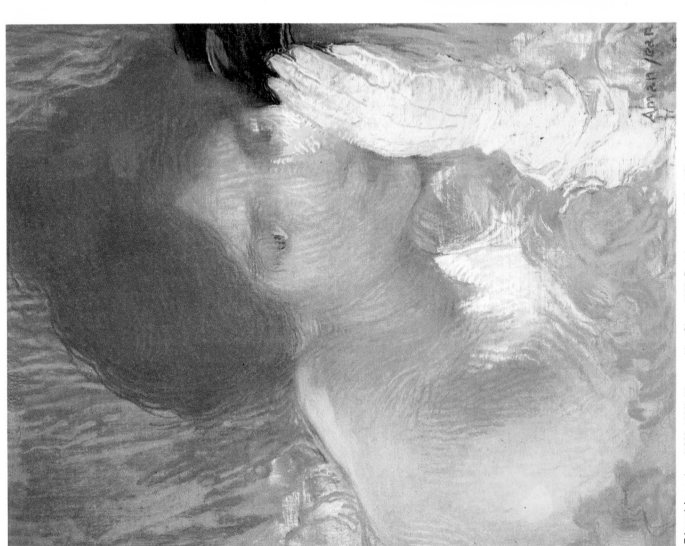

Edmond Aman-Jean (1860–1936). *Woman with a Glove.* 1902. Pastel on wood. 15⅞ × 12⅝"

Artists who work in an intimate style in pastels achieve tones both soft and vaporous and acid or ardent

About 1900, an entire generation of French artists who worked in an intimate style found that pastels provided the opportunity for employing rare, acid, vaporous, or ardent tones. Geneviève Monnier, who has seen in the works of these artists the source of certain modern photographic processes, has written that in them "vagueness gives more mystery to certain scenes treated as apparitions." Edmond Aman-Jean's fuzzy strokes blur the face of the lady in his *Woman with a Glove* (above), which we seem to see from a distance through a frosted windowpane. The artist, who was one of Georges Seurat's few friends and who shared his studio for several years, worked with strokes discreetly separated and obtained effects that, beyond textural differences, bring to mind the researches of certain contemporary

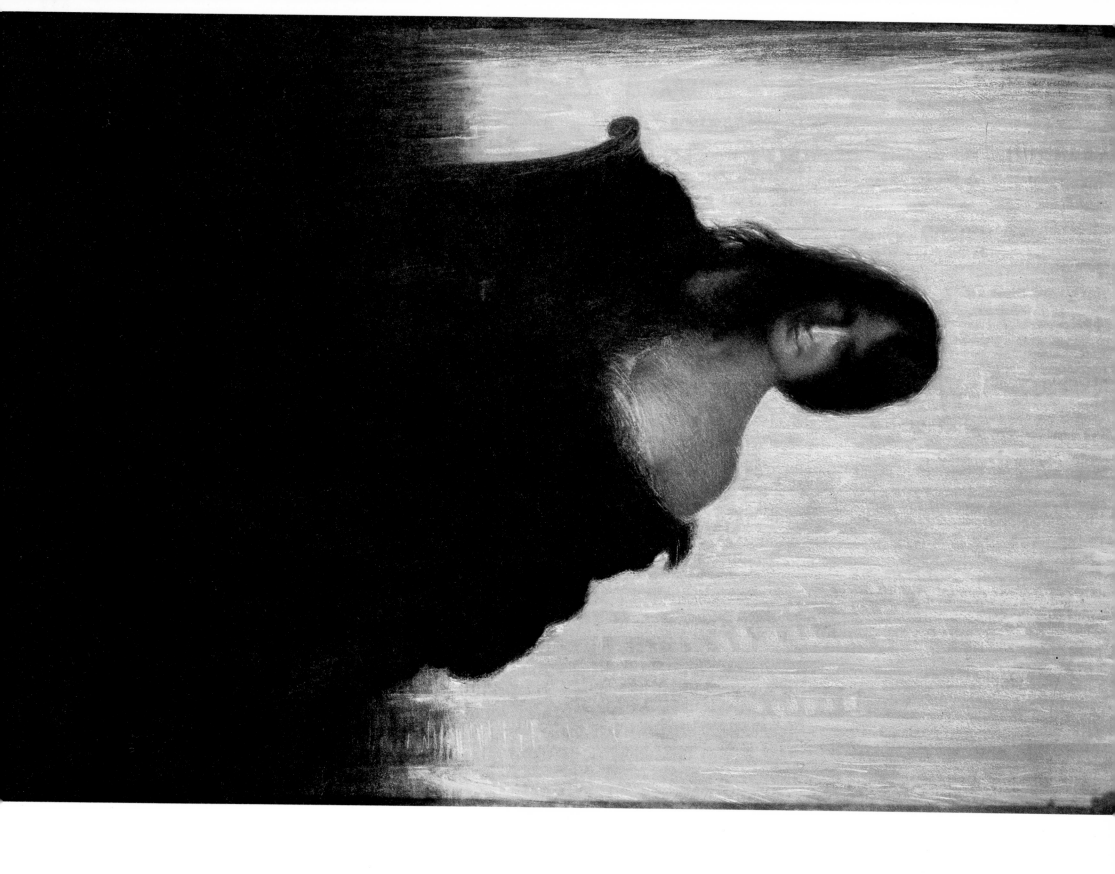

A blue both aquatic and profound reigns supreme over Picasso's melancholia

Against a geometrical background each time highlighted by a luminous area, Pablo Picasso outlined his languid, prostrate, battered figures with their strangely vegetal hairstyles. "For the period of a year," wrote Guillaume Apollinaire, "Picasso experimented with this aquatic painting, blue like the damp bottom of an abyss, and inspiring pity." Actually Picasso's Blue Period lasted from 1901 to 1904. In an atmosphere of dereliction, although sufficiently literary, the young artist combined the influences of Paul Gauguin, Théophile Alexandre Steinlen, Edvard Munch, Sir Edward

Burne-Jones, and even that of a sixteenth-century Spaniard, Luis de Morales. But the artist's innovation lay in his use of color. By insisting on a cameo-like technique of painting tone on tone, Picasso tore his painting away from the principle of local color and from realism. He made no claim of restoring an atmosphere but of creating one. Picasso's blues escape any naturalist function and act directly on the viewer. In *Melancholy* (right) the main subject is not the seated woman but the modulation of the large blue and green areas.

34

The ambience of the studio and the teaching function of the model are subverted by a rain of pure tones

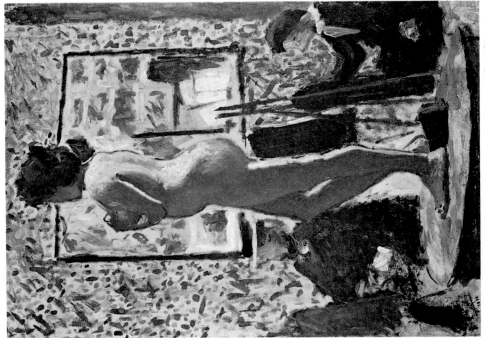

Albert Marquet (1875–1947). *"Fauve" Nude.* 1898. Canvas. 28¾ × 19⅞"

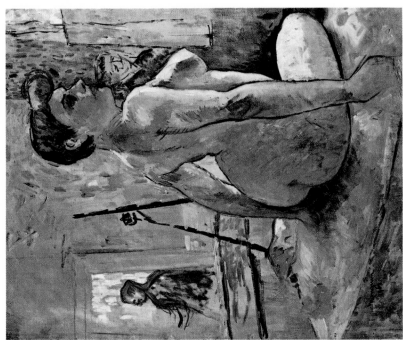

Henri Manguin (1874–1949). *Nude in the Studio.* 1903. Canvas. 36¼ × 28¾"

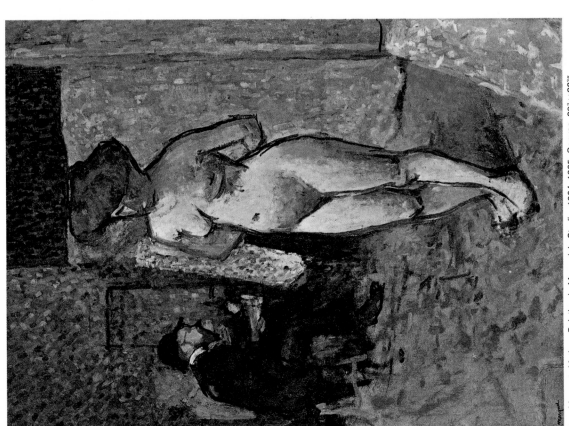

Albert Marquet. *Matisse Painting in Manguin's Studio.* 1904–1905. Canvas. 39¾ × 28¾"

Henri Matisse (1869–19..
Nude in the Studio. 18..
Oil on cardboard. 25⅝ × ...

Several years before Fauvism publicly appeared as an established tendency, color had imposed itself as specific energy increasingly more independent of the represented object. The tradition of the model —characteristic of academic teaching—was subverted by a chromatic effervescence, which Albert Marquet and Henri Manguin reserved for wallpapers, floors, and screens in their works, but which Henri Matisse imposed on the model itself in the flamboyant eruption of his red *Nude in the Studio* (right). This 1898 work by Matisse was painted side by side with Marquet's *"Fauve" Nude* (above). These two works are distinguished by their differences. Marquet did not dare impinge upon the model's integrity; Matisse, who that same year had read Paul Signac's text *From Delacroix to Neo-Impressionism,* risked the most passionate *équivalences.*

Throughout his entire life Matisse persisted in basing his art on references taken from the outside world of appearances, but at the same time he claimed the absolute right of transposition. Thus in 1935 he stated: "What was the interest in copying an object that nature supplies in unlimited quantities and that we can always conceive more beautiful? What is important is the relationship of the object to the artist, to his personality, and to his power to organize his sensations and emotions." And, during the same period, speaking to the painter André Masson, Matisse said: "I place a bouquet of various flowers on the table in order to paint them. Once the painting is finished, I want a gardener to be able to recognize the various species of this bouquet, but I don't know what happened en route. It has become a round danced by young girls."

Matisse drowns the silhouettes of his women in a debauchery of trembling and barbed strokes

Henri Matisse freed himself from outline. His figures became less drawn in advance through outline than produced by the apparently erratic accumulation of blurs.

Heavy, large, and thick, these blurs seem to emerge directly from the tube. Even if set apart by a discreet border, the figure in *The Japanese Woman at the River Bank* (left) can scarcely be distinguished from the colored chaos surrounding her, which is comparable to a palette's disorder. Only the concentration of blue and violet strokes that denotes the fabric of the woman's dress permits the figure to be isolated from its context. In the *Outstretched Nude* of 1906 (right), however, there is no longer even a border. The figure has been created like a negative *in reverse* from the green strokes that define it. Here the pigment and texture create the figure—no longer does the figure impose itself indifferently on the supposedly neutral and interchangeable surface.

Here and there outline changes into flat areas. Far from limiting itself to signifying the object, it spreads, extends, and participates *as pigment* in the general economy of the canvas. The silhouettes are lacunary and hatched. Like Paul Cézanne—yet taking his method to an extreme—Matisse refused to enclose his forms and allowed them to blend into the surrounding surface. The support is omnipresent. It frontalized the composition. In these figures it is impossible to distinguish the represented object from the representational process.

Henri Matisse. *The Japanese Woman at the River Bank.* 1905. Canvas. 13¾ × 11¾″

André Derain (1880–1954). *Boats at Collioure*. 1905. Canvas. 18½ × 22"

André Derain. *Collioure*. 1905. Canvas. 28⅛ × 35⅞"

As a rebellious follower of Georges Seurat, André Derain gave his color strokes such proportion that they exist by themselves before they denote a landscape. In this he emphasized Paul Signac's and, above all, Henri Edmond Cross' bias; they too at the beginning of the century tried to escape from the influence of the apparent inventor of pointillism. It was Henri Matisse who acted as the link between generations. Working under the friendly thumb of Cross and Signac in Saint-Tropez in 1904, he joined Derain at Collioure the following summer, and side by side the two artists engaged in exalting experiments in pure color. "He's a

much more extraordinary person than I thought from the point of view of logic and psychological speculations," wrote Derain of the older artist. Matisse encouraged him especially to leave bare the white texture of the canvas, using it on the one hand (*Boats at Collioure*, above) to represent the sun's dazzling rays and on the other (*Collioure*, above) to promote the luminosity of the canvas as surface. "The great mistake of all painters," explained Derain to Maurice Vlaminck as early as 1903, "is to have . . . wanted to render the effect of the moment of nature . . . and not to think that a simple luminous *assemblage* puts the mind

in the same state as it is in when looking at a landscape."

The blue screen of spaced strokes that covers the seascape in *Boats at Collioure* (right) has been cleverly heightened by green and red strokes, and the areas between the brushstrokes help to ensure that the canvas breathes. In the lower part of the work, the raw canvas has been left practically unpainted to indicate the quay. In a few weeks at Collioure, Derain produced thirty oils, twenty drawings, and fifty sketches. They represent along with his contemporary series of London landscapes the peak creations of his career.

By enlarging Seurat's little dots,
Derain affirms the independence of his polychromatic punctuation

André Derain. *Boats at Collioure.* 1905. Canvas. 23⅝ × 29½"

41

André Derain. *Big Ben*. 1905. Canvas. $31\frac{1}{8} \times 34\frac{3}{8}''$

42

André Derain. *Old Waterloo Bridge.* 1906. Canvas. 31¼ × 39¾"

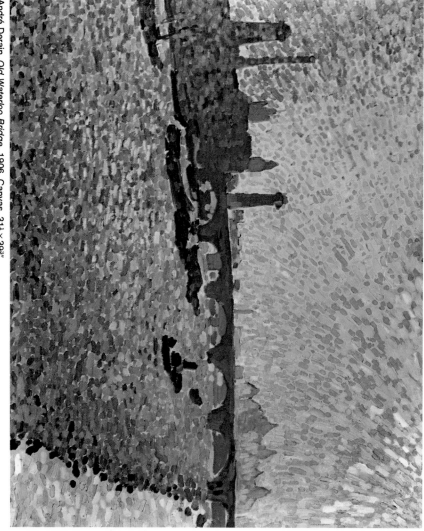

A shower of confetti transfigures the sky of London

Sent to London by the art dealer Ambroise Vollard, who hoped to repeat the great success Claude Monet had recently obtained with his views of the Thames (1899–1904), Derain, working at the very same places where Monet had painted, executed a joyful and brilliant synthesis of the work of Vincent van Gogh, Henri Edmond Cross, Paul Signac, and the painter

of the *Nymphéas.* For Monet's ghostly reverie of Westminster, he substituted the molecular scattering of swelling and noisy color spots seemingly gushing forth from the sun, a shower of confetti or of small sticks in which we rediscover the echo of the *Saint-Rémy Nights* of Van Gogh. "Van Gogh," Derain later confessed, "was the god of my adolescence. . . . His art constantly

pursues and haunts me." Yet when we see these immobile red spots and the monumental solemnity revealed in *Effects of Sunlight on Water* (above), we are reminded of Joseph M. W. Turner, as though Derain, enchanted with his vivid palette, had thought for a moment of recreating the spaces in which the great English Romantic artist had moved.

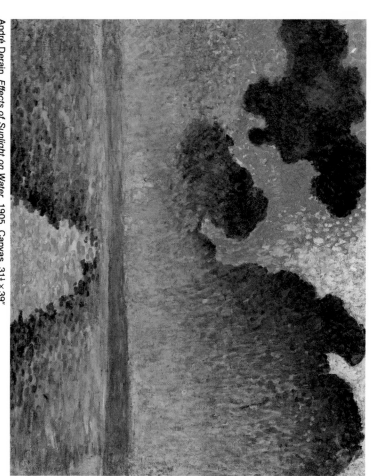

André Derain. *Effects of Sunlight on Water.* 1905. Canvas. 31¼ × 39"

subordinate to that which is represented.

"This is what differentiates the "mosaic" constructions of Robert Delaunay and Jean Metzinger, in which the brushstroke, far from making itself invisible, displays itself in flat geometric areas. Instead of melting in an optical effect, the rectangular spots state their irrevocable and indivisible existence and heighten one another by simultaneous contrast. The exaggeration of the process—in addition to pushing forward the picture plane—makes the interaction of the colors the represented anecdote, rather than the work's principal theme. Although the method was applied very systematically by Metzinger in his *Bacchant* (above), we note that certain areas escaped Delaunay in his *Portrait of Metzinger* (right). The shirt front, the nose, the eyes and eyelashes, and the outline of the chin all appear like so many heteromorphous collages. The "mosaic" surfaces of these modern paintings obviously recall the decorations of Roman and Early Christian basilicas with their tiny varicolored marble cubes (*tesserae*) or smalts—or for that matter the patterns of certain Coptic fabrics. But the intention is not the same. Delaunay's and Metzinger's paintings announce, in addition to the simultaneous contrast of colors, the principle of retinal surface destruction, which became the beginning of Op Art. The twentieth century made pointillism a process of dissolution of the iconic figure, of form, and of space. Whereas Byzantine artists constructed the image, modern artists *deconstructed* it (for an intermediary stage, see pages 168–169).

Robert Delaunay (1885–1941). *Portrait of Metzinger.* 1906. Canvas. 21⅝ × 16⅞″

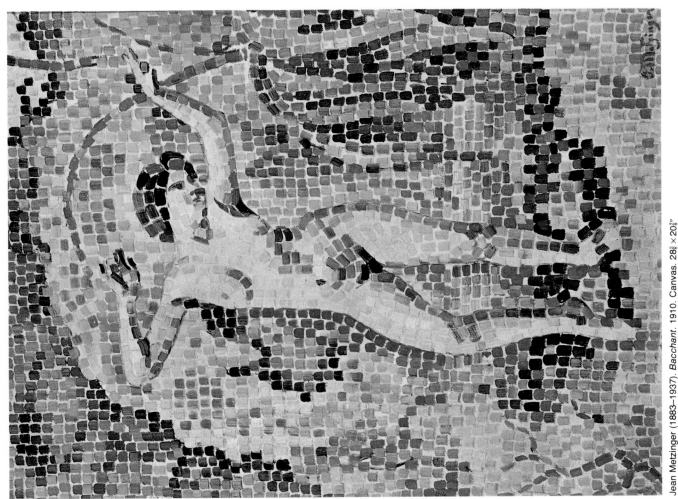

Jean Metzinger (1883–1937). *Bacchant.* 1910. Canvas. 28⅜ × 20⅞″

A regular pavement of rectangular areas interposes itself between image and spectator

Like André Derain, Robert Delaunay—who threw himself into Divisionism in 1906–1907—was both faithful to and rebeled against Georges Seurat's experiment. From Seurat he took the principle of a modular unit, an ever-similar stroke that invests the entire picture surface. Seurat, in revealing the principles of pointillism, became one of the founders of twentieth-century art. "He is the first painter in history," wrote Meyer Schapiro, "to have created paintings whose material is entirely homogeneous." By separating the laying down of pigment by brush from its realistic ultimate purpose, Seurat established the principle of an independent texture between the illusionist scene and the spectator. However, the moment one steps away from the canvas, this texture disappears: the small dots melt in one's view and compose an indistinct chromatic mass

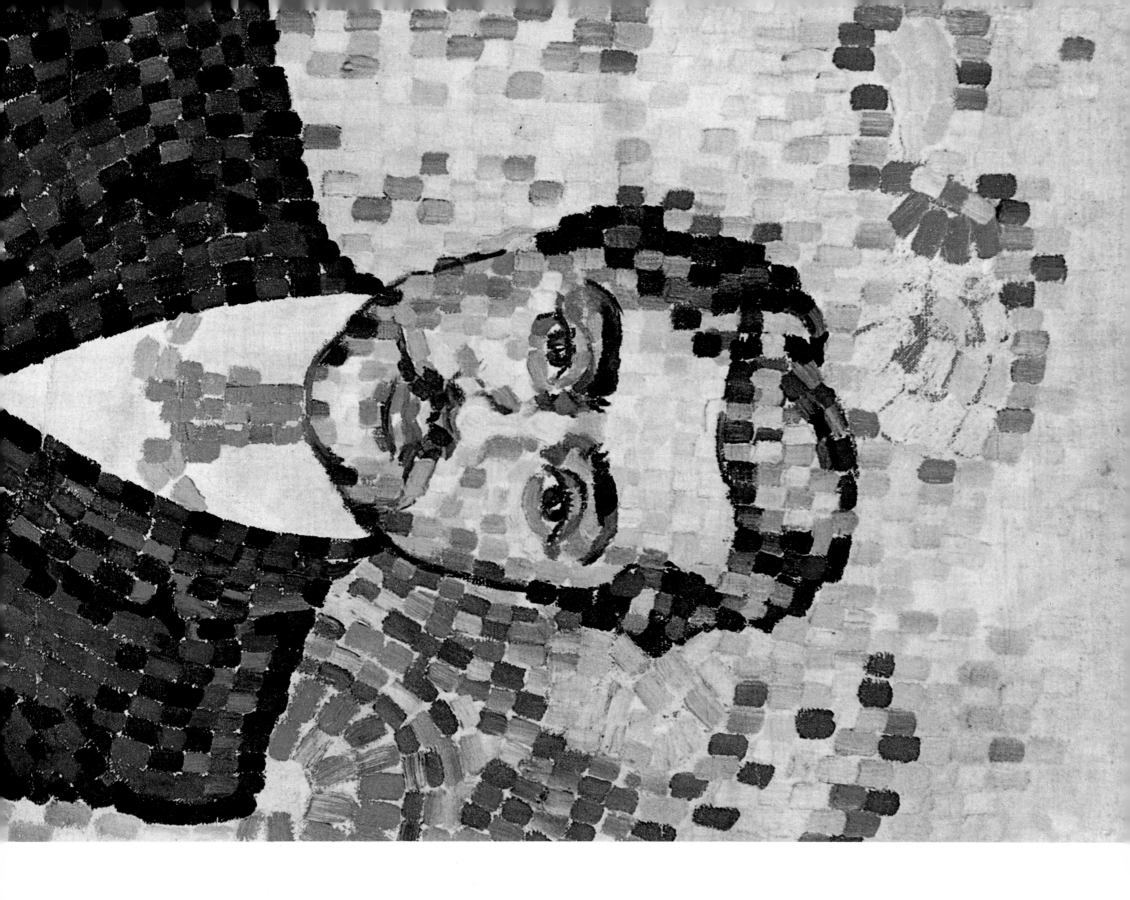

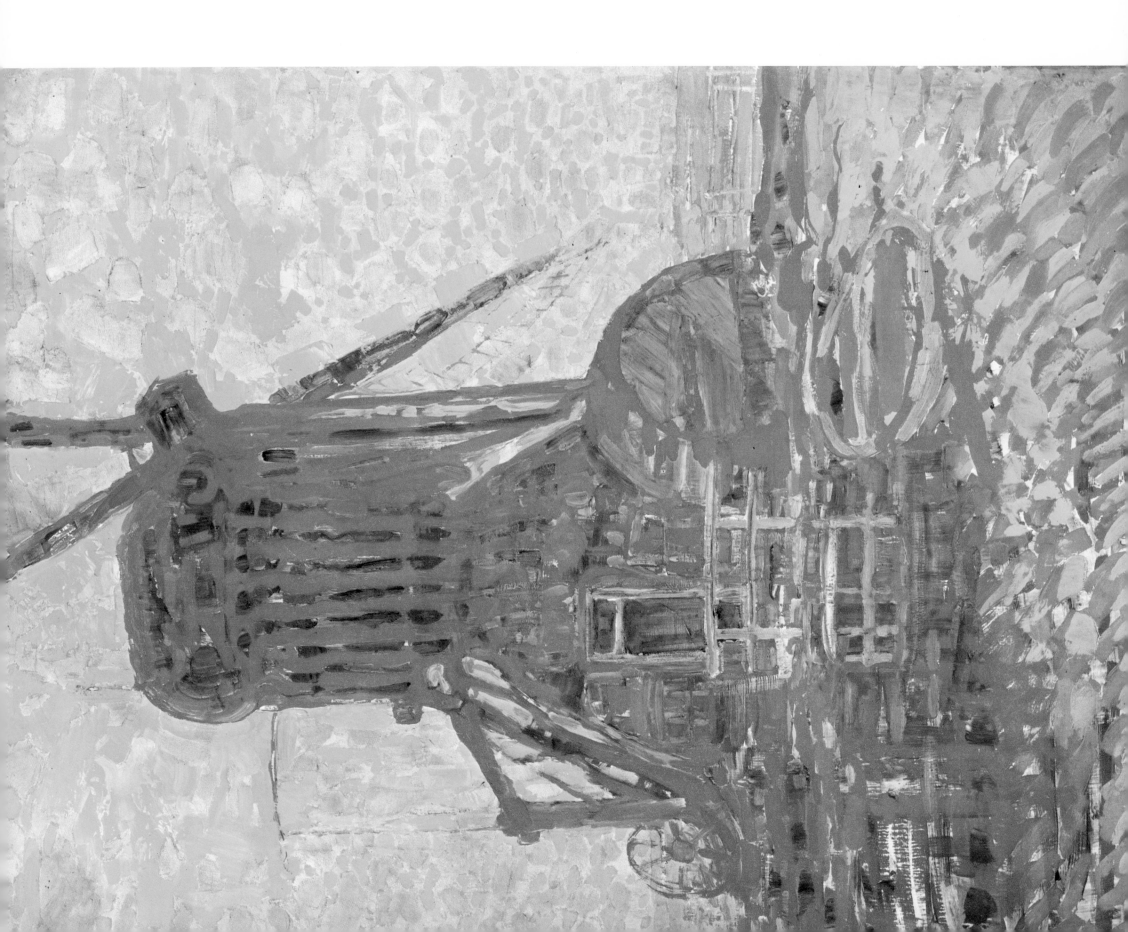

A silent optical pulsation electrifies the immobile landscapes of these Dutch painters

Piet Mondrian (1872-1944). *Windmill in Sunlight*. 1908. Canvas. 44⅞ × 34".

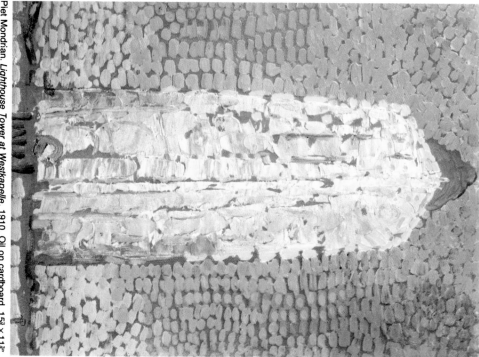

Piet Mondrian. *Lighthouse Tower at Westkapelle*. 1910. Oil on cardboard. 15⅞ × 11⅛".

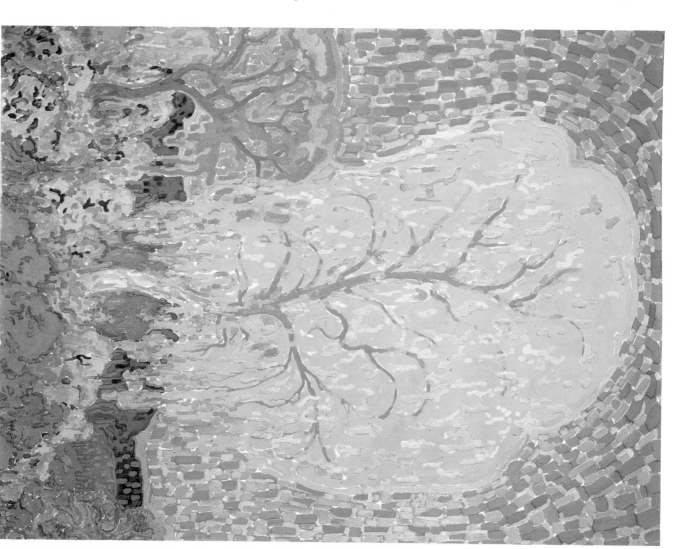

Leo Gestel (1881-1941). *Autumn*. 1910-1911. Canvas. 44⅛ × 34".

In the steps of Vincent van Gogh (an important retrospective exhibition of his work took place in Amsterdam in 1905) and of Jan Toorop (who developed the Neo-Impressionist vein from 1889 to 1908), the young Dutch school threw itself into color experiments, which in boldness equaled those of Die Brücke in Germany and the Fauves in Paris. A windmill standing in a peaceful landscape near Amsterdam offered Piet Mondrian the pretext to paint a violent red apparition in which the optical pulsation from the calculated opposition of primary tones creates a kind of dazzling effect (*Windmill in Sunlight*, far left). For two years the artist continued his original experiments based on Divisionist techniques, amplified by

the deliberate use of heavily applied brushwork, as in *Lighthouse Tower at Westkapelle* (left). Surface activation through retinal excitation reappeared several times in Mondrian's Neo-Plasticist work and finally triumphed in the *Boogie Woogies* of the New York period (1942-1944). We see the same technique of transposition in Leo Gestel's *Autumn* (above), in which a garland of flat areas in three colors encloses a yellow tree that has an acrylic luster. In each case, the object represented—massive, centered—tends to invade the image when not butting against one of the edges. Mondrian emphasizes his search for frontal monumentality by choosing a counterplunging point of view to accentuate it.

47

Trees become red. The surface of the painting is covered with a network of interlaced capillaries

Maurice de Vlaminck (1876–1958). *The Gardener.* 1905. 27⅛ × 37¼"

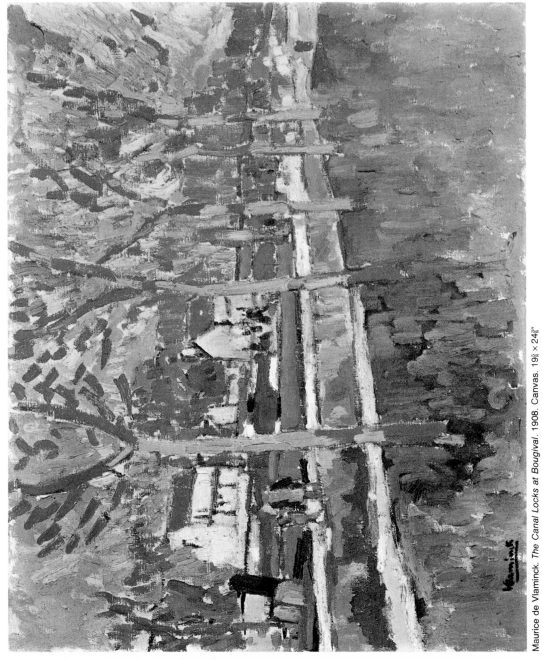

Maurice de Vlaminck. *The Canal Locks at Bougival.* 1908. Canvas. 19⅞ × 24⅜"

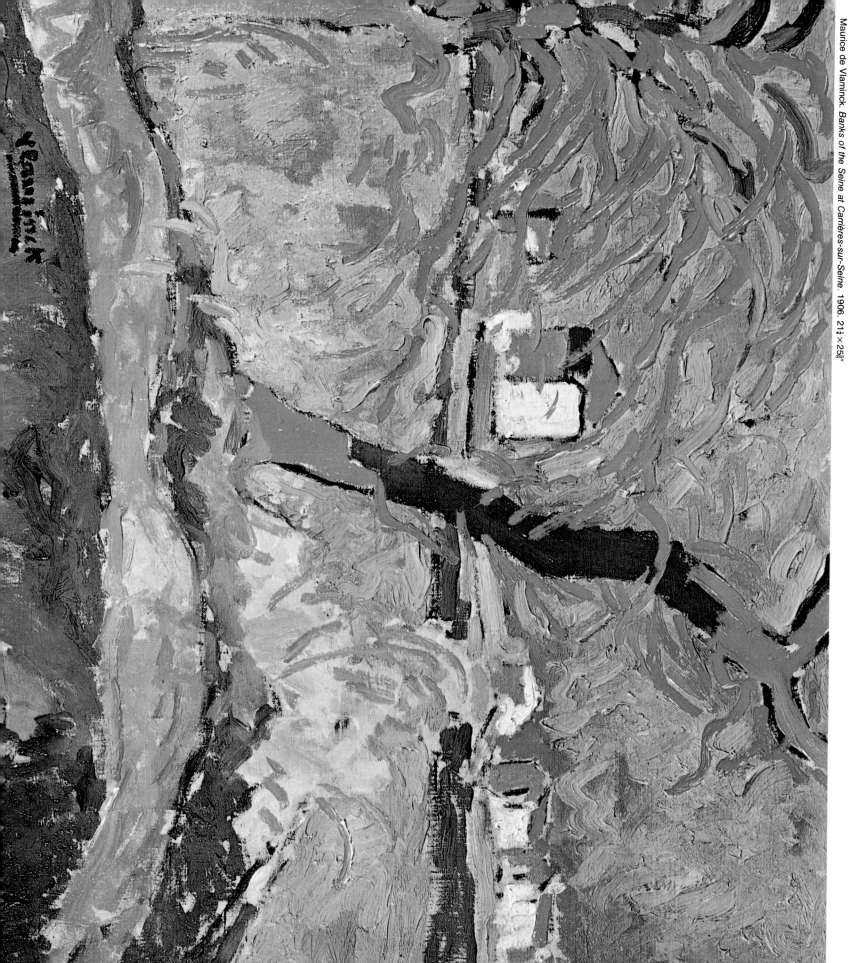

Maurice de Vlaminck, *Banks of the Seine at Carrières-sur-Seine*, 1906, 21¼ × 25⅝"

"One day I was at Bernheim's, in the Rue Laffitte, at the Van Gogh exhibition [1901]. I saw Derain accompanied by a gigantic-looking fellow who, in a tone of authority, cried out his enthusiasm. He said: 'You see, you have to paint with pure cobalt, pure vermilion, pure veronese.' I still think that Derain was a bit afraid of him. But he admired him for his enthusiasm and warmth . . ." Henri Matisse's words show the kind of painter that Maurice de Vlaminck wanted to become: a type of village strongman who ignored subtleties

and allowed his temperament to speak. Only Vincent van Gogh found grace in Vlaminck's eyes, whom he swore he "loved better than his own father." He had no idea what a tireless theoretician of his own painting the Dutchman was, and Vlaminck naïvely imagined him to be a primitive and a madman. Vlaminck stated that he himself worked "tube against canvas. When I have the color in my hands, I don't give a damn about others' paintings: life and myself and life."

This ruggedness had its successful expressions: to denote the branches of a tree, Vlaminck used a network of red venules, which created an effect of visual fidgeting in his *Banks of the Seine at Carrières-sur-Seine* (below). He divided the tree trunks into several tones, insisting that the chromatic effect take precedence over the logic of appearances. Beginning in 1907–1908, Vlaminck was influenced by Paul Cézanne, and his style gained in rhythm and in discipline, as exhibited in *The Canal Locks at Bougival* (below left). But the shock of Cubism proved fatal to Vlaminck. As André

Salmon remarked in 1912, "Vlaminck, a giant with loyal and categorical thoughts like the upper cuts of a good boxer, lost, not without amazement, his conviction of being a typical Fauve. He never imagined that one could exceed in boldness the violence of Vincent van Gogh. He returned to Chatou, pensive but suffering not converted."

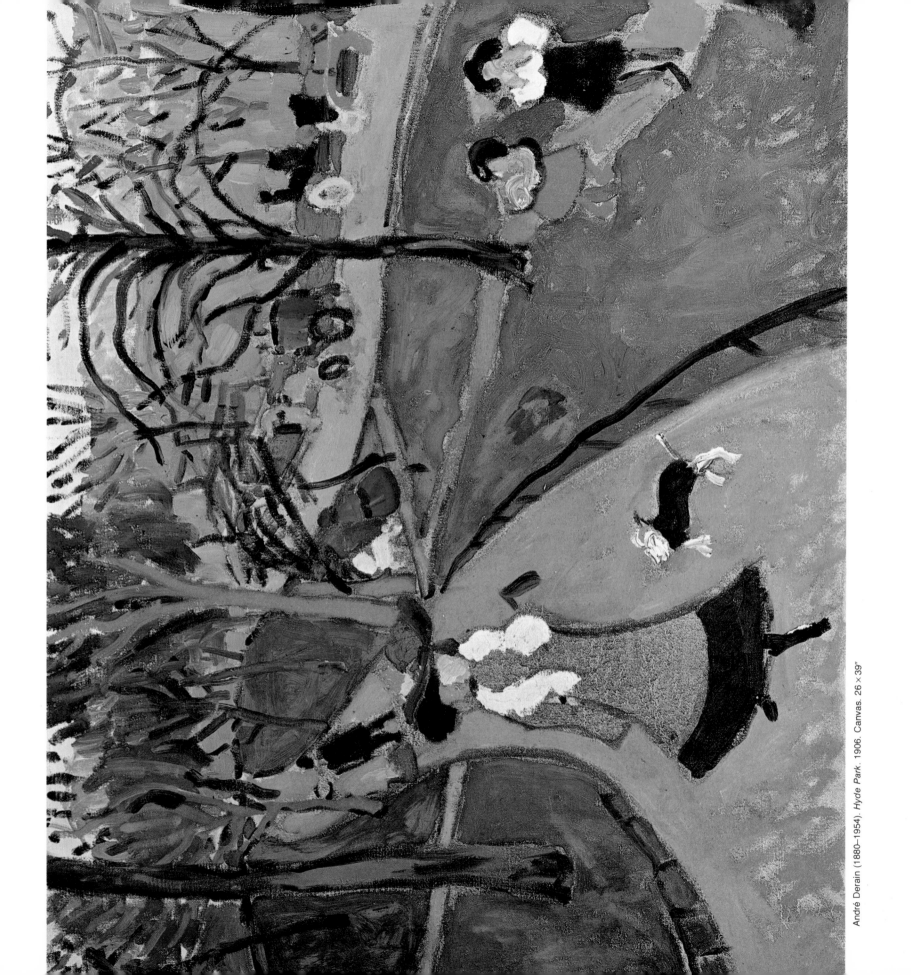

André Derain (1880–1954). *Hyde Park.* 1906. Canvas. 26 × 39"

50

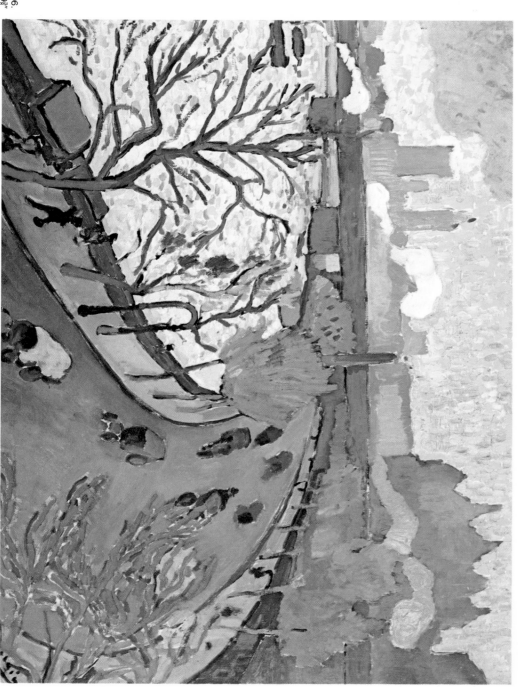

André Derain. *Westminster Bridge.* 1906. Oil on canvas. 31⅛ × 39⅜"

Arabesque lines give rhythm to the paintings of Derain with their large flat areas as in cloisonné

André Derain's Neo-Pointillism (see pages 40–43) ended in a return to Paul Gauguin, whose canvases he carefully studied in 1905 at Collioure—alongside Matisse—in the Monfreid Collection, and which revealed to him the efficiency of the arabesque as a construction tool. The curve controls the entire space by harmonizing the image, and the represented object becomes merely one element of the whole ensemble. In *Hyde Park* (left) the same sinuous line is found in the contour of the grounds and trees, in the dresses, and even in the hat worn by the strolling woman. "I will go as far away as possible from whatever gives the illusion of something," wrote the Pont-Aven painter, "and once shadow is the sun's *trompe-l'oeil*, I'll have to do away with it." This represents Derain's attitude as well. Derain also gave free rein to his fantasy as a colorist, juxtaposing green and pink areas as in a cloisonné enamel (*Westminster Bridge*, below), where one sees pink trees, a yellow Thames, a yellow sky, and a green street. The artist—especially in *Hyde Park*—retains the irreplaceable charm of the sketch particularly in the dog and in the strollers, and he even imitates here and there the quality of a child's drawing (as in the horses and carriages in the background). The canvas forms the material of the foreground stroller's dress and it is constantly present among the colors.

51

An orgy of pure tones delineates
the spotted faces of artists painted
by artists

Marcel Duchamp (1887–1968). *Portrait of Doctor Tribout*. 1910.
Oil on cardboard. 21⅝ × 17¾"

André Derain (1880–1954).
Portrait of Vlaminck. 1905.
Oil on canvas. 16¼ × 13"

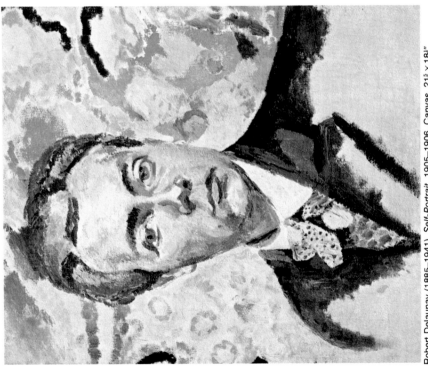

Robert Delaunay (1885–1941). *Self-Portrait*. 1905–1906. Canvas. 21⅝ × 18¼"

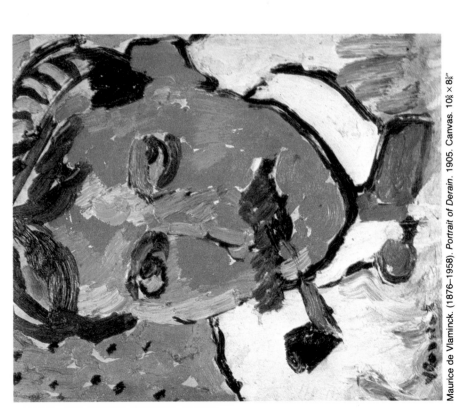

Maurice de Vlaminck. (1876–1958). *Portrait of Derain*. 1905. Canvas. 10⅞ × 8⅞"

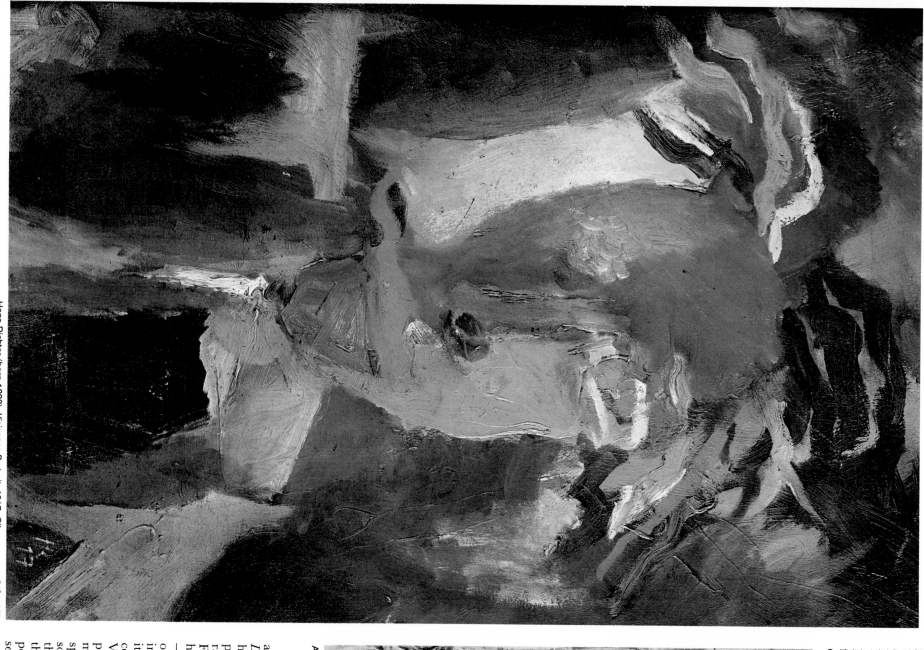

By attacking the human face, modern painters upset a traditional taboo. Although Charles Baudelaire had proclaimed at the height of the nineteenth century—"I want meadows red in tone and trees painted in blue. Nature has no imagination. . . ."—he was careful not to demand the same treatment in portraiture. Vincent van Gogh and Paul Gauguin transgressed this ban only marginally. Their exaggerated tones chiefly concern accessories and backgrounds: the pink beaches of Gauguin's tropical period, the *chéchia* worn by the Zouave whose portrait Van Gogh painted at Arles. The face is what is finally attacked in the prophetic (and never exhibited) portraits painted by Édouard Vuillard (see pages 30–31), in James Ensor's grinning visages (these are usually masks), and in the smearings and eccentricities of the Fauves in 1905. Henri Matisse went only once to the Salon des Indépendants, where he was booed. His wife, who posed for his *Woman in a Hat,* did not dare enter.

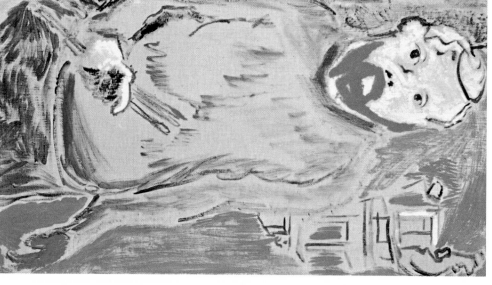

Facetious banterers suggested as a model to the future creator of *The Dance* (see pages 194–195) a hideous woman outrageously painted in all the colors of the rainbow. In the treatment that the Fauves and their successors applied here to the faces of their fellowmen —who until then one was capable of believing were made "in the image and likeness of God"— it is "nature" itself that is countermanded. In Louis Vauxcelles' phrase "the orgy of pure tones," by invading the models' features, creates in the spectators—like a projection— something intimate and protected: they in turn become the objects of the painter's extravagance. A person's integrity becomes secondary to a painting's integrity.

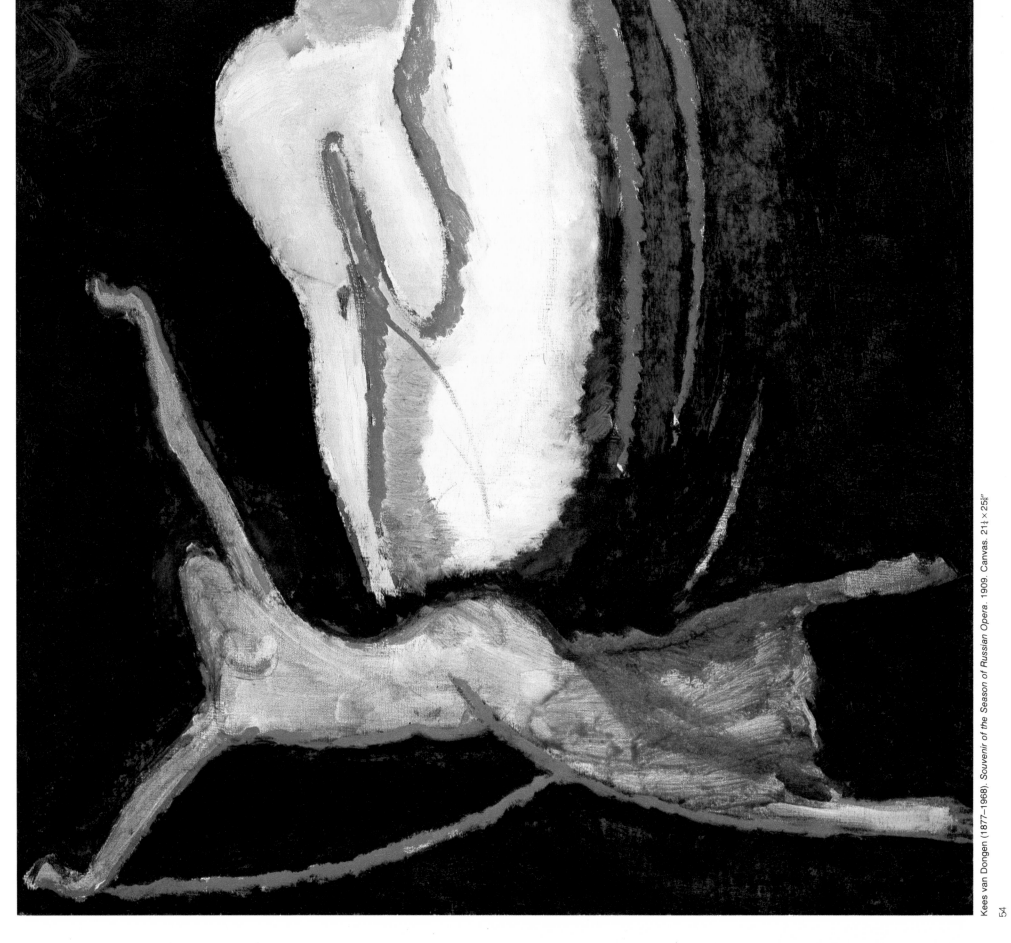

Linear or painterly, Van Dongen's color
opens the path to abstract tachism

Kees van Dongen (1877–1968). *Souvenir of the Season of Russian Opera.* 1909. Canvas. $21\frac{1}{4} \times 25\frac{7}{8}''$

54

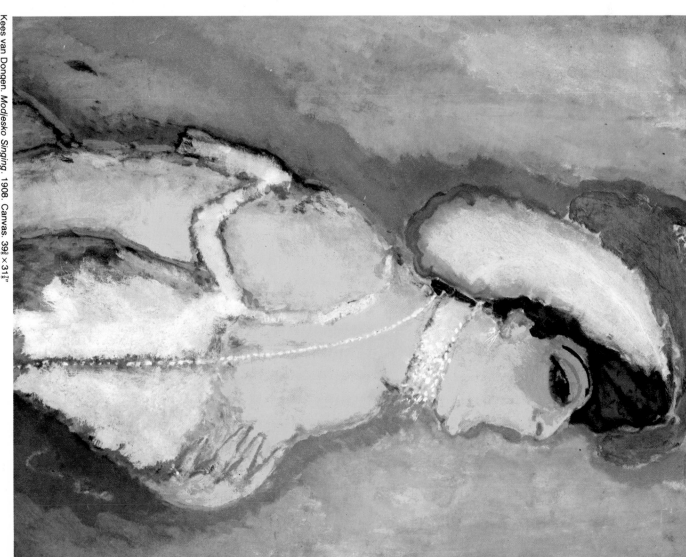

Kees van Dongen. *Modjesko Singing.* 1908. Canvas, 39⅜ × 31⅞"

Although Kees van Dongen's work disintegrated very quickly into frivolity and artifice, one cannot diminish Van Dongen's historical importance since he helped to bring about a new color lyricism as Fauvism was dying out—a new color lyricism of which Wassily Kandinsky was the principal representative. "Van Dongen's passion for color," noted Marcel Giry, "led him (about 1907) to a kind of abstract tachism soon destined to exert an important influence."

From June 1906 to June 1907, Kandinsky, then living in Sèvres, not far from Paris, turned for inspiration to the dribbling, spread out, melted brushstrokes of Van Dongen's broken tones, freeing

himself from the compact, smooth style that characterized his painting until 1908, the increased density of which recalled Canaletto's sparkling small brushstrokes. Directly, or indirectly through his compatriot Alexei von Jawlensky, the Russian artist retained the unsteady surge of large colored flourishes, the interpretation of tones, and the melting outline, all characteristic of Van Dongen's work. A detail of *Modjesko Singing* (above), such as the hat, or the outlining in *Souvenir of the Season of Russian Opera* (left) very naturally fit into one of Kandinsky's "figurative" canvases of 1910 (see *The Cow,* page 57) or into an "improvisation" dating from 1911 (see *Lyric,* page 280).

Color escapes from form.
In diluting itself it overflows and submerges
the world of appearances

Color overflows the represented object's frontiers and spreads like an inundation over the surface beyond the borders—see *Impression III (Concert)*, below. An independent system of large brushed color areas is superimposed—and cancels—the system of represented forms. Beginning with the Fauve vocabulary of Kees van Dongen (see pages 54–55), in a few months Wassily Kandinsky revised his

pictorial conceptions so thoroughly that subject matter now appears in his paintings only as lines, small fibers, or debris, all drowned in the expansion of lively tones. The beast in *The Cow* (right) dissolves into the landscape. Kandinsky deliberately juxtaposed the white hide of the cow against the white mountain above it bordered in blue. He wants the spectator's eye, traveling from one to the other almost without obstacle, to create an

outline that goes beyond the bounds of each. His deliberately indecisive brushstroke and his wavering blotting-paper effects simulate pigment impregnation in the canvas. Diluted areas seem to be absorbed into the grain of the canvas. This material *trompe-l'oeil* prefigures Helen Frankenthaler's and Morris Louis' solutions forty years later. This time it is the canvas itself that will absorb and drink in the liquidity of the colors.

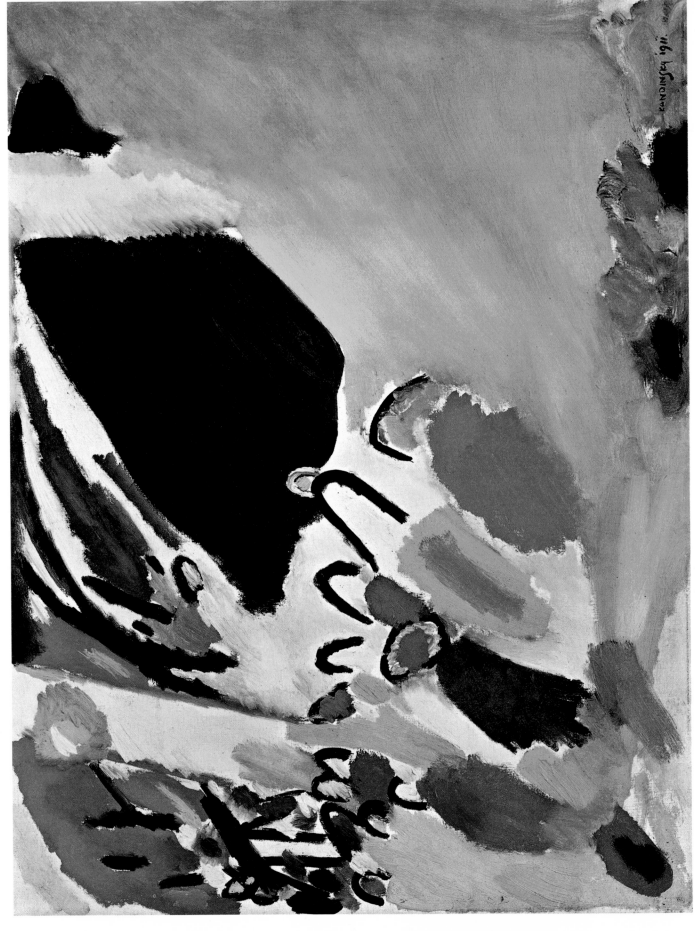

Wassily Kandinsky (1866–1944). *Impression III (Concert)*. 1911. Canvas. 37¾ × 41⅜″.

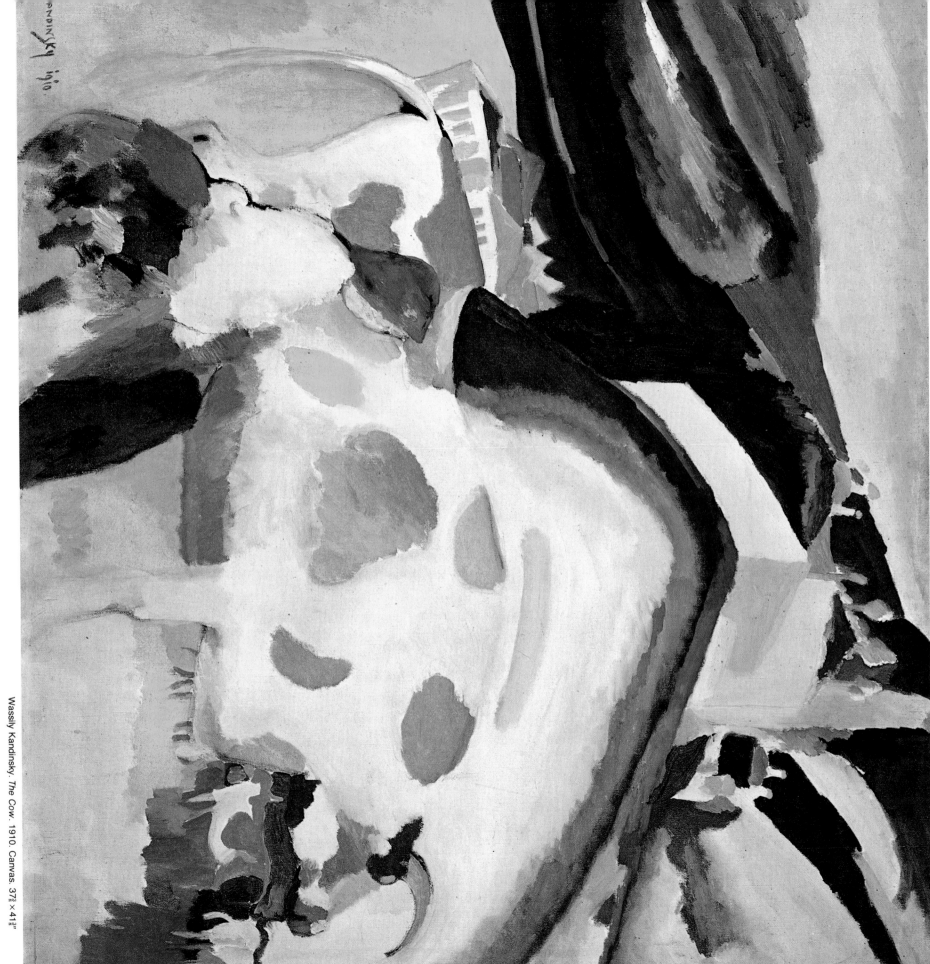

Wassily Kandinsky. *The Cow.* 1910. Canvas. 37⅞ × 41¾"

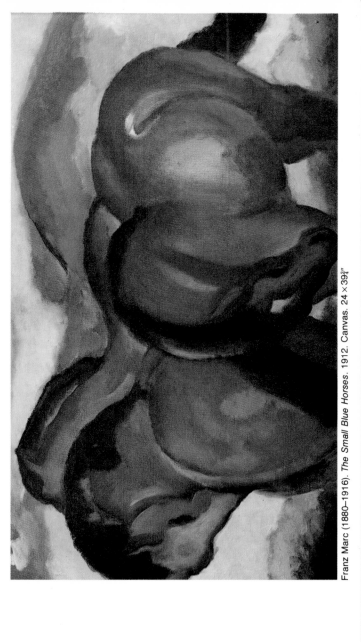

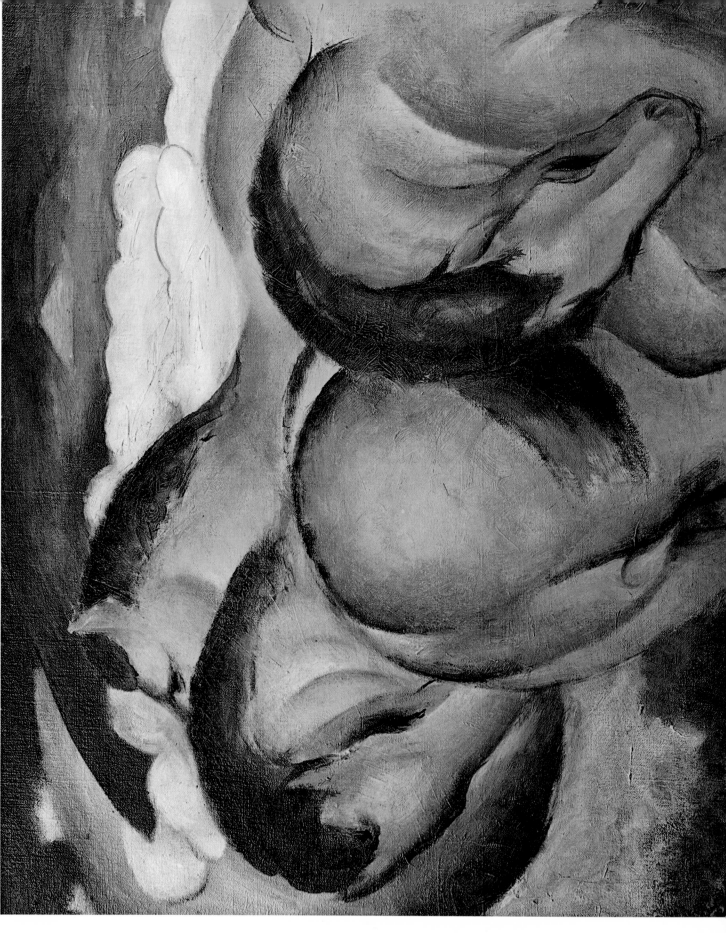

Franz Marc (1880–1916). *The Small Blue Horses.* 1912. Canvas. 24 × 39¾"

Marc's multicolored horses contain the dream of a new pantheism

The kind of tender pantheism that led Franz Marc to the maternalizing curves of the animal kingdom caused him to identify himself with animal expression. About 1911, he asked himself with a Franciscan simplicity worthy of St. Francis' *Fioretti* (*Little Flowers*), "Is there a more mysterious idea for the artist than to imagine the way nature is reflected in an animal's eye? How does a horse see the world? Or an eagle? Or a deer or a dog? What a miserable and soulless convention that leads us to place animals in a landscape that pertains to our eyes rather than plunging ourselves into the

animal's soul in an attempt to understand his vision of things." Through a display of plastic rhymes, Marc made the strong hindquarters and necks and withers of his wild horses echo the curves that on every side denote the mountains and the earth's movements (symbolized in *The Small Yellow Horses*, left, by the great arc of blue that encloses the upper section of the painting). Nature becomes a yellow river in *Horse in the Countryside* (above), where free forms play. This area recalls certain land spaces in the masterworks of German Romanticism, for example those

strolled in by the protagonist in Georg Büchner's incomplete novella *Lenz* (1838). As in Henri Matisse, the search for *equivalences*—at the expense of a literal faithfulness to so-called local color—makes it possible in turn to compose in contrasting spectral tones two almost identical paintings on a common theme (*The Small Blue Horses*, upper left, and *The Small Yellow Horses*, left). Under the influence of Futurism, Marc, using gyrating and blending effects, soon attempted to integrate himself more and more into the underlying harmonies of the organic world.

However, Malevich immediately found an original path. In 1916 he wrote, "Colors were oppressed by commonsense, enslaved by it. And the color spirit weakened and died out." In *Taking in the Harvest* (left), he chose an acid range of colors—violet, green, vermilion—and submitted all the figures represented, both of sheaves and peasants, to the generalized harmony of flashing cones (except the ground, which is treated as a flat area). The canvas is crowded, the figures are compact, the plunging viewpoint limits the perspective, and the square shape of the work emphasizes the effect of accumulation. In *The Woodcutter* (right) there are several frontal components—especially the two white divided ovals and the tube in the foreground. The cylinders tend to axonometric projection (parallel edges), and the vanishing points increase, prefiguring Malevich's and El Lissitzky's later researches in this area. Certain colored areas, such as the woodsman's blouse, gradually dissolve to offer a foretaste of the blurring in Malevich's work of 1917–1918 (see page 214).

The archaic style adopted by Malevich for his peasant series (characterized by playing-card outlines, stiff attitudes, and antinaturalistic schemes) was adequate to his intention since he wished to express "a social preoccupation in a primitive form."

Kazimir Malevich (1878–1935). *Taking in the Harvest.* 1912. Canvas. 28⅞ × 29¼"

Malevich changes pastoral scenes of country life into a metallic and flashing chaos

With three elements—a dominant red color, stereometric form, and a metallic texture for represented objects—Kazimir Malevich proposed a radical transformation of the peasant scene. Ilya Repin and the "Traveling Artists," in nineteenth-century Russia had excelled in this specialty, a type of calendar art. Here we encounter the dual influence of popular Russian folk imagery (nests of dolls, woodcuts, furniture decoration, and signs) and the Western avant-garde, where since 1908–1911 Pablo Picasso (see pages 140–141) and Fernand Léger (see page 161) had attempted to reduce the human figure to geometry.

Kazimir Malevich. *The Woodcutter.* 1912. Canvas. 37 × 28"

DISTORTION

The expressive distortion of Classical canons and reliance on the technical artifices of Symbolism favor painting's textural components

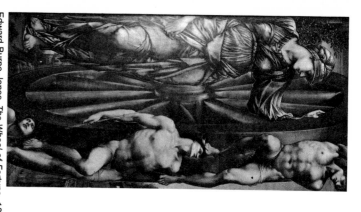

Auguste Rodin. *Flying Figure*
Speaking of Rodin, Matisse said: "What a sculptor often, and what a draftsman always. His drawings and watercolors did not receive their rightful place; a major place. Every artist worthy of this name is indebted to him for something . . ."

Alfred Kubin. *Terror.* 1900–1903
His nightmare visions—along with those of his friend Paul Klee—hastened the repudiation of Naturalism

Edward Burne-Jones. *The Wheel of Fortune.* 1883
His melancholy figures influenced all European Symbolism, especially the Picasso of the Blue Period

S ymbolism," "Idealism," "Expressionism": in the index of these various -isms, painting in the years 1880–1920 produced a body of works that are related only to a single point: they all break away from the Renaissance model (see "Signs and Men"), which they attempt to stretch and distort without claiming to go so far as to overlap it and radically to cancel it.

If the transgression sometimes stops on the way, if it appears at best as the *après-coup* of the system, this is because it acts within it. One of Emil Nolde's remarks in this respect well illustrates the ambiguous position of those who gathered under the heading of Expressionism: "The more we move away from nature while remaining natural, the greater is art." A *relative* opposition to the dominating code is but a way of marking its permanency as law, as a law capable of ruling both traditional painting space and any attempts *to reform* it. However, along with the constitution of a new space based on the consideration of the painting's materiality (as color, surface, texture, gesture, see Chapters 1, 3, 4, 5, and 6), a huge production was developed at the turn of the century, called Expressionism, Symbolism, Idealism, Decadentism, Neoprimitivism, a situation that recalls the Mannerist wave, which, four centuries earlier, had likewise attempted to corrupt the Euclidean arrangement. It is not by chance that certain solutions were common to both periods: the fought order was the same.

It should at once be emphasized that expressive distortion (or its opposite, nuagism, the deflation of the represented object) is not to be sanctified as an eternal category of art, an "innate" need characteristic of the painter's "nature." It is a historical moment that articulates—and that attempts to oppose—the domination of the Renaissance model. To state that distortion is eternal (as a genre) is to state at the same time that what it distorts is eternal also; it is to make the Euclidean projective diagram the paragon, the point of comparison of all formal systems. Even if this scheme is characterized by its astonishing resistance, even if for five centuries—until Paul Cézanne—it managed gradually to absorb its transgressions, it was, nevertheless, part of a History, which it contributed to represent. A History that sooner or later—as this book relates—dismissed it as a dominant system. Deep-rooted as it is in Western illusionism, we are not surprised that expressive distortion inscribed itself in a long line of "deformers." If necessary, it resurrected artists hidden by official tradition. Matthias Grünewald, El Greco, Honoré Daumier (as a painter) are

dismissed it as a dominant system. consideration of the painting's materiality (as color, surface, texture, gesture, see Chapters

Giorgio di Chirico's first steps. In his *Memoirs*, the latter also mentions Max Klinger (see page 71), his teacher in Munich, who was also Paul Klee's and Josef Albers' teacher, and Arnold Böcklin (see pages 70, 76–77, and 87), who moreover inspired Giorgio di Chirico's first steps. In his *Memoirs*, the latter also mentions Max Klinger (see page 77), Segantini, and Gaetano Previati (see pages 90–91). Previati's theoretical writings and Divisionist manner made him one of the sources of Italian Futurism. Klee began with Alfred Kubin (left) and was interested in James Ensor's chalky textures. The Russians mention Mikhail Vrubel (see pages 74–75) as their paragon. Auguste Rodin influenced Henri Matisse with his drawings (left) and Umberto Boccioni with his sculptures. Piet Mondrian painted several Symbolist works (see page 95). Caspar David Friedrich inspired Max Ernst and René Magritte.

At the strategic crossroads where modern art was invented, there was, therefore, this almost incongruous presence of often official artists, the majority of whom would not have had the slightest intention of questioning traditional space. Hence our feeling that beyond the conventional classifications and

twentieth-centuries discoveries to which we should add Hieronymus Bosch, Pieter Bruegel, William Hogarth, Francisco Goya, Johann Heinrich Füssli (Henry Fuseli), Jean-Baptiste Carpeaux, the early Paul Cézanne, Vincent van Gogh, Paul Gauguin and his woodcuts, and others. Goya's *La Quinta del Sordo* (*The Deaf Man's House*) and Daumier's *Ecce Homo* accomplish more or less by anticipation the program of German Expressionism. Others—on the "idealist" side —sought their identity for example in Leonardo da Vinci or in the linear style of Sandro Botticelli, Andrea Mantegna, or Albrecht Dürer or in Gothic and Mannerist engravings (Urs Graf, Matthias Grünewald, Lucas Cranach, and others).

To turn for a moment from the sources and toward the consequences of Symbolist, Decadent, or Expressionist production, an important fact appears that makes us reexamine the traditional genealogy of the history of modern art. We note not without surprise that most of the consecrated painters of the twentieth century were closely or distantly influenced by them. The Fauves went through their first campaign with Gustave Moreau. In Barcelona Pablo Picasso borrowed from Sir Edward Burne-Jones (left) and from Edvard Munch (see pages 102–103), who also influenced Kees van Dongen. Wassily Kandinsky saluted Dante Gabriel Rossetti, Burne-Jones, and Giovanni Segantini (see page 84) as the putative fathers of abstraction. He praised Franz von Stuck (see page 71), his teacher in Munich, who was also Paul Klee's and Josef Albers'

given that the theoretical categories updated by and for the most disruptive art (of which Cézanne is the totemic figure) are made to work on such paintings, we will see the emergence of the system's upkeep, its backflow, as though history *also* took this path, as though the vast process of the materialization of the pictorial object at the turn of the twentieth century *also* had its effect—and often its origin—in "theme" painting. Certainly what is *not explicit* here is concealed beneath the multiplication of iconographic anecdotes (mythologies, poetical matter, politics). There are very few books dedicated to these schools that do not reduce themselves to a long discourse on the moods of the period and of its artists. Taken in its denotative logic, the commentary puts aside the noniconic elements, the *spacings* of the painting. Attention is concentrated on the "subjects": the city, a tentacular proliferation or a prefiguration of the fraternal City, a concentration of merchandise or a cradle of the proletariat, a place of vice and of death or of hope that shines. A nostalgia arises for nature identified with the lyrical past of the species. Industrialization stretches traditional bonds with a sensory totality that Gaston Bachelard described in depth in his archeology of rusticity. Now, in reaction to the violent Western cultural values, there is the return to popular and "wild" traditions. The Neoprimitivism of Michael Larionov, Nathalie Gontcharova, Kazimir Malevich; "quotations" of African art by artists who, in contrast to the Cubists (see Chapter 3), by no means sought to understand its plastic specificity. "In Germany," Jean Laude has noted, "the Expressionists turned for inspiration to African sources only to rediscover the psychic states that they attributed tendentiously to the *Urmensch* (original man).""

the epicenter of this melancholia that Georges Seurat explained in his seascapes of the Bay of Somme and of the coast of Normandy. A pernicious anemia struck the painters. Their images were on the point of fading away. They have turned their backs on us. In 1888, Friedrich Nietzsche, writing about Richard Wagner, said: "Nothing is more modern than this general illness of the entire system, this decrepitude, and this overexcitement of the entire nervous mechanism." Eight years later, Émile Zola stigmatized "the English aestheticism [that has] arrived and finally put the clear French genius out of gear [and that has created only] fetid lilies grown on the swamps of false contemporary mysticism." Hypochondria turned to anxiety with Edvard Munch whose paintings have such titles as *The Cry, The Sick Child, The Murderer, and Vampire.* This is the period (1886) when Maurice Barrès noted in his *Cahiers* (*Notebooks*): "But always, above all in this neurasthenia my feeling of death grows, as does this swarming of worms in a cadaver that is my whole secret life, my sentimental agitation." It was death that Odilon Redon made his companion: "I walked down the cold and silent paths of the cemetery and near deserted tombs. And I experienced mental calm. Oh, death, how generous you are! What strength against anxiety the thought of your peace gives me!" It was finally death that James Ensor described derisively in his carnival figures. "I am relegating myself to the inside of the mask's solitary world, full of violence, light, and striking effect." Neurosis leads to introspection, the exploration of the unconscious, the unlimited space of dreams and fantasies (Sigmund Freud published his *Interpretation of Dreams* in 1900). As for love a woman is either an icon—an untouchable virgin—or a castrating ghoul. To quote Françoise Cachin: "They are merely Herodiases, Salomes, and Judiths, Thracian women tearing apart Orpheus' body or dreamingly contemplating his severed head." Androgyny, narcissism, and homosexuality were echoed—in literature as in painting—to Charles Baudelaire's horrified notice: "A woman is natural, that is, abominable." Barrès was scandalized by *Monsieur Vénus,* published by Rachilde (Marguerite Vallette) in 1889: "Certain minds are dreaming of an asexual being. Such imagination smells of death." Languor and autism—parallel to the Nabis' militant Roman Catholicism—favor a syncretic religiosity nourished by Édouard Schuré (*Les Grands Initiés,* 1889) and Feodor Dostoevsky (eight of his novels were translated into French between 1884 and 1890). Arthur Schopenhauer and theosophy

A theme also of anger and rebellion: Georges Rouault hated "this carnivorous period in which we are living," that witnessed the "triumph of the bloody tide of human imbecility." He stigmatized the Belle Époque, its lower middle-class mediocrity, its cowardice, its hypocrisy, and the greed of the "decent people" mentioned by his friend Léon Bloy, "flabby monsters impossible to get rid of, equally incapable of abominations of vice and abominations of virtue." These curses have their pendant in the turn-of-the-century yearnings and morbidity anticipated in English painting by the Pre-Raphaelites, in Belgium by Xavier Mellery, Fernand Khnopff, and Jean Delville and in France by Lucien Lévy-Dhurmer, Edmond Aman-Jean, Séon, and Osbert, to name but a few. The dead city of Bruges was

Edward Robert Hughes. *A Dream Idyll.* 1902

Herbert J. Draper. *Tears for Icarus.* 1898

Anonymous. *Garibaldi Triumphs Over the Forces of Evil.* c. 1900

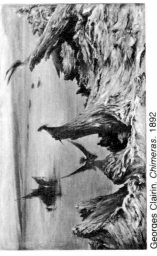

Georges Clairin. *Chimeras.* 1892

In the feathery material of wings and in the aquatic or celestial expanses, academic artists found a pretext to loosen the constraint of the "rules of art"

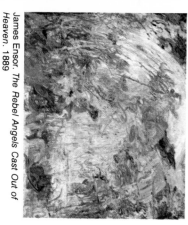

James Ensor. *The Rebel Angels Cast Out of Heaven*. 1889
Practically liberated from any representative constraint, the heavy paint is now spread in viscous colors

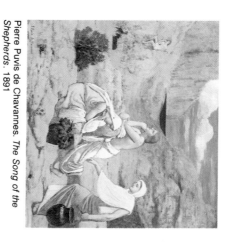

Pierre Puvis de Chavannes. *The Song of the Shepherds*. 1891
An underlying geometry gives rhythm to these flat perspectives and their corresponding harmonies

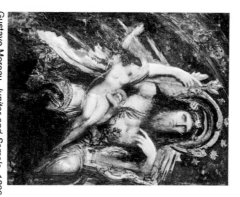

Gustave Moreau. *Jupiter and Semele*. 1896
The richness of textures "speaks" as much as the figures

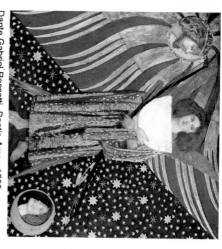

Dante Gabriel Rossetti. *Dantis Amor*. 1859
Rossetti's pious imagery broke with the unitary space of the Renaissance and anticipated the decorative and frontal conceptions of an artist such as Gustav Klimt

served as the antidotes to "materialism" that people, though in the warmth of comfortable town houses, wanted to denounce. The extravagant magico-esoteric bazaar of the mystagogue Joséphin Péladan (known as the Sâr, founder in 1890 of the Order of the Rosicrucians of the Temple and of the Grail) proposed notably "to awaken the idealism of society." He inspired the passionate adherence of artists noted for their compunction—as well as their arrogance—Fernand Khnopff, Jean Delville, Émile Bernard, Ferdinand Hodler, Félix Vallotton, Paul Sérusier, Charles Filiger, Xavier Mellery, Georges Rouault—somewhat after the manner of those who formerly had rallied to the monastic ideal of the Nazarenes (1810) or to the Pre-Raphaelite "fraternity" (1849).

Such were some of the themes that occupied "fin de siècle" painting, and their present return to the foreground of fashion and business is obviously based on the paleo-Surrealist peculiarity of their mimicry. At best the work is taken for the moods (fear, spleen, anger) that it exhibits, and never for its textural innovations. Where Stéphane Mallarmé, in the preface to his *Coup de dé*—which stemmed not only from poetry but also from painting and from a musical score—speaks of "prismatic subdivisions of the Idea," one behaves as though only the Idea were to be retained and not the significant innovation promised in the announced diffraction. Yet, we have seen that the transformative effects of a thematic painting are to be sought in the noniconic spacings that it produces as if in spite of itself. Everything occurs as if the material and chromatic deployment of the surface worked the image *from below*, as though *literalness* were more important than literature. By its material basis, this perversion of the pictorial scene was noted in the two antagonistic and complementary currents in which the pathos of the movement found enjoyment: an expressive current that forced the represented object to compulsive exaggeration; and an Intimist, introvert, Decadent current that, on the contrary, suggested its effacement.

In the case of the Intimists, the evanescence of the object, the dissolution of the image seemed to occur by a kind of slipping or "fading in." It would seem that the vagueness of the theme (cloudy, fluid, musical), the "floating of the reverie" (Mallarmé) would blur the outline of things to the point of offering them merely as surface, as histological surface. So far as, in the name of *correspondances*, artists wanted to paint what Baudelaire "saw" listening to Wagner: "Immensity with no decor other than itself," all denotation was finally

evacuated. Vagueness is pervaded by texture, the signs blur the surface like a spot on a blotter covers and gradually drowns the lacunary traces of inscriptions. Tending to the amorphous and vaporous, the represented object disappeared into the pigmentary excipient. Here Mallarmé designated the path that recommends "not painting the thing but rather the effect it produces." To name an object is to get rid of three-quarters of the enjoyment of the poetry that is made of guessing it little by little. Suggesting it is the dream. It is the perfect use of this mystery that constitutes the symbol." That the *suggestion* in painting results in privileging what is unnamed in the system, its ground, its fabric; that by dematerializing the represented object we better reveal the substantial evidence of the representing material—that is what Odilon Redon's work proves. When he speaks of "putting the light of spirituality in the humblest means, even in blacks," when he wants to show "everything that transcends or illuminates or amplifies the object and raises the spirit in the region of mystery, in the disorder of the irresolute and its delicious anxiety," it is clear that he intends above all to be certain that his works have a "supplement of soul." But the truth is that he loads his surfaces with large informal areas in which the drowning of ectoplasm finally gives the glistening charcoal blacks a specific expressivity.

Wavy or ethereal, the iconic figures usually gathered under the heading of Symbolism or of Idealism are frequently melanges. Hair, seaweed, branches—it is all the same. A mixture of the human body and of water (Arnold Böcklin, Léon Frédéric, Lucien Lévy-Dhurmer), of the vegetable world and the woman (Giovanni Segantini), of the imaginary and of reality, of the fantastic and of the prosaic, of the decorative and of the corporeal (Charles Filiger, Gustav Klimt). Painting is crowded with hybrids in the act of desubstantializing, of splitting into two kingdoms, of engulfing themselves as beings, as autonomous *constitutions*.

These painters invent and reinvent rare techniques. Often reticent in using oils, they employ pastel, (even in large-size format), crayons, chalk, sanguine, tempera, and touched-up photographs (Fernand Khnopff). They seek brilliancy and reflection (mosaic, faience, incrustations, gold layers, silver layers, flat marquetry areas) or on the contrary dullness (paste painting, pencil, monochrome). The two-dimensional materiality revealed in such techniques finally perverts the artist's specular intention. The *painting* is more important than what is *painted*. James Ensor's heavily plastered walls,

his curtains harassed by traces of brushstrokes exist *first* as pigmentary crusts—to the point that in *The Rebel Angels Cast Out of Heaven* (see page 65), there is a Dubuffet-like "texturology." The same is true of Giovanni Segantini. Marcel Brion assures us that "in order to render both the fine and the solid crystalline atmosphere of a high mountain, he had imagined a granular matter whose irregularities stopped the light and tactilely recalled the contact of stone, bark, roots. . . ."

If we go from the Intimist side to the spectacular and hyperbolic Expressionist side of modern painting, we note the same return of material components. Expressionism claimed to be the studied distortion of academic canons. It emphasized the angularity of an elbow, enlarged the mouth into a grin, the eye into a shadowy hole. It tortured represented objects for a better expression of the artist's unhappy conscience. Auguste Rodin said to Paul Gsell: "I accentuate the lines that best express the spiritual state I am interpreting." Gaston Bachelard, in the same direction, mentioned a sculpture, *Young Man Imploring*, made by a man who was born blind. It represents a nude adolescent raising his arms to heaven. The legs are thin and scarcely formulated. On the other hand, the hands are enormous, greater than the forearm, itself greater than the arm. "Here," writes Bachelard, "it is really the *hand* that implores, it is because it is stretched out that it increases. . . . It is really a form experienced by a blind man, experienced within, it exists by actually animating the *muscles of imploration*." In order better to express this obsession, the artist sacrificed the other parts of the work and developed to a maximum those that bore his true message: supplication and dereliction. But modern art has shown that such an Expressionist conception was highly insufficient the moment it anchored itself to the status of the object denoted instead of standing with the material's requirements. As early as 1908, Henri Matisse pointed out the limits of "distortion" and emotional exaggeration. "Expression, for me, does not lie in the passion that will break out in a face or that will be stated by a violent movement. It is in the entire arrangement of my painting: the place occupied by the bodies, the empty spaces around them, the proportions—all this participates."

The "distortion" produces its effects pictorially speaking only by the excess it creates, by what escapes the painter's control and overcomes his denotative and sentimental intentions. Thus we have Chaim Soutine, whose empathic intensity is so strong that it operates at the expense of representation. We

are no longer (see page 111) before a tormented landscape but before a torment immobilized in landscape. At most, the desire of fusion, the convulsive character of the manipulations are expressed by the artist's aggressivity in regard to the canvas. Soutine passes from retention to expulsion, from drowsiness to frenzy. "His slow laziness," related Andrée Collié, "made him often silent. He always seemed to be keeping himself for mysterious enterprises, better days. . . . He never drew. He was afraid of weakening his inspiration by breaking it up through a series of attempts. . . . We saw him finding his way then, really beyond himself, literally rushing to the painting and finally finishing it (he even employed his thumb one day when painting furiously), using paint directly from the tube and launching himself into demented alchemies." During certain periods he would destroy eight out of ten of these works executed in a trance. His choice was not dictated by criteria of quality. He often damaged the best of them. In the words of Pierre Courthion, "He rarely punctured the canvases in the center where he had a motif or a figure but almost always on the side and with a knife so that it would require recanvasing. Some Soutines still reveal traces of his strange moods; they have a piece of canvas glued to the back." Everything happened as though the artist wanted to intervene in the very material of the work, as though he wanted to mutilate it, as though the painting were not only a landscape, a still life, but a wound, the trace of a work and of a body.

This double meaning we also see at work in Edvard Munch, in whom anxiety at first sight seems communicated by the choice of iconographic themes: evil women, vampires, dead children. But how can we explain that this anxiety permeates as well the fresh figures of young girls bending over a bridge or dancing a round in country moonlight? Before turning to the painting's theme, Munch's specific climate is transmitted by the organic evidence, the insidious flow of the pictorial substance. He believes he is painting a virgin vine (see pages 102–103). Actually he is giving us troubling, sticky textures that awaken an entire play of obsessive metaphors. Here the spectator can easily make, to his advantage, the economy of a heavily literary denotation. The threatening viscosity of the pigment is sufficient. It reminds us of the painful experience of the body as wound, bleeding, spitting of blood, glairs, moods, excrement, pus, placenta. In Jean-Paul Sartre's words: "In the very apprehension of viscous matter, a sticky, compromising, and balanceless substance, there is something like

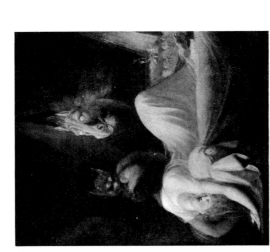

Johann Heinrich Füssli (Henry Fuseli). *The Nightmare*. 1790–1791
Breaking into the dream justifies corporeal distortions and the importance of informal areas

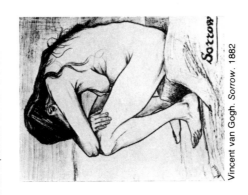

Vincent van Gogh. *Sorrow*. 1882

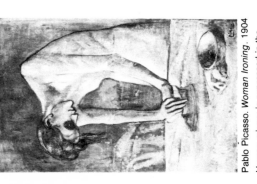

Pablo Picasso. *Woman Ironing*. 1904
Human misery is expressed in the insistent angularity of the outline

Edvard Munch. *The Kiss (Fourth Version)*, 1902
The grain of wood crosses the image and imposes itself on the foreground

Paul Gauguin. *Tobacco Jar with Self-Portrait*, 1890

Medardo Rosso. *Head of a Child*, 1893

Auguste Rodin. *Fugit Amor*, 1885–1887
In sculpture, the figure tends to become engulfed in the material—clay, wax, marble—that encloses it

the haunting of a metamorphosis. To touch the viscous matter is to risk turning into viscosity. . . . Softness is merely a destruction that stops halfway." An anguishing substance therefore *as substance*. Sigmund Freud pointed out the libidinous correspondence: "There is a very clear sexual meaning in the attitude of neurotic children who cannot bear the sight of blood or red meat and who vomit on seeing eggs and noodles." The opacity of Munch's drooping forms, their insistent weight are reinforced by a network of venules, sulfurous, vinous colors that wind their way across the canvas with no other aim than their own existence. Some paintings were entirely covered by a vertical rain of linear strokes that blurs the scene or else scattered with spots tending to the amorphous, transparent puddles of turpentine that light up the pigment. Often it was the outline that detached itself and became self-sufficient, as though to add to the uncertainty of the form. It designated it and at the same time—by this distance—made it unreal and fluidified it, and threw doubt on its reliability as form. Or again (*The Kiss*, left) it was the support (beneath the paint) that crossed the image and in the foreground stated itself as grain, matter.

The assumption of painting's material values finally led to the problem of limit and margin. "The time is still far off," wrote Félix Fénéon in 1922, "in which the painting and its setting will have a firm relationship so that if we photograph one we must photograph the other." Yet this is one of the least debatable contributions of the currents generally classified as Expressionist, Symbolist, and Idealist, that they show an interest in mixing up the boundary between the space of the inscription and its supposedly neutral context: frame, wall, environment. The return that is made here to pre-Renaissance plastic systems (Byzantium for Xavier Mellery, Charles Filiger, and Gustav Klimt) or Mannerist ones (Walter Crane, Jean Delville), in addition to the fact it relativizes and denaturalizes one's perspective habits, poses with emphasis the question of painting as an element of a syntactic chain in which architectural (even institutional) context is at once an important part. (A history of art is still to be written in which the picture would appear in its time and place, no more than a punctuation within a vast spatio-temporal discourse exemplified by Fontainebleau or Versailles).

If we pointed exclusively to the iconic meaning of a Gustav Klint or of a Giacomo Balla, we would run the risk of dismissing the solutions that these works suggest as the articulation of the object and of what is

outside it—its *beyond-the-frame* status. The traditional setting stated itself as painting's *phatic* element (hailing, attracting the spectator) and as the frontier between the wall and the image of illusion that this *framing* was to strengthen. The Symbolist frame, on the contrary, offers itself as a *parergon*, a nibbling of the frontiers and a metastasis of the plastic object. Invading, proliferating, often developed to the point of becoming an actual piece of the harness-maker's art or of the goldsmith's work, or else "scotomizing" some part of the painting, it adds an additional physical evidence to the image. Yet at the same time, the enclosure, constantly diminished, carried away, scattered, prevents the isolation and the specification of the object in a periphery, a cutting up, a beaconing. An object, therefore, is in an abyss whose edge admits being a passage before functioning as a limit and that does not cease transgressing what Jacques Derrida has called the "appropriating mastery" of a discourse closed to itself.

It is not the least paradox of this period that the question of the extension of the frame was posed with such obstinacy by schools of painting that (beginning with the Pre-Raphaelites) did not conceal their spiritualist or mystical aim. For the source of the pictorial enclosure is perhaps to be found in the gesture of the haruspex tracing in the screen of sand some of his forecasts or cutting out a part of the sky with his pointed stick. Turning to the etymological source of the word "*contemplare*," Francis Ponge has cited the latin "*templum*," which "in its early augural sense meant a *quadrato* space in the sky and on earth in the midst of which the omens *si raccolgone*." Any square, any enclosure would retain in itself the echo of these ancient religious practices. It would be the setting where the gods' words were read. It is this dissimulated persistence of the enclosure and its margin a nodal point of contemporary art.

Walter Crane (1845–1915). *The Horses of Neptune*. 1892. Canvas. 33⅞ × 84⅝"

Walter Crane transforms the spume of the waves into a Mannerist phantasmagoria

The fusion of nature's elements so dear to Symbolism is illustrated in a spectacular manner on the large screen in which Walter Crane has depicted a row of ornate, webfooted mares incarnating long swelling waves. Sea spray and horse hair intermingle. The candid presentation of a very horizontal composition and the repetition of the same figure along an invisible sinusoid recall Jules Étienne Marey's chronophotographic research on movement.

Crane's sharp and restless Mannerist style, his "strong and precious line" (to cite Henri Focillon), were inspired by Sandro Botticelli, whose work he studied thoroughly in Florence in 1871, and by the watercolors of William Blake. For this disciple of William Morris—draftsman, well-known illustrator of children's books, theoretician and promoter of the Arts and Crafts movement, and inspirer of Art Nouveau—line was the pictorial element par excellence. "Since line is primordial, let the draftsman in the adaptation of his art base himself on the flow of the line: determining line, emphasizing line, delicate line, expressive line, line that controls and unifies. . . ."

The influence of the "pontiffs" of academic painting is sometimes underestimated by art historians, who enjoy opposing their pupils' genius in a nutshell to the masters' repressive obstinacy. In the case of the German and Swiss Symbolists, an entire mythological pathos widens the ditch that separates us from a far-too-slick style, that narrowly followed museum lessons. "They were sincerely obsessed by the enigma of human destiny," wrote Henri Focillon, "but what they brought to bear on it is the burden of Germanic fatality." Yet Wassily Kandinsky admired Franz von Stuck, his ostentatious Munich teacher who dominated the entire Bavarian art scene and whose painting *Prestissimo* is shown to the right. "He spoke with a surprising love of art, of the play and fusion of forms, and I found him a very likable person. . . .I had to reflect for a long time about his remarks after he corrected me, but a posteriori I nearly always found them to be good" (1913).

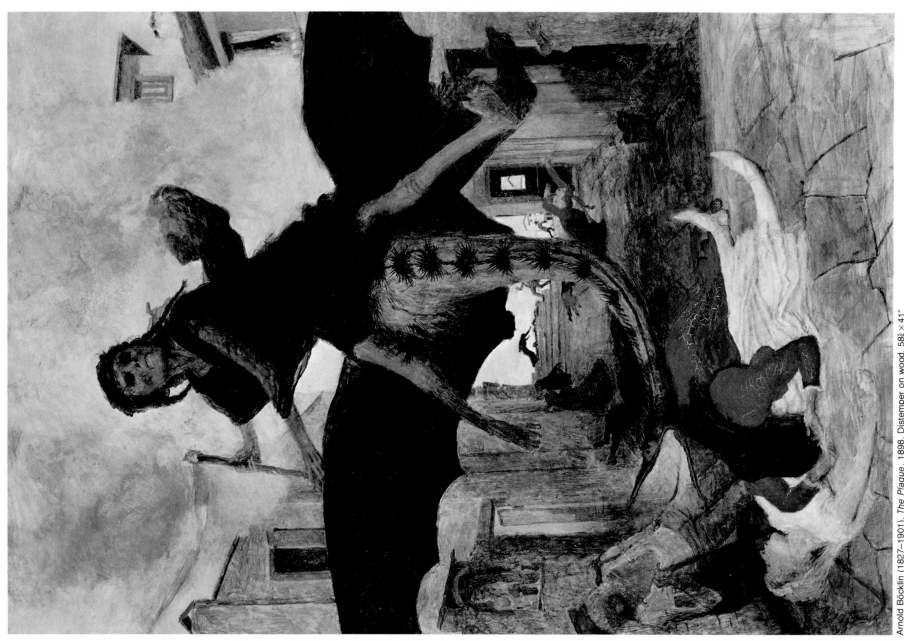

Arnold Böcklin (1827–1901). *The Plague*. 1898. Distemper on wood. 58⅝ × 41"

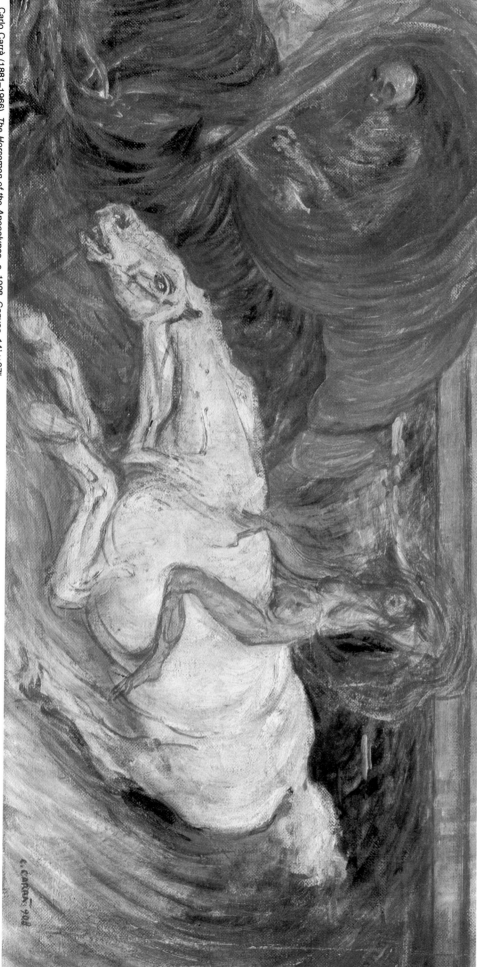

Legendary horsemen populate the imagery of Symbolism

As for Arnold Böcklin, Giorgio de Chirico was indebted to him as a child for his earliest artistic emotions. The beginnings of his *pittura metafisica* were directly inspired by the painter from Basel, and De Chirico appreciated that Böcklin "knew how to take advantage of the tragic aspect of statues." In 1920 De Chirico published a homage to the painter of *The Plague* (left) in which he stressed the quality of his treatment. "From the Old Masters he retained technical solidity and cleanliness and also a feeling of the material's vibration and inner life, which makes a painting strange and beautiful and long haunts the spectator." One may rediscover the same Symbolist influences in the early paintings of the Futurist artist Carlo Carrà. His *The Horsemen of the Apocalypse* (below) recalls in one of Walter Crane's iconographic themes (see pages 68–69) a style inherited from Gaetano Previati (see pages 90–91).

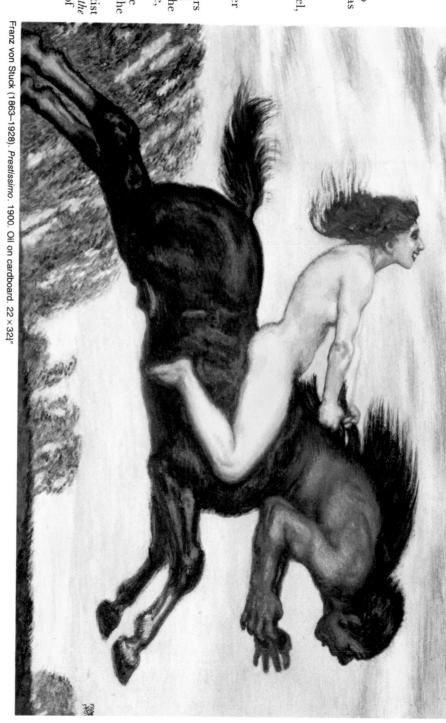

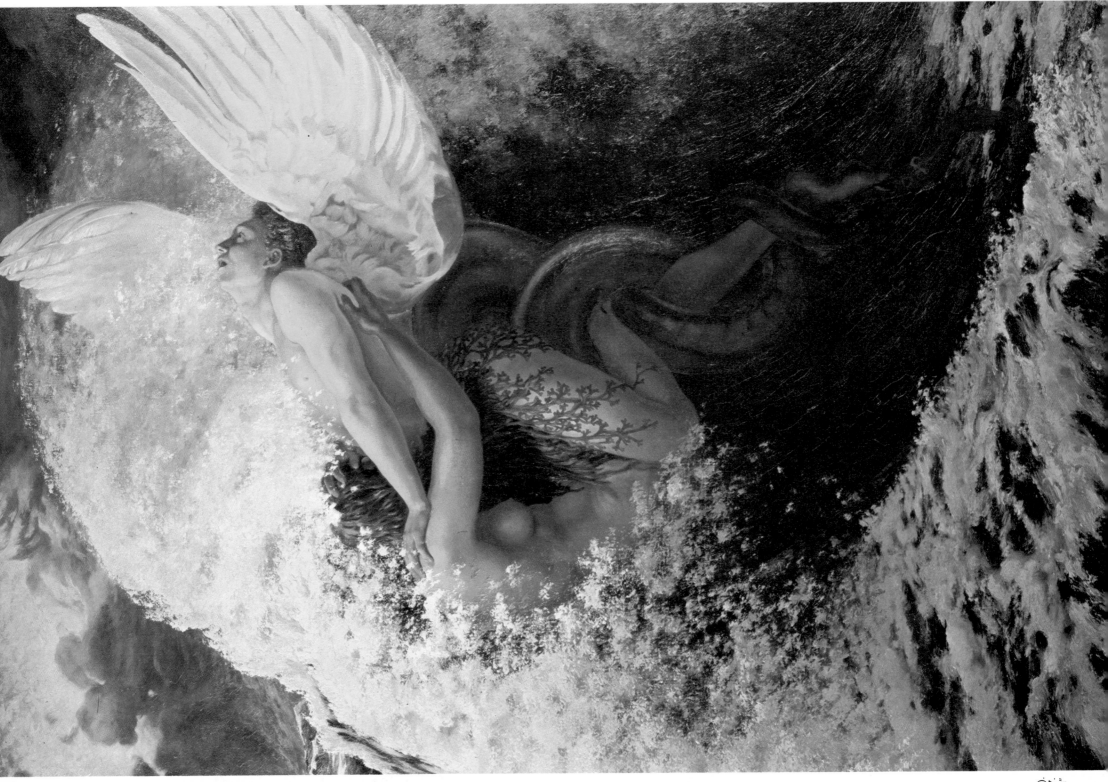

72

Chimeras couple frenetically or poetically against a dense background

Carlos Schwabe is chiefly remembered for his illustrations of Émile Zola and Charles Baudelaire and for the touching oddity of his *Évangile symboliste*. A Swiss of German origin, an admirer of Albrecht Dürer, a forerunner of Art Nouveau as early as 1892 with a poster for the first Salon de la Rose-Croix, he reveled in his work in painting tight muscles, muscle tensions, and muscle spasms. *Depression and Ideal* (left), in which two marine and celestial spirits twist and embrace, is the large-scale oil version of a watercolor of 1896 illustrating Baudelaire's *Les Fleurs du mal*.

The Marriage of the Poet and the Muse (right) represents one of the most typical characteristics of the Symbolist movement, a flight with passionate determination from the contingencies of the modern, industrial, and commercial world. There is very little perspective depth in either painting; it is linear vitality that counts above all else. Despite their anatomical treatment, the bodies in these paintings exist only to incarnate the energy-generating curves and scrolls designed by the painter.

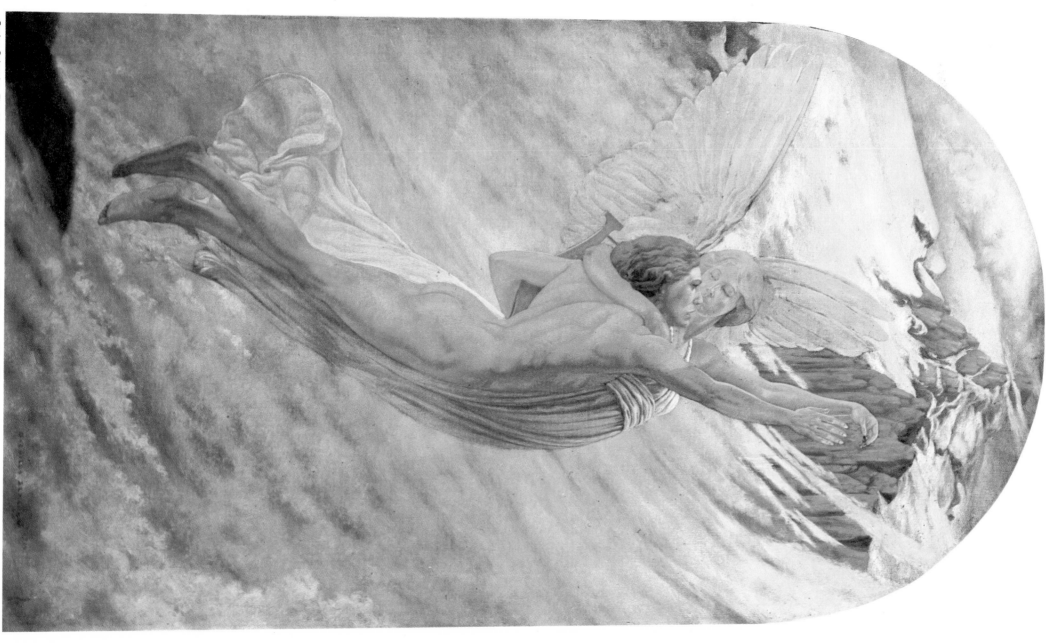

Carlos Schwabe. *The Marriage of the Poet and the Muse*. c. 1900. Canvas. 41⅞ × 22"

73

Mikhail Vrubel (1856–1910). *The Pearl.* 1904. Pastel and gouache on cardboard. 13¾ × 17⅞"

The large panels of Mikhail Vrubel —"the Russian Cézanne"— are covered with a flaky crust that is independent of the painted subject

"His influence on our visual conscience was as decisive as Cézanne's." By placing Mikhail Vrubel—an artist almost unknown in Western Europe—among the sources of Kazimir Malevich's generation, the Russian Constructivist sculptor Naum Gabo (see pages 130 and 273) marks the effect of the historical rupture created by a painting that turned to Byzantine art, exceeded it, and worked it to the point of achieving strange squamiform, crystalloid,

feathery surfaces—crusts that seem to be inlaid and full of fossil flowers, bits of slate, and mineral debris. Vrubel revealed his passion for Byzantine art by participating in the restoration of the twelfth-century church of Saint Cyril in Kiev. In 1890 he wrote to his sister: "Byzantine painting differs profoundly from three-dimensional art. Its essence lies in the ornamental arrangement of the forms that emphasizes the 'flatness' of the walls." Vrubel later spent a year studying the mosaics of Ravenna, Venice, and Torcello. The poetical singularity of Vrubel's work stems from the fact that it confronts on often very extended panels a Byzantinism drawn to the point of textural delirium, and figures frequently reduced to allusions inherited from the Renaissance system. Admitted to a St. Petersburg psychiatric hospital in 1902, Vrubel became blind in 1906 and died there in 1910.

Mikhail Vrubel. *The Demon.* 1902. Canvas. 54⅜ × 152⅜"

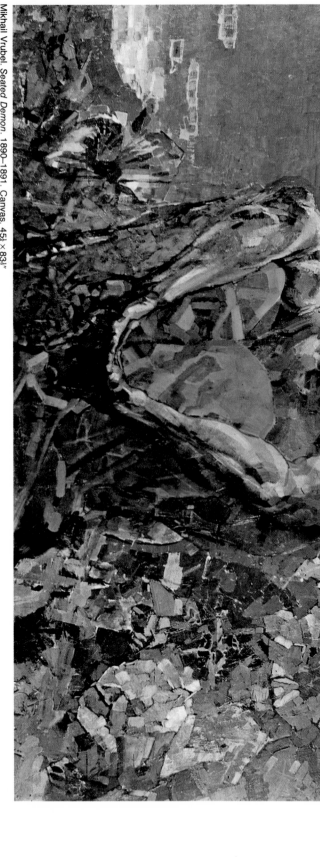

Mikhail Vrubel. *Seated Demon.* 1890–1891. Canvas. 45¼ × 83½"

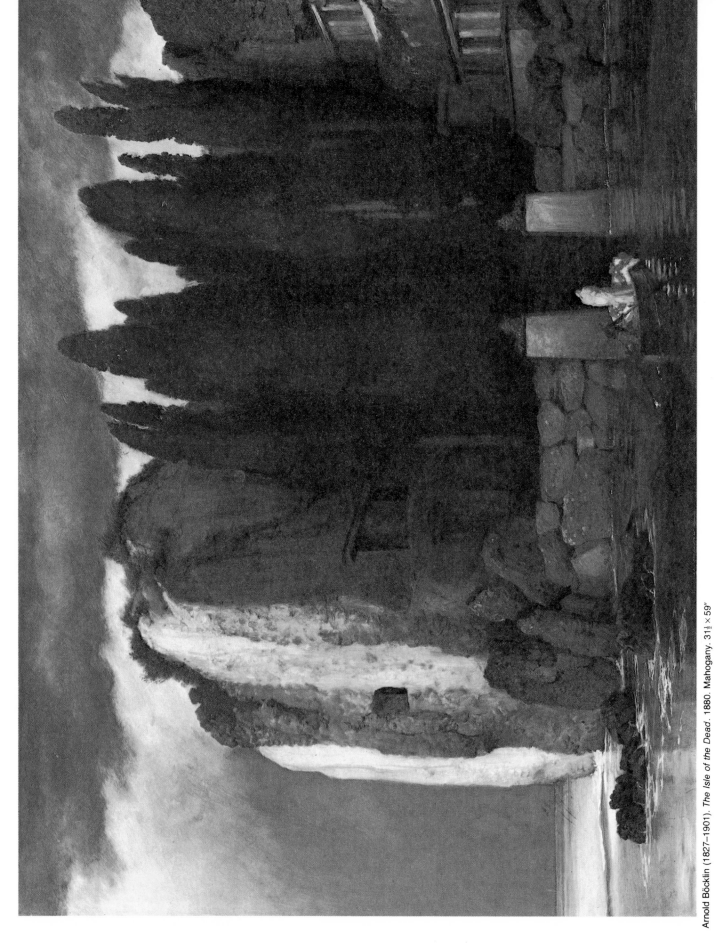

Arnold Böcklin (1827–1901). *The Isle of the Dead.* 1880. Mahogany. 31½ × 59″

In a shadowy twilight
is the passage of death

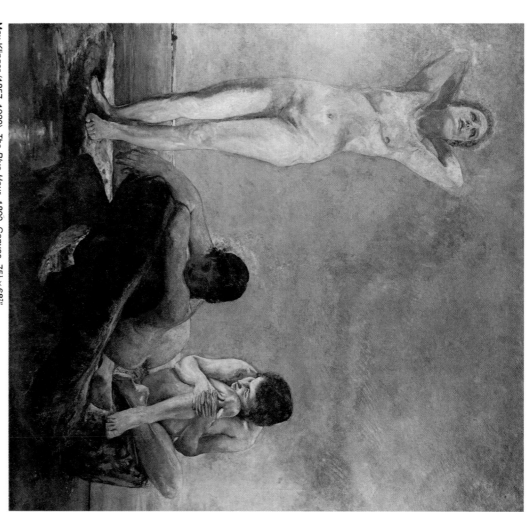

Max Klinger (1857–1920). *The Blue Hour.* 1890. Canvas. 75¼ × 68¾″

Since Caspar David Friedrich, water—"the melancholy-producing element," according to Joris Karl Huysmans—has nourished German Symbolism and Romanticism. Although the title of Arnold Böcklin's most famous work, *The Isle of the Dead* (left), is not the artist's but his dealer's, the painting was inspired either by an Ischia landscape or perhaps by the cemetery-island of San Michele in the Venetian lagoon, and it retains our attention by its extremely sober attitude and by its telephoto-lens effect, which is frequent in Böcklin's work. Never has the pathetic imagery of the last voyage been achieved with such economy of means. The dark cluster of cypresses, the crypts with their rectilinear porticoes (one of which, on the right, is surmounted by the painter's initials), the glaucous immobility of the sea, the red garlands adorning the coffin reflected in the water, the figure silhouetted in white standing in the boat (we shall rediscover this figure in Giorgio de Chirico), the central reinforcement of the rocks—everything is presented in an organized and monumental representation of the return to the bosom of the earth. Böcklin painted five versions of this picture.

In his *The Blue Hour* (above), the German painter Max Klinger—whose engravings rank among the masterpieces of oneiric Symbolism —opposes the prosaic evidence of his solidly created human figures to the unreality of a yellow, effervescent light. We must cite De Chirico in order to understand how this painting was able to fertilize directly not only the Metaphysical School but also Surrealism, which made it a source of inspiration. In a text of 1921, De Chirico praised in Klinger "a sentiment of gentle and Mediterranean tranquility: happy figures stretched out on the seashore in the shadow of pine trees, in sunlight that is not strong; the scarcely marked intuition of an *ennui* that hangs over everything: water, ground, plants, men, animals; a profound feeling of a distant but by no means terrifying horizon, the nostalgic feeling of peace that comes after a great effort."

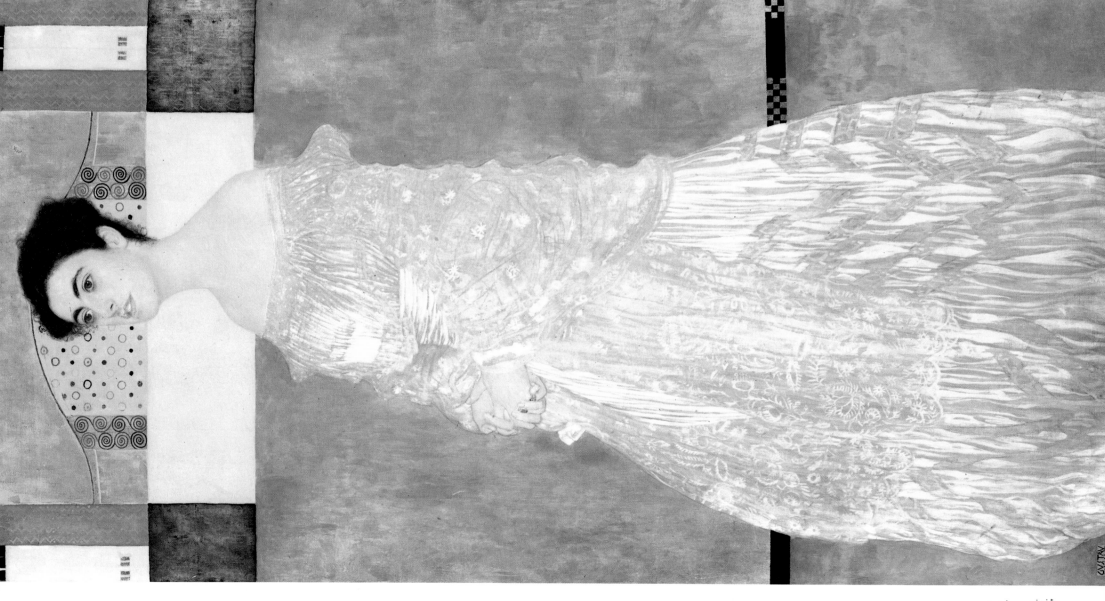

A marquetry of rectangular forms occupies and structures the picture plane

With Fernand Khnopff, as with Gustav Klimt, a regular geometrical pattern, parallel to the frame, controls the painting's background, which is summarized in a juxtaposition of planes without reduction. The figure is cut by the lower edge of the canvas, increasing the effect of frontalization. The monochromatic floor is treated vertically. Nothing indicates perspective, except the shadow that models and detaches the silhouette is more emphasized in the work of Khnopff. A pupil of Xavier Mellery (see page 85), a friend of the English artist Sir Edward Burne-Jones, and a painter who was sensitive to the melancholy of Pre-Raphaelite works, Khnopff made many portraits of his tenderly loved sister, the main source of his inspiration, as in *Portrait of the Artist's Sister* (far right). The intimacy comes discreetly through here in the symbolic paraphernalia of gloves, keys, heavy-sewn doublet, and turned lock.

Klimt was a leading figure of the Viennese Sezession founded in 1897, along with the architects Josef Hoffmann and Joseph Maria Olbrich. Usually Klimt began a painting with a more decorative intention in mind than Khnopff. The influence of Charles Rennie Mackintosh and the Glasgow School is revealed in the ornamental marquetry that underlies Klimt's portraits of women; he never painted men. In the *Portrait of Margaret Stonborough-Wittgenstein* (right), if one discounts the face, the model tends to embrace the frontality of the flat areas that follow the dress' sinuosity and frame her. The geometrical components that occupy the upper part of the composition are not symmetrical. They add a decentering illusion to the central position of the model, whose left eye is equidistant from both edges of the work. In Klimt's later work the figure disappears almost completely in the decor (see page 96).

Gustav Klimt (1862–1918).
Portrait of Margaret Stonborough-Wittgenstein. 1905.
Canvas. 70⅞ × 35⅞".

Fernand Khnopff (1858–1921).
Portrait of the Artist's Sister. 1887.
Canvas. 37¼ × 29⅞".

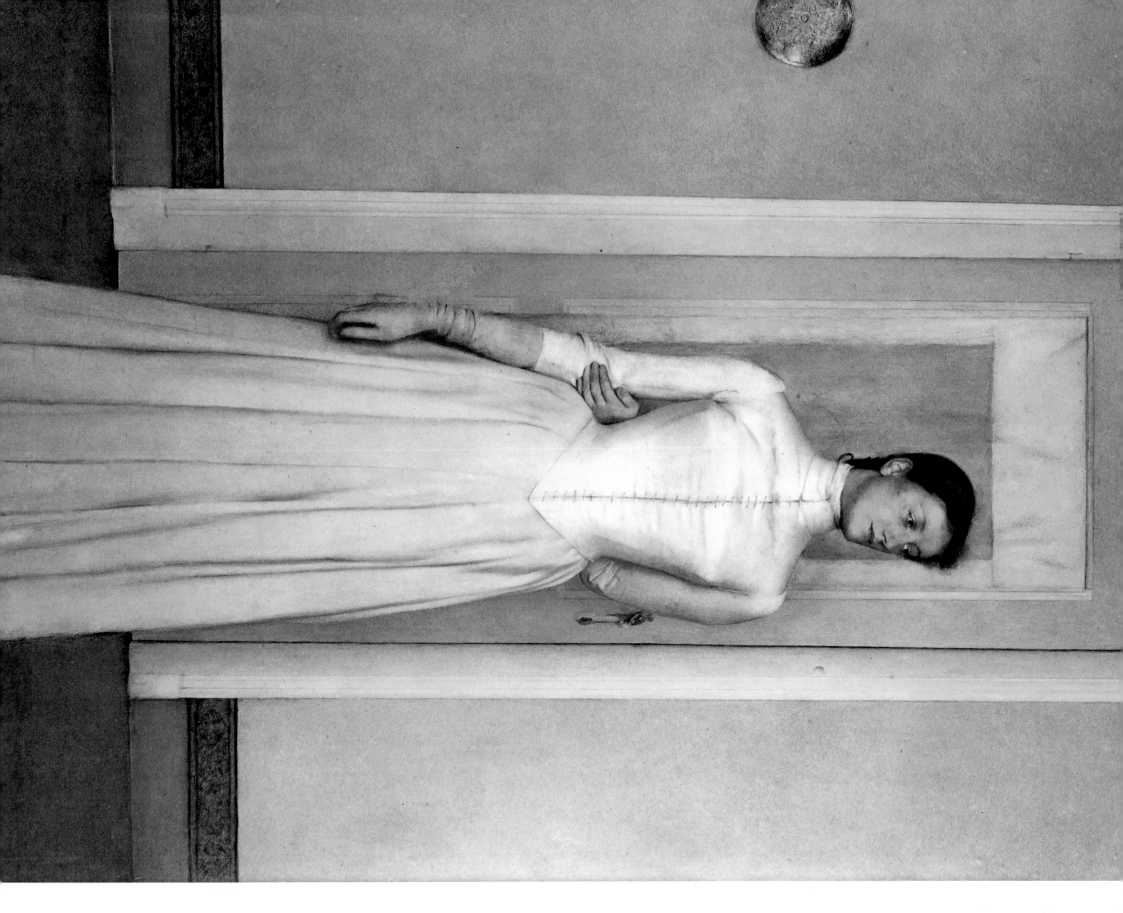

Fernand Khnopff (1858–1921). *Downfall.* c. 1900. Pastel. 24⅜ × 18⅛″

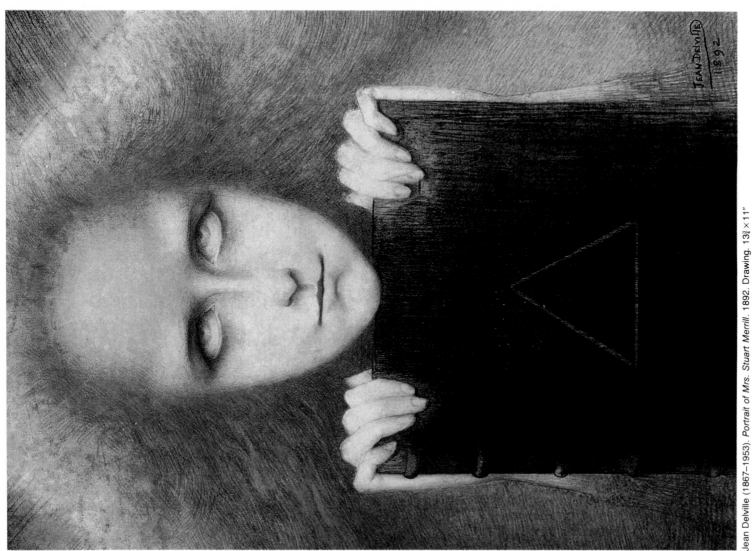

Jean Delville (1867–1953). *Portrait of Mrs. Stuart Merrill.* 1892. Drawing. 13¾ × 11″

In the depths of these expressions of the Sphinx lies the neurotic abyss of the *fin de siècle*

In the troubling vampire expressions that Fernand Khnopff and Jean Delville give to their female figures, one can see—despite the insidious neutrality of these faces—an accumulation of forbidden acts, guilt, and frustrations of a period that fostered the invention of psychoanalysis. An expression that attracts and petrifies the spectator, is doubled by the effect that summoned him to a fixed spot in front of the painting, in the intersection of invisible lines creating the monocular viewpoint.

The Symbolists reinvented and reactivated the range of technical means. Often put off by the brilliance of oil painting and protective varnishes, they sought to achieve in pencil and in pastel a dull effect, a mat quality, a grain that absorbs and retains the spectator's eye rather than rejects it. The large blue stone worn by Khnopff's model in *Who Shall Deliver Me?* (right) reveals the white of the paper. The immaterial and volatile hair is nothing more than a fine red net veined with a black pencil. The same process is more systematically executed in the reddish crop of hair of the model in Delville's *Portrait of Mrs. Stuart Merrill* (above), who, imbued with Occultism, is—according to the painter's explanation—holding a book inscribed with "the perfect triangle of human knowledge."

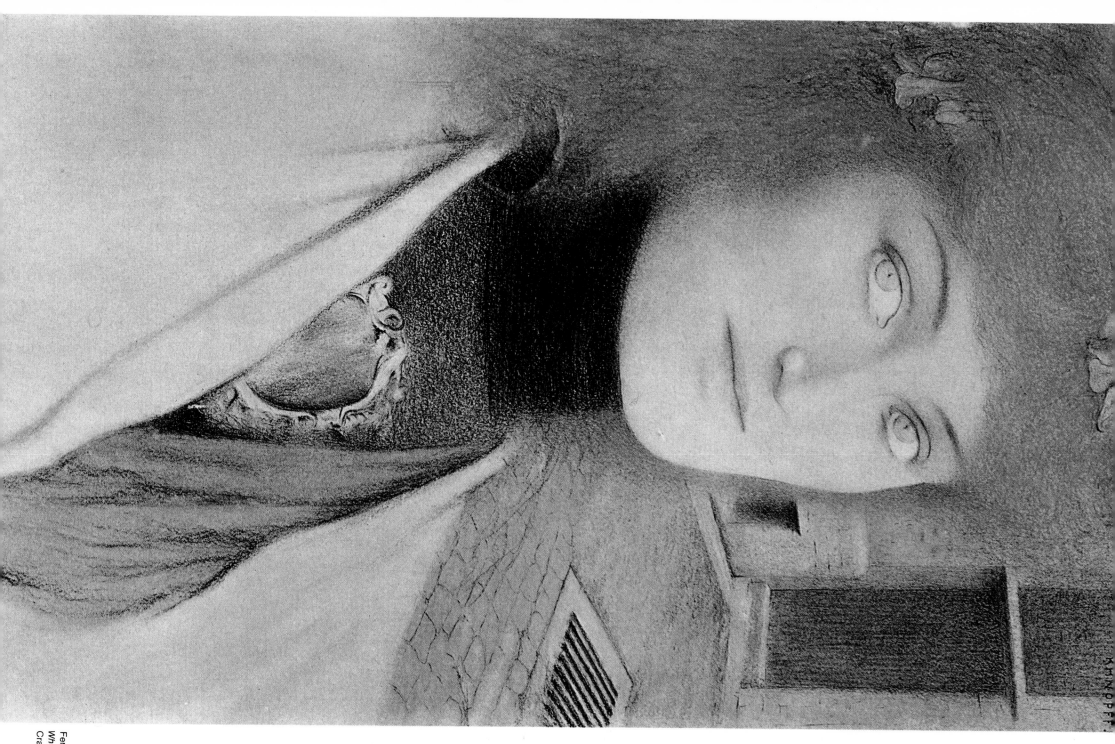

Fernand Khnopff.
Who Shall Deliver Me? 1891.
Crayon on paper. $8\frac{5}{8} \times 5\frac{3}{4}''$.

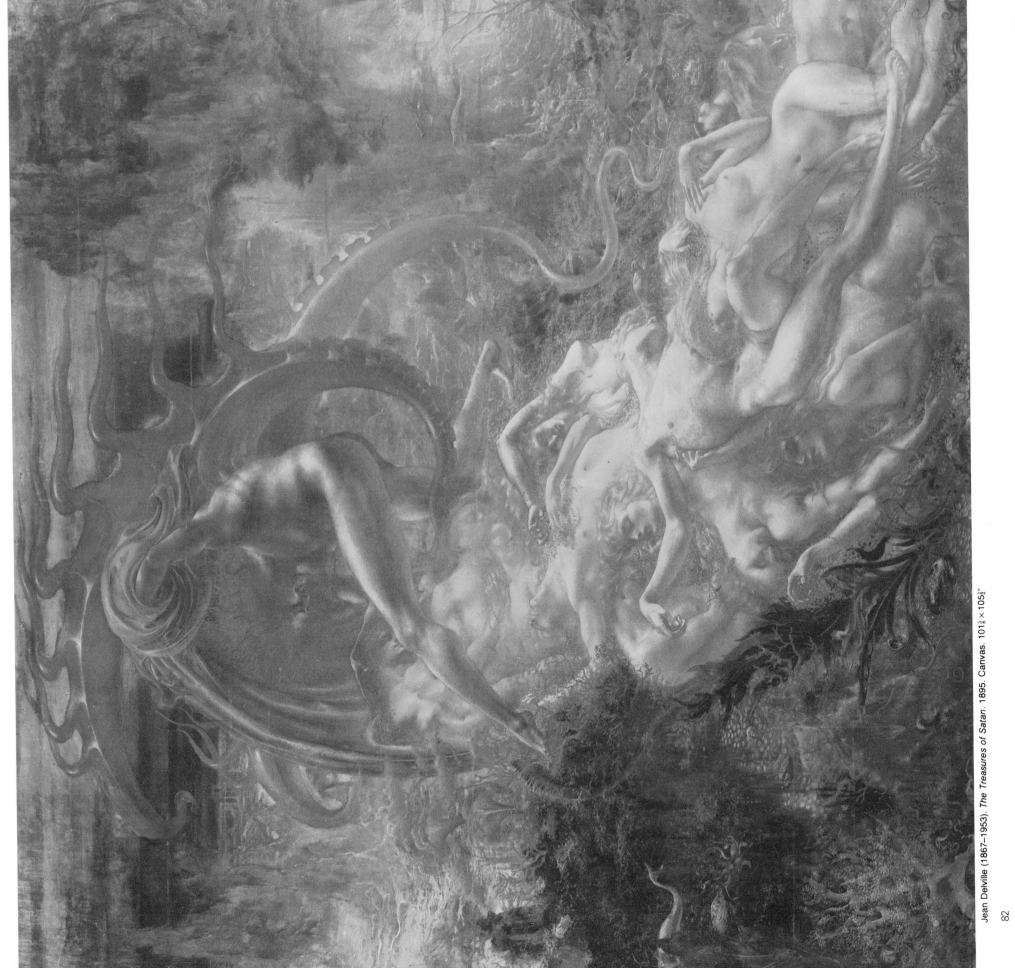

82

Sunk among the coral reefs, seaweed, and octopuses, the cluster of bodies plunged into a hypnotic sleep in Jean Delville's *The Treasures of Satan* (left) is less a demonstration of the curse that has been called down upon it than a pretext for the obvious sensuality of its drawing. Delville's hell is watery and his tentacled Satan moves about rather gingerly in the same atmosphere as that of a magic lantern. The Belgian artist has employed for this showy esotericism the amazing ease of his Mannerist style, the boldness of a monochromatic color scheme, and textures that announce Max Ernst's later research in this area—for example, see the rocks in the background on the right in *The Treasures of Satan* and the seashells in the foreground in *Orpheus* (above).

For Delville creation was bathed in an "astral fluid" of divine origin, "a second state of the substance and great magnetic reservoir of nondefined forces," cited by Francine C. Legrand. In his *Orpheus*—whose model was a woman—he multiplied the luminous small dots that are reflections of stars. According to Legrand, "The human head is built according to the rhythm of planetary laws; it is attractive and radiating, and moreover it is on it that the astral influence absolutely manifests itself. There is no difference between the networks of planetary attractions and the way nervous tissues radiate outward." What is unusual here is the extravagant arrangement. The very precise rendering of the lyre with

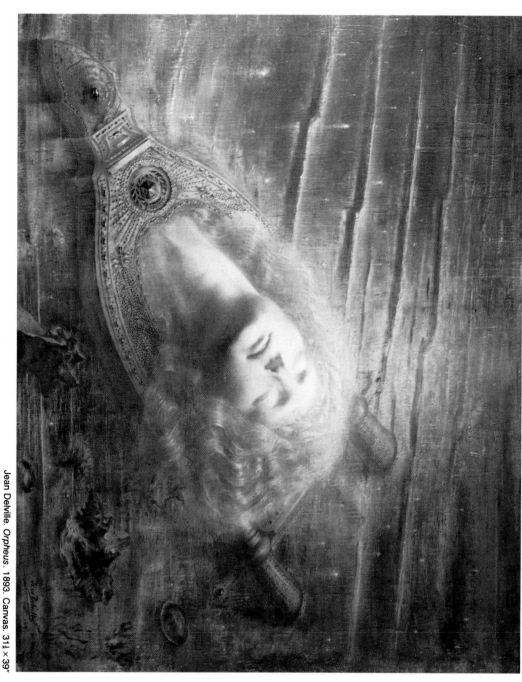

Jean Delville. *Orpheus*. 1893. Canvas. 31¼ × 39"

its *trompe-l'oeil* incrustations contrasts with the evanescence of the face, which appears asleep, cut off from the body. This dream "assemblage" violates the spectator's empirical vision and seems to cling to traditional spatial rules only in order to deny them in interpretation. A friend of the poet and novelist Villiers de L'Isle-Adam, the founder of the Salon of Idealist Art in 1895, and an active member of Péladan's Rosicrucians, Delville did not cease to polemicize against the materialism of his time. At the end of the century, he denounced "the wretched spectacles of Ensor, Monet, Seurat, Gauguin, who, on the pretext of freeing aesthetics, frame the most nauseating studio detritus to the applause of imbeciles and snobs."

Beneath the myth or the allegory
the painting imposes itself as texture and substance

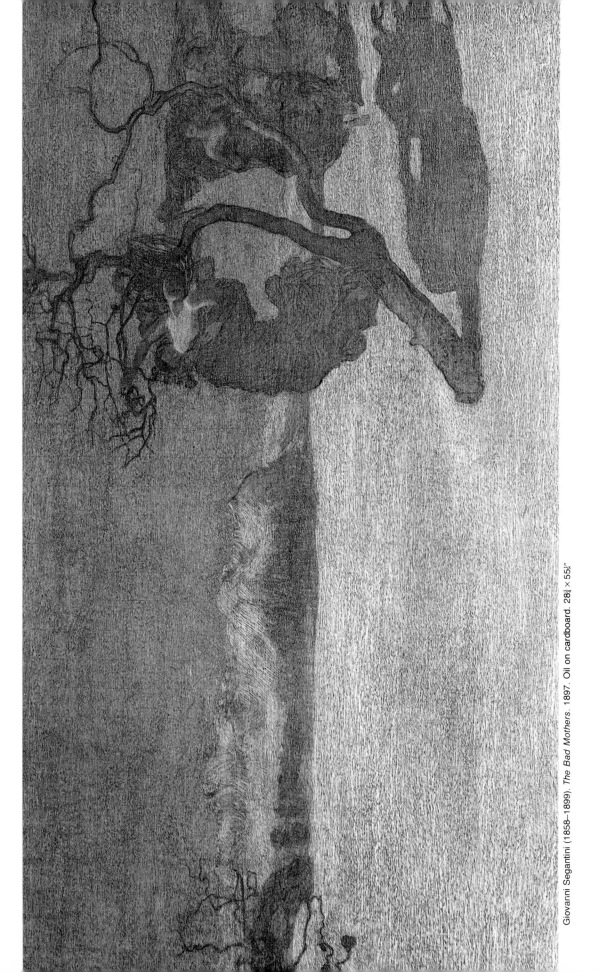

Giovanni Segantini (1858–1899). *The Bad Mothers*. 1897. Oil on cardboard. 28¼ × 55¼"

A Buddhist legend condemns bad mothers to float endlessly after their death above deserted snowfields. Giovanni Segantini, who lost his own mother when he was five years old and later made maternity his main theme, displayed uniform space on a moonlit night in his *The Bad Mothers* (above). In the foreground a wandering creature with bare breasts, which a child clutches, arches her body, her hair caught in the branches of a tree. In an essay devoted to Segantini, the psychoanalyst Karl Abraham, a

contemporary of Sigmund Freud, interpreted this painting of denied love in detail—both to left and right there are sterile mazes of dry branches against the crystal-clear night. The artist's originality, however, lies chiefly in his treatment. The substantial presence of the physical world exalted the Italian painter, who spent his entire adult life in the Swiss Alps. "I bend to the earth and kiss the blades of grass, flowers. . . . I am thirsty, O earth, and bend over thy immaculate and eternal springs, I drink, I drink thy blood, O earth,

the blood of my blood."
Segantini's works are like a sediment of dense matter extracted directly from the mountainous soil. Wassily Kandinsky pointed out this textural dimension in 1912: "He took the finished forms of nature, mountain ranges, stones, and animals, and reproduced them down to their smallest detail. Yet despite their strictly realistic appearance, he knew how to create abstract images." Under its naïve metaphorical appearance, *Autumn* (right) by the Belgian artist Xavier Mellery has—in addition to the

same iconographic theme—a similarity of surface treatment. An obstinate and fine rendering gradually saturates the forms. A constantly repeated scrawling—even where sudden surges of a modest gesturality are not lacking —finally forms areas of a dull and leaden density. Mellery was a master in the invention of subjects and settings. His allegorical figures, against their gold backgrounds, cleverly mingling with their surroundings, have achieved lasting appreciation.

Xavier Mellery (1845-1921).
Autumn. 1890.
Watercolor and pencil on paper.
35⅜ × 22½"

CHUTE DES DERNIÈRES FEUILLES D'AUTOMNE

Léon Frédéric. *The Glacier, the Torrent.* 1898–1899. Canvas. 80¾ × 50".

Frédéric (1856–1940). *The Glacier, the Torrent* (detail).

Léon Frédéric. *The Lake, Stagnant Water.* 1897–1898. Canvas. 80¾ × 50".

Arnold Böcklin (1827–1901). *Naiads at Play.* 1886. Distemper on canvas. 59½ × 69¼"

By treating their fantasies with the documentary detail of a genre scene, Arnold Böcklin and Léon Frédéric produced troubling kitsch images whose candor awakens a somewhat perverse sexual longing. "The accumulation of pink young bodies in attitudes both innocent and lascivious in the two side panels of Frédéric's triptych dedicated to Beethoven" (far left and left), as remarked by Francine C. Legrand, lends itself to interpretations that the Belgian artist, who was strong and meticulous, would certainly not have understood; Frédéric was enamoured of a social ideal and wholly devoted to what Octave Maus described as "the inexorable precision of detail" when he portrayed his child models in abandoned positions and represented them almost lifesize in his work. The obsessive character of his inspiration has created a

construction of accumulation, a piling up of forms, a surface proliferation that breaks with the compositional harmony inherited from Classical art.

Henri Focillon reproached Böcklin for the finicky naturalism of his mythological reveries. "He tears his Tritons away from some village working bench and precipitates them, still sweating from their interrupted task, into soapy waves where they kick away with their big feet." But this robustness à la Jacob Jordaens is not the only thing his painting sometimes affirms beyond the bounds of good taste. In his *Naiads at Play* (above) there is also a compulsive motility in the twistings of the figures. The gleam of the scaly bodies rises against a blocked background in a centrifugal, spiral surge, prefiguring twentieth-century research in the depiction of movement.

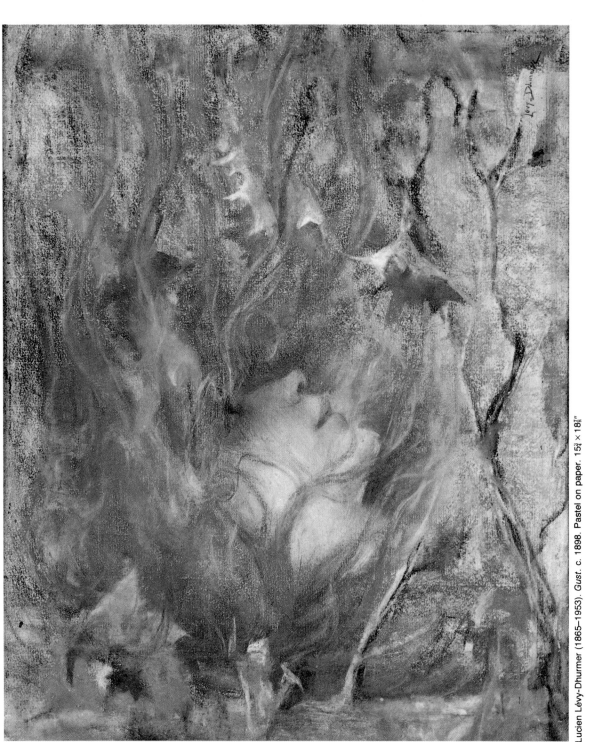

Lucien Lévy-Dhurmer (1865–1953). *Gust.* c. 1898. Pastel on paper. 15⅜ × 18⅛"

The image dissolves itself into its textural support

Of the generation of French painters in the intimate style who created a place for themselves at the turn of the century between academic painting on one hand and Impressionism on the other, Lucien Lévy-Dhurmer—along with Edmond Aman-Jean (see pages 32–33)—was the most gifted both with charm and with technical proficiency. For eight years the art director of a faience factory, Lévy-Dhurmer worked to reconstruct the metallic reflections of Hispano-Moresque and Persian ceramics. As early as 1900, the critic Jacques Sorrèze noted the influence of this experience on Lévy-Dhurmer's paintings: "The very tight, very compact backgrounds, an amalgam of molecules of disparate tones, recall the ceramist who is accustomed to combining the metallic reflections of fired sandstone. Emerald, burnt sapphire, and blended opal backgrounds against which the drawing stands out in a striking way are emphasized and enveloped by this dream fog." A confusion of red-blond strands of hair and dead leaves nestles the tender profile of a modern Daphne in *Gust* (above), and a mass of stiff, wild seaweed engulfs the face of Medusa in *Medusa, or Furious Wave* (right). By fading away, the image liberates great areas where the soft pastel radiation acts by itself and no longer refers to specific representation. Lévy-Dhurmer, who collected butterflies all his life, no doubt found in them in a natural state small nonfigurative paintings that he often amplified in his own work.

Lucien Lévy-Dhurmer. *Medusa, or Furious Wave.* 189[]
Pastel and charcoal on paper. 23⅜ × 15[]

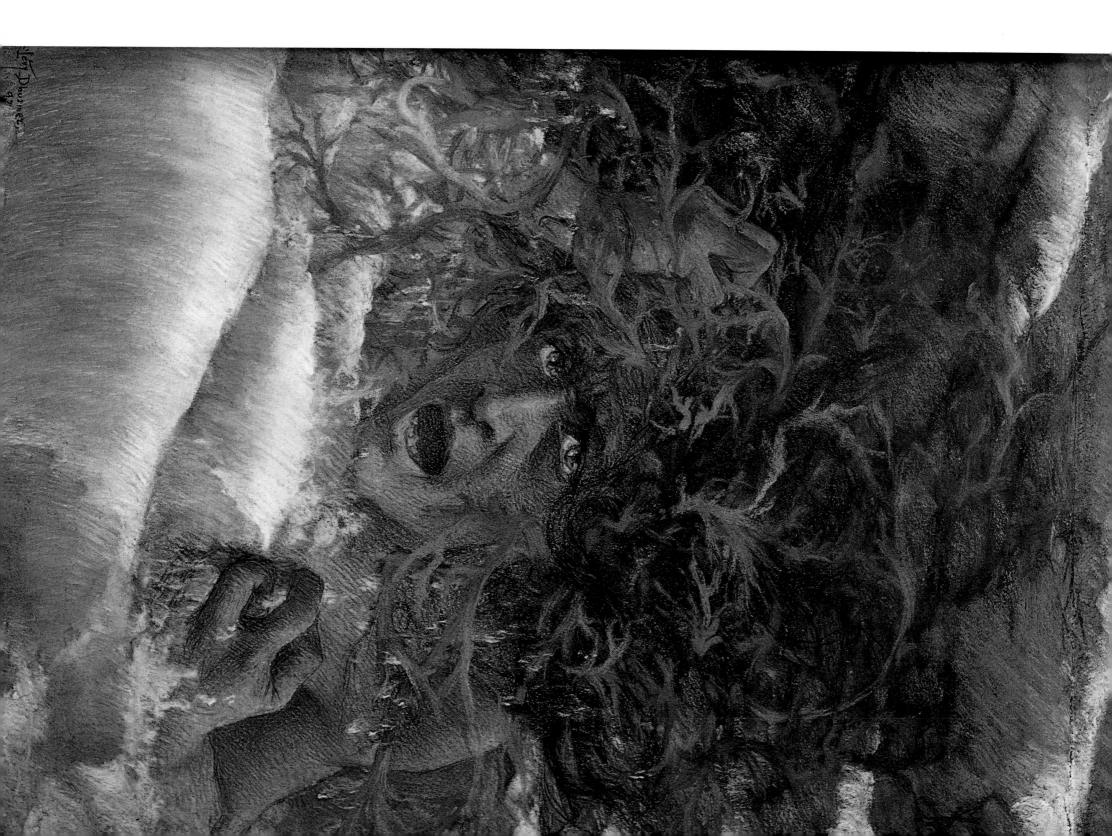

Previati's linear, filament-like style
elongates and prolongs his ceremonial figures

Doubly serial, in its themes and in its style, the work of the Milanese Divisionist Gaetano Previati lends itself—in the manner of the Ravenna mosaicists—to the unfolding of decorative figures, rows of angels or of young girls with identical gestures and attitudes. His very apparent technique is characterized by the alignment of long flexible filaments that gently embrace and prolong the forms and give the entire work its textural unity. "These filaments," noted Annie-Paule Quinsac, "are of pure color with a close intensity, but with no systematic relationship of complementaries." Previati, long almost unknown in his own country, linked Symbolism and divided brushstrokes in a grandiose and lyrical vision. Like Giovanni Segantini or Giuseppe Pellizza—we will rediscover this convergence with the Futurists—he employed a technical knowledge in his reveries —of which the detail of *The Funeral Rites of a Virgin* (left) and *Assumption of the Virgin* (right) rank as two important examples—that make him the principal Italian color theoretician of the beginning of the century. His volumes *The Scientific Principles of Divisionism* and *The Technique of Painting* gather together all European studies from Isaac Newton to Michel Eugène Chevreul, from Herman L. F. von Helmholtz to Ogden N. Rood, on the subject of optical phenomena and mixtures of colors. "Previati is the greatest artist Italy has produced since Tiepolo," wrote Umberto Boccioni, who was greatly influenced by him. The two accompanying illustrations of Previati's work recall the words of Edgar Allan Poe: "The death of a beautiful woman is without doubt the most poetic subject in the world."

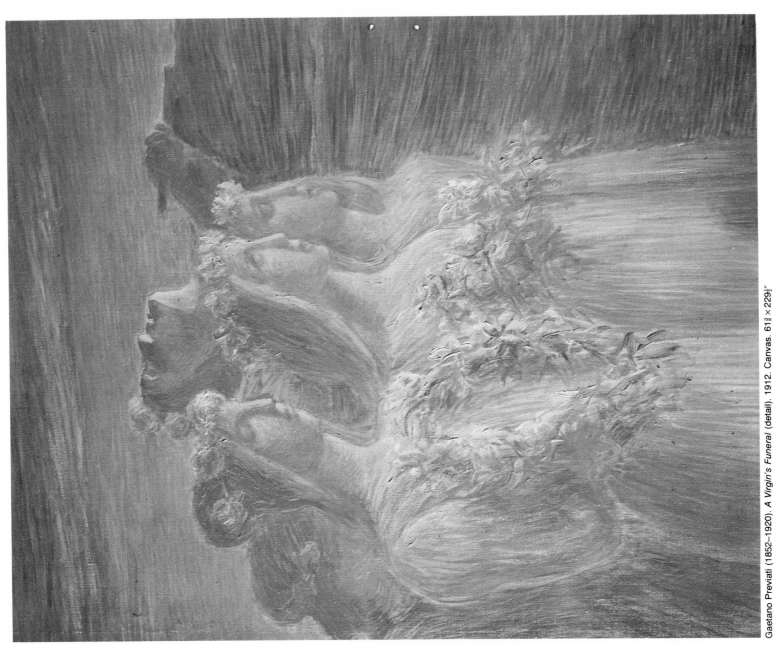

Gaetano Previati (1852–1920). *A Virgin's Funeral* (detail). 1912. Canvas. 61⅜ × 229¼″

Gaetano Previati. *Assumption of the Virgin.* 1903–1908. Canvas. 40¼ × 33⅞″

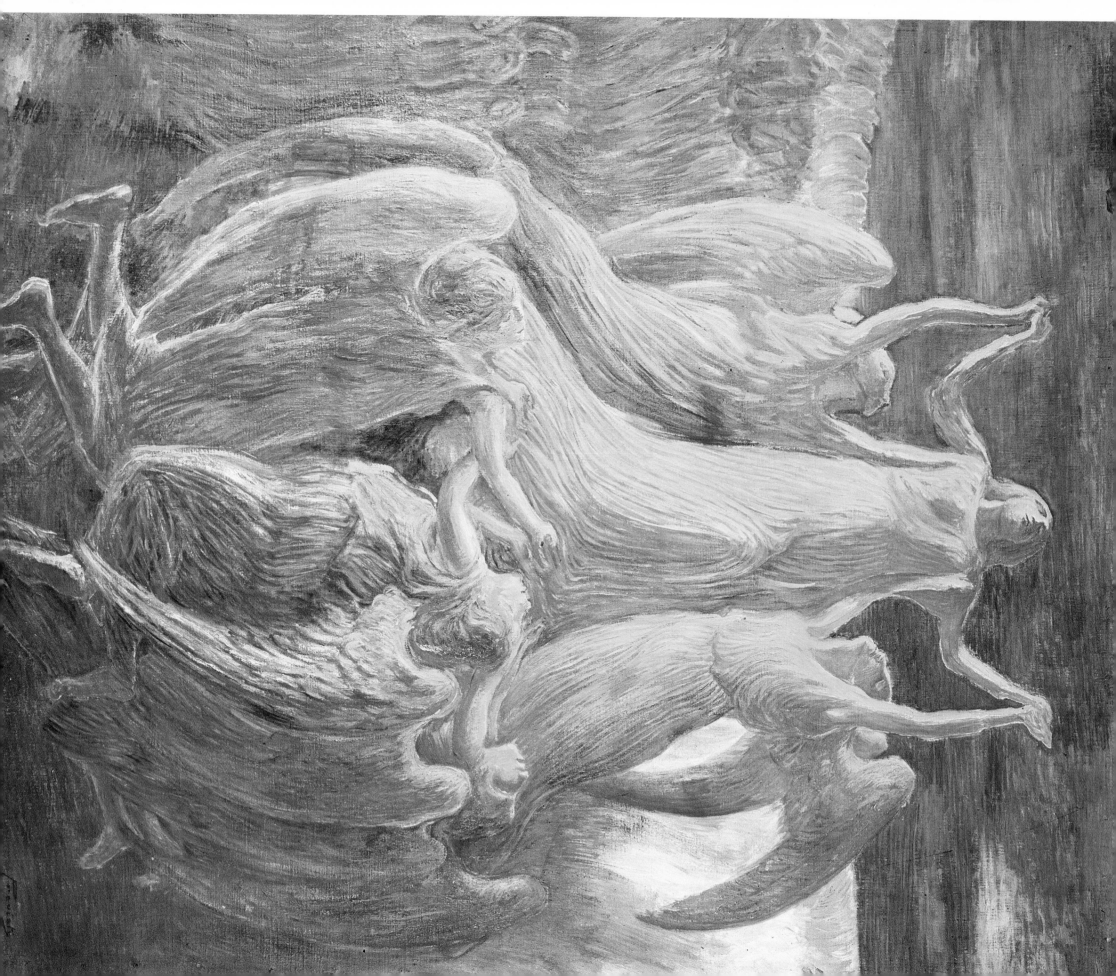

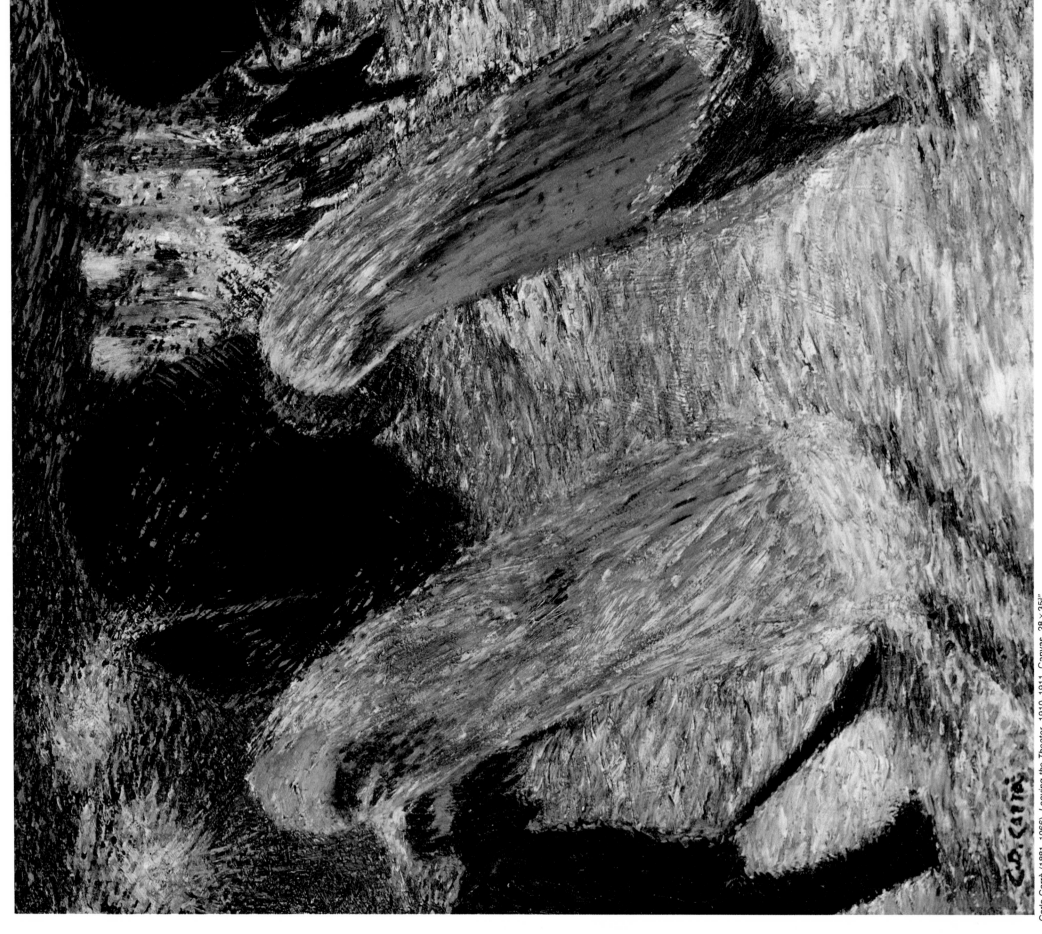

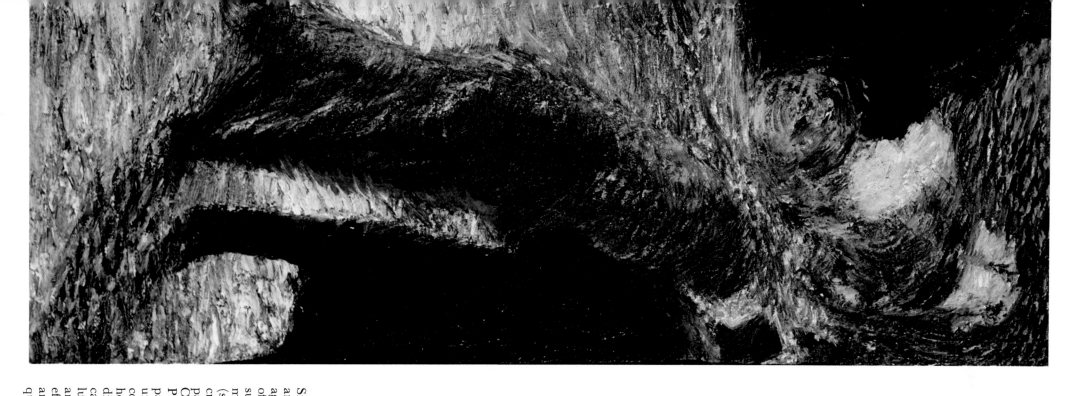

Swaying and somnambulistic crowds disturb the viewer's equilibrium

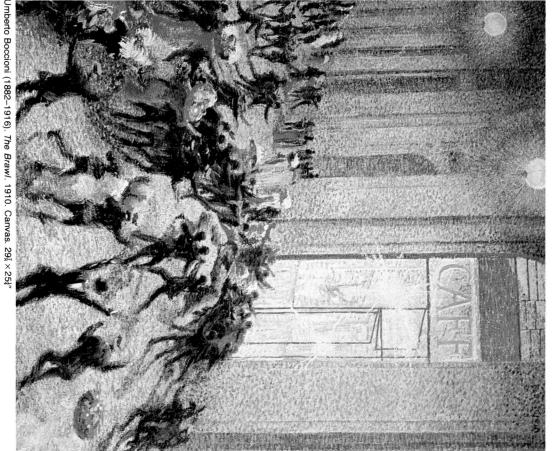

Umberto Boccioni (1882–1916). *The Brawl.* 1910. Canvas. 29⅜ × 25¼"

Since the works of Edgar Allan Poe and Charles Baudelaire, the agitation and sudden excitement of urban crowds have been the subject of exalted or gloomy meditations by painters and poets (see pages 292–293). In order to create the reeling silhouettes in his painting *Leaving the Theater* (left), Carlo Carrà borrowed Gaetano Previati's separated strokes (see pages 90–91). The snowy ground of uncertain horizontality, the contradictory teetering of the hooded bodies and shadows, the distorted black blobs of the carriages, the scattering of luminous areas—all these create an unbalancing and coenesthetic effect on the spectator. His stability and personal equilibrium are questioned.

The stabbing of two prostitutes in the Galleria Vittorio Emanuele in Milan offered Umberto Boccioni the occasion, in his *The Brawl* (above), to describe in plunging perspective the Brownian (molecular) movement of a crowd of idlers—wriggling larvae, a frightening swarm of insects irresistibly attracted by the dazzling lights of a café window (which is turned back to the picture plane, as the sign shows). The gay punctuation of flowered hats contributes to the animation of the scene, which the insistent and static verticality of the architectural perspective in the upper half of the composition oppresses like a stone column.

93

A programmed painting develops
that purifies and geometrizes
the appearances of the world
of the senses

Giacomo Balla (1871–1958). *Iridescent Interpenetration, No. 7.* 1912. 30¼ × 30¼".

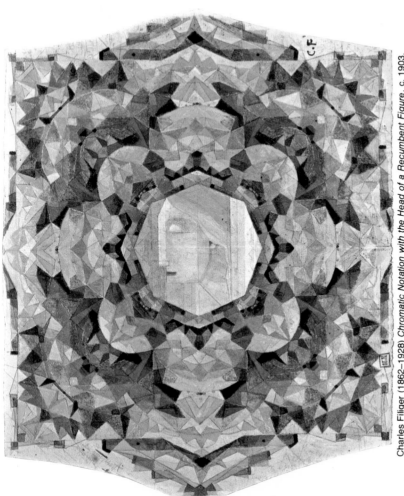

Charles Filiger (1862–1928) *Chromatic Notation with the Head of a Recumbent Figure.* c. 1903.
Watercolor on paper. 9½ × 11⅜"

At the beginning of the twentieth century, the complicity of geometry and mysticism was emphasized when painters in horror of naturalism returned to a Byzantine system of painting. Charles Filiger, an intimate friend of Paul Gauguin who settled in Brittany in 1889 where he spent his entire life, was a religious spirit who sought to free himself from the material world by simplification and abstraction. If one excludes its central medallion, the *Chromatic Notation with the Head of a Recumbent Figure* (above), constructed like a piece of polygonal marquetry, escapes any reference to the external world of reality. Filiger's passionate defender, the playwright Alfred Jarry, author of *Ubu Roi*, spoke in 1894 of an "expiatory Giottism, a monk's painting in seashells from strange countries, respectfully covering sarcophagi—the way death sticks to the eyes we close of eternity for eternity."

The same antimaterialist desire for purification is expressed by the figure in Piet Mondrian's *Evolution*

(far right). At the same time that Mondrian painted *Evolution*, he became an adherent of a theosophical group. The nostrils, nose, and breasts of the figure in *Evolution* are square, and the sexual area and the central section of both stars are triangular. Here one sees the resurgence of an idea cherished for thousands of years—that of a harmonious interrelationship of geometry, the creation of the world, and human morphology.

Giacomo Balla dedicated an entire pantheistic and cosmic cult to light. His series of paintings entitled *Iridescent Interpenetrations*, begun at Düsseldorf during a trip in 1912 (see page 302), schematize not only the solar flux but also—as in *Iridescent Interpenetration, No. 7* (right)—the rainbow and the regular organization of eucalyptus trees that he drew from his balcony overlooking the Via Paisiello in Rome. The *Interpenetrations* are prophetic works that anticipate with mastery the entire serial and systematic art of the period 1930–1960.

Piet Mondrian (1872–1944).
Evolution (detail of central panel), 1910–1911.
Canvas, 70¼ × 33¾"

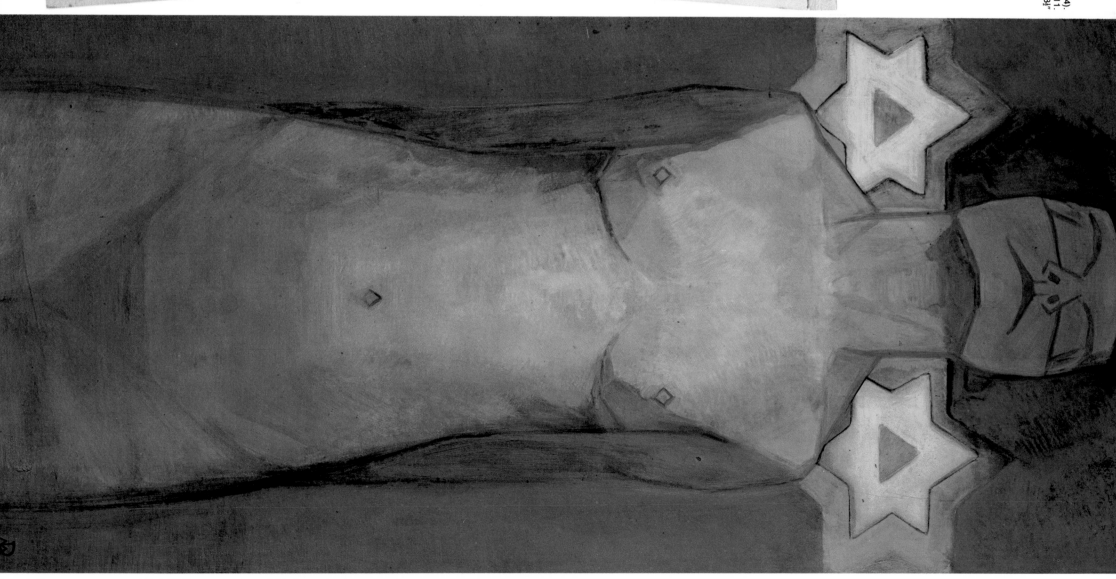

The frontal emphasis of decorative motifs makes the painting into a "mural"

Deliberately associating painting and the applied arts, illusionist image and ornamentation, painting and wall, Gustav Klimt shattered the academic categories of painting. In his *Judith* (far right), the feminine figure with her sensual mouth and thick black hair is twice enclosed: first in a light frame with a repetitive loop motif and then in gold-leaf loops that invade the figure (the neck, the arms, the lower belly) as though better to inscribe it on the picture plane. This principle is also emphasized in Klimt's *Waiting* (left), one of nine preparatory paintings he executed for the frieze in the Hotel Stoclet in Brussels (see page 13). Here figurative components are reduced to a few inches: the area of the head and the arms. The rest is merely a proliferation of scrolls and triangles, with an eye here and there, a decorative scheme that originated in ancient Egypt and that here serves to reveal the two-dimensional character and *murality* of the work (one can compare it to Pablo Picasso's *Man Leaning on a Table*, see page 183). Using metallic or silver paints, the Viennese artist made the surface an autonomous texture that produces its effects of brilliancy, dullness, and optical instability, without subordination to the figurative elements. Before becoming a *stage*, the work is field and material.

Klimt's paintings were shown in Venice in 1899 and greatly influenced the Italian Liberty style. His work inspired both Vittorio Zecchin and Galileo Chini. The latter artist painted *Spring*, a detail of which is shown (right). *Spring* is the central part of a huge work more than 13 feet high that displays boldly the principle of frontal accumulation of geometrized elements so dear to the Viennese master.

Gustav Klimt (1862–1918). *Waiting*. 1905–1909.
Tempera, watercolor, gold leaf and silver leaf on canvas. 76⅜ × 47⅝"

Galileo Chini (1873–1956). *Spring* (detail). 1914.
Tempera, stucco, and gold on canvas. 157½ × 157½"

Gustav Klimt. *Judith*. 1901.
Oil and gold leaf on canvas. 33¼ × 16½"

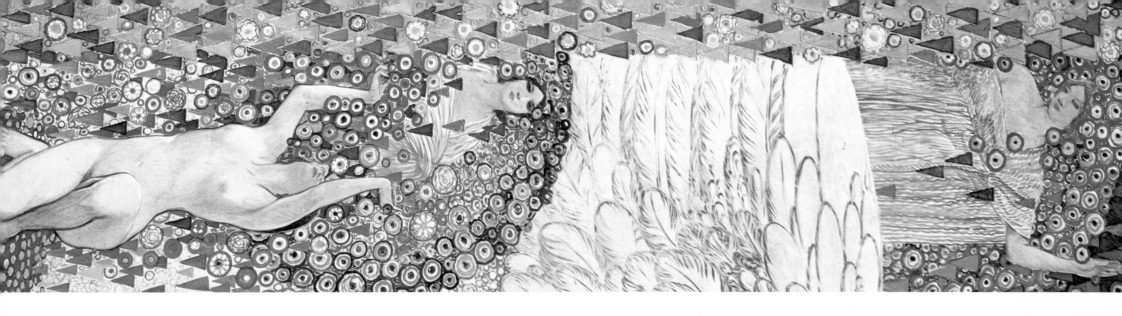

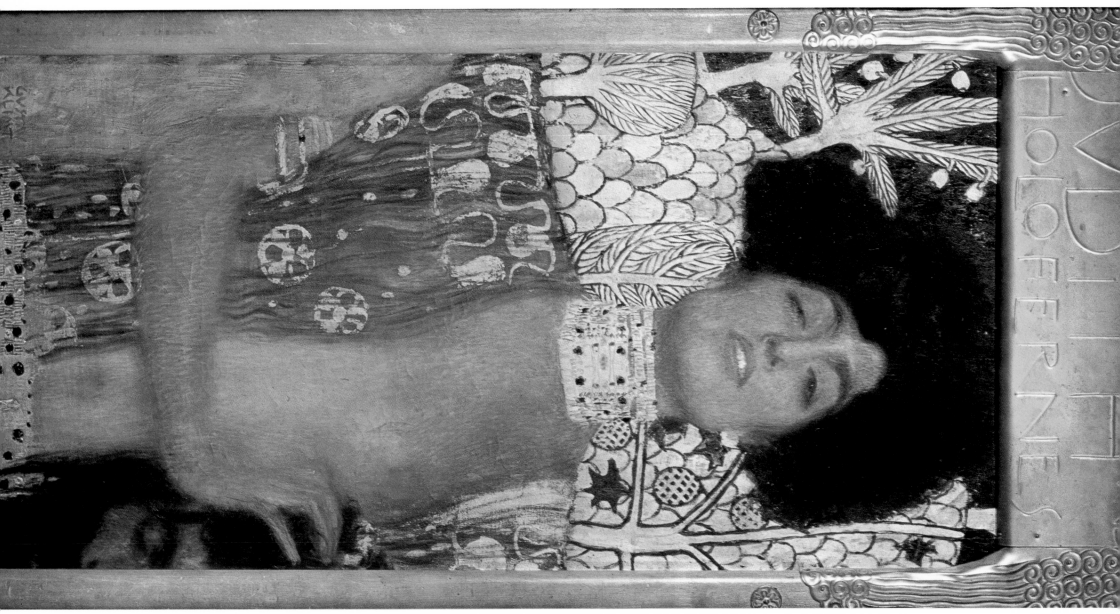

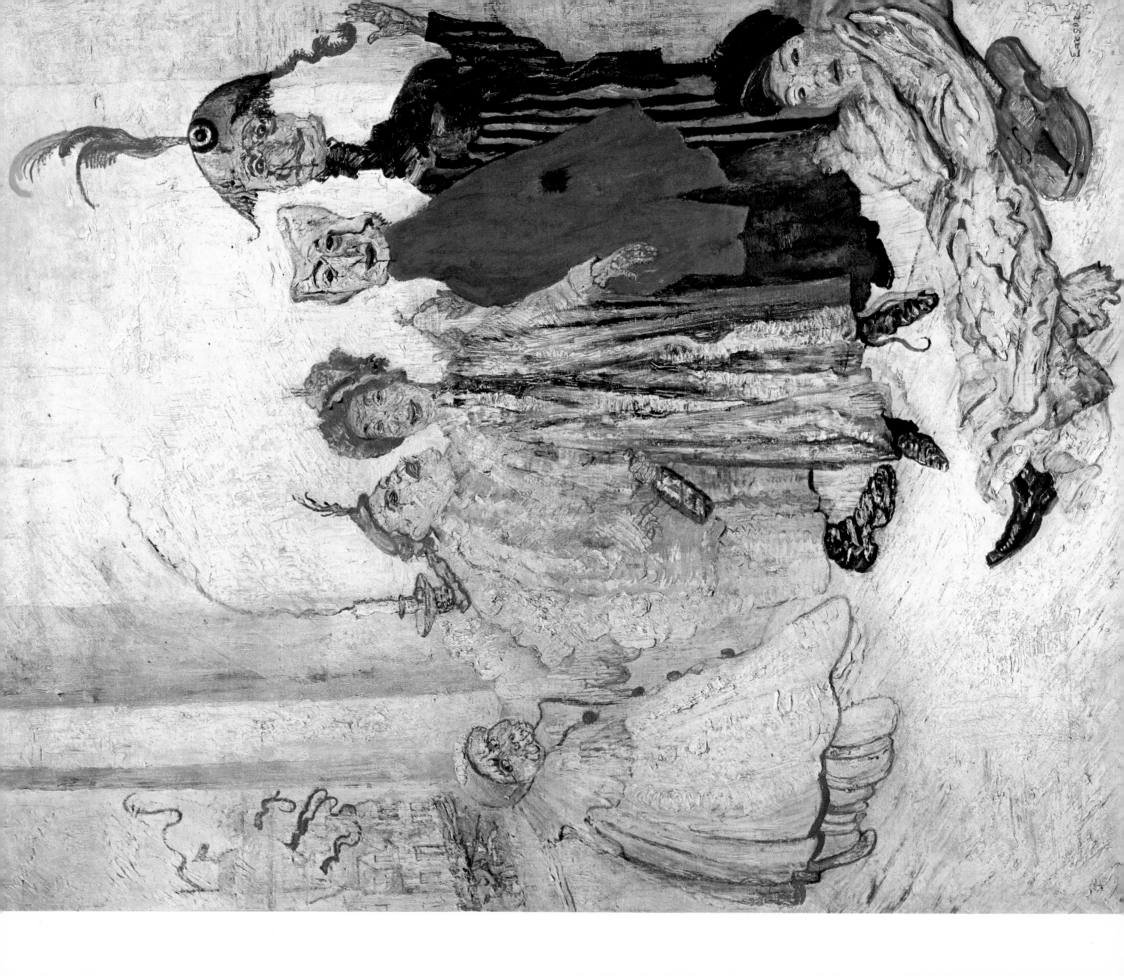

Between the mask and the skeleton, the puppet and the cadaver, there is practically no place in James Ensor's art for the human figure. The social being, defined by cheap finery and grimaces, occupies the entire scene, and becomes all the more suitable for caricature because his agitation and his mimicry of the "conventional braggart" are doomed to final effacement. The masks merely hide a skull. The society that Ensor judges is not a theater. It is Grand Guignol, it is a sport of massacre. He constantly plays on the ambiguity of its decor: a theatrical scene with wings and *trompe-l'oeil* openings or real space with windows and exits.

Ensor has fascinated twentieth-century artists from Paul Klee to Emil Nolde because of his innovations in using materials. His chalky and plastery heads, viscous, roughly worked, scraped, and crossed by colors, and his backgrounds so thick that they resemble roughly trowelled plastering mark the assumption of pictorial texture as a specific element of the painter's work, practically dispensing with a figurational pretext. *The Entry of Christ into Brussels* (see pages 100–101), painted when Ensor was twenty-eight years old, is a spectacularly large specimen of his rebellion and boldness (the canvas is almost 16 feet wide). The background scene bursts forth, a vomited outpouring into the collective frustration parading in the foreground—an uncontrollable, vociferous carnival with a host of skeletons, judges, bishops, military figures with clown's heads, and also Jesus Christ, who for Ensor represents the anarchist and the rebel. The banners that read "Long Live the Social State," "Doctrinary Flourish of Trumpets," and

"Always Successful" recall with a burlesque note that during his early years Ensor was in contact with freethinking circles and with persons exiled by the Paris Commune. In regard to the techniques used by Ensor in this work, according to a report cited by Francine C. Legrand made before its restoration in 1950, one finds "every technique from thin glazing to very thick impasto. In the lower right (against the frame) is a head drawn in charcoal.... Other heads (or parts of the background, clothing, accessories) are painted in irregular impasto to the point of becoming a kind of rough-cast plastering. Other parts, such as heads and masks, have a homogeneous coating as consistent as sealing wax...."

James Ensor. *The Surprise of the Wouse Mask.* 1890. Canvas. 42¼ × 51½"

Ensor's macabre Grand Guignol outlines itself in a rough-cast plaster that has been heavily worked

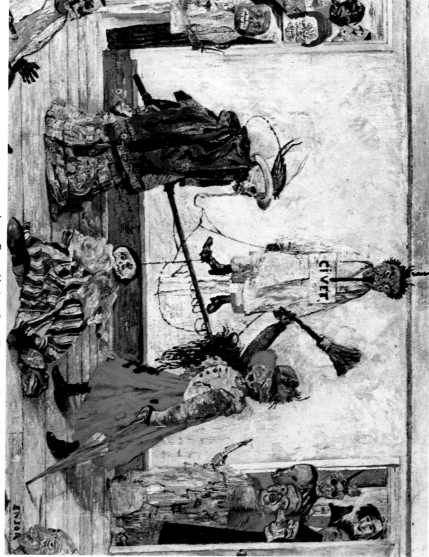

James Ensor. *Maskers Quarreling over a Hanged Man.* 1891. Canvas. 23¼ × 29¼"

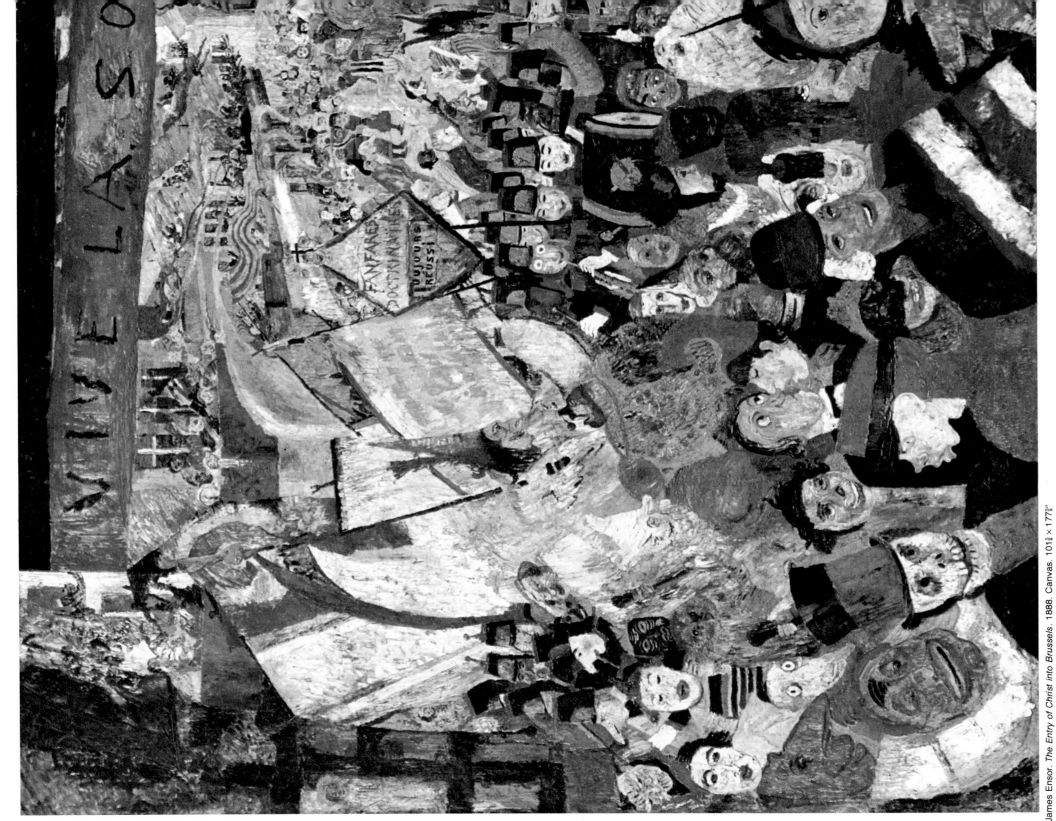

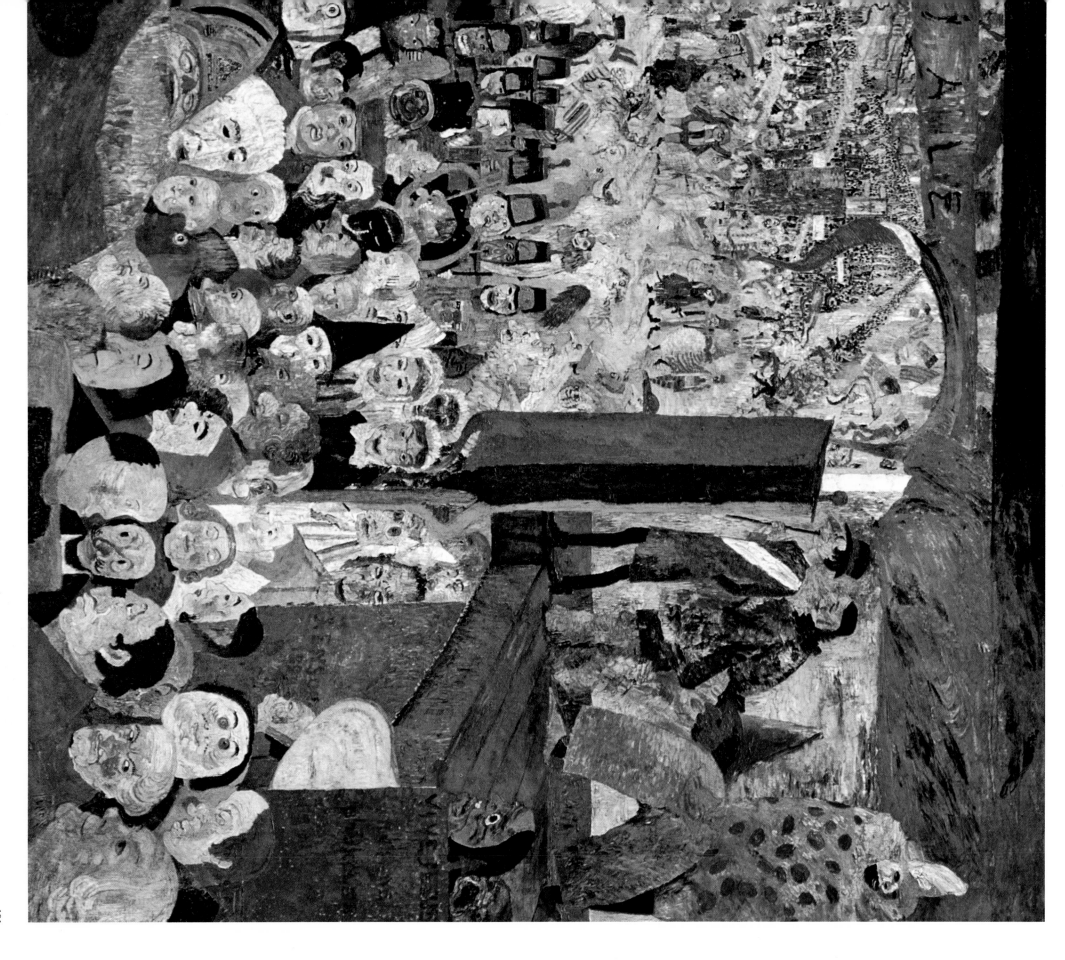

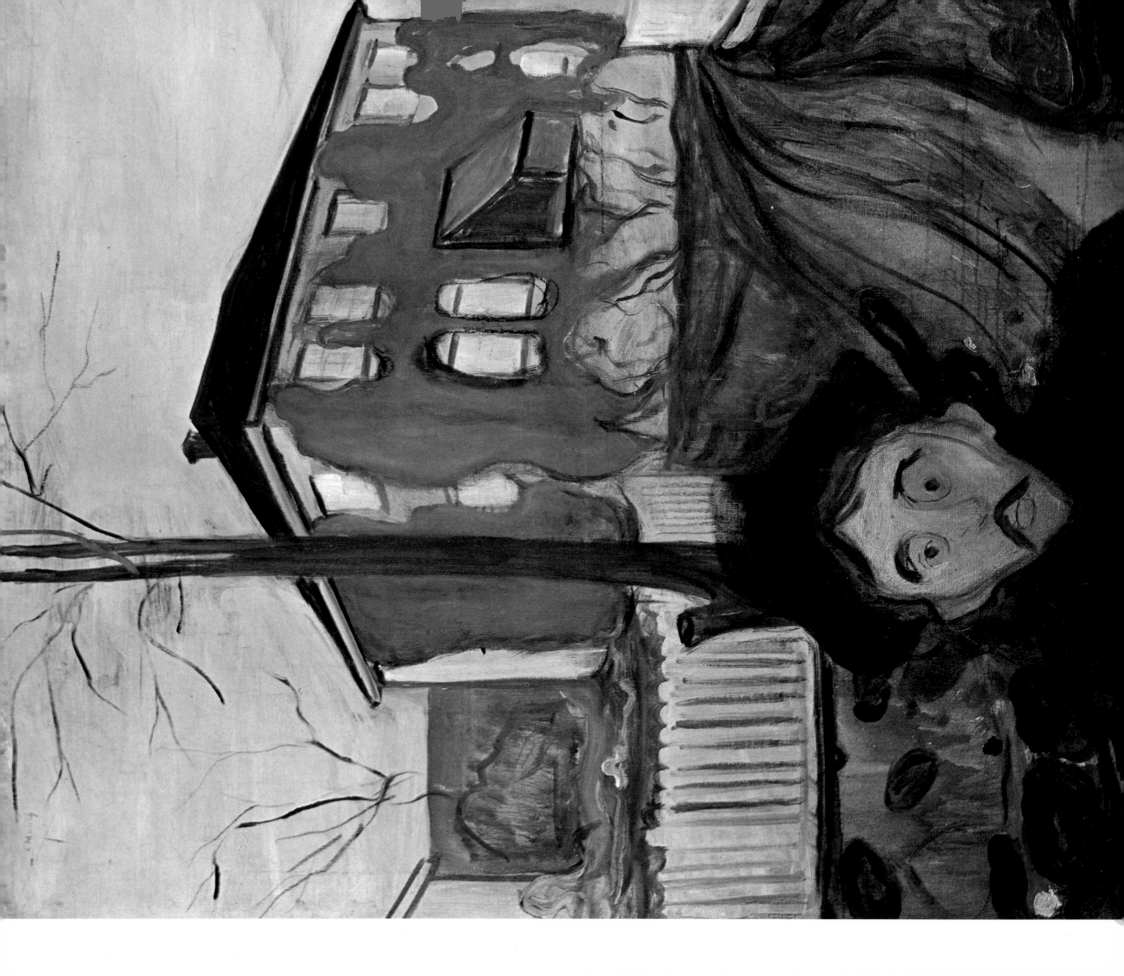

The confession of a morbid anxiety revealed in bloodred, viscous forms

Under the pretext of a "realism of the soul," Edvard Munch related through his subject matter and choice of colors a very physical story of blood and death. On the one hand, he established a program of humanitarian spirituality. "One cannot forever paint women knitting and men reading," he remarked in 1889. "I want to represent people who breathe, feel, love, and suffer. The spectator should recognize what is sacred in these figures so that he will discover himself in their presence, as though in church."

On the other hand, however, Munch's brush changed things into bloodred puddles, a flow of lymph and pus denoting an object such as the vine growing on the house in *The Virgin Vine* (left), the stained sky of *The Cry* (upper right), and the liquid hair that belongs to a vampire in *Vampire* (lower right). In extension, Munch's brushstrokes become a vein, a gutter, a drain. Total anxiety is metamorphosed in these canvases, and without making too laborious a search for his sources of inspiration, one can note that when he was five years old his mother died of tuberculosis and when he was thirteen years old his sister died of the same disease. More than once Munch stayed for extended periods of time in a sanatorium—in 1905 he portrayed himself in a cadaverous state in an operating room, and in 1908 he was treated for several months of depression. He progressively withdrew from life until his death in 1944.

In his own fashion, Munch, who spent his most fruitful years in Norway, Paris, and Germany, solved the problem of the opposition of surface and illusionistic third dimension, which at that time was preoccupying Paul Gauguin and his followers. In *The Cry* Munch strongly emphasizes the vanishing line on the left, while the background in the upper part is heavy with very obvious, oily, slick brushstrokes whose imprecision prevents a spacing out in depth. (A yellow line even covers the face of one of the strollers.) These pigmentary trails curve and return to the surface as though to deny—or at least not to overemphasize—the perspective of the bridge.

Edvard Munch (1863–1944). *The Virgin Vine.* 1898. Canvas. 47¼ × 47¼".

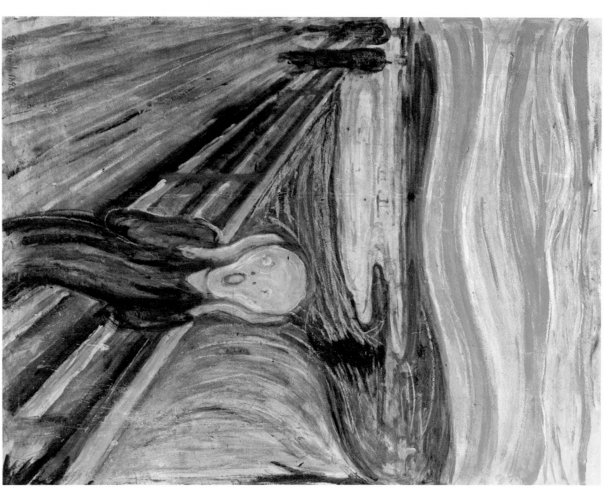

Edvard Munch. *The Cry.* 1893. Canvas. 35⅞ × 28¼".

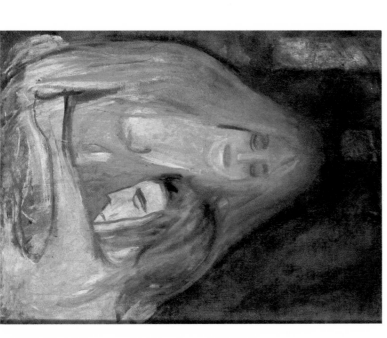

Edvard Munch. *Vampire.* 1898. Canvas. 33⅞ × 26¼".

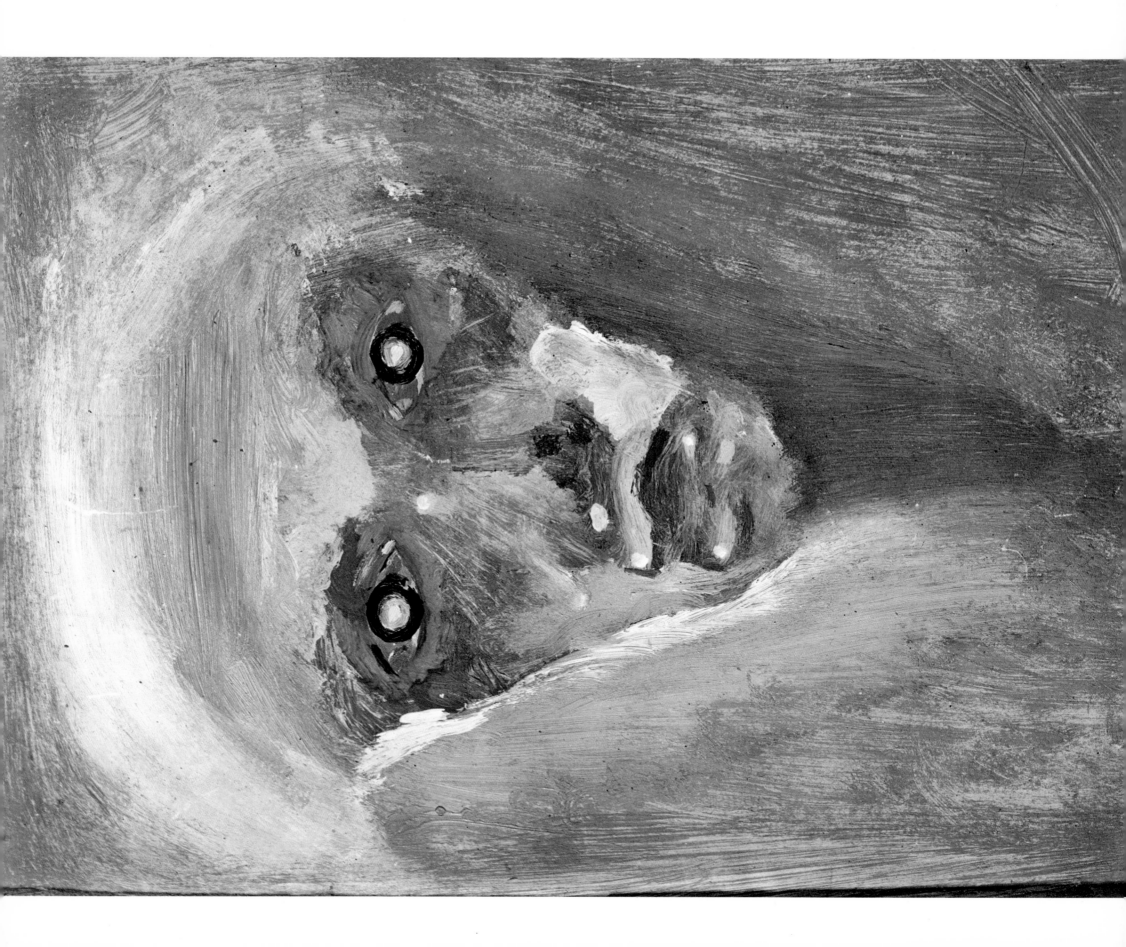

Haggard or petrifying, these eyes challenge the spectator

Treated in various ways, the abyss of the eyes fascinated European Symbolists at the turn of the century (see pages 80–81, 97, 102, 115). Arnold Schönberg, a follower of Die Blaue Reiter movement, purified the image he painted in *The Red Look* (left) to the point of leaving the viewer face to face with only the bloodshot eyes of a figure of nightmare. This economy of means and expressive efficiency impressed Wassily Kandinsky, who wrote in 1912: "It is interesting to

see with what simplicity and sureness the composer Arnold Schönberg uses the painting medium. In general his only concern is inner harmony. He ignores all flourishes and slight embellishments and with him the 'poorest' form becomes the richest."

Umberto Boccioni attempted the same effect in his *Modern Idol* (above), in which the murderous and morbid eyes of a woman, under a straw hat decorated with brightly colored flowers, rival the luminous spots the painter scattered above. In their manifesto of April 1910 the Futurists compared a lamp's existence to that of a person: "For us a man's pain is as interesting as that of an electric lamp, which suffers with spasmodic starts and cries out with the most heartrending expressions of color."

In his early self-portraits, Pablo Picasso experimented with a Medusa-like and petrifying expression in the eyes. At the age of twenty and with a precocity soon to become legendary, he used brutal, authoritative strokes to delineate the face that he inserted with broken-line stiffness into his

Self-Portrait (below). From out of it his famous eyes plunge into ours for a face-to-face examination from which the artist expects petrification and hypnosis to result. Picasso remembered this technique when, in 1907, he painted his early masterpiece *Les Demoiselles d'Avignon* (see page 135).

Larionov borrowed from children the comical stiffness of their graffiti

The neckless lady of Michael Larionov, cut out like a folkart doll, greedily announces the advent of spring in *Spring* (far right). ["Becha," in Cyrillic (pronounced "vesna") is the Russian word for "spring."] This painting marks the apogee of Russian Neoprimitivism. By deliberately using for artistic inspiration rustic and childish expressions (as in *Soldier on Horseback*, right), peasant woodcuts (called *Loubok*), and graffiti, Larionov affirmed an anti-Western, Slavophile vein that simultaneously defied the canons of the Imperial Academy and the rules of the aristocracy.

Michael Larionov (1881–1964). *Soldier on Horseback*. 1908. Canvas. 35 × 39"

But these examples of "raw" art—which at that same time in Munich Wassily Kandinsky and Franz Marc were comparing in the pages of the almanac of Der Blaue Reiter in importance to their own work as well as to that of Paul Cézanne, Henri Matisse, and Robert Delaunay—also generated new spaces by avoiding Classical concepts. In *The Soldiers* (left) Larionov covered almost the entire surface of the painting with a deep and arbitrary red in which, a bit in the manner of certain of Matisse's works, he placed shadowless figures. Any attempt at composition has been lost in the erratic distribution of forms. Taking as inspiration medieval icons and manuscripts, whose makers inscribed on the very image the identity or the words of their subject, Larionov identified in writing some of the subjects he depicted in *The Soldiers*, such as "sword," "soldier," and "beer." In the words of J.-C. Bouillon, this technique constitutes an ironic coupling: those who cannot understand these common images may read explanations of them.

Michael Larionov. *The Soldiers* (Second Version). 1909. Canvas. 34⅛ × 40½"

Michael Larionov. *Spring*. 1912. Canvas. 33½ × 26½"

Emil Nolde tried to prolong the art of Vincent van Gogh, Edvard Munch, and James Ensor and to develop an aesthetic of paroxysms. "Instinct," he wrote, "is ten times stronger than knowledge." His arched and dislocated convulsions serve to justify an aggressive palette that exceeds the dynamism of his forms and that by projection tries to create the corporeal mobilization of the spectator. "In him," Paul Klee wrote later, "operates a man's hand, a hand that is not without weight, with a calligraphy that is not without spots. The hand, secretly bloody, of the nether regions."

But in order to limit itself to instinctual assertion and to present itself as an art of uncontrollable flux and as the laboratory of a new barbarism, Expressionism eventually took up certain tenets of National Socialism. Nolde was one of the first members of the Nazi Party in Schleswig-Holstein. When Paul Joseph Goebbels came to power in Adolf Hitler's dictatorship, he hung Nolde's paintings in his office, and he sent a message to Norway for Edvard Munch's seventieth birthday, in which he greeted Munch as "an artist of the Germanic-Nordic race." John Willet has cited an illuminating passage that Hitler's future propaganda chief wrote in a novel he authored in 1933: "Today we are all Expressionists. We are people who want to extract from ourselves the forms of the outer world. Expressionism edifies a world in its own breast. Its power and secret are in its passion." The book burnings of 1937, and an order forbidding Nolde to continue his "degenerate" painting, marked the limits of the artist's relationship with the Nazis.

Cries, trances, ecstasies: Nolde unleashes a savage parade of instincts

Emil Nolde (1867–1956). *Dance Around the Golden Calf.* 1910. Canvas. 34⅝ × 41¾"

Emil Nolde. *The Dancers.* 1920. Canvas. 41¾ × 32⅞"

Maurice Utrillo (1883–1955). *Paris Seen from the Square Saint-Pierre* (detail)

The joy of experimenting with pigments wins out over the observation of subject matter

With Maurice Utrillo expressivity lay not so much in the banality of a Montmartre scene often pictured on postcards as in the use of a fatty, viscid, bituminous impasto spread out like goose tracks on the canvas (see the detail of *Paris Seen from the Square Saint-Pierre*, above). The heavy oil paint with its reliefs and opacities frontalizes the painting, which becomes terrain, ground before becoming image. For a short period Utrillo integrated and even exceeded Camille Pissarro's Parisian paintings by his textural invention.

Using a vacillating and convulsed mountainous landscape as a pretext, as in *The Hill at Céret* (right), Chaim Soutine made his

canvas a cesspool through a furious mixing of impasto. Other than a few red lines to denote houses atop the hill, nothing in this chaos suggests anything based on empirical observation. The configurations that reveal themselves—eyes, heads, cuts of meat, tripes, wounds, mud, slime—owe their existence mostly to the projections of our imagination. At most the artist furnishes—through the ambiguity, the immaturity, and the organic quality of his spots—the *commonplace* from which fantasy takes form. Jackson Pollock in his canvases of 1946 and Jean Dubuffet in his *Hautes Pâtes* later returned to Soutine's technique.

Chaim Soutine (1894–1943). *The Hill at Céret. c.* 1921. Canvas. 28¾ × 21¼″

Maurice Utrillo. *Paris Seen from the Square Saint-Pierre. 1906–1907. Canvas. 19¼ × 23¾″*

Kirchner's neurasthenic faces are angular, emaciated, and pallid

From 1910 to 1919 Ernst Ludwig Kirchner, the central personality of the Expressionist movement Die Brücke, founded in Dresden in 1905 under the patronage of Vincent van Gogh, Paul Gauguin, and Edvard Munch, attempted to impose on his fellow artists a "Gothic," angular, and dramatic version of Cubism and African art as interpreted by Pablo Picasso and André Derain as early as 1907.

Although Kirchner and his Die Brücke friends retained certain stylistic elements of the Cubist manner, nevertheless they did not assimilate the spatial conceptions that developed beginning with Picasso's *Les Demoiselles d'Avignon* (see page 135) up until the *papiers collés* of 1912–1914. "As they confused 'Constructivist distortion' with 'Expressionist distortion,'" wrote the art dealer and theoretician Daniel-Henry Kahnweiler, "they sincerely believed that they and the Cubists were aiming at the same target."

Consequently, for Kirchner painting became chiefly the means of expressing nervousness, instinct, and the aspirations to paradise of a dehumanizing urban society—the vital obsessions of a period with a presentiment of the upheavals of war to come. "I paint," Kirchner said, "with my nerves and blood," and later, about 1914, he stated that "the sole aim of art is to express life by pure tones and simple forms." His typical passersby, prostitutes, and showgirls announce the creatures of the stage and those of the Expressionist cinema of the 1920s from Robert Wiene's film *The Cabinet of Dr. Caligari* to Bertolt Brecht's play *Baal*.

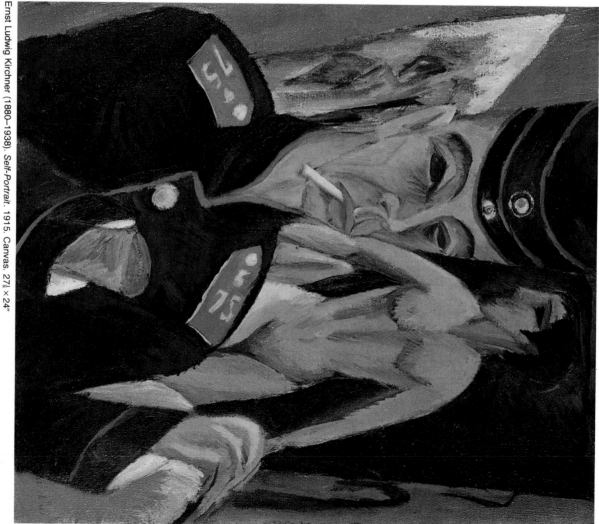

Ernst Ludwig Kirchner (1880–1938), *Self-Portrait*. 1915. Canvas. 27⅜ × 24"

In his *Self-Portrait* (above), painted at the height of World War I, Kirchner shows himself in his studio along with a model. The amputated limb that emerges from his uniform symbolizes the impossibility of painting during that terrible time. Traumatized by the sight of trenches, Kirchner suffered from one depression after another until finally, in 1917, paralyzed in arms and legs, he was admitted to a sanatorium in Davos, Switzerland. He returned to Germany only occasionally until he was condemned in 1937 by the Nazis as a "degenerate" artist. They removed 639 paintings by Kirchner from museums. The following year the artist committed suicide.

The raw evidence of plastic fact is in Rousseau's monumental simplifications

An entire science of exaggeration led Henri Rousseau (called Le Douanier) to overdimension his figures. His distortions of scale create an arising, invading effect reinforced by the insistent, static quality and monumental perpendicularity of his figures. The incomparable presence of these plastic objects is by no means the fruit of any "innocence." In 1910 Rousseau remarked, "People say my work is not of this century. You realize very well that I cannot now change my style, which is the result of obstinate work."

Rousseau's technique is simplification and repetition. The solid black of the schoolboy's blouse in *The Child on the Rocks* (right) and the systematic multiplication of white dots on the girl's dress in *The Child and the Doll* (left) in both cases give the form its frontality. The serial character of the mountains and of the flowers prevents the viewer from lingering over the details of each in order to read them plurally in their function of occupying the surface. The stereometric compactness of the legs and of the heads of the figures and of the doll deprive them of any anecdotal or atmospheric ambiguity. Apparently, these are symbols. By taking illusionism just short of the point of caricaturing it, Rousseau finally broke the dictatorship of the "small true moment" inherited from an incorrect interpretation of Impressionism. He inaugurated an emblematic conception of the image. It is not by chance that the first collectors of this "naïve" painter included Robert Delaunay, Pablo Picasso, and Wassily Kandinsky. About the artist, Kandinsky wrote in 1912: "Henri Rousseau opened the path to new possibilities of simplicity. For us, this aspect of his highly varied talent is now the most important."

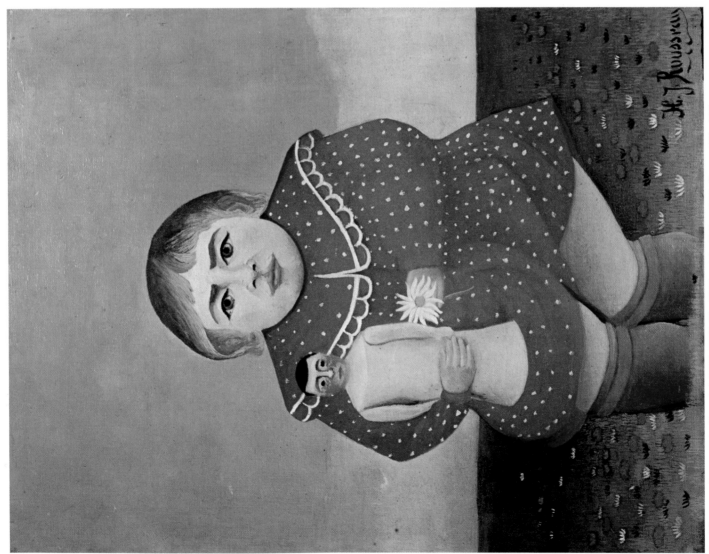

Henri Rousseau (known as Le Douanier) (1844–1910). *The Child and the Doll.* c. 1908. Canvas. 26¾ × 20½"

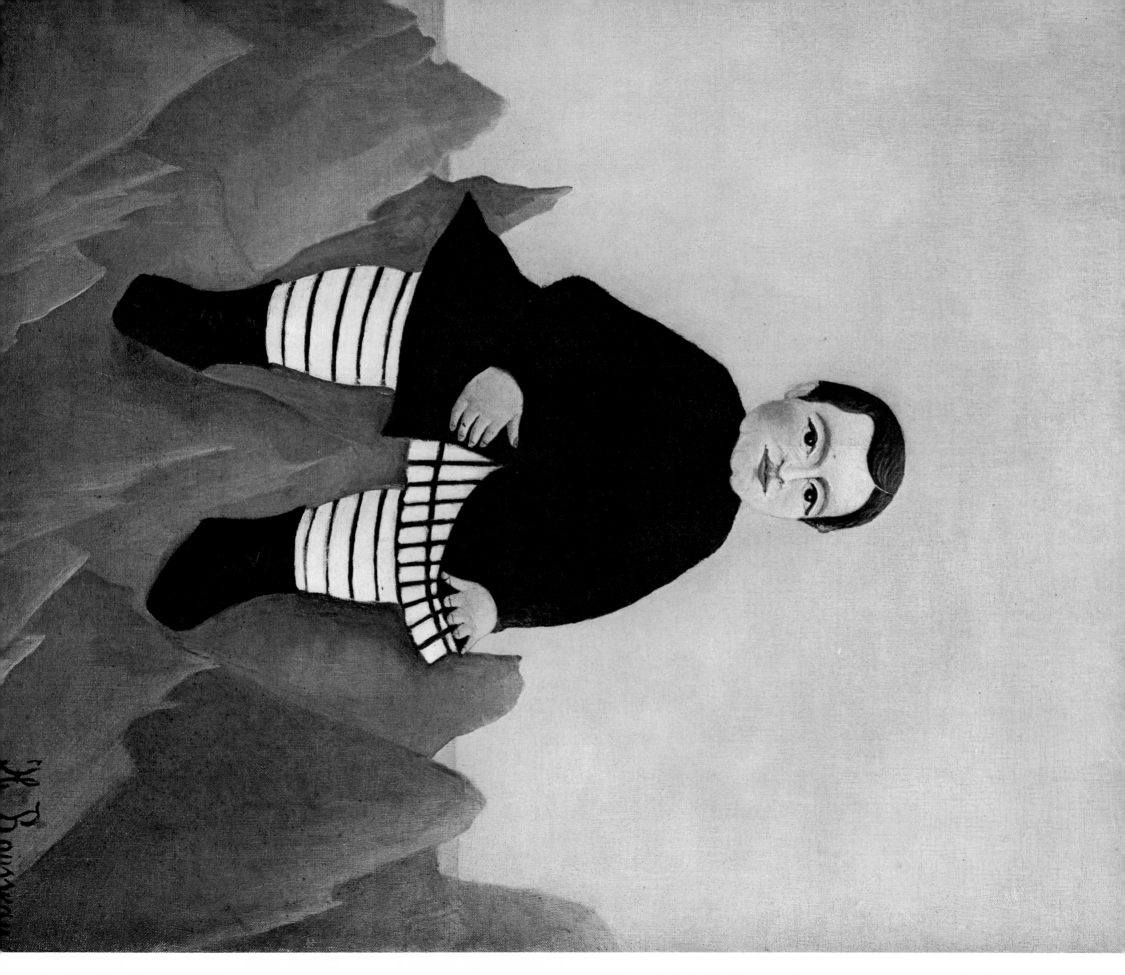

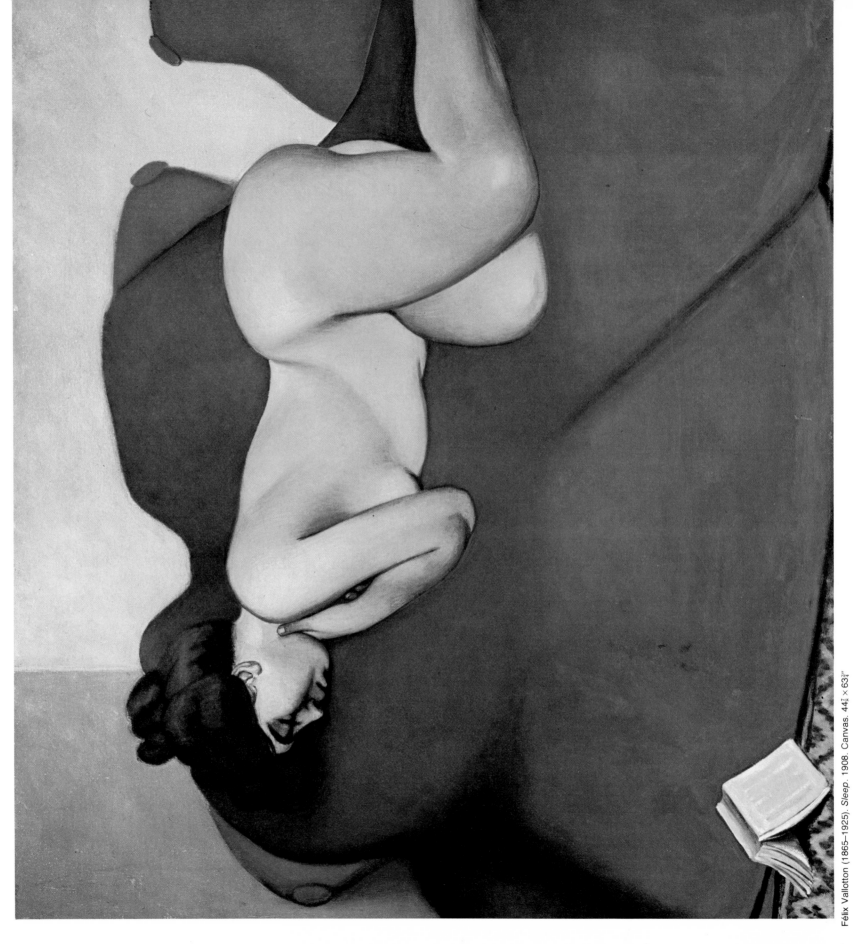

Félix Vallotton (1865–1925). *Sleep*. 1908. Canvas. 44⅞″ × 63¼″

116

F. VALLOTTON. 08.

The sensuality of Jean-Auguste-Dominique Ingres ("this real master," according to the critic Thadée Natanson) and the plasticity of Henri Rousseau's figures were the two principal sources of inspiration for the Swiss painter Félix Vallotton, an ex-Nabi, when after 1900 he painted a series of bourgeois and suggestive nudes with a hyperrealistic precision. "Rousseau overwhelms everything," wrote the Swiss artist as early as 1891, "he is the alpha and the omega of painting." From Ingres he borrowed a strong outline to enclose his figures. "But whereas almost all of Ingres' distortions are extensions," remarks Jacques Rivière, "almost all of Vallotton's are shortened. The line holds the model's arms and legs. Instead of accompanying them, it prevents their development and forces them to remain in a kind of angular folding that is so painful we cannot feel that it will last." In *Sleep* (left), the outline of the woman—who is the contour of the woman—who is of compact flesh with ivory reflections—is developed and repeated in the clear curves of the coverlet and cushions. Here atmosphere is created by a tricky balance between the studied prosaic quality of the interior scene and a clear rendering that smudges the body's particularities to offer merely a synthetic image, a quintessence of the nude.

As for the plump Europa hoisting herself onto the back of the bull Jupiter in *The Rape of Europa* (above), she emerges from the stylized waves in such a manner as to recall the Nabis' *japonisme* and Paul Gauguin's Tahitian landscapes. "For Vallotton there were no longer any forbidden, almost unavowed satisfactions or perversities to surprise him," Natanson, who often published his woodcuts in *La Revue Blanche*, continued: "On the contrary, these things earned his curiosity, but, of course, his curiosity alone." In 1920 Vallotton himself explained, "I paint for well-balanced people who are not without—very much who are not without—a bit of unconfessed vice."

Vallotton spiced his bourgeois nudes with "a bit of unconfessed vice"

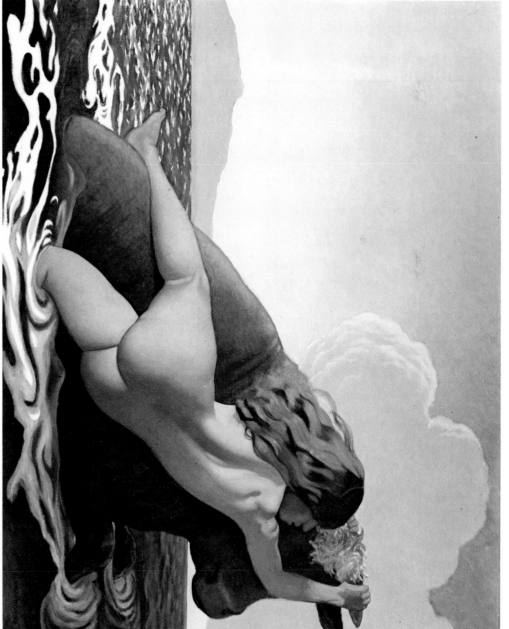

Félix Vallotton. *The Rape of Europa.* 1908. Canvas. 51¼ × 63¾"

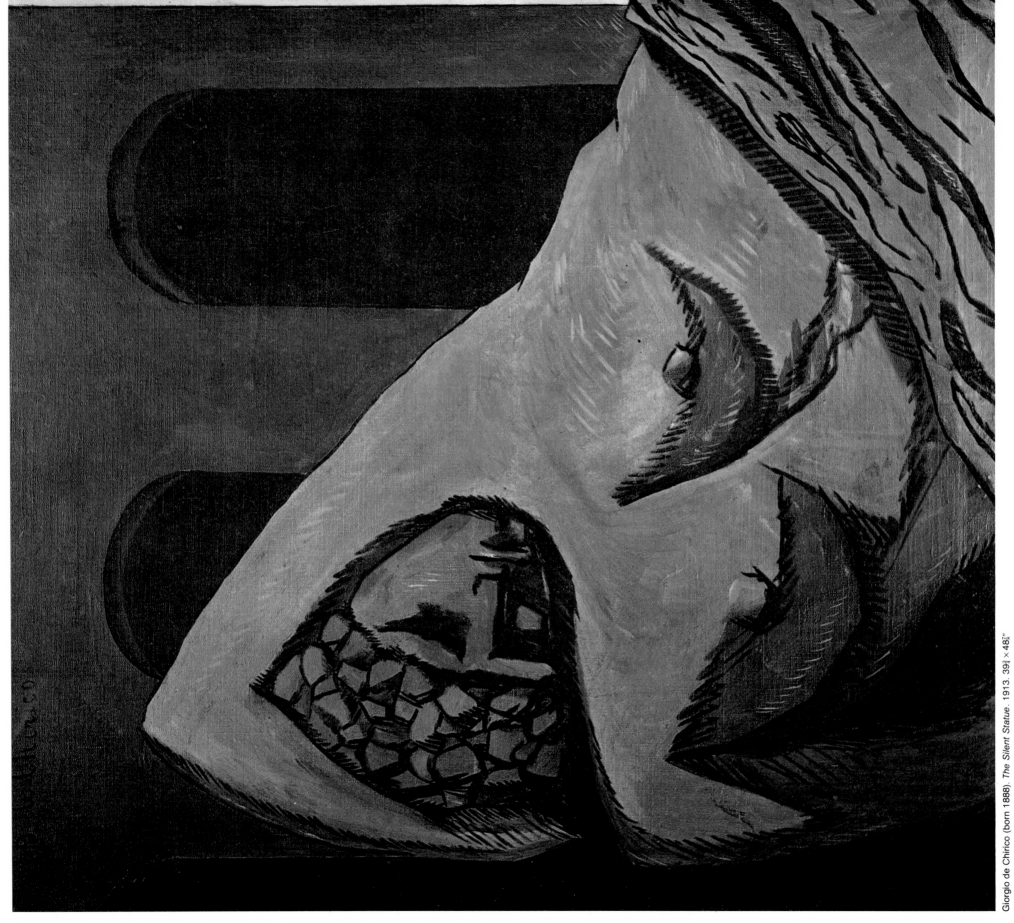

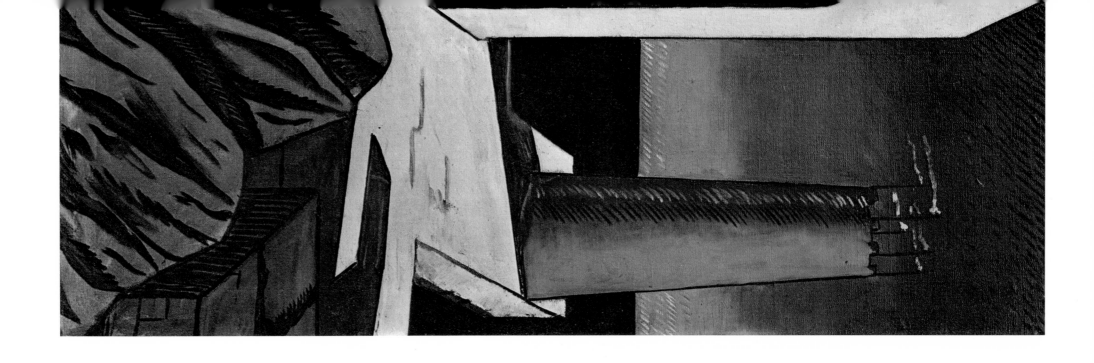

A fictional architecture is shared by light and shadow

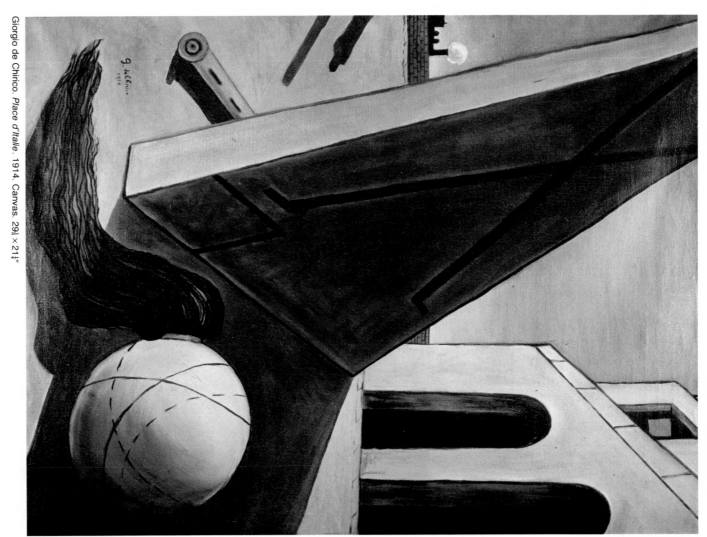

Giorgio de Chirico. *Place d'Italie*. 1914. Canvas. 29¼ × 21¼"

Fascinated by the architecture of the past—both by that of the Renaissance in Florence and Ferrara and by that of the Neoclassical period in Turin—and by the representation of architecture in painting (Giotto, Pietro Perugino, Piero della Francesca, Andrea Mantegna, Vittore Carpaccio, Nicolas Poussin, Claude Lorrain), Giorgio de Chirico turned to a perspective straightening simultaneously contracting the picture plane. For example, in *The Silent Statue* (left), compare the width of the two side arcades. De Chirico completed this study by a very contrasted play of shadows, by the affirmation of angles and contours, and by giving a general clarity to the hallucinatory superexistence of monuments, statues, and objects. "Who can deny," he asked, "the

troubling relationship that exists between perspective and metaphysics?"

In *Place d'Italie* (above) geometrical elements of undetermined use have been placed in such a manner that their presence, as well as their position, worries the viewer. De Chirico wrote in 1914, the same year he painted this picture: "I remember a bright winter's day at Versailles. Silence and peace reigned supreme. Everything looked at me with mysterious, questioning eyes. And then I understood that every palace angle, every column, every window possessed a spirit, an impenetrable spirit. . . At that moment I became aware of the mystery that drives men to create certain strange forms. And creation appeared to me as being more extraordinary than the creators."

119

Giorgio de Chirico (born 1888).
Hector and Andromache. 1917.
Canvas. 35⅜ × 23⅝"

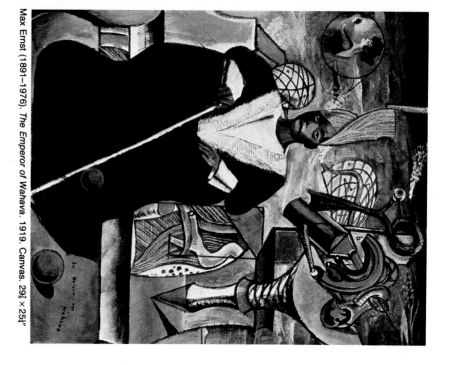

Max Ernst (1891–1976). *The Emperor of Wahava.* 1919. Canvas. 29¼ × 25¼"

De Chirico stages the bric-a-brac of our dreams

The combined obsessions of a land surveyor and of a fetishist seem to have presided over those stage settings in which Giorgio de Chirico turned to every kind of precision instrument (T-squares, rulers, triangles) as well as accessories borrowed from department store warehouses, the property departments of opera houses, and antique stores (including mannequins with eggs for heads and adorned with Art Nouveau motifs, statues, etc.). He erected theater decors at the vanishing point, where, as Roberto Longhi noted, the exaggerated figures of Renaissance painting present themselves. For a last time he speculated on the fifteenth-century idea of complicity between scenographic spaces and pictorial illusionism.

From 1913 on, De Chirico also undertook a reinterpretation of recent painting with his post-Cubist *assemblages*, including *Metaphysical Interior with Small Factory* (right). In a generally tight space he presents a variety of objects, often treated with *trompe-l'oeil* precision, and among them he places views of incongruous spaces (such as the factory) in order to undermine the

enclosure of the work from inside the work.

De Chirico, the heir to Arnold Böcklin and Max Klinger, was the link that joined Symbolism and Surrealism. Under his influence, such Dadaists as Max Ernst (above) and Raoul Hausmann (see pages 264–265) reinserted

perspective space into their work. As far as there was a question of creating an image of something strange or a part of a dream world, the painter merely had to turn to traditional conceptions of space that habit has made us regard as natural.

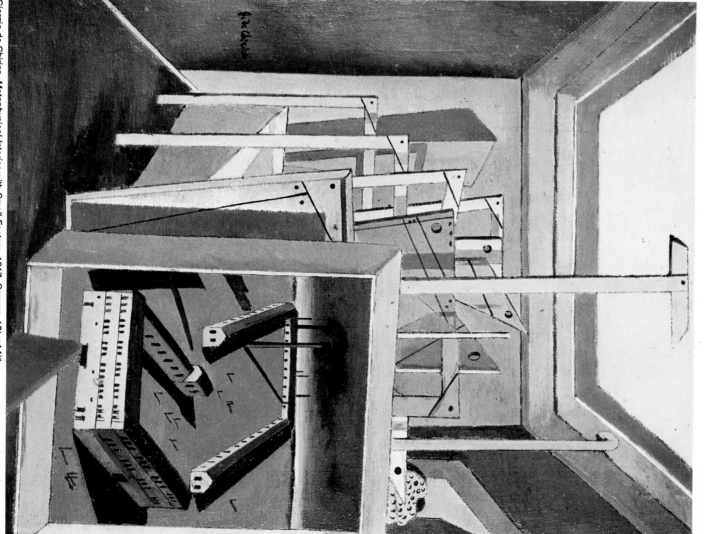

Giorgio de Chirico. *Metaphysical Interior with Small Factory.* 1917. Canvas. 18⅛ × 14¼"

Carrà's petrified dummies are
half men, half statues

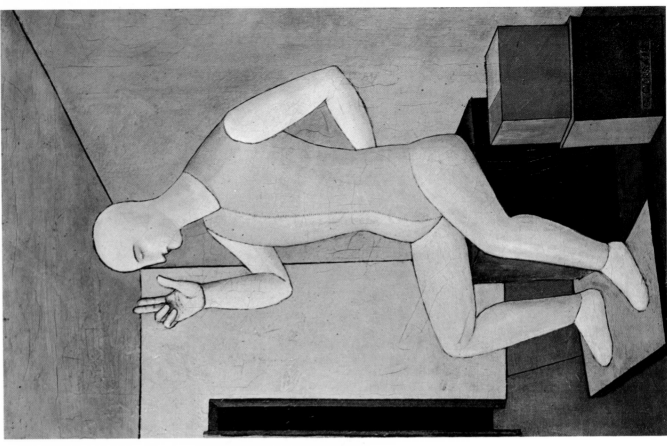

Carlo Carrà. *The Hermaphrodite Idol*. 1917. Canvas. 25⅝ × 16½"

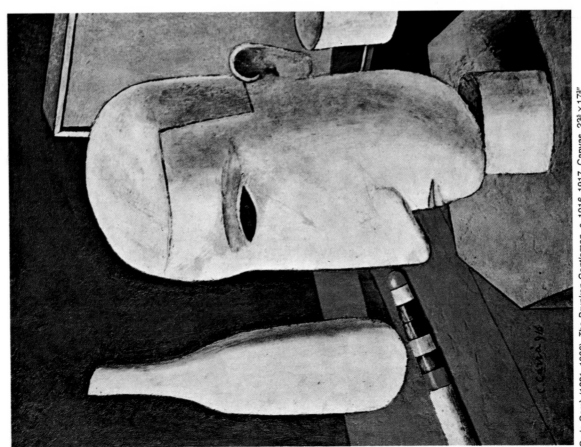

Carlo Carrà (1881–1966). *The Drunken Gentleman*. c. 1916–1917. Canvas. 23⅝ × 17¾"

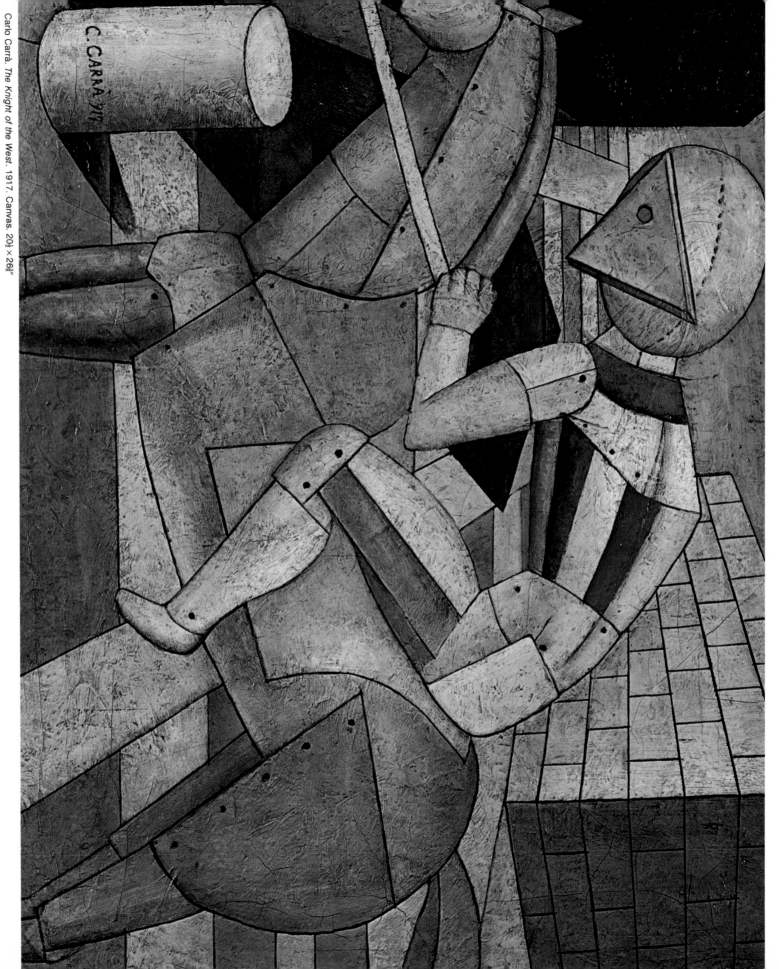

Carlo Carrà. *The Knight of the West*. 1917. Canvas. 20¼ × 26⅞"

Having reached the limits of his Futurist experiments with the Manifesto of 1913 ("The Painting of Sounds, Noises, and Odors" —see page 304—and after a period in which he made Cubist collages, Carlo Carrà sought a return to national values. In 1907 he published articles on Giotto and Paolo Uccello. In 1917 his meeting with Giorgio de Chirico in a Ferrara military hospital furnished him with the formal system he required for a new departure. "We never knew indifference," he wrote in 1919, "but now our spasmodic passions have ceased to preach. We prefer to dissimulate in the eyes of

the profane. We are alone in the depths of our period, alone with our sins, alone with our researches. By a strange and archaic paradox, we have returned, almost without knowing it, to pure Classicism."

As Caroline Tisdall has pointed out, in *The Drunken Gentleman* (far left), dated 1916 by the artist, the croquet stick, the shadows, and the background were added by Carrà after his meeting in Ferrara with De Chirico—therefore, at the earliest in 1917. This canvas, by the additions Carrà made to it, marks the artist's passage from a rationalist and frontalized conception stemming from Cubism

to an illusionist and dream space inspired by Symbolism via De Chirico. Carrà, as compared with De Chirico, preferred stereometric and simple forms, ordinary things, and simple titles without the literary allusions that inspired De Chirico. The horse-and-rider motif with which the Futurists and Wassily Kandinsky so often illustrated the idea of movement becomes fossilized in Carrà's *The Knight of the West* (above) into a figure of which it is difficult to say whether it stems from statuary or from human form.

123

The descendants of De Chirico carry on the puzzles and paradoxes of Surrealism

Of all Giorgio de Chirico's heirs, the Bolognese painter Giorgio Morandi—whose "metaphysical" period lasted from 1918 to 1920—most applied himself to rediscovering something of the plastic discipline that belonged, for example, to Piero della Francesca.

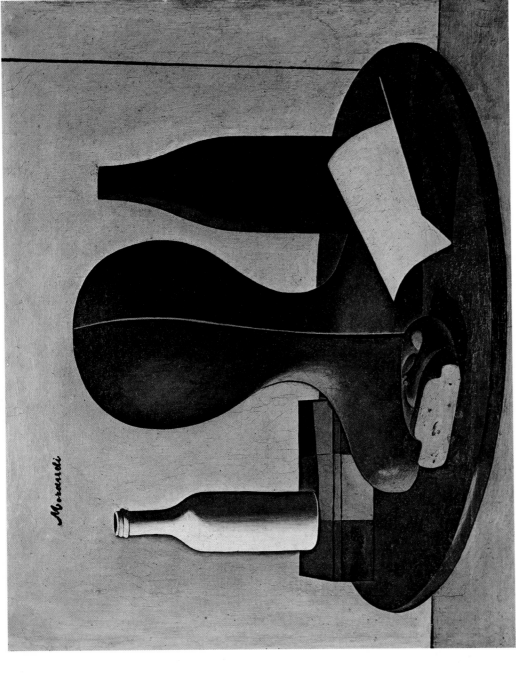

Giorgio Morandi (1890–1964). *Still Life*. 1918. Canvas. 18½ × 21¼"

A still life—in the case of *Still Life* (above) simply a table without legs against a two-color background—became for him merely a means of articulating and balancing a monumental and immobile composition and of suspending objects beyond time by a play of volumes, reflections, and textures.

René Magritte carried De Chirico's lesson further by giving frequently to his scrupulously slick paintings the formal aspect of enigmas, charades, or puzzles lacking in meaning. In *The Use of the Word* (left), which shows a staircase that leads nowhere, Magritte replaced the letter "i" of the French word "sirène" with a finger surmounted by a small bell. Max Ernst later remarked of Magritte that "he produces entirely handmade collage."

With Ernst himself (see page 261), the taste for textural research (rubbings, impregnations, transfers, and later even drippings) was accompanied by a constant curiosity about metamorphoses, about the dual meaning of things and materials. For example, in Ernst's *At the First Limpid Word* (right) the fingers that emerge from one of the windows also are the legs of a woman. Moreover, in the giant flora that rise detached against the sky the viewer sees the influence of Henri Rousseau.

René Magritte (1898–1967). *The Use of the Word*. 1936. Canvas. 23⅜ × 29¼"

CHAPTER 3

THE PULVERIZED OBJECT

The object is decomposed into a puzzle of fragments. The painting seems to propose a close synthesis of many aspects of the motif. Classical linear perspective is abolished

Paul Cézanne. *Quarry.* 1898
Cézanne takes the different sides of the object denoted and folds them toward the picture plane

Juan Gris. *Head.* 1911
The face's two main components—front view and profile—join themselves into a single image

"Cube maniacs," "cube lovers," "Cocubists," "ignorant geometers," "Kanaka art," "Kraut art"; at the outset Pablo Picasso and his followers received poor press reviews. The critic Louis Vauxcelles reflected a rather general opinion when, in 1912, in *Gil Blas* he denounced "the assault of barbarous Cubism," the work of "foreigners" who "colonize Montrouge and Vaugirard [districts of Paris]... Disgusted by their native asphalt, they debark in hasty hordes to Matisse's studio and without culture, without knowledge, without probity assimilate in four months the new recipes, which they apply with even greater exaggeration."

Why this bad temper? Behind the circumstantial insults lay a tradition to be defended. The real crime committed by the Cubists was that they upset the dogma of the unique point of view. They finally burst the lock that, despite many attempts, continued in one way or another to control the spatial gradations of the pictorial scene. Through what Guillaume Apollinaire described as "the miserable knack of perspective," an entire ideological device was unfolded, the projection of a humanism that began by posing Man and the World as exclusive of one another. To cite Pierre Francastel: "In order to feel Renaissance space, it is always necessary to imagine a personalized individual who is looking at the world. If not, this space would have no form."

Anthropocentrism, submission of the perceived world and of the perception of the world to the immobile control and domination of reason. Here Claude Lévi-Strauss spoke of "the possessiveness" of Classical art, of its claim "to devour" the object by its identical "reproduction" on canvas. This is an illusionist decoy (see "Signs and Men") that the Cubists ill used at first with the result that in the beginning they merely continued in Paul Cézanne's footsteps. To quote Picasso: "Cézanne was for all of us like a mother who protects her children." Omnipresent in the avant-garde of the 1900s (exhibitions and homages in 1904, 1905, 1906, and 1907) the painter from Aix caused the decisive perturbation of the traditional pictorial code by proposing an interpretation of the referential object that could be read as the result of several approaches and successive points of view rotated on the frontality of the canvas. This is how Cézanne was understood at the beginning of the century. There where monocular perspective reduced, petrified, and censored the living world, he undertook to break the vis-à-vis, to confront the *motif,* to enter into a "dance" in which multiple components of observation were summoned simultaneously. The Cubists stressed attitude: everything occurred as though, tired of straining to see what lay on the other sides of Mont Sainte-Victoire, they simply decided one fine day to move their folding easel and to plant it on the other side of the mountain. They revealed the object under the most different angles, none of which were more decisive than the other. They accumulated notions and information. The painting became the synthesis that came near to all the possible aspects of a figure. They reduced before our eyes not only several points of view but also several durations of time. The painter borrowed simultaneously from his memory and from his immediate observation. He mingled what he saw and what he sees (see Chapter 4). This attitude was corroborated by the expectations of modern science, which, to cite Siegfried Giedion, "considers space from a point in movement and not as the absolute and static unity of the Newtonian system." Early twentieth-century art could not remain with the three-dimensional conceptions established by Euclidean geometry during a period when mathematics was beginning to "manipulate" figures and dimensions that the human mind was incapable of representing.... It was no coincidence that during the same time (1905), Albert Einstein began his famous *Electrodynamics of Mobile Bodies* with a careful definition of simultaneity.

The "dance around the fruit dish," as Robert Klein described it, undertaken by Pablo Picasso and Georges Braque, also confirmed the observations of the psychologists. As Henri Wallon stated: "The unique image is not the point of departure. Perception begins by multiplying the points of view for the needs of practical action where it becomes absorbed." The child who is making a drawing—not for his own amusement but in order to apprehend the world around him and to situate himself in the heart of things—also begins by diversifying his angles of attack. He will show two eyes on a figure in profile. On the same plane he will draw a car and the driver seated inside it. His "realism" has nothing in common with the spatial order inherited from the Renaissance. He is closer to the Cubists than to Raphael.

The final rapprochement was Cubism and mass civilization. In an era of speed, of the media, of the photographic plate, how can one conceive of an aesthetic based on a single point of view? When the individual is the product of an endless bombardment of information, how can one present those relationships with the world as linear? Cubism expressed the precocious awareness

that something basic had changed in man's system of interpreting the empirical reality around him. Difficult to control, not able to be enclosed, reality flees from every fixed point. A double crisis: to the dissemination of the observed object responds the splitting up of the subject that observes it.

The expansion of Cubism and the development of modern art as a whole were favored—in any event hastened—by the meeting in late 1907 of two men, Pablo Picasso and Georges Braque, whose dialogue created a prodigious experimental effervescence. "Braque's temperament," wrote their common friend Wilhelm Uhde, "was clear, orderly, measured, bourgeois; Picasso's gloomy, excessive, revolutionary. In the spiritual marriage they concluded then, one contributed great sensibility, the other a great plastic gift."

Soon they were inseparable. They visited exhibitions and galleries. "We were living in Montmartre, seeing and speaking to each other every day. During those years things were said with Picasso that no one will ever say again . . . that no one will ever again understand. . . . It was rather like a mountain rope-climbing party. We were both working a great deal. . . . Above all we were very concentrated." In 1911, 1912, and 1913, they even spent their holidays together in the South of France. Picasso cut himself off from almost all friendly and professional relationships as though his discussions with Braque sufficed. No longer did they exhibit. It was sheer luck to see one of their works in the Rue Vignon in the gallery of Daniel-Henry Kahnweiler, a twenty-five-year-old dealer. They laughed at criticism, cutting short any discussions with such peremptory remarks as: "It is forbidden to speak to the pilot." The astonishing thing was their assurance. "My friends only wanted to work," Kahnweiler tells us, "they didn't want to provoke anyone, they were sure of what they were doing. . . ." The war ended a collaboration that was beginning to dry up. Picasso wrote: "On August 2, 1914, I drove Braque and Derain to the Avignon station. I never saw them again." But the seven preceding years proved of such wealth of invention that every great tendency of modern art, however rebellious, was irrigated there: Expressionism, Futurism, Constructivism, Suprematism, Neo-Plasticism, even the art of Henri Matisse. Moreover, the itinerary—from flat area to flat area—was complex and sinuous, beginning like a peal of thunder in Les Demoiselles d'Avignon (see page 135) and ending with the revolutionary innovations of the collage (see Chapter 5) via African art

and poses. For the Cubist generation, the encounter with "fetishes"—which no one, in 1905, as yet considered "art"—occurred in museums or in shops selling bric-a-brac. Kahnweiler has described himself with his friends scrutinizing "opaque glass cases, guarded by the dusty dummies of the old Ethnological Museum of the Trocadéro." Apollinaire, the Cubists, Maurice de Vlaminck, and Max Jacob in turn visited those dark and rarely visited rooms. They bought African masks and Polynesian sculptures. "We acquired these for a few francs at old Heymann's place in the Rue de Rennes (we called him 'the slave trader'), or in Marseilles in the Place Saint-Ferréol. What we were seeking was neither rarity, antiquity, nor material beauty. Picasso and Braque turned to these objects only as an encouragement for their own work." This point of view was confirmed by a contemporary, the poet André Salmon, who in 1912 wrote: "Picasso's enthusiasm (for the art of the colonies) was not supported by a vain appetite for the picturesque. The Polynesian or Dahomean images appeared reasonable to him." Could these anonymous figurines with short legs, with faces chopped up as if by an ax, planted with nails, and incrusted with seashells appear reasonable? The fact is that Picasso found in an entire continent the confirmation of his method. By turning to the "sponsorship" of African art, he justified in his own system the ostensible use of a code that owed practically nothing to empirical observation; a code that assumed the aspect of an arbitrary signaling and referred to "reality," without claiming "to reproduce" it in its anatomical veracity (see "Signs and Men"). It was thus at that time Henri Matisse's opinion when he remarked to Kahnweiler, while showing him a Seated Woman in his collection, that "this woman's anus, hidden by the chair, was represented under the chair." For Picasso the "African" experience was the first step in an approach that took him insensibly from a system of signs of the Cézannian type, still conditioned by representation, by the respective proportions of the objects in the heart of the "motif," and by the concern to inscribe the object in the context of its ambience—to a painting in which the distribution of signs would depend more on the frontal, plastic logic of the painting than on the supposed coherence of exterior nature (see Chapter 4).

But the art of the colonies not only had the merit of stating itself as an anti-illusionist code, but also it was a prodigious demonstration of sculptural volumetry. And this sense of three-dimensional space could

Pablo Picasso. Costume for the Ballet "Parade" (The Manager in Dress Coat). 1917

Sonia Delaunay. Costume project for a poem by Joseph Delteil. 1923

Ivan Puni. Ambulant works. Berlin, 1921

Ivan Puni. Painting-wall. Berlin, 1921
Launched by Cubism and by Constructivism, the work tends to transgress its frame. It gains the entire wall, the stage, even the street

Babangi mask

Crest of a Bambara headdress

Pablo Picasso. Guitar. 1912

Picasso destroys the tradition of closed volume. By folding and cutting out sheets of metal, he obtains a construction in edges in which the masses are emptied and replaced by their structure. To indicate the hole in the guitar, the artist arranged a projected cylinder. Vladimir Tatlin developed Picasso in his reliefs suspended by metal wires

Ashanti doll

African art confirms the Cubists in the possibility of an art of illusion and transposition in which the work's internal structure is more important than the anatomic truth of the model

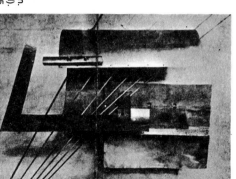

Vladimir Tatlin. Corner relief (detail). 1914-1915

not help but fascinate artists raised in the impoverished tradition of Western statuary. Where African art is raw articulation and interlocking volumes, European art is a refinement of surface details. Thanks to veiling effects, to the fluid flowing of material, Western statuary goes without a break from one plane to another, from a torso to a leg. Systematically solicited light emphasizes the hazy patterns. It slips in among the folds of stone, in the draping of the tunic. Its function is to drown and to dematerialize the outlines. From Phidias to Jean Goujon, it simulated rounding off and movement. To quote Carl Einstein: "The work becomes the admitted expression of a perpetual genesis." From refinement to refinement, one ends up with techniques that are almost pictorial, especially at the close of the nineteenth century with its statuary of "lard," the unleashing of the "gelatine" when academic art believed that it had completely replaced the frank occupation of space by an epidermal thrill.

Such is the paradox of sculpture before Constantin Brancusi and Alexander Archipenko: it leans toward the conditions of painting, whereas painting attempts to simulate three dimensions. For the Europeans, the rhythmic articulation of volumes is far less important than the frontal part of the work. Who could describe with precision the other side of Gian Lorenzo Bernini's *The Ecstasy of Saint Teresa*, of Jean Antoine Houdon's *Voltaire*, of Auguste Rodin's *Eternal Spring*? In this case, it is our knowledge of anatomy—and not the unitary logic of volumes—that enables us to extrapolate the details we do not see.

Let us compare it with an Ashanti doll (left): cylindrical brow, arms tight to the body and bent at the elbows, stiff legs, feet parallel or lost in the base—the work wants to be immutable and outside time. The symmetry is rigid, thus increasing the monumentality. The African sculptor's aim is to develop his volume, "to make room" for the *vital force* that he attempts to establish there. Hence these simplified, schematic forms, this imperious manner of driving three-dimensional possibilities to their ultimate consequences. The work offers itself at once; at first glance, we instantly grasp its rhythm and structural logic. It is a sudden vis-à-vis in which everything is given to the viewer at once. And it is so sudden that one has a certain uneasiness, as though he were too close to the statue, too inscribed in its "territory." In African art there is what could be called an "effect of appearance." Insofar as this art is not intended for spectators but for "spirits," when one has it before one's eyes, it acquires too much presence. It is not only at one and the same time inaccessible and too near, but also available and self-enclosed. Each form is nourished by all the others. Each is both autonomous in its own volume and dependent on a common rhythm. The coherence and power of the mass are more important than anatomical truth. One easily sees every aspect of an African sculpture, even those that are "on the other side" and escape our instantaneous perception. Seeing the shutters of a Dogon granary representing three figures, Michel Leiris noted that "the volume corresponding to the chest of each of the three figures recalls, by amplifying it, the volume of his beard and the drawing of bent arms, elbows turned frontward. . . . This same volume is repeated in the legs, the bent knees repeating the bent elbows with greater insistence." It is this "echo" construction with its responding forms that the Cubists soon called "plastic rhymes."

Fascinated by the statuary of "peoples without writing," Picasso and Braque—but also André Derain, Fernand Léger, and Henri Matisse—introduced its plastic canons into their paintings (see pages 140–141 and 160–161). African art, for them, had several merits: it offered a simultaneous reaction to the dilution of the object which the Impressionist innovation has been reduced to and it went against the sentimental aspects of the Symbolist school—which in 1910 Jean Metzinger called "the irritating ridicule of the theoreticians of *emotion*." Paul Cézanne's letters to Émile Bernard, published in 1907, included this recommendation: "Treat nature by the cylinder, the sphere, the cone, the whole placed in perspective"—a sentence that moreover by no means takes into account the Cézannian aesthetic. It strengthens the conviction that it was necessary to emphasize on the canvas the stereometric aspects of the subject matter. From here derived the name given by Louis Vauxcelles to the new tendency, when, in November 1908, speaking about Braque, he said, "He constructs metallic and distorted figures that are terribly simplified. He despises form, reduces everything—places, figures, and houses—to geometrical schemes, to cubes." A name that, scarcely formulated, scarcely adopted by the general public, became a countermeaning and a factor of confusion because, as early as 1909, Braque's and Picasso's Cubism extracted itself from African volumetries to result in its opposite and to return to its initial vocation (that of *Les Demoiselles d'Avignon*): the awareness of the space plane. The representation of volumes—insofar as it

perpetuates illusionism to the point of producing during the "African" period its exasperated image—was but a parenthesis, a detour, an archaic regression from which Braque and Picasso soon emerged. They turned to a "bombardment," a methodical fragmentation of the figure in discrete, alveolar units (see page 148). They thus obtained a striking, demultiplied volumetry entirely in sharp edges—from which the graft of Constructivism (left) emerged. Finally, they reduced these convex and concave forms to a network of facets turned down on the plane (see page 151). It remained to blend the facets in a single frontal fabric. The Cubists succeeded by borrowing from Cézanne his technique of "passages": the outline is interrupted, the edge broken, the frontier between planes hazy, thus creating a fluidity of one facet to another (see pages 152–153) and emphasizing the textural unity of the surface.

Cubism produced its theory at the same time as its painting. As the latter developed, new interpretations were at work on it—often contradictory. Thus beginning in 1910—with Jean Metzinger—the argumentation changed. One passes from the idea of multiple viewpoints (*in situ*) invented for Cézanne to the idea of a "conceptual" realism. Following Guillaume Apollinaire's famous phrase of 1912, Cubism was "the art of painting new ensembles with elements borrowed not from the reality of *vision* but from the reality of *conception*." With Braque and Picasso the rapport with subject matter, to quote Michel Leiris, "seems to tend, if not to gratuity, at least to pure allusion," thus showing the rise of the material substance of the work; the argument of the multiple viewpoint as a supplement of *realism* subsequently lost its actuality. The more the canvas offered itself as such—and not as sky or distance—the more the sign admitted itself as sign. The *visual* "fidelity" appeared to give way to the *conceptual* "fidelity." On looking at Picasso's *Portrait of Wilhelm Uhde* (see page 150), it is obvious that the artist has by no means gone round the model in order to discover the most significant angles but on the contrary that he worked without bothering about a literal "reproduction." Wilhelm Uhde was not so much a *motif* as a pretext. "I paint things as I think them," said Picasso, "not as I see them."

As a matter of fact, the need to establish several aspects of the same figure was not a twentieth-century innovation. Using diverse artifices, such as mirrors and reflections, without infringing on the spacing out of the perspective, Classical painting, from Diego Velázquez to Jean-Auguste-Dominique

Ingres, frequently offered the spectator several views of the same object. Giorgio Vasari relates that Giorgione, in order to show the superiority of painting over sculpture, "painted a figure showing his nude back; at his feet was a clear fountain reflecting his face, on the right a breastplate corselet that offered a side view in the shiny metal, and on the left a mirror revealing the other side." One knows also of numerous paintings that concentrate in the same space two aspects of the same person, such as Peter Paul Rubens' *Heads of a Negro* (right), Philippe de Champaigne's *Portrait of Cardinal Richelieu*, and Hyacinthe Rigaud's *The Artist's Mother* (right).

The (*conceptual*) idealist argument suggested by Guillaume Apollinaire and especially by Maurice Raynal was grafted onto the foreclosure of the theory of multiple viewpoints (*visual* "fidelity"). In 1919 Maurice Raynal wrote, "Cubist painting presents the very idea of objects in their purest interpretation," and enables one "to know the object in its essence . . . absolutely free of any useless detail." Here the critic called Plato to his rescue: "The senses perceive only what passes, the understanding that which remains." This so-called absolute truth of the Cubist object had the defect of wanting to bring back to a narrowly conceptual function a representation that actually tended more and more to blend in the formal structure of the canvas by integrating itself to its plastic economy. (A painting, according to Paul Klee, "whose object is a 'nude man' is not to be represented according to human anatomy but according to that of the painting.") Above all, it was by subordinating itself to subject matter that pictorial practice attempted to drive back, *to check* the textural reality of the surface, the evidence of the *spacing*, the significant fertility of the noniconographic parts of the canvas.

The theory of "the realism of conception" produced by Apollinaire and Raynal was therefore a dead end. It vainly attempted to interpose itself in the slow movement that tried to take modern art from an aesthetic of visual observation to an aesthetic of the materiality of the object.

This was a false theory that was always greater with Synthetic Cubism (see Chapter 4), a "logocentric" theory based on the transcendency, the immutable permanency of the object denoted. It was a confusionist theory that one could still see working in 1923 with a "materialist" such as Nikolai Tarabukin: "The alternating surfaces and volumes that we see on the Cubist canvases . . . intend to give greater and closer

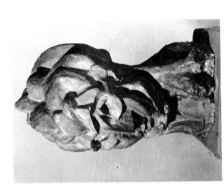

Pablo Picasso. *Head of a Woman.* 1909

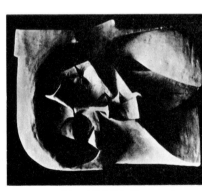

Umberto Boccioni. *Concave and Convex Abstraction of a Head.* 1912–1913

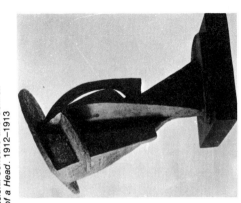

Alexander Archipenko. *Head.* 1913

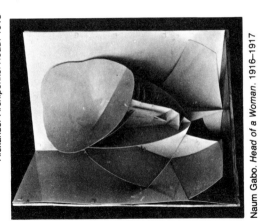

Naum Gabo. *Head of a Woman.* 1916–1917
The mass is embossed and hollowed out.
The combination of empty and full areas results in the metal ribs of Constructivism

knowledge of the authentic reality of this object." It was an inadequate theory at the time that it was formulated (1910–1912) since Cubism—however arbitrary it may have been in the use it made of iconic signs—was still linked, despite its having them, to atmospheric space, to "visual" realism. Françoise Will-Levaillant pointed to "the maintenance in spite of itself of an entire logical constraint in the order of construction . . . of the object. In general a pertinent, vertical order of succession is retained, whether it is a question of a person, a guitar, or a bottle." In other words the arrangement of the iconic figures was still a tributary of the subject matter and of the Euclidean conception of space. One does not look yet at a tabular arrangement of pictorial diagrams disposed side by side but at a design that retained links with its denoted matter (as a result most of the Cubist paintings of this period were centered). It was the ambition of Fernand Léger (who "blew up the table" under the still life), Francis Picabia, Frantisek Kupka, Robert Delaunay, Wassily Kandinsky (who offered harmonies free of gravitation), Piet Mondrian (who imperatively freed an orthogonal structure) to cut away from the "logical" distribution of space inherited from Classical painting. Yet Analytical Cubism—even if, as we have just seen, it was again taken in the perspective space—furnished the first instruments that offered priority to the material entity of the work and tipped over onto the tangible side of the painting-object what the preceding hypotheses (multiple points of view, "conceptual realism") maintained on the other side of the image (representation).

The first inductor of this materialization was the representation of chiaroscuro that, as early as 1910, no longer intended to make volume, "turn," nor to emphasize the modeling but to inscribe itself as sign. One sees light disseminating itself by regular strips over the entire canvas without obeying the logic of a single source. One is in the presence of a conjunctive network of spots whose purpose was to suture the multitude of facets and to form them into a unitary frontal fabric (see page 153). The second inductor: transparency. The Cubists granted themselves the right to superimpose objects, to show with the same clearness those that were below and those that were above (to the point where it is very difficult to determine the spreading out of figures in depth). This is a process that involved another: the systematic use of metonymy, since the accumulation of signs, their superposition, and their frontal use condemned one to using only fragments—often edges. The painter gave but a side of the bottle, only a part of the newspaper. The guitar was reduced to three cords, the violin to its f-holes, the table to a short curve. This double movement of densification and denaturalization of signs postulated an active spectator capable of deciphering, of reconstituting the entire object from a sign— and *a contrario* of unraveling in the polysemantic proliferation the meaning of the scene. In 1912 Albert Gleizes and Jean Metzinger said, "Some forms must remain implicit and such that the spectator's spirit may be the chosen site of their concrete birth." This is what Paul Klee said in another way: "The eye should *graze* the surface, absorb it part by part, and put all the parts into the brain, which stocks impressions and reconstitutes them into a whole."

Soon an impossible task arose: the riddled, lacunary space of the Cubist painting became unreadable. This was the hour of synthesis, of clarification, of surface.

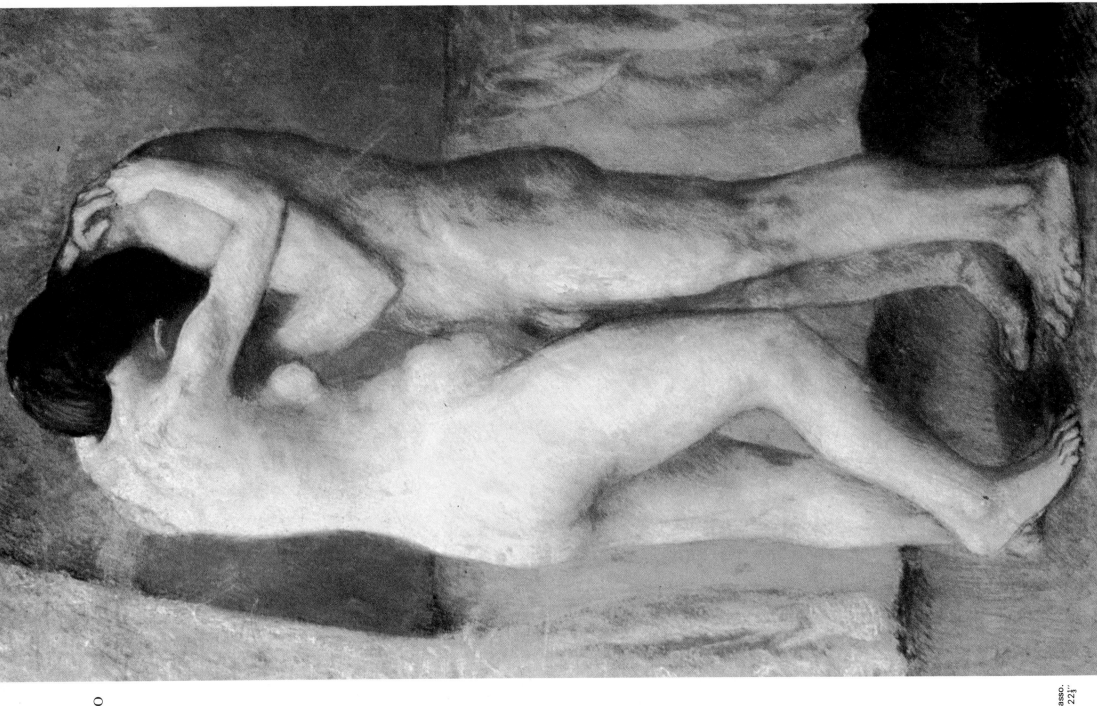

The human body, formerly a sentimental inspiration, changes into a powerful geometrical framework

Two different visions of the human body and two opposing conceptions of painting are contrasted in Pablo Picasso's *The Embrace* (right) and in his *Two Nudes* (far right). *The Embrace* comes from the sentimental and humanitarian side of Picasso, which created his reputation in the artist's Blue Period (1901–1904). A melancholy inherited from Pierre Puvis de Chavannes and Paul Gauguin and an inherent biological catastrophy deriving from Munch relate these two figures, who seem to be overcome by an insurmountable destiny. This painting is also a layman's lamentation and an image of tenderness. The austere composition places the round stomach of the future mother in the center of the work. The sloping curtain accompanies the movements of the shoulders.

"Picasso," explained Jaime Sabartés, a witness of his early career, "believes that Art is the son of Sadness and Pain. He believes that Sadness lends itself to meditation and that Pain is the basis of life."

From *The Embrace* of 1903 to the *Two Nudes* of 1906, one goes from an Expressionist, emotional distortion to an entirely different level: in the latter painting the stereometric determination of the figures marks Picasso's will to state above all the constructive severity and the formal logic of volumes. In developing powerful and compact geometries, the artist no longer claims to be a witness to either a miserable or a poetical atmosphere. He deliberately cuts himself off from any realistic aim. What counts is the density of the plastic expression and the authority of these static and cylindrical figures, placed face to face, almost as though one of them stood before a mirror and looked at her reflection. The drapery background drives the figures forward toward the viewer. The eyes are simplified, the limbs and feet (compared with those in *The Embrace*) are heavy. Between the creation of these two works Picasso made a study of Catalonian Romanesque painting, attentively observed the Archaic Cretan and Greek art collections in the Louvre, and in particular discovered Iberian sculpture. John Golding has remarked, in fact, that the *Two Nudes* is "Picasso's most Iberian canvas."

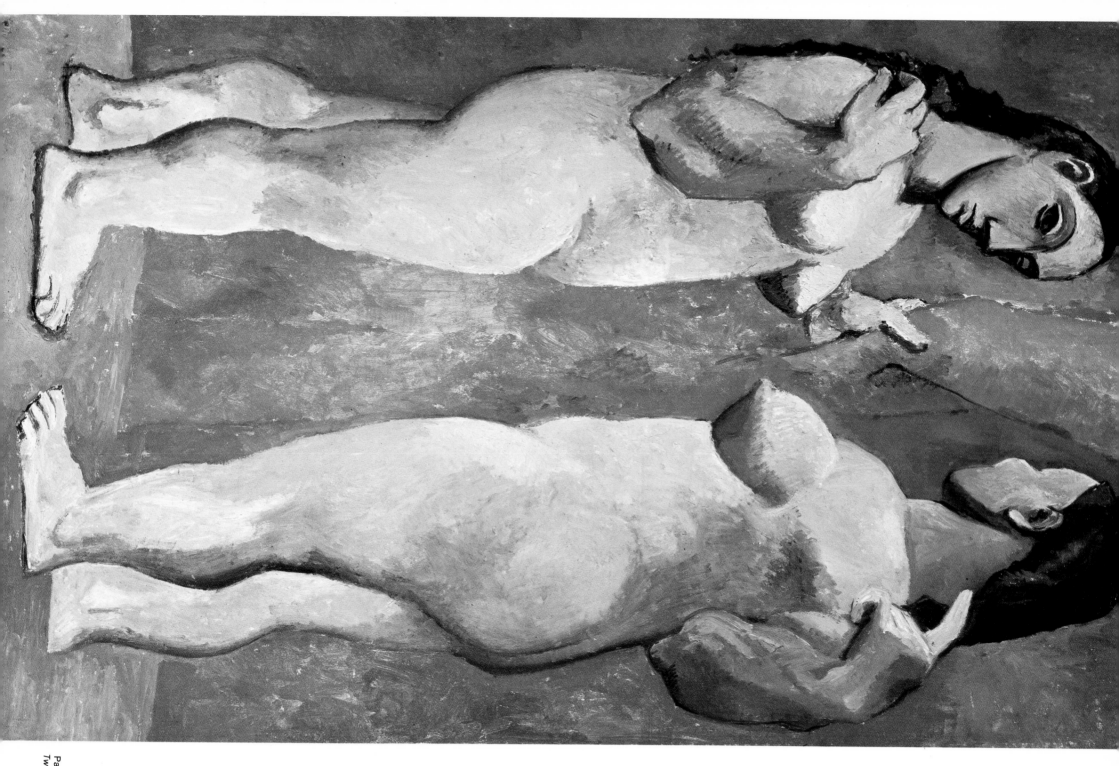

Pablo Picasso.
Two Nudes. 1906. Canvas. 59½ × 36⅝″

133

"We will soon find Picasso hanged behind his large painting," said André Derain. An inaugural and monumental work of a long incomprehensible savagery, *Les Demoiselles d'Avignon* (right) marks a rupture not only in Pablo Picasso's production but also in the history of Western art.

The painting's initial title was *The Philosophical Brothel*, and the final one—applied only in 1920 after the sale of the canvas to the couturier Doucet—refers to the Carrer d'Avinyó (Avignon Street) in Barcelona, which housed a bordello. Paradoxically, the most famous work of the twentieth century was seen for the first thirteen years after its creation only by a few dozen visitors admitted to Picasso's studio. Scarcely reproduced before 1925, exhibited in public for the first time in 1937, the *Demoiselles* made its way, confidential, capillary, through the influence it exerted on a small number of important artists. Foremost among them was Georges Braque, who gave up Fauvism the moment he measured the importance of the *Demoiselles*.

Picasso began to develop this project during the course of the year 1906. Nineteen sketches (not including those of individual figures) followed one another until spring. At the beginning Picasso planned a painting with seven figures—five women and two men, including a sailor, who are visible in the *Study for "Les Demoiselles d'Avignon"* (above left). Then the male figures disappeared, and the demoiselles turn their eyes no longer to the man standing on the left but to the viewer. The table, at first circular, becomes orthogonal with an angle aggressively raised toward the center of the composition. In the last study he made before he painted the picture (*Study for "Les Demoiselles d'Avignon,"* below left), a very apparent play of spots on the right emphasizes the equality of the background with the figures. The canvas returns to the arrangement of this last sketch at the cost of an important tightening of the space. The figures who previously floated in a rectangular space are now deliberately heaped up, almost interlocked, which gives a feeling of gushing brutality to the painting. The *Demoiselles* is a work of singular unity, and it has a

deliberately heterogeneous movement. The triple stare levelled at the spectator is a unifying device, as is the work's depth, which is both pointed out and compressed, as though the figures' surge was engulfed in the frontalized texture of the canvas. The surface of the work is entirely harmonized through the play of the angular forms that characterize not only the represented objects (elbows, breasts, knees, tables, and watermelon) but also the undefined areas that separate them. Yet at the same time, the silhouettes, although tightly fitted together, find an entire specific area in which to unfold almost without touching one another. Each obeys a different projective system and cohabitates

with the others only as if they all formed parts of a collage.

The diverse reference points of this painting (Paul Cézanne, Paul Gauguin, and Iberian sculpture for the figures on the left, and African masks for the faces of the figures on the right), the various ways in which the hands have been treated, and the illogical manner in which the seated character seems to be at the same time turning her back to us and facing us—all these express a position that the American critic Leo Steinberg termed taking sides: Picasso wanted to break the unified Cartesian conception of space. "It is the representative space," he wrote, "(confronted in their variety) that become the objects of the painting."

The savage irruption of Picasso's *Demoiselles* into modern art determines a new course

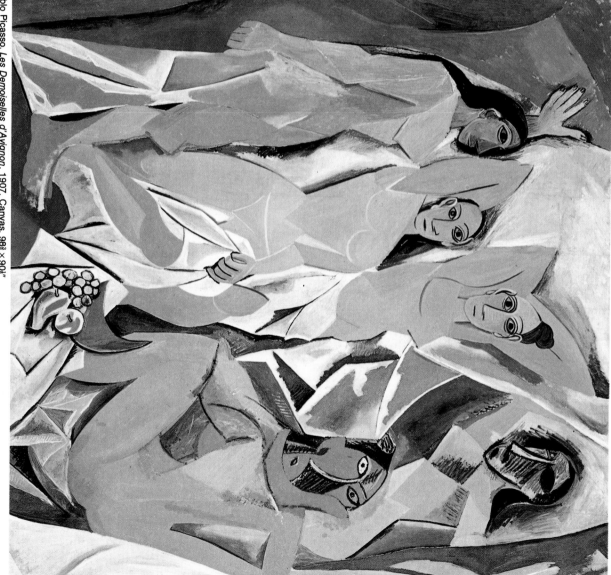

Pablo Picasso. *Les Demoiselles d'Avignon.* 1907. Canvas. 96⅜ × 90¼"

135

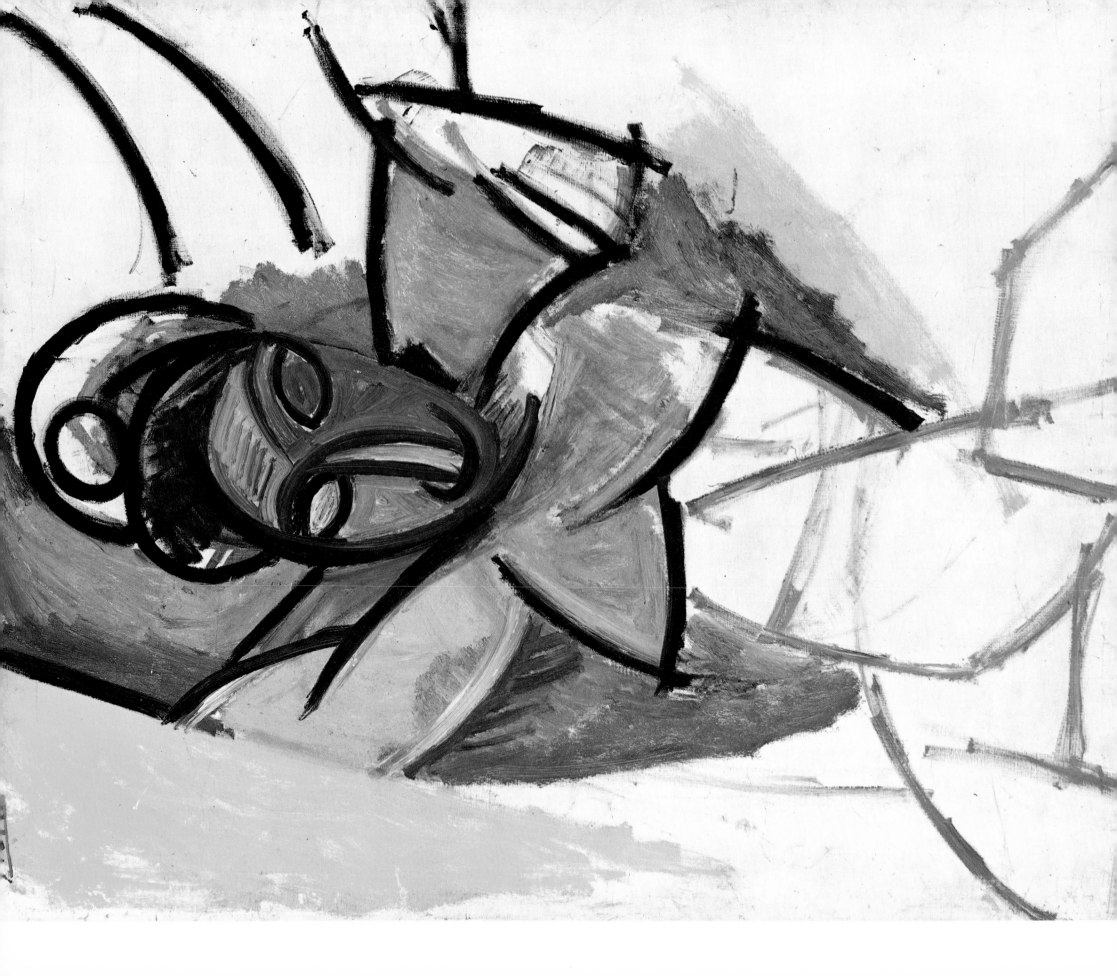

These hideous, barbaric masks challenge the canons that produced the *Mona Lisa*

The contemporaneous studies that Pablo Picasso made for his *Les Demoiselles d'Avignon* (see page 135), like a ship's log, offer lively examples of the artist's relentless researches during the development of this large canvas and chiefly the solution he planned at one time of "Africanizing" all the figures. Three of these studies and two related paintings are shown on these two pages and the following two pages.

At one point Picasso was obviously planning to spread throughout the entire work the influence of African sculpture he finally brought to bear only on the two figures at the right. The study of the woman (far left) with her raised elbows would make a plausible substitute for one of the central women in the painting. On the other hand, in another study (left) one finds the strange seated figure of the finished painting in an almost unchanged form, with a very small mouth, asymmetric eyes, left hand resembling a baseball bat, and a comical Spanish headdress. Here for the first time Picasso applied his system of very apparent regular streaks that crush the modeling of the nose and transform its shadow into a hatched surface. This same hatching appears beneath the arms of the figure standing to the right in the finished painting (see page 135) and on the forehead of the figure in the sketch for the painting (far left).

The lacerations on Congolese masks and the parallel lines covering Dogon doors furnished Picasso with the technical means he sought to indicate volume without worrying about illusionist representation. "At that time," he said, "people claimed that I placed the nose upside down.... But I really had to place it askew for them to see that it was a nose. I was sure that later they would see that it was not askew." Here Picasso's aim was to prevent the projection of figurative elements that would contradict the original frontality of the canvas. The noses of the five figures in *Les Demoiselles d'Avignon* are all—each its own way —flattened out on the canvas.

Thus, in painting such raw appearances up until that time unknown in Western art, Picasso seems deliberately to have taken a direction opposite to that of five centuries of humanism. This explains the reaction of the painting's earliest viewers, that of Henri Matisse, for example. For them this work seemed a provocation—it was a mockery not only of the researches of modern art but also of the canons of painting. It was a slap in the *Mona Lisa*'s face. As the poet André Salmon, one of Picasso's friends, wrote: "It was the hideousness of the faces that froze the half-converted with fear."

Chopped, angular, and mottled: the icons of Picasso's African period

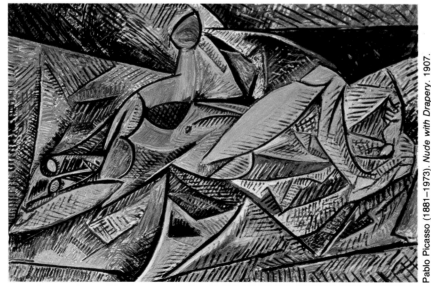

Pablo Picasso (1881–1973). *Nude with Drapery.* 1907. Canvas. 60⅛ × 43¾"

The seemingly carved figures that Pablo Picasso increasingly produced during the period he worked on *Les Demoiselles d'Avignon* (see page 135) create a surging effect upon the spectator. The silhouettes in these works are projected forward. The viewer has an immediate perception of an overall form that suddenly rises before him and frankly forces him to look at it. This dramatization of the image—in which Carl Einstein finds one of the constituent characteristics of African art—was increased both in the study to the right and in the painting to the far right by the use of basic tones whose liveliness is found neither in the final version of *Les Demoiselles d'Avignon* nor in the paintings of the Cubist period (note the contrast of reds and blues in the face of the figure in the study, right). Modeling is canceled in favor of a

great use of hatching, as in the curtains in *Nude with Drapery* (above). In order to increase frontality, the grain of the bare canvas is revealed. Large white areas—and rather small ones used to outline the forms in the study to the right and in the painting to the far right—ensure the visibility of the canvas.

In the *Nude with Drapery* (above), now in the Hermitage, Leningrad, which Picasso painted during the summer of 1907, streaks invade the entire painting. One can readily see in this work the consequences of Picasso's botanical observations. He was then drawing palm leaves, and many forms shaped like these leaves appear in this painting. The three nudes in these three works— two with raised elbows—are attempts to integrate Picasso's new African style into the large-sized canvas of *Les Demoiselles d'Avignon.*

Pablo Picasso. *Study for "Les Demoiselles d'Avignon."* 1907. Canvas. 36⅛ × 16⅞"

138

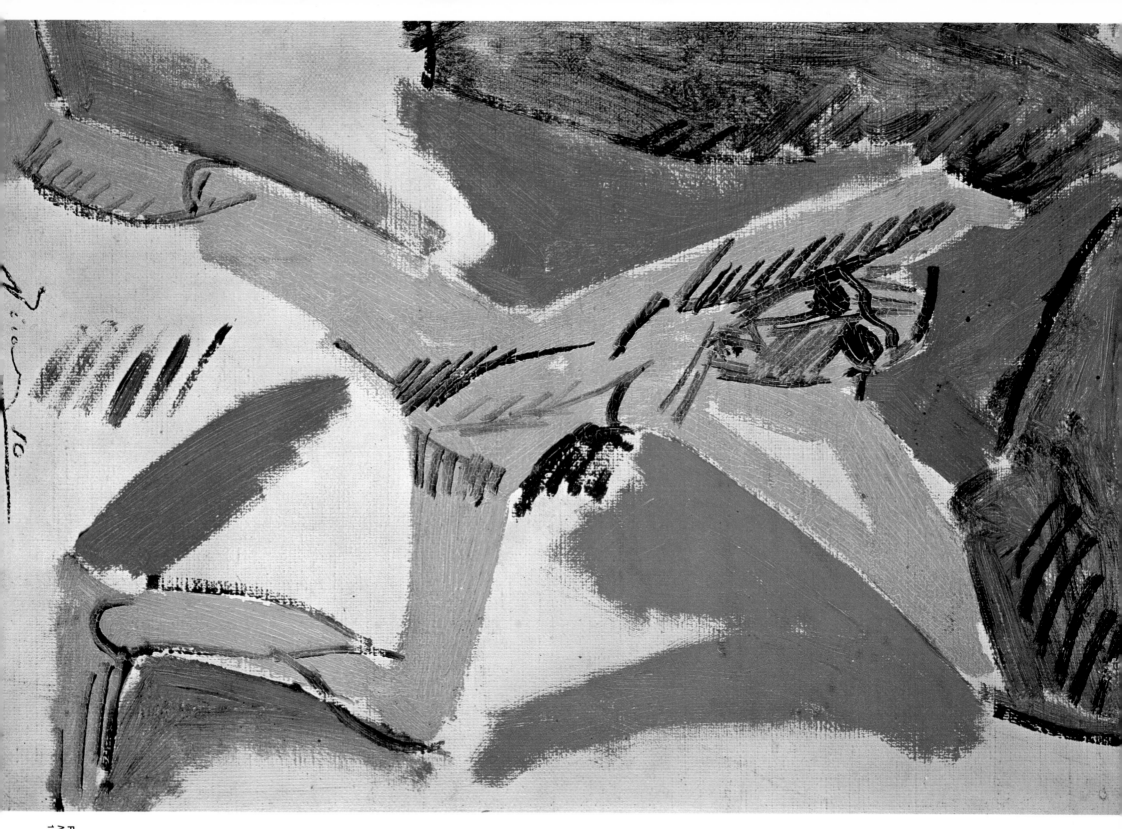

Pablo Picasso.
Nude with Drapery.
1907. Canvas. 12¼ × 8⅞"

Picasso wanted to compete on canvas
with the dimensionality of African statuary

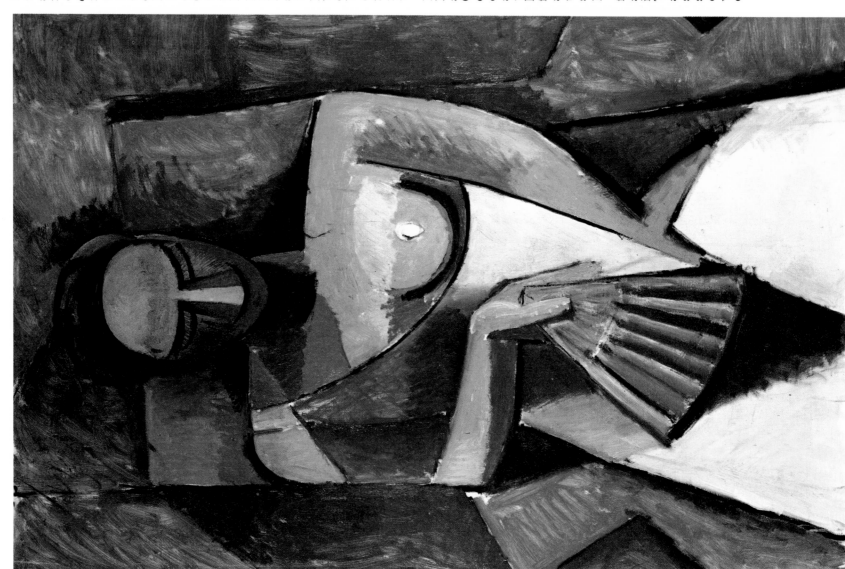

In 1908, fascinated by the treatment of volume in African statuary, Pablo Picasso broke away from his disposition to frontality as expressed in *Les Demoiselles d'Avignon* (see page 135). Whereas in that large painting he had subordinated the volumes of the two-dimensional reality of the canvas, in the two paintings shown on these pages he did the opposite. Here contours are emphasized, and the noses are preeminent, their conical form directly inspired by Congolese masks. In these works the strongly marked contours lose their angular characteristics, hatching disappears, and the plunging perspective stresses the roundness of the skull. Never before have illusionism, sculptural suggestion, and the imitation of three dimensions been so pronounced. Here we have faces without eyes, closed like fists, organized in plastic rhymes of black African statuary. The same curves denote eyes, noses, breasts, foreheads, and clavicules, and they respond like echoes from one end of these paintings to the other.

In the *Woman with a Fan* (left) Picasso has broken the horizontal line of the figure's shoulders according to a strongly exaggerated Cézannian technique. He deliberately superimposed the line of the right arm and that of the armchair. The flat white areas of the dress hold and frontalize the lower part of the painting. The figure appears to be both seated and standing, a spatial ambiguity that allows the coexistence in the same work of flat areas and perspectival depths.

Picasso and Georges Braque found in African Negro art an anonymity and a collective inspiration that fascinated them. This was the period—between 1907 and 1914—when they neither signed nor dated their works. They seemed to dream of a more communal art, of a refinement that would respond to more than the expressive need of the individual.

Pablo Picasso (1881–1973). *Woman with a Fan*. 1908. Canvas. 59¼ × 39¾″

Pablo Picasso. *Head of a Man*. 1908. Oil on wood. 10⅝ × 8¼″

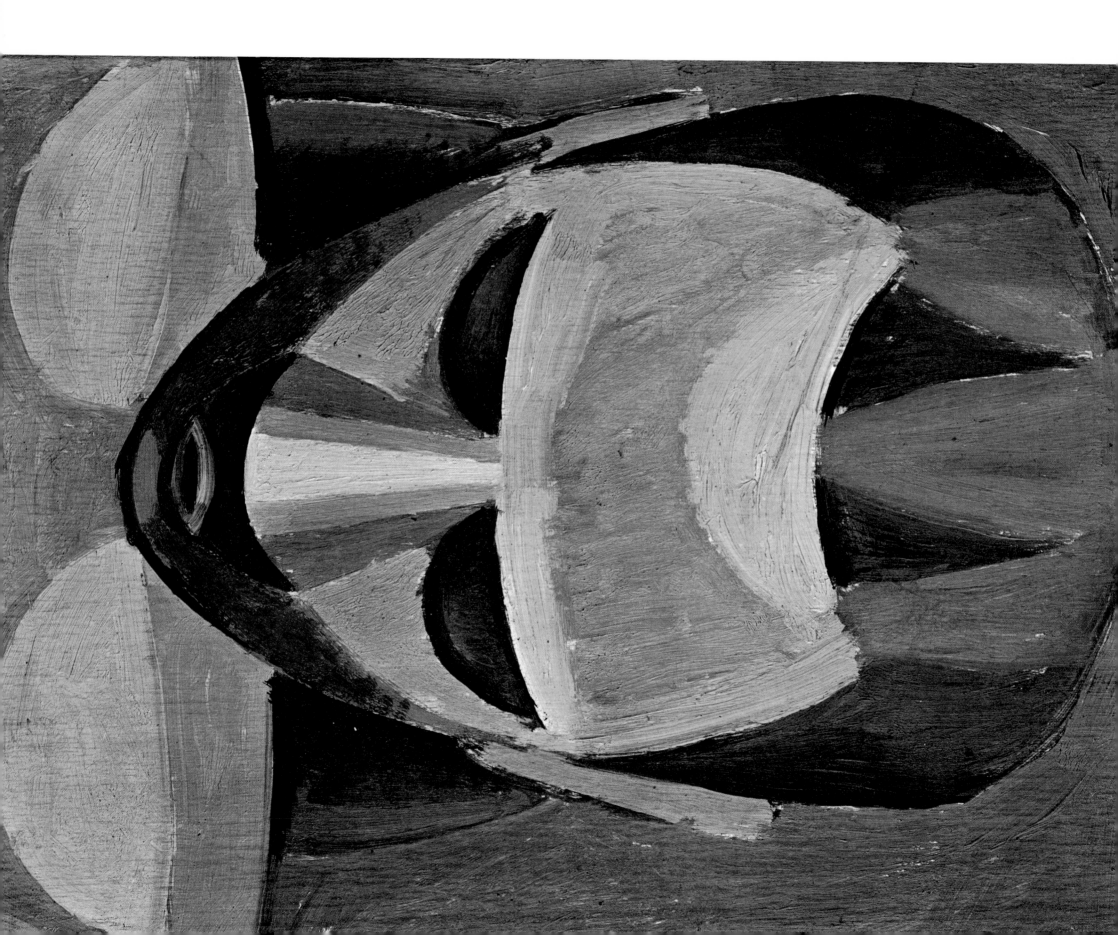

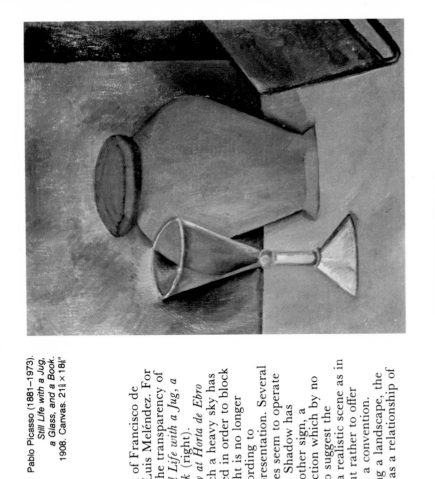

In its sharp stiffness and exaggeration of edges, illusionist space reveals itself as arbitrary

The apparent affirmation of edges characterized the exploratory phase of his art in which Pablo Picasso, gradually freeing himself from African models, made an inventory of Paul Cézanne's vocabulary. The use of a plunging viewpoint in order to limit the perspective, the radical simplification of volumes, refusal to employ atmospheric haziness, the employment of multiple vanishing points in order to prevent the formation of a single space, and the use of a chromatic poverty in order not to distract concentration from the problem of form—all these devices reveal Picasso's structural and tectonic work of this period in which geometrical simplicity won out over empirical observation. The severity and the Spanish stiffness remind

one of the work of Francisco de Zurbarán and Luis Meléndez. For example, note the transparency of the glass in *Still Life with a Jug, a Glass, and a Book* (right).

In *The Factory at Horta de Ebro* (below) in which a heavy sky has been emphasized in order to block the horizon, light is no longer distributed according to chiaroscuro representation. Several luminous sources seem to operate simultaneously. Shadow has become just another sign, a schematic reduction which by no means claims to suggest the atmosphere of a realistic scene as in Classical art but rather to offer itself as a code, a convention. Before becoming a landscape, the painting exists as a relationship of forms.

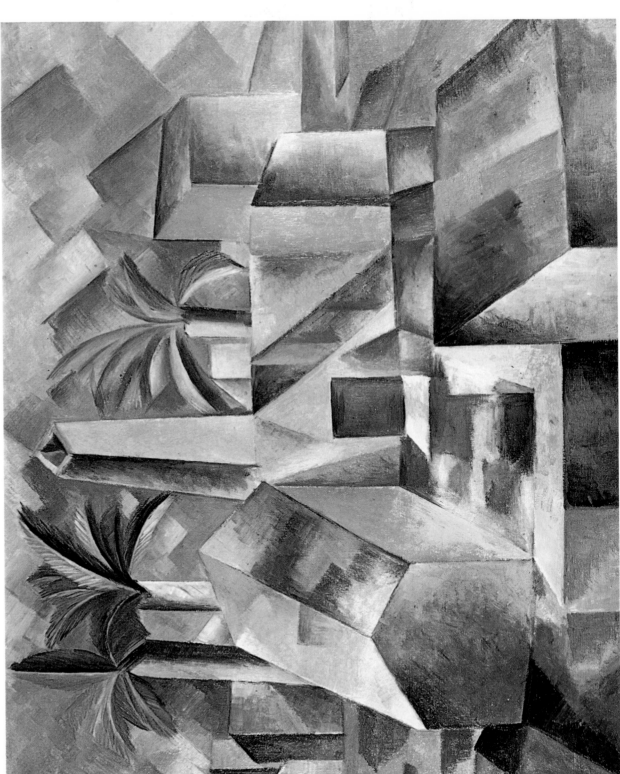

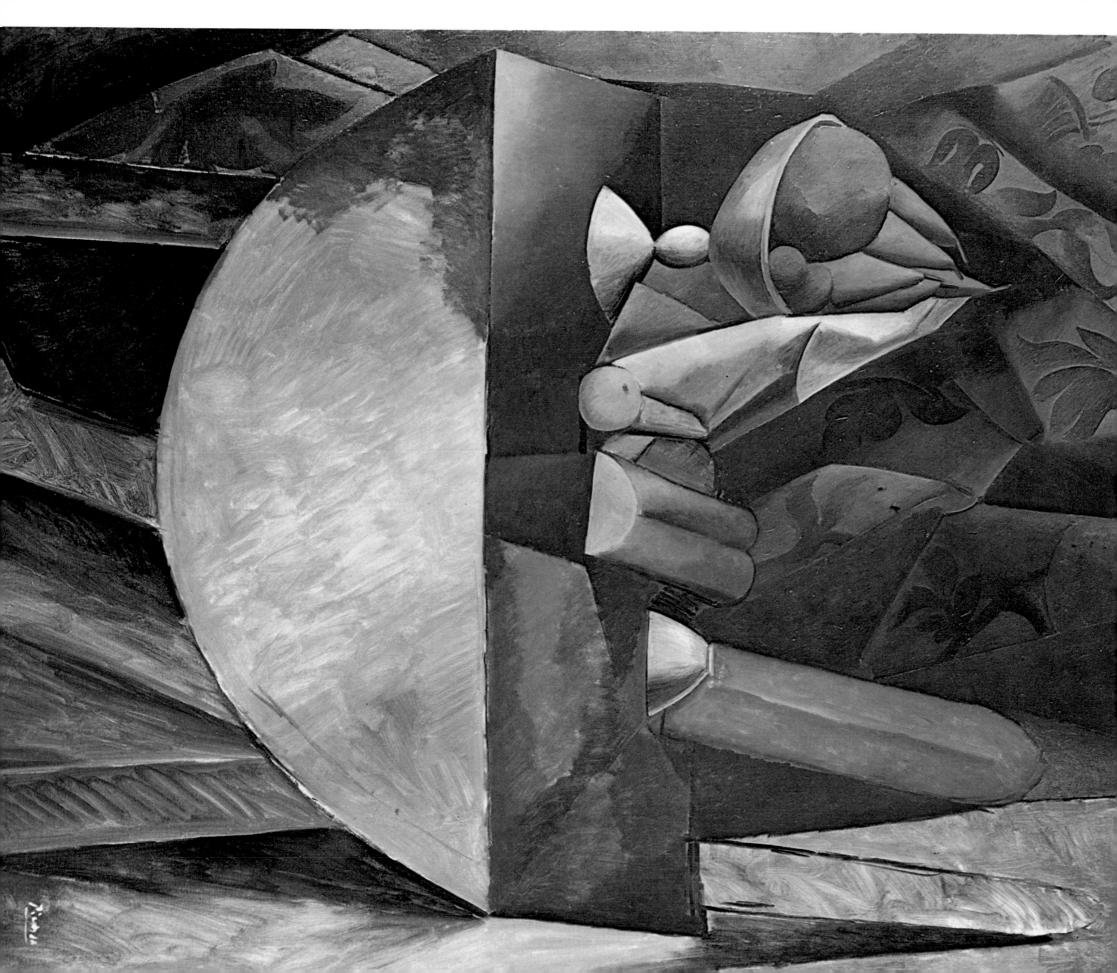

Raoul Dufy. *Trees at L'Estaque.* 1908. Canvas. 18⅛ × 13″

Raoul Dufy (1877–1953). *Green Trees at L'Estaque.*
1908. Canvas. 30⅜ × 24¼″

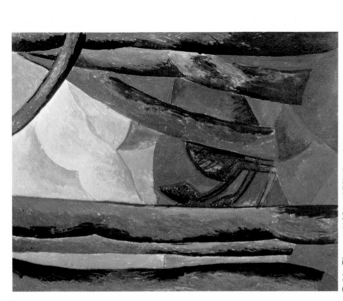

Pablo Picasso (1881–1973). *Landscape.*
1908. Canvas. 25¼ × 19¼″

The landscapes of the South of France become geometrized: houses are turned into cubes and trees into cylinders

Less sensitive than Pablo Picasso to the prestige of African statuary, Georges Braque was at the same time more open to Paul Cézanne's example. In his *Houses at L'Estaque* (right), painted on the very site where Cézanne himself had worked, Braque attempted to resolve the contradiction underlying the whole Cubist production of 1908. How does the artist at one and the same time present strongly structured volumes and take into account the frontal plane of his canvas? Braque's solidly arranged granite blocks without openings are, nevertheless, subtly linked here and there by "passages", that relate one plane to another and help to flatten out the image. Thus, in the foreground, to the right of the tree, one can note the blending of two surfaces. In the same manner the roof of the house in the center, whose slope does not join the wall angle, takes into consideration two façades without respect for traditional perspective. The tree in the foreground of the painting mingles inextricably with the third plane, and its branches harmonize with the green spots in the upper part of the composition. There is no sky—in order to keep the viewer's concentration riveted on the frontal plane. The canvas's harmony is created by a line of diagonals that develops the space plane. The whole composition is

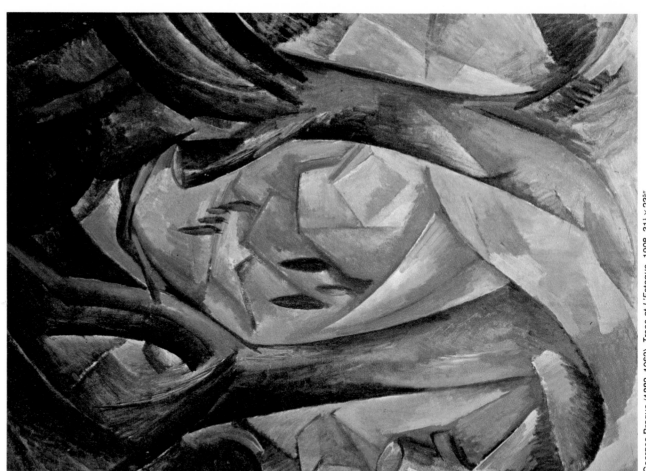

Georges Braque (1882–1963). *Trees at L'Estaque.* 1908. 31⅛ × 23⅜″

clear from one end to the other, and outlines are even more emphasized in order to designate the distant houses.

This canvas gave Cubism its name when the critic Louis Vauxcelles wrote the following commentary about it in an article in November 1908: "Braque scorns form, reduces everything, places and figures and houses, to geometrical schemes, to cubes." It was this same contradiction between volumes and flat areas that Braque wanted to solve in the

two other landscapes by him shown here—*Trees at L'Estaque* (left) and *Landscape at L'Estaque* (above right). Raoul Dufy as well wished to achieve this solution. He worked on the same site with Braque, and under his influence Dufy painted a series of forest landscapes, including *Green Trees at L'Estaque* (above left) and *Trees at L'Estaque* (above left). Meanwhile, Pablo Picasso developed ascetic architectures that reveal his interest in Henri Rousseau, as in his *Landscape* (above left).

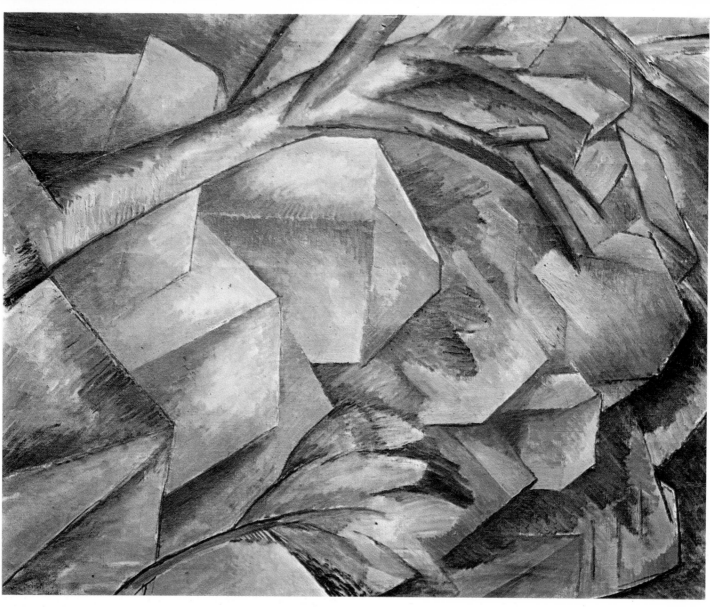

Georges Braque. *Houses at L'Estaque.* 1908. Canvas. 28¾ × 23⅝"

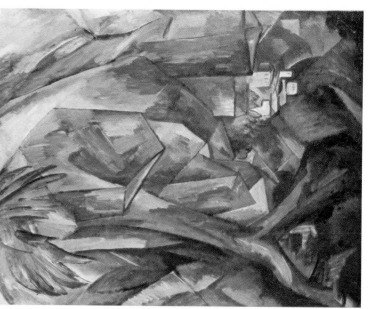

Georges Braque. *Landscape at L'Estaque.* 1908. Canvas. 31⅞ × 25⅝"

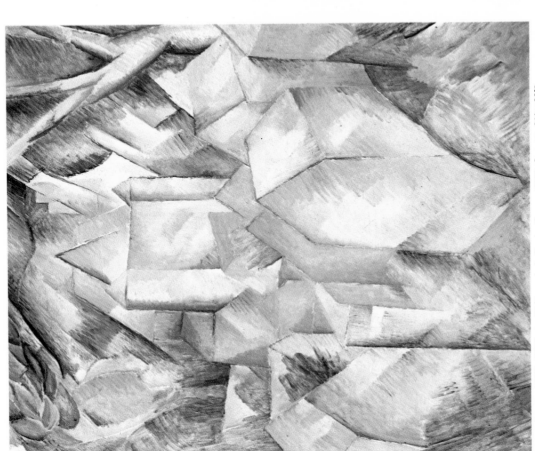

Georges Braque (1882–1963). *Le Château de la Roche-Guyon.* 1909. Canvas. 29¼ × 23⅝"

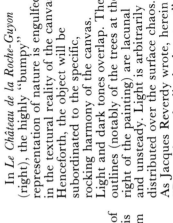

Georges Braque. *Le Château de la Roche Guyon.* 1909. Canvas. 31⅞ × 23⅝"

Georges Braque. *Le Château de la Roche-Guyon.*
1909. Canvas. 36¼ × 28"

Represented objects interpenetrate and flatten out, tending to cancel themselves in the rocking rhythm of the canvas

The melting of the outline opened up for Georges Braque—following in Paul Cézanne's footsteps—the path to frontality. In 1909 he chose a site near Mantes, a hilltown perched high up and surmounted by a château, where Cézanne had worked alongside Pierre Auguste Renoir. There Braque painted eight landscapes inspired by the verticality of his subject. Three are shown on these two pages. Despite the counterplunging perspective, the sky is absent in all three works. Each painting represents a different stage in the treatment of the

subject represented. In *Le Château de la Roche-Guyon* (above left), one sees generalized "passages": the outline treatment has neutralized the different perspectival depths. The spreading out of the perspective, however, and the round towers have been given greater emphasis. In the painting of the same subject (above right), it is the greenery that ensures a uniform scene. Braque borrowed from Cézanne that artist's lamellate, very obvious brushstrokes and covered almost the entire composition with them.

In *Le Château de la Roche-Guyon* (right), the highly "bumpy" representation of nature is engulfed in the textural reality of the canvas. Henceforth, the object will be subordinated to the specific, rocking harmony of the canvas. Light and dark tones overlap. The outlines (notably of the trees at the right of the painting) are lacunal and unsteady. Light is arbitrarily distributed over the surface chaos. As Jacques Reverdy wrote, herein "Braque's methodical adventure" achieved its first result.

146

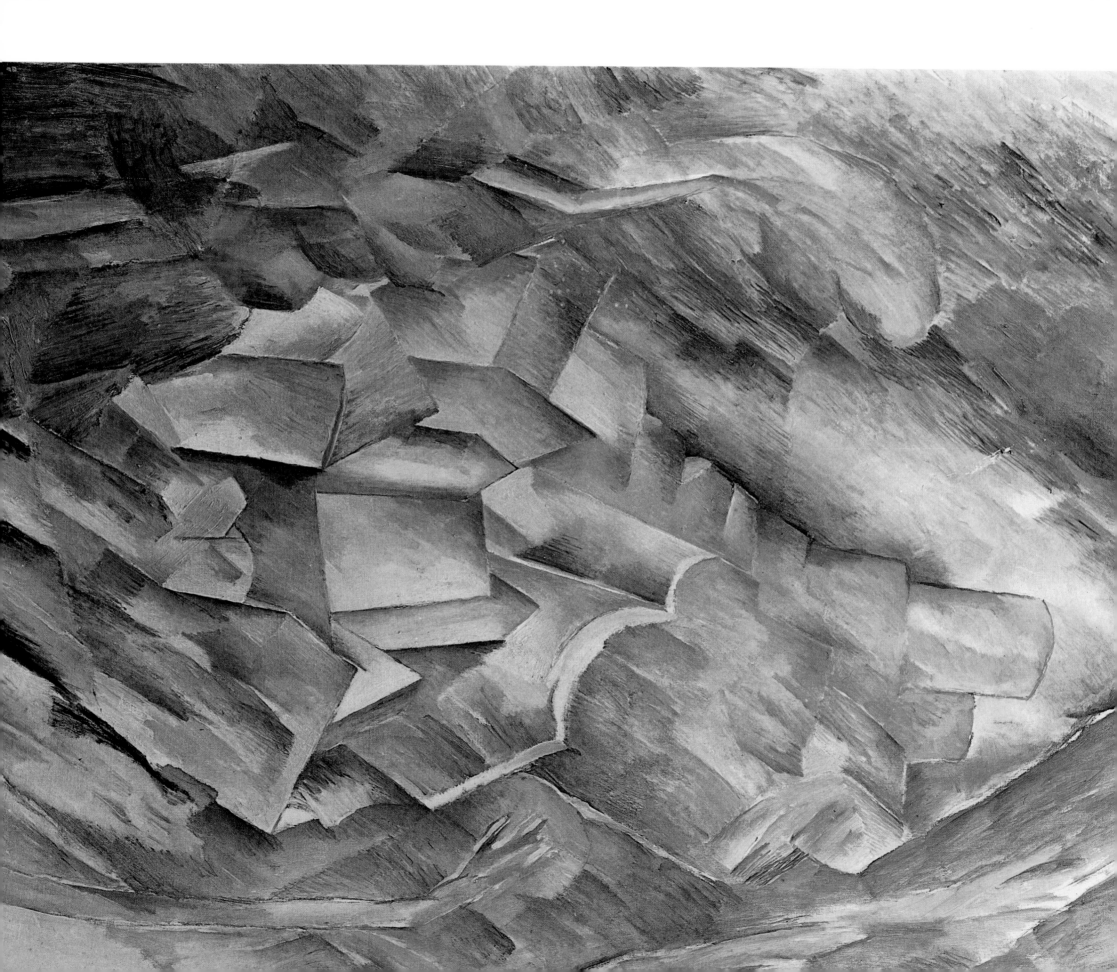

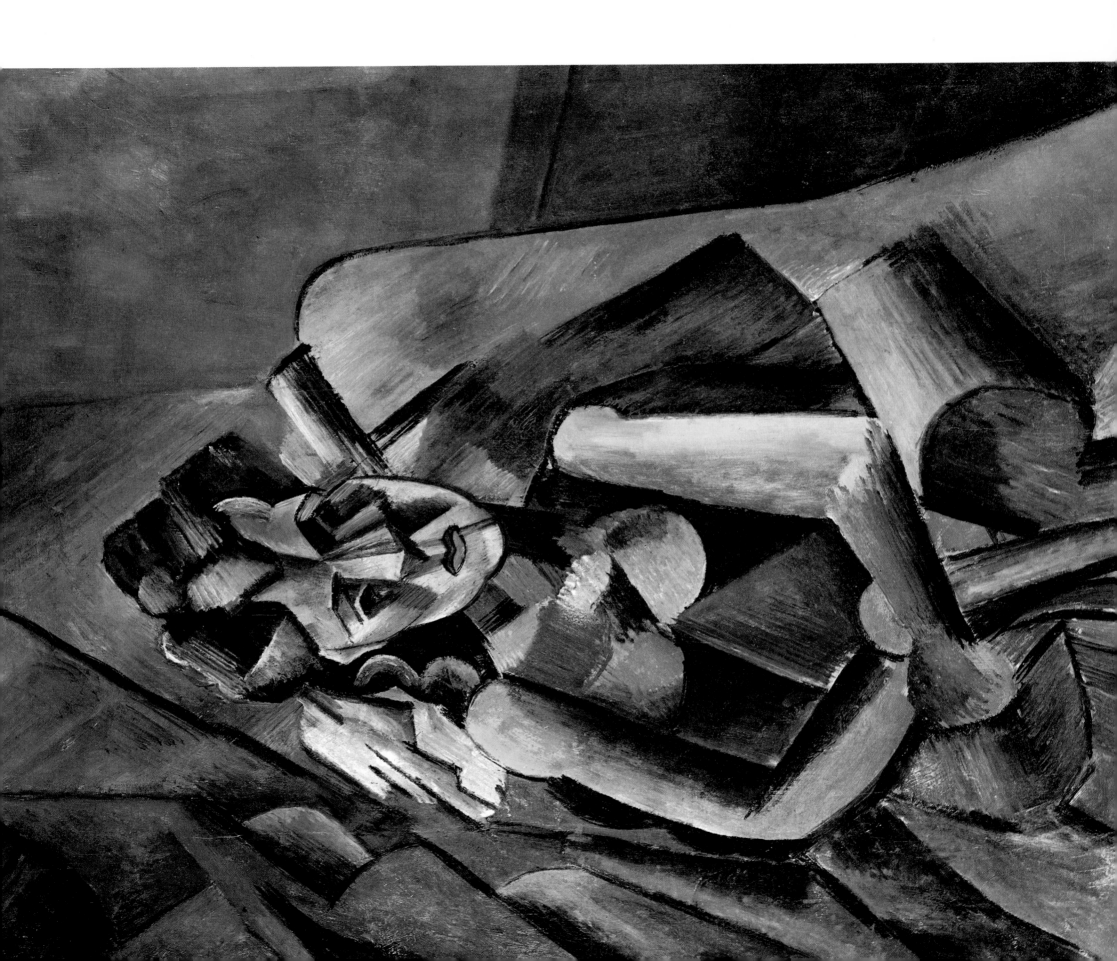

As early as 1908–1909, continuing the two-dimensional treatment of *Les Demoiselles d'Avignon* (see page 135), Pablo Picasso undertook to reduce the representation of volumes as he had treated them at the height of his African period (see pages 140–141). This reduction was achieved through the subdivision and pulverization of mass into small units. Many craters were hollowed into faces, edges proliferated, and the figures changed into a kaleidoscope of facets, each of which can be read as either flat or having depth. Contrary to the current interpretation of Cubism, Picasso geometrized the planes rather than going round the object. It is a question of frontalizing what is modeled, of using the canvas surface, and not of multiplying the viewpoints (above, below, right side, wrong side, etc.) at any cost.

Cubism was searching for a reality. Before 1914 Picasso had explained to Leo Stein: "A head . . . it is a matter of eyes, nose, mouth, which can be distributed any way you wish—the head remains a head" (cited by Edward Fry). The artist of *Les Demoiselles d'Avignon* insisted on stating the difference (in 1928) between this free division of iconic elements and abstract painting. "Abstraction! What an error! What a gratuitous idea! When you place tones one against another and make lines in the air without their corresponding to anything, you make at most a decoration. And precisely during this period [that of Cubism], we were passionately preoccupied with exactness. We only painted from a vision of reality. Each painting at this time, what an effort! What scruples it required not to let anything escape. . . ." Thus, the oddness and the obscurities of this style of painting are to be considered aesthetic components of the work. "Cubism and Futurism," observed Roman Jakobson, "largely use the perception-rendered-difficult process. . . . Since the object is really transubstantiated, the most experienced eye has some difficulty in discovering it, and the result is a great charm."

Pablo Picasso (1881–1973). *Woman Seated in an Armchair*. 1909. Canvas. 39⅜ × 31⅞"

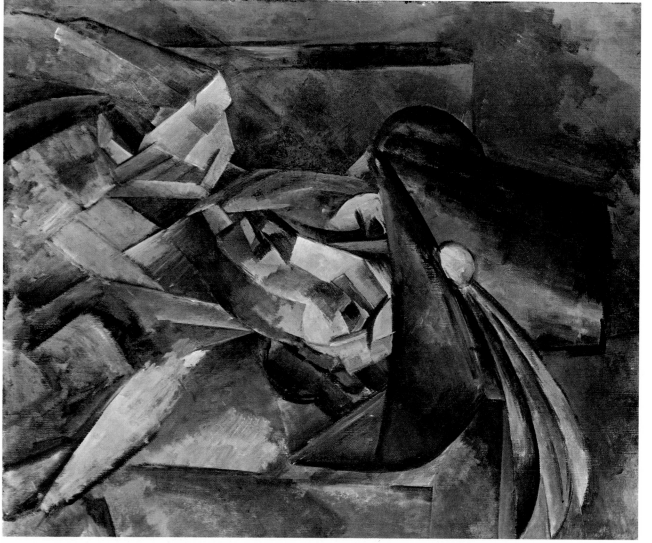

Pablo Picasso. *The Lady in a Black Hat*. 1909. Canvas. 28⅞ × 23⅝"

Picasso fragments and reduces his volumes, and the facets turn back toward the space plane

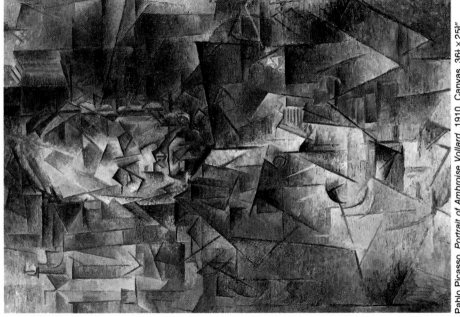

Pablo Picasso. *Portrait of Ambroise Vollard.* 1910. Canvas. 36¼ × 25⅞"

Pablo Picasso. *Portrait of Daniel-Henry Kahnweiler.* 1910. Canvas. 39⅜ × 2

Portraiture submits to the rigidity of a system of straight lines, and the picture plane constitutes itself through superimposition and transparency

In 1910, from his *Portrait of Ambroise Vollard* (right) to his *Portrait of Daniel-Henry Kahnweiler* (far right), Pablo Picasso developed the so-called Analytical (or hermetic) phase of Cubism. An explosion seems to have taken hold of and broken the ancient art of portraiture. The figure now is pulverized into fragments that no longer can be reorganized according to the logic of what is being depicted but according to the special laws of painting. It is a question chiefly, as Georges Braque said, "of constituting a pictorial fact." The represented objects blend into what surrounds them by interlocking, "passages," superimposition, and transparency. The textural elements become autonomous and speak for themselves. The verticals and horizontals multiply at the expense of curves, as though to make a web of the surface and to repeat the frame's form. Light, distributed by small rectangular brushstrokes, unifies the diversity of objects into a single, frontal, connective fabric. Those objects that one can still distinguish—the carafe, the face, the hair, the hands, even the watchchain in the *Portrait of Daniel-Henry Kahnweiler*—are secondary to the linear structural arrangement that regulates the entire construction. As Wassily Kandinsky wrote late in 1911, "By logic, Picasso manages to destroy the 'material' elements not by dissolution but by a kind of parceling out of isolated parts and by the constructive dispersion of these parts of the canvas. Astonishingly enough, by proceeding in this way, he seems, nevertheless, to want to conserve material appearance."

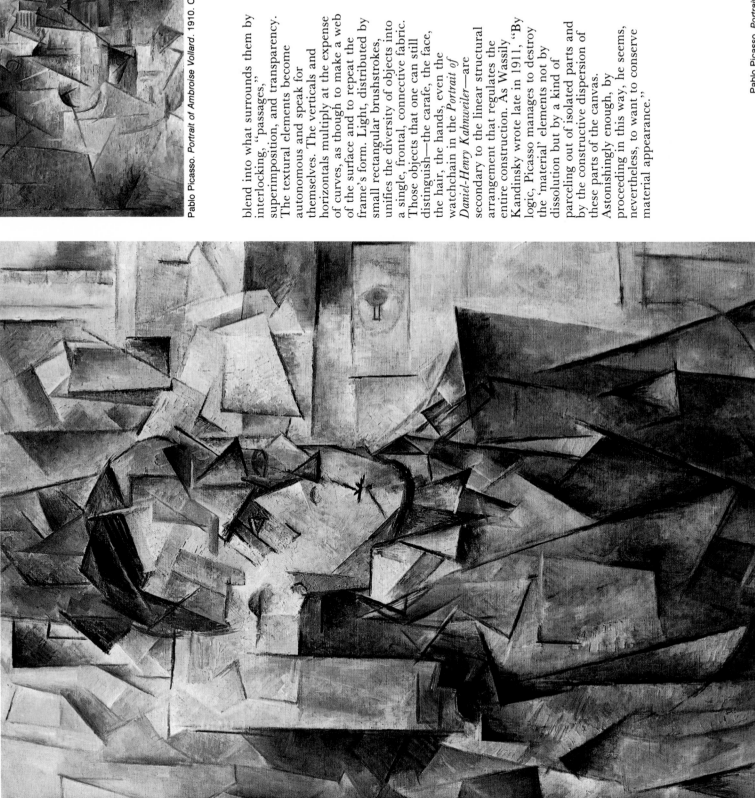

Pablo Picasso (1881–1973). *Portrait of Wilhelm Uhde.* 1910. Canvas. 30⅛ × 22¼"

150

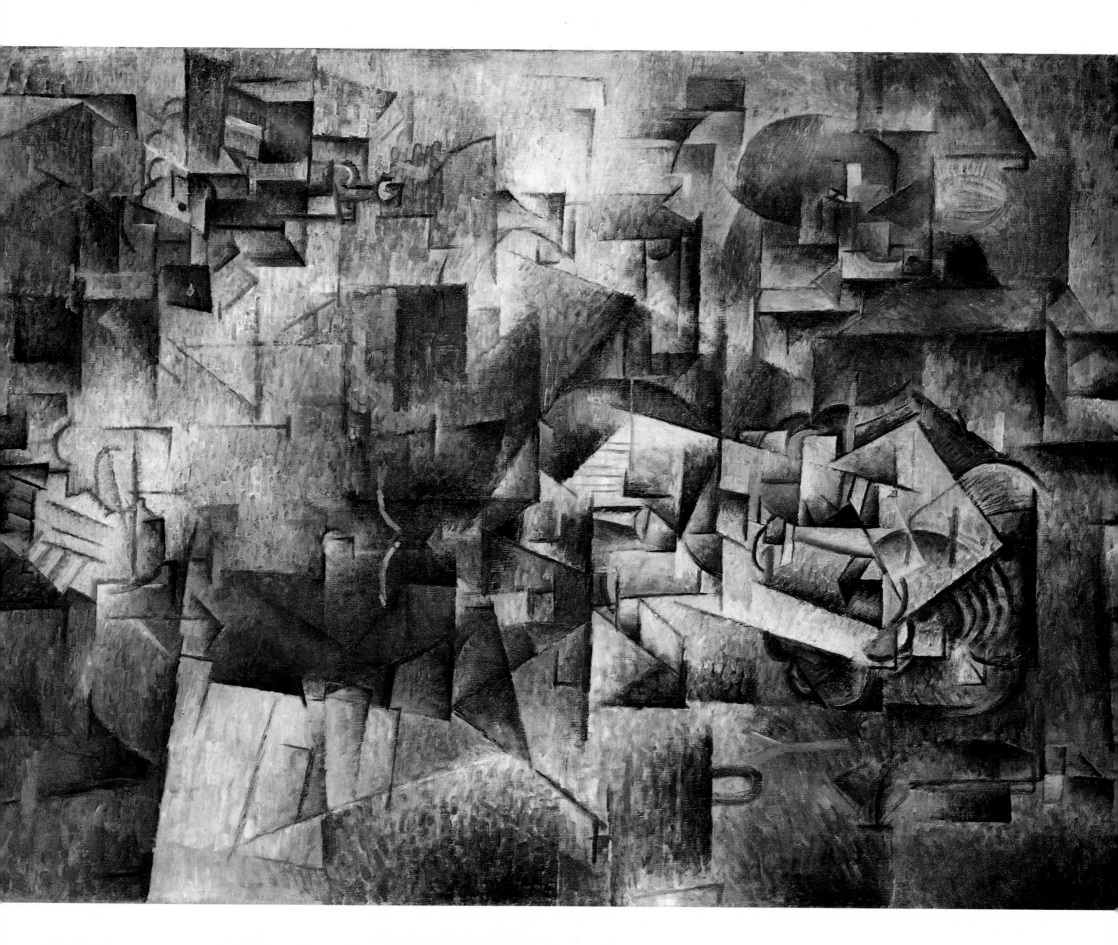

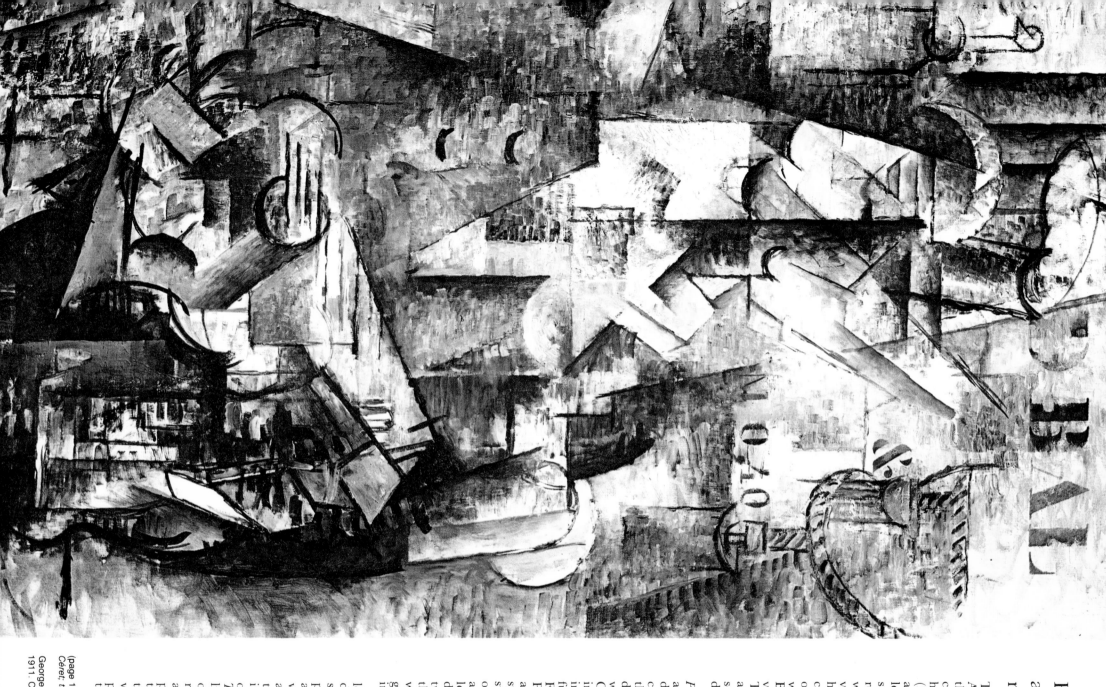

Forms, anecdotes, depth— all destroy one another in the rich texture of the painting

The frontal culmination of Analytical Cubism can be seen in the confrontation of the two canvases by Georges Braque shown here. One of them—*The Portuguese* (left)—represents a standing figure, and the other—*Céret; The Roofs* (far left)—deals with a horizontal subject: the diminishing lines of the roofs of a small town, seen from a window. By bringing forward the various perspective angles of the houses to the picture plane, by carefully interlocking the space outside the window and the three wall sections framing that space, Braque obtained a surface as vertical as that of *The Portuguese*. The frontalization of the canvas is aided by the equal *pizzicato* scattering of slight touches that denote light.

Painted in the same town, *The Portuguese* pictures a guitar player among the advertisements for dances and the inscriptions in a café. In the upper right corner of this work, a hatched line perhaps designates the upper section of a window blind. This is the first Cubist painting that has lettering independent of the theme. This innovation was to have a rich future, as it was taken up by the Futurists, by Kazimir Malevich, by Paul Klee, and by others because it allowed the confrontation of two systems of different signs: a plastic system in which the lettering occupies a space in the canvas and a linguistic system in which the letters have a verbal context. By definition a letter is two-dimensional. It is parallel to the canvas, and thus it contrasts with other objects in the painting— guitar, glass, carafe—that are inscribed in three dimensions.

In choosing to insert various letters of the alphabet into his description of a café, Braque speculated on the ambiguity of the place he represented and arranged a very clever transition. Café windows at that time had advertisements and figures fastened to the very surface of the glass to indicate the names and the prices of drinks. As a result, the letters in *The Portuguese* can be read both as linguistic signs independent of any object and as elements of a representative scene. (There is an additional ambiguity: the letters are partly covered by brushstrokes, as though the artist had inscribed them into the very fabric of the work or, better still, used them to promote textural frontality through their two-dimensional presence.)

Georges Braque. *The Portuguese.* 1911. Canvas. 46⅛×31¾″.

(page 152). Georges Braque (1882–1963). *Céret; the Roofs.* 1911. Canvas. 34⅜×25¾″.

153

Profiles separate, and the unity
of the body itself is questioned

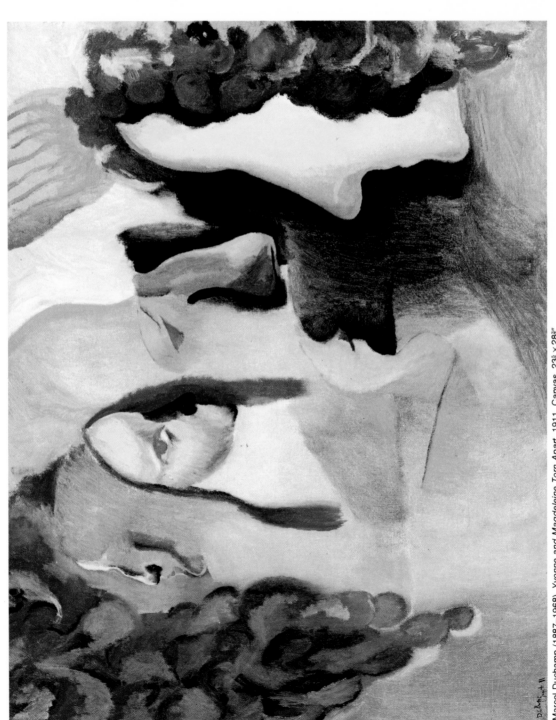

Marcel Duchamp (1887–1968). Yvonne and Magdeleine Torn Apart. 1911. Canvas. 23⅝ × 28¾"

The moment that Marcel Duchamp discovered Georges Braque and Pablo Picasso in Daniel-Henry Kahnweiler's art gallery in 1911, he set out to surpass their conceptions. At a time when Paul Cézanne was everyone's lodestar, Duchamp turned to Odilon Redon and borrowed his fluid gradations, his employment of which is illustrated in *Yvonne and Magdeleine Torn Apart* (above). In this split portrait of two of his sisters (there are two profiles of each), Duchamp began by transgressing a Cubist constant by showing his figures neither in three-quarter nor in frontal view. Whereas Picasso gathered his elements into a single mass, Duchamp chose to treat each of them separately. Whereas they are superimposed and interlocked in Cubist paintings, here the aspects of the face slide laterally, are separate, and are distributed over the entire canvas.

The same thing happened when Duchamp painted two chess players, each in two positions, in his *Portrait of Chess Players* (right). These enigmatic figures, which seem to borrow their immobility from the pieces they are handling, were painted in gaslight in order to escape any naturalistic color. The scene reveals Duchamp's interest in chess. After 1920, he devoted much of his time to the game. "I took chess very seriously and enjoyed it because I found it had much in common with painting," Before World War I, Henri-Pierre Roché often saw Duchamp in his studio, near the Jardin des Plantes, Paris, "with his pipe, in a deep armchair, not far from his well-adjusted Irish stove, with four chess games being played by correspondence on four large vertical chessboards attached to the walls, and so obviously happy that one hastened to leave him alone."

Marcel Duchamp.
Portrait of Chess Players. 1911. Canvas. 39¼ × 39¼"

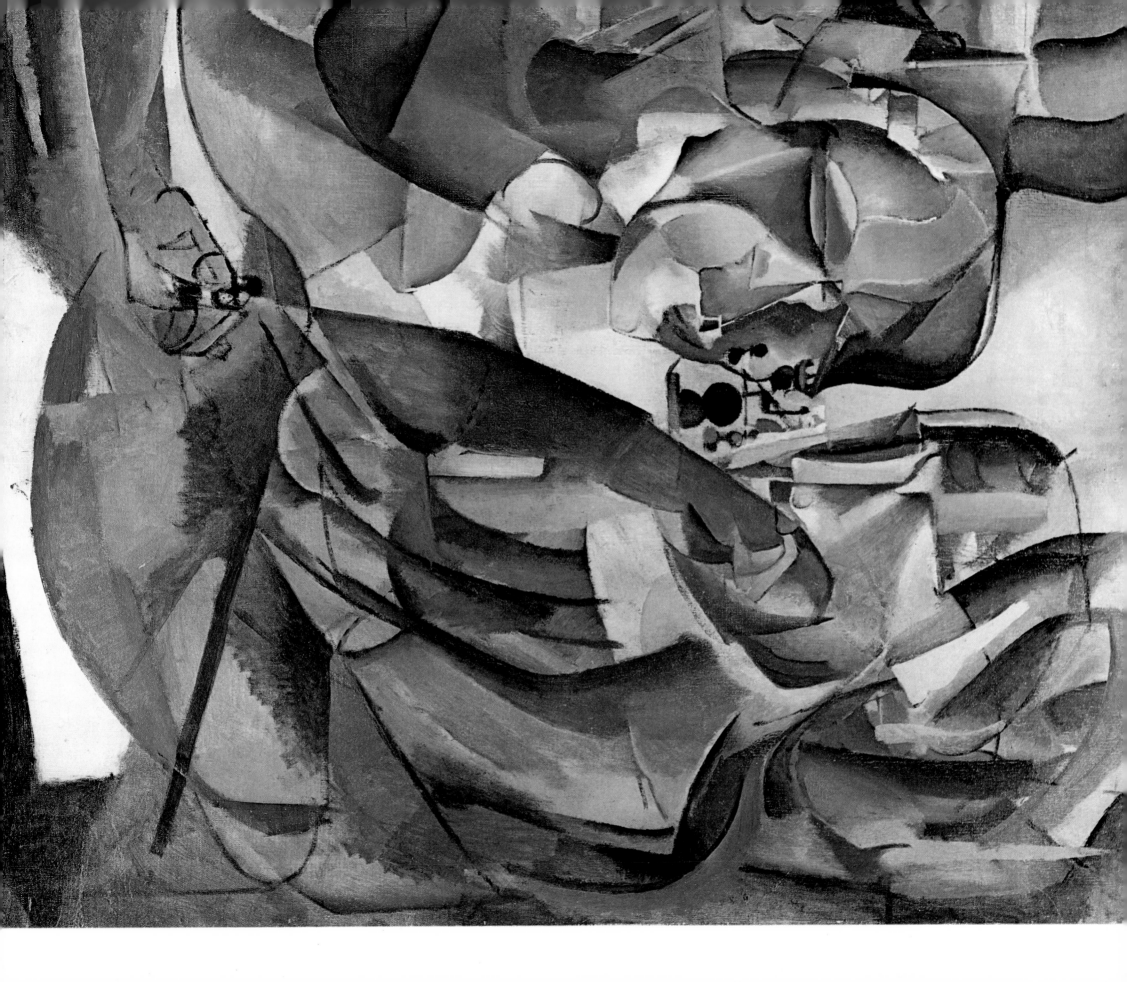

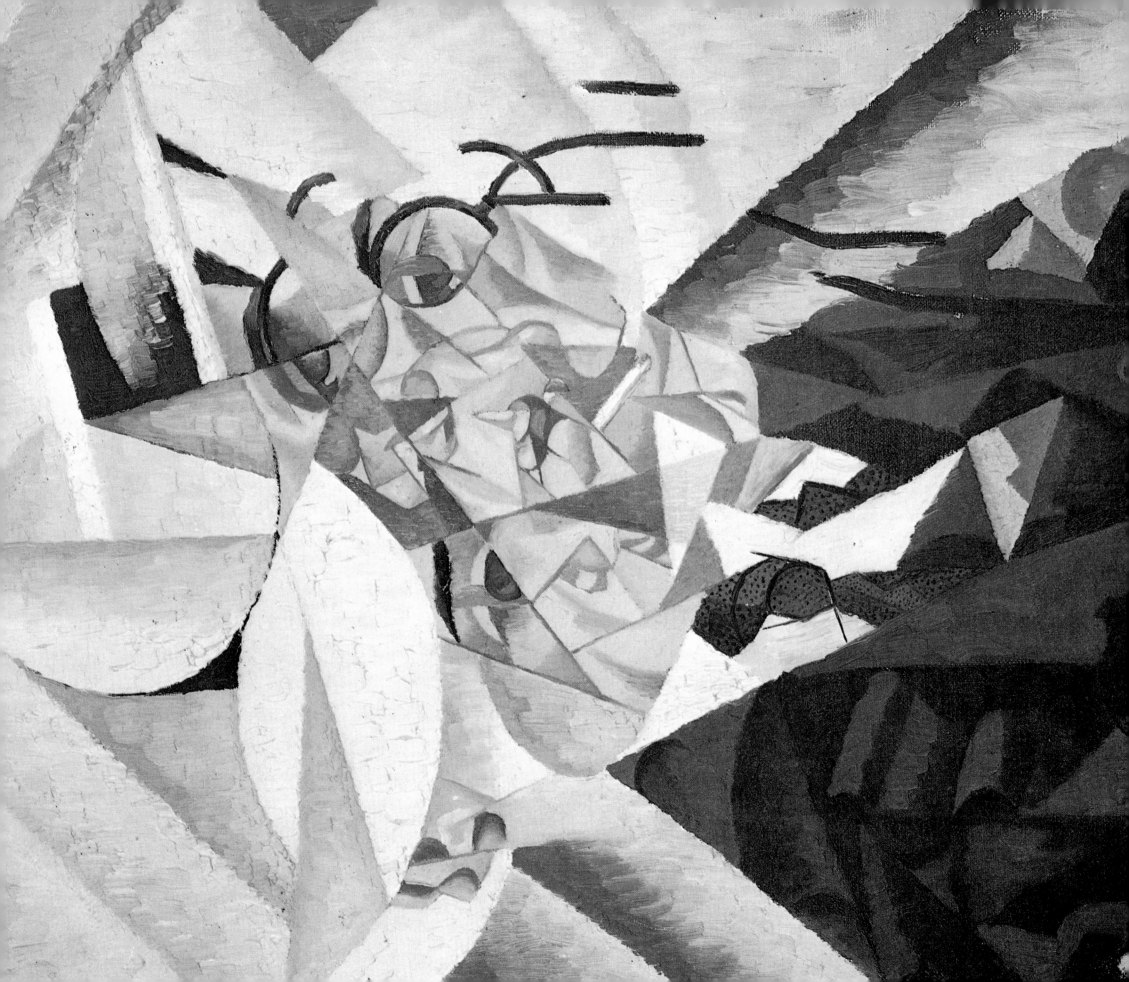

The human face splinters itself as in a broken mirror

Gino Severini, an Italian artist who settled in Paris as early as 1906 out of admiration for Georges Seurat, stands at the crossroads of pointillism, Cubism, and Futurism. In his *The Obsessive Dancer* (right), Severini split up the figure of the woman and fragmented the image of the cat, yet one cannot speak of the representation of motion. As the title of the work suggests, it is really a series of flashes intended to transcribe a nocturnal hallucination. One should note, moreover, that the small silhouettes of the dancers, near the face of the woman, although in movement, have been kept almost whole, unfragmented. A triple pattern assures the unity of the surface and subordinates the subject matter of the painting: a patchwork of angular forms that occupies the entire picture plane (except for its base), a regular pointillist mosaic, and finally the presence of the canvas between brushstrokes.

Color changes in the figure—there is more blue in the right one than in the one on the left—illustrate a phrase of the Futurist Manifesto of April 1910. "How can we still see the human face pink, while our life intensified by somnambulism has increased our color perception? The human face is yellow, red, green, blue, violet. A woman's pale face as she studies a jeweler's window has greater iridescence than the prismatic flames of the jewels that fascinate her as though they were a lark."

Severini organized his *Self-Portrait* (left) of 1912 by using a broken-mirror effect. A friend of both Georges Braque and Pablo Picasso, he closely followed the development of Cubism and in this painting offers us a spectacular and aggressive version of this style. The sliced surface seems to be in the manner of certain works by Juan Gris (see page 245). The artist's monocle, eye, and tie have been torn apart by the shifting planes. A subtle gradation of clear tones ensures the luminosity of the whole and contrasts with the brutal treatment of the figure.

Gino Severini (1883–1966). *Self-Portrait.* 1912. Canvas. 36¼×25⅜"

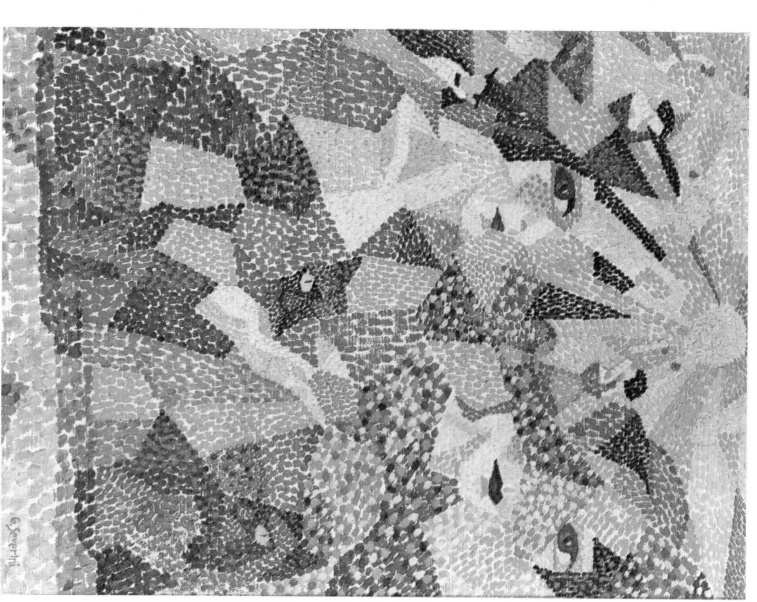

Gino Severini. *The Obsessive Dancer.* 1911. Canvas. 28¾×21⅞"

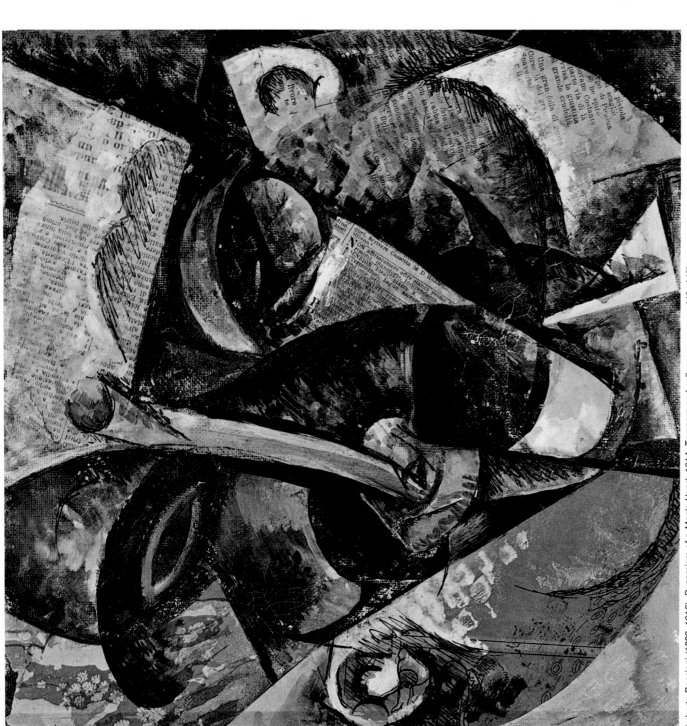

Umberto Boccioni (1882–1916). *Dynamism of a Man's Head*. 1914. Tempera and collage on canvas. 11¾×11¾"

These two paintings by Umberto Boccioni, dating from 1914, reveal a new interest in the Cubism of 1907–1909. However, Boccioni has added a wild exacerbation and a convulsive manipulation of odd textures such as those furnished by newspaper, leaflets, cardboard, the scrawls of heavy brushstrokes, and even a woman's photograph in his *Dynamism of a Woman's Head* (right). In the abrupt cutouts, twisting faces, and agglomeration of ends touching one another, a sculptor's

hand is peremptorily present (see page 235), and it takes the material beyond the anecdote to become the real object of the investigation.

These two paintings form part of the limited work of a prolific artist who at his death (during World War I) left more than five hundred paintings and sculptures. From 1914 to 1916 Boccioni—as though he had come to the end of the road —produced only a few hesitant reprises of Pablo Picasso and Paul Cézanne.

Boccioni makes up his dislocated faces with pieces of worthless metal

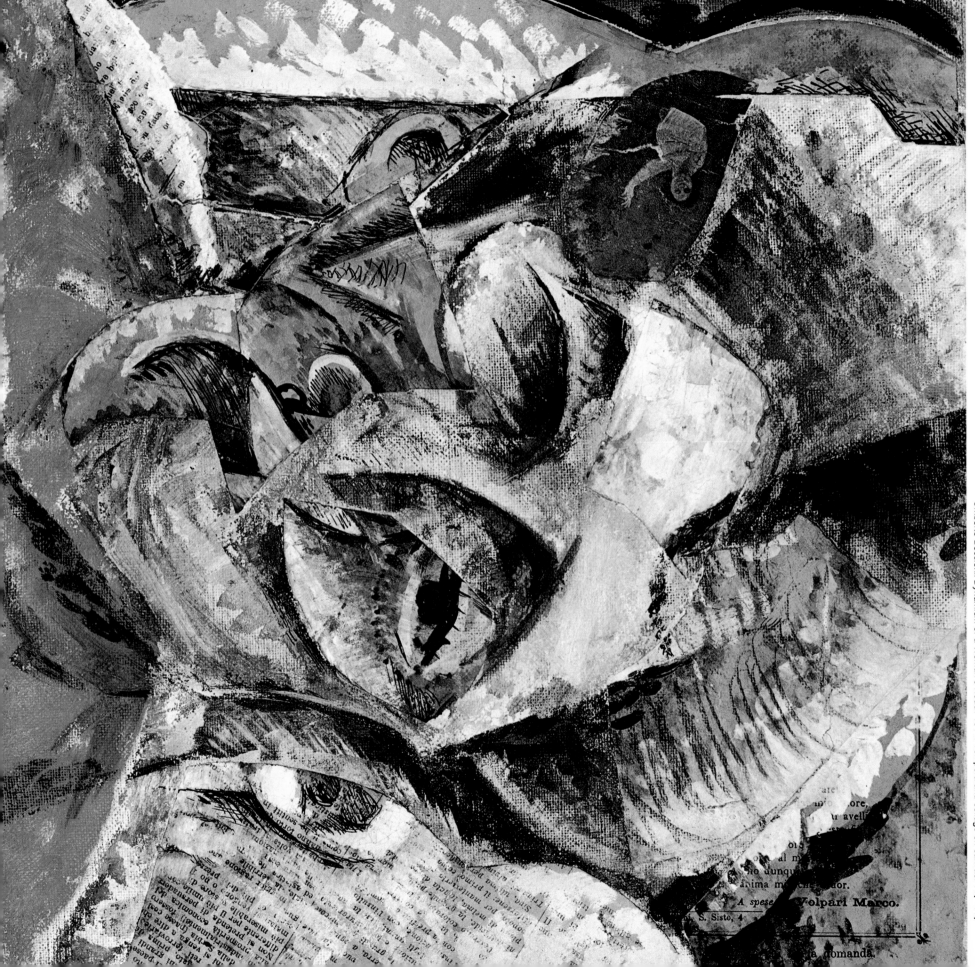

Umberto Boccioni. *Dynamism of a Woman's Head.* 1914. Tempera and collage on canvas. 11¾×11¾"

The interpretation of nature becomes systematized through serial repetition and the fusion of the animal, vegetable, and mineral kingdoms

Henri Rousseau (known as Le Douanier) (1844–1910): *The Dream*. 1910. Canvas. 80¼×117¾"

A uniform truncated module rules Fernand Léger's large canvas *Nudes in the Forest* (right), in reference to which, in 1911, the critic Louis Vauxcelles suggested the word "tubism." "Here is a lad," Pablo Picasso remarked in this connection, "who offers something new since he's not given the same name as us." This unity of plastic vocabulary—still emphasized by a restricted color choice—encompasses not only the trees and the various vegetation in the foreground of the painting but also the three principal silhouettes of the woodsmen (one of whom is seated in the center). With this treatment of the vegetable kingdom, Léger gave a foretaste of what he would soon generalize, beginning with metal tubes. As early as 1911 Jean Metzinger judiciously described this canvas as "a living body whose trees and figures are its organs." And if at first the poet and critic Guillaume Apollinaire saw merely "a wild appearance of piled tires," two years later he had a better conception of the work's originality. "The woodsmen themselves bear traces of what their hacking does to trees, and the general colors participate in the greenish and strong light that descends from the foliage."

In contrast to Georges Braque and Picasso, Léger seems to be content here with traditional perspective, and he was doubtless influenced by his friend Henri Rousseau, whose false naïve style was a true anti-Impressionist war machine. In Rousseau's *The Dream* (above) the precision of the botanical subjects—deliberately enlarged to the point of becoming gigantic—and the serial treatment of the plants and flowers contribute to removing the painting from any illusionism (one finds, for example, the same simplified vegetal forms in the groves painted by Fra Angelico). To those who questioned him about the strange presence of a couch and a nude woman in a jungle, Rousseau replied, "This woman asleep on her couch is dreaming that she has been transported to the forest and that she is listening to the sounds of the charmer's instrument."

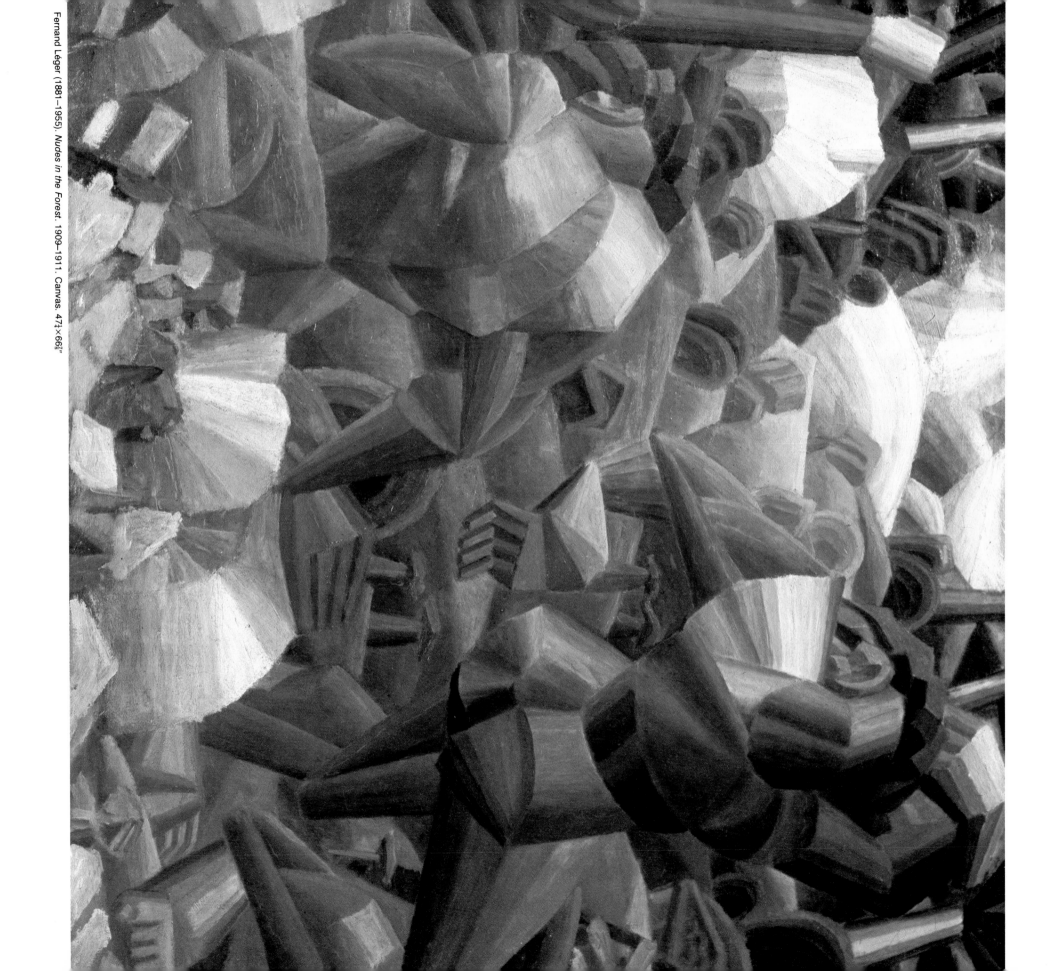

Fernand Léger. *The Woman in Blue.* 1912. Canvas. 76×51½"

Flat areas rise in the kaleidoscope of explosive representation

In contrast to the highly concentrated, self-enclosed Analytical Cubism that developed simultaneously in the work of Georges Braque and Pablo Picasso (see pages 150–153), *The Wedding* (right) by Fernand Léger is enlivened by the principle of infinitude, a centrifugal force, a lyric dispersal that makes this large composition Léger's most complex work. The painting was a wedding gift for the poet André Salmon, and fragments of superimposed and interlocking images radiate with dream freedom around the central couple. They are gathered up in a circular movement, and are seen either facing the viewer or in a receding position. The "memories of Norman orchards," to quote the poet and critic Guillaume Apollinaire, are articulated in the details of the procession. The entire composition is crossed by a flow of clouds that gives *The Wedding* an

aerial dimension and an atmospheric fullness. The clouds also serve to frontalize the picture plane. In this work Léger chose the most ductile, vaporous element to stabilize his design.

In *The Woman in Blue* (above)—a work contemporaneous with Braque's *papiers collés*—these same clouds, hardened and outlined, have become flat areas that harmonize the surface and conceal the seated figure. The viewer now sees only the shoulders, arms, and hands of the woman. The blue of her dress and the large black spot in the upper left corner are geometrized in the same way. However, Léger, who did not want to abandon dynamic tension, soon reinserted three-dimensional figures into his paintings. In his *Contrast of Forms* (left) he simultaneously played on the confrontation of straight lines and curves, reds and blues, volumes and flat areas.

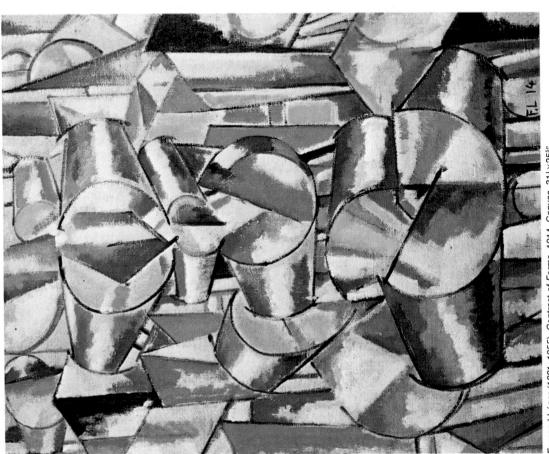

Fernand Léger (1881–1955). *Contrast of Forms.* 1914. Canvas. 31½×25⅝"

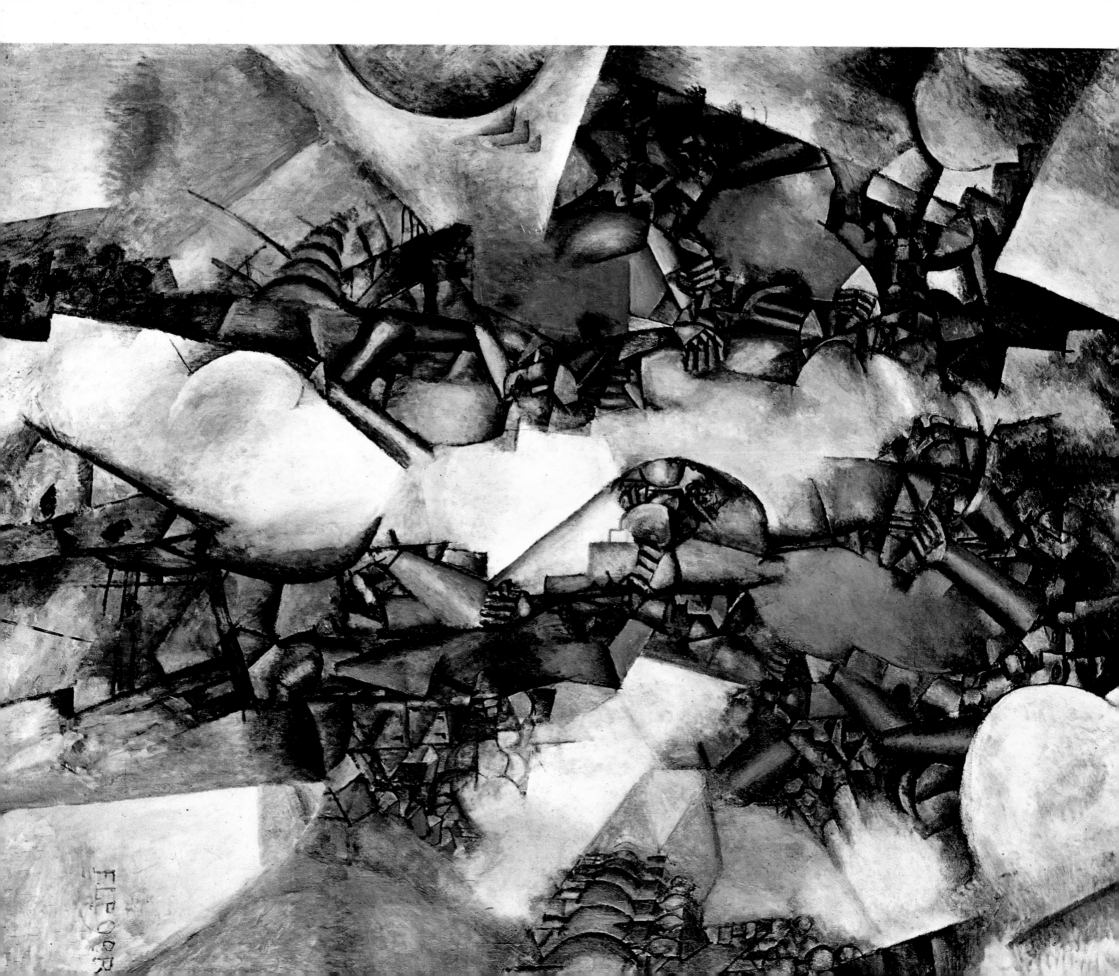

The human body borrows from machines the impersonal reflections of their polished pipes

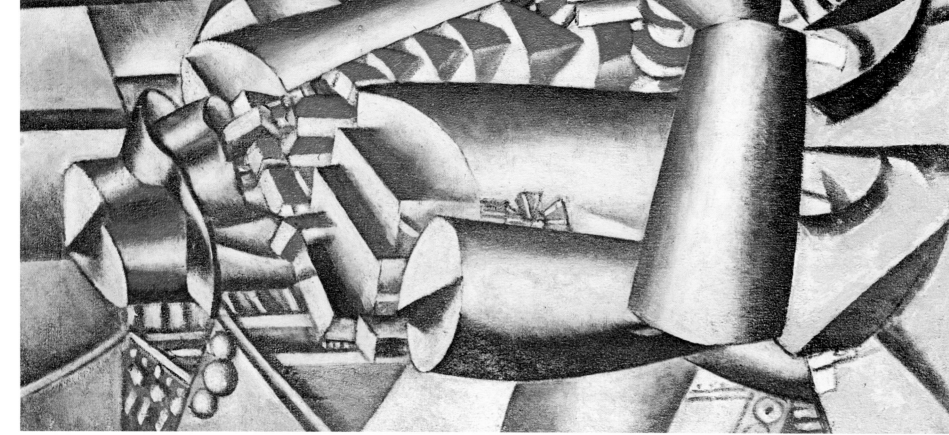

Fernand Léger. *The Card Game.* 1917. Canvas. 50⅛×76"

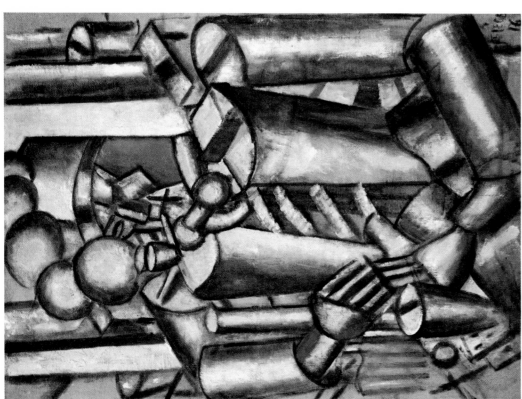

Fernand Léger (1881–1955). *The Soldier with a Pipe.* 1916. Canvas. 51¼×38⅜"

Cubism and war combine their effects in these two paintings by Fernand Léger in which human bodies—truncated and disjointed—become gears, pistons, ball bearings, and robots. During World War I at Verdun, Léger was "dazzled by a 75-mm. shell opened in full sunlight, a magical light on the white metal. It taught me more about my plastic development than all the museums in the world." Although this fascination is clearly felt in his *Contrast of Forms*, painted in 1914, and in his *Nudes in the Forest* (see pages 160–161)—and although one finds in the work of Paul Cézanne several cylindrical motifs, such as milk pots and coffee pots—in Léger's work reflection plays a major role. Léger was sufficiently bold to generalize his tubular obsession by making industrial artifacts—clear, cold, and polished—the prototypes of his figures. "As I found the machine so plastic, I wanted to give the human body the same plasticity."

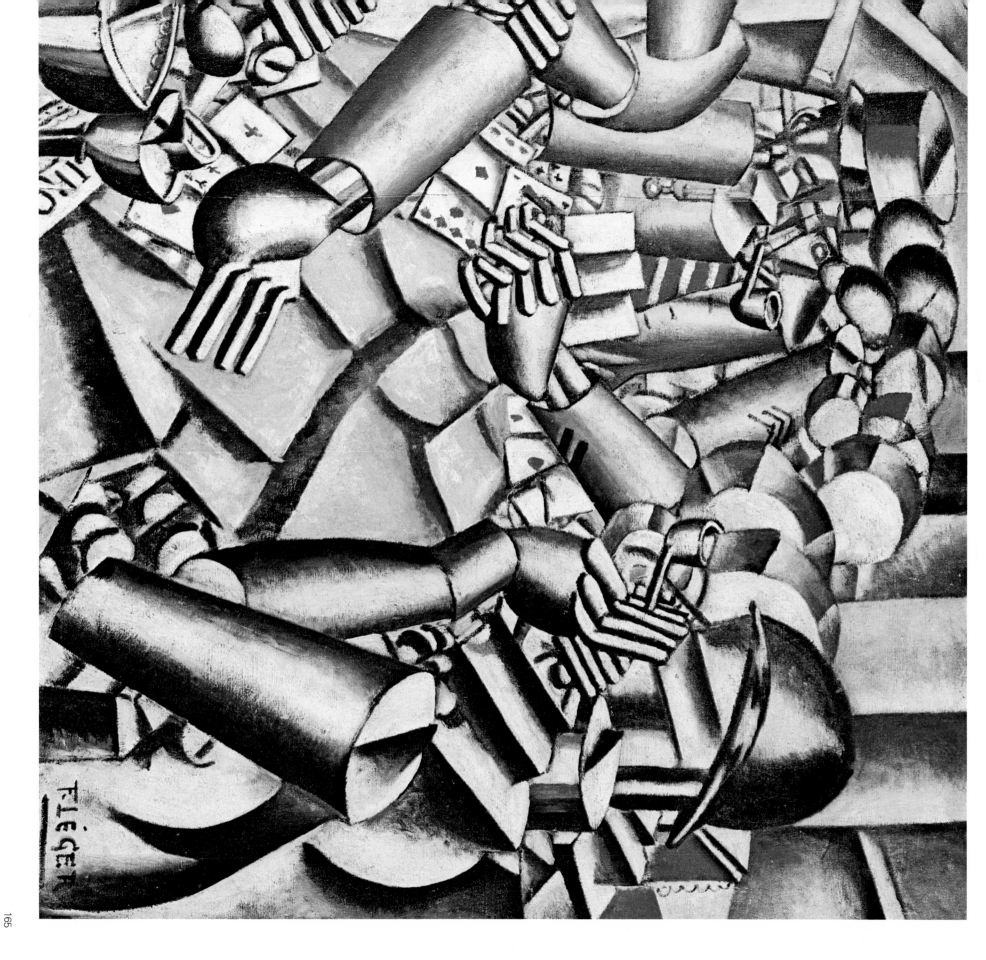

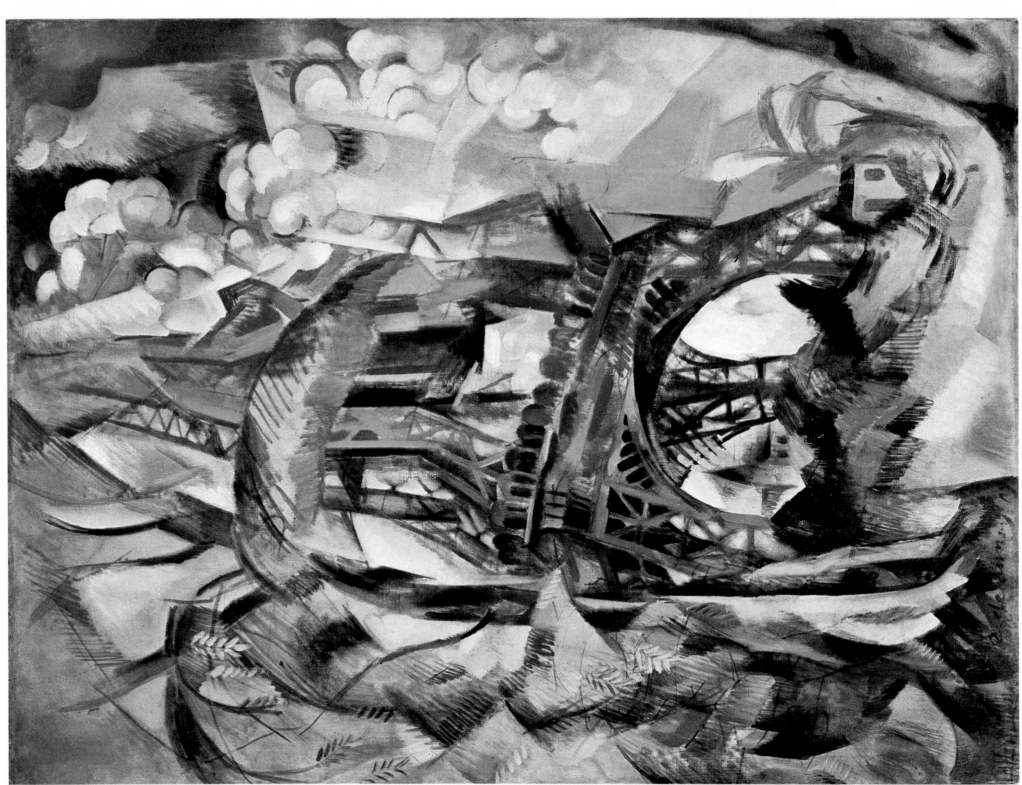

Robert Delaunay (1885–1941). *The Eiffel Tower with Trees.* 1909. Canvas. 48⅛″×35⅛″

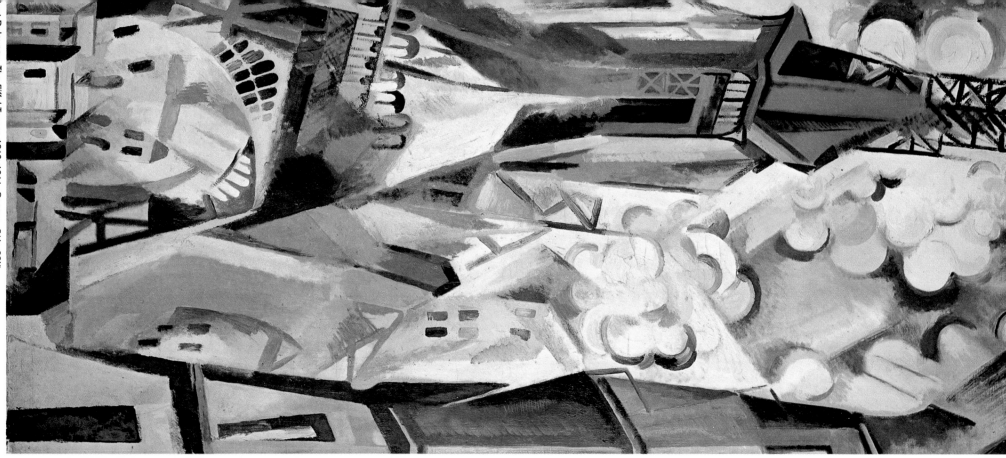

Delaunay shatters the logic
of metal architecture
in order to subordinate it
to the coherence of the canvas

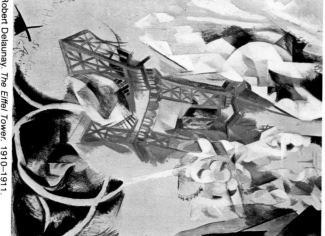

Robert Delaunay. *The Eiffel Tower.* 1910–1911. Canvas. 76½ × 50½"

No art formula known then could claim to solve plastically the case of the Eiffel Tower. Realism reduced it: the old laws of Italian perspective thinned it out. The tower rose in the Parisian sky like a hairpin. When we walked away from it, it dominated the city, stiff and perpendicular; when we approached it, it bent and leaned above us. Seen from the first platform, it corkscrewed, and seen from the top, it crumpled with its legs spread out and its neck drawn in. Delaunay also wanted to depict Paris all around it and to situate it [in its milieu]. We tried every point of view, we looked at it from every angle, from every side, and its sharpest profile is that seen from the Passy footbridge. . . . Finally, Delaunay disjointed the tower in order to bring it into his own scope; he truncated it; he inclined it in order to give it its 1,001 feet of vertigo; he adopted ten points of view, fifteen perspectives, some seen from above, others from below; the houses surrounding it are taken from right to left as a bird flies, ground to ground. . . .

The French writer Blaise Cendrars, a friend of Delaunay during the feverish years he painted the series of the tower, later described the birth of these canvases in a text written in 1924.

"He was always haunted by the tower and the sight of it from my window much attracted him. . . ."

Describing the climate that existed at the time he created his series of paintings of the Eiffel Tower, of which three are illustrated here, Robert Delaunay wrote in his *Notebooks:* "Drama, cataclysm. This is the synthesis of an entire period of destruction: a prophetic vision. . . . The desire for a great cleaning, for burying the old, the past, everything, for entombment. . . ."

Modern-day viewers of Delaunay's studies of the Eiffel Tower are more inclined to see an epic and dynamic extension of the Cubist vision to an object that, at the time Delaunay painted it, had dominated Paris like a symbol of its modernity for twenty years. By attacking it, Delaunay explained that he wanted to "shatter" the tower and make it dance, like Cézanne had "shattered the fruit dish."

A screen of regular strokes
gradually blocks out the high-handed
perspective of earlier painting

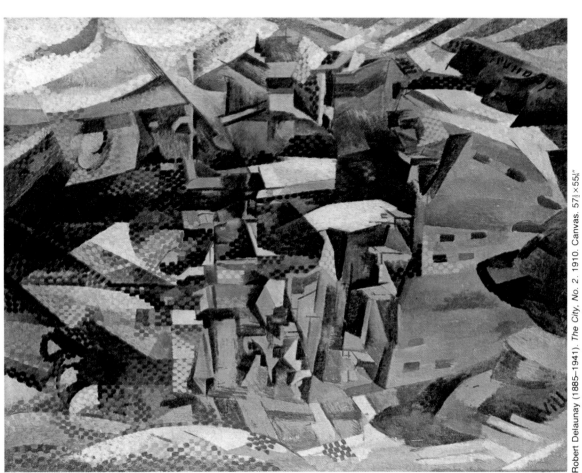

Robert Delaunay (1885–1941). *The City, No. 2.* 1910. Canvas. 57¼×55¼"

Robert Delaunay. *Windows on the City, No. 4.* 1910–1911.
Canvas. 44⅛×50¼"

Interposing itself like a curtain—or a moucharaby—a regular pattern of geometrized strokes gradually obstructs the window opening in Robert Delaunay's *Windows on the City, No. 4* (right). This pattern becomes a net almost independent of the city landscape it conceals in Delaunay's *The City, No. 2* (above). Here it is a unit of punctuation that emphasizes the frontality of the canvas at the expense of its illusionist depth. Whereas Georges Seurat submitted his small dots to the requirements of the outlines of the subject matter he depicted, Delaunay freed them by increasing them, at the same time forming the autonomy of his pictorial means. A subtle use of color links Delaunay's pointillist network to the details of his landscapes—roofs, wall, doors—and at other times to the patchwork of horizontals and diagonals that crosses his canvases at right angles without any representational function.

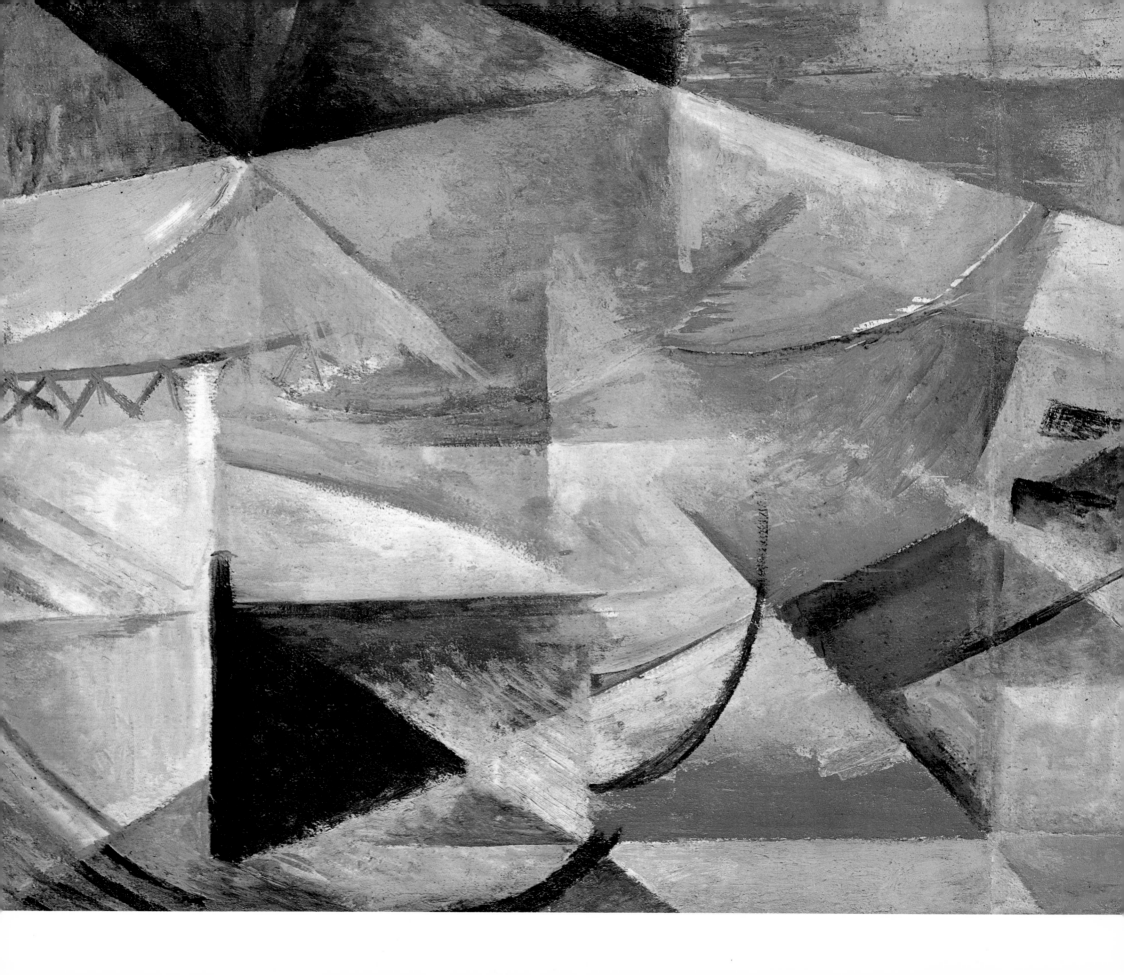

Delaunay makes a Parisian landscape into a patchwork of pure colors

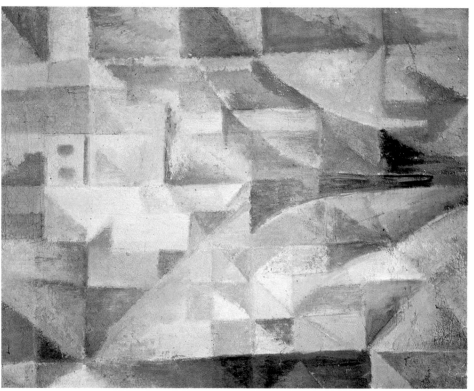

Robert Delaunay. *Windows*. 1912. Gouache on cardboard. 17¾×14⅛"

Robert Delaunay's series of paintings on the theme of windows marks a decisive moment in the liberation of painting's formal components. Delaunay claimed to have found the theme in Stéphane Mallarmé's poem entitled "Windows"; "*Que la vitre soit l'art, soit la mysticité . . .*" ("Let the window be either art or mysticism . . ."). More than twenty versions of Delaunay's window paintings, most of which date from 1912, exist. In the three works illustrated on these pages, parts of the Eiffel Tower float in a harmony of flat areas in which, according to the poet Guillaume Apollinaire, "a holy and wonderful color intoxication" triumphs. It was at this time that the author of *Alcools* invented the word "Orphism" in order to relate Delaunay to music. "Constructive colors," "pure painting," explained the artist, who, in a letter to Wassily Kandinsky in 1912, mentioned the "laws that I have found based on researches into the transparency of color, comparable to musical notes, laws that forced me to find *color movement*."

The source of the checkering in these works is in the last Mont Saint-Victoire paintings by Paul Cézanne, who also wanted, "to build by color." But whereas the painter from Aix attempted to maintain a balance between the representation of a landscape and the formal organization of his canvas, Delaunay frankly favors the surface over representation and offers us plastic arrangements that work more and more by themselves. Here color rules supreme. Delaunay, visiting an exhibition of work by Georges Braque and Pablo Picasso with Fernand Léger, exclaimed—not without feigned simplicity for he was well acquainted with their canvases—"But those guys paint with cobwebs!"

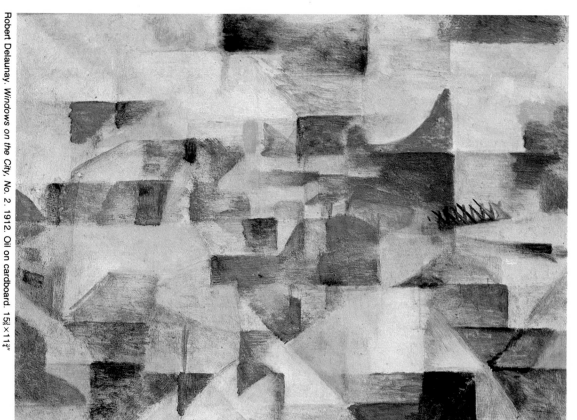

Robert Delaunay. *Windows on the City, No. 2.* 1912. Oil on cardboard. 15⅝×11¾"

CHAPTER 4

FRONTALITY

Painting is identified with its two-dimensional support. No longer is it the external world but the internal logic of the painting that dictates form. Step-by-step surface organization gains over all representational depth

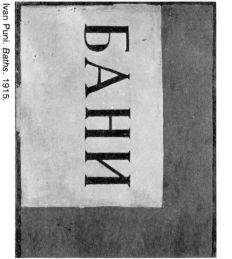

Sonia Delaunay. *Blanket.* 1911. Sonia Delaunay wrote in 1956: "About 1911 I thought of making for my newborn son a cover consisting of bits of fabric, like those I saw used by Russian peasants. When it was finished, the arrangement of the fabrics seemed to me to stem from Cubist ideas, and we then tried to apply the process to other objects and to paintings."

Paul Cézanne. *Terraced Hills with Houses and Trees.* 1870–1874. Cézanne's linear simplifications directly anticipate the vertical and horizontal lines to which Mondrian, in 1913–1914 (see page 206), gradually reduced his urban landscapes

"I want to paint a glass, I will inscribe a circle on my canvas to show its volume, but it may happen that from this circle I make a square since this form is not alone on the canvas." This statement by Pablo Picasso in 1909 marked a reversal in the order of priority of the elements that are used in the development of a painting. Surface is no longer an area in which preconstituted forms find their place or even a neutral screen on which the sign of the object is projected with complete independence. It is the place that *produces* this form or that figure. The plastic components are an important part of an overall structure that makes them interact.

This structural economy overrides the "logic" of denotation. There is overstretching, alteration, explosion—soon effacement—of the referential signs for the benefit of the internal laws of the pictorial *system*. In the antagonism between representation and construction, it is construction that wins out. "The task," to use the words of Kazimir Malevich, "is not to render the objects, but to make the painting. . . . Every real form that is not created by the forceful necessity of painting is an act of violence on the latter. . . ."

Better than anyone else, Juan Gris explained how in his work the organization of forms preceded their transformation—allusive as it was—into signs representing the object. "For example, I compose with white and black . . . then I arrange the white to make it become a piece of paper and the black to make it become a shadow. . . . It is not painting X that manages to match my subject but subject X that manages to match my painting. . . . Pictorial mathematics leads me to representative physics. The quality or the dimension of a form or of a color suggests to me the denomination or the adjective of an object. . . . With a bottle Cézanne makes a cylinder, I . . . with a cylinder make a bottle, a certain bottle. Cézanne heads toward architecture, I begin with it." Daniel-Henry Kahnweiler, moreover, who was present at many a transformation, stated that once the distribution of forms had ended "a few parallel lines on a white surface would change them into a page of music, a few examples of printing type into a newspaper, and a circle drawn flat into a dish."

But at the moment that the sign of the object—or the nonreferential form—subordinates itself to the internal logic of the work modern art is faced with an alternative that can be summarized in the antagonism between *composition* and *construction*. *Composition* is the art of arranging dissimilar forms on a surface in such a way that they reciprocally balance and cancel out one another. The work is a conquered tension, it submits to an unchangeable order that is itself a reflection of a stable, timeless, infrahistorical conception of world order. Among all the possible conceptions of painting, it is a feeling of immobility that is suggested, the idea of possible control over things and forms. This conception triumphed in the Classicism of a Nicolas Poussin and a Georges de La Tour and later with Jacques Louis David and Jean-Auguste-Dominique Ingres (regulating and never totally strict schemes whose transgressions arise from the winding up of that system). Composition postulates a scene, a shallow depth on which the disparity of the figures can acquire a specific identity. In order to appear, the peculiarity of each form requires that it rise against a background. *Construction*—on the contrary—is the articulation of discrete elements endowed with a formal relationship that blurs the difference. One can compare it to adjustment, to an industrial assembly that combines parts of the same technical nature. The similarity of elements suggests the idea of permutation. A result of construction, expression is the regular network of identical units (pattern, checkering, patchwork, net, dripping) that ensures the uniform covering of the canvas (see pages 171 and 294–295). The reticular covering of the surface cancels what Malevich in 1915 called "the prettiness of division," the opposition of form and background. The painting itself takes over as a picture plane—exclusive of any hollowing out of the perspective.

This course of action toward homogeneity originated in the checkered work of Paul Cézanne, which as we saw in "Signs and Men," destroyed the isolation of the figure and inscribed it in the texture, the "weaving" of the work. Another source was folk art, covers, shawls, marquetry, and mural decorations, which artists assimilated in order better to ensure the assumption of the surface (left). In 1919 Piet Mondrian made the first checkered work in the history of painting (see page 209), soon relayed by *art concret* and its various methods of systematic projection onto the design. But as early as 1911 it was Juan Gris who made the decisive breakthrough by placing on the Cubist canvas an almost unitary pattern that restricted the form (and/or sign of the object) to the yoke of a transverse line (see page 178 right).

The antagonism between *composition* and *construction* was the nodal point where the historical fathers of Cubism stumbled—and first of all Georges Braque. In 1912, during the very time that Braque was decisively reducing the plastic scene to frontality in his *papiers collés*, he succumbed to the prestige of Classical values and claimed to be the heir of

the great French tradition. If we consider, on the one hand, the *Man with a Violin* (1911) in the Kunsthaus, Zürich (left), marked by an explosion and the extreme scattering of its graphic signs, and, on the other hand, a *papier collé* of 1912 (see page 241) we note that the frontality and the effort toward synthesis allowed by the latter are both perverted by the return of a plastic rhetoric that forces into the background what was trying to come to the foreground (an increase in white areas, perspective lines in lead pencil, atmospheric floating of the composition). Whereas in his oil paintings of the same period, Braque seemed to want to gather up the entire surface and at the same time open the way to Mondrianesque flattening (see page 206), in his *papiers collés* the fascination of a petrified formal order condemned him to return to the mannered compositional arrangements connoted by the words "quality," "elegance," "refinement," and so on. In 1912 a friendly critic Roger Allard echoed the wishes of others for "an artistic order in this mathematical chaos." Albert Gleizes demanded in 1913 "an initial balance in the composition by the play of lines, surfaces, and volumes." And Léonce Rosenberg reassured (himself) by noting in 1919 that there was "nothing arbitrary in [Cubist] architecture. On the contrary, everything is determined by feeling and submitted to the eternal laws of balance." The mediocre Purism of Amédée Ozenfant and Le Corbusier was created in 1920 from this theoretical ritard. In 1921 Gino Severini did not hesitate to entitle a treatise on painting *From Cubism to Classicism*. Even Juan Gris—we have seen the founding role that he played in the development of a system of regular weaving on the picture surface (1911–1913)—was fascinated by this anachronism. In 1921, he wrote, "In my method I cannot escape from the Louvre; my method is that of always, the one that the masters have always used, whose *means* are constant." Hence the failure of an enterprise that ended in catastrophe, whose destiny the perspicacious Guillaume Apollinaire had foreseen. "This art of ornament insists on piously collecting the last signs of Classical art, like the drawings by Ingres and the portraits by David," he had written in 1913.

In its deconstruction of the compositional system stemming from academic painting, modern art found an unexpected ally: chance. There was a convergence between the checkering of the surface, which led Mondrian, and the research that deliberately introduced a principle of uncertainty into the process of production of the work. In both cases the singularity of the form was questioned. Hence Marcel Duchamp's

stoppages-étalon (1913–1914) whose outline was dictated by a horizontal straight line dropped from a height of one meter (39⅜ inches) onto the horizontal plane (here the artist spoke of "canned chance"). These are sarcastic assaults on the "eminent dignity" of the artist, who claims that like a despot he controls the formal organization of his painting.

If, as we have seen, the *papier collé* stopped short with Braque, who allowed himself to be held back by the traditions of composition without thoroughly exploring their invention, nevertheless this process had a rich future and its discovery was an inaugural event in twentieth-century art. In September 1912, Braque, ever attentive to the technical aspects of his "craft," noticed in an Avignon shop window a piece of wallpaper that imitated the grain of wood. He decided to use it in his paintings. Henceforth, his works integrated large monochromatic flat areas, generally black or brown, whose chief merit was to purify and to clarify the increasingly profuse surface of the productions of Analytical Cubism. The *papier collé* offered a peaceful regularity of a tangible surface, and it stated the frontality of the work and backed it up against the wall. By original means, this effort toward frontalization was an extension of Cézanne's research and Paul Gauguin's synthetism. It supported Pierre Bonnard's and especially Édouard Vuillard's efforts of the 1890s when their paintings seemed to be torn and juxtaposed pieces of wallpaper. Finally, it was contemporaneous with the work of Henri Matisse, who, in 1911 (see pages 198–199), reached a very spacious frontality. But *papier collé*'s chief merit is that it freed color from the subordinating and constraining relationships it had to the figure's outline. Braque distributed his monochromatic flat areas without making them coincide with the limits of the denoted object. In *The Guitar* (see page 241), the brown tone of the wood was indicated by a cutout placed arbitrarily on the drawing of the instrument. The form of the guitar (indicated in pencil) and its color (indicated by the cutout paper) are two separate signs that combine only in the spectator's mind. "Here we clearly managed," stated Braque to Dora Vallier, "to dissociate color from form and to see its independence in relationship to form, for this was the important thing: color acts simultaneously on the form but has nothing to do with it." Color and texture were now elements of specific information, indications that "spoke" for themselves and gave information on the referred object *according to their own code*. Formerly when the artist outlined the represented object, this was

Georges Braque. *Man with a Violin*. 1911
Cubism reached the limits of the figure's molecular explosion. A reorganization was announced—in terms of surface and no longer in terms of representation

Utagawa Kunisada. *The Actor Onoe Tamizo*. c. 1842

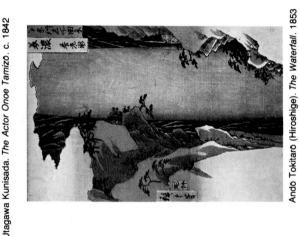

Ando Tokitaro (Hiroshige). *The Waterfall*. 1853
By its perspective straightening (the same treatment for the foreground and the distance) and by its frontal arrangement of decorative elements, Japanese art inspired both Henri Matisse (see pages 190–191) and Gustav Klimt (see page 96)

174

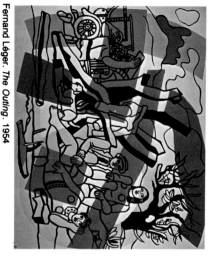

Fernand Léger. The Outing. 1954
Léger distributes his flat color areas with no consideration of the objects denoted on the canvas. No longer does color have a signaling purpose; it functions exclusively to enliven the surface

Luca Cambiaso. The Preparation of the Cross.

Herbert Bayer. Alphabet. c. 1927
In the sixteenth century as in twentieth-century Bauhaus typography, it is often the delineating shadow that creates the illusion of volume. The object represented (cross or letter) does not distinguish itself from the white support

a means of *holding* it, of submitting it to the supposed coherence of the referred object. Now there was a *play* between the components of the sign and their spacing out, and this articulation multiplied the possibilities of the effects. At the same time, color, having acquired its independence, autonomized line. The artist drew on the colored areas, and his lines—his graffiti—freed from the constraints of the *effect of reality*—developed according to their autonomous rhythm (see pages 180 above left and 181). They were perceived as transparent since their displacement caused them to be inscribed on surfaces independent of the figure they denoted.

We shall see that this practice of displacing was not new in the history of art. As early as the fifteenth century painters had confronted it when they had attempted to solve the contradiction that—according to Pierre Francastel—weakens Leon Battista Alberti's system: the opposition between a strict delineation of the outline of objects and the undulation of colored areas that are superimposed in order to represent light (which—in the referred object—exceeds the limits of the object it illuminates). In the sixteenth century—especially in drawings and washes—the artist did not hesitate in order to allow shadow brutally to cover the outline by a *passage* of a darker (or lighter) tone. Poussin's frontalized washes in the seventeenth century—as well as those of Luca Cambiaso (left)—heralded Cézanne's constructive method. Here the shadows, far from being softened, acquire an effective plastic existence. It is they that qualify the object whose outline is no longer indicated. At the Bauhaus, Herbert Bayer returned to the principle of the delineating shadow for one of his alphabets (left). The process became general in the eighteenth century, especially with the Tiepolo family, and in the nineteenth century with Francisco Goya, Honoré Daumier, and Gustave Doré. Constantin Guys made it the determining element of his drawing style. As for Impressionism, it pulverized light into a sowing of clear spots, a "camouflage" that drowned and *disqualified* the denoted object. Cubism completed and hardened this tradition. The fruit of specific manipulation—bricolage onto the area of contemplative thought"—the *papier collé*, by definition monochromatic and independent of pigmentary texture, made the independent application of the colored flat area tangible and apparent. The cutout arrangement preceded the denotation of objects. The artist organized his papers on the surface *before*

changing them—by adding a line—into a referential sign. The approach was abstract and formal *before* becoming representative. As a result, the *papier collé* took part in the "synthetic" conception inaugurated by Juan Gris in 1911. Another innovation: the cutout flat area broke with the traditional economy of representation: as to designating the color of the object, a *sample* of it was enough—even though the spectator had to extrapolate the whole by beginning with the fragment. Fernand Léger drew the consequences of the method when he threw freely on the canvas—like *an addition or an expense*—a few independent layers of lively tones (left). So likewise did Raoul Dufy, a virtuoso of the "soft-focus effect." So did Piet Mondrian, whose geometrized spots, free of any referential sign, float in the heart of the canvas, disassociated from their old outline (see page 208).

Traveling along very different roads Henri Matisse achieved the frontal autonomy of his plastic components, thanks to an effort of continuous emancipation—anticipated in *The Joy of Life*, stated in *The Dance* (see page 176) and the decorations for the Barnes Foundation, and reaching fulfillment in the striking *papiers collés* of his old age (see pages 228–229). He went from a closely denotative outline that enhanced the iconic sign to the arabesque. Here the source was not Paul Cézanne but Émile Bernard and Paul Gauguin, themselves nourished in the techniques of the stained-glass window, enamel, Japanese curves, and the underlying circular tectonic quality of Ingres' work. The paradox was that by increasing the outline to excess that the Synthetists freed themselves from representation. Their black borders became autonomous and ambiguous surfaces: they participated in both the represented and the nonrepresented contiguous to it. This is an antirealistic process contrary to Leonardo da Vinci's advice: "Therefore, O painter, do not outline the body with a line!" This process with Jan Toorop, Henry van de Velde, and the art of 1900 led to interlacings with vegetable connotations.

With Henri Matisse, the deployed arabesque assumes and at the same time calls upon the entire surface. The canvas rises before our eyes like the silent smack of a flag. Everything suggests a synchronic approach, an instantaneous reading: the chromatic unity of the flat areas, the use of a single background colored from top to bottom on the canvas (see pages 198–199), the verticality of the ground (see page 196), and the absence of shadow. "A painted surface ... should offer the eye a surface

seen in gaps in the work, in the very heart of the scene represented, in order to remind one —as Cézanne did—of the material basis of painting. The fact of the canvas' fabric as an object was accentuated by the hollowed out lines in *reserve* (see pages 226–227). Speaking of the virgin surfaces in Chinese painting, Bertolt Brecht stated that "in these empty spaces, the paper or the linen stands out with very special value. The artist is not content to deny the surface by covering it entirely. The mirror in which something is reflected retains its value as a mirror, implying among other things a happy renunciation of the complete submission of the viewer, whose illusion can never be total." But if the *distanciation* (the struggle against the viewer's alienation) happens at the expense of the effect of reality and if the *reserve* is to acquire its full critical dimension, a disturbance of the perspective scheme must simultaneously question the image. With Cambiaso and Poussin, we have seen that Classical drawing is rich in virgin surfaces that easily integrate into the Euclidean space to denote, for example, the dazzling effect of reflection or the paleness of distance. Except for invading an important part of the surface area, like a metastasis, what is lacking is then reintegrated into the projective system as form or depth. The disruptive violence of the *reserve* is reassimilated by the machinery of illusion. Even if the canvas were bare of any inscription—or if it offered a perfectly homogenous surface, like certain monochromes of the 1930s and 1950s—the phenomenological perception would continue to create gradients. The selective functioning of the optical nerve does not permit absolute frontality. We tend toward it but never achieve it.

The work is not only made up of canvas support and inscription on the surface, but also is *soil*. During the second half of the nineteenth century, one saw the emphasis of the assumption of the pigmentary texture that gradually exceeded a denotative function to release a meaning unto itself and at the same time a new chain of connotations. Painters such as John Constable, Jean-Baptiste Huet, Charles-Françoise Daubigny, Auguste Ravier, Adolphe Monticelli, Gustave Moreau, and Vincent van Gogh in his dark period or in his *Sunflowers* and his *Saint-Rémy Nights* gradually assumed this textural independence from iconic significance. Where Leonardo da Vinci saw a battle scene in the spots on a wall, the painter began to see a play of spots in a battle scene. Asked to name what he was painting, Gustave Courbet—who preferred the palette knife, which favors a "wide swath"—had to interrupt his work, step back,

resistance without which it is unbearable." Taking to its extreme a method of construction frequently seen in Cézanne's backgrounds, Matisse distributed over the space of the canvas the same decorative theme (rosettes, a herringbone motif, small flowers). This principle of a unifying pattern, of a homogenous and repetitive decor (left), he found both in the Oriental tradition (left) and in transcriptions of Chinese, Egyptian, Persian, and Arabic motifs on the wallpapers produced by the English Arts and Crafts movement of Charles F. A. Voysey and Arthur H. Mackmurdo, which was itself inspired by Owen Jones' systematic recension in his work *The Grammar of Ornament*, published in 1856.

The more a structure simplifies itself, the more the eye tends to prolong it along the surface of the wall. With Matisse one sees this imaginary lateral development of the painting fully worked out. In the decoration for the Barnes Foundation (left), Matisse deliberately limited the outline of his figures —large arabesques suddenly are interrupted by the wall—to enable one to follow them mentally beyond the space in which they are inscribed. Robert Delaunay's circular *Harmonies* can also be conceived as gears extended infinitely over a vertical axis—like Constantin Brancusi's *The Endless Column* (left)—as can the Futurist paintings that clearly indicate the liberation of the picture frame (see page 307). On the other hand, Mondrian significantly tempered this process during the period in which his style freed itself from Cubism (1913–1916). He softened the edges of the canvas in order to prevent the contamination of the neighboring wall and to close the pictorial object on itself (see page 206). But soon—after the parenthesis of 1920–1922 when the black lines did not always reach the edge of the painting—the artist allowed an effect of proliferation of his orthogonal structure into the space beyond the frame; this increased with an incomparable authority.

Thus modern painting seemed to grant the edges (frontiers) of its works an expansion that, on the contrary, it tried to throttle in depth. Mondrian, for example, believed in 1919–1920 that "natural plasticity, natural roundness, the corporeal quality of objects give us a purely materialistic vision, whereas their flat aspect makes them appear much more interior. The new painting arrives at the conviction that modeling, whatever it may be, materializes painting."

An apparently absolute weapon in the fight against perspective depth and the fiction of modeling was the awareness of the canvas support. The raw canvas or its priming is

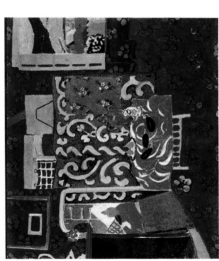

Henri Matisse. *Interior with Eggplants*. 1911–1912

Abu Zayd Helps to Recover a Camel. Arab manuscript. Fourteenth century
Borrowed from Oriental art, the methodical repetition of a decorative theme, such as a small flower or a herringbone pattern, on the entire surface ensures its frontality

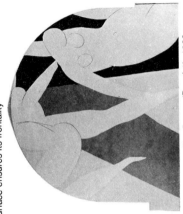

Henri Matisse. *The Dance* (Panel 1). 1932

Constantin Brancusi. *The Endless Column* (Final Version). 1937
The artist works with the spectator's imagination and asks him to extend his *Endless Column* infinitely into space. Or, like Henri Matisse, he invites him to complete his dancers cut off by the frame

Władysław Strzemiński. Unist Composition, No. 10. 1931

Paul Cézanne. Rocks at Bibemus

The white paper acts both as surface and as the material of the objects denoted

and scrutinize his canvas before exclaiming, "It's a bundle of sticks!"

By tightening his focus, Claude Monet devoted huge paintings to very restricted themes. He made a world out of a detail and a detail into a world: rock fragments, extremities of the flower beds, the dividing line between the bank and the water on a few yards of river. Germain Bazin has pointed out the mineral, almost porous character of Monet's *Cathedrals*. "His painting becomes a kind of cement as though imitating material, even old stones." The heavy and dark flows of Cézanne's Expressionist phase were soon relayed by many "accidents in production"; scars, smudges, erratic zigzags of the paint brush that disturb the relative unity of the surface (sky, sea)—as though by the insistent reminder of his *hand*, the artist wanted to avoid the spectator's being caught in the trap of illusion. This presence—thick, opaque, inert—this superpresence of a pigmentary layer creates a "tactile" apprehension in the spectator, who is projected into the triturations, the "cooking" process of the artist at work. Granular, viscous, oily, the consistency of the medium suggests manipulation and by projection enlivens for the spectator the way the painter applies, spreads his *substances*. Cubism's cerebralism has been so strongly emphasized that in the end the viewer fails to perceive its inventiveness in the use of materials. Nevertheless, this development was striking in Braque, for example, who began by exalting the texture of the object to be painted and then made the painted object a texture. "When fragmented objects appeared in my painting about 1909, this was my way of approaching the object. . . . I began above all by making still lifes because in the still life there is a tactile space, I would say almost manual. . . . This responded to the desire that I always had to touch things and not only to see them. . . ." Three years later, this "tactility" became pictorial. Braque inserted strange materials into his work: sand, sawdust, ashes, iron filings, and coating plaster. "I saw how much color depends on material . . . and what greatly pleased me was precisely the 'materiality' offered to me by the various materials that I introduced into my paintings."

This was the starting point of a vast exploration of a work's textural effects. Paul Klee developed an infinitely variable questioning of the significance of the process of pictorial production by comparing dozens of strange materials—fabric against cardboard, graffiti on a thick ground of cardboard (see page 219), a concave canvas invaded by plaster, and so on. As early as

1912 young painters in Russia swore only by *ploskost* ("surface") and by *faktura* ("texture"). That same year, David Burliuk recommended "the study of surfaces," which he divided into three main structures: granular, fibrous, and lamellate. In early 1914 Vladimir Markov devoted an entire book to texture while producing his first nonfigurative counterreliefs in common materials (see page 129). In 1918 Alexander Rodchenko obtained rich effects by contrasting two blacks—the one materialized by a "rough surface, the other by a lustrous surface, covered with a heavy coat of varnish with plaster added." Painting, as the theoretician Nikolai Tarabukin explained at that time, should "create gustatory and olfactory sensations." Hence the strange scene described by the writer Benedict Livshits offered in 1912 by a young Russian avant-garde artist, "After punching a hole in his latest canvas, Vladimir [David Burliuk's brother] dragged it along the path and threw it into the liquid mud. . . . He immediately covered the lumps of clay and sand that had stuck to the surface with a heavy coat of paint and, *similia similibus*, his landscape became the flesh of the flesh of the land of Hylaia" [a region bordering the Dnieper River in the Ukraine, its name deriving from the Greek word *hylē* meaning "wood" or "forest"].

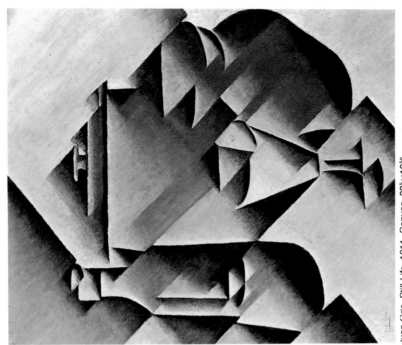

Juan Gris. *Still Life*. 1911. Canvas. 23⅜×19⅝"

The theme submits itself
to the discipline of a linear yoke

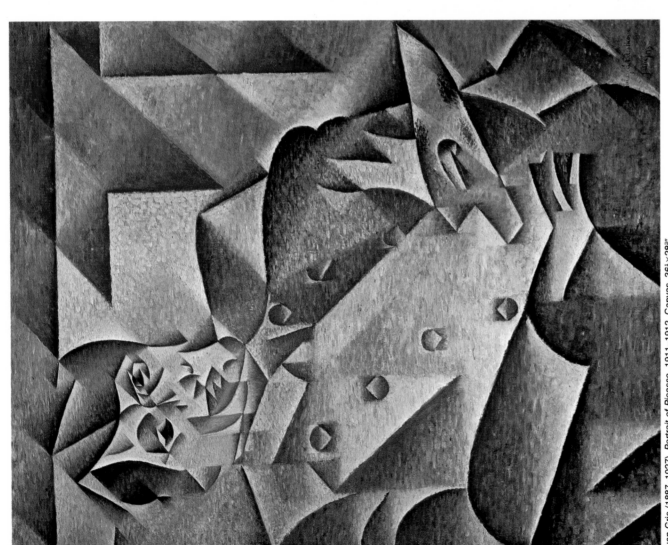

Juan Gris (1887–1927). *Portrait of Picasso*. 1911–1912. Canvas. 36¼×28¾"

Juan Gris. *The Artist's Mother*. 1912. Canvas. 21¼×18¼"

In 1906, at the age of nineteen, Juan Gris arrived in Paris and there he closely followed Cubism's gestation *in situ*, the Place Ravignan. However, the Spanish artist did not show his work in public until five years later when he was certain of making an original contribution to what his predecessors had developed. Exhibited at the Salon des Indépendants in 1912, his *Portrait of Picasso* (above left)—called by the critic Louis Vauxcelles "supremely stupid"—created a sensation. Not only was it a homage to the artist who inspired it, but also it was a softened expression of a new surface conception of which Gris' still lifes of the same period offer the most radical formulation. For several months, just before the beginning of 1912, Gris was one of the most advanced artists in

Europe—along with the Robert Delaunay of the *Windows on the City, No. 4* (see pages 168–169) and the "gestural" Umberto Boccioni of the *Farewells* and of the first version of *Moods; Those Who Depart* (see pages 294–295). Bringing Paul Cézanne's intuition into fruition, Gris created a painting in which the full and the empty areas are strictly equalized (above right). A unitary thread controls the surface. The object represented submits to the yoke of a diagonal line. The reticular structure takes precedence over the subject represented. In this *Still Life* (above right), Gris anticipated Piet Mondrian's frontal lines (see pages 206–209).

However, as early as 1912 the process lost some of its systematic severity. The *Portrait of Picasso* (above left) contains accentuated edge effects not repeated

throughout the entire painting, and it also has a gradation from blue to brown (from bottom to top) that contributes to creating an illusionist depth. Yet the oblique lines make up the face, the jacket, and even the buttons whose positions have been systematically alternated. The spectator will find the centered composition of Picasso's portrait once again in Gris' *The Artist's Mother* (right). In this work the strong lines connected to the corners of the canvas architecturally construct the face, inscribe it on the surface, and subordinate it to the discipline of the construction. The features of the model have been crushed in order to avoid an effect of relief: the work has been created with that very apparent texture of horizontal strokes that recalls Georges Seurat's sketches.

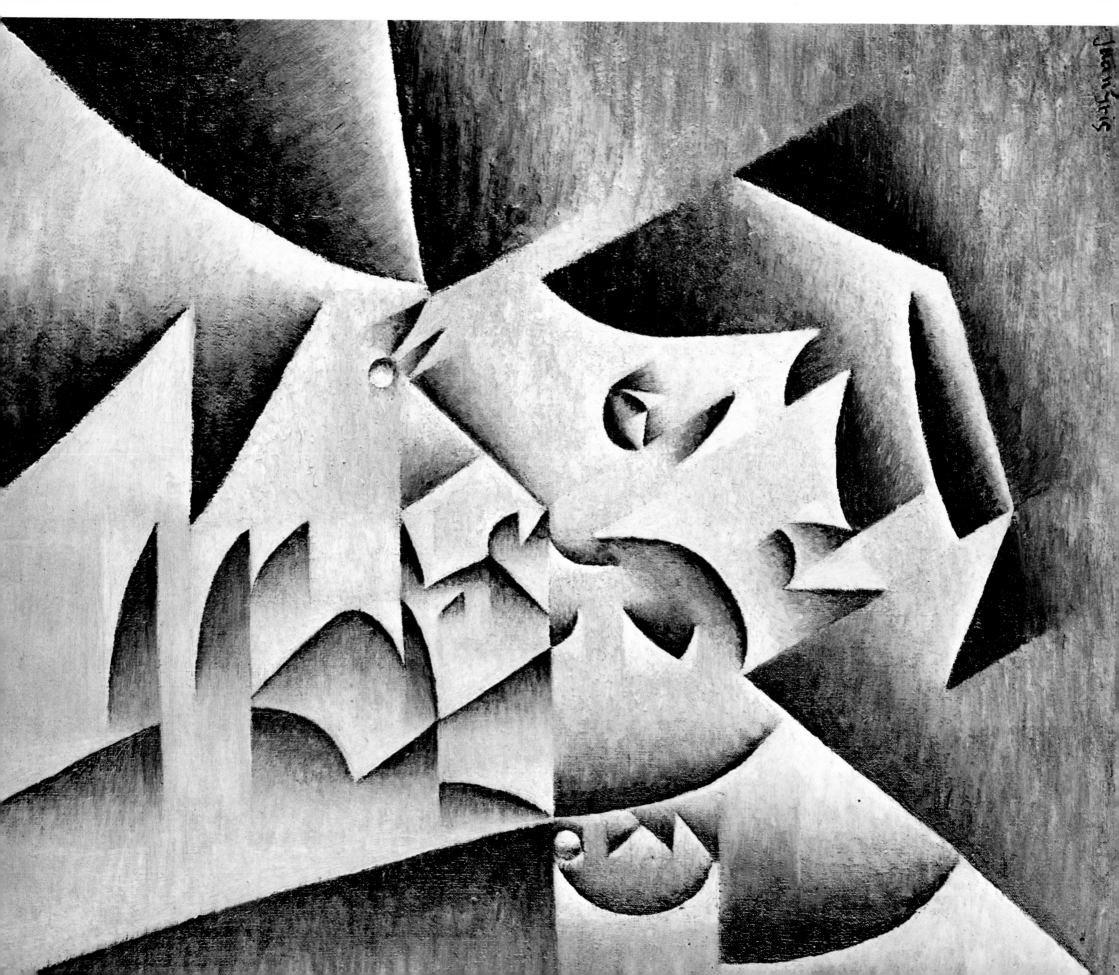

The frame dictates the shape
of Picasso's rectangular
silhouettes

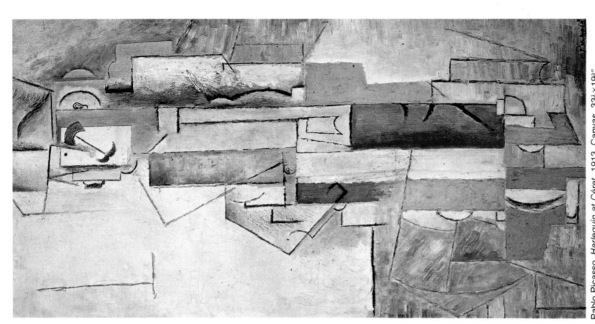

Pablo Picasso. *Harlequin at Céret*. 1913. Canvas. 33¾×19⅝"

Although by different processes, the same geometrization transforms Pablo Picasso's figures into heavily juxtaposed rectangles. The figure tends to become parallel to its frame and to its supports.

According to the art historian William Rubin, allusion definitely supplants illusion. Picasso executed these rectangles in oils (below left), glued canvas (above), plain paper (above left), and newspaper (right). In the *Head of a Young Girl* (below left), Picasso used cutout and painted canvas with a reworked surface, including the hair whose outline was obtained by cutting it with a pair of scissors—a technique that can appear uselessly complicated. Why not work directly on the canvas? But at this stage of its development, Cubism emphasized the manipulation, the

fabrication of the work. The puttering about stresses the anti-illusionist aspect of the image, and Picasso has even attached one of his *papiers collés* with a pin. Paradoxically, the fake wooden comb is used not to imitate plywood but to draw hair.

In *Man in a Hat* (right) the geometrized flat areas aid the dissociation of the drawing in charcoal and the color area. The newspaper represents the lighted part of the face, the blue part being in shadow. The almost identical lines in the parallel blue and newspaper rectangles denote two profiles with but a single mouth. This freedom in the dissociation of components of an image is exhibited again in the *Head* of 1914 (above left) and results from an extreme fantasy.

Pablo Picasso (1881–1973). *Head*. 1914. Charcoal and *papier collé* on cardboard. 17⅞×13⅜"

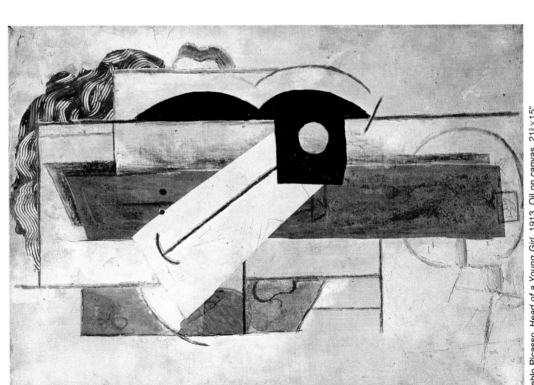

Pablo Picasso. *Head of a Young Girl*. 1913. Oil on canvas. 21⅝×15"

Pablo Picasso. *Man in a Hat*. 19 Charcoal, ink, *papier collé*. 24¾×1

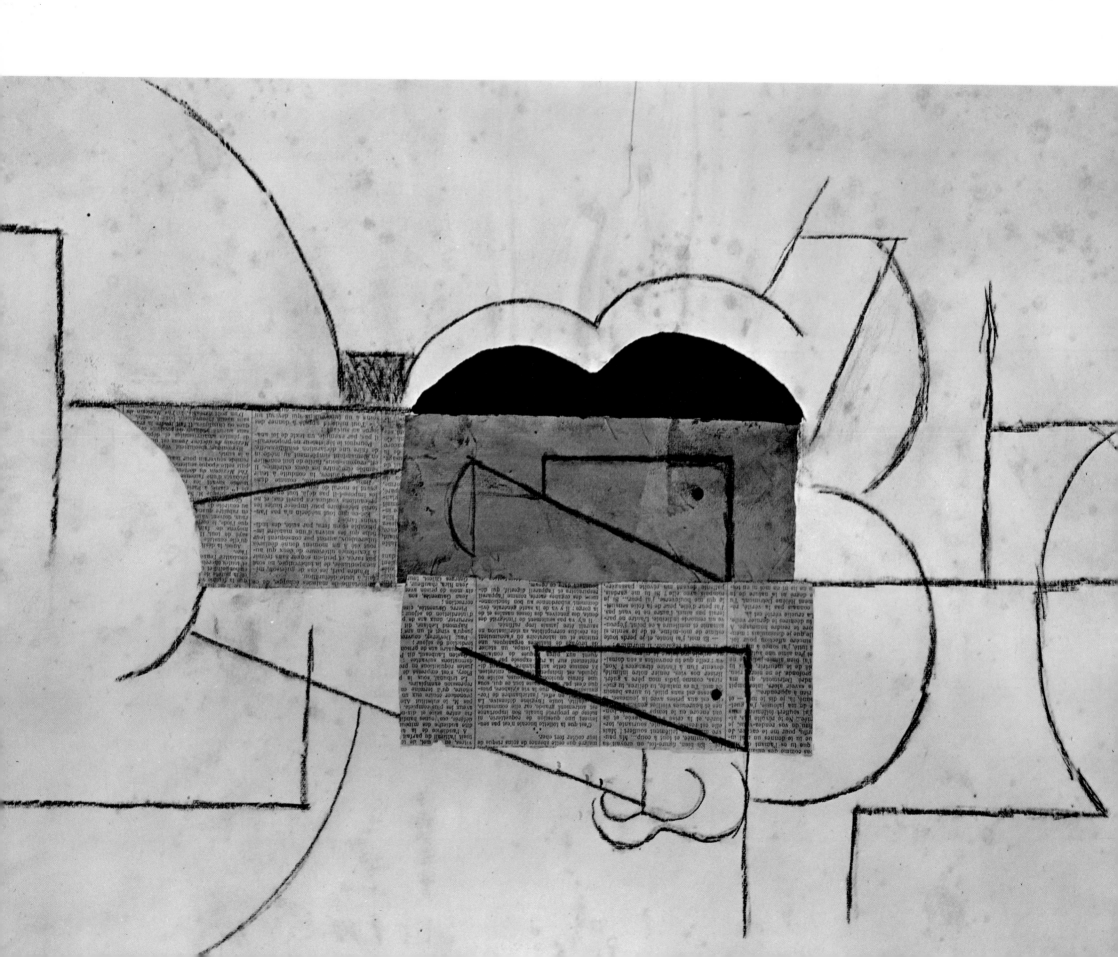

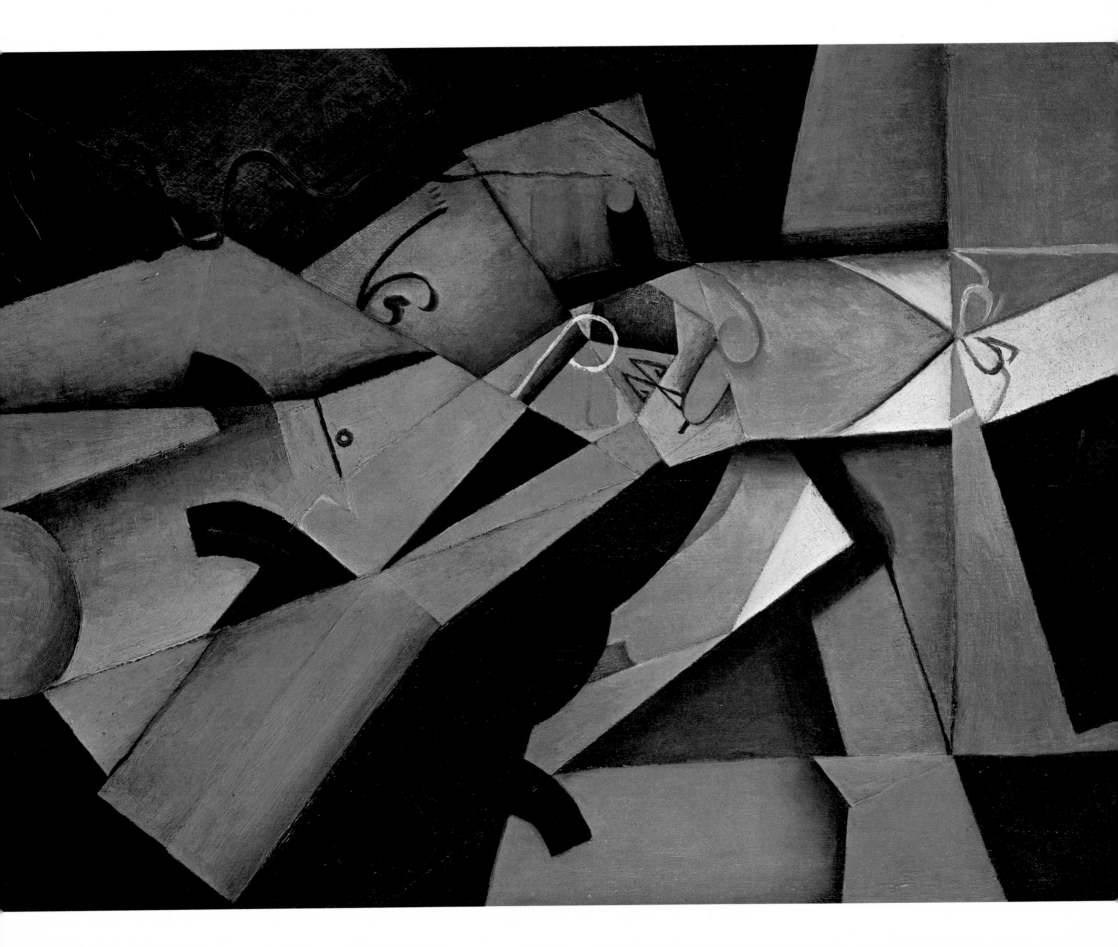

Juan Gris gave his model in *The Smoker* (left) a double treatment: he made the figure flat, bringing to the surface the neck, an ear, the chin, and other features. He then broke the figure up into colored areas that he juxtaposed not according to the logic of the figure but according to the requirements of his plastic organization. This organization is based on two contrasting systems: at the bottom and on the left there is a stabilizing play of horizontals and verticals that repeats the frame, and in the center there is a linear fanlike deployment whose departure points are grouped slightly below the center of the painting. The colors, chiefly green and blue, have been distributed, for the most part, arbitrarily, without consideration of the model. For example, the hat has been treated in three tones, and the face of the model in five or six. Into this puzzle Gris inserted a few effects of relief in the neck, the hat, and elsewhere. The stylized smoke in the upper part of the painting on the right, lighted on a single side, seems to be an allusion to the meanderings common in art about 1900.

In his *Man Leaning on a Table* (right) Pablo Picasso also submits his model to a geometrical severity, but not without humor. The head, which has been simplified to the extreme, is no more than a rectangle planted with two white dots for eyes that are scarcely larger than the infinite number of dots that occupy much of the surface of the painting. Picasso's large-scale work has taken over the techniques of *papiers collés*, and it presents itself as a collection of false cutouts made by hand. The leaning motion of the man is indicated by a few diagonals in the middle of the painting to the right, and the feet of the armchair are indicated by vertical friezes at the bottom that suggest sawed wood. Here also colors are independent of the model. The artist has carefully avoided giving any particular tone to his figure. By spreading confusion, he wants the painting to be seen first as surface and structure and then as image. Here is a work at the very limits of representation. Only the eyes point to the existence of an iconic reference. A frame painted with false coffering, with forms that overlap here and there, doubles the painting's effective edges.

The work's internal logic explodes the coherence of the model

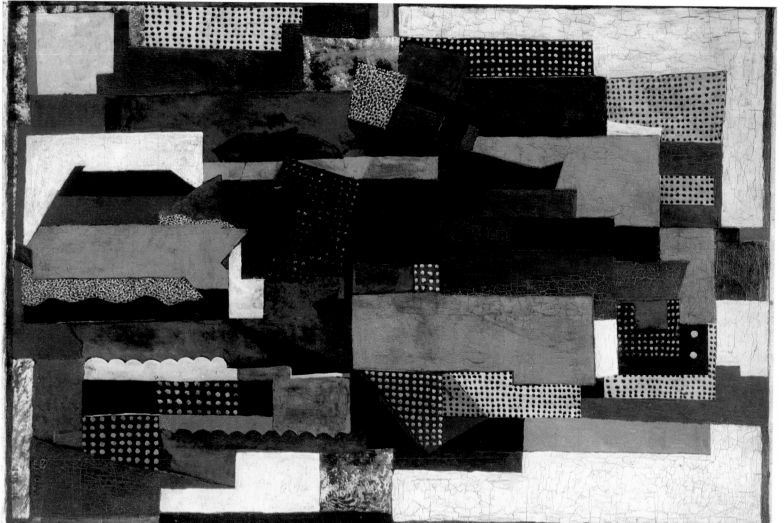

By accenting the structural primacy of the work's components, whereby the interdependence of forms is more important than the discipline of representation, Cubism created a tabular conception of image. From now on, half rebus, half poster, the work, freed from all referential logic, all "natural" coherence can be seen as a painted *assemblage* of miscellaneous objects distributed according to the artist's whims. This is the fortuitous encounter not long before claimed by the poet Lautréamont "of a sewing machine and an umbrella on a dissection table." In Kazimir Malevich's *An Englishman in Moscow*, one of his alogical and pre-Dada compositions—illustrated to the left—a church, a saber, a candle, a pair of scissors, words, a saw, and a ladder all coexist on the most diverse scales.

In *M'amenez-y* (below) Francis Picabia has arranged motor parts treated in perspective along with a deliberate and rather poor play on words—"*ratelier d'artiste*." To express the frontality of his *Homage to Apollinaire* (right), Marc Chagall planted his Siamese twins (Adam and Eve) on the flat area of a target inspired by the researches of his friend Robert Delaunay.

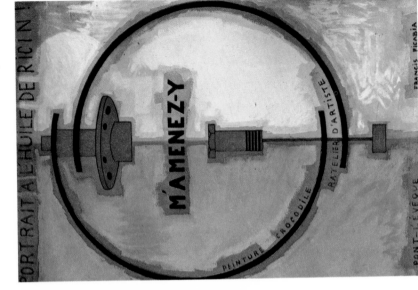

Francis Picabia (1879–1953). *M'amenez-y.* c. 1918–1920. Oil on cardboard. 55⅞ × 40¼"

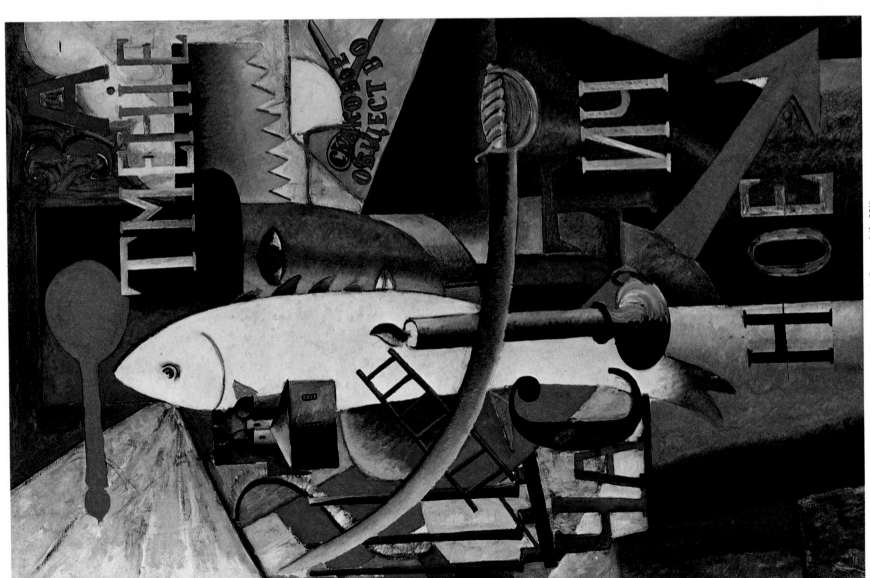

Kazimir Malevich (1878–1935). *An Englishman in Moscow.* 1913–1914. Canvas. 34⅝ × 22¼"

The alogical and tabular juxtaposition of objects breaks with the systematic organization of Classical painting

Marc Chagall (born 1887). *Homage to Apollinaire.* 1912. 78×74"

A planimetric pattern gradually absorbs represented figures

If one compares one of his nudes to another, it is fair to say that Frantisek Kupka went from a symbolical, expressive, and volumetric conception of the human body to a much more geometrized version inscribed in the orthogonal harmony of the background. On the one hand, the very realistic human figure in *Dancer* (below) rises against a decorative background completely foreign to it, and on the other hand, the reclining figure in *Planes by Color, Large Nude* (right)—constructed from frankly arbitrary flat colored areas—absorbs the planimetric system based on horizontals and verticals that controls the entire canvas by

softening it. *Dancer* reveals the conflict of an artist who stemmed from the Baroque culture of Central Europe (note Kupka's signature) and who turned to more and more audacious and conceptual formulas in the milieu of the Paris crucible. Contrasted here in the same canvas are the two directions that Kupka in turn devoted himself to during the years 1909–1912: a solution to the representation of movement that anticipated those of Marcel Duchamp and the Futurists, and a geometrical and lyrical abstraction that made him one of the principal precursors of modern art (see pages 286–287).

Frantisek Kupka (1871–1957). *Dancer*. 1907. Oil on canvas. 21⅛×18⅛"

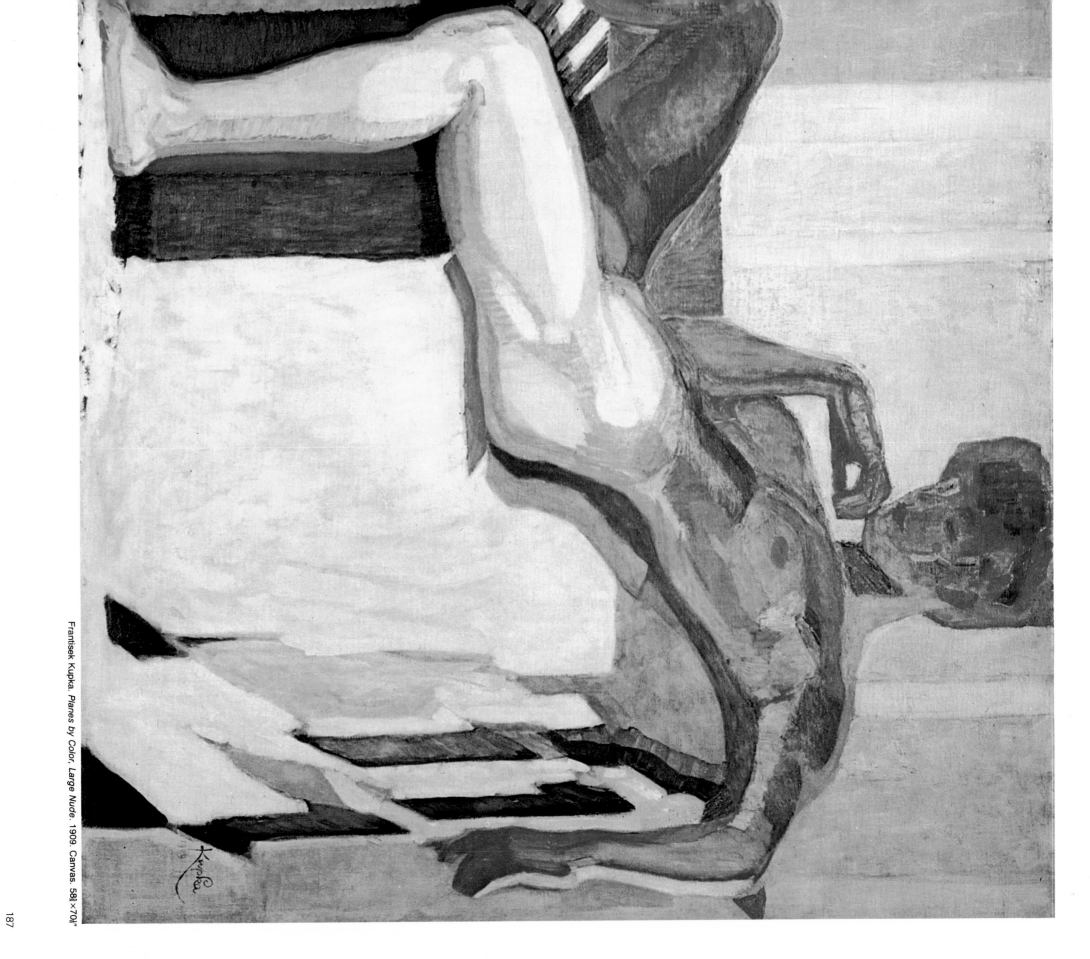

František Kupka. *Planes by Color, Large Nude.* 1909. Canvas. 58⅜ × 70⅞"

Frontality declares itself through a play
of vertical green tree trunks or through a hollowing out
of the pigmentation

Maurice Denis (1870–1943). *Landscape with Green Trees.* 1893. Canvas. 17¾×16½"

Two conceptions of frontality are visible on these two pages. For Maurice Denis, Paul Gauguin's heir, the theoretician of the Nabis, and the apostle of Synthetism, a painting was above all, according to the famous phrase of his manifesto of 1890, "a flat surface covered by colors assembled in a certain order." In his painting of 1893 *Landscape with Green Trees* (left), Denis put the accent on flattening the represented space, contracting the perspective, obliterating details, and elongating without gradation the green verticals that represent tree trunks.

For the Russian painter Michael Larionov, on the contrary, frontalization intervenes on the level of a work's texture. In his painting of about 1905 *Rain* (right), the rain is the pretext for an arrangement of trembling but continuous lines, parallel to the frame, that bluntly break with any naturalistic rendering of a shower. These lines were obtained through hollowing out the pigment, which reveals here and there the canvas underneath the coating that the artist has partially covered with trails of white paint. Whereas Denis sought his surface effect in the treatment of representation, Larionov found it by working directly on the very surface of the canvas.

Michael Larionov (1881–1964). *Rain.* c. 1905. Canvas. 33¾×33½"

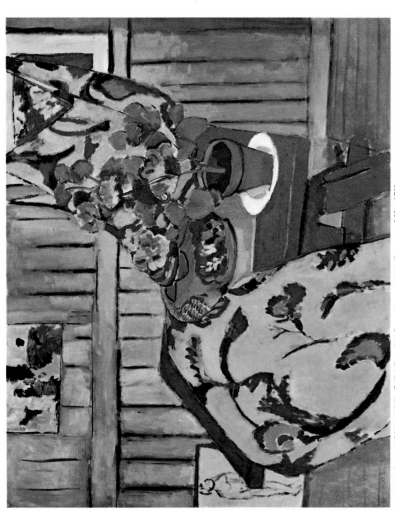

Using the same piece of fabric as a subject, Henri Matisse made two paintings, both illustrated here, that represent two different solutions to the problems of frontality. In 1925, Matisse said, "Cézanne, you see, is a kind of god of painting. In times of doubt, when I was still seeking my way, often frightened by my discoveries, I used to think: if Cézanne is right, I am right, and I know that Cézanne was never mistaken." With the drapery in his *Still Life with a Geranium* (above), Matisse used a cascading effect typical of Paul Cézanne. The table is lowered toward the viewer, and the dish and the pot of flowers are treated according to two different viewpoints. The painting visible in the upper right of the composition comes forward from the two parts of the fabric that partly conceal it, as does the blue triangular spot nestled in the feet of the table, whose central bar has a vertical line that seems to belong to the floor. A play of interlacing arabesques binds together in a common harmony the geranium's flowers, its leaves, and the textile's decorative motif. This deliberate mixing up of the viewer's perspective references favors the flattening out of the image.

Matisse chose to employ a much more radical solution in his *Coffee Pot, Carafe, and Fruit Dish* (right). Here the surface is almost entirely covered with a unified decor of open arabesques, a very deliberate, very significant motif that emphasizes the atopical, even centrifugal aspect of the work in contrast to the Cubist still lifes and portraits of the same period (see pages 142–143 and pages 148–149). The idea of composition becomes inoperative the moment the artist, according to an ornamental tradition borrowed from the East, methodically repeats the same motif over the entire surface of a work. In this painting Matisse escapes total frontality only through the volumetric rendering of the dishes and pot in the center and through the opening on the right that breaks the surge of the arabesques. This opening itself, however, has been treated with a very sophisticated ambiguity: a few brushstrokes that move beyond its outline bring it back to the picture plane and throw doubt on its depth.

A chintz drapery fills up the entire painting

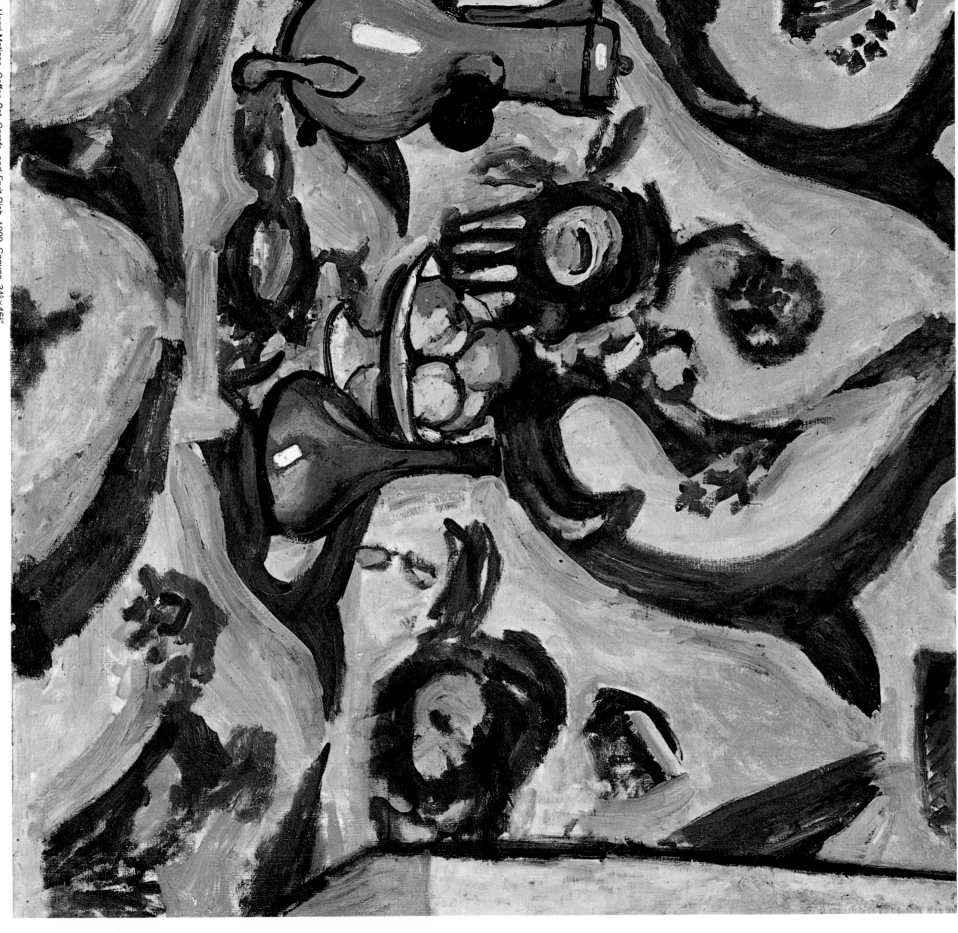

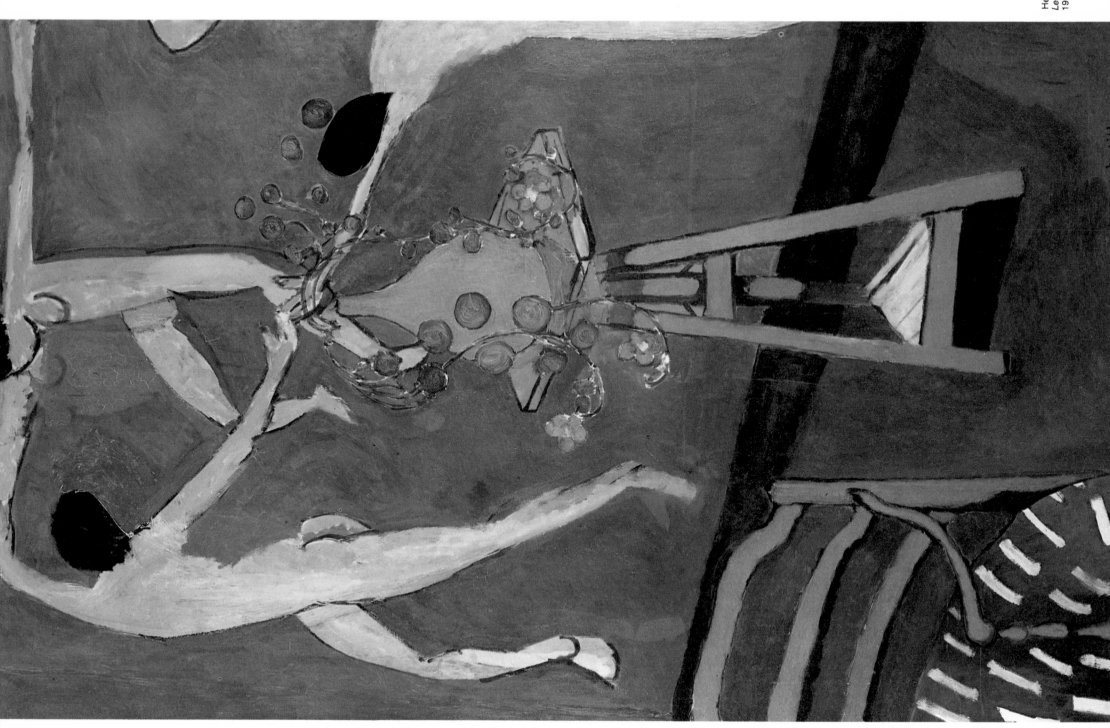

From 1909 to 1912 Henri Matisse, using choreographic, athletic, or musical themes, produced a series of paintings that rank among the founding works of modern art. Two of these paintings, both entitled *The Dance* and made within a few months of each other in 1909 and 1910, mark the stages of a rhythmic and chromatic simplification rendered more operative by the huge size of the canvases. The first version (right) is in the Museum of Modern Art, New York, and the second version (see pages 194–195) is in the Hermitage, Leningrad.

"I knew," Matisse wrote in 1934, "that my musical harmony was represented by green against blue (representing the relationship of green pine trees against the Riviera's blue sky) and that to complete the effect I needed a tone for the figures' flesh. What appeared essential to me was *the*

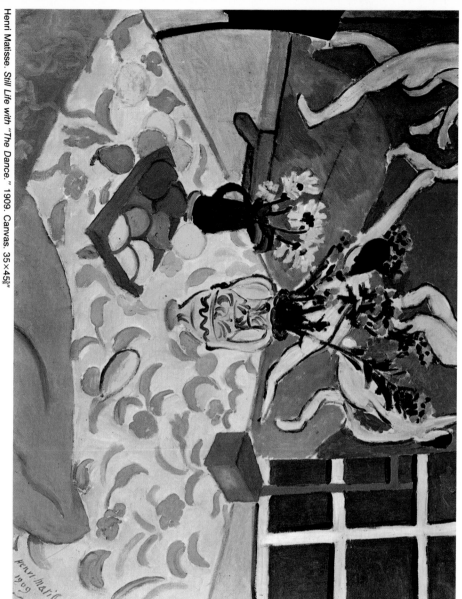

Henri Matisse. *Still Life with "The Dance."* 1909. Canvas. 35×45⅝"

Matisse's Dionysian impulse results in the quantitative expansion of colored areas

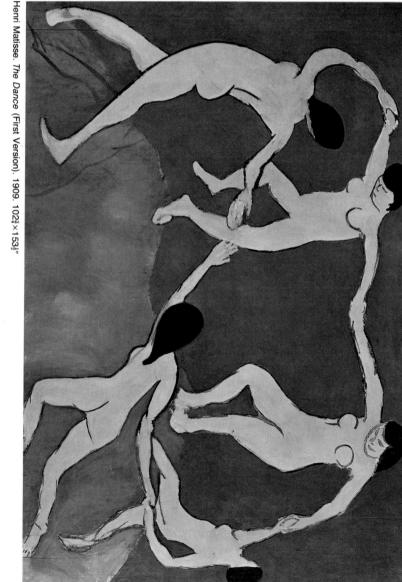

Henri Matisse. *The Dance (First Version).* 1909. 102¾×153½"

quantity in color surface." Immediately before beginning the first of these huge works, Matisse visited the Moulin de la Galette, to watch the dancers performing the farandole (a popular dance of Provence). "The dancers holding hands run across the room, gathering up the people who are a bit lost. . . . It's extremely gay. . . . On returning home I composed my *Dance* on a surface measuring almost 13 feet, singing the same tune that I heard at the Moulin de la Galette."

Using a technique that became more and more characteristic of him, Matisse made his own works the motifs of new paintings—as in, for example, *Les Capucines à la Danse* (far left) and *Still Life with "The Dance"* (left). In these works his paintings play an ambiguous role because they have both surface (like material objects) and depth (like represented scenes). In *Les Capucines à la Danse* the painter has deliberately revealed his numerous changes in his treatment of the dancers. Here he has placed his nudes against an evenly blue background. The curvilinear distribution of the flowering stems adds to the Dionysian lightness of the entire design.

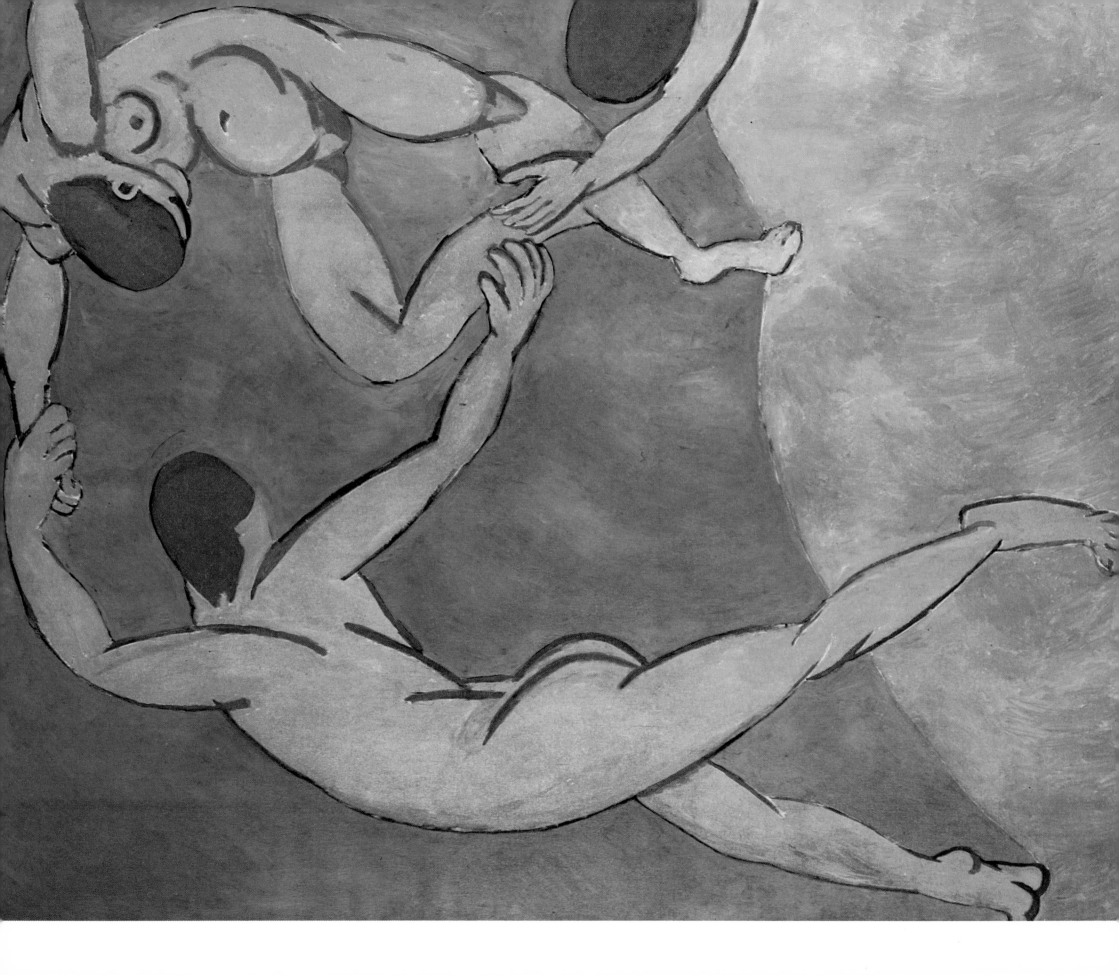

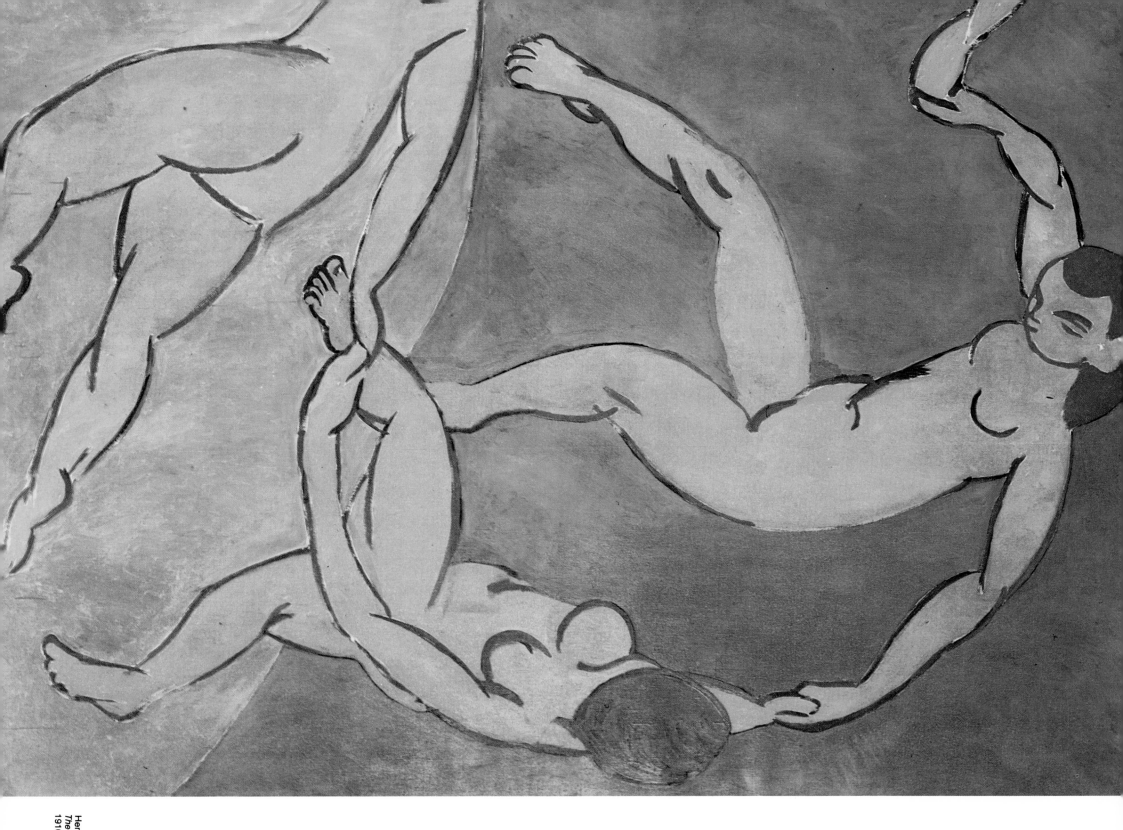

By dividing the surface of his paintings into wide monochrome bands, Henri Matisse was able to do away almost entirely with the representational details of nature. Before it becomes a field or a lawn, his painting is a juxtaposition of flat areas arranged side by side. What the work loses thereby in description, it gains, however, in texture. In order to make his colored areas more active, Matisse adopted the same method he used in the second version of *The Dance* (see pages 194–195), now in the Hermitage, Leningrad. Instead of spreading the paint uniformly, he played "a bit with the brush, varying color thickness in such a way that the white of the canvas showed through more or less in transparency." When the blue representing the sky in *A Game of Bowls* (lower left) risked sinking into depth, he made two distinct, though very close, bands of color.

Kazimir Malevich in his *The Bather* (right) emphasized, not without "brutality," Matisse's entire technique, as he had been able to study some fifty paintings by Matisse—especially the two illustrated on this page—in the famous Shchukin and Morozov collections in Moscow. Outlines are heavily emphasized, the nude is employed as a theme that favors using the arabesque, traces of pencil markings show changes in the legs, and the surface is entirely occupied by the figure as in *The Dance*. In this work Malevich insists on brushstrokes and material accidents, and serene French painting is upset for the benefit of a primitive style inspired by Michael Larionov (see pages 106–107), who, for example, led Malevich to dress up this figure with two powerful right feet.

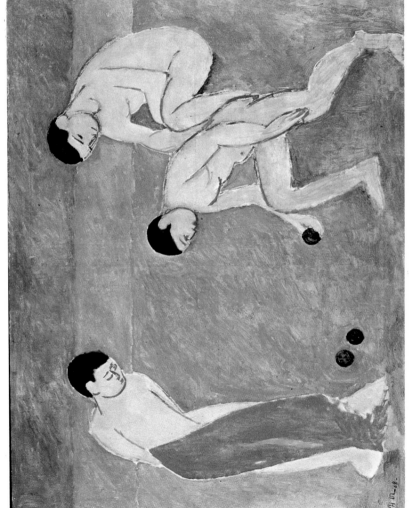

Henri Matisse. *A Game of Bowls.* 1908. Canvas. 46¼×57⅞"

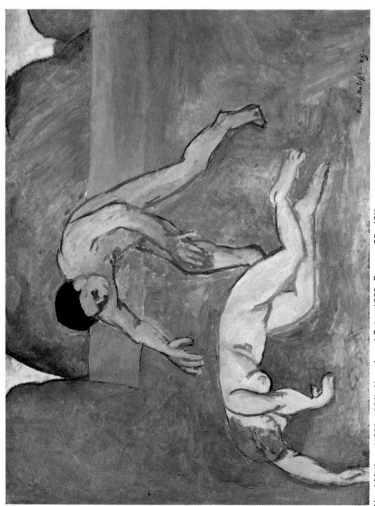

Henri Matisse (1869–1954). *Nymph and Satyr.* 1909. Canvas. 35×46¼"

The "little play of the brush" concretizes and enlivens those areas without figures

Kazimir Malevich (1878-1935).
The Bather. 1910.
Gouache on paper. 41⅞×25¼"

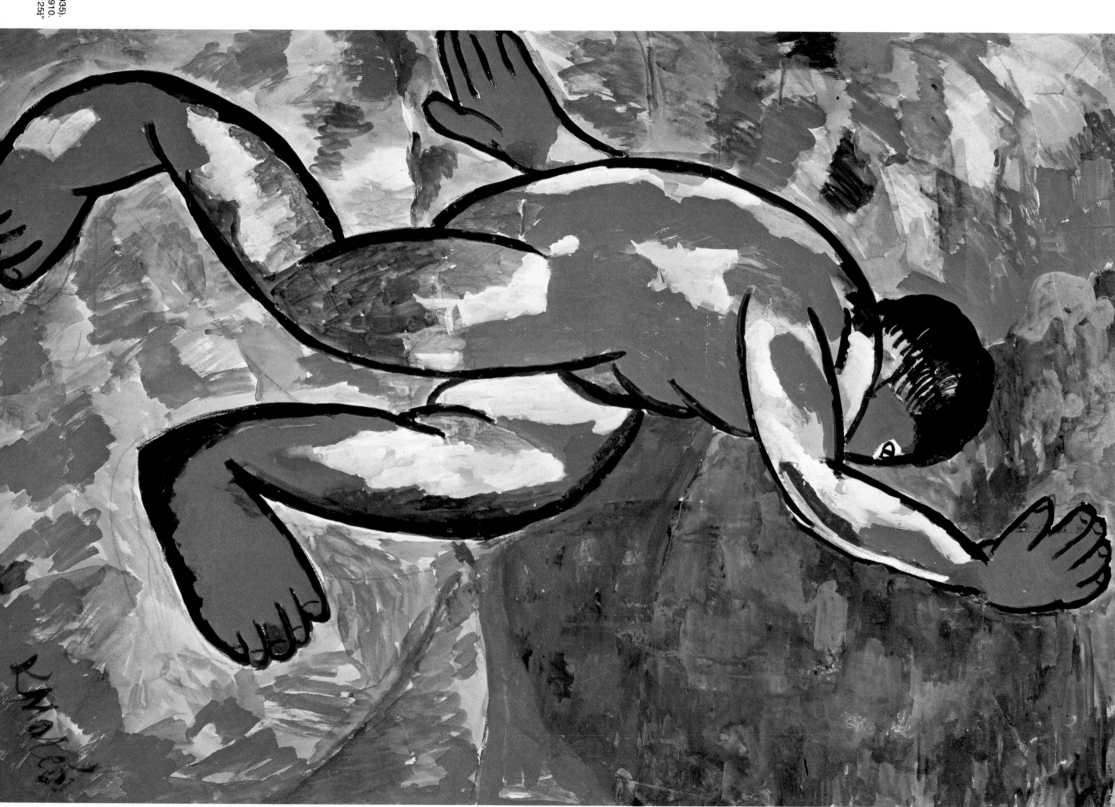

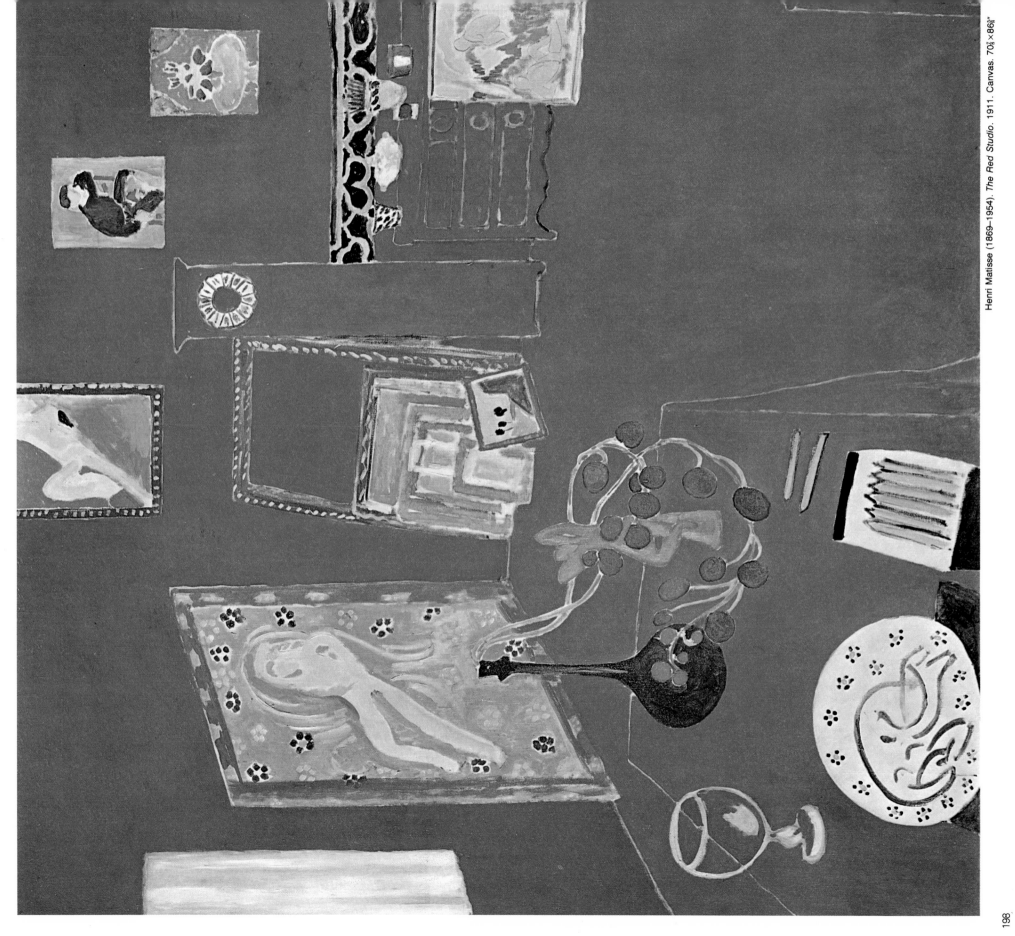

In a bold way that outdoes Edvard Munch's most ambitious lithographs and woodcuts, Henri Matisse reversed the order of pictorial components. It is no longer the objects, surrounded by a background, that are important, but rather it is the background, the emptiness—large, spacious, and airy—that becomes the real theme. The large, flat, red area of *The Red Studio* (left), which covers the canvas almost without gradation, contains narrow furrows to denote the table, the chair, the clock, and the buffet. The white of the support, heightened here and there with brushstrokes, serves to demarcate outlines. Objects are drawn *in reserve*, the artist being satisfied not to cover the edges that outline and constitute them.

Throughout this canvas, and without diminishing the importance of the total composition, Matisse has placed various works of his own in sparkling color areas. He speculates on our visual habits. He crams into the pigment what the viewer tends to bring into the foreground and places in the foreground the color that the viewer spontaneously reads as background.

In Matisse's plunging view of the Cathedral of Notre-Dame in his *A View of Notre-Dame* (right), the elements represented have been reduced to a few notations: the bar and the small arch of the window mingle with the deck and arch of the bridge, and on the right the spectator sees the reflections of the balustrade decor. The effect of light on the cathedral has been obtained by *reserving* the surface and allowing the canvas to appear. As in *The Red Studio*, it is the monochrome background—in this case, blue— that ensures the work's importance.

From the top to the bottom of the painting, a single color

Henri Matisse. *A View of Notre-Dame*. 1914. Canvas. 57⅞×37".

Inside and outside, near and far combine in rounded arabesques

The window theme, so frequently used by Henri Matisse, offered him a means of uniting in one sensation and in one formal structure the near and the far. "My feeling of space is one from the horizon to the interior of my studio room. . . . The walls of my window do not create two different worlds." In *The Blue Window* (right), the very controlled opposition between a series of rounded motifs and a horizontal-vertical discipline (parallel to the frame) mark the artist's desire for permanence and balance. Matisse declared in 1947: "My use of the plumb line has proved a constant benefit. The vertical is in my mind. It helps me to state the direction of the lines, and, in my quick drawings, I do not indicate a curve, for example that of a branch, in my landscape without being aware of its relationship with the vertical. My curves are not crazy."

Criticizing Impressionism, Matisse remarked that "a quick translation of landscape only gives a moment of its duration. By insisting on its character, I prefer to risk losing its charm and to gain more stability." This stability has also been achieved by the reduction of colors to a dominant one—here a blue that in its darker parts (the trees) recalls *Bonjour, Monsieur Gauguin*, a self-portrait painted at Pont-Aven in 1889. Yellow, green, and red spots are repeated and frontalize the space; the sculpture,

the base of the vase on the left, the fruit in the fruit dish, the plate or doily in the foreground, and the illuminated façade of the studio at the far end of the garden are of the same cream tone.

Color, for Matisse, calls upon a bodily response. "Paintings that are refinements, subtle gradations, energyless blendings call for handsome blues, reds, and yellows, materials that stir man's sensual instinct. . . . A blue, for example, along with a radiation of its complementary colors, acts on feeling like a strong blow of a gong."

In *The Window (The Yellow Curtain)* of 1915 (left) the landscape is summarized in a few curves framed by light green. The curtain folds are the only allusion to perspective depth, which is fought by the black breakouts, falsely negligent, below the image; the white lines that indicate the presence of the canvas in reserve under the flat colored areas; the overlapping green in the lower part of the window; and finally the landscape limited to two tones denoting on one hand the sky and the pond and on the other the vegetation. Matisse stated in 1908: "Everything that is not useful in a painting is, in itself, harmful. A work includes a harmony of the whole: in the spectator's mind any superfluous detail will take the place of another essential detail."

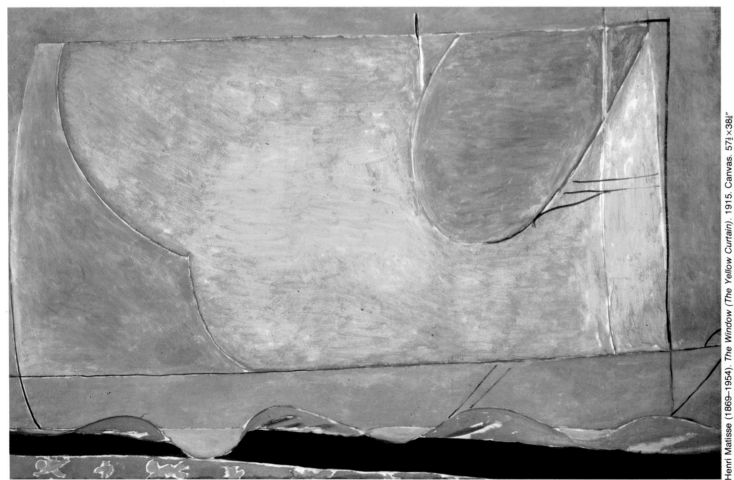

Henri Matisse (1869–1954). *The Window (The Yellow Curtain)*. 1915. Canvas. 57¼×38⅛"

Henri Matisse.
The Blue Window.
1912. Canvas. 51×35⅝".

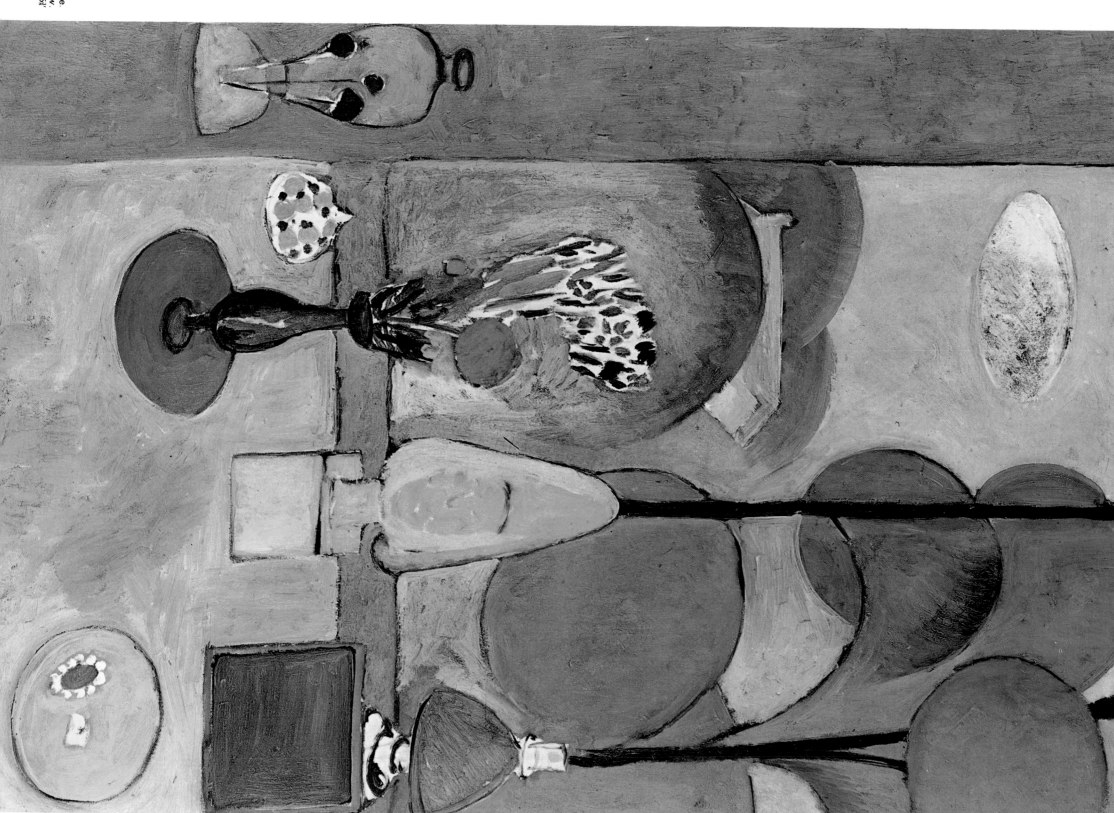

his son Pierre seated at a Pleyel piano (as inscribed in reverse), surrounded by a painting (in the upper right), a metronome, and a sculpture (in the lower left). When we consider the textural and chromatic reality of the canvas, we realize that it is the gray areas, operating edge to edge, that qualify the painting within the painting (including the figure in it), the open window space, and the interior walls. There are no shadows or gradations. The full or truncated triangular forms of the metronome, the face, the green area, and so on offer a diversity to the strict horizontal and vertical lines. The black open frieze of the balcony is repeated in the open music stand. "A moment arrives," wrote Matisse in 1908, "when all the parts have found their definite relationships, and from that moment on it would be impossible for me to rework anything in my painting without redoing it entirely."

Matisse never went so far again in the reduction of subject matter as in his almost abstract painting *French Window at Collioure* (right) in which a few oblique lines suggest the shutters. The space consists almost entirely of a dark blue area in which the viewer sees, through a lateral lighting, the outline of a wrought-iron balcony. When creating this work, Matisse at first painted in all the details of the window, but he suppressed them in the course of his last sessions. This technique suggests a palimpsest art in which the work of elaboration and development is not entirely effaced in the final result. The *French Window at Collioure* is an enterprise related on the one hand to the blacks that Matisse admired in Édouard Manet and on the other to the black square that Kazimir Malevich was developing in Russia at the same time to represent what he called "the sensibility of the absence of the object." It is not an accident that, taking up the window motif that had served as metaphor for illusionist painting ("the painting is a window on the world"), Matisse by his treatment gave it an amphibiological status: it is a hollow, an abyss, a depth, and *at the same time* a wall, an enclosed space, a frontal coating of pigment. "A work of art," Matisse wrote in 1908, "should have its own complete significance and impose it on the spectator even before he knows the subject. When I see Giotto's frescoes in Padua, I am not concerned about which scene in the Life of Christ I am looking at, for I immediately understand the feelings aroused in me: they are in the lines, in the composition, and in the color, and the title merely confirms my impression."

In Henri Matisse's *The Piano Lesson* (above) the vertical layout of the surface has achieved its maximum expression. We are very close to what a painting by the American Abstract Expressionist artist Barnett Newman will offer thirty years later: a monochrome area cut by lines that assures the *mural quality* of the color, *reinforcing* it in the same way that we speak of concrete being reinforced, preventing the eye from optically creating any floating areas. Sticking to his subject, Matisse represents

Henri Matisse (1869–1954). *The Piano Lesson*. 1916–1917. Canvas. 96¼×83½"

The ambiguity of windows, whether open or walled up

In three paintings spread out over a
period of four years and reproduced
on these two pages, Piet Mondri...
committed himself successively t...
Fauve landscape (see pages 46–4...
inspired by Vincent van Gogh i...
The Red Tree (above left) in whic...
he emphasized the impact of colo...
on the canvas by an arbitrary
palette reduced to the sustained

Piet Mondrian.
Apple Tree in Blossom. 1912.
Canvas. 30¼×41¾"

The tree gradually bends
to the curved module
that gives rhythm to
the picture plane

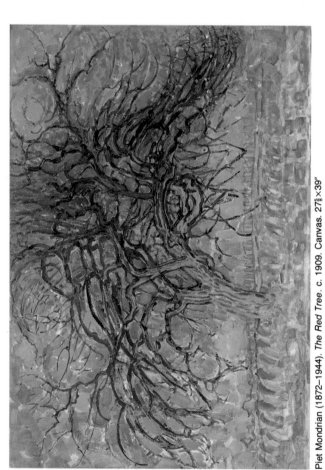

Piet Mondrian (1872–1944). *The Red Tree.* c. 1909. Canvas. 27⅝×39"

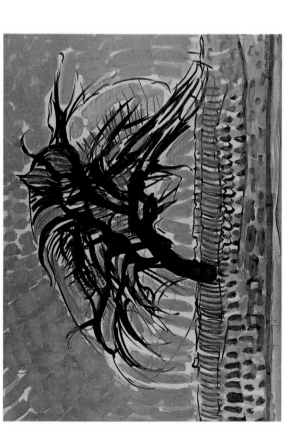

Piet Mondrian. *Tree.* 1909–1910. India ink and watercolor on cardboard. 29¼×39⅜"

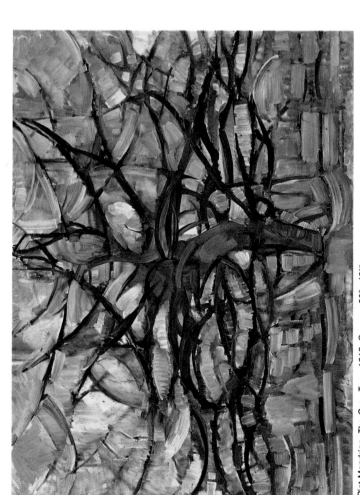

Piet Mondrian. *The Gray Tree.* 1912. Canvas. 30¼×42⅛"

contrast between the two main
tones of the red tree and the
blue background; then to an
Expressionism in *Tree* (middle left)
in which the black ink creates the
desolate and nocturnal aspect of a
Chinese scroll; and finally in *The
Gray Tree* (below left) to a formal
systemization of Cubist origin from
which the Dutch artist gradually

developed one of the most severe,
radical, and influential techniques
of the century.

In the two canvases painted in
1912 after his arrival in Paris at the
age of forty—*The Gray Tree* (below
left) and *Apple Tree in Blossom*
(above)—Mondrian developed a
system of the lateral expansion of
his drawing by an increasingly

systematic repetition of an
ellipsoidal module—a visual rhyme,
so to speak—that synthesizes the
tree branches. The problem is
displaced: the artist passes from the
representation of a "subject"
(outlined on a background) to the
occupation of the phenomenal field
of the canvas. As in the case of the
Cubists, color is sacrificed to the

clarity of the demonstration and to
the unity of the pattern. That same
year, in order to mark his new
departure, Mondrian—who was
then known as Mondriaan—
dropped one of the "a"s" in his
name.

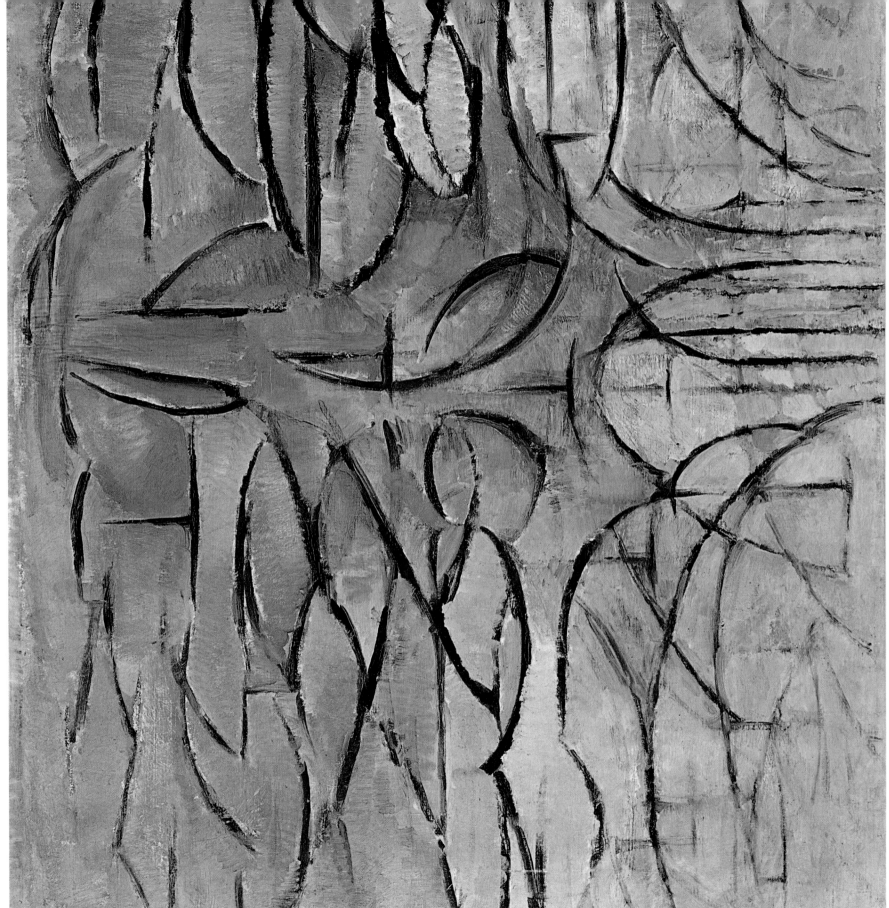

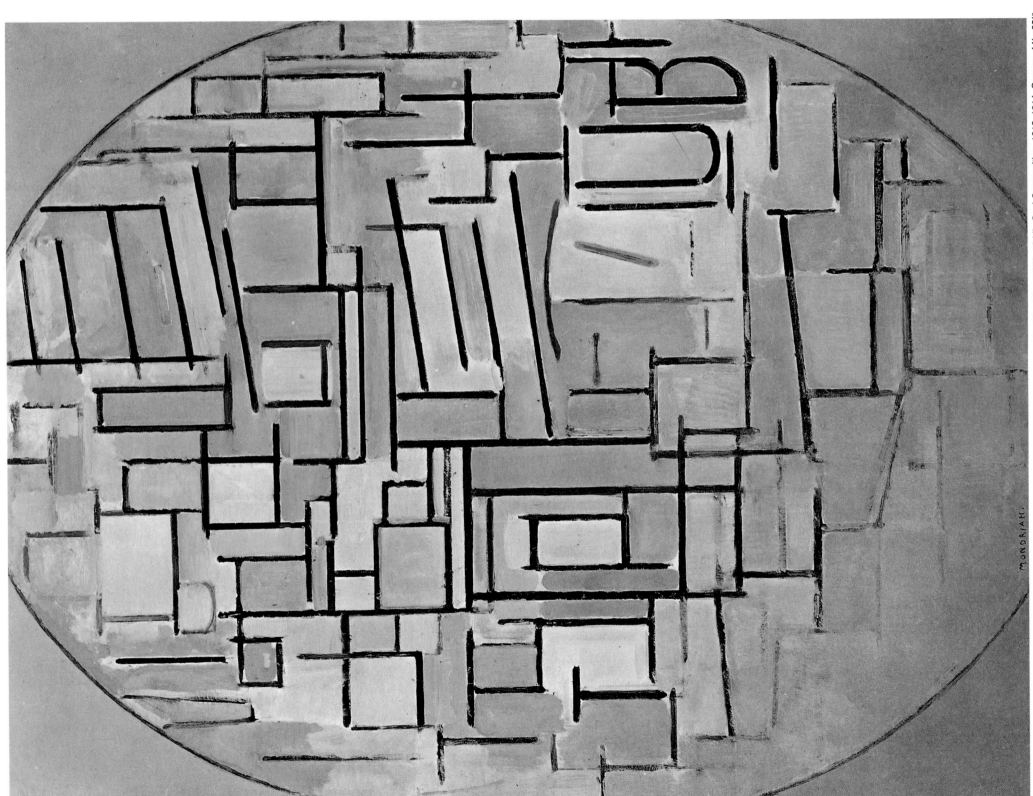

Piet Mondrian (1872–1944). *Oval Composition.* 1913–1914. Canvas. 44¼×33¾″

Continuing his methodical occupation of the picture plane with a repetitive and unitary line, Piet Mondrian turned to the facets and linear simplifications of the Cubism of the years 1910–1911 (see pages 150–153) in order to develop his constructive system of surface space. But in contrast to Georges Braque and Pablo Picasso, he tended to eliminate all atmosphere, light, and depth for the sole benefit of frontality. In 1919–1920, Mondrian wrote: "The natural roundness, in short the corporeality, gives us a purely materialistic vision of objects, whereas the flat treatment causes them to appear to us more interior." In order to reconcile his planimetric aspiration with the depth of the scene he represents, Mondrian preferred to choose two-dimensional iconographic themes—for example, as in his *Oval Composition* (left), the side wall of a house covered here and there with posters of which there remains in the painting merely the word "KUB" or, to take another example, the façade of a building in which only the balcony escapes from the horizontal-vertical homogeneity of form, as in *Composition in Gray and Yellow* (above).

For Mondrian the right angle was "the strong support." "In Nature we can note that all relationships are dominated by a single primordial relationship, that of the extreme *one* opposite the extreme *other*," wrote Mondrian in 1919–1920. "The abstract plasticity of relationships represents this primordial relationship in a precise manner in the duality of the position formed by the right angle." At the time Mondrian was painting these two canvases, the artist had not solved the problem of the limits of the work. Hence, when the spectator notes the blurred effects of the outside edges of these paintings, he can read them either as atmospheric effects (as in Impressionism) or as material effects (textural values) depending on whether he views the work as a represented scene or whether he considers it exclusively an object that refers only to itself.

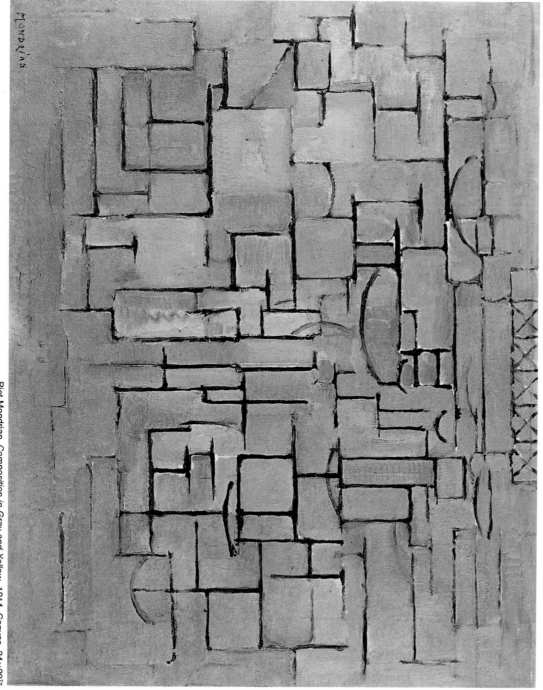

Piet Mondrian. *Composition in Gray and Yellow*. 1914. Canvas. 24×29⅜"

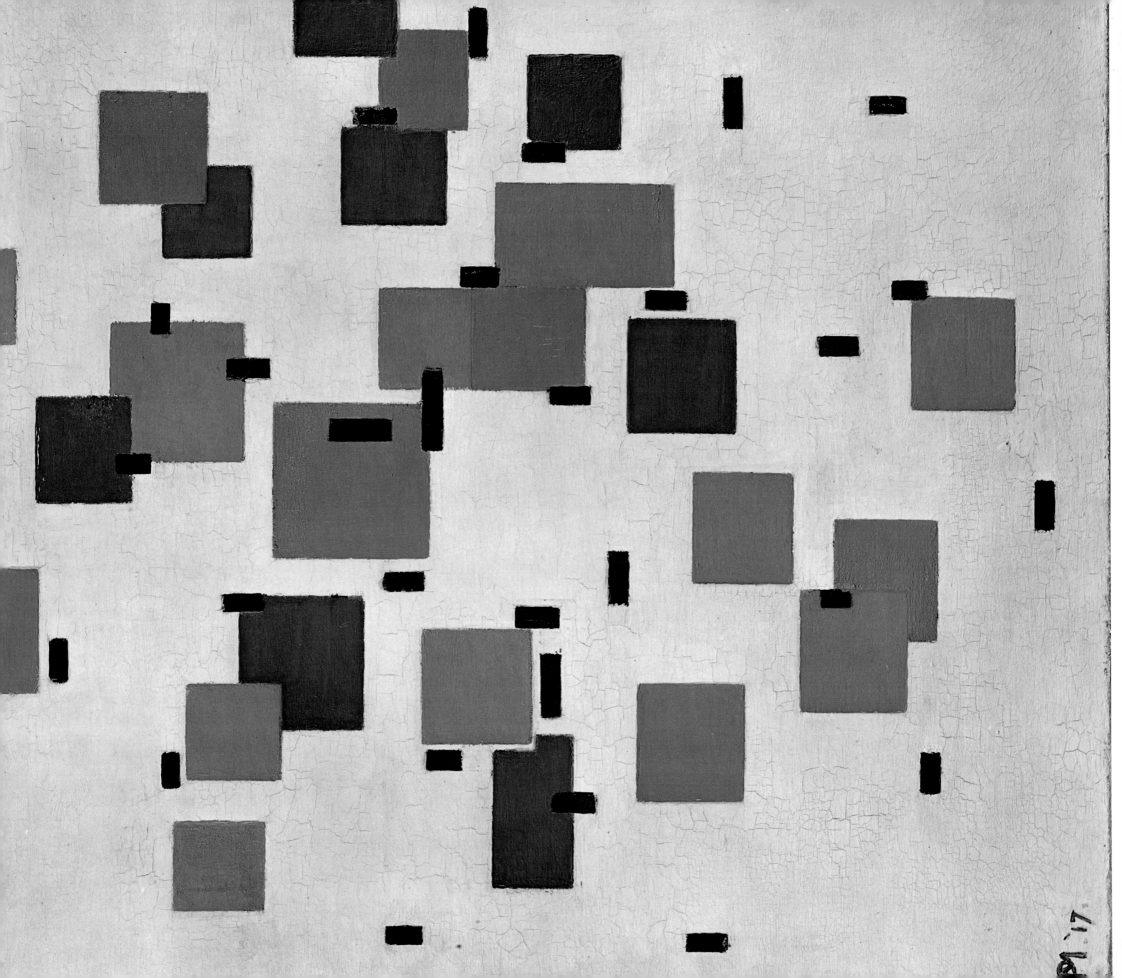

From floating squares to a regularly checkered design, the structure stiffens— only the color "speaks"

In two years, using a strictly logical process, Piet Mondrian went from a conception of a floating pictorial space to a view of it as a rigidly checkered structure. In his almost square *Composition in Color A* of 1917 (left), the orthogonal forms are distributed over a white area that acts as background. They appear to be suspended in an endless "sky," according to contradictory spacing: sometimes the blue overlaps the pink or brown, sometimes the opposite occurs. Only the small black sticks are never inscribed under the colors.

In another painting of the same year, *Composition III with Color Planes* (above right), the viewer sees a tightening of the rectangles, and white has lost its importance. The floating of the rectangles has been reduced to the point of cancellation in a work of 1918, *Composition in Color Planes with Gray Outlines* (middle right), in which the black lines, an extension of the small black sticks of 1917, enclose the forms. A geometrical pattern now controls the surface. "The meeting of the rectangles," Mondrian later explained, "merely signified the extension of the verticals and horizontals of the previous period through the entire composition." The artist tended toward the "unchangeable," "universal beauty," "repose," "the harmony of rapport," and "the balance of tensions." He tried to neutralize one by the other, as he explained in 1920, "the active and the passive, the exterior and the interior, the masculine and the feminine, spirit and matter, which are merely one

in the universal scheme of things." In 1919, in his *Composition in the Checkered Pattern with Dark Colors* (lower right), Mondrian arrived at a systematic organization of the surface whose austerity remained unequaled in his work. Nevertheless, even in the arid appearance of this grill of 256 rectangles isomorphic to the canvas, chance elements intervene to ensure an open feeling. The choice of warm tones, their unequal division, the artist's care to disseminate them throughout the canvas (he engaged in much repainting), the chromatic variations of the linear pattern separating them—all these create a lively, optically modulated surface. Here in its pure state one finds the fruitful opposition between a static, structural conditioning and the incoercible freedom of color that underlies the Dutch artist's works.

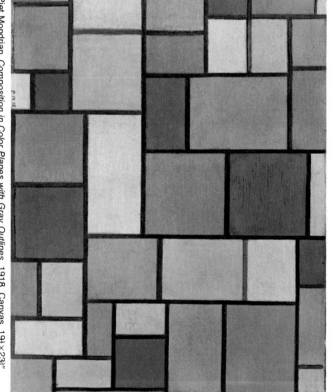

Piet Mondrian. *Composition in Color Planes with Gray Outlines.* 1918. Canvas. 19¼×23⅜"

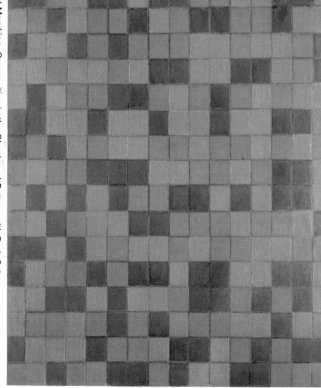

Piet Mondrian. *Composition in the Checkered Pattern with Dark Colors.* 1919. Canvas. 33⅞×40¼"

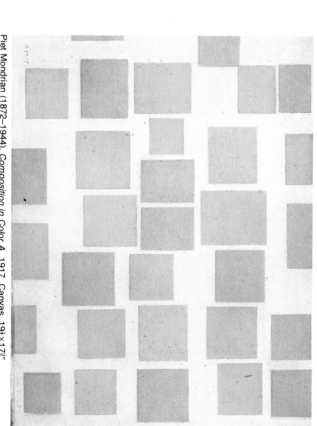

Piet Mondrian (1872–1944). *Composition in Color A.* 1917. Canvas. 19¼×17⅞"

Mondrian. *Composition III with Color Planes.* 1917. 18¼×24"

Submitted to chance or programmed, art dares its limits

Chance and the search for a "scientific" art were the two extremes of temptation after the break with Cubism left modern art in a vertiginously free situation. "Absolutely intact traditions older than Plato and Aristotle," wrote Robert Klein, "led art either to a studied approach, an act of inspiration, or an act of expression, but in every case opposed it in a radical way to chance." Jean Arp broke away from these traditions with his torn papers of 1916–1917, in *According to the Laws of Chance* (left). The origin of this work has been documented by his friend Hans Richter. "In his Zeltweg studio, Arp had been working on a drawing for a long time. Dissatisfied, he finally tore up the sheet, allowing the pieces to scatter on the floor. Later, when by chance he happened to look at the pieces lying there, he was surprised by their arrangement, which expressed what he had vainly tried to say beforehand. . . . He considered this provocation of chance an act of providence, and he carefully began to paste down the pieces in the order dictated by chance." This impoderable element that the Dadaists introduced into their work —particularly Arp but also Marcel Duchamp, Max Ernst, and others —was one of the technical sources of verbal and graphic automatization disseminated by the Surrealists.

Among the "scientific" group, Theo van Doesburg, who at the beginning had followed closely his friend Piet Mondrian's method, soon denounced its "Classicism." Even so, his *Composition XII* of 1918 (far left) resembles an enlargement of the plus (+) and minus (−) signs of Mondrian's *Composition with Lines* of 1917 (see pages 216–217). "The perfect harmony that results from this pictorial discipline was profoundly Classical, and if we dismiss the figures, a painting by Ingres or Poussin is the same as one by Mondrian . . . ," as Van Doesburg was to write later. Beginning in 1924–1925 Van Doesburg attempted to give a dynamic quality to his Mondrianesque topology by the use of oblique constructions, shifting between color and outline, activations of vision and environment. Finally, in 1930 he dared a scientist act of faith that—according to the dream cherished by the French aesthetician Charles Henry and by Georges Seurat— claimed once and for all to program all the techniques and even the effects of art.

Jean Arp (1887–1966). *According to the Laws of Chance.* 1916–1917. Torn papers. 18⅛×13"

(page 210). Theo van Doesburg (1883–1931). *Composition XII.* 1918. Canvas. 29¼×21¼"

At the very moment in which painting, following in the footsteps of Paul Cézanne, began to accentuate the surface, disturbing elements arose from the heart of this practice that modern art later included in the vocabulary of Op Art. The three-color engraving called *The Open Window* (right) by the English artist Edward Wadsworth, a member of the Vorticist movement, remains outstanding for its studied overlapping effects and its shifted checkered design that question the compactness of the picture plane and make the permanence of any form improbable. Here one finds the smudges characteristic of popular woodcuts, playing cards, and other Épinal prints up to the nineteenth century. The print, and before it the linoleum block, was the medium that enabled Expressionism to reach the optical fragmentation of the surface after the end of World War I. Bortnyik, Kassak, Moholy-Nagy, and Béothy in Hungary and Peeters, Van Dooren, and Delhez in Belgium were already following in the path of the Symbolist woodcuts of Charles Doudelet of the turn of the century. Increasingly, a contrasted cutting of the surface of the plate in a black and white rhythm led to an optical reaction that anticipated by thirty years the false novelty of Op Art.

The same optical suggestion dominates the gouache—*Composition* (left)—by the Hungarian artist Alfred Reth, who settled in Paris in 1905. In it he proposed the paradox of a fluid tiled pavement in a regular pattern that encloses and envelopes a series of vertical objects—trees or beams. On the one hand, the immediate presence of the support, especially in the foreground *reserves*, ensures the frontality of the image, which has been reinforced by light pencil lines. On the other, the perspective depth of the checkered design with its accidents and its derivatives sways the viewer in a space almost oneiric.

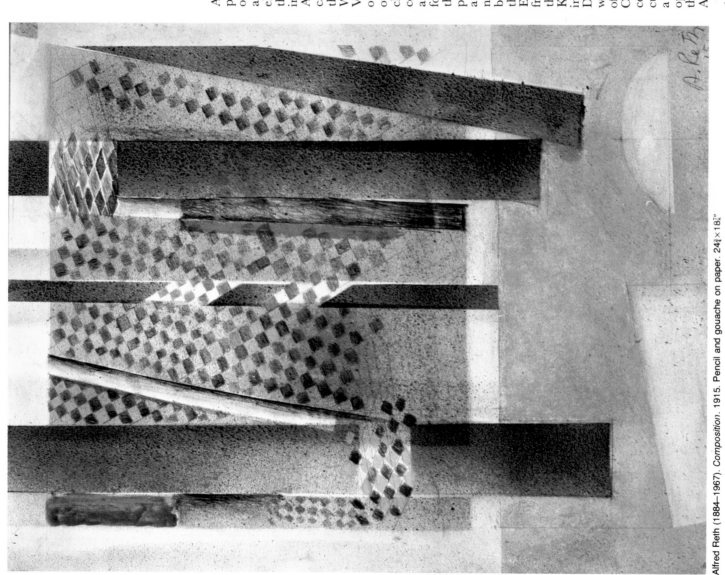

Alfred Reth (1884–1967). *Composition*. 1915. Pencil and gouache on paper. 24¼×18¾″

The image becomes confused
within the confines of geometry

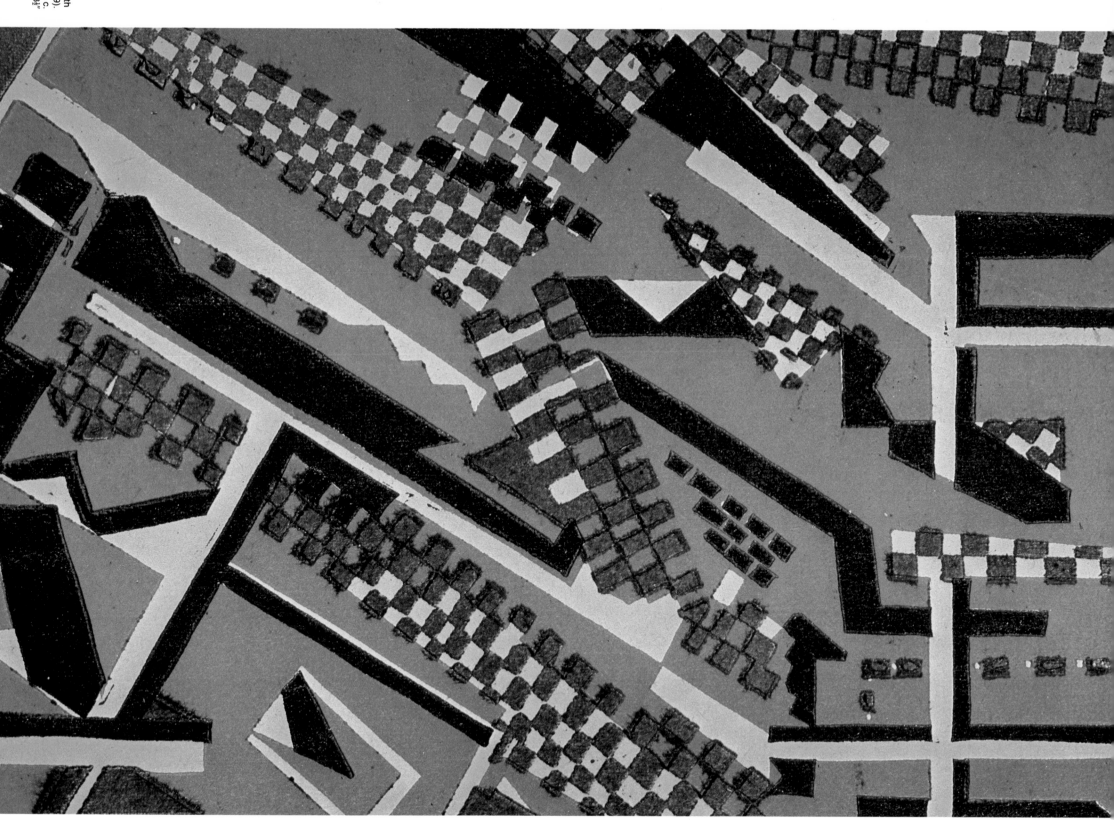

Edward Wadsworth
(1889–1949).
The Open Window. c.
1915. Woodcut. 6¼×3½"

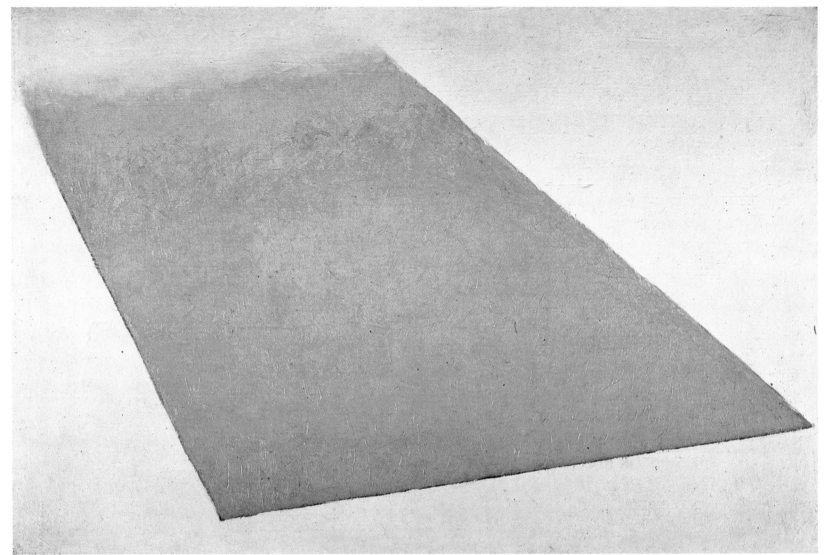

Aerolites drift
in a cream-colored sky

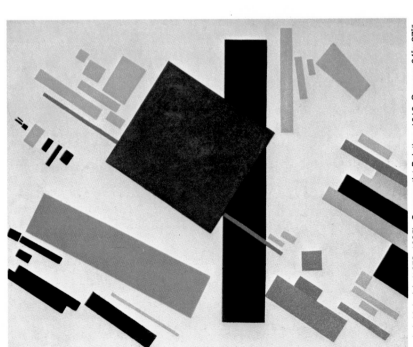

Kazimir Malevich (1878–1935). *Suprematist Painting.* 1916. Canvas. 34⅜×27⅞"

Satellites, asteroids, flotillas of comets: for Kazimir Malevich, in 1915, the canvas represented a celestial space where heavenly bodies moved in relationship to one another. Rather than a static field with balanced pictorial forms, his painting suggests a magnetic field in which the elements, detached from the laws of gravity, attract and repel one another according to the vitality of their moving masses. Any submission to weight is ignored. Unlike in Piet Mondrian's paintings illustrated on pages 208–209, there are no verticals in the three paintings by Malevich illustrated here to create gravitational roots. Beginning in 1917–1918 with his *Suprematist Painting* (right), aerolites are diluted in the ether. Malevich's cosmic reverie turned to the irradiation of represented objects. Yet the yellow plane that vaporizes as it heads for the infinitude of the sky can also be interpreted as a restatement of textural surface in which this form is engulfed by being worn away. In an act of provocation not without theoretical intent, Malevich wrote in the catalogue of the Tramway 5 Exhibition of 1915 opposite the numbers 2 to 25 that indicated his work: "The author ignores the content of the paintings."

Kazimir Malevich. *Suprematist Painting.*
1917–1918. Canvas. 41⅛×27⅞"

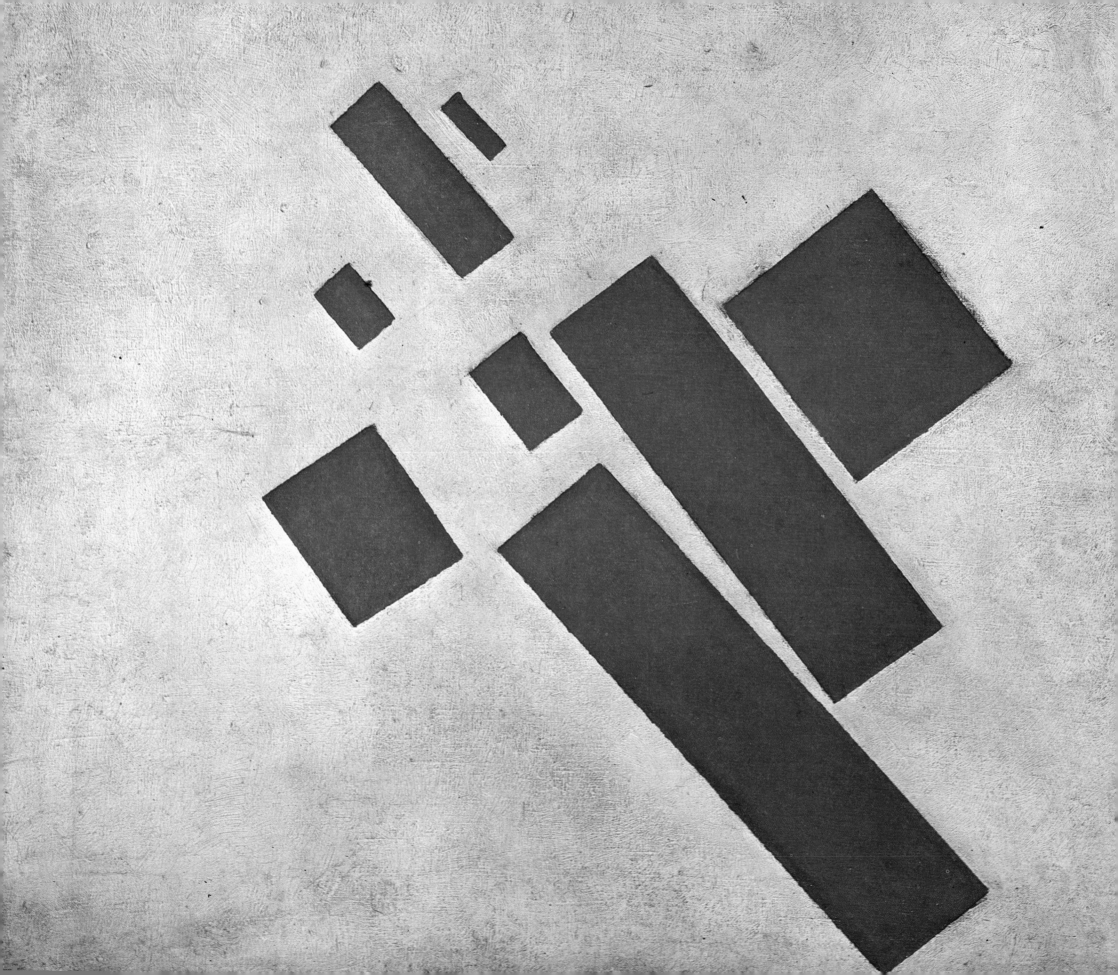

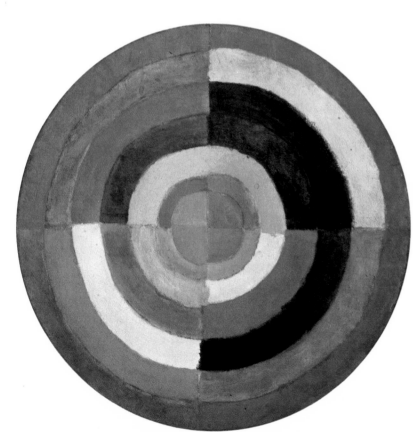

specific definition of the pictorial means by eliminating all the parasitic elements—representation, illusion of depth, compositional balance, and the rest. Art claims to be the object of its own discourse. How far can the artist erase the compositional, iconic elements, even the textural ones, of the painting without removing the very idea of the work? In 1912 Robert Delaunay proposed a polychrome target—in his *Simultaneous Disc* (above left)—without modeling, which, wrote Pierre Francastel, "reveals the awareness of painting's strictly nonobjective possibilities." With greater clarity than Wassily Kandinsky in his *Compositions* of the same period, this painting states itself as an object without reference to pure color.

Piet Mondrian began with a decanted description of the sea and its reflections and arrived—in his *Composition with Lines* (right)—at a sowing of interchangeable plus (+) and minus (−) signs. The horizontal-vertical became the basic unit of a system in which the orthogonal frontality of the lines, which are identical from top to bottom, though less numerous in the upper part, very efficiently combat the perspective depth. The work is now merely the elements of a shorthand system that have been dispersed aleatorically. Any brush effects have been canceled by the geometrizing rectitude of the small black forms. Just as Paul Cézanne's lamellate brushstrokes became obvious through their equivalence to the flatness of the canvas, so Mondrian's signs take into account the rectangular frame, the picture plane, and his subject (the sea). This arbitrary mode of inscription announced the definitive obliteration of the represented figure.

This obliteration was finalized by the *White Square on a White Background* (below left), by Kazimir Malevich, the first achromatic painting in the history of art. This limited work can be read either as surface, as a textural screen in which a form—"the last one"—is about to vanish, or as an emptiness, an abyss, an infinite mystical space in which the vague and floating square predisposes the spectator to cosmic meditation.

For Malevich, the impoverishment of the plastic organization of the work is the condition of the spectator's projections and driftings. "I transfigured myself to the zero of forms and then went beyond zero to creation, that is, to Suprematism, the new pictorial realism, the nonfigurative creation," he wrote in 1915–1916. In 1923 Malevich's followers exhibited two white monochromes, without form, suspended horizontally from the white ceiling of a gallery.

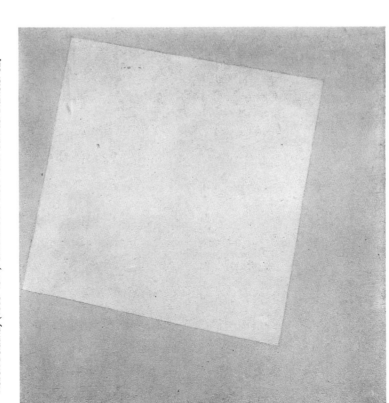

Robert Delaunay (1885–1941). *Simultaneous Disc*. 1912. Canvas. Diameter 52¾"

Kazimir Malevich (1878–1935). *White Square on a White Background*. 1918. Canvas. 30¼×30¼"

Target, square, cross: the dizziness of a "degree zero" in painting

The obsessive search for a *minimalism*, a "degree zero" of painting, characterized the post-Cubist generation of the 1910s. Reduction of means, pouring out, and purification all seemed to aim at the same goal: to produce a

Piet Mondrian (1872–1944). *Composition with Lines*. 1917. Canvas. 42½×42½"

216

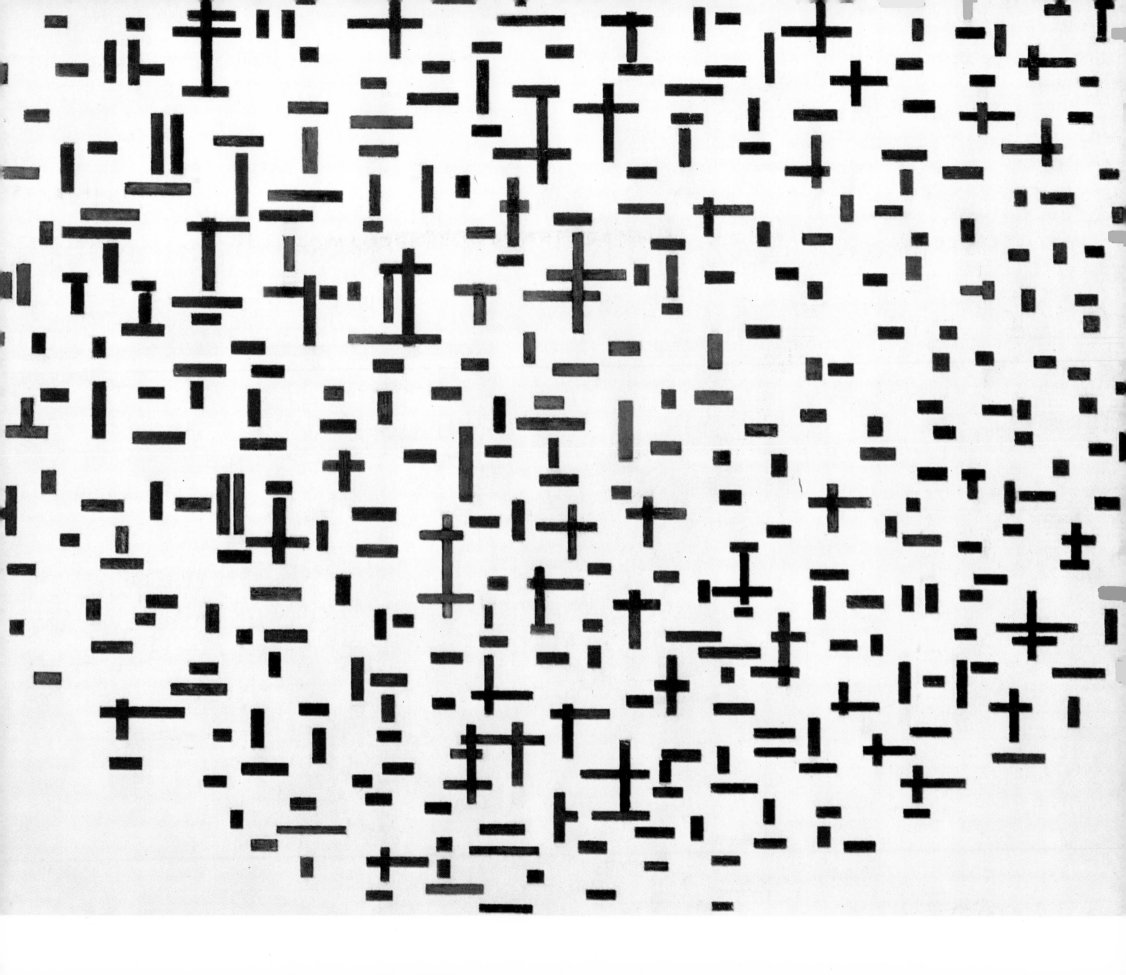

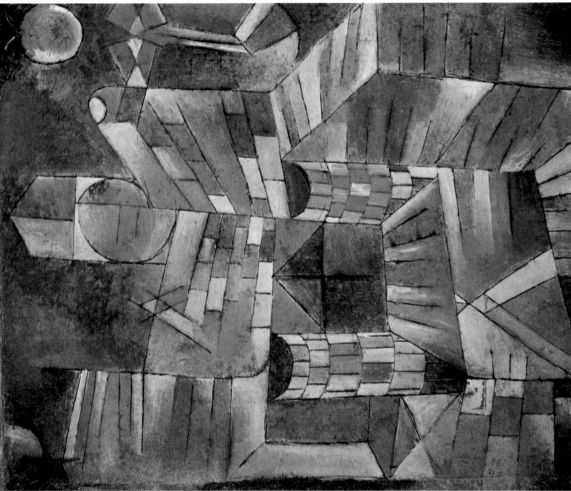

Paul Klee. *Architecture at the Window.* 1919. Oil on paper. 18⅞ × 15¾"

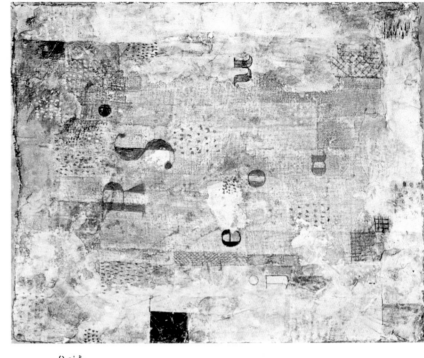

Paul Klee. *Florentine Villas.* 1926. Oil on cardboard. 19¼ × 1

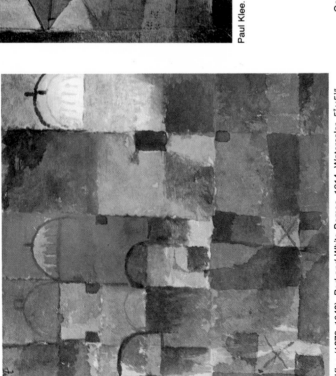

Paul Klee. *The Vocal Fabric of the Singer Rosa Silber.* 1922. Gouache and chalk on canvas. 20½ × 16⅜"

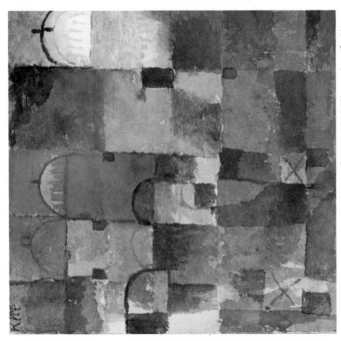

Paul Klee (1879–1940). *Red and White Domes.* 1914. Watercolor. 5⅞ × 5¼"

Klee the alchemist:
he experiments
with an infinite number
of textural grounds

During a trip to Kairouan, Tunisia, in 1914, Paul Klee discovered for himself—like the effect of an inner ripening—the principles he had noted two years earlier in the work of Robert Delaunay, according to him the creator of "autonomous painting living an entirely abstract plastic existence without a natural motif." Except for a few domes, Klee's Tunisian watercolor—*Red and White Domes* (above left)—returns to the checkered and patchwork construction of Delaunay's series of *Windows* (see pages 168–171), gathering up in a single movement the totality of the surface and its two-dimensionality. Once this surface had been recognized as a specific field for painting, Klee turned his efforts in two directions. He either used the illusionist ground to deny the

interior space by proposing contradictory projective systems, aporetics, or perspective *folies* (as in *Architecture at the Window,* above right), or, on the contrary, he revealed the material components of the work, its ground and fabric. He transposed a singer's tessitura to a painting's texture, the grain of her voice to the grain of a canvas in his *The Vocal Fabric of the Singer Rosa Silber* (below right). He engraved the features of his work *Florentine Villas* (right) as though they were scratched, scraped, or worked by the tip of a stylus in its very "flesh." With its falsely naïve appeal, the graffiti in this painting are a derisory caricature of traditional representation that claims to show nature as it is and to reflect it like a mirror.

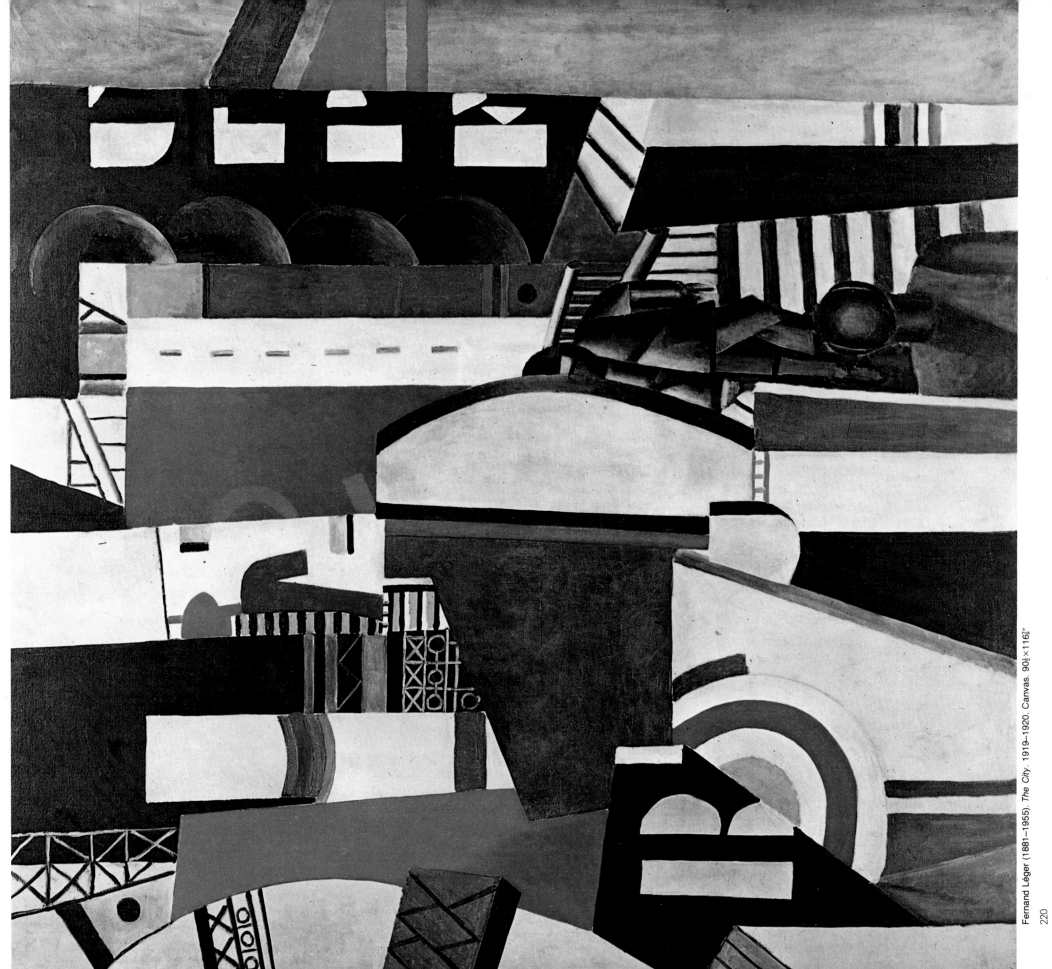

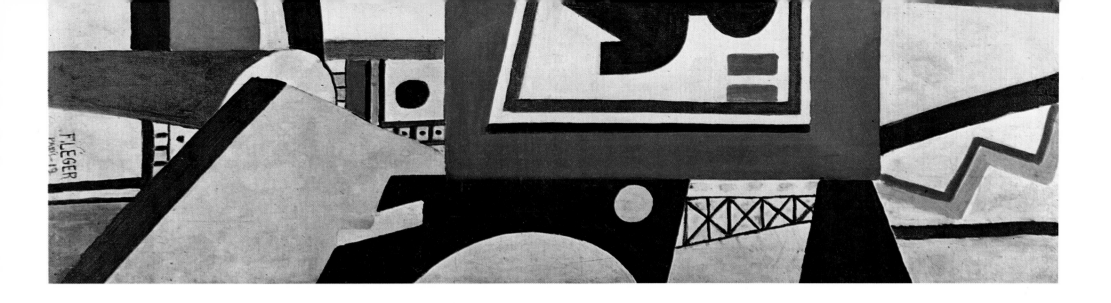

Fernand Léger. Mechanical Elements. 1918-1923. Canvas. 83¼×65¼"

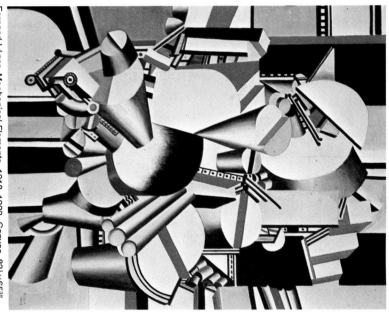

Fernand Léger. The Tug. 1920. Canvas. 41×52"

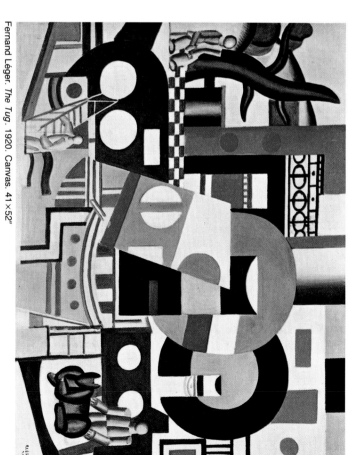

Crushed, adjusted, the city as mechanism

To enclose his space and to prevent the eye from traveling into endless depth, Fernand Léger begins with a base, a background composed of geometrical elements with dominating verticals and horizontals. Then to contrast with these flat areas, he distributes other forms that imitate modeling. Thus, in *The Tug* (above), the tree, the shaft, the column, the pedestrian bridge, the figures, and the dog are all treated in volume; the canvas is not immediately frontalized but in permanent frontalization; there is something at play in this space that the spectator has to make work by crushing or unfolding the perspective.

In Léger's *Mechanical Elements* (left), there is an abundance of forms represented in relief. They occupy the center of the work. The cone trunks recall the 75-mm. shell that fascinated Léger during World War I. "Beauty," he wrote in 1924-1925, "is everywhere, in a set of pots, on a white kitchen wall as well as in a museum.... Go see the Automobile Show, the Aviation Show, the Paris Fair, which are all the finest shows in the world.... The agricultural machine itself becomes a pleasant figure and is dressed up like a butterfly or a bird."

In *The City* (far left) elements treated in the round are rare. They have been reduced to the mast—moreover, imposing—in the foreground. On the other hand, the canvas contains abundant verticals, and its frontalization is reinforced by the distribution over its surface of colored areas in identical tones of strong red and black. Blaise Cendrars, in a dialogue with Léger in 1954, summoned to mind this famous canvas-manifesto, one of the most famous the artist ever painted. "We used to stroll together a great deal in Paris and would meet in the most different spots, often the Place Clichy. This is why I associate *The City* with the Place Clichy. In regard to its composition, its distribution of masses, and its extraordinary colors, they are those of the Place Clichy."

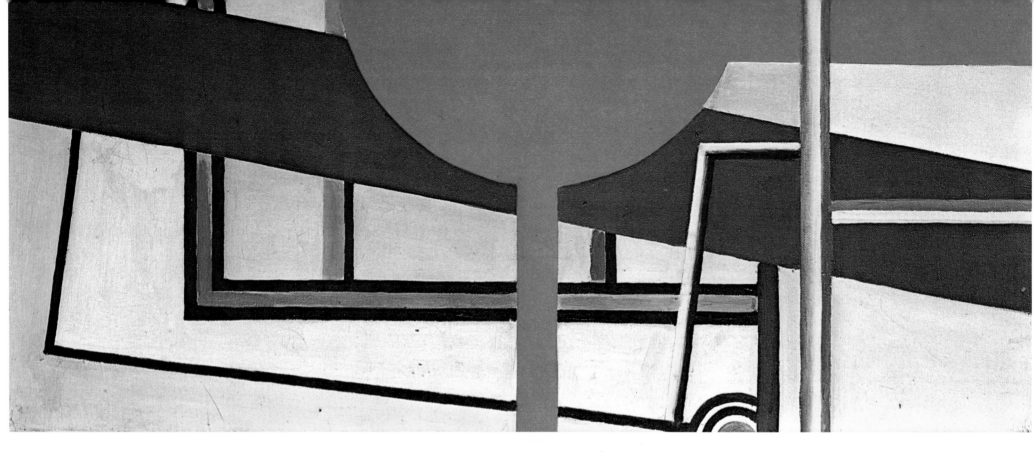

Fernand Léger. *The Man in a Sweater.* 1924. Canvas. 25⅝×36¼"

Léger's simplifying genius invents the modern poster

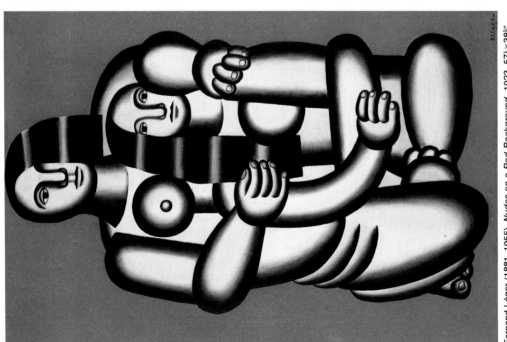

Fernand Léger (1881–1955). *Nudes on a Red Background.* 1923. 57½×38⅛"

To obtain what he called the "state of organized plastic intensity," Fernand Léger wanted both to compete with and to profit from the visual power of machines and mechanisms. A work is only valid if it stands up beside a car, a crane, a set of pipes. Plunging into the urban and technical chaos of his time, Léger gathered—like a catalyst—everything that impressed him: forms, metals, reflections, and then organized them in his own way in order to increase the force of the impact. "If we want to create and to obtain the equivalent of the 'fine object' that modern industry often produces, it is very tempting to use this equipment as raw material," he wrote. In his canvases he concentrated the disparate images that he collected in his daily life, counting on the concentrating effect to bring them off. He declared, "I am certainly above most commercial phenomena: it is infinitely rare that useful elements are associated in such rapport that they compete in beauty with my desire of organization by contrast."

222

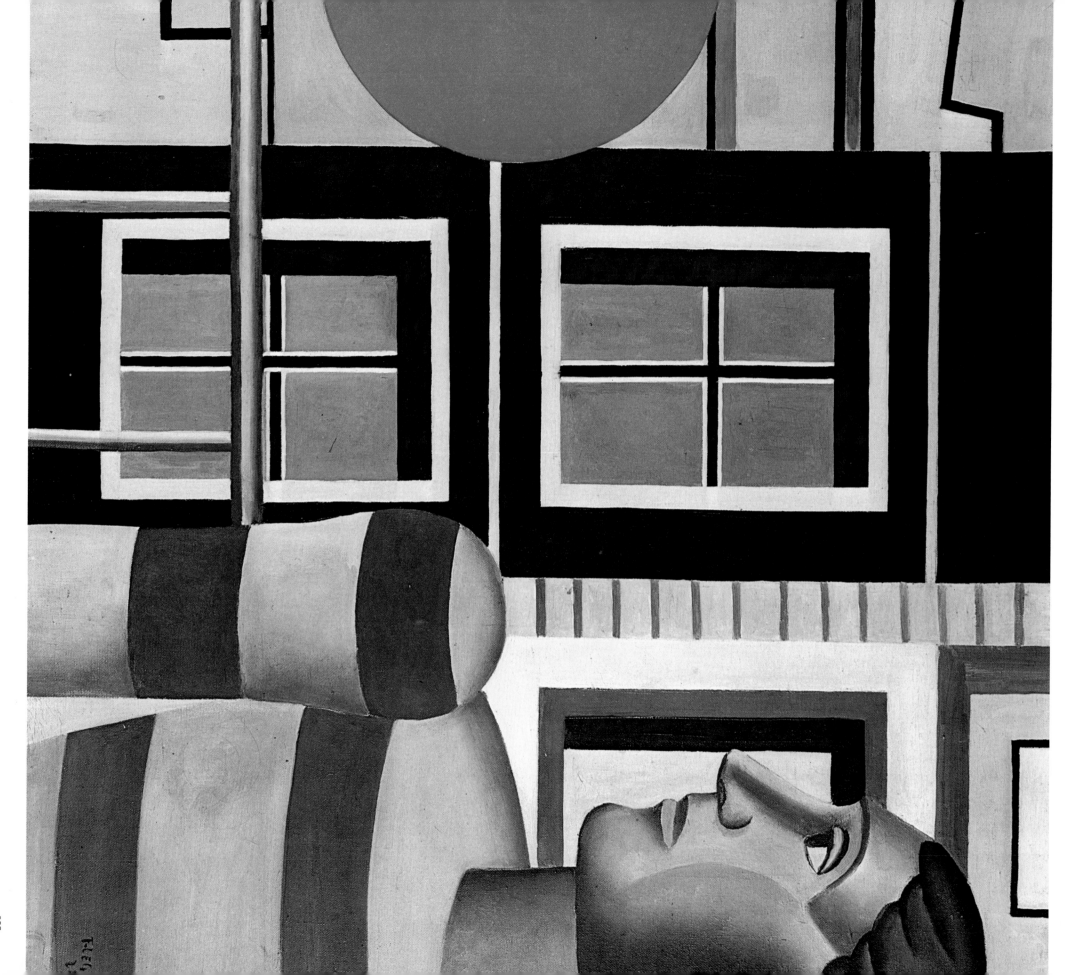

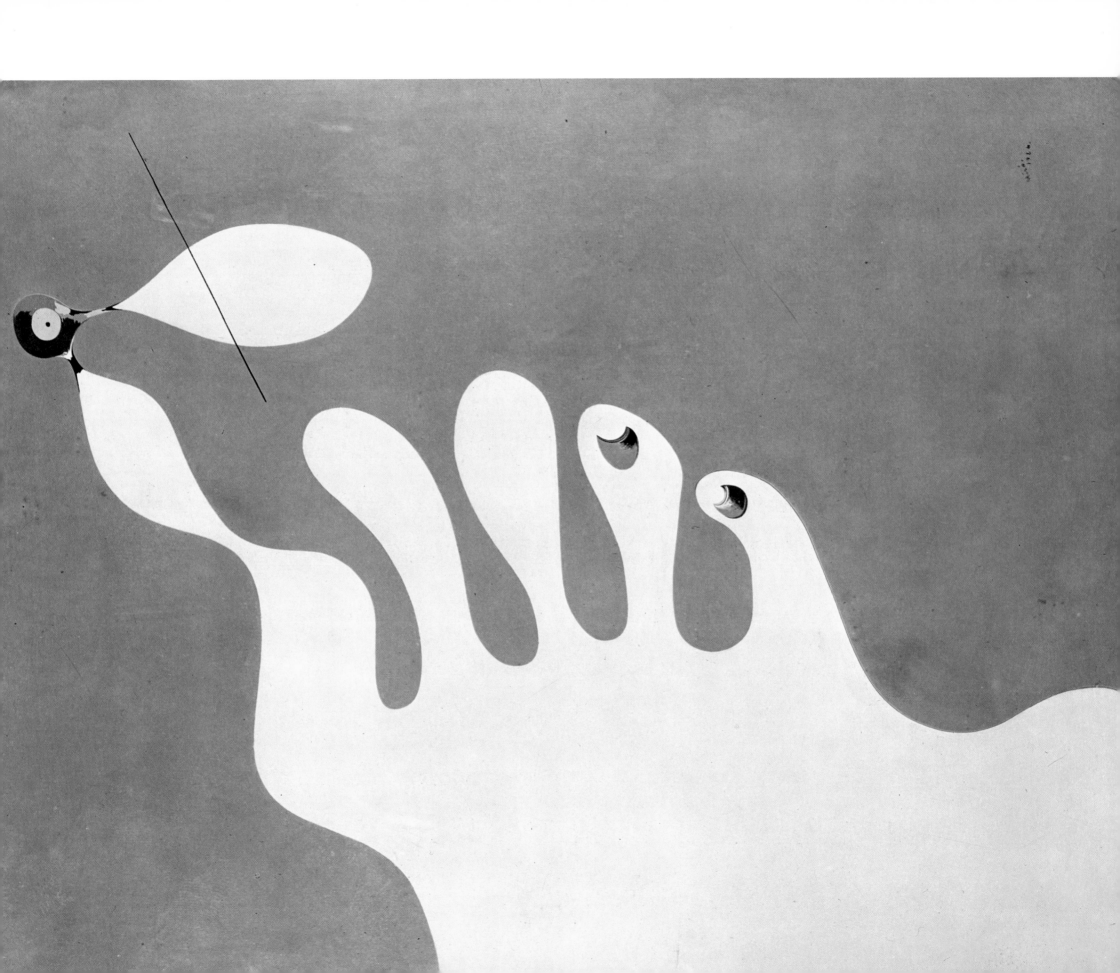

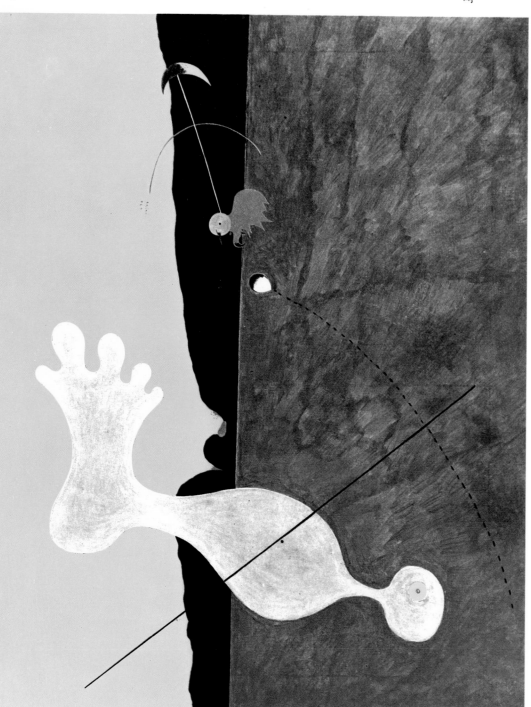

Amoeba-like figures move against large flat areas

Joan Miró painted his comical silhouettes—without modeling—against very spacious backgrounds. Sometimes this background is designed as surface and appears as matter ("cooked" textures, traces of brushstrokes, breakouts). In other cases—but more rarely—it is treated in depth, either smooth or vaporous, as an endless sky as in *Hand Catching a Bird* (left). It was Henri Matisse's work (see page 196) that took Miró from the centripetal composition characteristic of the Cubists and, noted the American critic Clement Greenberg, "inspired him to open his painting, to enlarge it to the point of soft, frontierless space." The spatiality used by the Catalan painter in his works of 1924–1927, again according to Greenberg, "had a great influence on abstract art in the United States."

In regard to the sinuous figures cut out in the foreground of Miró's paintings—amoeba-like forms, organic syntheses of the members of the animal, vegetable, and mineral kingdoms—all things being equal, these are also found in the work of Jean Arp, Paul Klee, Alexander Calder, and Wassily Kandinsky (in his Parisian period), as though an entire exchange program linked their different research. In the three paintings illustrated on these two pages, Miró has nailed his figures to the surface of the canvas by using either a continuous or a dotted line.

Joan Miró. *Figure Throwing a Stone*. 1926. Canvas. 29⅛×36¼"

Joan Miró. *The Statue*. 1925. Canvas. 31⅛×25⅞"

225

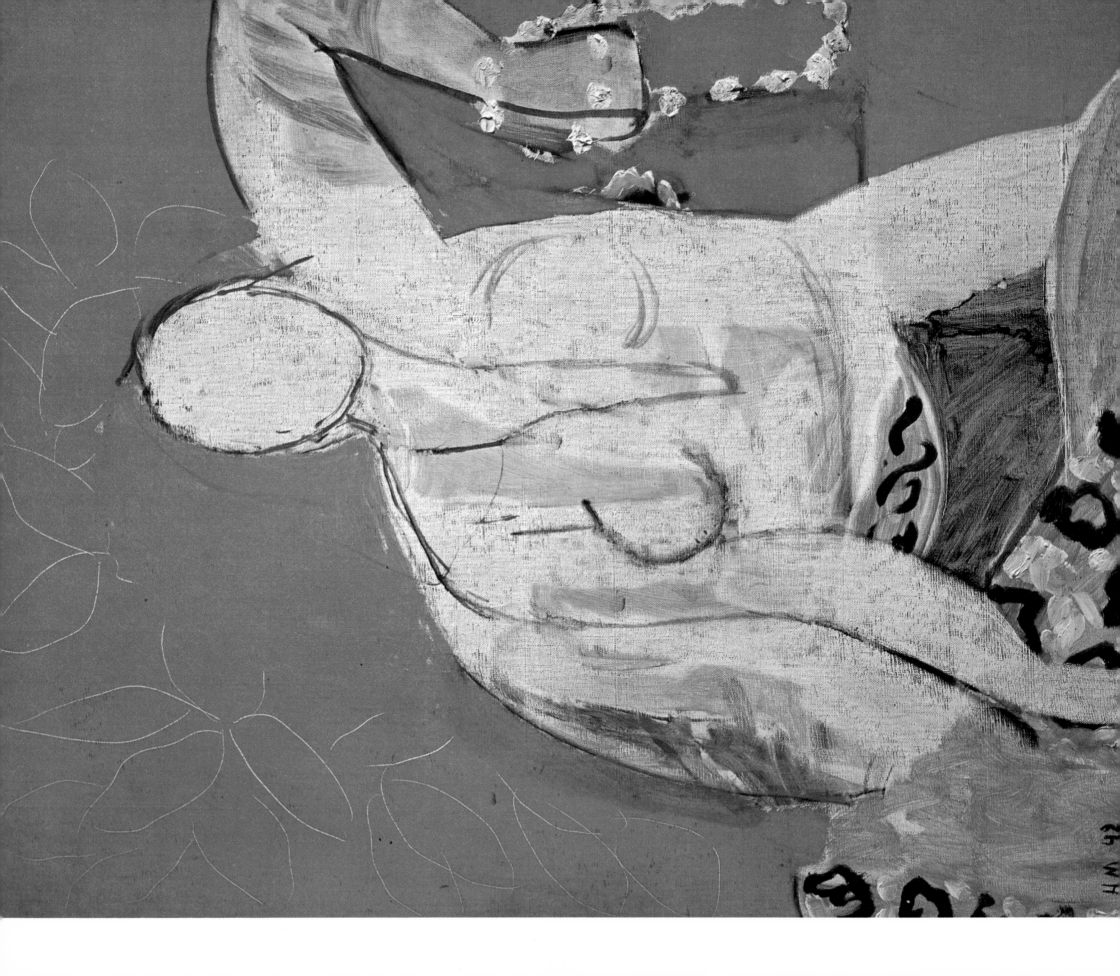

Taking to an extreme the method he used in *The Red Studio* (see pages 198–199), Henri Matisse built out of the canvas itself—coated or raw —the central figure of his painting (rather than only its outline). The background, treated in *reserve*, serves to constitute the foreground of the image, and the artist has not hesitated to show the viewer the raw grain of his canvas in *Young Woman with a Pearl Necklace* (left). The presence of the canvas has been made possible only by the extreme discretion of the figural indications, which have been summarized in a few brushstrokes or in a few pencil lines that denote the neckline of a blouse or the roundness of a breast. Matisse stated in 1908: "I am going to paint a woman's body: first, I give it grace and charm, but I have to condense the significance of her body by seeking its essential lines. At first glance, the charm will be less apparent, but it will come out in the long run in the image I will have obtained that will have a greater and more fully human significance."

Matisse's paintings have to be worked on, completed by the spectator's participation. "If we put in eyes, a nose, a mouth, this is of little use. On the contrary, it paralyzes the spectator's imagination, and it forces him to see a person of a certain form, a certain resemblance. . . . From the moment the indications become economical and the artist *says* as little as possible, the work opens up

to the spectator's participation, his contribution. In Matisse's *Woman in a Turban* (above), one sees the coating of the canvas everywhere: it forms the silhouette of the figure, the bed, the lines of the tiling, and the lines of the floor area. The surfaces are perfectly frontal, and only the diagonals of the bed and the table, crossed by one arm of the armchair, suggest depth. Matisse's powerfully clarifying techniques were used later by Tom Wesselmann and Martial Raysse to develop the urban imagery of Pop Art.

Henri Matisse. *Woman in a Turban*. 1929–1930. Canvas. 70⅞×59⅝″

Canvas coated or raw: the background comes before the image

By cutting strongly into colored papers, Matisse achieves a form decanted to its essentials

His *papiers découpés* are the apotheosis of Henri Matisse, who in them synthesized the plastic and technical preoccupations of an entire life. "This is not a beginning, but an achievement. This requires an infinite amount of subtlety and long experience. . . . With more of the absolute, more abstraction, I achieved a form decanted to its essentials. . . ." By cutting out shapes directly from large sheets of paper previously colored in gouache according to the tone and dullness desired, Matisse claimed

that he had rediscovered "the sculptor's direct cutting," and flattered himself on concentrating two working steps into a single gesture. By no means did he begin by drawing an outline and then continue by following it with his scissors. "I draw directly into color," he declared. The evidence of the colored field dictated the invention of the form—and vice versa—in the unity of the bodily movement in which the artist used all of his visual and polysensory experiences. "You cannot imagine

how during this period of the *papiers découpés* the sensation of flight [of doves] released in me helped me to adjust my hand when it led the path of my scissors. . . . It was a kind of linear, graphic equivalent of the sensation of flight." In these living colors, to use Georges Duthuit's words, "an unforeseeable and irresistible furrow of steel is at work." Each color has its own mood. "I do not cut oranges or reds as I do greens or blues: there is a tenderness in this green."

Henri Matisse (1869–1954). *Acanthus*. 1953. Cutout gouache. 122⅜×138¼"

Henri Matisse. *The Snail*. 1953. Cutout gouache. 111¾×113"

Henri Matisse. *Souvenir of Oceania*. 1953. Cutout gouache. 112½×112⅞"

228

THE REAL OBJECT

The artist introduces the real object into his compositions. Collages, assemblages, ready-mades, photomontages—all are stages of the same approach: the replacement of the representation of things by their presentation

African art makes an art out of the assemblage of odd objects (mirrors, nails, and seashells). Cubism learned this lesson

Nkisi magic statue

Mandingue mask

Paul Gauguin. *Still Life with a Horse's Head*. 1885

Léon Gérôme. *Sign for an Optician*. 1902
The arrangement of represented objects according to an intellectual or linguistic presupposition disrupts ancient compositional schemes. Beginning with the idea of a confrontation of cultures, Paul Gauguin arranges a "display" that resembles a collage of odd images.
In a painting-gag that could have been inspired by Raymond Roussel, the academician Léon Gérôme invents and distributes his own from the play of words: "Au petit chien."

I n May 1912 Pablo Picasso, wishing to draw a chair, glued to a work-in-progress a piece of oilcloth that was an imitation of a chair's cane bottom. This insertion of a manufactured object into the closed pictorial space was to have incalculable consequences.
In his book on Cubism, John Golding speaks of "the most violent blow ever aimed at traditional painting." Developing this method, Picasso soon took the liberty of integrating into his paintings any kind of object directly borrowed from life: stamps, visiting cards, match boxes, music scores, tobacco wrappers, newspapers, and so on. Everything takes place as if the artist, tired of denoting elements of the outside world and giving an *image* of them on canvas, had decided to integrate the subject matter and no longer to call forth the representation of things but to make use of *things themselves*.
The origin of collage can be sought in the study undertaken by the Cubists for five years on illusionism, the fundamental mechanism of Western art. So long as it was a question of projecting a three-dimensional object on a two-dimensional support, modern painters—by emphasizing the frontal aspect of the picture plane and by integrating the inscription of signs into this frontality—could show the operative presence of certain laws and reveal the seeming (see Chapters 3 and 4) under the "similar." But what is the situation of a painting that wants to denote an object in *two* dimensions? To copy the object would mean accepting the possibility of a "faithful" transcription and at the same time reintroducing the function of illusion of traditional painting. To escape this, painters had but one solution: to take the *thing itself* and insert it as such into the canvas.
The "savage" transfer of nonartistic components into the work's symbolic space and the brutal irruption of manufactured objects (or, occasionally, of such natural ones as skin, bits of wood, tree leaves, and so on) into an idiom based on the manual and artistic creation of iconic signs, immediately appeared, in 1912, as a mockery of the *tekhné* that in the Western world had always been present in the production of images.
Guillaume Apollinaire at once grasped the importance of collage. As early as 1913, he wrote: "I have no fear of art and no prejudice concerning the materials used in painting. The mosaicists painted with marble or colored wood. Someone mentioned an Italian painter who painted with feces, and during the French Revolution, someone painted with blood. You can paint with whatever you like; pipes, postage stamps, post cards or playing cards, candelabra, pieces of oilcloth, shirt collars, wallpaper, newspaper." Conversation

In his book on Cubism, John Golding speaks at that time centered definitely on the unexpected and often provocative collision of elements, some of which were part of the pictorial practice, others of which were taken from basic artifacts, that is, from those foreign to the socio-cultural status of the "major" arts of the Western world.
Here again recourse to African statuary justified this audacity. The African artist made great use of nails, glass, mirrors, and fabric either according to metaphorical criteria (two seashells to denote the eyes), functional identity (clothing, eyeglasses, bracelets, necklaces, teeth, wigs), or exclusively magical criteria (the blade of a knife stuck into a piece of wood and so on).
Without going so far, at the beginning Cubist collage made use of potential relics since it integrated objects of a specific civilization and period that had produced them (advertisements, daily newspapers, pieces of wallpaper, and so on). In contrast to the unitary texture of oil painting or fresco, the disparate components that now made up a work created a differential and aleatory aging: newspapers yellow quickly, whereas oilcloth remains unchanged. Cubism did not ignore—and even favored—this changing of a work through aging. The vulnerability and the fragility of the collage were affected by time.
Collage was invented a few months before the *papier collé*. Apparently very similar, the two approaches present different attitudes. The *papier collé* is, above all, surface and form; it participates in what Georges Braque called "the pictorial fact." It does not attempt to exceed painting but rather to strengthen it. Braque's large black area replaced pigmentary ambiguities and iconic proliferations with a clear monochrome that gave order to and frontalized the painting (see Chapter 4). Collage proceeds in the opposite manner. By introducing into the canvas existing objects perceived as such by the spectator, it questions the limits of painting and often, as we shall see, makes them recede. In his *The Lavabo*, Juan Gris, instead of *representing* a mirror, glued several pieces of a real mirror directly to the canvas (see page 243). This disruptive intervention of a domestic object immediately began to *work for itself*. Since a mirror is intended to reflect the surrounding world, its precipitation into the painting threatens the work's cohesion, and the entire question becomes one of what is going to gain the upper hand: the painting or the strange element that has been inserted into it like a wedge. A painting and/or a mirror, *The Lavabo* is a mixture whose unity is weakened from within by the integration of an element whose potential changes—such as

231

polished wood panel and left certain parts unpainted: the *reserve*, according to the compositional logic, appears as imitation wood and the real wood as a lure.

any reflection—are dependent upon the endless scenes it transcribes.

If the aforementioned definition easily divides collage and *papier collé*, the Cubists as consummate manipulators of pictorial semantics continued to spread confusion. A press clipping was either offered for what it is —a copy of *L'Indépendant* or of *Le Courrier* —reduced by synecdoche to fragmentary proportions—or it can function first of all as a surface in gray tint, a simple flat area with no reference. (This second hypothesis meets the status of the *papier collé* defined here as a colored surface that is part of a primarily formal/structural logic, and lacking—at least in the first stage—a denotative inscription.) This preliminary dichotomy (object and/or surface) somewhat simplifies things. Each of the two categories mentioned is endowed with a *second* effect: the piece of newspaper is *also* surface and the tinted surface is *also* newspaper. The question here is only to indicate a hierarchy in the two successive effects. The Cubists, moreover, took sly pleasure in placing *in the same work* press clippings that reflect both of the above polarities (see page 238). Object and/or surface: this is not the only ambiguity. Displacement—the catachresis—is the master, the fundamental spring of Cubist collage. A painting's requisition of an outside object is almost always indirect. Referring to the example of a newspaper, Picasso explained, "We have tried to rid ourselves of *trompe-l'esprit* [to replace visual illusion by mental illusion]. A piece of newspaper was never used to represent a newspaper; we used it to define a bottle, a violin, or a face. We never used an element literally but always outside of its usual *context* in order to produce a shock between the original vision and its new final definition."

In order to reveal the simulacrum of any iconic practice, the Cubists even integrated certain types of manufactured objects that admit *at once* to being false, illusionistic, and pretend to describe *something they are not*. In the first collage, *Still Life with Chair Caning* (see pages 236–237), we have noted that the cane seating is actually oilcloth. Similarly, wallpaper that imitates the cornice of an apartment can be used to designate the outline of a table (left), the line of an imitation wooden comb, and a young girl's hair (see page 180 below left). As though the aim of the artist was to contaminate what he represents by its false denotation, *trompe-l'esprit* can also refer directly to its subject matter, and the paper imitating wood can refer to another falsehood, that of the two-dimensional representation of a guitar. Another trick: Juan Gris painted on a

These works reveal an amazing intellectual virtuosity based on relatively poor and repetitive material, as though Picasso, Braque, and Gris had attempted to exhaust every possible contradiction of the representational signs and to cast definite doubt on the denotative function of art. Picasso wrote: "If a piece of newspaper can become a bottle, this leads us to reflect on the activity of both newspapers and bottles. This displaced object entered a universe for which it was not made and to which it remains a stranger. We wanted people to reflect on this strangeness because we were conscious of living in exile in a scarcely reassuring world." At its outermost limit, this *distanciation* acts not only on the object denoted but also on the very method of the denotation, on the collage. The manufactured object—a box of matches, a package of tobacco—previously unwrapped and placed flat on the table will be completed by perspective lines indicating its volumetric aspects (left). Or else the shadow is indicated in pencil, as though parodying the "atmosphere" and the modeling of traditional still lifes. Here then are two contrasting systems—illusionism and the direct gluing on of the object—and their confrontation fully reveals the arbitrariness of the approach: each treatment denounces the other as a system and in order to confront and to deny these two projective systems, Braque arranged a *trompe-l'oeil* nail among the striking elements of a Cubist composition (left). The final variation: beginning in 1914, Picasso, Braque, and Gris painted false collages in oil, imitating the flecked paper and imitation wood used by tapestry decorators. The circle was now complete. Cubism had transformed into artifice a process whose actual purpose was to put an end to mimesis.

Hence our suspicion. Regardless of what they allowed to be said, the real activity of the Cubists at the turning point of World War I was related not so much to the study of the relationship of iconic signs and subject matter as to the internal mechanisms of painting as a device. In this Picasso and his friends opened the path to a theoretical exploration called Formalism whose basis was assured by the Russians as early as 1915.

"The notion of form," stated Eikhenbaum, "has obtained a new meaning; it is no longer a sheath but a dynamic and concrete integrity, which has a content unto itself, beyond any correlation. Here is the divergence between the Formalist doctrine

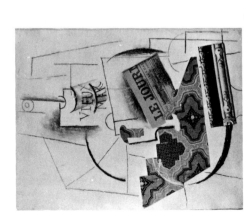

Pablo Picasso. *The Bottle of Vieux Marc.* 1913
Real objects transposed into a work designate something other than what they are. A cornice of wallpaper denotes the edge of a table

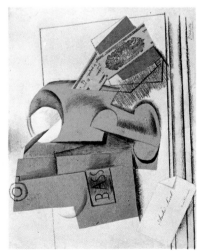

Pablo Picasso. *The Bottle of Bass.* 1913–1914
Picasso folds a packet of tobacco and glues it flat. But he indicates the volume with a few pencil lines that imitate ancient perspective

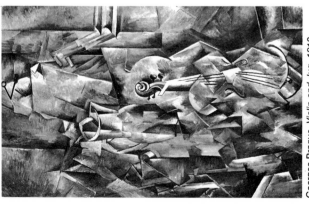

Georges Braque. *Violin and Jug.* 1910
By painting a *trompe-l'oeil* nail in the upper part of his still life, Braque confronts—and criticizes one by the other—two projective systems: Cubism and Classical illusionism

Man Ray. *Rayograph*

Kurt Schwitters. *The Secretariat.* 1919

and the Symbolist principles, according to which something of the "content" should be glimpsed "through the form." The pictorial "language" becomes self-referential. Paraphrasing Roman Jakobson in regard to the *literalness* of literature, we can say that the aim of the pictorial theory was no longer painting but *pictoriality*. The meaning of the Cubist collage was to be sought in the manner—significant in itself—in which the structural elements of the image were organized. A confrontation of heterogeneous means (for example, the introduction of photographs into a painted texture), aporetic figures (the subject matter contradicting its material: a bottle made of newspaper), introducing and setting into space nonpictorial codes (linguistic or mathematical signs), use of one technique by another (fake collages painted with a brush), the transgression of the picture frame by a proliferation of decorative and/or iconic elements—all of these creative systems *within* the pictoriality always end by questioning painting itself: its specific quality and its limits, the region that it claims to occupy in culture and in society. All of these problems arising out of the painter's work (for example, why respect or transgress the frame?) question not only the painting in process but also all works past or present classified as plastic art. It is as though all painting were also a critical review of other painting (Picasso is Paul Cézanne's critic, who himself was Nicolas Poussin's critic, and so on). By its deliberate ambiguities of interpretation, collage deliberately broke with the logic of denotation in earlier representational art. The picture used to acquire its coherence from the practical quality of its denoted objects. A bottle was *made* to be placed on a table. But now the bottle is *also* newspaper and the table wallpaper. The sign has an amphibiology, or, better still, it echoes several virtual meanings. It is a generalized reference structure since each element is endowed with an entire chain of meaning: a spot refers to the paper of which it is made, which refers to the idea of imitating wood, which in turn refers to the guitar, and so on. Jacques Derrida has stated in this regard, "Nothing either in the ingredients or in the system is ever simply present or absent. On either side there are merely differences and traces of traces." The *phenotext* (the work's being there spread out before us) is fertilized by the *genotext* (the infinite number of meanings working in and beyond it).

Even before the introduction of the collage in 1912, conventional signs unrelated to the painting invaded it—like so many intertextural "archaeo-collages"—and subverted its plastic economy: letters, numbers, and words in Cubist painting, arrows, and + or ∞ signs in the works of Marcel Duchamp, Robert Delaunay, Paul Klee, Wassily Kandinsky, and El Lissitzky, to name but a few. Like collage, the introduction of lettering into Cubist painting brought with it a wealth of ambiguities. It can reproduce an inscription as such (a window advertisement). It can indicate the identity of an object (Vieux Marc brandy) whose characteristics can be suggested by a few graphic indications. The letter, therefore, neither depends on the size nor on the contour of the object. It is autonomous and floats on the picture surface without becoming circumscribed by the material characteristics of what it describes (see pages 236–237). Another use of the letter is to summon to mind the psychic image of an object or a person outside the subject matter: "Eva," "Bach," "Cortot." Here the inscription functions as an atmospheric supplement. The inscription "Ma jolie" brings into the pictorial space a feminine evocation that "colors" the entire painting, even if the painting itself represents only a guitar or a round table (Marcel Duchamp later spoke of the use of words as "an additional color that is not in the rainbow"). Finally, the letter can be transformed into sonorous notation. By repetition, vowels and consonants offer the equivalent of amplified sound. For example, Carlo Carrà wrote on a painting: "EEEVVVVIVAAA" (see Françoise Will-Levaillant, "La Lettre dans la peinture cubiste," 1971).

In any case, the letter exerts a function of frontalization. Perceived as a flat area when read, generally arranged on a two-dimensional surface (book, newspaper, or poster), it carries into the picture its original printing flatness. Laterally crossing over the frontiers of the object it identifies, overlapping two adjoining planes, and sometimes being independent of any iconic denotation ("BACH"), it leads to a flattening of the image.

The setting into space of linguistic signs is one of the characteristics of modern art—from William Blake, Paul Gauguin, Symbolism, and the Arts and Crafts movement in England up to Michael Larionov (see pages 106–107), Robert and Sonia Delaunay, Carlo Carrà (see page 267), El Lissitzky, René Magritte (see page 124), and so on. During the century, a growing number of painters devoted themselves to the poster and to illustration, media privileged to use the inscription of the

word as shape. Whereas literature, beginning with Stéphane Mallarmé, was preoccupied with putting writing space to work ("the white/blank spaces assume importance"), painting tended to summon or, better, to absorb the letter as a surface component (note in the upper part of Paul Cézanne's *Portrait of Achille Emperaire*, executed about 1869, the bold indication of the stencil). For the first time in the Western world since medieval Gospel books, the plasticity of lettering was taken up by painters. The letter, the word were no longer neutral, transparent, simple vehicles of the logos.

Collage and the insertion of the letter into painting are two aspects of the same formal logic underlying and constituting Cubism. Cubism acquired a dynamic quality through the confrontation of heterogeneous techniques, which taken together enter into the general category of montage. Thus painting confirms or anticipates a structural model, which, as Walter Benjamin noted, reflects industrial society. *Montage* is linked to mass production, to an architecture of stressed steel, to the machine as made up of gears consisting of parts and wheels, to the newspaper and to the radio which juxtapose unrelated information, to the serial, to the comic strip, and so on. Film montage in its experimental aspect—the Futurists' "editing by analogy," Sergei Eisenstein's "editing-collisions," Dziga Vertov's "ciné eye," Dadaist and Surrealist films, and so on—is related to the collage, and often it is a result of it. The use of the *insert*, the sudden appearance of a metaphorical image, of a strange body in the continuity and the unity of a story (such as a lion to indicate anger) reminds us of Picasso's strange assemblages. In the "free words" of Futurist poetry, Dadaist leaflets, and *photomontage*, this is also the case even if, as José Pierre has remarked, this technique is often characterized by the egalitarian enumeration of its elements (see page 266) than by the central effect, where the Cubists generally stopped.

In 1913, Marcel Duchamp presented as a work of art a *Bicycle Wheel* whose fork is planted on a wooden stool (left)—a strange, scandalous, innovative act. The *Bicycle Wheel* is a decisive stage in the appropriation of the real object by art (or, as we shall see, of art by the real object). The work is akin to both the Cubist collage and the ready-made: it is still an assemblage (the stool not only is a base, but also it is part of the structure). Here for the first time all the elements were exclusively prefabricated objects selected from daily life. To complicate matters, the artist also emphasized the visual fascination of his work: the rotation of the spokes, he said,

"creates very pleasing and very consoling effects" (thus, in passing, Duchamp pointed to his role as precursor in the invention of kinetic art; see Chapter 6). The first undeniable ready-made (even if the "artist" claimed that originally he put a short phrase on it) is the *Bottle Rack* of 1914 (left). No longer do we have an assemblage: Duchamp bought the object in a Paris department store and offered it as such as a work of art. Nor is there any question of satisfying us. Duchamp stated: "The choice of these ready-mades was never based on an aesthetic enjoyment. This choice was always based on a reaction of visual *indifference* as well as on a total absence of good or bad taste. . . . Finally [there is] a complete anesthesia." In 1917 Duchamp repeated this performance by exhibiting at the first Exhibition of Independent Artists, held in New York, a urinal baptized *Fountain* (left) under the name R. Mutt. Rejected by an insulted jury, the object was defended in Duchamp's review *The Blindman* in significant terms: "It makes little difference whether Mr. Mutt has or has not executed the fountain with his own hands. He *chose* it. He took an everyday article from daily life and *showed* it in such a way that its utilitarian significance disappeared under its new title and its new point of view. He created a new way of thinking for this object." By insisting on putting his *Fountain* on exhibition, Duchamp suggested that in order to function a ready-made requires not one but two interventions. On the one hand, the utilitarian instrument that the artist has isolated must be taken away from its usual space—the space that gave it meaning and marked it as a utensil—and, on the other, it must be transported to a cultural site, a space that this time consecrates it with an aesthetic character. Like a word in a phrase, any object is taken in a sequence that conditions it. As a *displaced* object in a new *setting*, the ready-made acquires its effect, its "magic" from the setting in which it is placed and that surrounds it, which then becomes a constituent part of its being. Thus the ready-made is really the extension and development of the collage, which also presents itself as the insertion of a fragment of the outside world (such as a newspaper) into a space defined as an artistic setting (sometimes a painting, sometimes a museum). Yet by taking the artist's arbitrariness to its extreme, by refusing any personal intervention to the object, Duchamp suddenly revealed in full light the decisive role of the socio-cultural institution: frame, altarpiece, church, palace, museum, gallery, collection, worship, political device. It is the institution that names the object, that decides

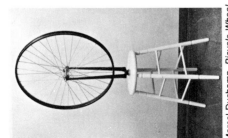

Marcel Duchamp. *Bicycle Wheel.* 1913

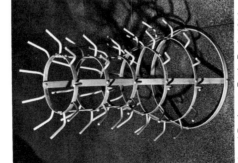

Marcel Duchamp. *Bottle Rack.* 1914

Marcel Duchamp. *Fountain.* 1917

Marcel Duchamp and Man Ray. *Raising of Dust.* 1920
By transplanting manufactured objects directly onto the terrain of artistic institutions, Marcel Duchamp reveals the latter's socio-cultural and ideological functions. It is the institution that qualifies the objects and designates it as art or not. (*Raising of Dust* was obtained by photographing the dust that accumulated on *The Large Glass* as it lay horizontally. See page 259.)

Umberto Boccioni. *Fusion of a Head and a Window.* 1912
To his sculptured head Boccioni adds a real window crossbar (with pane fragments) and a chignon of real hair. The vertical rays framing the face represent light

Robert Rauschenberg. *Monogram.* 1963
The real object can be canceled in the image's illusionist space (as is evident in the belltower in the landscape above) or, on the contrary, it can play a disturbing and disruptive role, such as the parrot that Miró has placed on the top of his sculpture. Rauschenberg takes up this principle on a grand scale in his painting-assemblage *Monogram*

Joan Miró. *Poem-Object.* 1936

Anonymous. *Landscape.* Nineteenth century

whether or not it is *art*, that gives it meaning —a meaning, moreover, that can be reduced to the status of a luxury possession, a sign of belonging to a social class, or even a way of declaring the special, elitist condition of its "creator." A painting, before being an object in itself, is always the meaning of the institution exhibiting it. The ready-made—by its radical gesture—implicitly questions the function of creativity in Western society since the Renaissance. Whereas elsewhere and previously art functioned as the symbolic enterprise of vast groups of society, as *aesthesis*, as a dynamic spatial projection of a large consensus, the assembly line of the modern art object has been reduced to the interaction—inflicted with entropy—of an artist with a museum and/or dealer and a tiny fraction of the population. Duchamp's intervention of turning to "just anything" on sale in a department store shows that everything is "beautiful" and that if everything is "beautiful," nothing is beautiful, that the concept of beauty is not operative, and that the artist's task is first of all to question the institutional enclosure where ideology wants to put him.

Indeed, it is this question of limits that collage and ready-made have posed in turn. In accordance with the disruptive energy that it harbors, the object of extrapictorial origin can either be engulfed in the work, canceled as an object, comply to the laws of composition (in the case of collage) and to the museum (in the case of ready-made) or, on the contrary, it can create an explosion in the picture or museum by its excessive penetrating force, by the disproportionate character of its intrusion. Reality can be submerged in the work or the work in reality. Apparently highly heterogeneous elements can be integrated into the painting without encountering any resistance. In the *Landscape* (left), the presence of a real clock (endowed, moreover, with movement) does not disrupt the logic of the illusionist space. On the other hand, the appearance of a stuffed animal in an assemblage (left) seems a monstrous intrusion assimilated only with difficulty by the institutional language of art—at least at the time this assemblage was produced. In the conflicting relationship of the outside object to the painting (or of the object to the museum), there is always a breaking point; a dividing line either swings to the side of plastic (or museum) organization or swings the entire thing into the incoercible, into *nonart*. This frontier is always moving, hammered away at by the artist. Whereas new laws are made up that try to control and to classify the previous ones, the artist pushes forward toward the limits of the acceptable,

gradually integrating into his work, by means of *happenings*, environments, and so on, living people and events. By a continuous movement of proliferation, the artist seems to want wholly to devour the real, as if by an unquenchable desire for expansion he would cover the entire fields of time and space and end up with the utopian equation: art equals life.

For more than fifteen years art seemed to be stuck with this infinite nibbling at its limits. Too many artists were satisfied to imitate Duchamp and to select from a Woolworth-type store supposedly eccentric variations on the *Bottle Rack*. They pretended to believe that novelty lay in the choice of the object—whereas in this case it was the gesture itself that constituted Duchamp's work. "When I discovered the ready-mades," wrote Duchamp, "I hoped to discourage the carnival of aestheticism. But the Neo-Dadaists use the ready-mades to find out their aesthetic value. I threw the bottle rack and the urinal in their face as provocations, and now they are admiring their aesthetic beauty!"

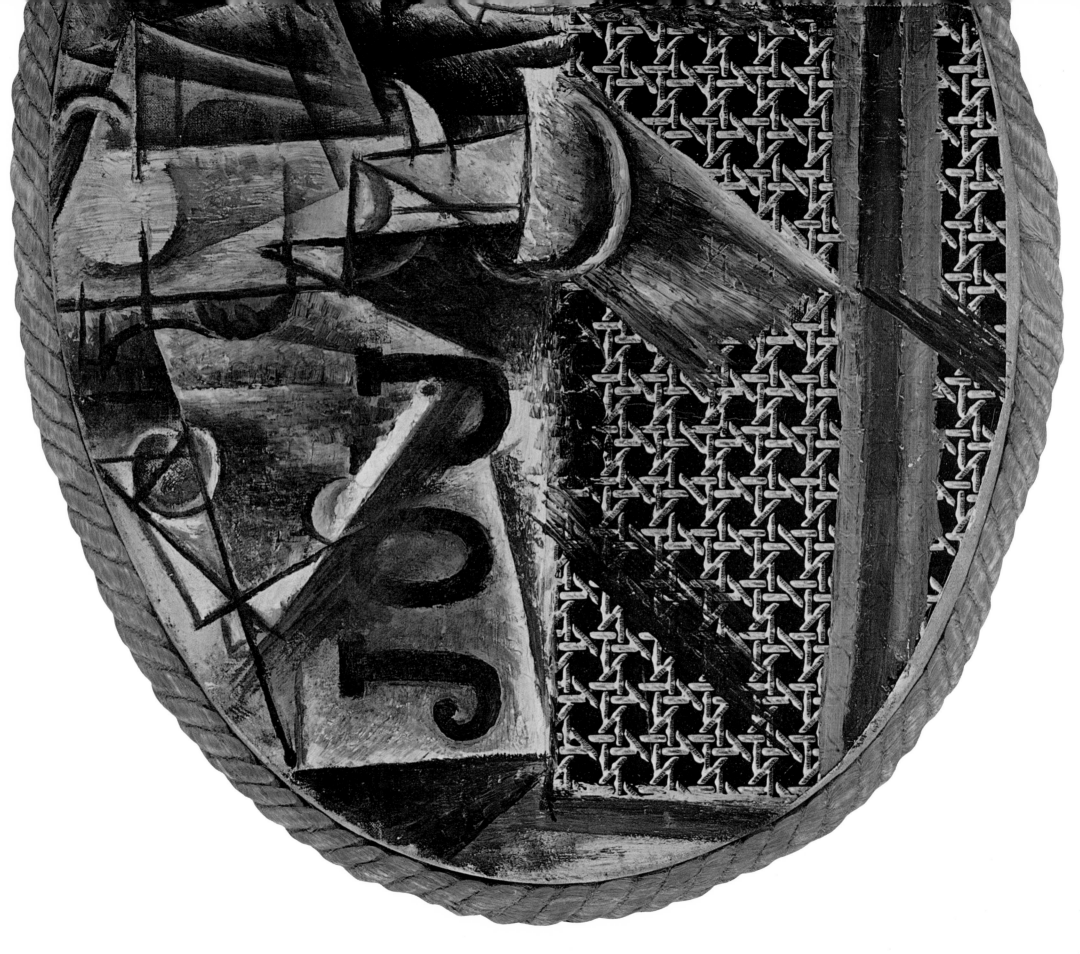

A *coup de force* threatens the traditional coherence of painting: the first collage

Pablo Picasso's brutal integration of oilcloth imitating chair caning into a composition of May 1912—*Still Life with Chair Caning* (left)—marked a decisive step in the artist's development and in the entire history of modern art. For the first time, a manufactured object was massively introduced into a painting. A mockery of craftsmanship and the artist's style and "signature," collage at the outset was a way of integrating a two-dimensional object within a work without copying it. But this incongruous introduction of a foreign element into the manual, handicraft practice that up until then had been the basis of painting soon threatened its very coherence, as we will see when we examine assemblages and ready-mades. The moment an industrial object participates in artistic expression, it subverts the painting's specific and enclosed character, and it was not only by chance that Picasso symbolically enclosed his first collage with heavy cord as though to parody the traditional frame. A true infernal machine that continued to question the limits of painting, collage enriched itself by taking on an additional complexity. For if an industrial object is

inserted into a work, it is put there to express something other than itself. The chair caning here is represented on an oilcloth that does not interject its qualities into the composition. The "real" object is also a decoy, and this ambiguity with a rich future reintroduces in the field of the symbolic a material that pretends to escape from it. An oversized inscription "JOU" (for "journal" meaning "newspaper") occupies the upper left part of the painting. It floats and extends beyond the outlines of the newspaper itself, whose surface is transparent, revealing a space that it should cover. The letters are covered with brushstrokes that arise from the "background" of the canvas. This overlapping of planes contradicts traditional perspective spacing. The chair itself is cut by a large bar that seems to mark its edge, yet the caning continues beyond this barrier right up to the frame. Here again traditional logic is not respected. The work is oval, and therefore it breaks with the rectangularity of the wall (or in the case of this reproduction with that of this volume). This emphasizes the relative independence of the painting in its environment.

Wallpapers and pieces of newspaper achieve the dignity of a work of art

Beneath their rough appearance, the collages and *papiers collés* of 1913 stimulated Pablo Picasso to an almost inexhaustible subtlety and invention. In his *Still Life with Violin and Fruit* (below), the printed newspaper (with the exception of the letters from the title,

"URNAL") has been used as an abstract colored surface and by no means as a newspaper in and of itself. In the upper left part of the painting, it has been used to represent the bowl of a fruit dish perched on a foot made up of a light rectangle. The artist has been careful not to outline the fruit in order to keep the character of an added image, and to stand aloof from *trompe-l'oeil*. Edward Fry has noted that, beneath the glass drawn in on the right, the press clipping has been shifted, compared to the other pieces of newspaper, in order to produce an effect of transparency. The whiteness of the table is actually the support itself, and the raw forms, in the lower left, designate a chair. It is the same brush in imitation wood that figures the violin and the upper part of the table. The two profiles of this violin are depicted together, but the second side has been treated in a granular material. The f-holes and the strings have been sketched in pencil, and the instrument's scroll has been rendered with an all but Classical precision.

In Picasso's *Guitar* (right), a white sheet of paper indicates the lighted part of the instrument and a piece of wallpaper the unilluminated part. The ivory bar in the upper left of the work represents the guitar's neck and the black bar to its right its reverse side. A piece of newspaper denotes the sound hole. The three tassels drawn in charcoal in the lower right corner are the extremities of an armchair in which the instrument has been placed. The work seems to have been begun in the direction of its width, and we can distinguish the same tassels, half obliterated, in the upper right corner. Some critics have seen a deliberate—and sarcastic—choice in the advertisements that the viewer can read on the front page of *El Diluvio*. One, that of Dr. Casasa, offers the services of a specialist in the treatment of venereal diseases, another those of an eye doctor.

In his *Le Point du Jour*, André Breton recalled the years that "yellowed these pieces of newspaper whose ink, still fresh, contributed substantially to the insolence of the splendid *papiers collés* of 1913. . . . It all happened as though Picasso had counted on this impoverishment, this very dismemberment. It is as though in this unequal struggle, whose outcome is never in doubt, in which the creations of the human hand fight against the element of time, Picasso wanted to yield in advance, to reconcile himself with what is precious, what is ultrareal in the process of its decay."

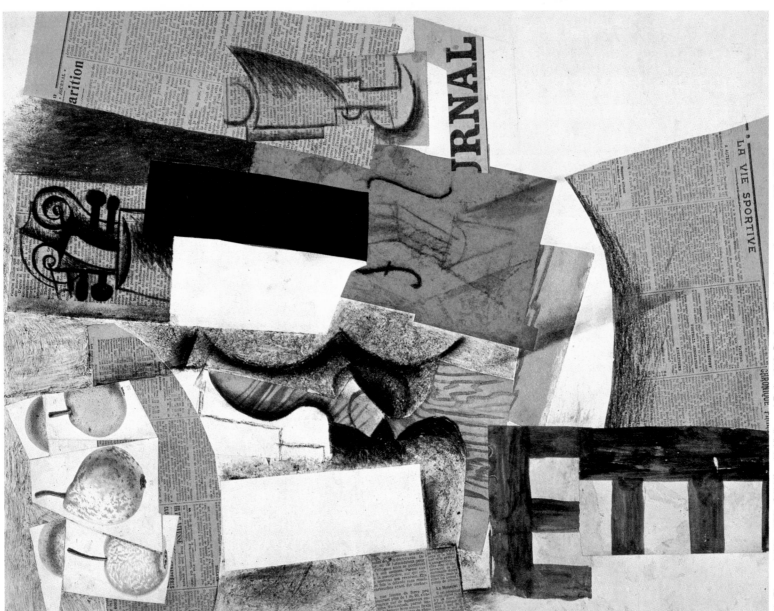

Pablo Picasso (1881–1973). *Still Life with Violin and Fruit*. 1913. *Papier collé* and charcoal on paper. 25⅜ × 19⅞″

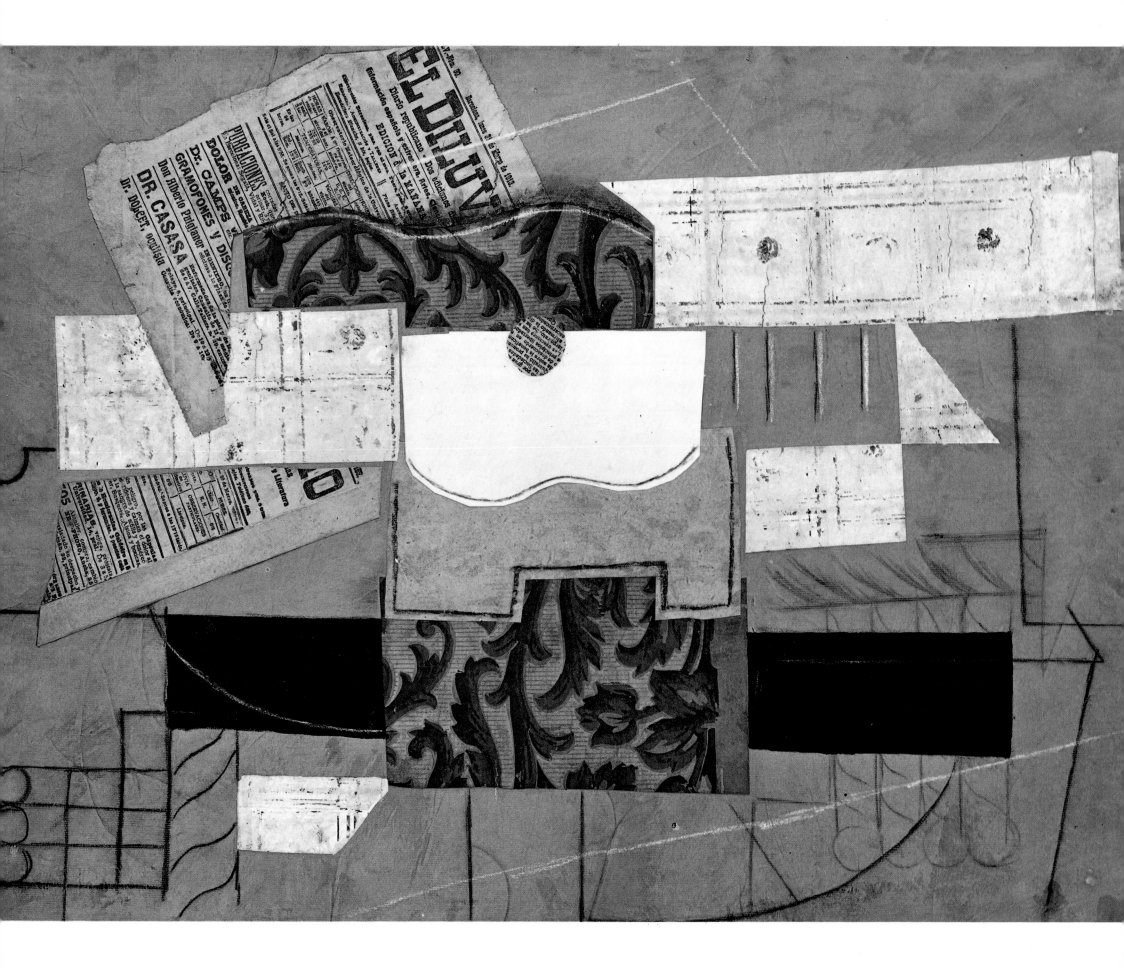

Collage dissociates color and outline

After the profusion of his works in the Analytical Cubist style (see pages 152–153), Georges Braque undertook in 1912 to arrange his compositions in large, monochrome flat areas accented with pieces of newspapers, programs, corrugated papers, tobacco wrappings, pieces of wallpaper, and other types of collage materials. In his *The Guitar* (right) the sheet of imitation wood is intended to indicate the guitar's color and texture. The right-angle cutout is deliberately arbitrary. It does not superimpose itself on the rounded forms of the instrument indicated in pencil. Color and outline are dissociated, and the spectator must organize them mentally.

In order to show the guitar's physical qualities (its brown wood), Braque used a fake material (a piece of printed paper imitating wood) rather than a piece of real wood). The decoy (the imitation wood) refers to the decoy of the painting. In recentering his composition, Braque returned to the traditional values of French painting. Even the intrusion of an element foreign to manual handiwork, such as the newspaper clipping in *Still Life on the Table* (below), operates in a climate of rather precious research in which black plays a determinating role—from both Édouard Manet and Stéphane Mallarmé we know that black can have a muted elegance. All around the central motif, the leaf, on which is inscribed the drawing of a table, again becomes depth and distance in contrast to Paul Cézanne, who attempted to cancel the distinction between form and subject. Writing about Braque the year of this *Still Life*, 1913, the poet and critic Guillaume Apollinaire clearly saw that he had transported Cubism "to a temperate climate."

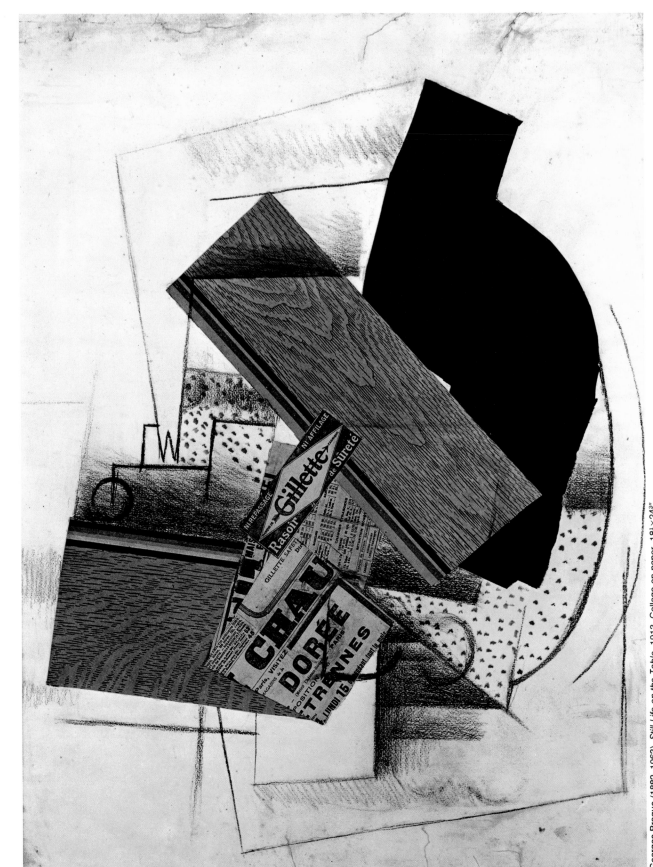

Georges Braque. *The Guitar*. 1912. *Papier collé on paper*. 27⅝×24

Georges Braque (1882–1963). *Still Life on the Table*. 1913. Collage on paper. 18⅛×24¼"

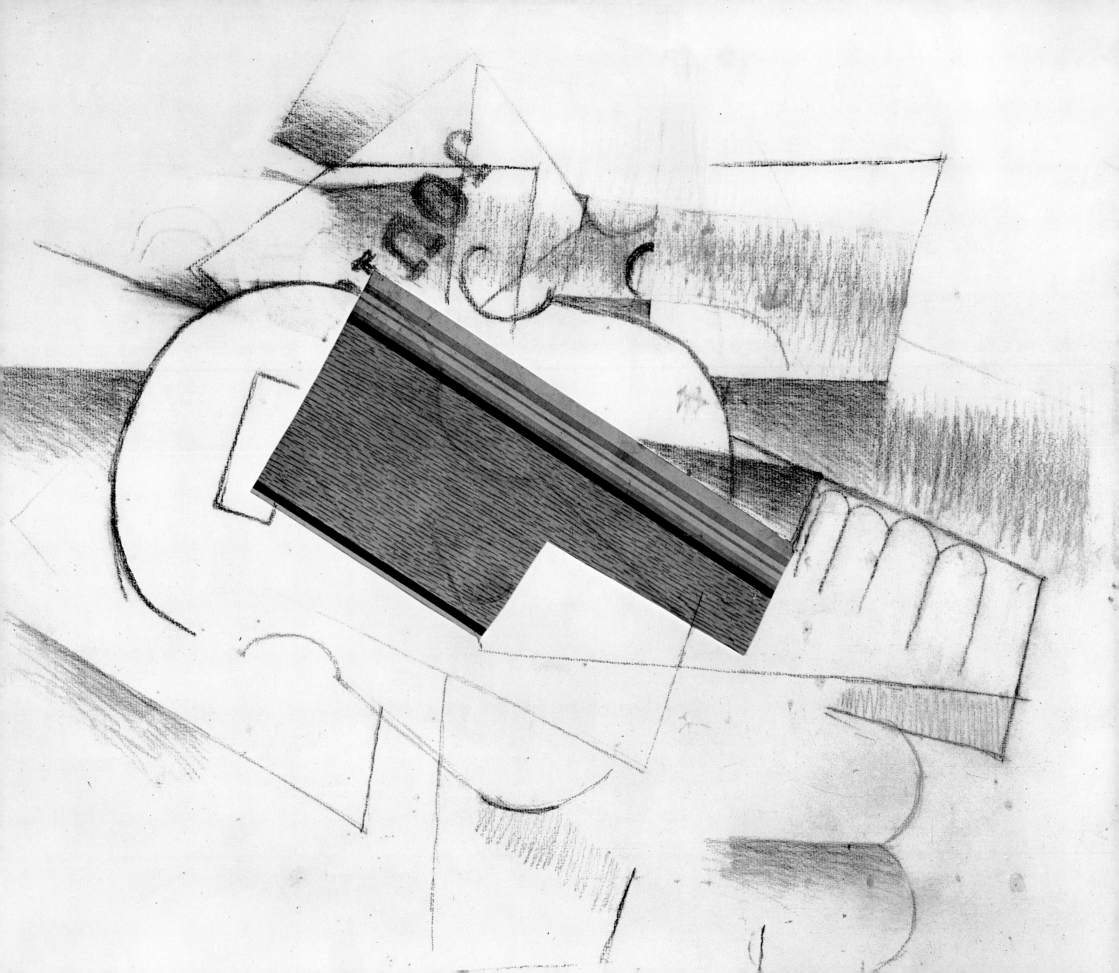

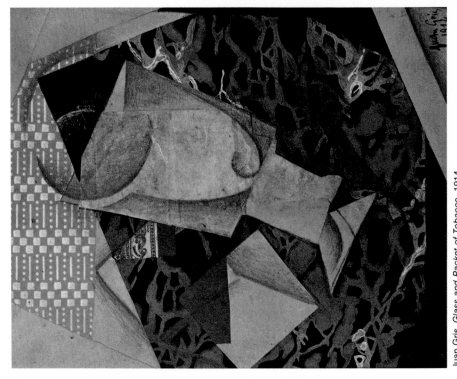

Juan Gris. *Glass and Packet of Tobacco*. 1914.
Oil and *papier collé* on canvas. 10⅜ × 8⅞"

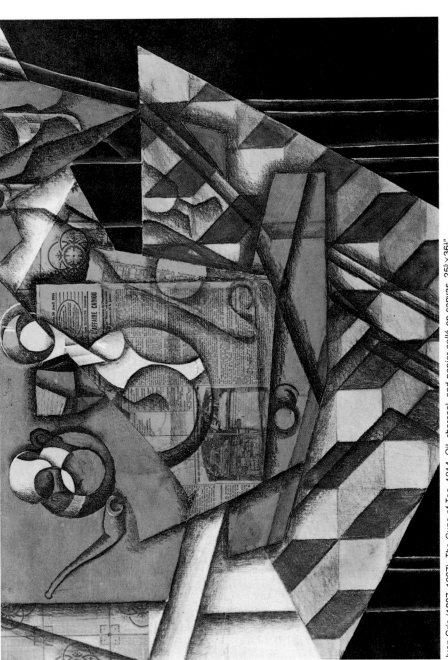

Juan Gris (1887–1927). *The Cups of Tea*. 1914. Oil, charcoal, and *papier collé* on canvas. 25⅝ × 36¼"

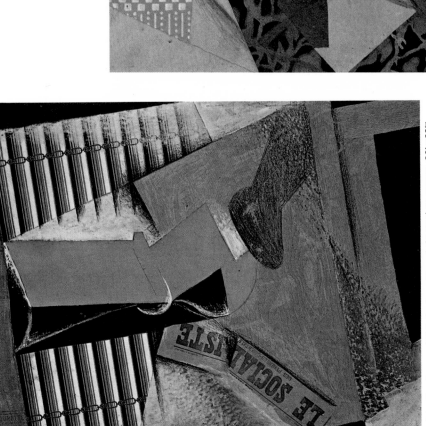

Juan Gris. *The Screen*. 1914. *Papier collé* and charcoal on canvas. 36¼ × 28⅞"

By integrating the fragments of a mirror, Juan Gris made the painting the screen of an infinite metamorphosis

Of all the audacities of Cubist collage, the gesture of Juan Gris' introduction of the fragments of a mirror into a painting—*The Lavabo* (right)—is one of the most provocative. "A surface can be transposed in a canvas," he explained, "a volume can be interpreted, but a mirror, a changing surface that reflects even the spectator? You can only glue it into a work in its form as glass." The moment a reflecting material finds a place in a work, it adds a factor of instability and of chance that makes it literally infinite since it is nourished on the diversity of the scenes it reflects. This process later enjoyed a rich posterity in the aleatory, kinetic, and Neodadaist art of the years 1950–1960.

But *The Lavabo*, built according to the Golden Section (the relationship between the smallest part and the largest part is equal to the relationship between the largest part and the whole?), also offers the viewer a study in Classical *trompe-l'oeil*: the curtain whose rod is homeomorphic to the upper edge of the painting. The work is also unusual for the narrow overlapping of such added elements as labels with an ashy texture. A curious drip crosses the composition horizontally at the level of the curling iron. In contrast to the relief of the curtains, the shutters in the background have been treated in small, white, hesitating brushstrokes.

After the fashion of Paul Cézanne, Juan Gris, in order to prop up his canvas, frequently used a frontal reference, such as the wallpaper in *Glass and Packet of Tobacco* (below left), tiling as in *The Cups of Tea* (above left), or a shutter as in *The Screen* (middle left). In this last painting, the shutter, the newspaper, and the table in imitation wood are all made of *papiers collés*, heightened by the use of blue areas to express shadows and white spots for slanting rays. In contrast to Georges Braque, Gris—for example, in *The Cups of Tea*—always tried to occupy the entire surface of the painting.

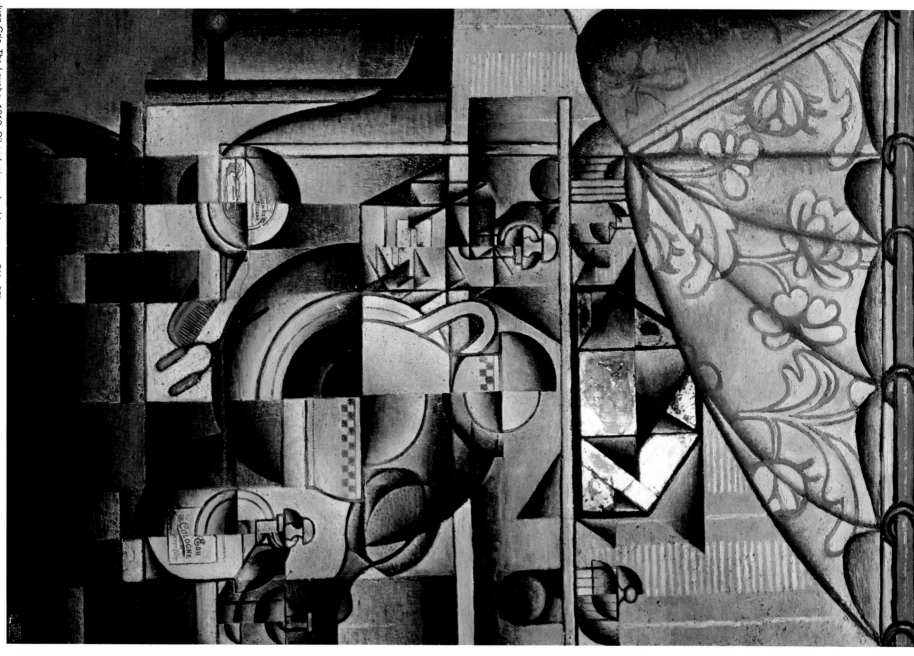

Juan Gris. *The Lavabo.* 1912. Oil and mirror glued to canvas. 51¼×35"

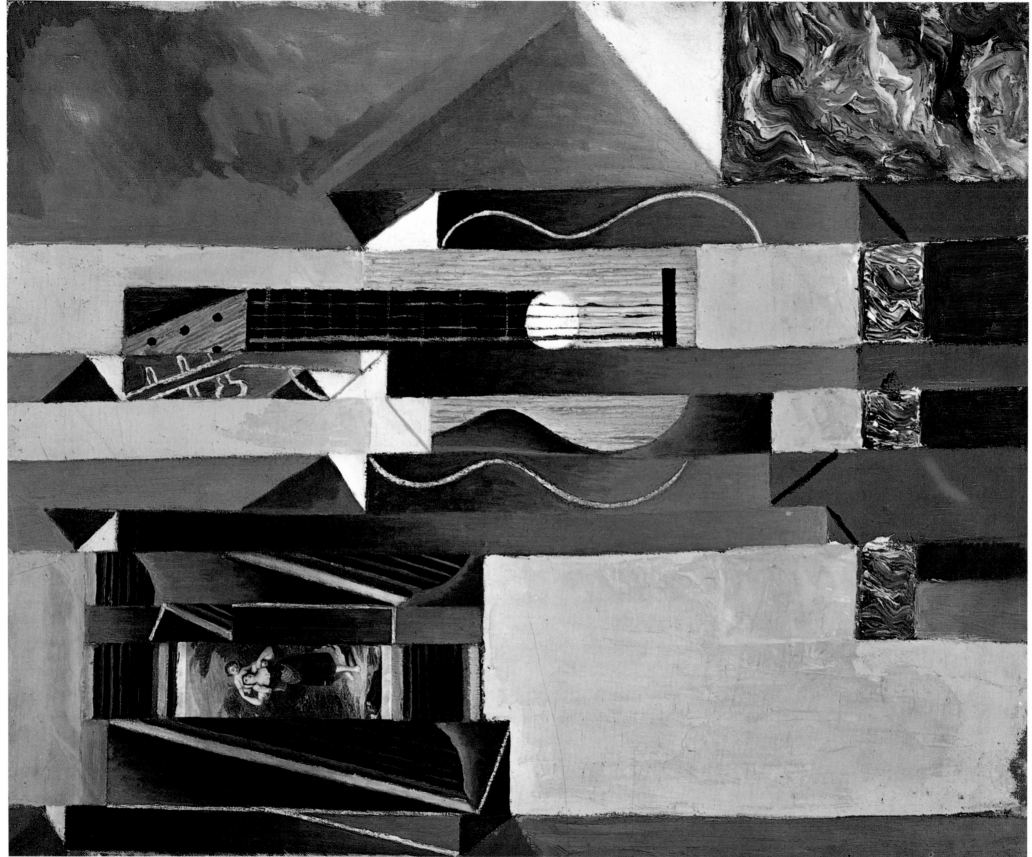

Juan Gris (1887–1927). *The Guitar*. 1913. Oil and *papier collé* on canvas. 24×19¾"

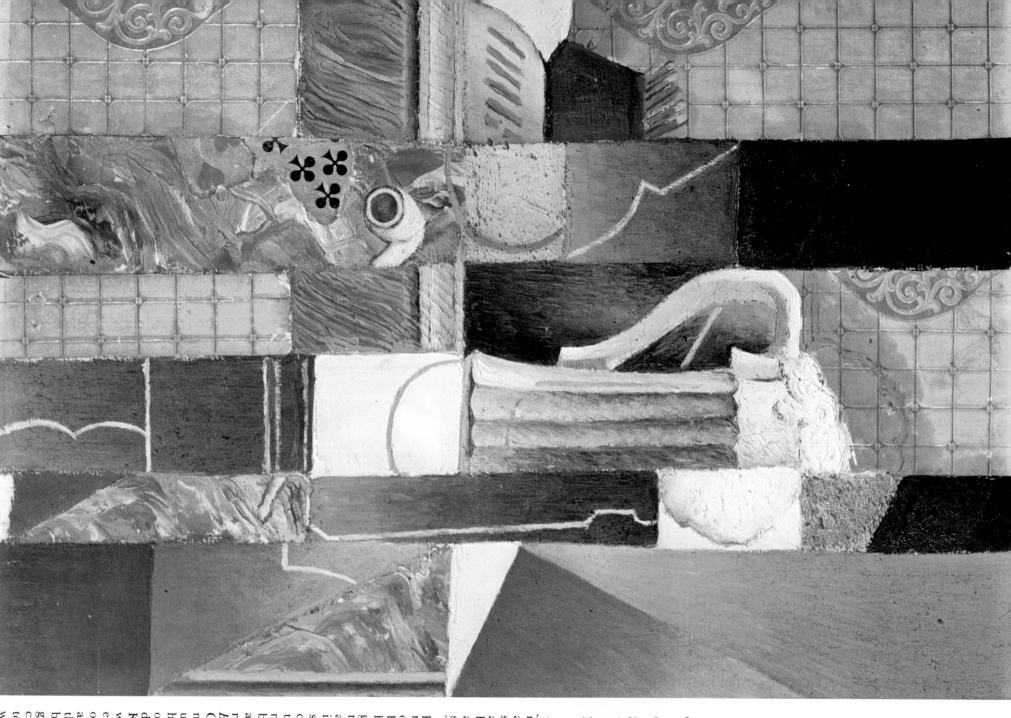

Gris. *The Beer Mug and Playing Cards.* 1913. Oil and papier collé on canvas. 20⅛ × 14⅞"

The image,
cut up into thin
strips, admits to
being surface and
matter

Juan Gris' "strip" constructions
mark the supremacy of a work's
autonomous architecture over its
subject matter. In these works the
artist imposes on the economy of
his painting a predetermined,
authoritative structure that
strengthens its surface character.
This structure then takes
precedence not only over the
representational anecdote but also
over the traditional composition
based on the equilibration of
heterogenous masses. The
guillotining of the image renders
the artist's intervention tangible
and obvious. The unity of the work
is no longer maintained by the
scene's coherence but by the
division of identical fragments over
the entire picture plane: imitation
marble, squared wallpaper, and
blue nonrepresentational areas
along with green and black areas
responding like an echo. In *The
Beer Mug and Playing Cards* (left)
Gris attempted to achieve a
mineralization of the surface by
using sand and ashes. "He thought
he could lessen the viscous aspect
of oil painting," wrote the art
dealer and historian Daniel-Henry
Kahnweiler, "and again do away
with any virtuosity in the
execution." Into the upper left part
of Gris' *The Guitar* (far left), the
artist has inserted an old engraving
that seems partly to be concealed
by a fold, whereas in reality it is
glued to the painting. It serves to
cite a perspective depth in contrast
to the frontality of the work as a
whole.

245

Ivan Puni (1894–1956). *Relief with Dish.* 1919. Linden and ceramic. 13×24″

Tassels, balls, dishes: nothing escapes the artist's thirst for experimentation

Cubism's extreme freedom and fantasy were among the principal sources of inspiration for the absurdist and Dadaist currents that were born in Europe and in the United States during and after World War I. In its comical appearance and in the deceiving negligence of its execution, Pablo Picasso's *Still Life* of 1914 (right) reveals very precise intentions. "Together the border frieze and the glass are of the same length as the table section and the knife," Werner Spies has noted. He has also pointed out that the table is bent toward the viewer as in Paul Cézanne's paintings. The texture of the fringe and the tassels offers a contrast to the milky white glass, shown in cross section with a piece of wood, halfway, indicating the content level. Slices of cheese and salami anticipate the inventions of the Pop artist Claes Oldenburg fifty years later.

The same is true of the constructions of Ivan Puni made in Russia—such as *Relief with Dish* (above) and *White Ball* (left). One of Kazimir Malevich's companions, the organizer of scandalous exhibitions in Petrograd (Tramway V and 0.10), Puni had provoked the anger of his contemporaries as early as 1915 by planting a real fork in a painting. In January 1916 a local newspaper *The Day* printed his ideas, which were akin to the very spirit of Dadaism. "Raphael's silly little paintings can only inspire infinite pity in those who look at them. . . . The supreme expression of beauty is a drawer with a white ball inside. . . . A painting can be cut into two. One part will be exhibited in Moscow, the other in Petrograd, etc." White ball, dish, or fork, for Puni as well as for the Dadaists a painting must be able to take in and metamorphosize any object of daily life.

Ivan Puni. *White Ball.* 1915. Plaster and painted wood. 13⅜×13⅜×4¼″

From the Cubist collage
to the Dadaist assemblage,
freedom loses all patience

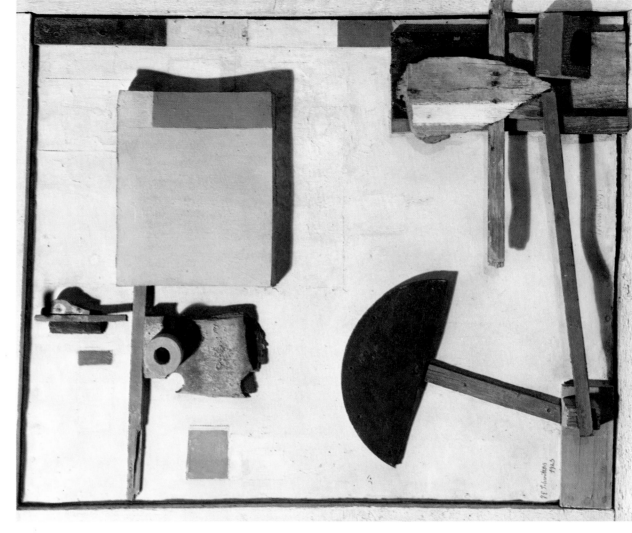

Kurt Schwitters (1887–1948). *Merzbild Kijkduin.* 1923. Various materials on wood. 29⅛×23⅞"

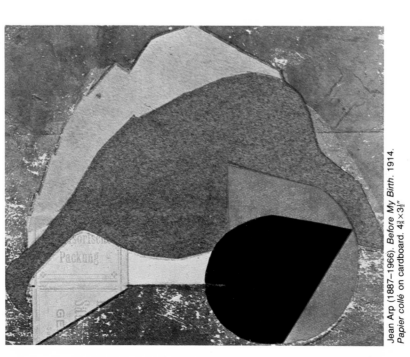

Jean Arp (1887–1966). *Before My Birth.* 1914.
Papier collé on cardboard. 4⅜×3¼"

The collages that Jean Arp made during 1914–1915 ensured the transition between Juan Gris' very structured works (see page 242) and Kurt Schwitters's Dadaist assemblages. Arp worked like a Juan Gris who had restricted himself to the nonfigurative substructure of his forms. In his *Before My Birth* (far left), Arp used cutouts—made by scissors and "guillotining"—against the "guillotining"—against the cardboard. He distrusted manual dexterity. He went without a transitional phase from this severe type of collage to relief and to sculpture.

With Kurt Schwitters one enters the category of catchall paintings. As his friend Hans Richter wrote, "With him there is no trace of 'the death of art,' 'a-art,' or 'anti-art.' On the contrary, every used tramway ticket, envelope, cheese paper, cigar band, torn sole, steel band, pen, or kitchen cloth, in short, anything thrown away, all these were integrated in his passionate desire in order to recuperate a worthy place in life, that is, in his art." From 1920 to 1936, Schwitters devoted most of his time to developing his *Merzbau* ("Merz house") in Hanover, Germany. "Merz" was chosen as the generic title of his production because as an antiphrase it was an abbreviation of "Commerzbank." The *Merzbau* developed the principle of the accumulation of rejected material forms of interior architecture. Schwitters, who began his *Merzbau* with a central core of plaster (he was the man who said, "Everything the artist spits is art"), organized the infinite proliferation of a sculpture of debris and *objets trouvés* that invaded his apartment and then the floor above it. In 1943 a bombardment ruined the masterpiece of the Hanover Dadaist, as though reality had generalized his project by canceling it.

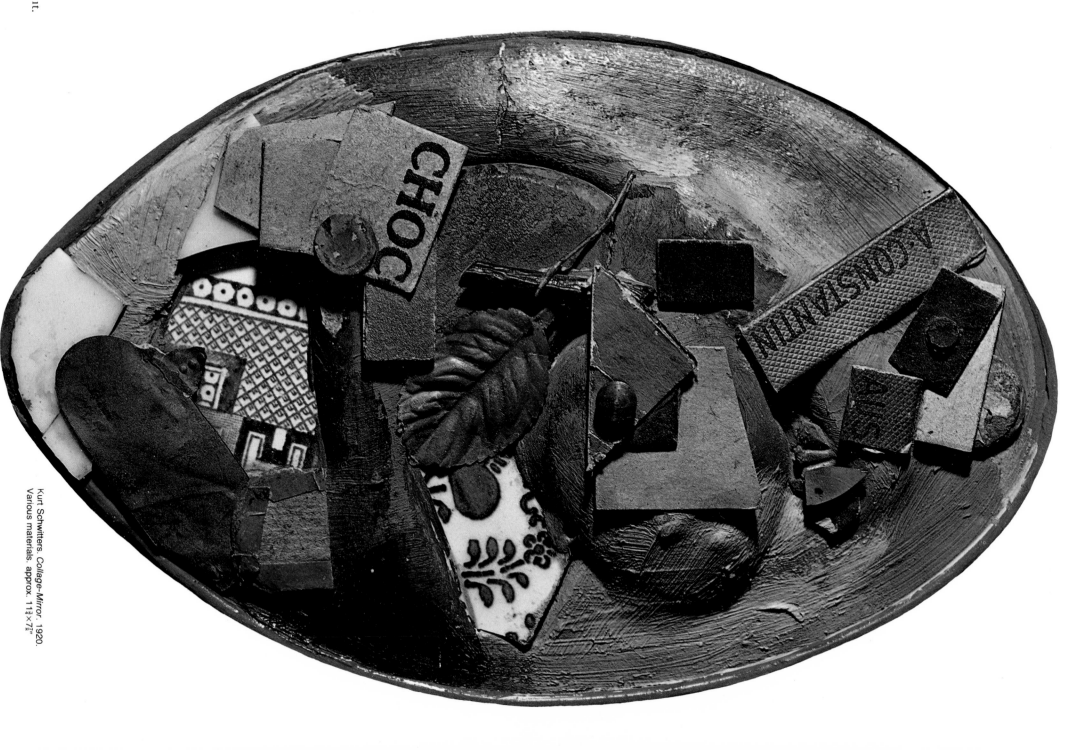

Kurt Schwitters. *Collage-Mirror.* 1920. Various materials. approx. 11¾×7⅞"

249

The wall shows through the painting and becomes—unexpectedly—a component of the work

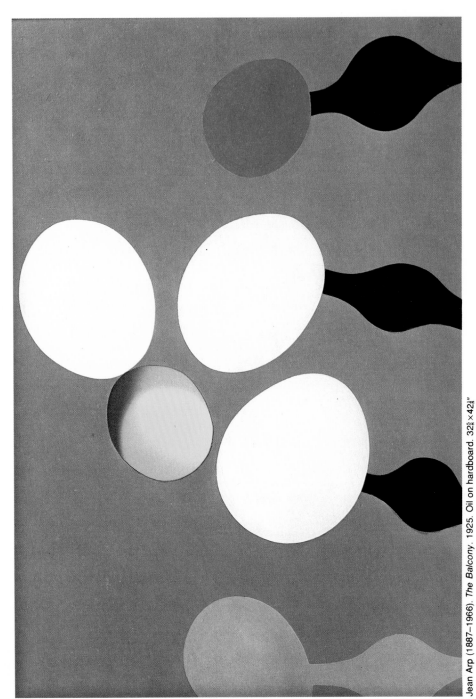

Jean Arp (1887–1966): *The Balcony*. 1925. Oil on hardboard. 32½×42¾"

Jean Arp's paintings with holes, as early as 1914, were the first to use the wall against which they were hung as a component part. Surpassing the experiments of Paul Cézanne and the Cubists, which allowed the grain of the canvas to be seen between the brushstrokes, the artist undertook, in these works, to go through the canvas and to reveal the prosaic presence of the wall behind it. In the dancer's leg in *Dancer* (right), as in the oval form of the constellations in *The Balcony* (left), the background is an unexpected and complementary element, a variable that disturbs the economy of the work and gives it an aleatory dimension. In this form or in others (see pages 210–211), chance is a constituent part of Arp's work.

Jean Arp. *Dancer*. 1925. Painted plywood. 57½×42⅞"

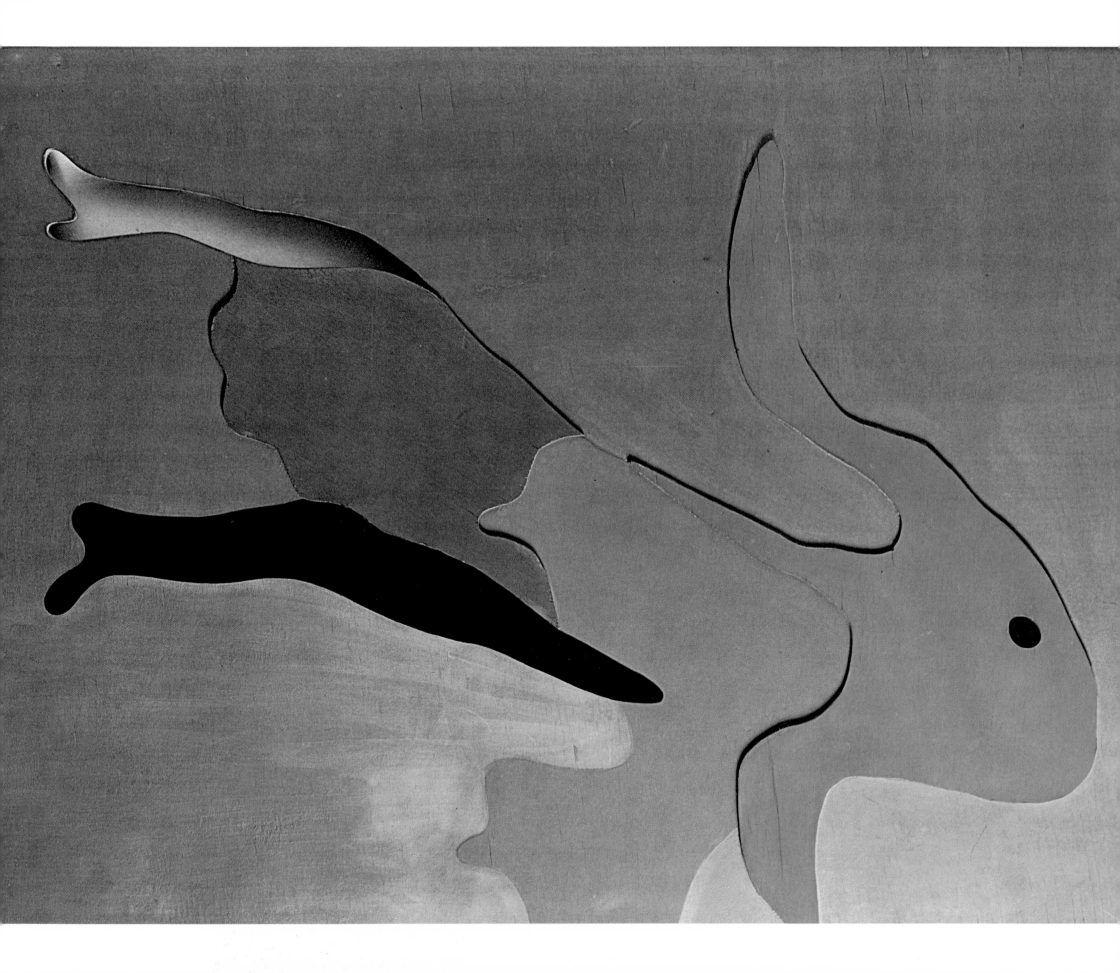

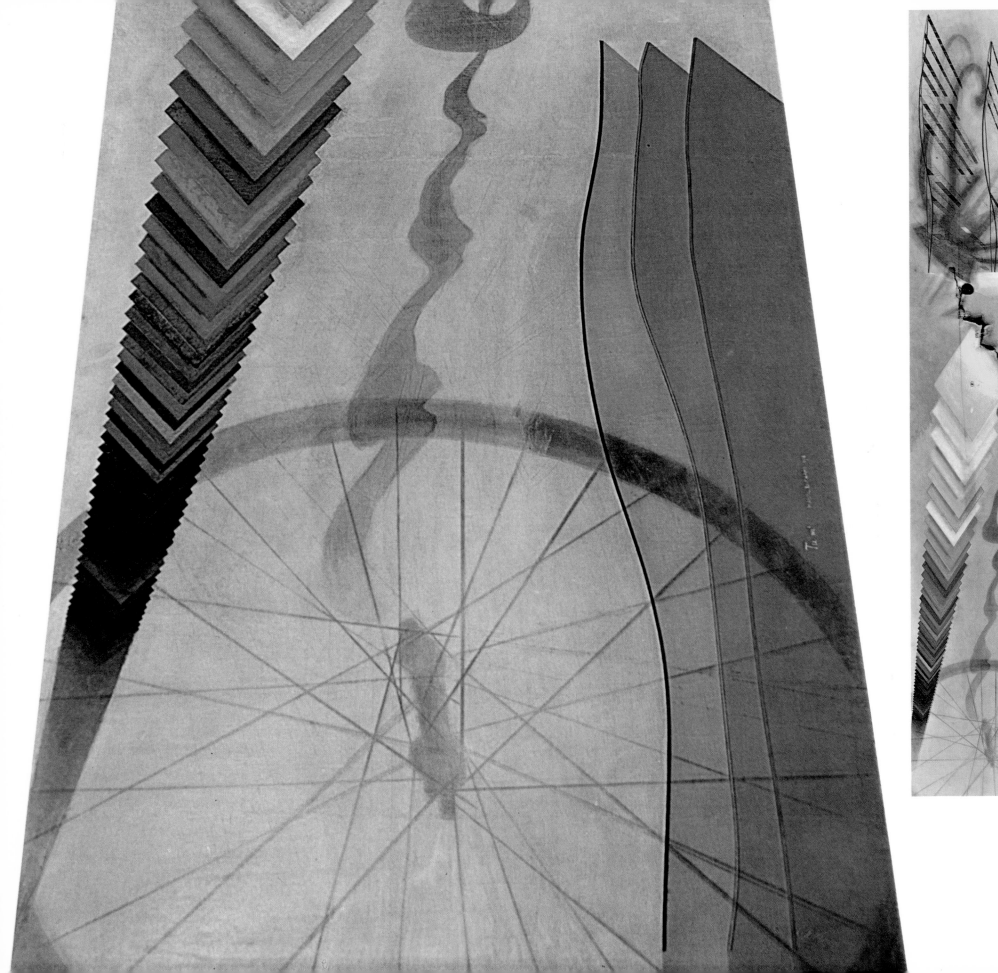

Marcel Duchamp (1887–1968). *Tu m'*. Canvas, swab, safety pins, washer, bolt. 27⅝×122⅞". Side view (far above) and front view (above)

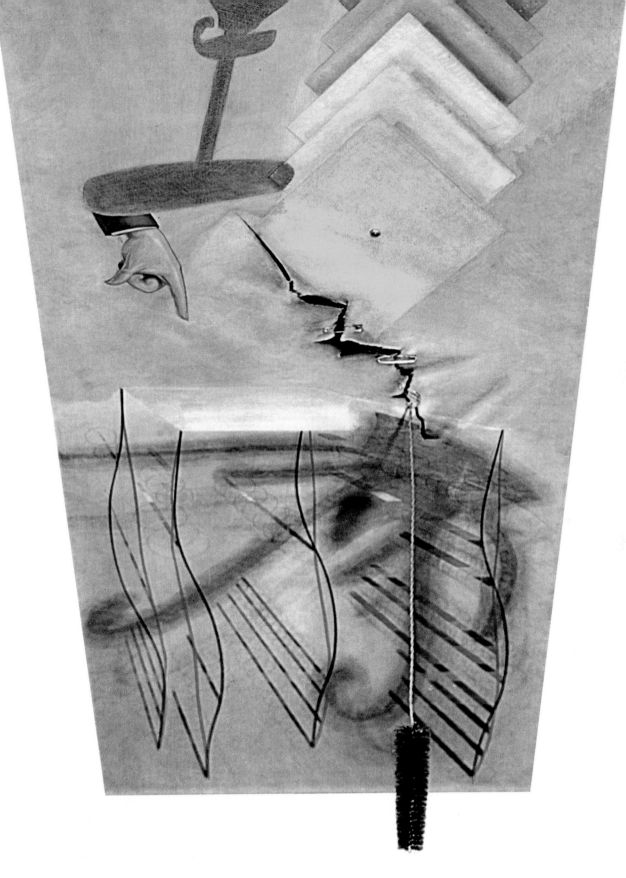

Duchamp spreads confusion: he inextricably mingles real objects and illusion

Using a strange title—*Tu m'* (view from the side, *above*; view facing, *left*)—whose elision suggests something rude (*Tu m'emmm . . .*), Marcel Duchamp offered, in 1918, a painting that aimed at being both a concluding statement and a program. Side by side—as though to illustrate a treatise on painting—coexist several contradictory ways of occupying the canvas space. Three objects, including two of his most famous ready-mades (the wheel and the hat rack), are represented by their shadows. The third, a corkscrew, is highly distorted according to an anamorphic technique later used by the Surrealists, chiefly Salvador Dali. The corkscrew is completed by a hand done by a sign painter. On top of the shadows and covering them (which proves them to be false shadows) are two representations of *sloppages-étalon*,

whose outlines were produced by the intervention of chance. (For an explanation of this technique, see page 174.)

An infinite sampling of color swatches is spread out toward the horizon in aerial perspective, and they have been clamped into place in the foreground by a real screw and bolt. Extending almost two feet out of the composition, a black brush points toward the spectator, and a false rip painted in *trompe-l'oeil* has been "repaired" with three authentic safety pins stuck into the canvas. The illusion of perspective suggested by the flow of colors is contradicted by the crack and above all by the presence of the manufactured objects (safety pins, bolts, and brush), which reveal the material existence and therefore the frontality of the canvas.

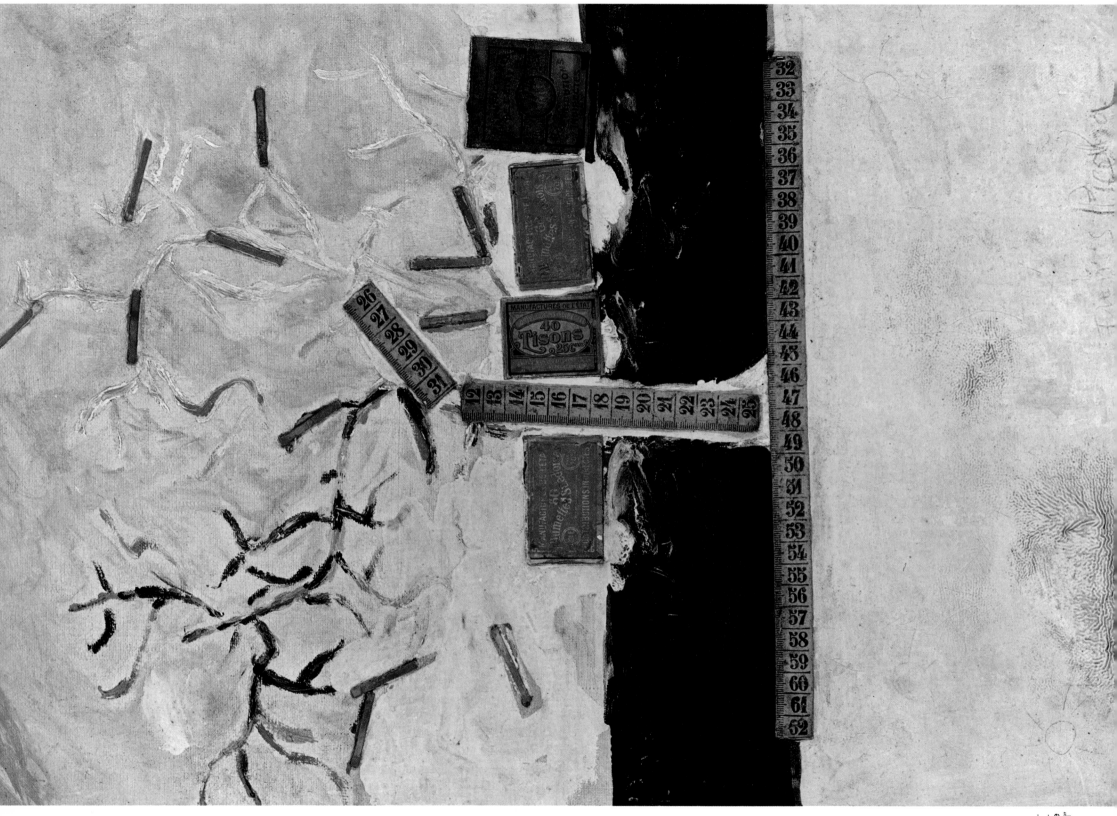

Francis Picabia (1879–1953).
The Centimeters. 1918.
Oil and collage
on canvas. 22×15⅛"

254

The collages that Francis Picabia made during the last phase of the Dada movement recall in a burlesque and provocative manner the landscapes that made him famous at the beginning of his career: a ten-year period (1898–1908) during which he painted a thousand Impressionist canvases directly inspired by Alfred Sisley and Camille Pissarro. But Picabia's collages also are a development as well as a parody of the Cubist work. Just as Pablo Picasso had used oilcloth to represent the cane seating of a chair (see pages 236–237), so Picabia cut out a rectangle of soft measuring tape (also of oilcloth) and used it to denote a tree, whose branches were then made of matches as in his *The Centimeters* (left) or of feathers as in *Feathers* (right).

Picabia's borrowings from the world of manufactured and natural objects were never direct. The materials he plundered always represent something else. His aggressive exhibition of so-called prosaic and common materials—toothpicks, hairpins, matches, and cocktail straws—is in contrast, as José Pierre has remarked, to Kurt Schwitters' conceptions. Whereas Schwitters, who was described by Richard Huelsenbeck as a "got-up-for-the-occasion genius," turned to the squalor of refuse and restored it by his aesthetics and brought it up to the level of art, "Picabia persisted in poking fun at the artistic enterprise and also in dragging it to the edge of the commonplace, of futility, and of insignificance." He fits the analysis of the German philosopher Walter Benjamin: "The Dadaists attached less importance to the commercial use of their works than to the fact that one could not make them objects of contemplation. One of their most common means of achieving this aim was the systematic debasement of the very materials of their works."

Picabia's pastiche landscapes deride the art of painting

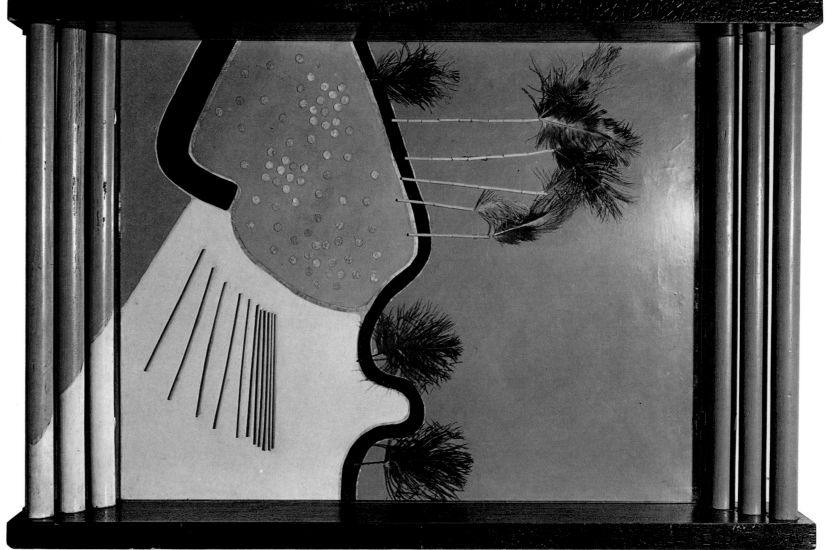

Francis Picabia. *Feathers.* 1921. Feathers and wood on canvas. 46⅞×30¼"

The surface is desacralized—and lends itself to the most eccentric games

In realizing a series of heads with the most extravagant materials—buttons, steel pen nibs, and heel taps—arranged in a very simplified play of curves, Francis Picabia obtained images of great visual efficiency, even though his intention was to mock painting: these images gain their surprise effect from the double reading they propose as figures and as added objects, as seen in his *Portrait of Mme Robbie de Massot* (left). At this time Picabia was also developing his researches in imprinting and tracing. In 1919, when he went to meet the Zürich group of Dadaists, they found him in his hotel room busily taking apart an alarm clock whose mechanism, dipped in ink, was then pressed onto a sheet of paper, which was then decorated with inscriptions. Forty years later Fernandez Arman's *"allures d'objets"* took up the same technique with little change.

In *The Cacodylic Eye* (right) ("cacodylic" comes from the Greek words *kakodes*, which means "stinking," *odmè* which means "smel," and *ute*, which means "material"), Picabia juxtaposed images—an eye, five photos, a drawing of the Fratellini clowns—with signatures and short statements made by the artist's friends, including Marcel Duchamp, Jean Metzinger, Jean Cocteau, and Benjamin Péret. The statements are more or less spontaneous ("I'm returning from the country," "I have been called 'Dada' since 1892"), and were written throughout 1921 by visitors who were obviously placed suddenly before the work. The important thing here is the new relationship between the painting and the spectator, who becomes a cocreator of the work. He leaves his imprint on a part of the surface until then untouched. Works created through participation and manipulation in the 1940s and 1950s partly stem from this painting gag, which in its own fashion is the reliquary of an era.

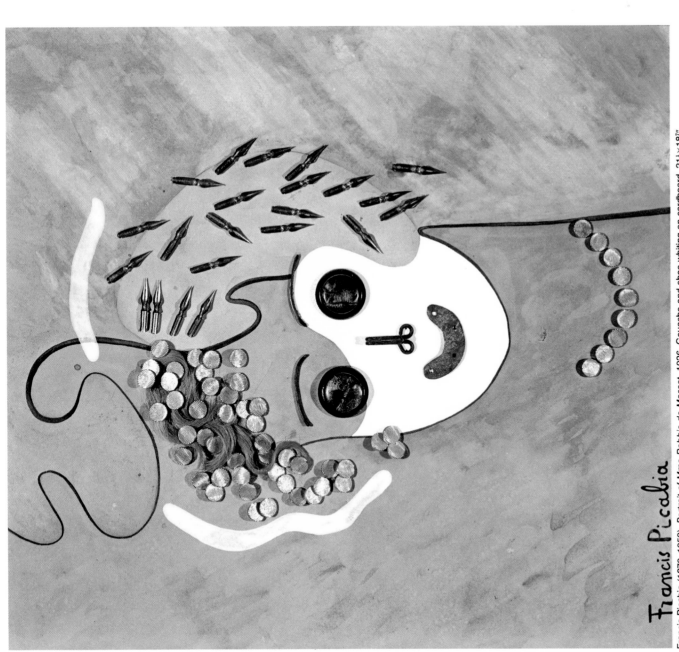

Francis Picabia

Francis Picabia (1879–1953). *Portrait of Mme Robbie de Massot*. 1926. Gouache and shoe whiting on cardboard. 21¼×18⅞"

Francis Picabia. *The Cacodylic* 1921. Oil on canvas. 57¾▶

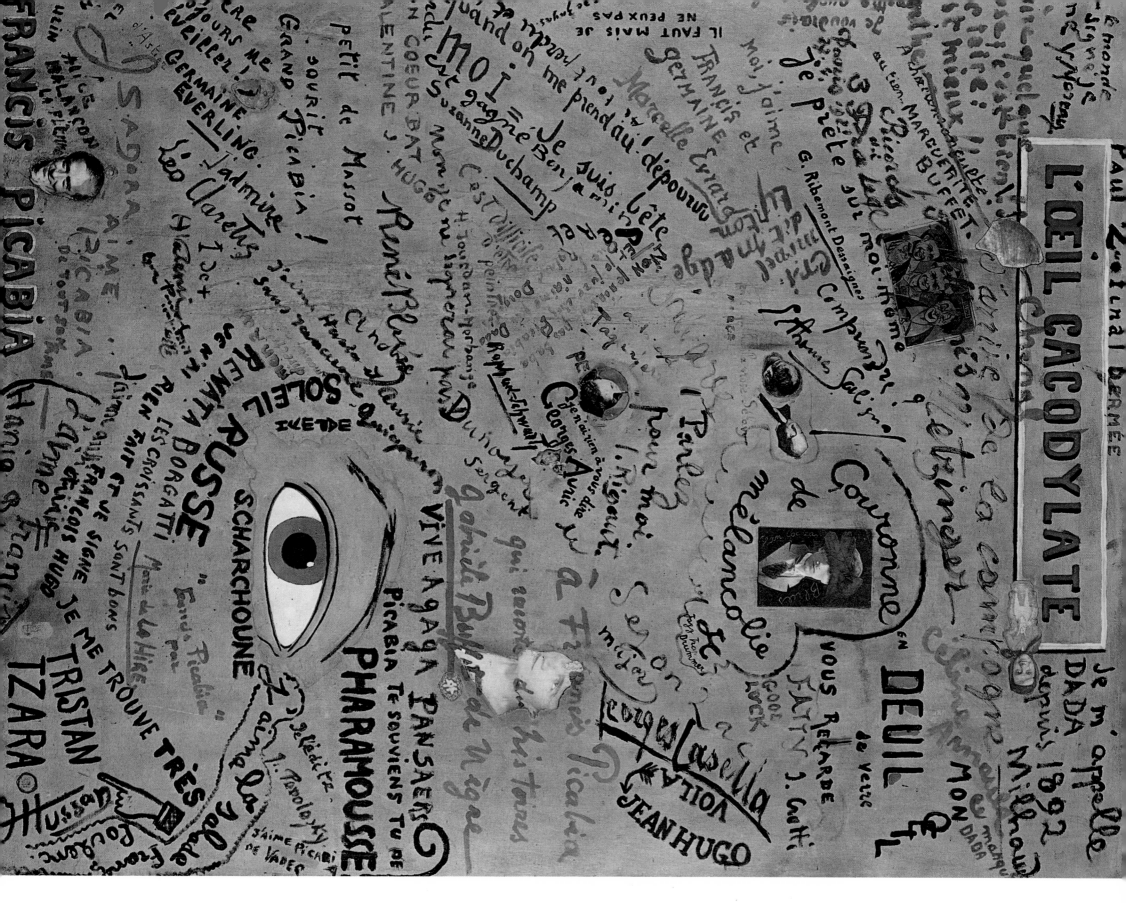

257

The painter invents conceptual traps that question the contemplative ends of art

Marcel Duchamp (1887–1968). Apolinère Enameled. 1916–1917. Rectified ready-made, zinc plate. 9¼×13⅞"

In his rectified ready-mades, Marcel Duchamp was content to select an image or an object from among many manufactured products and through discreet intervention to divert it from its utilitarian function. In the advertisement for Sapolin enamels that he used in *Apolinère Enameled* (above), he changed only a few letters in order to misspell deliberately the name of his friend Guillaume Apollinaire, the poet and critic. He also added the scarcely perceptible reflection of the young girl's hair in the mirror. In *The Bride Stripped Bare by Her Bachelors, Even*, also called *The Large Glass* (right), one finds this same relationship between the ready-made object and pictorial practice reversed. Here first the painting is created. But the

transparency of the glass panels make it possible to view as ready-mades the extrapictorial elements that can be seen through the glass: visitors, the walls of the museum, and other paintings, all of which constantly change. Insisting on this aleatory dimension of his work, Duchamp stated in 1967: "The idea of transparency is useful in order not to fix a thing. If you like trees or something, you can place them behind the glass. This adds an artificial but very serious dimension. . . ." The artist has used a means of escaping from the "padding" between forms and the white coating of the background. Transparency permits him to suspend his figures in space without connecting them by a common texture (notice, on the other hand, that most of these

figures obey Classical perspective). Left unfinished after eight years of work, *The Large Glass* consists of two sheets of glass more than nine feet high (each one sandwiched into two others of the same size). The outlines are made in lead wire, and large layers of the same metal cover the reverse side of the colored areas. In 1926 when this work shattered during transportation, Duchamp, far from cursing its fate, congratulated himself on the accident. "I like these cracks," James Johnson Sweeney relates the artist as having remarked, "because they do not resemble broken glass. They have a form, a symmetrical architecture. Better still, I see a curious intention for which I am not responsible, a *ready-made* intention so to speak, which I respect and love."

Marcel Duchamp. *The Bride Stripped Bare by Her Bachelors, Even (The Large Glass)*. 1915–1923. Oil and lead wire on glass. 110¼×

Painting expands into three dimensions and creates the desire to touch it

Otto Dix—like Jean Dubuffet twenty-five years later—borrowed from children's drawings a candor that is actually very cultural. As for Max Ernst, he was directly inspired by the paintings of Giorgio de Chirico. Both artists added excrescences to the surface of their paintings that created in the spectator a desire to touch. Incongruous like warts, the half circles, either cracked or brilliant, that occupy the upper part of the tramway in Dix's *The Tram* (left) do not produce the same sensory effect as a traditional bas-relief. They obviously contradict the flatness of the image and suggest an extravisual perception.

The same is true of the smooth and oblong object that occupies the area of the house, which itself is built out from the picture plane, in Ernst's *Two Children Are Threatened by a Nightingale* (right). Moreover, the frame's enclosing function is questioned in several ways. The molding on the outer edge of the image is painted: in its upper part it takes on the adjacent colors of the painting, but below its brown color and the inscription of the title contradict them. The wooden button situated halfway along the molding and overlapping both frame and image demands to be touched. Finally, the barrier, whose post has been placed directly on the painted panel, largely extends beyond it and partly covers the massive wooden frame. As art dealer Sidney Janis noted in 1942, "The painting opens onto space that normally separates the spectator from the painting." Here Ernst asks the viewer to transgress an area until now inviolate—the area that keeps the spectator some distance from the painting.

Otto Dix (1891–1969). *The Tram.* 1919. Oil on wood and collage. 18⅛×14⅜"

Otto Dix (1891–1969). *Prager Strasse.*
1920. Oil on canvas and collage. 39¼×31⅞"

Waste and the symbols
of everyday life feed the
German Dadaists' vengeful verve

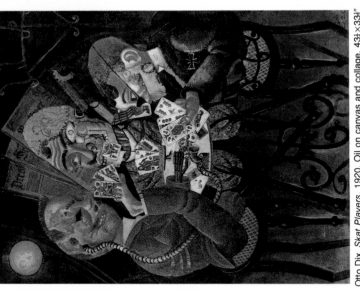

Otto Dix. *Skat Players.* 1920. Oil on canvas and collage. 43¼×33⅝"

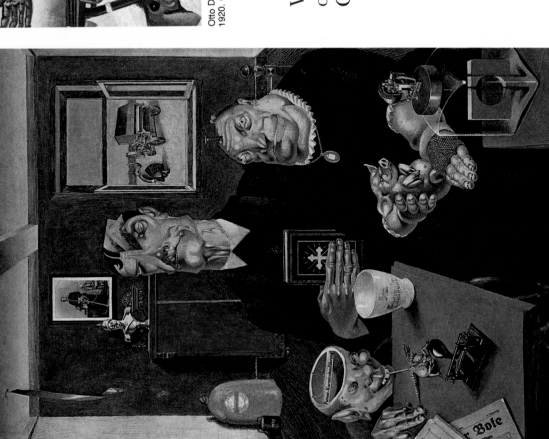

Georg Scholz (born 1890). *Industrial Farmers.* 1920. Oil and collage on wood. 38¼×27⅝"

The Dadaism of Berlin turned the collage into a political pamphlet. In contrast to Cubism (see pages 236–239) or to the work of Francis Picabia (see pages 254–255), Otto Dix and Georg Scholz used everyday materials for what they were. They produced their vengeful caricatures by literally taking over the symbols and the cultural instruments of the period. *"Juden raus!"* is the title of the newspaper that the legless cripple rolls over in

his cart in Dix's *Prager Strasse* (above left). Prager Strasse was a street in Dresden, Germany. The brain of the farmer in Scholz's *Industrial Farmers* actually is made up of real German banknotes.

The logic of collage and the social preoccupations of the German Dadaists should have resulted in manifestations in which politics would have been indiscernible from art. This is exactly what took place on June 20, 1920, at the Dadaist Mass held in

the Otto Burchard Gallery in Berlin. This was an exhibition of 174 works, including the stuffed figure of a German officer adorned with a pig's head suspended from the ceiling of the gallery. However, this demonstration was not repeated. The effects of the aborted revolution of 1918–1919 and internal quarrels hastened the dispersal of the most virulent group in Europe.

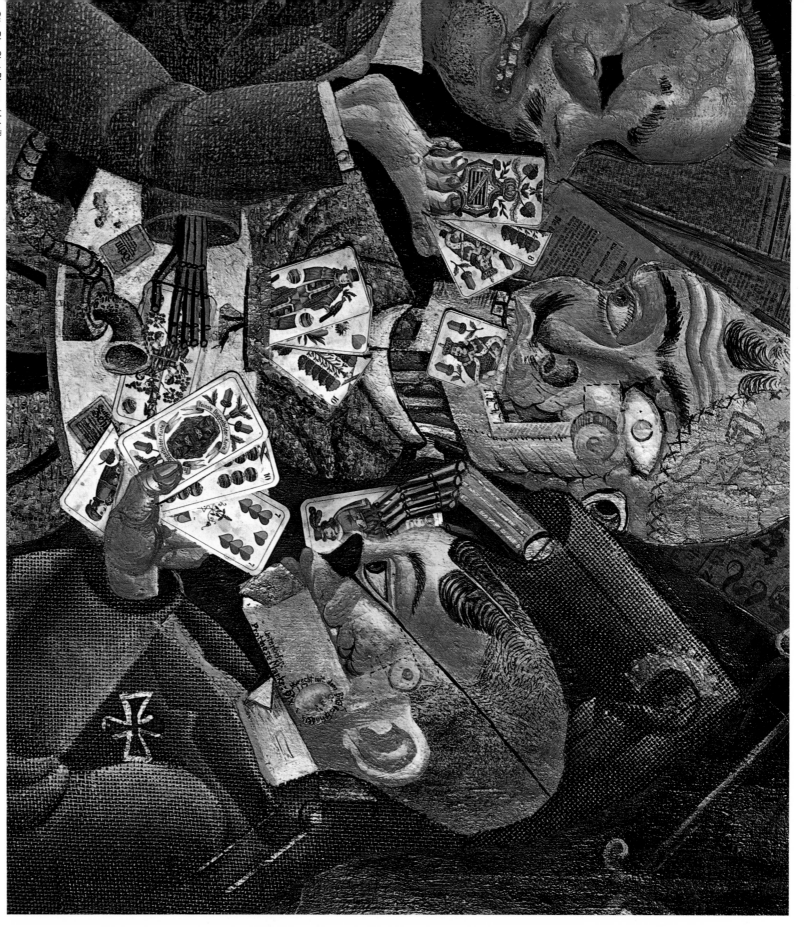

From harmless images, photomontage built a machine to wage war against logic

Hannah Höch (born 1889). *Dada Dance.* 1919-1921. Photomontage. 12⅛ × 9"

Even if Cubist collages had foreshadowed its invention, even if photographs had appeared in paintings as early as 1914 (see page 159), it was not until about 1918 that photomontage imposed itself on George Grosz, John Heartfield, Raoul Hausmann, Hannah Höch, and other artists as a specific technique. Raoul Hausmann noted that "almost every home had hanging on the wall a colored lithograph representing a grenadier in front of his barracks. In order to make this military memento more personal a photographic portrait of a soldier had been pasted in place of his head. This was like a stroke of lightning; we could—I saw it at once—make entire works consisting of cutout photos. When I returned

to Berlin in September, I began to pursue this new vision by using press and cinema photos."

Raoul Hausmann wrote a text in 1967 on the development of photomontage—his own and that of his companion Hannah Höch, which explains his famous photomontage *Tatlin at Home* of 1920 (left). "One day I was leafing through an American review without thinking of anything. Suddenly, I was struck by the face of an unknown man, and I do not know why I automatically made the link between him and [Vladimir] Tatlin, the Russian creator of machine art (see page 270). But I wanted to render the image of a man who had nothing on his mind except machines,

motor cylinders, brakes, and steering wheels. I took a good piece of cardboard, and I said to myself that this man should be seen in perspective. I then began to paint a room seen from above. I cut out the man's head and pasted it at the bottom of my watercolor. I began to cut out pieces of an automobile advertisement and assembled them above his eyes. Yes, but that was not enough. This man should think of great machinery. I therefore looked in my photos, and I found a boat's stern with a large propeller, and I placed it up against the back wall. Didn't this man also want to travel?—and here is a map of Pomerania on the left wall. Tatlin was certainly not rich, so I cut out from a French newspaper a man walking with an anxious expression, turning out his empty trouser pockets. . . . Then I drew a tailor's dummy in my painting. . . . From a book on anatomy, I cut out the image of the inner organs of the human body and placed it in the dummy's torso. At its feet, I put an extinguisher. I looked once again. No, nothing had to be changed. It was good. It was fine!"

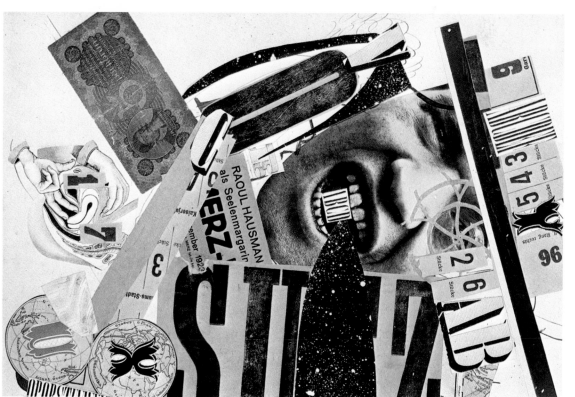

Raoul Hausmann. *ABCD.* 1923-1924. Photo and various materials. 15¾ × 10¾"

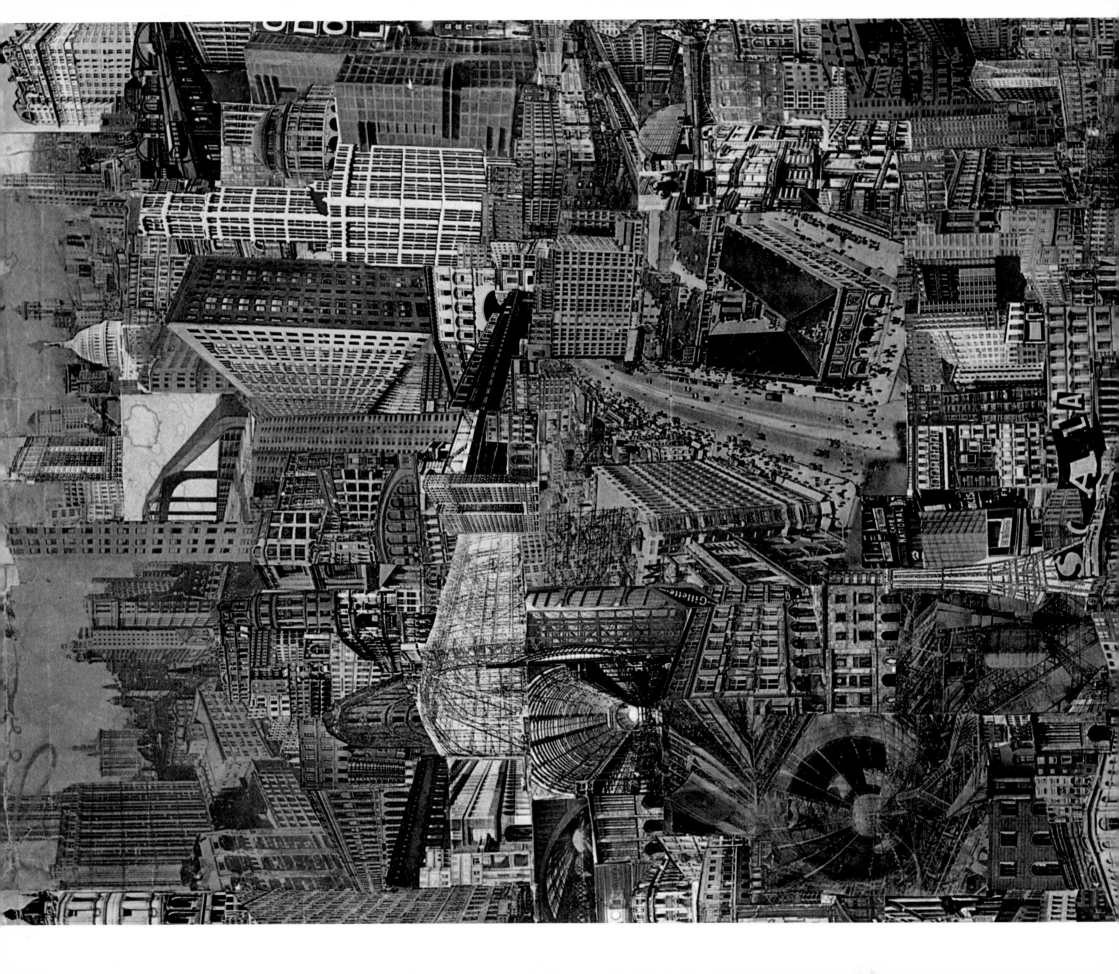

From an accumulative delirium a plausible image of the modern world is born

Whether it is a question of pieces cut out of newspapers—as in Carlo Carrà's *Interventionist Demonstration* (right)—or photographs—as in Paul Citroën's *Metropolis* (left)—a particular category of collage proceeds not from the organization of a central theme but from the dissemination of discrete and repetitive units. Here meaning stems from quantitative accumulation. Both the centrifugal jumble of *words at liberty* and the incoherent puzzle of urban photos refer to the noise and disorder of modern cities. In Paul Citroën's assemblage, in which all the scales and all the perspectives intermingle and cancel out one another, each image has, beyond that, been divided into an infinite number of microelements: the walls and windows that add to the feeling of profusion and disorder.

Carlo Carrà, who wanted his works to be proclamations, used onomatopoeia to sonorize this painting. By doubling and tripling the letters of a word ("EVVIVAAA"), he suggested an approach which would also mean reading aloud. A work used to be something to look at—now it was something to be listened to.

Paul Citroën (born 1896). *Metropolis*. 1923. Collage of photos, printed materials, and postcards. 29⅞ × 22½"

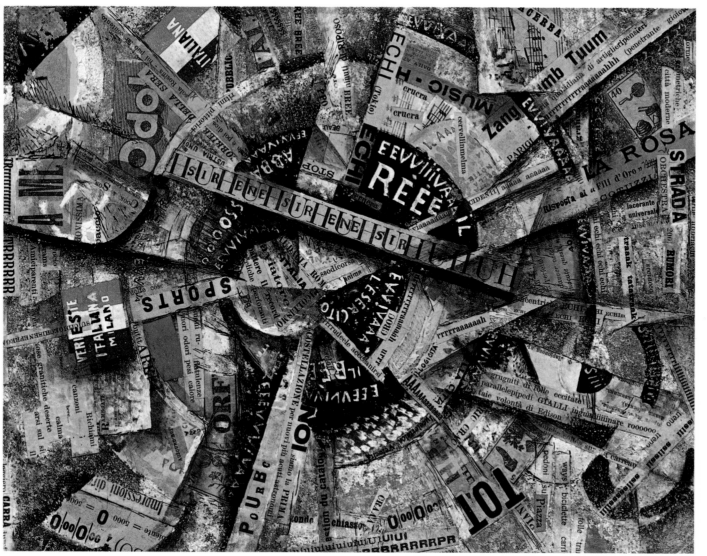

Carlo Carrà (1881–1966). *Interventionist Demonstration*. 1914. Collage on paper. 15 × 11¾"

MOVEMENT

Modern art undertakes to represent time and movement. This is its reply to the pet words of the period: energy, speed, mechanization

Umberto Boccioni. *Synthesis of Human Dynamism*. 1912
To express movement, volumes are twisted and torn apart

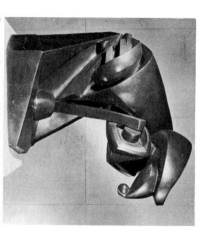

Raymond Duchamp-Villon. *The Major Horse*. 1914
The sculptor combines a horse's head and a locomotive's pistons

Francis Picabia. *Machines Turn Quickly*. 1916

Max Ernst. *Ice Landscapes*. 1920
The machine, exalted by the Futurists, creates irony among the Dadaists

Time and movement are not inventions of twentieth-century art. The *Victory of Samothrace*, disparaged by Filippo Tommaso Marinetti in his chapter on speed in his famous Futurist Manifesto of 1909 in which he confronted it with a racing car, says as much on the subject and perhaps more than many a Futurist painting. Moreover, Umberto Boccioni even borrowed certain of its elements for his sculpture *Synthesis of Human Dynamism* (left). "Modernity is what is transitory, fleeting, contingent," wrote Charles Baudelaire in 1863 in reference to Constantin Guys. In 1864 Ernest Chesneau stated, "Never has the prodigious animation of the public thoroughfare, of crowds swarming on the pavement and carriages in the street, of trees swaying in the boulevard in dust and light, never has the fleeting instant of movement been so perfectly captured in its prodigious fluidity as in this extraordinary, marvelous sketch that Mr. Monet has listed under the title *Boulevard des Capucines*." Both Joris Karl Huysmans and Walt Whitman praised the beauty of locomotives a quarter of a century before Marinetti. In one sentence, "We must be absolutely modern," Arthur Rimbaud summarized the innumerable and vehement proclamations of the Italian poet. In 1901 Saint-Pol Roux published "*L'Oeil goinfre (dans le rapide Marseille-Paris)*"—"The Guzzling Eye (in the Marseilles-Paris Express)"—"perhaps the most successful Futurist poem," wrote José Pierre, who also mentioned Alfred Jarry's *Le Surmâle* (1902) and Jules Romains' *unanimisme*.

In 1910 a critic was even able to distinguish a representation of time in Cubism. That same year Jean Metzinger believed he saw in Georges Braque "erudite confusions of the successive and the simultaneous." In 1911 he stated: "The Cubists have taken the liberty of going around the object so that, under the control of their intelligence, they can present a concrete representation in several of its successive aspects. Painting possessed space. Now it also exists in time." For the exegetes of the period, whose idealistic basis we described in Chapter 3, Cubism was conceived of as a "conceptual" realism, and its fragmentary interpretation of a guitar or of a person could actually be taken as the documentation of several successive perceptions, each painting being made up of layers of interlocking, stratified time that the spectator discovered all at once, and it was up to him to reverse the painter's path and to reconstruct mentally—in time—the represented object. In these terms, Futurism could be described as a dilated, lateralized

Cubism. For the exegetes the successive aspects of a person were superimposed, whereas for the Futurists the successive positions of a moving being were placed side by side, as much on the subject and perhaps more which he confronted it with a racing car, says maximum spatial extension inside painting. We shall see that these two interpretations are subject to the same "realistic" prejudice that—putting aside the specific material character of the painting—wanted to instrumentalize it and to confine it to the recording of natural phenomena. However, during the 1910s the words "time," "movement," "speed," "dynamization," "mechanization," and "modernity" were hammered out in every cultural capital and not without reason. We will mention only three reasons.

First, technical development: cars, airplanes, trains, the cinema, and so on, or rather, as Reyner Banham has noted, the new participation of the artist and of the poet in this technical development. They no longer were the passive witnesses of mechanical exploits but their exalted operators. In his Futurist Manifesto of 1909, Marinetti attempted to write—if we may be allowed the expression—Rimbaud's "*Le Bateau ivre*" ("The Drunken Boat") for the Fiat period. From Robert Delaunay's *Homage to Blériot* (see page 289) to Kazimir Malevich's *Planites* via Raymond Duchamp-Villon's *The Major Horse* (left), Luigi Russolo's *The Train in Speed*, Fernand Léger's *Mechanical Elements*, Gino Severini's *North-South*, and so on, the period was collectively fascinated by the wonders of "progress."

The second reason was the ideology of something new that almost everywhere accompanied the acceleration of industrial society. Actually, there is nothing in the discourse of the ephemeral that could grieve the social classes that controlled the development of wealth in the different European countries. The incessant changes of the means of production, the role of time as a raw material acting on stock market values, as Walter Benjamin has pointed out, prepared those in control of economic power to understand and support an aesthetic of change—in spite of the fears of the *petite bourgeoisie*.

Finally, science, the third factor, offered "objective" arguments. As early as 1912, Albert Gleizes and Jean Metzinger had adopted drastic measures in their volume on Cubism: "Euclid in one of his postulates states the indeformability of figures in movement. This spares us from being insistent. If we wanted to relate painting space to a geometry, we would have to refer to non-Euclidean scientists and long meditate on some of [Georg Friedrich Bernhard]

Cubism and Cubism as a contracted, concentrated Futurism—the one attempting to concentrate time in an image, the other, on the contrary, claiming to represent time in its

Riemann's theorems." This allusion to Riemannian topology, according to which in the words of R. Delevoy, "matter being postulated as deformable and extensible, a circle can become an ellipse, a sphere any convex surface without losing their initial qualities," confirmed in the painter's mind the corpuscular and undulatory theories that begin to circulate among the public before World War I. In *Le Nouvel Esprit scientifique* (1934), Gaston Bachelard stated: "Whereas matter offers itself to naïve intuition as designed, enclosed in its well-limited volume, energy remains without representation." An important part of modern art was about to dedicate itself to representing this nonrepresentation.

At the beginning of the century, time appeared in painting in three forms: in the time necessary to look at it and understand it, in the time necessary to make it, and in the time it represented. Certainly, the understanding of a painting—after the first shock of seeing it—postulates a visual examination, a *perceptive* groping. But modern art undertook to annex and program the effect of time required. For Paul Klee the effect was that of a palimpsest, and for him "the creation of the world lives as genesis beneath the visible surface, beneath the work's external appearance." He thus wanted to prepare paths "for the spectator's eye to explore, as an animal grazes in a meadow." To look is to become impregnated with the segment of time that is fossilized in the painting's texture—the ossuary-painting, the geological stratification, in which the debris of signs and the remains of figures lie dormant. Referring to his *Compositions* of 1910, Wassily Kandinsky stated: "I more or less dissolved the objects in the painting so that they would not be immediately recognized. . . . What is veiled in art is strong." Speaking of his early researches in Munich, he said in 1913: "I wanted to put into each part an 'infinite' series of tones that would not appear at first sight. At first they would remain entirely *hidden*, especially in the dark areas and be revealed only in *time* to the very attentive spectator, at first somewhat confusedly and later reechoing in increasing and anguishing force." Color slowly emerges from the canvas as in Nicolas Poussin's Virgilian backlighting and Rembrandt van Rijn's gold-encrusted old men blurred in the original night, early works that contemporary art—such as Albers', Rothko's, or Reinhardt's—teaches us to look at as matter, as pigment, and not any more merely as representative scene and compositional balance.

Many of Henri Matisse's paintings reveal changes, overpainting, cancellations. The

work is offered along with its history as a process of production, a work in progress, stages of a creation that could theoretically be considered infinite (this concept of a work's infinitude was adopted by such a contemporary artist as Martin Barré). From the point of view of time as lived by the spectator, the aesthetic of the unfinished refuses to reveal that only one episode in the painting's development (the last) results in certain *minimal* productions, such as Kazimir Malevich's *White Square on a White Background* (see page 216) and Piet Mondrian's *Composition with Lines* (see pages 216–217). Whereas Matisse gave us both the result and its gestation, Mondrian and Malevich offered works "still to be made" (speaking of the Suprematists, Chklovski remarked, "their paintings are more to be made than they have been made"). Their works are screens, they furnish an *open* structure in which the retention of the means is the condition necessary for the projections of the spectator. "Like any reading," wrote Hubert Damisch in 1958, "aesthetic perception at every moment goes beyond the material that it inspects." The "poorer," the skimpier the material, the better are the possibilities of extension. In modern art the most *economic* works, such as Kazimir Malevich's *Black Square on a White Background*, Marcel Duchamp's ready-mades, Piet Mondrian's checkered work, Naum Gabo's stem, Władysław Strzemiński's monochromes, Barnett Newman's wall-size paintings, and Lucio Fontana's perforated canvases, are also those that have caused the greatest commentary.

In the examination of the time needed for understanding a work we should also include —as we have already done on page 176 in regard to frontality—the transversal, ascensional dynamization created by the gyratory rhythms of Robert Delaunay for whom "seeing is a movement." His circular, interlocking colored forms create a cavalcade of vision from one end of the canvas to the other. And it is not by chance, as Paul Klee noted in 1917, that the artist generally chooses a format "that is impossible to take in at a glance." What he attempts to create is really a *successive* and not an instantaneous perception. Here we touch on the empathic, kinetic, dynamogenic effect of painting, described in 1867 by Charles Blanc in his *Grammaire des Arts du Dessin* and in 1885 by the theoretician Charles Henry, a friend of the pointillists. For the latter, any line releases the psychosensory mobilization of the viewer as his eye looks at the canvas. The Futurists remembered this when, in 1912, they wrote, "Perpendicular, wavy, and

Georges Seurat. *The Parade (Study).* 1887

Seurat represents light by regular brushstrokes, as the Italian Futurists later did (see pages 93, 291, and 307)

Vladimir Tatlin. *Project for a Monument to the Third International.* 1920

In his tower project, designed to exceed 984 feet, Tatlin integrated movement into an important symbolic architecture

László Moholy-Nagy. *Light Space Modulator.* 1921–1930

Moholy-Nagy invents a mobile and luminous structure that projects colored, fluid, and aleatory forms on the surrounding walls

Eugène Delacroix. Study for "The Death of Sardanapalus." c. 1827

Henri de Toulouse-Lautrec. Jane Avril. c. 1896

Albert Marquet. The Laundress. 1903

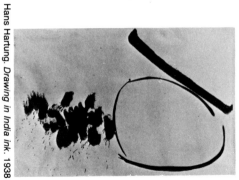

Hans Hartung. Drawing in India ink. 1938

Gesture—first dissimulated beneath the varnish of Classical painting—is gradually done for itself. The rich rhythms of Delacroix's The Death of Sardanapalus have their source in the scribbles and sketchy impulses in the study illustrated above. For inspiration, Toulouse-Lautrec and Marquet turn to the Japanese. In the index of gestural art, the twentieth century gives us works in which—as with Hartung—the sole indication is the hand's or the arm's energetic activity

seemingly exhausted lines can easily express languor and discouragement.... Confused jumping lines, straight or curved, mingled with sketchy gestures of haste, will express a chaotic agitation of feeling...."

In painting, time is consubstantial with space. The simple juxtaposition of two colors creates a time period in which they accommodate each other, an accommodation that works in reverse in the case of Op Art, which speculates on the distance between chromatic frequencies and thus creates fragmentation and imaginary pulverization of the surface. Matisse had a presentiment of this when he noted with anxiety at the time he was painting The Dance (see pages 194–195) that at a certain moment in the evening his huge canvas suddenly began to vibrate and quiver.

If modern art became aware of the time and movement required from the spectator for the understanding of the painting, it also displayed (took into consideration) the time needed by the artist to make a painting, and the artist's impulse in a gesture that is a flourish, that is an imprint, that is a sign of himself before it becomes a sign of reference. Tradition and academic painting pretended to ignore the bodily origin of pictorial practice. In the Mona Lisa, it is impossible to distinguish Leonardo's brushwork under the glazing. Certainly here and there throughout the centuries, the suppressed gesture was freed and imposed itself, as in Titian's last works and in the paintings of Peter Paul Rubens, Frans Hals, Rembrandt van Rijn, Diego Velázquez, Alessandro Magnasco, Jean-Honoré Fragonard, Francisco Goya, and Eugène Delacroix, to name only a few. But this generally occurs on condition the spectator stands back far enough so that he cannot distinguish the detail. A painting, Rembrandt explained, was not made to be "smelled out." One must turn to sketches for the original impulse that furnished the rhythmic basis of the work (left).

Twentieth-century art often proceeds contrary to this attitude. It illustrates Friedrich Hegel's phrase: "Like excretion, the plastic instinct is an act in which the animal becomes as though exterior to itself." The picture surface is the site of an inscription by the body and receives the "rain of brushstrokes," to cite Jacques Lacan, who asks, "Is this not like a bird, who, if painting, would shed its feathers, a snake its scales, a tree its caterpillars and leaves?" The painter's participation in the precipitation of color commas is related to an Oriental tradition, which as we are well aware had its influence on Vincent van Gogh's generation. Speaking of the Chinese brushstroke, Peter Swann

wrote: "This tool immediately registers every body movement. It should be maneuvered from the shoulder and elbow and not from the wrist. It can give a line any thickness and fully reveal the artist's personality." Yet the West has added a kind of anxiety to this practice. The artist's trace escapes from him. "The hand," said Paul Klee, "is the instrument of a distant sphere." When the impulse is stopped, when the influx dries up, it is like a small death. "The moment the subject stops, suspending his gesture, he is mortified," wrote Jacques Lacan. The painting is a cemetery of gestures.

To produce these gestures, however, such tension is required that it can even provoke a trance. In 1913 Carlo Carrà spoke of "a state of delirium in the artist, who to express a whirlwind must in a way become a whirlwind of sensations, a vital force, not a logical cold mind." Matisse was far from these extremes. Yet his conception of the arabesque was gestural. "Just as in speaking of a melon we use both hands to express it with a gesture, the two lines that delimit a form should restore it. Drawing is like making an expressive gesture with the advantage of permanence." Line (in 1902 Henry van de Velde wrote that line is "a force borrowed from the energy of the one who drew it") was handled by Matisse in such an obviously physical way that he always made his sketches the size of his final painting. Moreover, he mentioned this fact in 1908 in almost erotic terms: "We must always seek the line's desire, the point where it wants to enter or die."

There remains the third category of time: figurative time movement as represented. Let us note at once that here we are dealing with a kind of "realism." The work always has a reference, and the motion we are told of—in Milan as in Moscow, in Munich as in London—is always the movement of something other then the work itself. In 1912 Robert Delaunay wrote, "I love the synchronic time movement, which is the representation of the universal drama." And Wassily Kandinsky, who so frequently used the term "abstraction," was paradoxically also the one whose iconic representation is most apparent. All things considered, in its gyratory engulfment, J. M. W. Turner's Snowstorm (see page 272) is no more "realistic," atmospheric, or perspectival than Kandinsky's Compositions of the years 1911–1913 in which the debris of ancient landscapes is carried off in a speckled background. For the artist of With the Black Arc, "abstraction" was merely an "abstractization" whose origin, we know, lay in his "vision," in an "illumination" that

content to redouble indefinitely the effects of J. M. W. Turner's painting *Rain, Steam, and Speed*. Its importance can be grasped only by withdrawing from Marinetti's "macho" machinist rhetoric and returning to the pictorial sources of the movement. These were Giovanni Segantini's and Gaetano Previati's Divisionism (see pages 90–91), which turned to the autonomy of chromatic and textural means; a Symbolism that emphasized the noniconic elements of the surface (see Chapter 2) and that the Italians turned to the idea of coexistence on the canvas of representational themes borrowed from the present and the memory of the past (Edvard Munch, Fernand Khnopff); and, finally, Impressionism, which made the transitory and the intangible its favorite themes. To use Gino Severini's words, the Italians claimed they had made "a superior Impressionism," in which "everything is moving, everything is running, everything is rapidly changing," and in which "movement and light destroy corporeal materiality."

But the moment they considered themselves the heirs of Claude Monet and his contemporaries—and also of Medardo Rosso (see page 67)—the Futurists found themselves faced with the same alternatives (precisely the ones that Monet had tried to develop fully at Giverny in his series of *Nymphéas*). Should the artist work on image or on pictorial substance? On the side of the figured object or on that of the representing process? Should he stick to the anecdote, even if modernist, or question the limits of the canvas and texture? Until the Futurists made a trip to Paris as a group in the autumn of 1911, the dynamic quality of Futurist Impressionism tended toward a gestural painting without iconic figures, anticipating by half a century certain aspects of Action Painting (see pages 177 and 294–295). At a conference in Rome in the spring of 1911, Umberto Boccioni even dreamed of a period when "easel painting would no longer be suitable, colors would be perceived as feelings themselves; artists would paint with colored gases." All representation was swept away. As Marianne W. Martin has remarked, research was oriented toward a new relationship between the spectator and space. We are now at the acme of the movement. But the trip to Paris (and previous access to a few photographic documents) curtailed the initial impulse. The Futurists became dependent on Pablo Picasso and Georges Braque as well as on the Robert Delaunay of the *Eiffel Tower* series (1910), who proposed a system based on the interpenetration of planes by superimposition, transparency, and "passages" (see Chapter 3). This was a masterly system improved

occurred one night in Munich. Returning to his studio, Kandinsky saw an unknown painting of "indescribable beauty impregnated with great inner ardor." Upon checking, this work proved to be one of his own paintings that had been turned on its side. "Now I was decided: objects were harmful to my painting." Actually, what met his eyes that night—far more than an objectless painting—was literally a landscape pivoted 45 degrees on its axis. He saw, he chose to see "nature" reeling, swaying. And this is what he continued to represent until his Bauhaus period: the swaying and the chaos of the world.

These ambiguities ended with Italian Futurism, which explicitly adopted representation. It selected its "motifs" from modern life, even though many of them, such as sports, heroism, war, and patriotism, date from antiquity, and it presented them in a rousing manner (capable of awakening what Jakob Burckhardt has described as "the sepulcral quietude of the peninsula") and as a real worship of machinery. To cite the Futurist Manifesto of April 1910: "We must sweep away every subject already used in order to express our swirling life of pride, steel, fever, and speed." In 1912 Umberto Boccioni stated: "A valve that opens and closes in a rhythm is as handsome but infinitely newer than the rhythm of an animal's eyelid." In 1916 Kazimir Malevich found it easy to remark that only the subject matter was changed in going "from the world of meat to the world of iron."

The Futurists also turned to optical research (retinal persistence) in order, for example, to justify the stroboscopic effects transposed onto their canvases. In 1902 Frantisek Kupka had attempted this (left) by working from Émile Reynaud's praxinoscope. They needed to support their innovations with the guarantee of an objective knowledge, but their argument remained debatable. Since the characteristic of vision is precisely to synthesize retinal persistence, nothing sanctions the pretense that the representational decomposition is more "real" than a unified image. On similar themes, such as speed, movement, machine, and so on, a contemporary such as Fernand Léger adopted an attitude contrary to that of either Umberto Boccioni or Carlo Carrà. "Let us take our time. In this hasty and multiple life that pushes us about and cuts us into slices, let us have the strength to remain slow and calm and to work beyond the dissolving elements around us."

The historical importance of Italian Futurism is not to be sought in its "realism" —except one must consider that it was

J. M. W. Turner. *Snowstorm*. 1842.
Turner's cataclysmic, dense, and blurred paintings offer a foretaste of Wassily Kandinsky's lyrical abstraction

Jules Etienne Marey. *Horses*. Chronophotograph. c. 1896

Giacomo Balla. *Drawing for "Young Girl Running on a Balcony."* 1912. See page 309

Frantisek Kupka. *The Riders*. c. 1900–1902

For inspiration, Marcel Duchamp, Giacomo Balla, and the Italian Futurists turn to the physiologist Jules Etienne Marey, who, in the 1880s, did research on the decomposition of human or animal movement. Kupka in his drawing uses the stroboscopic effect obtained at the close of the last century by Émile Reynaud with his praxinoscope, an ancestor of the cinema

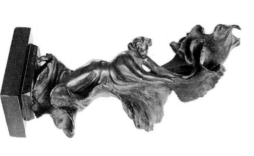

Pierre Roche. *Loïe Fuller*. 1900
In her demonstrations, the American dancer announced a new sensibility

Naum Gabo. *Kinetic Construction*. 1920
That same year—in different parts of the world—witnesses the invention of works that make real movement their operator

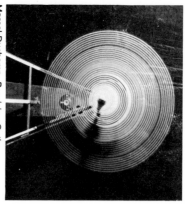

Marcel Duchamp. *Precision Optic* (in this photograph shown in movement). 1920

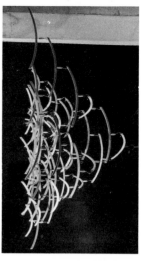

Man Ray. *Object of Obstruction*. 1920

upon over years of investigation but that brought the Italians back to the representational "motif." And while some painters—Delaunay with his *Discs* (see pages 288–289), Frantisek Kupka, Piet Mondrian (who arrived on the Paris scene in 1912), Francis Picabia, Marcel Duchamp, and others—attempted to escape from the representational conceptions of Cubism (in 1912 Braque himself reached the outer limit of readability), the Futurists attempted an impossible synthesis of their initial temptation to atomize and to cancel the object and the imperious tectonics that Picasso applied to the analysis of the subject matter. (Here one should assign a special place to Giacomo Balla who really did not become associated with Futurist activities until February 1913. His *Iridescent Interpenetrations* series begun in Düsseldorf in 1912 (see pages 94–95), his *Densities of Atmosphere*, and his *Abstract Velocity* (1913) rank among the key works in the history of modern art. (As their titles indicate, they are diametrically opposed to Boccioni's and Carrà's researches into representation.) To sum up, the Futurist method—fusion, extension, or serial multiplication of represented objects in the canvas space—adds to illusionism insofar as it places the accent on a component exterior to the static material quality of the painting: movement. The supposed mobility of the subject matter has no effect on the canvas permanence. A quarter of a century earlier, in referring to Impressionism, Félix Fénéon had noted, "Painters have not yet perceived the absurdity of solidifying in permanent material an anecdote and in general any exceptional and transitory scene." This same criticism was developed by Kazimir Malevich in 1915: "The Cubo-Futurists collected every object in the public square, broke them but did not burn them. What a pity!" He reproached them for stopping their development without accepting its real consequences: the disappearance of the iconic figure and the assumption of the surface as exclusive object of the production of art. What counted for Malevich is not the multiplied representation of a galloping horse or of a bird in flight. A photograph would be sufficient for that. Painting's mission was not to illustrate natural science. The important thing was what happens to the surface in terms of texture, gesture, and pigment as *terrain* in which the material components produced by (and producing) a given pictorial practice succeed in becoming organized into a structural and differential arrangement of forms and colors. In 1915–1916 Malevich wrote: "A painted surface is a real, living form." Here for this artist was not only the

Futurist impact but also its historical failure. The Italian painters persisted in their naturalist and specular intention, whereas through the alibi of motion they had begun to free the textural space from surface, a surface that finally began *to speak* for itself.

They stopped on the way. Yet at the same time they paved it. László Moholy-Nagy, who began his kinetic machine (see page 270) at the Bauhaus in 1921, did justice to them by explaining that "the possibilities of creating something new are discovered slowly through previous forms, instruments, and fields of structuration, which the appearance of something new renders old, but that, nevertheless, under the pressure of something new about to develop enjoys a euphoric flowering. Thus (static) Futurist painting provided a solidly defined theory, which was to annihilate it in the end, to the simultaneity of motion and to the presentation of instantaneousness during a period when the cinema was known but misunderstood.

As for the art of real movement—that which time operates—this soon enjoyed a very wide expansion with Giacomo Balla and Fortunato Depero who, in 1915, executed sonorous and manipulatable mechanical mobiles; Joaquín Torres-García who, in 1915, produced in Barcelona permutable toys whose principle was going to be used by the Madí group in Buenos Aires; Marcel Duchamp who invented *Travel Sculpture* in extensible rubber (1917) and *Precision Optic* in 1920 (left); Naum Gabo and his stem (left); and so on. Nor can we long forget Pablo Picasso. Daniel-Henry Kahnweiler has assured us "that about the year 1910 he [Picasso] had imagined mechanically moved sculptures" as well as paintings that "would have 'moved' like targets in the shooting stand of a traveling fair once the trigger had been released."

All this research will delve into the complementary concepts of participation and environment and express a desire to deny the vis-à-vis, to penetrate into things, and to reduce the distance between the object and the spectator, between the self and what is *opposite*, between the spectator and the producer. Perhaps it was a dancer who in the end had the best presentiment and most satisfied some of the confused aspirations of the plastic arts of this period. "In the ballet *Serpentine*," wrote Boris Kochno, "Loïe Fuller was an accessory made to receive around her and to send back the rays of the spotlights. The movements of her veils created striking changes of light and shadow. For the *Fire Dance*, she had thought up a glass floor containing projectors that made out of her entrance an hallucinatory apparition."

Giovanni Segantini (1858–1899). *Landscape with Figures*. 1897. Drawing. 7⅛×11¾"

Dedicated to speed, landscape gains in synthetic force what it loses in detail

Speed changes the painter's technique and his way of looking at things. In order to represent a mountain road used by automobiles in his *Automobile at Penice Pass* (right), Giuseppe Pellizza scraped the pigment off the surface with the tip of his brush. These scratches created a tension that originated in the painter's disorderly gesture. It was the energy of an arm that rendered the velocity of a car, scarcely sketched in at the right of the painting. The bodily gesture takes precedence over the subject matter—the image is subverted by the imprint. Pellizza, who hanged himself in his studio at the age of thirty-nine after the deaths of his wife and his youngest son, was one of the chief supporters of Transalpine Divisionism, whose contribution to modern art remains very underestimated. The son of peasants, he settled in the village of Volpedo, south of Turin, Italy; he was moved by Socialist ideas and read the works of William Morris, Karl Marx, Friedrich Engels, and Leo Tolstoy. Pellizza's work is a mixture of pantheism, diffused mysticism, and humanitarian preoccupations. Like the other Italian Divisionists, he emphasized —much more so than the French pointillists—a painting's textural components. In the porous, mineral manner of Claude Monet's *Cathedrals*, Pellizza's painting offers a kind of sampling of tellurian substances in their different granularities—note, for example, the ruggedness of the vegetation on either side of the road in *Automobile at Penice Pass*.

In the drawing *Landscape with Figures* (above), in which the topology and even the figures seem to have been blurred by the same gray-green steamroller, Giovanni Segantini already illustrates a statement by the Futurist artist Umberto Boccioni, who declared in 1914: "Men have not yet observed that trains, automobiles, bicycles, and airplanes have upset the contemplative conception of landscape."

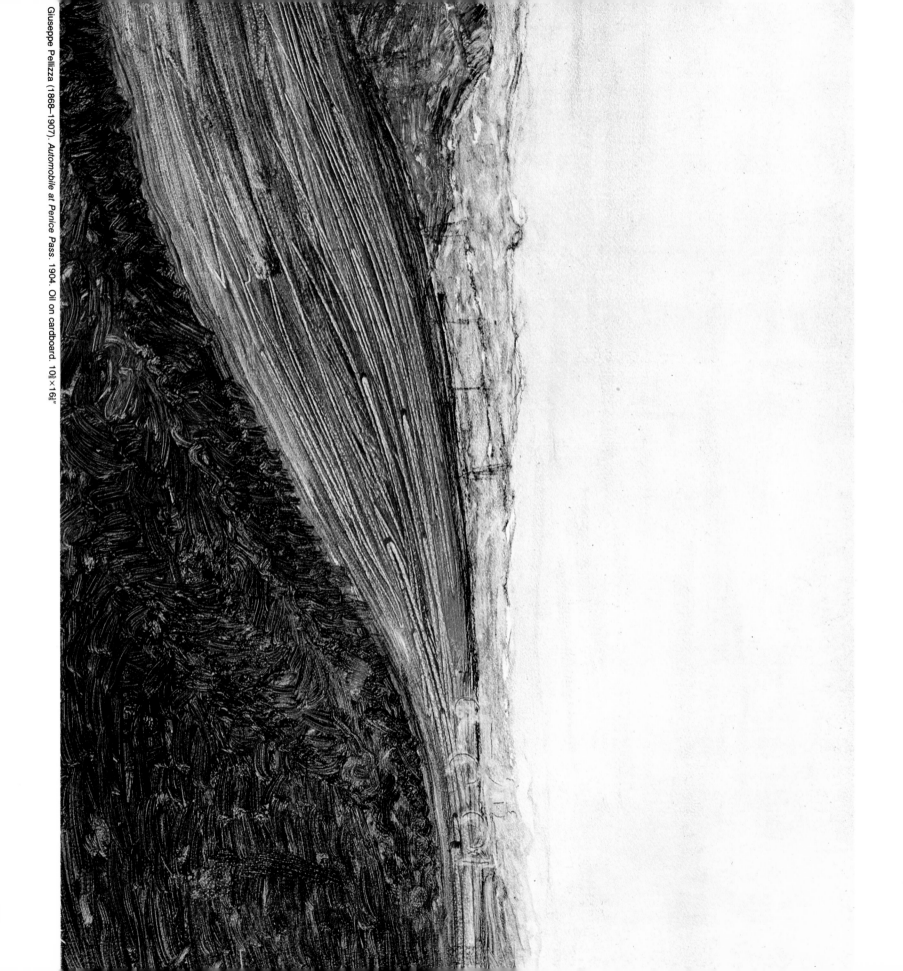

Giuseppe Pellizza (1868–1907). *Automobile at Penice Pass.* 1904. Oil on cardboard. 10⅜×16⅞"

In Boldini's convulsive flourishes, speed becomes a virtue

Giovanni Boldini (1845–1931). *Ibis at the Palais Rose in Le Vésinet.* 1910. Oil on cardboard. 10⅜×13¾″

Long famous—yet despised—for his easy brio as a society portraitist, as a pasticheur of Frans Hals, Thomas Gainsborough, Édouard Manet, and Edgar Degas, and as the rival of Paul-César Helleu and Antonio de La Gandara, the Italian painter of Paris Giovanni Boldini would be classified among the minor masters of the Belle Époque if we did not find in his style *alla prima* an explosive acceleration of line, a gestural violence, a "contorted and sensual

mannerism," to quote the poet and critic Guillaume Apollinaire, which—far beyond any figurative representation—inaugurated something close to Action painting. Henri Focillon spoke of Boldini's "convulsive, whipped elegances. . . . It is not animation but dizziness, the swooning frenzy of the dance, the sudden shaking of a motor, and already the delirious vibration of the cinema." Everything occurs as though Boldini, in the academic execution of his motif, suddenly

allowed himself to be carried away by a sort of gesticulation, a discharge, as though in spite of himself his style changed into a furious, electric, violent flourish. The network of lines that obstructs the foreground of the painter's room in *"The Cardinal" of Bernini in the Painter's Room* (right) and those that extend the movements of the ibis in *Ibis at the Palais Rose in Le Vésinet* (above) announce the "vehement and sulfurous" style that half a century later André Malraux credited Georges Mathieu with.

Giovanni Boldini. *"The Cardinal" of Bernini in the Painter's Room.* 1899. 20⅛×18¼″

Georges Rouault's inveighings against the times found their plastic expression in a powerful watercolor style in which the themes—religious or profane—were so many pretexts for a heavily imposed style. The glaucous transparency of Rouault's color is related to the artist's apprenticeship as a glazier. In regard to his clowns as well as in regard to his dancers, he succeeded in suggesting at one and the same time both slowness and speed, both improvisation and meditation. While still a gesture, his brush laid down a deposit of unchangeable thickness. Rouault's *Christ Flagellated* (right) marks a radical break with official religious art. The artist's inner fervor is expressed by a dual identification: the zigzags of the whip become those of the brushstrokes, the flow of blood becomes that of paint. The magnificent and expressive violence of this painting makes it a precursor of the more virulent canvases of Willem de Kooning forty years later.

"They never understood my basic thought in regard to this humanity that I seemed to mock," wrote Rouault in his *Soliloques*. "Unlike myself, they never heard with such intensity, in peace or in war, the death rattle of the slaughtered animal, the half-open jaw emitting no sound, as in an agonizing dream. Attached to this earth like old Pan, heavy and weighty, I see millions of human beings disappear in these terrible wars. And here I am, mute, voiceless, frozen on the spot, hypnotized like a bird by a serpent."

Georges Roualt (1871–1958). *The Wrestler (The Parade).* 1905. Gouache, watercolor, and pastel on paper. 8⅞×4¾″

Georges Rouault. The Din. 1905.
Watercolor heightened with pastel on paper. 27⅞×21¼"

Rouault's pamphletary fervor harasses
and whips up the surface

Georges Rouault. Christ Flagellated. 1905. 44⅞×30¼"

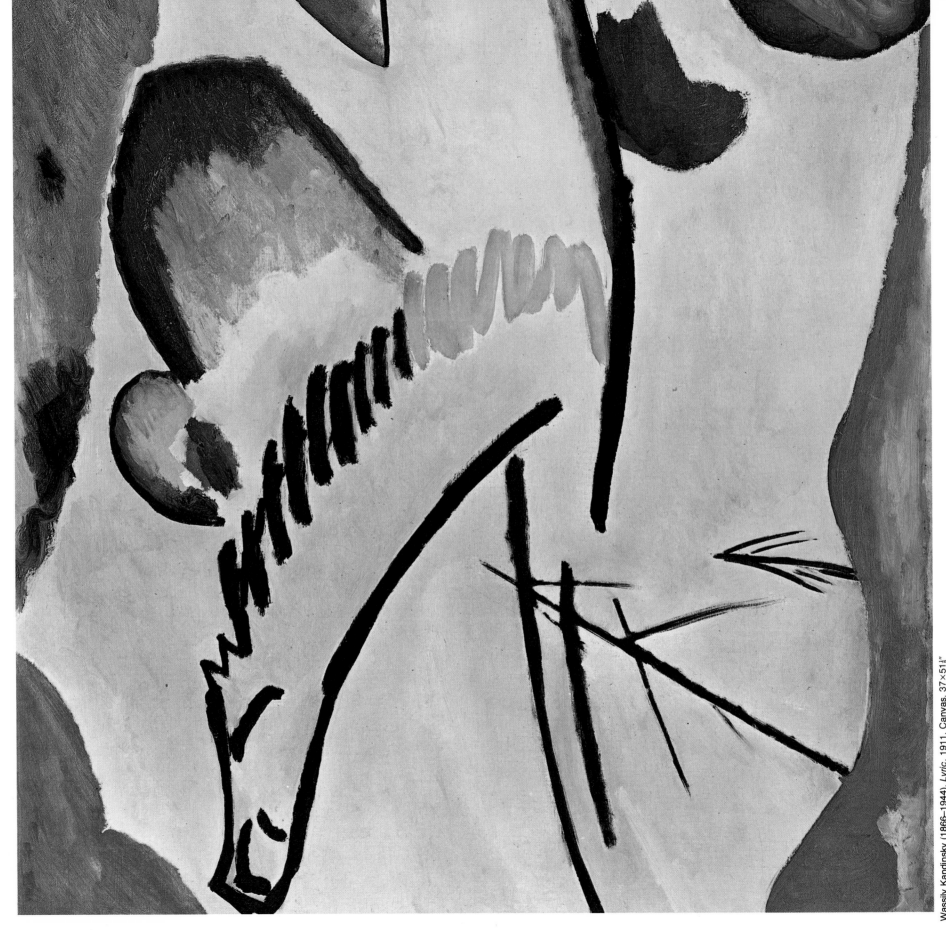

Wassily Kandinsky (1866–1944). *Lyric.* 1911. Canvas. 37×51⅛″

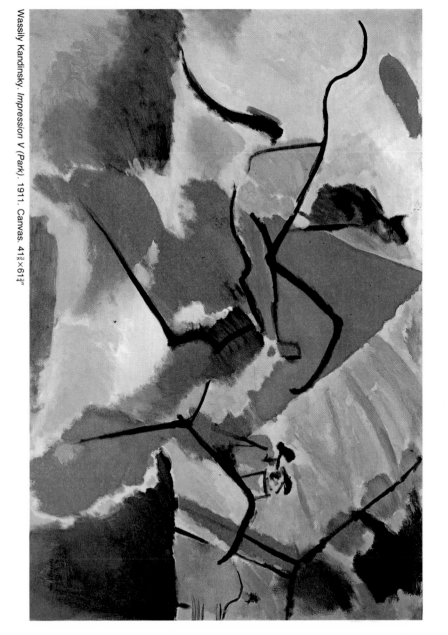

Wassily Kandinsky. *Impression V (Park)*. 1911. Canvas. 41⅛×61¾"

The residues of figures cross the gaudy space of the canvas

In order to paint both speed and the obliteration of represented forms, Wassily Kandinsky borrowed his archaic black line from the digital traces of prehistoric cave paintings (see pages 54–55 for what these spots with hatched outlines owe to Kees van Dongen's style). From 1910 to 1914, Kandinsky constantly hesitated between two ambitions: to establish exterior appearances and to promote a system in which line, as he expressed it in 1912, would be "free of the obligation to designate a thing in a painting and would itself function as a thing."

Kandinsky spent fifteen years in inculcating into his work an intuition he had about 1895 in Moscow when he saw a painting by Claude Monet. "It was the

catalogue that taught me that I was looking at a haystack. I was incapable of recognizing it. . . . I had confusedly felt that an object was lacking in the painting. And I noticed with surprise and confusion that not only did the painting seize you but also that it left an indelible mark on your conscience and always at the most unexpected moments one saw it float before one's eyes with its slightest details." In the two cavalcades illustrated on these pages—*Lyric* (left) and *Impression V (Park)* (above)—movement blurs the neat outlines and dissociates them from the color. The paintings become a palette crossed by the residues of the eaten-away figures, disarticulated and denatured by the outburst of their impetuosity.

Science and music inspire Kandinsky to tear himself away from the denotation of a static world

In order to produce a swaying and whirlpool effect, Wassily Kandinsky divided the masses in his work "so as not to show any architectonic center." He often placed "the heavy element above and the light element below," as he remarked in 1914. From this practice derived the feeling of a swaying universe in which no law of matter is valid that marks these works. But these gravitational transgressions are possible only if the painting, far from being a pure play of spots, is still inscribed in the atmospheric or cosmic field of representation. The forms inscribed in *With the Black Arc* (right) are in their own fashion "figurative." They rise from a cloudy background with its rich allusions to the movements of celestial bodies. Science and music are the two references that inspired Kandinsky to tear himself away from the denotation of a static world, one immediately perceptible, and to express the underlying energy of matter. Why persist in representing in detail objects that scientists present for the most part as unstable agglomerations of particles? Kandinsky was fascinated by the principle of atomic fission. "Everything becomes precarious, unstable, soft. I would not be surprised to see a stone melt in the air before me and become invisible," he said in 1913.

As for music, it at once suggested a nonmimetic practice to Kandinsky. Returning to a comparison that can serve to justify the emancipation of the plastic arts since Eugène Delacroix, he saw painting as a model that is deliberately bent on reflecting the artist's mood. This is to forget that the painting acquires meaning only from the work of its constituent materials, that it is by no means the projection of a phantasmagoria on an indifferent canvas but rather the permanent exchange of an intention and a material. In 1922, the Russian artist El Lissitzky criticized Kandinsky's idealism in writing that "he introduced the artistic formulas of contemporary German metaphysics" and that his work "is a kind of musical painting in which he expresses at any moment the state of his soul by a stenography of heavy color spots."

Wassily Kandinsky (1866–1944). *With the Black Arc.* 1912. Canvas. 74×77¼"

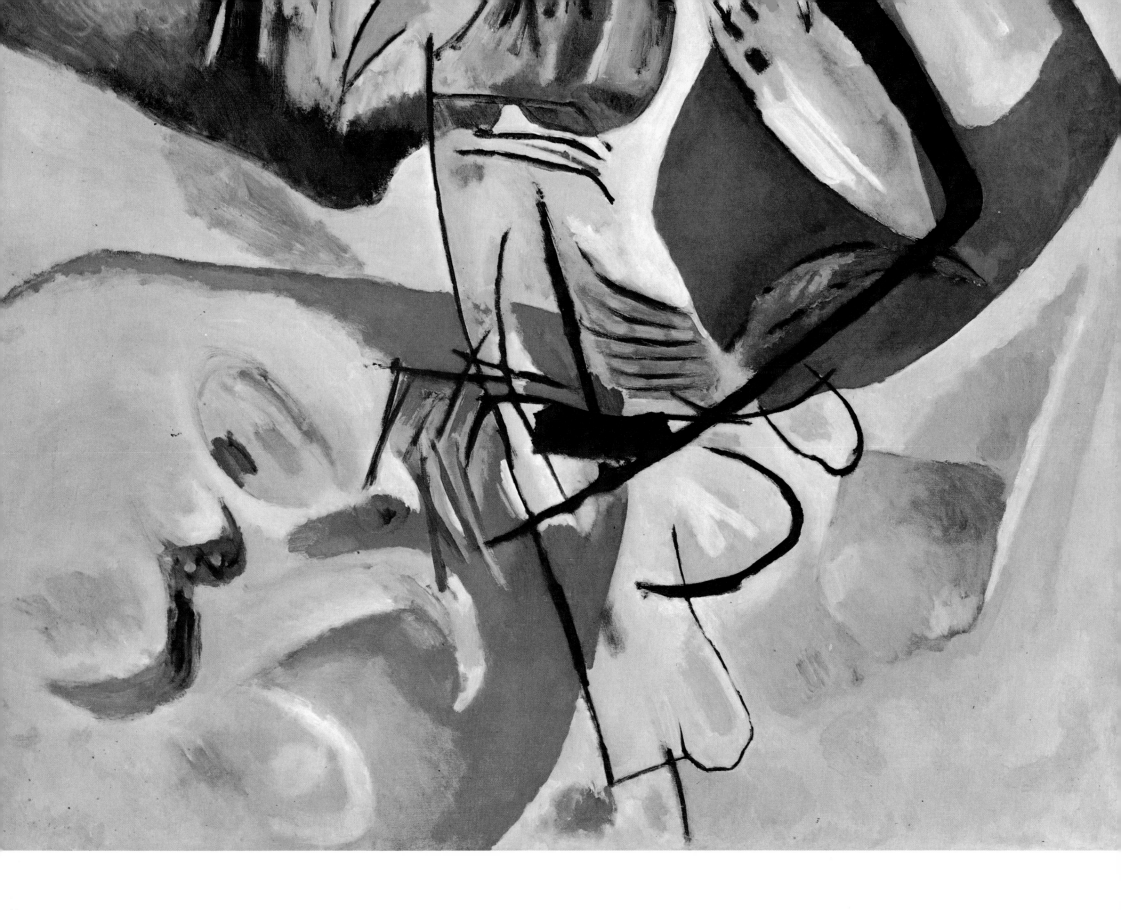

In imaging the fibrous unfurling, the amoebic agitation of organisms in mutation, Wassily Kandinsky sought to represent the moment when matter—lava, ice—has not yet participated (or no longer does) in the order of distinct natural kingdoms (animal, vegetable, mineral) and structured objects. "The implacable gyration of the stars," to quote Gaëtan Picon, carries off the substances in fusion in a centrifugal movement. With Kandinsky, these cosmic drifts refer specifically to such religious themes as the Deluge, the Apocalypse, and the Second Coming of Christ. His canvas is not only the description of a period of gestation or of dissolution, but also is in itself the "striking collision of different worlds destined to create the new world in their struggle, or, beyond their struggle, among themselves. Any work is created technically—just as the cosmos was born—out of catastrophes that, from the chaotic clamors of many instruments, finally form a symphony known as the music of the spheres. The creation of the work is a creation of the world."

In order to dramatize the movement of his forms, Kandinsky cut them off too short. Their surges run up against the edges of a painting and extend beyond them into the viewer's imagination. This violation of the frame also violates the irrepressible expansion of masses, but at the same time it both indicates and emphasizes them. Before becoming a composition, a work is offered as a crossing, a course. The famous abstract watercolor called *Improvisation* (above right) and dated 1910 by the artist has long been

Wassily Kandinsky (1866–1944). *Improvisation.* 1914. Canvas. 48⅜″×28¾″

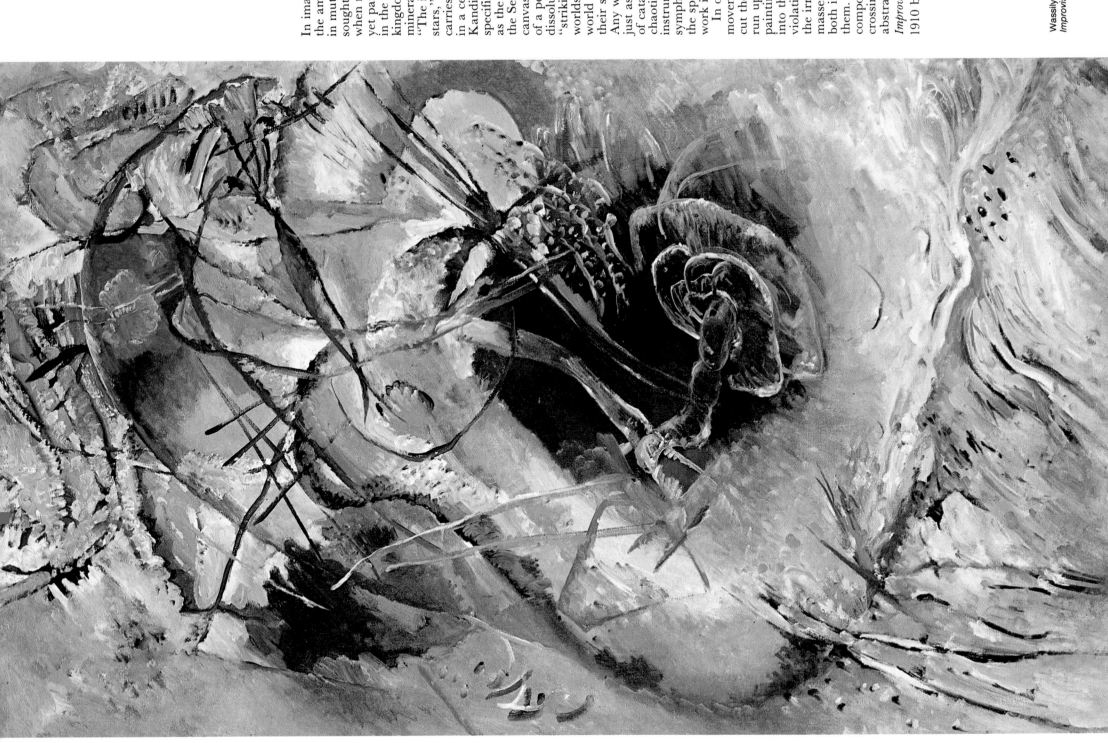

Forms run up against the edges of a painting and extend beyond them into the viewer's imagination

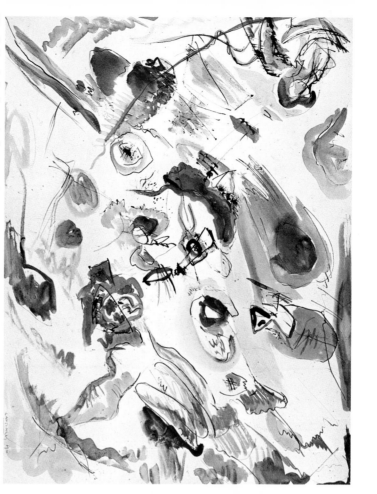

Wassily Kandinsky. *Improvisation.* c. 1913. Watercolor. 19⅝×25⅝"

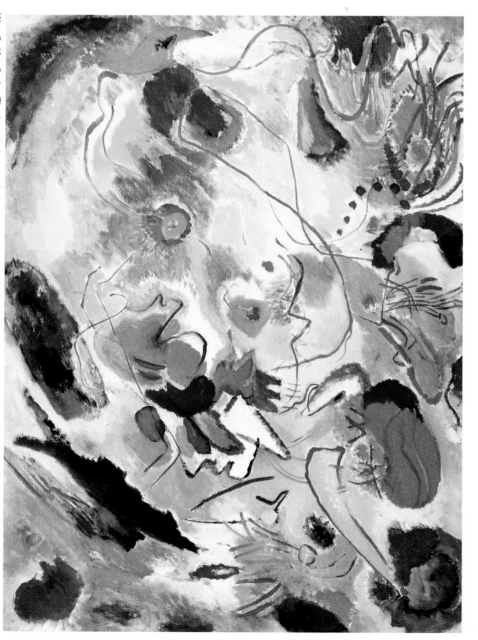

Wassily Kandinsky. *The Last Judgment, Study for "Composition VII."* 1913. Canvas. 30¼×39⅜"

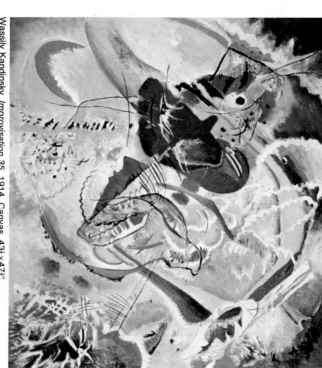

Wassily Kandinsky. *Improvisation 35.* 1914. Canvas. 43¼×47¼"

regarded as the first Western example of nonfigurative art. Recent stylistic comparisons, notably with *Composition VII* of 1913, which belongs to the Soviet government and of which a preliminary study is illustrated (below right), as well as the study of contemporary texts, have led to the later dating by three years (1913) of this watercolor, which thus takes its place among other works with similar preoccupations. This date better explains the abundant series of openly figurative works that "succeeded" it in Kandinsky's chronology.

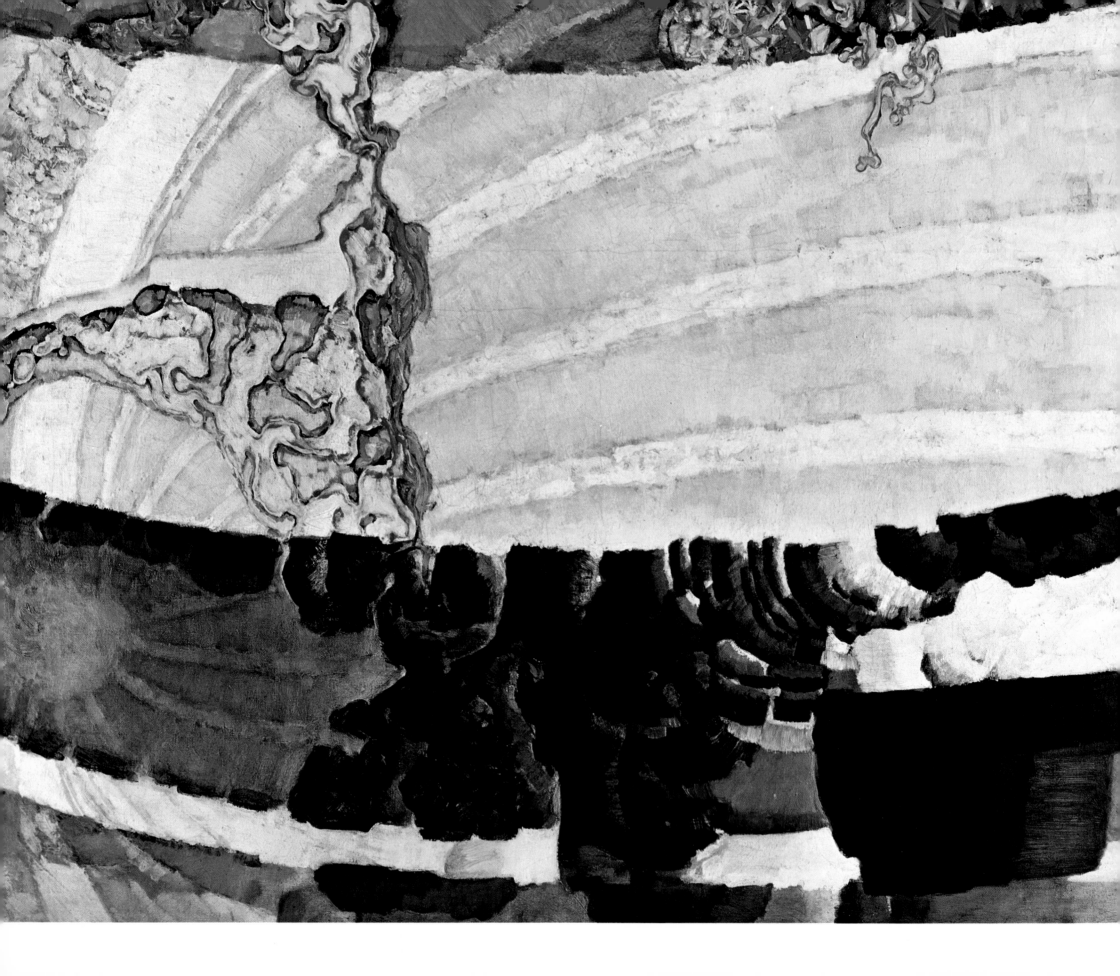

From the map of the stars, Kupka borrows a new topology

Frantisek Kupka applied himself to the study of astronomical plates and photomacrographs in order to invent a highly structured space that anticipated the accelerated and synthetic vision of interplanetary space travelers. In 1903 the geographer Elisée Reclus asked him to illustrate his six-volume historical study, *Man and Earth*. Six years later when he visited Uccle [a district of Brussels], he was passionately interested in the reconstruction of lunar soil that was preserved there. About 1913 Kupka wrote, "To become aware of the use of pictorial means, without becoming the slave of pictorial description, is now my goal." At that time he had already exhibited—one of the first ones to do so in Europe—a series of works whose titles reveal that they escape

the immediate representation of the perceptible world: *Amorpha, Vertical Planes, Fugue,* and *Cosmic Spring* (left).

In *Cosmic Spring*, the spatial complexity arises from the artist's superimposition of heteromorphic grills that associate with each other through transparency; the white heliocentric pattern of the background, the large curved bands of the foreground plane covered by either cloudy or crystalloid motifs—in this case opaque—in this case opaque—either cloudy or crystalloid. In *Animated Lines* (above), which was originally created in 1921 and lightly retouched by the artist in 1933, Kupka played on at one and the same time the acceleration of the perspective and the contradictions of the vanishing points that suggest a non-Euclidean abyss, a stratospheric dizziness.

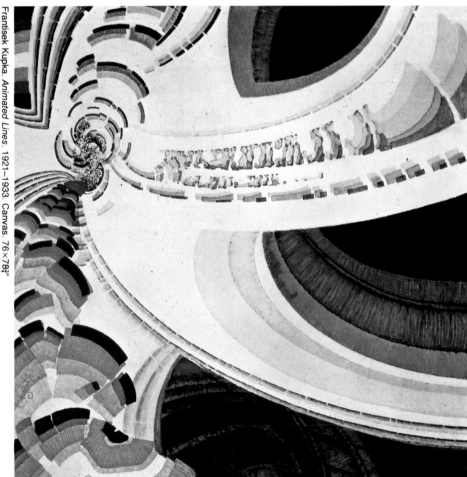

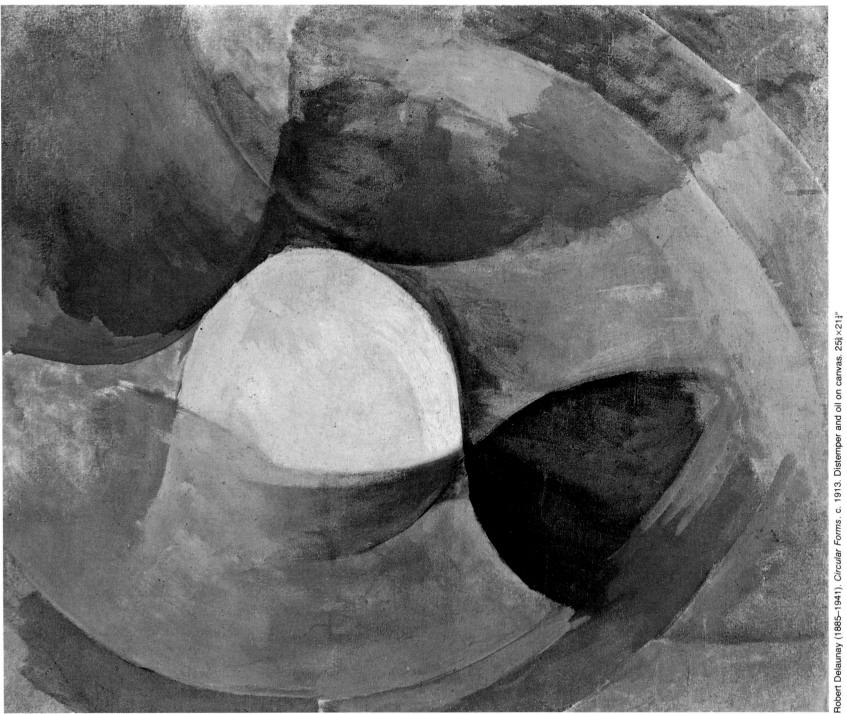

Robert Delaunay (1885–1941). *Circular Forms.* c. 1913. Distemper and oil on canvas. 25⅝×21¼"

The eye gets drunk on the endless gyration of colors

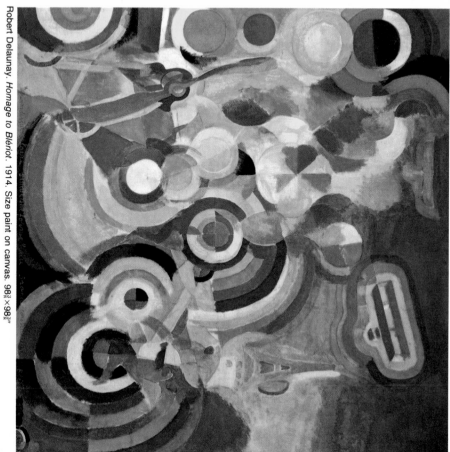

Robert Delaunay, *Homage to Blériot.* 1914. Size paint on canvas. 98⅜×98⅜"

In Robert Delaunay's "circular period," modern art established itself as a program to associate the vision of movement and the movement of vision. It was no longer a question only of representing this or that displacement of forms but of bringing the spectator's eye into a circulation without end. As Delaunay explained to the German artist August Macke, in 1912: "Seeing is a movement. Vision is the real creative rhythm." In his *Cahiers (Notebooks)* Delaunay wrote, "Color is used in its revolving sense: form develops in the dynamic circular rhythm of color."

Yet the independent organization of tones is intended not only to make the spectator turn his eyes round inside the canvas. A depth is created that owes nothing to the illusion of perspective. Colored

planes advance and recede according to their reciprocal action. Delaunay showed he was aware of color's stimulative effects and of the optical destruction of color when he wrote that "red and blue determine extrarapid vibrations physically perceptible to the naked eye."

In his *Homage to Blériot* (above), Delaunay skillfully associated his rhythms to images that, even though static, create the idea of spiral movement. This reference strengthens and accelerates their plasticity. The presence of Blériot's propeller, as well as of other airplanes in the sky (they might all be the same one), contribute a dynamic quality to the many interlocking circles—half targets, half suns—that animate three-quarters of the painting's surface.

Robert Delaunay, *Circular Forms; Sun, No. 2.* 1912–1913. Size paint on canvas. 39⅜"26¼"

In their determination to materialize the immaterial and to represent radiating light, painters covered their canvases with a reticular system of conventional signs—Léon Spilliaert used a pattern of long lines in his *October Evening* (left) and Giacomo Balla employed a pattern of chevrons in his *Electric Lamp* (right). In one as in the other, separation of colors favors a light optical quivering. In Balla, the arbitrariness in the denotation of the luminous flux is affirmed by the fact that, in order to express the dazzlingness of a lamp near the railroad station in Rome, he used a drawing technique very similar to the one he employed to express the decomposed flight of a swallow (see pages 310–311). It is speed itself that the Italian painter attempted to portray in both of these works, and his paintings soon took on such titles as *Abstract Velocity*, *Dynamic Expansion Plus Velocity*, and so on. The viewer should compare Balla's *Electric Lamp* with the more static effect sought by Balla's pupil Umberto Boccioni in the lamplights in *The Brawl* (see page 93).

October Evening is an exception in the work of the Belgian artist from Ostend, Léon Spilliaert, whose gouaches, pastels, drawings in crayon, all solidly composed, were generally inspired by Paul Gauguin, Symbolism, and Art Nouveau. This largely treated surface entirely given over to luminous flux can be added to the investigations of presenting light and its effects by contemporary Italian and Russian Futurists.

In order to materialize light, the artist repeats conventional signs from edge to edge of the painting

Giacomo Balla (1871–1958). *Electric Lamp*. c. 1912 (antedated painting). Distemper on canvas. 68⅞ × 44⅞"

Umberto Boccioni (1882–1916). *The City Rises.* 1910. Tempera on cardboard. 14⅜×23¾"

A maelstrom of lively spots announces the city's awakening

A wild energy pervades the sketch of *The City Rises.* The animal figures and the human silhouettes that surround them are pulverized in a maelstrom of vermiculated strokes, which Mary Martin in *Futurist Art and Theory* has compared to the precipitate movement of iron filings attracted by a magnet. While working on this canvas, Umberto Boccioni stated that he had been inspired by the words of the Italian poet Filippo Tommaso Marinetti, the leader of the avant-garde: "Any work without aggressive character cannot be a masterpiece." In 1914 Boccioni explained the explosive scattering of his central motif. "A moving horse is not a stopped horse who moves but a horse in movement, that is, something else that must be conceived and expressed in an entirely different manner."

The counterplunging point of view adopted by the artist places the observer in the position of being submerged by the wave of violence that seems to be unleashed from the painting—as though in order to illustrate a phrase in the Futurist manifesto published in 1910. "Painters have always shown us objects and placed persons before us. We will now place the spectator in the center of the painting." Beyond the horse are scaffoldings that symbolize the Futurist obsession with novelty. "To hell with realistic and constructed things, bivouacs of sleep and cowardice!" wrote Marinetti. "We love only the huge scaffolding, moving and passionate, which we know how to consolidate at any time and always differently with the red cement of our bodies steeped in will."

Horses fascinated Boccioni, as they did Franz Marc and Wassily Kandinsky. Boccioni wanted to learn how to ride a horse, and he died, in 1916, in the front line of battle after falling from one.

The imperious gesture
of the painter sweeps and
controls the entire surface

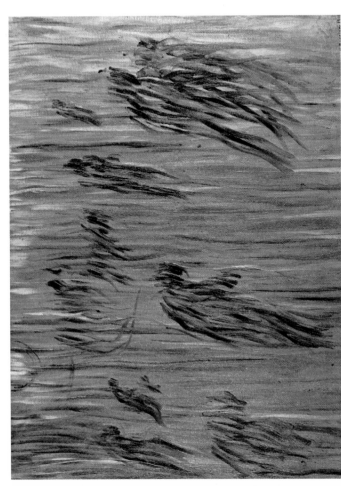

Umberto Boccioni (1882–1916). *Moods: Those Who Remain.* 1911. Canvas. 28×37¾"

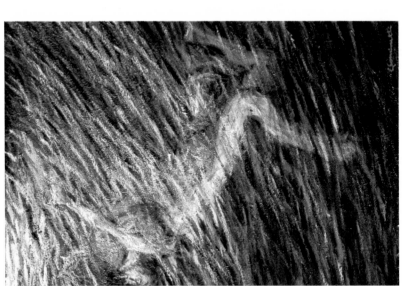

Giuseppe Cominetti (1882–1930). *Lovers in Water.* 1911. Oil on cardboard. 17⅞×11⅜"

The despair of the figures of those who remain in *Moods; Those Who Remain* (above), as well as the kaleidoscopic vision of the travelers in the express train in *Moods; Those Who Depart*, are just so many pretexts for an imperious or subtle sweeping of the entire surface by brushstrokes free of denotative preoccupations. This freedom heralds Action Painting almost forty years later. Especially in *Moods; Those Who Depart*, almost a linear system that avoids any compositional tendency or any balancing of masses controls the entire painting. It is not only the notion of a figurative object but also that of forms themselves that tend to disappear.

Nevertheless, these paintings of Boccioni still contain in the background referential allusions, and the observer should note the beautiful boldness with which in *Moods; Those Who Depart* he has interlocked on the same plane the travelers' faces, bits of landscape, houses, poles, trees, even the train's glistening door handles—all elements that in empirical experience would not face the viewer at the same time.

For his *Lovers in Water*, the Italian Divisionist Giuseppe Cominetti, who had settled in Paris in 1909 and become friendly with Gino Severini and the Futurists, adopted the principle of a regular network of long strokes covering the entire surface. The choice of an aquatic theme, however, which does make plausible a naturalistic interpretation of the technique, rather limits the painting's ambition.

Umberto Boccioni's *Moods* mark the extreme limit of his innovations in painting. As early as the end of 1911—after returning from a trip to Paris—he allowed himself to be subjugated by the so-called realistic components of Cubism and repressed the powerful abstract gestural thrust he had displayed in *Moods; Those Who Depart* (right). Doubtless inspired by Beethoven's "Les Adieux" sonata, the series on the theme of departure is a striking statement of an almost exclusively corporeal conception of pictorial practice.

294

Umberto Boccioni. *Moods; Those Who Depart.* 1911. Canvas. 27⅞×37⅞"

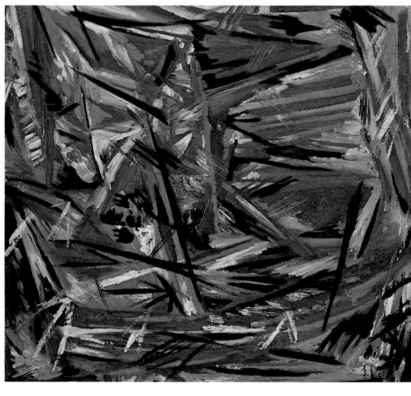

Larionov discards objects and retains only their radiation

In launching Rayonism—its Manifesto was published in Moscow in 1913—the Russian artists Michael Larionov and Nathalie Gontcharova proposed an Impressionism without the representation of objects. "Between the objectivized forms before our eyes, there is a real undeniable crossing of rays coming from

vibrates with less intensity than the same blue applied with greater thickness. . . . Colors have a timbre that changes according to the quantity of their vibrations, that is, of their thickening and of their brilliance. . . . The researches of Rayonist painting are based on the variety of thickness, that is, of depth, of the color it uses. . . ."

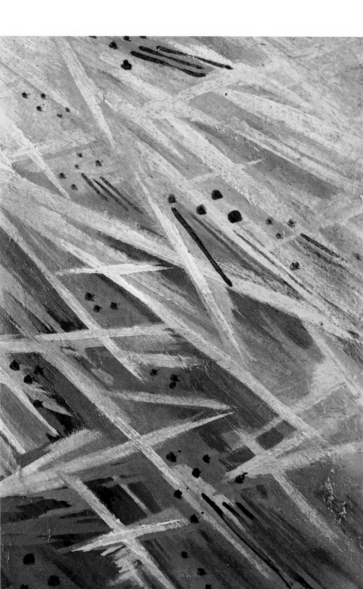

different forms. These crossings compose nontangible new forms that the eye of the painter can see," Larionov stated in 1914. Such formulations, inspired by contemporary discoveries in regard to radioactivity, X-rays, and ultraviolet rays, are actually fictional reality, scientific reveries. They serve as an alibi for Larionov's and Gontcharova's specifically pictorial work.

Continuing Italian Futurism and its *linee forze*, the two Russian artists made important proposals on how to go beyond form—their canvases becoming patterns independent of any composition—and on the material aspect of the painting—proposals regarding texture, width, thickness, and so on. The real significance of their work lies in their choice of materials—and naturally in their use of color, whose thickness is more important than the external objects it designates. Larionov declared in 1914: "A blue spread flat over the canvas obviously

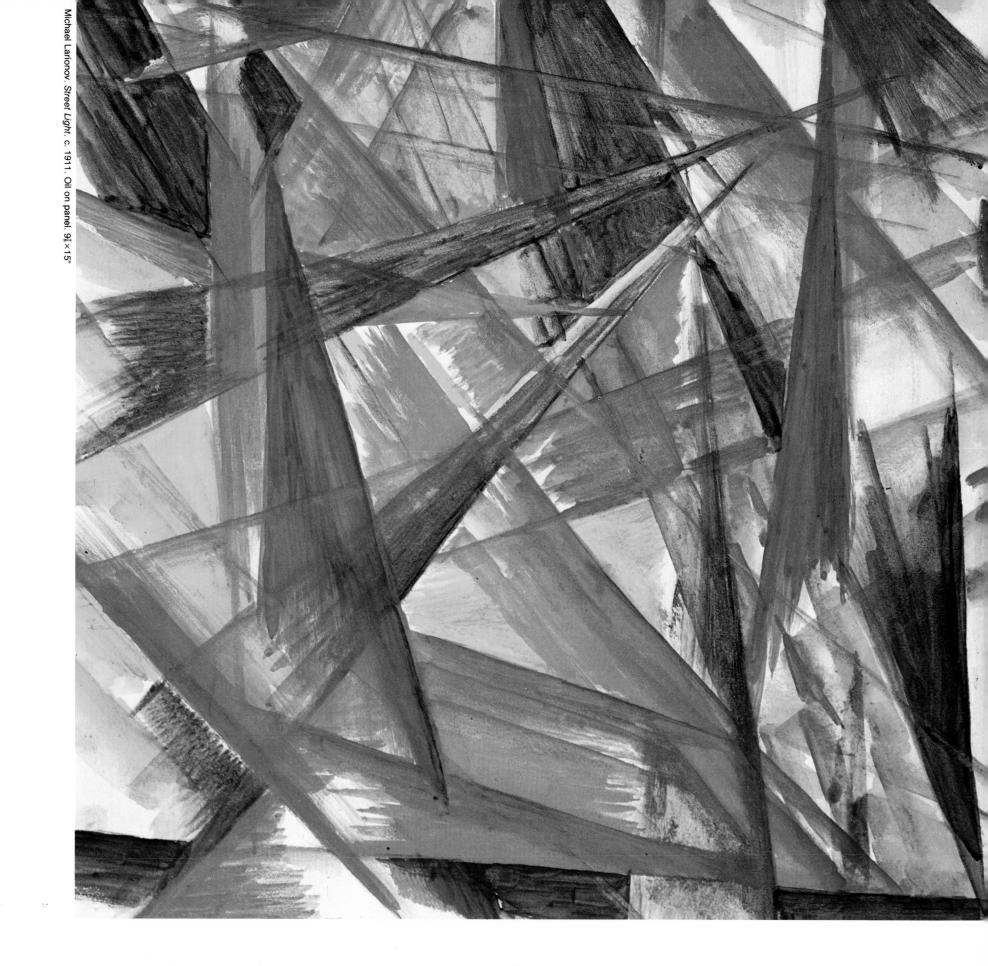

Michael Larionov. *Street Light.* c. 1911. Oil on panel. 9⅞×15"

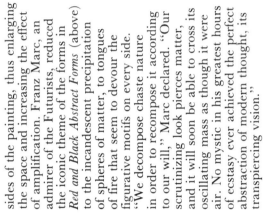

In the centrifugal frenzy of forms
is the study of primordial energies

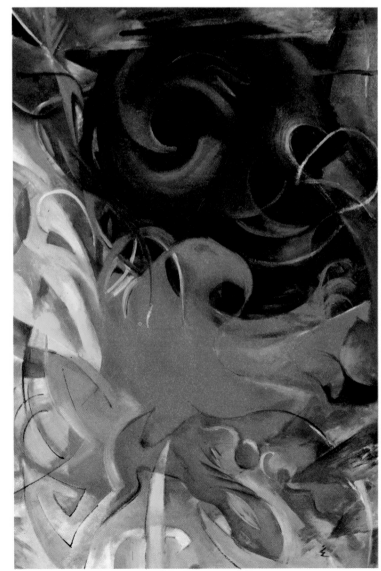

Franz Marc (1880–1916). *Red and Black Abstract Forms*. 1914. Canvas. 35⅞×51⅜"

In his large Synthetist canvas *Dynamism of a Football Player* (right), Umberto Boccioni combined five years of pointillist, Futurist, and Cubist experiments. The reference to subject matter has been engulfed in the centrifugal gyrations of the split, dotted, kaleidoscopic mass that represents not so much a football player as the unlimited expansion of his energy in the environment. In this work it is not a question of stroboscopic morcellation that would cut out the player's movements in a plausible sequence of successive snapshots (for examples, see pages 301–303), but rather it is a question of expressing through Futurism's *linee forze* the disintegration, the atomistic dissemination of a core

of high-density molecular matter over the entire surface of the canvas. In 1914, Boccioni declared: "The object is not seen in its relative movement, but it is conceived in its living lines, which reveal the manner it would decompose according to the tendencies of its forces."

This description of an explosion requires an experienced intelligence of the figurative motif. The artist is restricted to "a terrible tension in order to remain continually within the object, to experience its sensibility, and to recreate its universe." During the execution of his *Dynamism of a Football Player*, Boccioni—who had studied Wassily Kandinsky's work in Berlin in 1912 —added strips of canvas to three

sides of the painting, thus enlarging the space and increasing the effect of amplification. Franz Marc, an admirer of the Futurists, reduced the iconic theme of the forms in *Red and Black Abstract Forms* (above) to the incandescent precipitation of spheres of matter, to tongues of fire that seem to devour the figurative motifs on every side. "We decompose chaste nature in order to recompose it according to our will," Marc declared. "Our scrutinizing look pierces matter, and it will soon be able to cross its oscillating mass as though it were air. No mystic in his greatest hours of ecstasy ever achieved the perfect abstraction of modern thought, its transpiercing vision."

Umberto Boccioni (1882–1916). *Dynamism of a Football Player*. 1913. Canvas. 76¼×78¾"

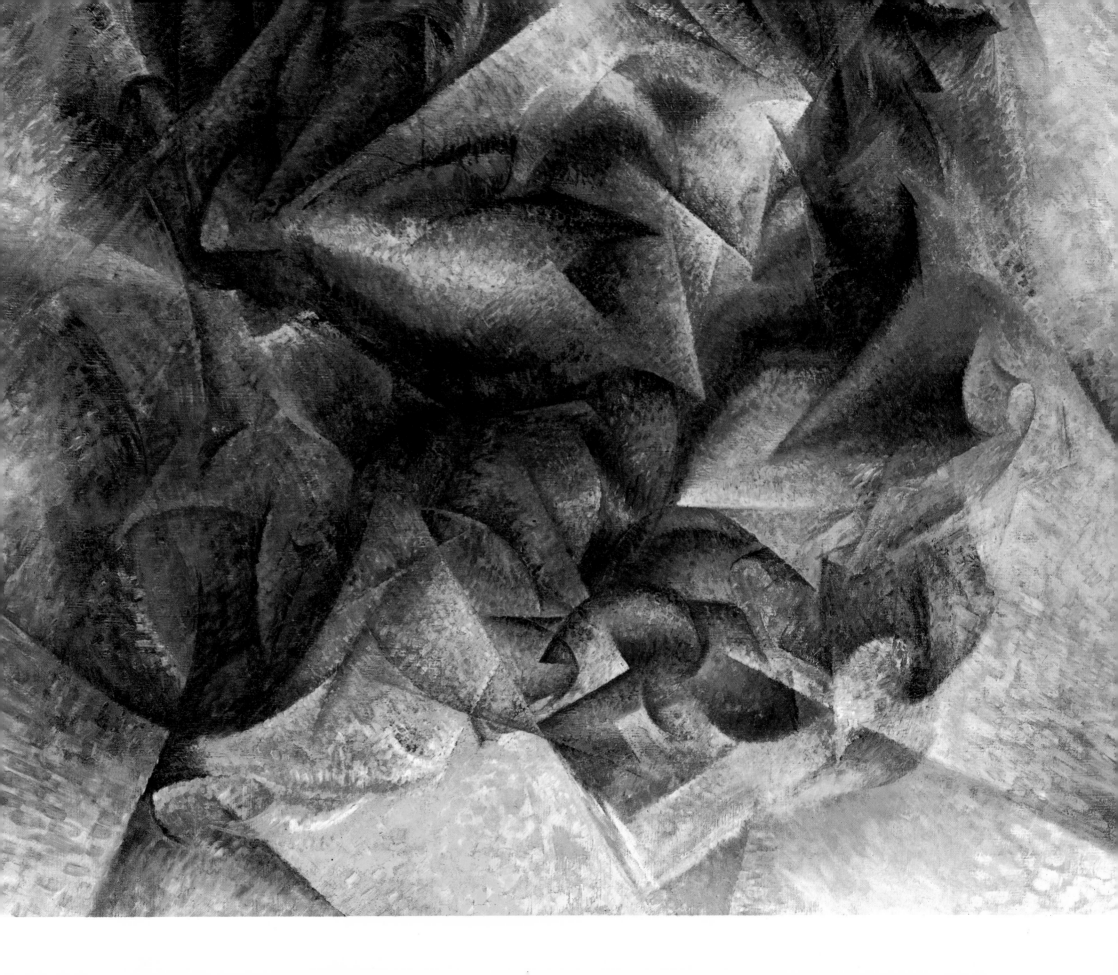

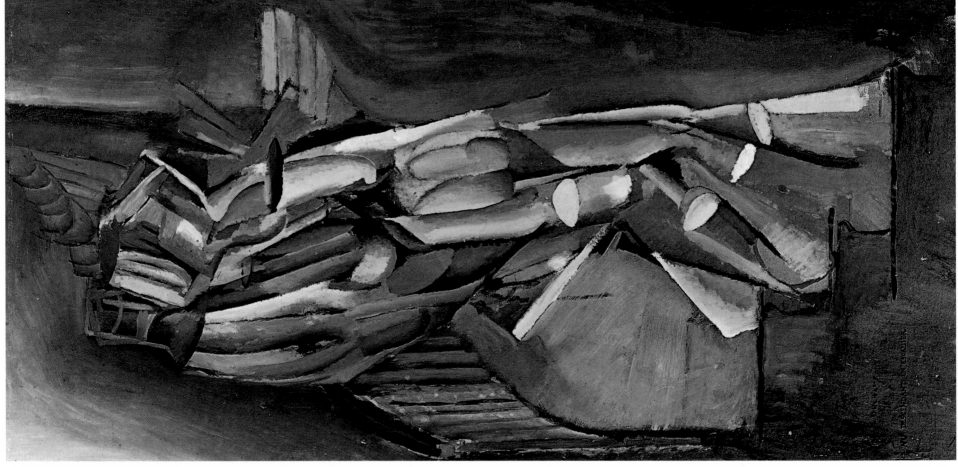

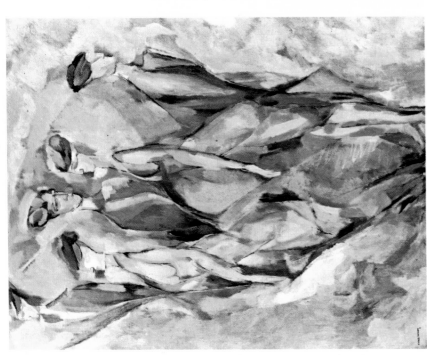

To represent movement, Duchamp unfolds his alert nudes into a fan

In a few months, no doubt influenced by Italian manifestoes whose content he discussed at Frantisek Kupka's, Marcel Duchamp went from a plural representation of the same person— as in *Portrait, or Dulcinea* (above) and as in the two works illustrated on pages 154–155—to the description of his displacement. *Portrait, or Dulcinea* transcribes in five simultaneous images the silhouette of an anonymous woman seen in the street. The Belgian painter, Fernand Khnopff, in 1889, had attempted the same approach in *Memories,* a portrait of his sister in seven images.

In the next phase of Duchamp's development, illustrated in *Nude Descending a Staircase, No. 1* (right), the action is both reduced to a minimum (to the steps on the staircase) and multiplied to a maximum following a method that Duchamp borrowed from photographic research done in the 1880s. He evolved in some sort from Eadweard Muybridge (separate images taken by several cameras) to Jules Étienne Marey, whose chronophotographic effects link the body's successive movements in the same fade-in

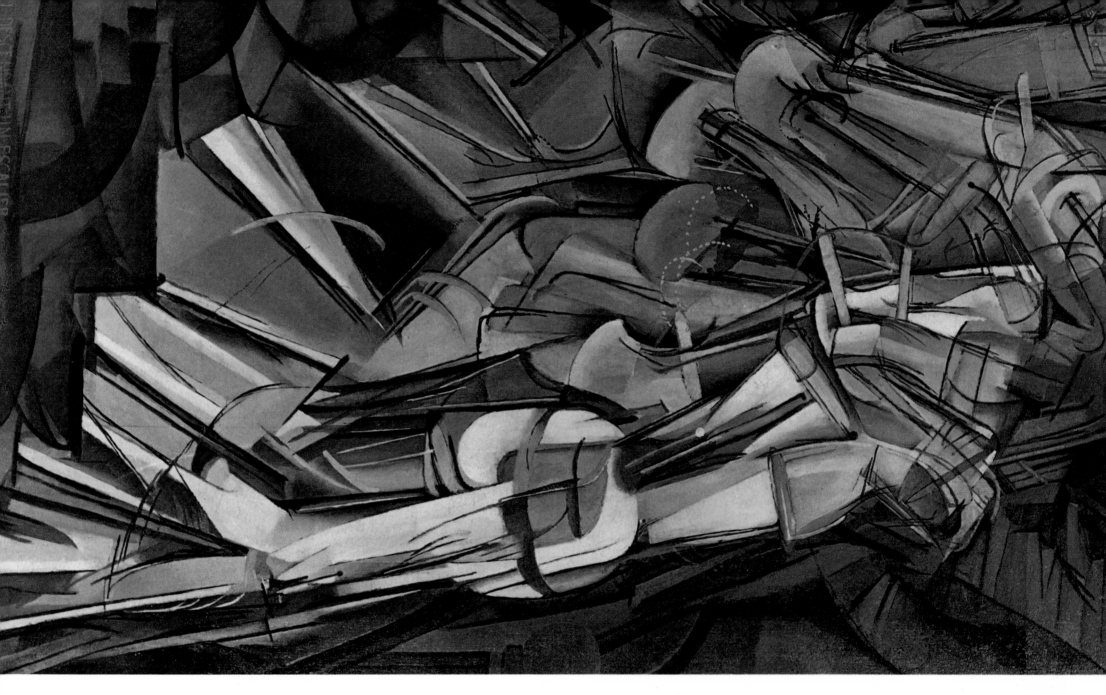

Marcel Duchamp. *Nude Descending a Staircase,
No. 2.* 1912. Canvas. 57⅞×35".

(see page 272). The project was
sketched out in the first *Nude* of
1911, still very compact, and was
stated—as though by dilatation—in
Duchamp's famous painting of
1912, *Nude Descending a Staircase,
No. 2* (left). "I completely gave up
the naturalistic appearance of the
nude, retaining only the abstract
lines of some twenty different static
positions in the successive
descending movement," Duchamp
stated.

Duchamp's famous painting of
1912 created ostracism and
scandal. When the artist wanted to
exhibit it at the Salon des
Indépendants, the followers of
Cubism rejected it. "Some people
such as [Albert] Gleizes who were
extremely intelligent found that the
Nude was not exactly in the line
they had already traced. . . ."
Shown a few months later in the
Armory Show in New York, the
Nude created a memorable
controversy. A critic compared it
to "an explosion in a tile factory."
To quote a witness, Henri-Pierre
Roché, "The painting was
considered by half of America a
diabolical work and by the other
half a liberating masterpiece. At
that time Marcel Duchamp, along
with Napoleon and Sarah
Bernhardt, was the Frenchman best
known." Polemics in the press,
interventions by puritanical
leagues: the *Nude* was reproduced
everywhere, attacked, and soon
purchased. "What contributed to
the interest created by this
canvas," Duchamp lucidly
explained, "was the title. No one
creates a nude woman who is
descending a staircase. It's
ridiculous. . . ; A nude should be
respected. . . ."

301

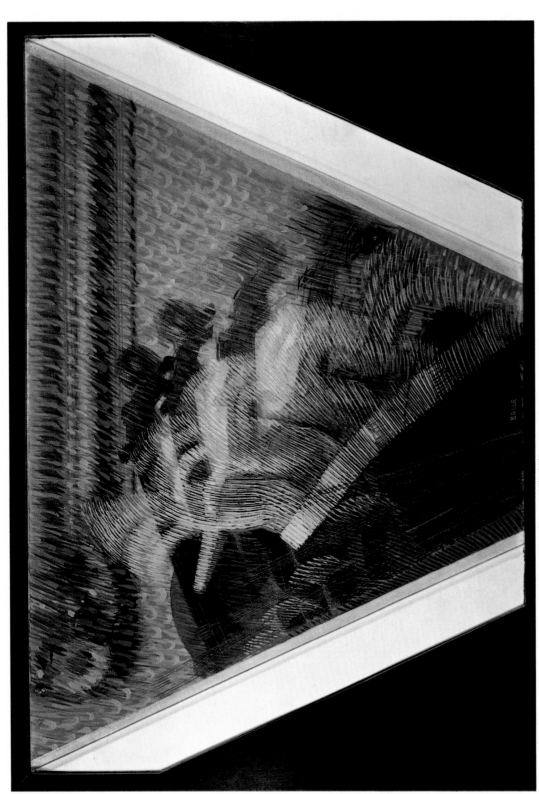

Giacomo Balla (1871–1958). *The Rhythms of the Bow.* 1912. Canvas. 20¼×29¼"

By fractioning the action,
Balla frees the informal areas

"A running horse does not have four hooves, it has twenty and their movements are triangular." This phrase from the Futurist Manifesto of April 1910 announced an entire Positivist-inspired research on the representation of movement. It confirmed contemporary experiments by Frantisek Kupka and heralded those by Marcel Duchamp (see pages 300–301). In regard to Giacomo Balla, it emphasized that artist's taste for experimental observation, and it gave him the idea of integrating into his work Jules Étienne Marey's chronophotographic effects—for ten years Marey's work had been well known in Italy (see page 272).

It was in May 1912, in Tuscany, that Balla painted a basset hound belonging to his pupil Countess Nerazzini in *Dog on a Leash* (right). He determined—not without humor—the arrangement of the figures and the grain of the floor from photographs taken from a very low point of view (that of a dog or a child). Strollers have been reduced to their shoes—those of a woman (foreground) and a man. This reduction of gestures and objects has created areas originally treated in small dots, areas that

herald the constructions of Naum Gabo and of Antoine Pevsner.

Balla executed *The Rhythms of the Bow* (above) a few weeks later in Düsseldorf, Germany, in the home of another pupil, whose husband was an amateur violinist. It associates in a staccato effect the violinist's left hand and the rectilinear lines of movement made by the bow (to the left of the painting). The closeup view puts the spectator into the executant's territory, completely up against the instrument. His hands have been rendered by long, divided strokes, either yellow, green, red, or black. The lower extremity of a massive frame occupies the upper part of the painting, and the artist has covered it with a shower of colored commas. With Balla, as with Cubists, the separate stroke is intended to express the idea of music.

This painting is in the unusual form of a trapezoid enclosed in a rectangular Sezession-style frame made by the artist. This shape affirms the ascending movement of sound, and it makes the black part of the frame into an element of mediation within the architectural context.

Giacomo Balla. *Dog on a Leash.* 1912. Canvas. 35⅞×39⅜"

The stimuli of the modern city engender an uproar of syncopated images

The brouhaha of city life is the preferred theme of Italian Futurism, as illustrated in Carlo Carrà's *What the Tram Told Me* (below) and in Gino Severini's *North-South* (right). The means of modern transport inspired the syncopated constructions of disparate images meant to represent the incoherent accumulation of stimuli in an observer's eye as he moves rapidly about. It is a question of a collage form whose components are spread out in time. Here are relevant remarks from the Futurist Manifesto of April 1910: "How many times on the cheek of the person we were talking to did we not see the horse that was passing far away at the end of the street? Our bodies enter into the couches on which we are sitting, and the couches enter into us. The bus bounds for the houses it passes, and the houses in turn rush toward the bus and merge with it."

Evoking these urban scenes, Eugenio d'Ors mentioned "a kind of descriptive drunkeness before infinite human profusion," and Marcel Duchamp noted "an Impressionism of a mechanical world." Futurism wanted to establish what Walter Benjamin has cited as "unconscious seeing," instantaneous images imprinted on the retina before empirical logic is restored to it and renders every fragment of the object according to its functional coherence. This is a prelogical realism whose elements, however, tend to become autonomous as rhythm and texture.

Carlo Carrà (1881–1966). *What the Tram Told Me*. 1910–1911. 21⅝ × 25⅝"

Gino Severini (1883–1966). *North-South.* 1912. Canvas. 19⅞×25⅝″

From a dancer's convulsive leaps, Severini makes a model of the expansion of color

Combining in a series of *Dancers* what he had learned from both Cubism and Futurism, Gino Severini rapidly poured out by decantation a rather indistinct play of forms to represent simultaneously very diverse realities. He called this technique "plastic analogies." In 1913–1914 Severini declared: "The spiral forms and contrasts of yellow and blue discovered by my intuition one evening after following a dancer's action can be rediscovered by affinity or by contrast in the spiral flight of an airplane or in the sea's reflection." He claimed a "complex realism that totally destroys the integrality of matter, considered henceforth only at the maximum of its vitality and that can be expressed: dancer-airplane-sea, or Galeries Lafayette [a Parisian department store]-transatlantic-etc."

In *Blue Dancer* (left), the Italian artist recalled the advice of the French poet and critic Guillaume Apollinaire when he pointed out in a polyptych by the fifteenth-century artist Carlo Crivelli the presence of manufactured objects arranged in relief—keys, a bishop's cross, a tiara, a pectoral—and Severini thus incrusted the robe of his personage with coins. These metal particles frontalize the painting and heighten its tactility.

In his *Forms of a Dancer in the Light* (right), Severini—adopting a technique frequently employed in medieval art—did not hesitate to transgress the frame in order to accent the expressivity of the painting's centrifugal movement, thus emphasizing the boundlessness of the energetic core that occupies the center of the work.

Gino Severini. *Forms of a Dancer in the Light*. 1913. Canvas. 28×

Gino Severini. *Dancer at the Bal Tabarin*. 1912. Canvas. 24×18¾"

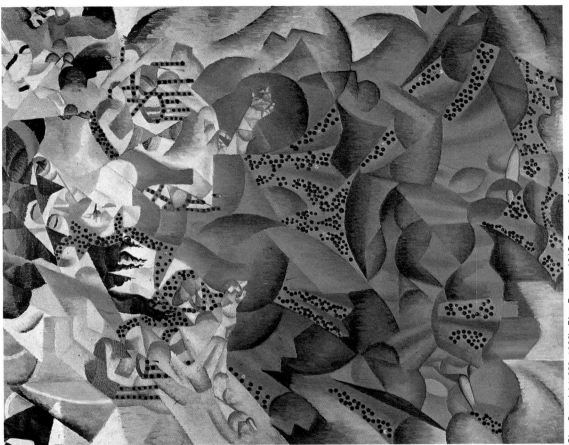

Gino Severini (1883–1966). *Blue Dancer*. 1912. Canvas. 24×18¾"

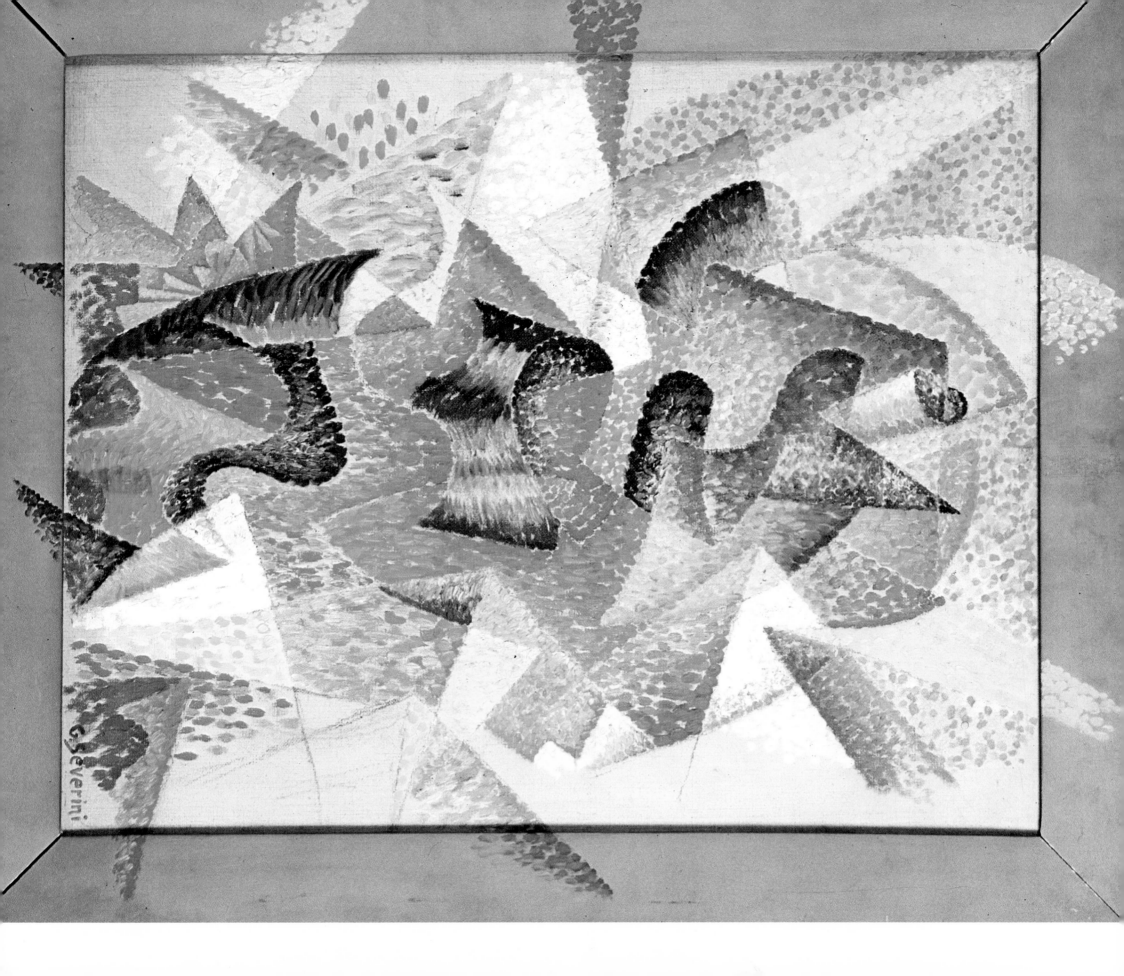

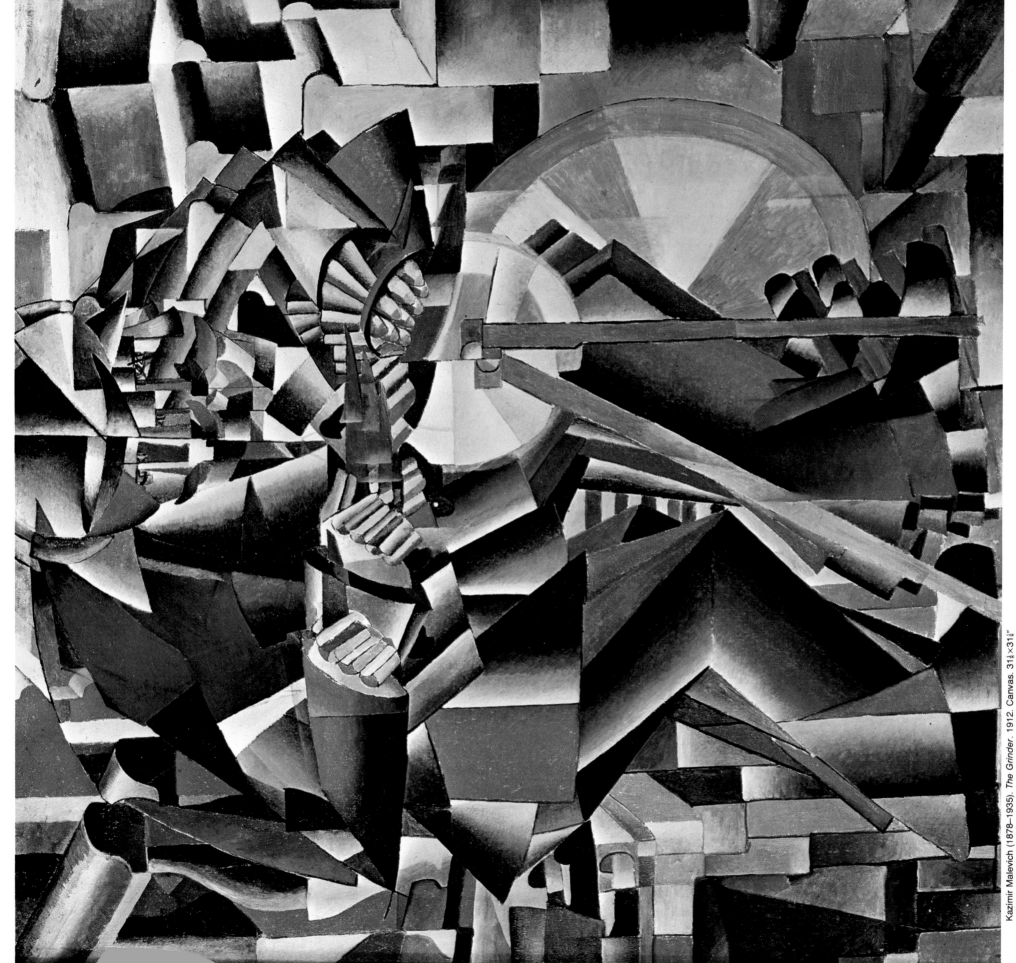

Kazimir Malevich (1878–1935). *The Grinder*. 1912. Canvas. 31¼×31¼"

A cinematic use of slow motion breaks up and reduces familiar gestures

In the portrait of his daughter Luce ("Light") running on a balcony—in *Young Girl Running on a Balcony* (right)—Giacomo Balla frontalized and lateralized the stroboscopic effect that he had inaugurated in his *Dog on a Leash* (see page 303). Movement has been indicated only by cream-colored trails at knee level. The balustrade—more recessive in the real space—comes forward in the painting to indicate retinal persistence. The child's ankle boots become dark from left to right. The dematerialization of the image has been obtained, paradoxically, by the use of thick, full brushstrokes. Two vertical strips represent the window frame, stabilizing the construction and giving by contrast to the course of the young girl the character of spontaneous apparition. Other brushstrokes, four or five times thicker, indicate the floor and the left boundary of the opening. This painting has no background; in it the surface is no more than an assortment of juxtaposed spots.

In order to indicate the jerky gestures of the figure in his *The Grinder* (left), Kazimir Malevich turned to the Futurist style of decomposing movement—this work represents his only attempt in this direction. Without doubt there is a bit of irony in the artist's choice of a handicraft scene, and an archaic one at that, and it is a parody of the Italian obsession with machines. For the Russian artist, any submission to industrial production seemed a way of confirming and strengthening the prejudice of representation of art. He stated in 1916: "Following the form of airplanes, automobiles, we will always be waiting for new forms projected by technical life. . . . Following the form of objects, we cannot head for pictorial autonomy, for immediate creation." What Malevich retained from Italian Futurism was the opening toward pure painting, beyond any referential denotation. "We are in the presence of a blow on the integrity of objects, on their breaks, on their sections, that approaches the annihilation of representation in the art of creation," he said in 1915.

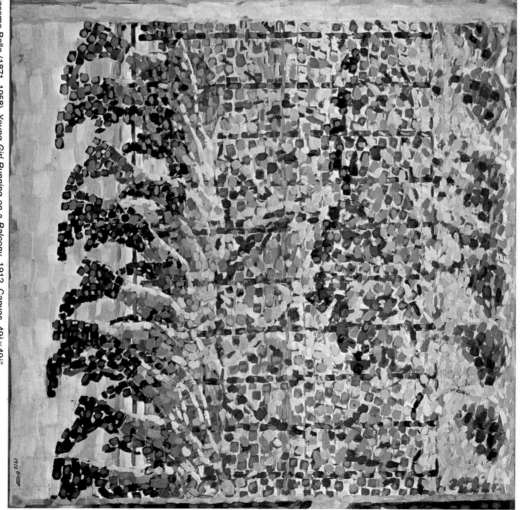

Giacomo Balla (1871–1958). *Young Girl Running on a Balcony*. 1912. Canvas. 49¼×49¼"

Giacomo Balla (1871–1958). *Flight of Swallows*. 1913. Canvas. 16¼×20⅞"

In deploying itself,
a flight of swallows
generates an entire
picture plane

Giacomo Balla. *Flight of Swallows*. 1913. Distemper on paper. 22⅞×33¾"

Giacomo Balla. *Lines of Allure + Dynamic Successions*. 1913. Canvas. 39⅜×47¾"

Starting with a simple motif—a pair of swallows against a background of variably spaced strokes (in *Flight of Swallows*, above left)—Giacomo Balla, increasing his studies of the subject from nature, achieved more and more complex situations to the problems posed by his theme (in *Flight of Swallows*, above right), until he produced in the autumn of 1913 his *Lines of Allure + Dynamic Successions* (right). This painting is a magnificent counterpoint, a combination in fugue of two movements: the displacements of the swallows in the sky and the displacement of the artist in the pursuit of his subject. "The person's step," to use Balla's phrase, is represented in this painting by the clear sinusoids that cross the canvas. To them has been added the spectator's eye movement as it follows the expansion of the curves from one end to the other. The architectural elements, shutters, blinds, balustrade, have been pulverized and integrated into the diagrammatic rhythm of the whole. The swallow—for Balla the symbol of hope and renewal—became the generator of the surface. By repetition, the anecdotal motif ended by annuling itself in the dynamic fullness of lines that rules the work and constitutes it as an autonomous plastic fact.

310

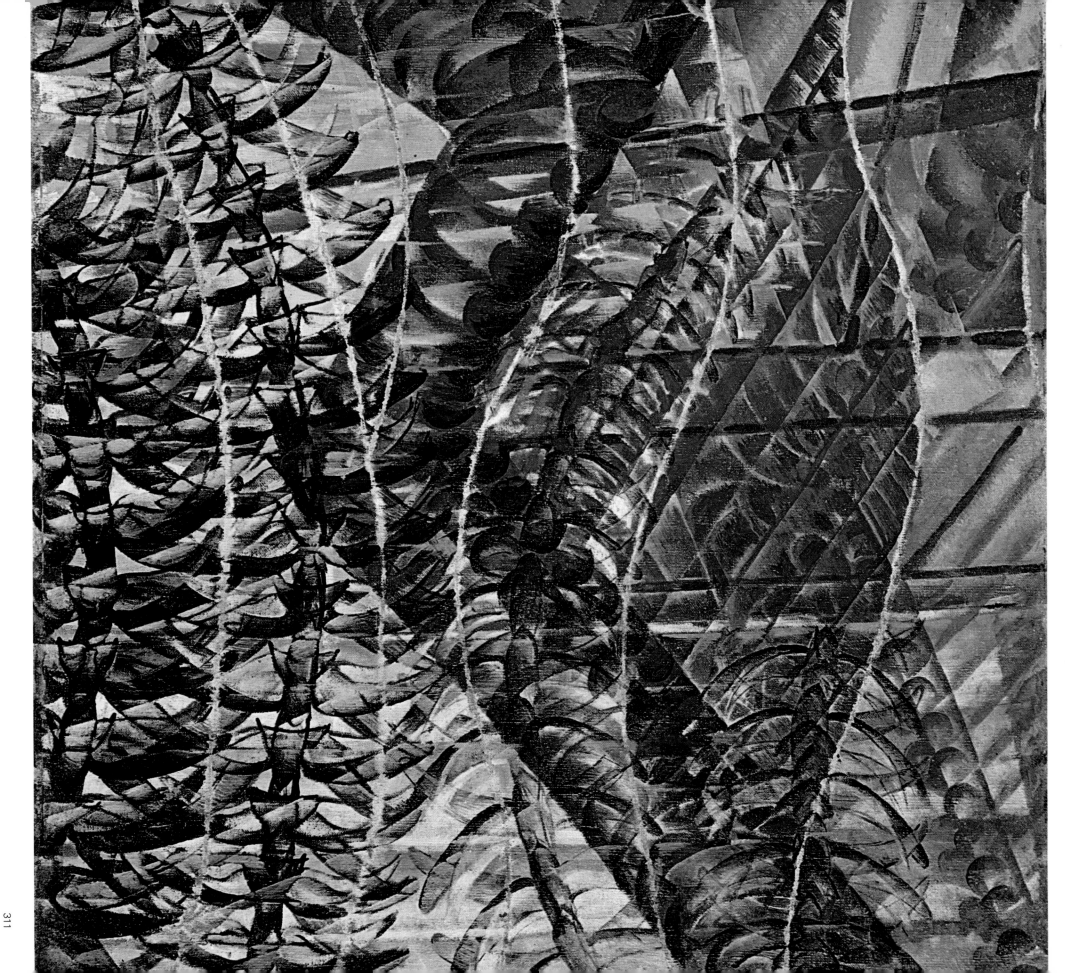

MODERN ART MOVEMENTS

SYMBOLISM

At first better known in its literary aspects (Stéphane Mallarmé and his followers), Symbolism is also remarkable for its pictorial manifestations, which are only now beginning to come to light. As a movement, it dates its birth to 1886: Arthur Rimbaud's *Illuminations*, Vincent van Gogh's arrival in Paris, Paul Gauguin's activity in Brittany, and the publication of the Manifesto of Symbolism by Jean Moréas (September 18, 1886, in *Le Figaro*). It was a question of "clothing the Idea in a sensible form" (a phrase that well marks the literary presuppositions of the new movement). Symbolism was consecrated by the publication of Mallarmé's *Poésies* (1887), the exhibition of the Pont-Aven group (Paul Gauguin, Émile Bernard, etc.) in 1889, and Odilon Redon's growing celebrity (more as an engraver than as a painter). Pierre Puvis de Chavannes (frescoes in the Panthéon, Paris) produced paintings in a very frontalized style, and Gustave Moreau exhibited works in which the luxury of detail and the decorative excess drowned the painting's "subject."

Symbolism, however, was international, for one notes the aesthetic community of the Russian painter Mikhail Vrubel, the Viennese Gustav Klimt, and the Frenchman Gustave Moreau. In England the movement was represented by the Pre-Raphaelites (Dante Gabriel Rossetti, Edward Burne-Jones) and by Aubrey Beardsley, who illustrated works by Oscar Wilde. In Germany Franz von Stuck's visions (he later taught Paul Klee and Wassily Kandinsky) were related to those of Arnold Böcklin, who inspired Giorgio de Chirico. In Italy (where Mallarmé was adulated), the movement had an influence whose extent and effects one can better see today. What would Futurism have been without Giovanni Segantini, Gaetano Previati, and the Italian Divisionists? In the Northern countries, Xavier Mellery, Fernand Khnopff, Jan Toorop, Johan Thorn Prikker, the Group of XX, and Félicien Rops (who had settled in Paris) made a decisive contribution. Although Symbolism, unlike Impressionism, was not a revolution in painting, nevertheless its international expansion, its attention to textural values, and its importance in the training of many artists of the twentieth century force one to restudy its productions.

EXPRESSIONISM

The word "Expressionism" designates either a precise artistic movement that occurred almost at the same time as Fauvism and whose center of activity was Germany, or by extension a trend in contemporary art that would link Vincent van Gogh to Jackson Pollock. First used in France (Henri Matisse and his friends exhibited in Berlin in 1911), the word "Expressionism" finally came to designate (after Fechter used it in this context in his monograph of 1914) the group of artists known as Die Brücke (1905–1912). The historical origin of Die Brücke was linked to the deplorable situation of German art at the close of the nineteenth century: an all-powerful academic painting encouraged by an autocratic political power. As a form of reaction, this situation caused the birth in 1892 of the Berlin Secession, which introduced the work of modern artists.

Thus, by simultaneously discovering Gustav Klimt, Paul Cézanne, Vincent van Gogh, Edvard Munch, James Ensor, Japanese prints, and "primitive" art, young painters were able to emerge from the cultural ghetto. From the Norwegian Munch and the Flemish Ensor, considered both as the ancestors of and as participants in Expressionism, they retained at first the crisis of the "subject" (they wanted to represent not objects but feelings) and the means used to fulfill this program (how to transmit these feelings in and by representation). Munch's morbid fantasies interested them—*Anxiety* (1894), *Puberty* (1894), *Melancholy* (1899)—as well as his formal work: the obvious material quality of the wood in his engravings, the contradiction between the frontalized foreground and the background perspective. With Ensor they were interested not only in the symbolism of the masks he habitually painted but also in his gesturality (*The Rebel Angels Cast Out of Heaven*, 1889), as well as in the vertical arrangement of his figures (the accumulation of details in the upper section of the composition) and in the chalky texture of his canvases.

Gathered around Ernst Ludwig Kirchner, the group of young painters founded in Dresden in 1905 and called Die Brücke ("The Bridge") was a passage to the future; it was perhaps the most organized and most coherent group in all modern art. Its members formed no less than a real community whose activities (printing engravings and holding exhibitions) inspired Emil Nolde and Max Pechstein to become members, as did a few others. Despite their differences in treatment, at that time the canvases of the members of the group were almost identical. Actually, the works of the members of Die Brücke were greatly related to contemporary works by the Fauves and seemed to share the Fauvist organizational system by means of color and the importance of relationships.

The year 1910 witnessed the last exhibition in Dresden by the artists of Die Brücke. The members soon dispersed and abandoned their color researches for a rather banal post-Cubist style. Expressionism then became a huge polytechnic movement (literature, painting, cinema), extending its influence in contradictory and diverse ways. Either it found an outlet in politics–Die Brücke artists—those of *New Objectivity* (George Grosz, Otto Dix) worked for newspapers of the extreme left—or it went to the other extreme of realism, madness, marked by the work of Alfred Kubin and the young Oskar Kokoschka.

FAUVISM

A movement without a leader or a program, Fauvism was above all a group of painters who collected under a heading that they themselves never accepted. Henri Matisse related Fauvism's uncertain birth. "We were exhibiting at the Salon d'Automne. Derain, Manguin, Marquet, Puy, and a few others were hung together in one of the large galleries. In the center of this room the sculptor Marque exhibited a bust of a child very much in the Italian style. Vauxcelles (critic for *Gil Blas*) entered the room and said, 'Well! well! Donatello in the midst of wild beasts [*fauves*]!'." One merely has to date the episode (1905) and to mention a few names forgotten by Matisse (Charles Camoin, Maurice de Vlaminck, Louis Valtat, and Othon Friesz, as well as those of Raoul Dufy, Georges Braque, Georges Rouault, and Kees van Dongen) to point to the fortuitous origin of this "movement" that created one of the first scandals of the century.

Crystallized around Matisse's personality, Fauvism died about 1907 (the date it was taken over by Cubism), when its chief representative changed his style. After leaving Gustave Moreau's studio, where his fellow artists were Albert Marquet, Henri Manguin, and Charles Camoin, Matisse was influenced by Vincent van Gogh and Paul Gauguin (the arbitrariness of colors), and he long studied Paul Cézanne ("to construct by means of color") and Georges Seurat. Spending a summer at Collioure with André Derain (1905), he took advantage of this time to shake off "the tyranny of Divisionism" (Seurat's theory), and on his return to Paris Matisse exhibited the first of his so-called Fauve paintings. These were characterized not only by the abandonment of local tone, the use of pure color, and the evidence of the white of the *reserve*, but also by a violence controlled by the *play of relationships*. (In a painting, noted Matisse, "no point is more important than another.") His *Woman in a Hat* (1905) was booed. It was a question of liberating color (in this painting the shadow is green, the hair vermilion, and the face and hat multicolored), of "stirring man's sensual basis." Somewhat later Matisse retorted to the hostile criticism: "Above all, I did not create a woman, I made a painting." The public's animosity—as forty years earlier in regard to Édouard Manet's *Olympia*—was sufficient to make him by reaction if not the leader of the school (a role he was constantly refused) at least a master of avant-garde art.

The other Fauve painters were less fortunate, for neither Othon Friesz, Henri Manguin, Jean Puy, Louis Valtat, nor Charles Camoin produced any paintings to compare with the Matisses of that period. As for Maurice de Vlaminck, Kees van Dongen, Albert Marquet, and André Derain, the only work of theirs that is of any real interest is that produced during this brief period of Fauvism. Georges Braque soon joined Pablo Picasso in creating Cubism, and Georges Rouault continued alone his experiments in gesturality, texture (his canvases were often heavily loaded with pigment), and chiaroscuro. Matisse, for whom Fauvism was but a moment (and moreover a primordial one) in his development, became with *The Dance* (1908), *The Dessert* (Second Version) and *Music*—both now in the Hermitage, Leningrad [both 1910]—*The Red Studio* (1911), and *Interior with Eggplants* (1911–1912) one of the founders of modern art. A painter of "surfaces," tempted for a time by a certain academic style that his series of *Odalisques* of the years 1920–1930 exhibits, Matisse again revolutionized painting with his *Dance* of 1932, his *Pink Nude* of 1935, and his *Interiors* of the 1940s, and he upset all conceptions of drawing with the *papiers découpés* he created toward the end of his life. Long little known in France, although he was one of the constant references in American art, Matisse made a great comeback there thanks to the splendid retrospective exhibition held in Paris in 1970.

CUBISM

The most important "aesthetic revolution" of the twentieth century was Cubism. Its leading protagonists were Georges Braque, Pablo Picasso, Juan Gris, and Fernand Léger. Cubism not only influenced several generations of painters but also played an important role in architecture and poetry in terms of "taste." It was the same critic (Louis Vauxcelles of *Gil Blas*) who baptized Fauvism that gave Cubism its name when he mentioned "cubes" in an article on Braque's first exhibition in 1908. The name was launched, but it was accepted only with reserve by the artists concerned. Traditionally, Cubism had three phases: Cézannian (1907–1909); Analytical (1910), and Synthetic (1913–1914). Research was conducted at a feverish speed between 1907 and 1914 and terminated in a kind of academic art. After World War I and until about 1925, many artists used the style of Braque and Picasso but without innovation. Moreover, the most important effects of the Cubist explosion occurred elsewhere: Robert Delaunay, Piet Mondrian, and Kazimir Malevich, who came to Cubism but soon departed from it, prolonged it much better than its "proper" pupils such as Albert Gleizes and André Lhote.

After discovering—thanks to Matisse—African sculpture and after a passionate study of Paul Cézanne, in the summer of 1907 Pablo Picasso finished his famous *Les Demoiselles d'Avignon*, which historically marks the origin of Cubism. He became friendly with Georges Braque (who was coming from Fauvism and was well aware of the "relationships" in a painting's organization). Guillaume Apollinaire became the movement's poet and Daniel-Henry Kahnweiler opened a gallery that autumn that became its sanctuary.

The landscapes of this period (1908–1909) revealed the Cézannian orientation of Cubism (the Salon d'Automne of 1907 had a retrospective showing of Cézanne's work). Braque and Picasso attempted to take up where Cézanne had left off, namely, at a question as old as painting: the contradiction between the surface of the canvas and the illusion of depth (a contradiction fully revealed in one of Braque's paintings, *Broc et Violon* of 1909–1910, in which a nail in *trompe-l'oeil* is painted above a very modern still life). In 1910 Braque and Picasso limited their subjects (guitar, portrait, etc.) and their palette (camaïeu). Their method became complicated: the object was fragmented into multiple facets. They spoke of "Analytical" Cubism, even of "hermetic" Cubism.

In 1912 this hermetic quality was counterbalanced by the use of *collages* and *papiers collés*, creators of semantic ambiguities (this bottle is also an issue of *L'Intransigeant*) and of *trompe-l'oeil* (imitation wood, false chair caning, etc.). The movement was then at its height. No sooner was Cubism published than it was translated into many languages, including Russian.

Juan Gris, a newcomer, made a decisive contribution to Cubism. In his paintings of 1911–1913, he emphasized the synthetic and frontal construction of the canvas. His *The Lavabo* (1912), in which he introduced a real piece of mirror, was a major result of the technique of collage. Although Fernand Léger was close to the group, his canvases were far more volumetric and illusionist than those of Braque and of Picasso. After the canonization of Cubism by Guillaume Apollinaire's fine work, *The Cubist Painters* (1913), the movement lost much of its force. Braque returned to a certain Classicism, and Juan Gris ended in mannerism. Picasso and Léger continued to change their styles and to reveal their vitality beyond the era of Cubism.

FUTURISM

On February 20, 1909, the Italian poet Filippo Tommaso Marinetti published the Manifesto of Futurism in the Paris newspaper *Le Figaro*. The text exalted speed and movement ("a racing car . . . is more beautiful than the *Victory of Samothrace*"), danger, war, and mechanization, and it thundered against artistic nostalgia ("Tear down the museums. . . ."). In 1910 Carlo Carrà, Umberto Boccioni, Luigi Russolo (painter and musician, the precursor of *musique concrète*), Giacomo Balla, and Gino Severini, all

Of whom had met Marinetti in turn, published the Manifesto of Futurist Painters. Polished agitators, they continued as Futurists and as a group to occupy the foreground in the artistic scene—and often even the political scene—until the beginning of World War I.

The two great painters of the movement were Giacomo Balla and Umberto Boccioni, but the *Dancer at the Bal Tabarin* (1912) and the series entitled *Spherical Expansions of Light* (1912–1914) by Gino Severini rank among the finest achievements of Futurism. Likewise the splendid *Interventionist Demonstration* (1914) of Carlo Carrà inspired by the typographical delirium of Marinetti's *Words at Liberty* remains one of the landmarks of the aesthetics of collage.

In 1912–1913 Giacomo Balla, who experimented with Divisionism, made a series of canvases intended to represent movement. Inspired by Jules Étienne Marey's chronophotography, he wanted to decompose movement by the repetition and transparency of figures; see Balla's *The Rhythms of the Bow*, *Dog on a Leash*, and *Young Girl Running on a Balcony*. Balla also launched into systemic researches on the division of light and colors. His series *Iridescent Interpenetrations* ranks among the inaugural works of geometrical painting.

If Boccioni was an innovator in painting, he was also an initiator of modern sculpture—collages of objects, extension of the *linee forze* of a work in the surrounding space (1912).

If Futurism was one of the great pictorial movements of the century, its achievements in the fields of cinema, poetry, theater, and architecture were equally revolutionary. Whereas Italian Futurism via Marinetti strangely enrolled itself in the camp of Fascism, the Russian poets and artists who began with the program of Futurism and reached Constructivism, on the contrary, joined the October Revolution.

PITTURA METAFISICA

It is to Giorgio de Chirico, considered by the Surrealists as one of their precursors, that we owe the birth of *pittura metafisica*, between 1910 and 1915. Born in Athens, of German formation (Romanticism, mysticism), influenced by the Symbolism of Arnold Böcklin, De Chirico, about 1909, became fascinated by the rectilinear character of Classical Italian architecture. On his arrival in Paris in 1911, he reacted violently against the noisy avant-gardism of Cubism and Futurism. "I began to perceive the first phantoms of an art more complete, more profound, more complex, and in a word, at the risk of giving a French critic liver colics, more *metaphysical*." Result: *The Enigma of the Hour* whose strange uneasiness stems from an excess of (Sur)realist precision. Stiff figures, very distinct shadows, curvilinear perspectives, empty architectures: this threatening presence of "too much reality" will leave its imprint on the first paintings by Max Ernst, René Magritte, Paul Delvaux, and the others.

World War I found De Chirico in Italy (1915). Along with his brother, the poet Alberto Savinio, he was mobilized and assigned to the garrison in Ferrara. It was there that metaphysical painting became a school. De Chirico met Carlo Carrà, a deserter from Futurism, who, coming under De Chirico's influence, returned to the static representation of objects, on the whole producing works of less anguish and more irony than De Chirico. Far from Ferrara, an isolated Giorgio Morandi was taken into the movement by its founder. Emphasizing the extreme simplicity of De Chirico's first works, Morandi used an extreme economy of means in his intimist still lifes (a few colors, sometimes a few nuances of the same color, a few lines). *Pittura metafisica* did not survive World War I, and after some years spent in technical experimentations, about 1930 De Chirico broke violently with the work of his youth, and he then turned exclusively to an academic style completely lacking in interest.

DER BLAUE REITER

Der Blaue Reiter ("The Blue Rider") was more an artistic association than an organized group. It was created in 1911 from a split in the heart of another association founded in 1909 by Wassily Kandinsky. "Franz Marc," he related, "and I both loved blue, Marc blue horses, I blue riders. He himself created the name." In December 1911 the first exhibition that included not only works by Wassily Kandinsky, Franz Marc, and August Macke but also by the French artists Robert Delaunay and Henri Rousseau, the Burliuk brothers (Russian Futurists), and the composer Arnold Schönberg took place. In 1912 the second exhibition, including some artists who had left Die Brücke, grew into a vast presentation of international youth, and then turned exclusively to an academic style completely lacking in interest.

modernity (it was now proper to speak of a Blaue Reiter program) and revealed the presence of Paul Klee in the artistic scene. That same year saw the publication of Kandinsky's famous *On the Spiritual in Art* (one of the first defenses of so-called abstract art) and Franz Marc's *The Blue Rider Almanac* (which included, among others, articles on primitive art and on popular art, texts by Kandinsky on the problem of form, and articles by Arnold Schönberg, Franz Marc, Robert Delaunay, and others).

The group was then at the height of its activity, but it was dispersed by the force of the war—the war in which both Marc and Macke were cruelly killed. Paul Klee and Wassily Kandinsky became two of the most important figures of the art of the century.

SUPREMATISM

Kazimir Malevich designated his work under the classification of Suprematism about 1915 after he had freed it from Cubism and Futurism. Favored, like his Muscovite friends, by a certain geographical remoteness and by the excellent examples in the important Russian collections of modern art (accessible to the public), he undertook to make a theoretical reflection on the different achievements of Western art since Paul Cézanne. This reflection resulted in the *Black Square on a White Background* (1913–1915), a work that is often taken merely as a manifesto. It marks a clean slate after Malevich's apprenticeship (the work is a black square bordered by white, the canvas being square), this square representing, for Malevich, the "degree zero of painting." He emphasized the material reality of the painting and the resistance of the surface to the hollowing out of the perspective. Malevich then operated that which he later called "regression": numerous geometrical figures, diversely colored, in different scales, all inscribed on a white background at the very heart of which they seemed to float. An impression of nonmeasurable volume was suggested; it is a question of an astral reverie (an oneiric flight), and the paintings of this period strangely resemble cosmological maps.

With his *White Square on a White Background* (1918), the first achromatic work in modern art, Malevich seemed to loop the loop: beginning with a reflection on the notion of surface, he finally came to the representation of infinity. "For the color of space," El Lissitzky informs us, "he did not choose the simple blue of the color spectrum but the total unity, white." A limited work, *White Square on a White Background* marked a stop in Malevich's work. He henceforth devoted himself almost exclusively to the elaboration of a pictorial theory and to the construction of his *Planites*, the models of a dream architecture, toward the end of his life, as though in order to show the necessity of a cycle, he painted very figurative portraits in the Italian style.

Although the Suprematist Manifesto (1915) was signed by Ivan Puni, Bogouslavskya, Klioun, and Menkov, one could say that it was El Lissitzky (who worked with Malevich in his school at Vitebsk) who in the 1920s continued most intelligently Malevich's experiments by constructing his *Proun*, geometrical paintings or reliefs with an axonometric basis (a perspective without a vanishing point). Thanks to El Lissitzky, Malevich's work was introduced to the West.

DADA

Long underestimated in comparison to Surrealism, which succeeded it, the Dada movement was born almost simultaneously in Zürich, New York, and Paris. It later reached Germany, and it ended in Paris. In Switzerland, whose neutrality during World War I favored the gathering of anarchists from other countries, the Germans Hugo Ball and Richard Huelsenbeck along with Jean (Hans) Arp founded the Cabaret Voltaire in 1916. This café-gallery-theater was the place in which they developed an aesthetics of scandal that today appears rather like schoolboy pranks and yet at the time had an immense effect. The dictionary, consulted by chance, gave the movement its name, one of the bases of which was, precisely, ridicule by chance. During Dadaist evenings, "phonetic" or fortuitous poems were read in a thundering way, and in reviews Jean Arp's forms were "placed according to the laws of chance" to illustrate the poems of Tristan Tzara, the author of the manifestoes of Dadaism.

Meanwhile in New York, the ex-Cubist Marcel Duchamp exhibited his ready-mades (for example, a urinal signed R. Mutt). Ridicule, yes, but also a reflection on the sacralization of art and the artist in our society. The Spanish-born Francis Picabia, who also arrived in New York in 1915, developed an aesthetics of mechanisms that seems a parody of the program outlined by the Italian Futurists. In Barcelona he founded the review *391*, which became one of the first organs of juncture among the different Dadaisms.

In Germany—where its antimilitary demonstrations created a scandal—Dadaism developed very rapidly and took on a more specifically political character. In Berlin, George Grosz, Richard Huelsenbeck, Raoul Hausmann, and John Heartfield attempted to intervene in current social problems (the virulence of the latter's photomontage-tracts remains unequaled). In Hanover, Kurt Schwitters (destined to inspire many ideas of American Pop Art) developed the principles of the Cubist collage but chiefly built his *Merzbau*, a kind of environmental sculpture that finally invaded more than the entire space of his apartment. After launching into politico-artistic agitation, Max Ernst settled in Paris where he became one of the spearheads of Surrealism. The movement, moreover, broke up in Paris in 1922, and it was supplanted by Surrealism, from which painting through De Chirico renewed itself with symbolism and with "subject" painting.

DE STIJL

This group was formed in Holland and named from a review of the same name (*The Style*) founded by Theo van Doesburg in 1917. The periodical was destined not only to defend the principles of Neo-Plasticism launched by Piet Mondrian but also "to make modern man receptive to what is new in the visual arts." Certainly, Mondrian became one of the pivots of the group. Certainly, Mondrian was the star of the periodical during its first three years (he published texts on the simplification of plastic means and on the necessity to keep using horizontal and vertical lines, the three noncolors—gray, white, and black—and the three primary colors), but other painters formed the movement's initial core: Vilmos Huszar, Bart van der Leck, and Georges Vantongerloo (who attempted a mathematical approach to art). The painters were joined by such architects as Robert van't Hoff (much influenced by Frank Lloyd Wright whose work he studied in the United States), J. J. P. Oud (whose cities for workers proved to be a brilliant success), Jan Wills, and Gerrit Rietveld (who designed furniture, and the famous Schröder House in Utrecht). It was in *De Stijl* that Mondrian published his basic texts on the end of painting and on the desacralization of the artist.

Van Doesburg paid homage to Mondrian in the anniversary issue of 1923, but that same year he abandoned the principles of Neo-Plasticism and launched Elementarism, which caused his quarrel with Mondrian. In 1927 with Jean Arp and Sophie Taeuber-Arp he decorated the Brasserie l'Aubette in Strasbourg (since destroyed). As for Mondrian, who became one of the most important painters of the century, he patiently continued his researches in Paris without Van Doesburg's support. In 1928 the review ceased publication, by which date the group was completely dispersed. But Van Doesburg's wife published a last number after the death of her husband (1931) in homage to him. Far from having been a mere cultural agitator, Van Doesburg appears to have been an important painter. Mondrian took refuge in the United States during World War II, and he definitely changed his style in his final works—*Broadway Boogie-Woogie* (1943) and the unfinished *Victory Boogie-Woogie* (1944)—which heralded the achievements of Op Art. After a series of paintings based on mathematical equations, Georges Vantongerloo launched into experiments on the refraction of light by prisms, which inaugurated an art not only of natural processes. The review *De Stijl* made known not only the names of those who founded it but also the names of Frederick Kiesler, Jean Arp, El Lissitzky, Man Ray, Frantisek Kupka, Kurt Schwitters, Friedl Vordemberge-Gildewart, and many others.

GENERAL INDEX OF PAINTERS AND OF THEIR WORKS

ILLUSTRATIONS TO THE CHAPTERS

GLOSSARY OF SEMIOLOGICAL TERMS

By Craig Owen

Semeiology, or the science of signs, draws its vocabulary from a variety of disciplines ranging from Classical rhetoric through Freudian psychoanalysis and the structural anthropology of Claude Lévi-Strauss. Semeiology's stakes are, however, invested primarily in the model of language proposed by structural linguistics. Thus the entries in this glossary are for technical linguistic terms, which nevertheless acquire somewhat different meanings within a semiological frame. In semeiology, the linguistic model is adapted to the description and analysis of the entire range of cultural phenomena—from fashion and advertising through literature, music, and painting. What unifies semeiology as a general cultural discipline is its emphasis upon the sign. All of the terms defined below are in some way or another dependent upon the definition of the sign, which therefore stands first.

sign: According to the American logician C. S. Peirce, "a sign is something which stands to somebody for something in some respect or capacity." In general, semeiology considers anything that can be taken as substituting for something else as a sign. However, an important qualification is added: that "standing for" be the motive of the substitution. Ferdinand de Saussure, in his lectures at the University of Geneva between 1906 and 1911, inaugurated "structural" linguistics, the analysis of language as a system of signs.

Saussure defined the sign as a relationship of two terms. The linguistic sign unites, not an object and a word or name, but what Saussure called a "concept" and its material representation, either spoken or graphic—a "sound-image." The "concept" is not an object in the world, but a mental image of it; hence the capacity of the sign to conjure up nonexistent or fantastic objects. Similarly, the "sound-image" is not simply a spoken word or its graphic representation, but "the psychological imprint of the sound, the impression that it makes on our senses." Thus every sign is composed of two indissoluble faces, which Saussure likened to the two sides of a sheet of paper: a signifying face (the signifier), which common usage calls sign, and a signified face, the "meaning" or "object." Saussure's description of the structure of the sign is novel in that it locates the object designated by the signifier *inside the sign*, rather than outside of it.

analagon: A sign characterized by a relation of similarity or resemblance between signifier and signified. Most visual images—at least those of representational or figurative art—are *analaga*, since they appear to resemble the objects they designate. Semeiology classifies such signs among the "motivated" signs (see *arbitrary/motivated*).

aporia: A logical impasse. The term is used by the French philosopher Jacques Derrida to describe the occurrence in a text of a word with (at least) two mutually contradictory significations (such as the Greek word *pharmakon*, which signifies both "posion" and "cure"). The effect of such aporistic words is to make the meaning of the text fundamentally undecidable. (See Jacques Derrida, "La pharmacie de Platon," *La dissémination*, Paris, Seuil, 1972.) An example of a visual aporia might be a "collapsing cube," in which it is impossible to determine which of the two square faces is represented as being closest to the viewer.

arbitrary/motivated: A polar opposition used to characterize the relationship of signifier to signified. The first principle of Saussurian linguistics is that in language the bond that links signifier to signified is arbitrary in nature. This means that the signifier does not in any way imitate its signified; for example there is nothing in the concept "sister" to call forth the particular conjunction of sounds that designates it in English. Rather, the bond between image and concept is established by convention (arbitrary) signs are also referred to as "conventional"). Motivated signs, on the other hand, do possess a relationship of similarity between their two faces. Onomatopoeic words and the signs of figurative art are familiar examples of motivated signs. In the motivated sign, the formal properties of the signifier are derived from those of the signified.

articulation: It is a fundamental property of the sign that it is articulated. This does not mean that it is simply spoken distinctly or clearly. In Latin, *articulare* signifies "to divide into joints." To articulate is thus to divide into distinct, discontinuous segments. In linguistics, articulation designates both the subdivision of words into syllables or sounds and that of discourse into significant units (words).

bricolage: A term introduced by the French anthropologist Claude Lévi-Strauss. A *bricoleur* (a "handyman") builds new structures from the shards and fragments of old ones (and thus the contrasts with an *engineer*). *Bricolage* is the piecing together of heterogeneous or, frequently, incongruous elements into new combinations.

catachresis: A term derived from Classical rhetoric used to designate a metaphorical substitution (see *metaphor*) of a familiar sign for a new or unfamiliar concept. For a catachresis to have taken place, however, it is necessary for the substitution to have passed into common usage. A familiar example is the word *spaceship*, originally a metaphor, but now an accepted term.

code: See *arbitrary/conventional*.

code/message: The polar opposition code/message applies Saussure's distinction between language and speech (*langue/parole*) to signs other than those of language. For Saussure, it was essential to distinguish language as a systematized set of conventions necessary to communication from specific speech acts, or utterances. Language is not simply the sum total of all utterances but a system of conventional rules that govern speech and guarantee its intelligibility. Thus signs as they appear in specific instances are distinguished from the rules that control their selection and combination. Certainly a language does not manifest its existence except in discourse or speech; but speech acts are not the language. Semeiology has introduced the terms *code* and *message*, which correspond to language and speech, respectively. A code is thus a set of prescriptions for the selection of units and their combination into meaningful sequences. Every such sequence, or message, therefore refers back to the code according to which it was generated. Renaissance perspective is a familiar example of a visual code; any specific painting that employs single-point perspective constitutes a message in relation to that code.

connotation/denotation: In ordinary usage, *denotation* is the definition of a word, and *connotation* suggests all the things associated with it. Thus, *home* denotes the place where one lives, while it connotes comfort, intimacy, privacy, etc. Semeiology analyzes the structure of connotation thus: in a connotative system, a sign (the union of a signifier and a signified) is taken as the signifier of yet another sign. A connotative sign is thus one whose signifier is itself constituted by a sign. The first-order system is referred to as denotation; the second-order system as connotation.

conventional: See *arbitrary/conventional*.

difference (differential structure): One of Saussure's most famous dicta, "In language, there are only differences," points to an essential characteristic of sign systems. Signs do not exist in one-to-one relationships with objects, and therefore independently of other signs, but as elements within systems. Their meanings are determined by the positions they occupy in relation to the other elements of the systems, from which they differ in some significant way. Meaning, therefore, does not inhere within the isolated sign. Rather, it is the product of a differential relationship with other signs. Thus, for Saussure, "the idea or phonic substance that a sign contains is of less importance than the other signs that surround it."

icon: One of three classes of signs (icon, index, and symbol) distinguished by C. S. Peirce. Although iconic signs frequently resemble their objects or referents, resemblance is not a sufficient condition of iconicity. The iconic sign itself possesses some of the essential characteristics of its object. The traditional use of the term to designate a particular class of religious images elucidates this concept—a Byzantine "icon" is an iconic sign not because it is a "likeness" of a particular holy personage, but because it is believed to possess some of the magical qualities associated with him.

index: The second sign-type in Peirce's trichotomy of the sign (see *icon*), the index is a sign that is understood to be in an existential connection with its object. Thus indices are signs that were physically caused by their object; footprints and cast shadows are two familiar examples. The action of the index depends upon association with its object through contiguity, and not upon association through resemblance (icons) or intellectual operations (symbols). Personal pronouns (*I* and *you*) are also indexical, since they depend upon the physical presence of the speaker to be meaningful.

logocentrism: Jacques Derrida's neologism that describes the strategies according to which Western thought has granted privilege and authority to the

BIBLIOGRAPHY OF THEORETICAL WORKS

Gaston Bachelard. *The Poetics of Space.* Boston: Beacon Press, 1969

———. *La terre et les rêveries de la volonté.* Paris: Corti, 1948

Walter Benjamin. *Illuminations.* New York: Schocken, 1969

———. *Reflections.* New York: Harcourt Brace Jovanovich, Inc., 1978

Jacques Derrida. *Of Grammatology.* Baltimore: Johns Hopkins University Press, 1976

———. *L'écriture et la différence.* Paris: Seuil, 1967

———. *La dissémination.* Paris: Seuil, 1972

Michel Foucault. *The Order of Things.* New York: Pantheon, 1970

———. *The Archaeology of Knowledge.* New York: Pantheon, 1972

Sigmund Freud. *The Interpretation of Dreams.* Standard ed., vols. 4–5. London: The Hogarth Press, 1955

Jean-Joseph Goux. *Économie et symbolique.* Paris: Seuil, 1973

Roman Jakobson. *Selected Writings I.* The Hague: Mouton, 1962

———. *Questions de poétique.* Paris: Seuil, 1973

Julia Kristeva. *Semeiotikè, Recherches pour une sémanalyse.* Paris: Seuil, 1969

———. *La Révolution de la langage poétique.* Paris: Seuil, 1974

———. "L'espace Giotto," *Polylogue.* Paris: Seuil, 1977

Jacques Lacan. *Écrits.* London: Tavistock, 1977

———. *The Four Fundamental Concepts of Psychoanalysis.* London: The Hogarth Press, 1977

L. T. Lemon and M. J. Reis (eds.). *Russian Formalist Criticism: Four Essays.* Lincoln: University of Nebraska Press, 1965

Claude Lévi-Strauss. *The Savage Mind.* Chicago: University of Chicago Press, 1966

Stéphane Mallarmé. *Selected Prose.* Baltimore: Johns Hopkins University Press, 1956

Ferdinand de Saussure. *Course in General Linguistics.* New York: McGraw-Hill, 1966

Tzvetan Todorov. *Théorie de la littérature: textes des formalistes russes.* Paris: Seuil, 1965

Daniel Wildlöcher. *L'interprétation des dessins d'enfants.* Brussels: Charles Dessart, 1970

spoken word as opposed to writing and the graphic sign. The *logos*, or rational principle at the center of the universe, has from the beginning of philosophy been identified with speech. It is identical with the Word in Christian theology: the Word is the actively expressed, creative, and revelatory thought and will of God—expressed in Speech.

message: See *code*.

metaphor/metonymy: The Russian linguist Roman Jakobson distinguished metaphor and metonymy as the two fundamental linguistic operations. For Jakobson, speech implies both a selection of certain linguistic units and their combination into more complex linguistic units (for example, sounds into words; words into sentences). For Jakobson, selection between alternate possibilities implies the possibility of substituting one term for another, and thus similarity or equivalence between the two. Thus, relationships of similarity constitute the metaphoric pole of language. Metonymy, on the other hand, is based upon the combination of selected terms into more complex units, the components of which are in a relationship of contiguity.

moneme: A term used by the French linguist André Martinet to designate the minimal linguistic unity endowed with significance. Usually monemes are words, but some syllables, such as *re-*, *pre-*, and *-s*, are also monemes, since they have meanings independent of the stems to which they are affixed.

phoneme: The minimal units of all speech, phonemes are the sounds, in themselves nonsignifying, that are composed to make words. The word *cat* has three phonemes: /k/ /a/ /t/. Phonemes are not, however, identical with sounds, but are the restricted set of sounds used by a language to construct meaningful utterances. French, for example, has thirty-one phonemes, even though every French speaker is capable of producing more than thirty-one sounds.

polysemantic (polysemy): Of a sign having multiple meanings or significations.

reference (referential object): Certain signs are said to "refer" to their objects. This is particularly true in the case of indexical signs, which point to an object in the world. Iconic signs, insofar as they resemble an object in the world, may be said to refer to that object, which then becomes the "referential object."

reserve: In the language of art criticism, a reserve shape is a form constituted by leaving a particular area of the canvas blank, thus reversing conventional figure/ground relationships. *Reserve*, however, also has a specific meaning for structuralist thought. Jacques Derrida uses it to designate the reservoir of all the possible, frequently contradictory meanings of a sign. Jean Clay seems to implicate both definitions in his use of the term.

simulacrum: A reconstruction of an event or object in such a way that its internal rules of functioning are manifested. According to Roland Barthes, structuralist analysis is involved in the construction of simulacra, i.e. imitations of an object that do not simply aim to copy it, but rather to render it intelligible. Thus, the simulacrum has been defined by Barthes as "intellect added to object."

spacing: Drawn from the French Symbolist poet Stéphane Mallarmé's theoretical writings on poetry, spacing (*espacement*) designates the blank white spaces that surround words on the printed page. Jacques Derrida has emphasized spacing as a fundamental property of the graphic, as opposed to the spoken, sign. In the visual arts, spacing is used to designate the noniconic elements of a painting.

synchrony/diachrony: Saussure divided linguistics into two separate and mutually exclusive disciplines: the study of language from a diachronic (that is, historical) point of view, concerned with evolution, changes in a language through time, etc.; and the study of language from a synchronic point of view, that is, at a precise moment in time. Synchronic analysis proposes an abstract cut through the flux of linguistic evolution. It therefore represents a suspension or freezing of time.

synecdoche: A term drawn from Classical rhetoric designating a figure of speech in which a part stands for the whole, for example, "fifty sail" for "fifty ships." Synecdoche is frequently interpreted as a form of metonymy, a substitution of one term for another based upon their contiguity, rather than resemblance.

trace: An indexical sign constituted by a deposit on or imprint in a surface or substance. The term is also used by Jacques Derrida to describe the properties of the graphic sign.